Varieties of Visual Experience

ART AS IMAGE AND IDEA

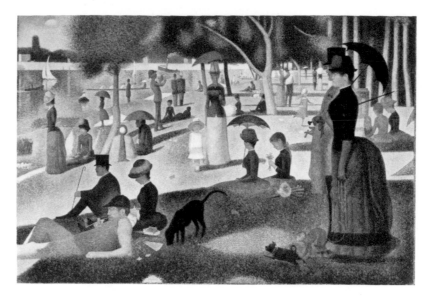

GEORGES SEURAT

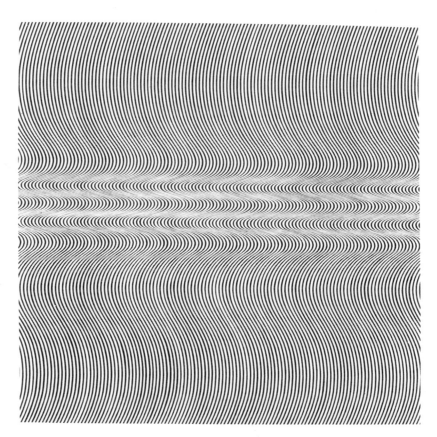

BRIDGET RILEY

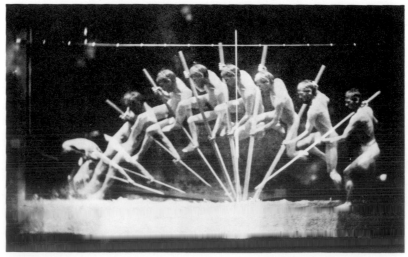

THOMAS EAKINS

Edmund Burke Feldman

PROFESSOR OF ART, UNIVERSITY OF GEORGIA

Varieties of Visual Experience

ART AS IMAGE AND IDEA

Prentice-Hall, Inc., Englewood Cliffs, N. J.

Harry N. Abrams, Inc., New York

SECOND EDITION

TO MY PARENTS

REVISED AND ENLARGED EDITION

Book Design: NAI Y. CHANG

Standard Book Number: 8109-0027-0
Library of Congress Catalogue Card Number: 71-174223

CONTENTS

Color sections are marked with an asterisk ()*

PART FIVE *The Problems of Art Criticism*

PREFACE AND ACKNOWLEDGMENTS

THIS BOOK IS MEANT TO STIMULATE THOUGHT and discussion about art as it enters into our private lives and our common existence. At a time when splendid works of art reference and specialized scholarship abound, only such a purpose seemed to constitute for me a valid reason for adding to the list of books on the subject. My guiding assumption has been that works of art illuminate life as nothing else can. Therefore I have tried to address myself to the recurring features of human affairs as I understand them and as they are known through visual form. This plan has necessitated my dealing with the thematic and utilitarian values of art before taking up stylistic, formal, and technical considerations. Such an approach seemed best for gaining the interest of the reader who wants to know how art is useful in daily life, how it speaks to him, and what it means.

In view of the gratifying reception the first edition of this book received, we decided to retain its basic plan in the present edition. However, important additions have been made: there is a new chapter on the imagery of films and television; discussions of color-field painting, primary structures, the shaped canvas, erotic art, earthworks, and megastructures are now included; a section on texture has been added to the chapter on the visual elements of art; and the material on criticism has been modified in the light of my own teaching and the advice of colleagues. The colorplates have been substantially increased in number and vastly augmented in quality. They have been organized into "visual essays" related to the written text and, it is hoped, are interesting and useful in themselves. So many have responded favorably to our use of visual juxtapositions in the first edition that we have here enlarged their size, introduced numerous new examples, and added a large number of explanatory captions.

Readers of the text and captions may wish to differ with some of my observations and inferences, or with the way they have been formulated. If so, I shall be pleased that they have found this material stimulating enough to porvoke questions, alternative views, or dissent. For my part, art is too important, and we should care too much about it, to be content with bland acceptance or plain indifference to any serious discussion of its uses and merits. As a teacher, I would be disappointed if students had little to say or think about, following any presenta-

tion I had made. Consequently, I hope the written commentary and the implications of the visual comparisons will serve to stimulate further inquiry about the issues which have been raised, both verbally and visually. Indeed, many works of art were selected not because they adhered to any consensus about an irreducible corpus of artistic monuments but because their presentation at a particular place in the text would make a critical point, or test the reader's understanding of some theoretical position, while leading, hopefully, to an appreciation of the meaning and quality of the work itself.

A book that tries to initiate a kind of humanistic dialogue must necessarily grow out of many such dialogues carried on over the years with teachers, colleagues, and students. I was fortunate as a boy to study with men who liked to talk about art while trying to teach me the rudiments of painting and drawing; hence, many important questions were raised for me in casual conversation long before I realized their significance in the world of learning and scholarship. Afterward, through college and university study, I acquired labels for those early questions and categories for their answers. Now I submit them in book form after they have passed through the crucible of so many conversations and encounters with artists and art that I cannot honestly say who is responsible for ideas that I, following a common delusion of authors, believe to be my own. Here let me thank them—teachers, students, colleagues and friends—for what they have given me in countless ways.

The preparation of this volume has entailed the collaborative labors of many able professionals in two fine publishing houses. At Prentice-Hall, I have been indebted to James M. Guiher, Jr. for encouragement in the initial writing of the book and for steadfast support in his role as publisher. To Ronald Nelson's editorial craftsmanship, I continue to owe a considerable debt. Harry Rinehart introduced a number of the visual ideas that we have endeavored to enhance in the more spacious format of the present edition. At Harry N. Abrams, Inc., I have had the benefit of wise counsel from a most experienced and tactful Editor-in-Chief, Milton S. Fox and a gracious Managing Editor, Margaret Kaplan. My thanks are also due to Patricia Gilchrest for editorial help. This volume relies heavily on ingenuity of visual presentation; hence, for the solution of innumerable problems of design and in the coordination of images with text, I am most grateful to Mr. Nai Y. Chang. My overflowing gratitude goes to Barbara Adler and her diligent staff: Susan Bradford, Nancy Klingensmith and Linda Sibley, who have obtained unobtainable photographs and slide transparencies while securing permission to reproduce works of art owned by museums, galleries, institutions and private collectors, near and far, without whose cooperation the task of disseminating our visual culture would be impossible. Finally, I have been most fortunate in my association with a university that provides its professors with a congenial environment for thought and study, teaching and writing.

EDMUND BURKE FELDMAN

Varieties of Visual Experience

ART AS IMAGE AND IDEA

THE FUNCTIONS OF ART

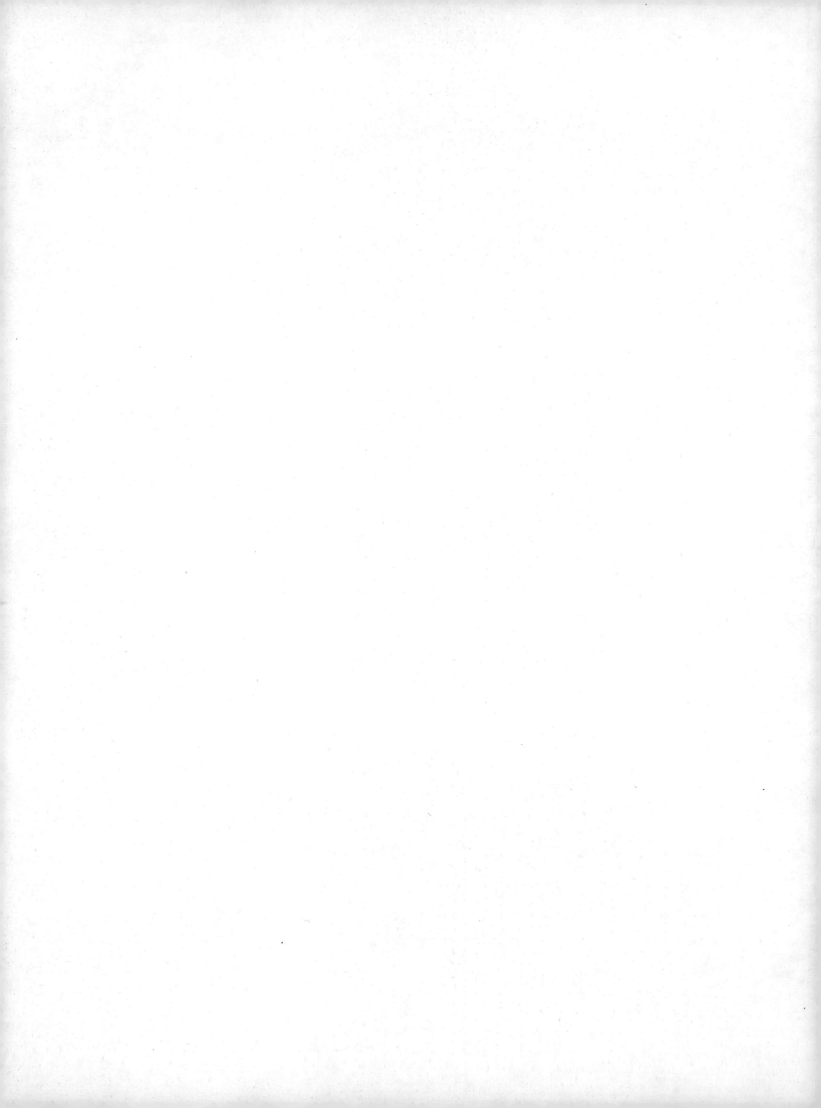

INTRODUCTION
TO *The Functions*
of Art

FOR MANY OF US, THE IDEA THAT ART FUNCTIONS, that it is useful or even necessary in the conduct of human affairs, is novel and is perhaps best greeted with skepticism. We have been conditioned to regard art as nonessential, as the product of man's surplus energy and wealth. Moreover, we think of the fine arts, *les beaux arts*, as being *uniquely* useless—impractical and unnecessary for meeting the fundamental requirements of organized living. Nevertheless, the visual arts have existed, in one form or another, throughout human history, and they appear to be thriving today. How can we explain their survival, and indeed their prominence, for so long under such varying circumstances and among so many diverse peoples? Do human societies tolerate art and artists because of some blunder in the organization of social life? Or is art practiced and prized because it satisfies vital personal and social needs? Clearly, this book is written in support of the latter premise. I hope to show that the visual arts—painting, sculpture, architecture, industrial design, the crafts, and motion pictures—are around us everywhere, employed in a multitude of useful ways in the life of everyone.

Contemporary art, which is known to many persons in its exotic, experimental, and abstruse manifestations, performs essentially the same functions in modern life as did its historic antecedents in other epochs. For art continues to satisfy (1) our individual needs for personal expression, (2) our social needs for display, celebration, and communication, and (3) our physical needs for utilitarian objects and structures. However, if it is granted that art *does* provide us with effective advertising designs, for example, as well as soaring airport terminals and handsomely designed tableware, refrigerators, and typewriters, we are nevertheless curious about how contemporary "extravagances" in paint, concrete, metal, stone, and plastic affect the quality of our lives. We realize that people who sell products need designers to create packages that can attract and persuade other people to make purchases. But what function is performed, or what significant need satisfied, by paint apparently splashed on a canvas which is then displayed for the amazement and/or edification of honest men?

Is there any reason why our time and energy should be spent in trying to understand the enigmatic work of artists who apparently have not taken the trouble to make their meaning clear? Furthermore, what connection, if any, is there between today's art and the masterworks of the past? Answers to these questions—or attempts to answer them—are what the following pages are about.

PERSONAL FUNCTIONS OF ART

Although man is a social animal who must live in groups and communities in order to survive, he does, of course, have a private and separate individual existence. He can never escape the consciousness of other men and their relation to him, but he also feels that thoughts occur to him uniquely, that there are things he feels or does that are his alone. Inside each of us a multitude of events takes place, and it appears to be our nature to tell others about them if we can. To communicate our ideas and sentiments, we use many kinds of languages. The visual arts constitute one of those languages.

As an instrument of personal expression, art is not confined solely to self-revelation; that is, it does not deal exclusively with the private emotions and details of the artist's intimate life. Art also embodies personal views of *public* objects and events that are familiar to all of us. Basic human situations like love, death, celebration, and illness constantly recur as the themes of art, but they can be saved from banality by the uniquely personal comment the artist seems to make about them. For example, adolescence is revealed in a new light by the sculpture of Wilhelm Lehmbruck; the expectation of death hovers over every painting by Edvard Munch; and there is an irrepressible love of living in the people painted by Frans Hals. It does not matter whether Hals's subjects were in fact somber or dreary types; when he paints them they appear to be in a cheerful mood. For the robust citizens he portrays, Hals's pictures may serve as signs of prosperity and contentment. For the artist, they are apparently *opportunities* to display his personal outlook: all in all, when the satisfactions of life are weighed against its hazards and frustrations, it is better to live and enjoy the potential for pleasure in each moment.

Perhaps all works of art function to some extent as avenues of personal expression for the artist. That role does not prevent them from serving other purposes, too. As you look at the examples in this volume, however, it should be quite clear that some works are thoroughly devoted to their official purpose. Others cannot avoid being vehicles, primarily, of the artist's personal vision and sensibility. In the modern world, this personal element has been treasured above all others. Consequently, the personal functions of art may seem today to constitute the very essence of art for artist and viewer.

Art and Psychological Expression

Visual images preceded written language as a means of communication. Here, however, we are not primarily interested in art as a vehicle for imparting information, since other languages have evolved as more effective, or more precise, instruments of communication. But we are interested in visual art as a means of *expressing* the psychological dimension of life.

Why is it necessary to distinguish between communication and expression? One reason is that art is not merely a language for translating thoughts and feelings inside of people into conventional signs and symbols outside of them which others might read; that constitutes communication in the sense that a street sign is communication. Art does this, but it also involves finding and forming lines, colors, shapes, and volumes so that they seem to mean something significant to the artist; that constitutes expression in the sense of painting a picture as opposed to lettering a sign. The materials and techniques of art become the artist's mode of expression; they *embody* his meaning since they help create it and give it objective existence. Without art—which is to say, without the use by man of particular materials in particular ways—there would be no possibility of finding objective expression for certain states of feeling and consciousness. Poems or songs cannot have the same objective meaning as paintings or sculptures about the same subject matter; they embody a different expression, a different set of meanings, because they are made of different materials and employ different techniques. In other words, a painting *of* a tree, like a

poem *about* a tree, is an objectification of feelings and states of consciousness somehow stimulated by the tree and given existence by the materials and techniques needed to create the painting or poem. Without words, syntax, rhyme, and rhythm, there would be no poem. Without colors, shapes, textures, and design, there would be no painting.

In *Man Pointing* by the late Alberto Giacometti (1901–1966), we see the sculptural expression of loneliness, of the individual who is physically and spiritually remote from other men. In a similar vein is Germaine Richier's (1904–1959) *Leaf*. The elongation of the figure in both works, the indistinctness of the bodily parts, the attenuation of the forms, and their general lack of corporeality suggest the difficulty we would encounter in attempting to communicate with the individual, to relate to him in some personal fashion. The figure seems surrounded by silence. The discovery of feelings such as these in sculpture, and of the ideas about man they imply, illustrates how art can be the vehicle for an exceedingly intimate kind of expression. Because the sculpture is not of a distinct individual but rather of a generalized type, we might conclude that the artist is not dealing primarily with the problem of a particular person but is commenting about a universal problem: men multiply their media of communication and the number of messages they transmit to each other, but they do not seem able, apparently, to *reach* each other; we are all isolated.

The feelings expressed by Giacometti and Richier may

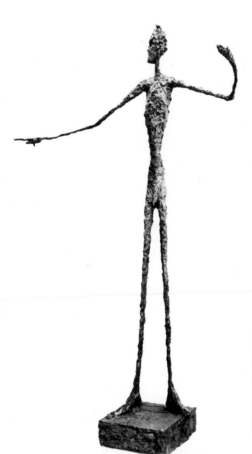

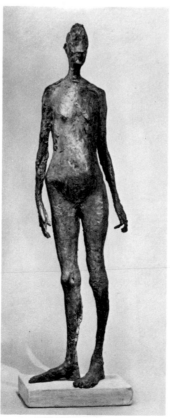

far left:
ALBERTO GIACOMETTI. *Man Pointing.* 1947. The Museum of Modern Art, New York. Gift of Mrs. John D. Rockefeller III

left:
GERMAINE RICHIER. *Leaf.* 1948. The Joseph H. Hirshhorn Collection

The tragedy of Giacometti's man is that he wants to communicate with others but cannot because of his spiritual isolation. Richier's man is a tragic victim or antihero, an ineffectual creature who is destined to fail.

GEORGE GROSZ. *The Poet Max Hermann-Neisse.* 1927. The Museum of Modern Art, New York

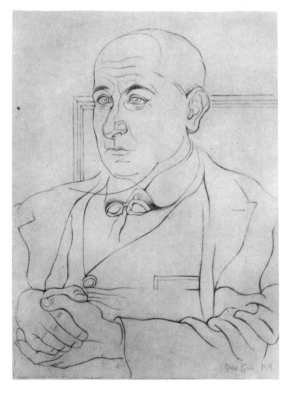

JUAN GRIS. *Portrait of Max Jacob.* 1919. The Museum of Modern Art, New York. Gift of James Thrall Soby

have more or less universal validity, but they are clearly derived from an individual, psychological appreciation of loneliness and remoteness. The portrait of a specific person, on the other hand, has fewer universal implications; it provides one of the principal artistic opportunities to search and probe the personality of an individual. At the same time, the portrait reveals the values of the artist in his approach to the search, in his choice of subject and treatment. In the portrait *The Poet Max Hermann-Neisse* (1927), George Grosz (1893–1959) presents a penetrating "map" of a man. The artist's linear style and powerful draftsmanship, highly developed in his career as a German newspaper satirist and caricaturist, gives us an almost painfully truthful account of the bones of the skull, the veins of the temple, and the worried wrinkles of the face and forehead. The carefully drawn hands, although folded, present in themselves a portrait of agitation. The Total quality of intense brooding is further accentuated by the rumpled clothing, whose folds seem to be in turbulent motion. Any portrait painter possesses the means to ennoble his subject, minimize his defects, and exhibit, in general, the ideal aspects of a person. But Grosz was a caustic, brutally honest reporter; he also seemed to enjoy dwelling on the fact that man is, after all, a peculiar-looking creature. He was obsessed with the moral ugliness of his country and his civilization and used art to express the far from ideal character of everything he saw. Art can embody distaste and aversion, too. Even in a man George Grosz presumably liked (the portrait situation here is intimate), he could not help seeing the frightening countenance of sickness, ugliness, and, possibly, cruelty as well.

The *Portrait of Max Jacob* by Juan Gris (1887–1927) shows a subject of about the same age in a similar pose. But here the effect is much more placid and serene. Indeed, the Grosz seems to express the restless Gothic or Germanic temperament, while the Gris exhibits the more relaxed and classic qualities of the Mediterranean world. The drawing is excellent in the latter, too, but the artist is unwilling to approach caricature; the gentleness of the sitter is emphasized. The artist does not flatter or idealize his subject; rather, he seems to be making a chart of the convolutions of his face, hands, and body, as if in preparation for the execution of a painting. Nevertheless, a quality of gentle humanity and inner repose emanates from the portrait, a work of high accuracy and delicacy of feeling *and also* of penetrating psychological insight.

The portrait is plainly suited to the expression of personality, but the landscape presents a different psychological problem. Still, in *An April Mood* by Charles Burchfield (1893–1967), we see the anthropomorphic possibilities of Nature when man seeks to project his moods upon her. The trees, stripped of leaves, give Burchfield the opportunity to characterize them as witches or druids or heroic relics, and by exaggerating the menacing character

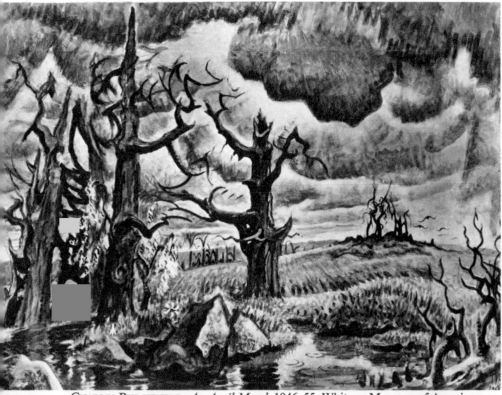

CHARLES BURCHFIELD. *An April Mood*. 1946–55. Whitney Museum of American Art, New York. Gift of Mr. and Mrs. Lawrence A. Fleischman

Two versions of the animation of nature. The Burchfield is theatrical: we feel that the trees are being asked to impersonate people. But Van Gogh truly believes the universe is alive.

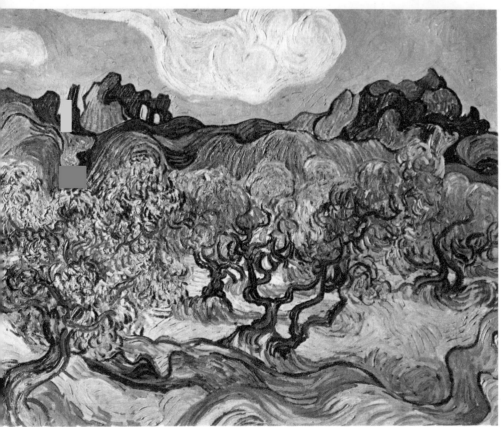

VINCENT VAN GOGH. *Landscape with Olive Trees*. 1889. Collection Mr. and Mrs. John Hay Whitney, New York

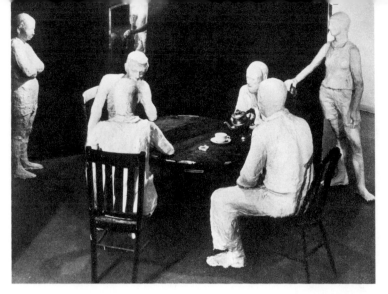

GEORGE SEGAL. *The Dinner Table*. 1962. Schweber Electronics, Westbury, New York

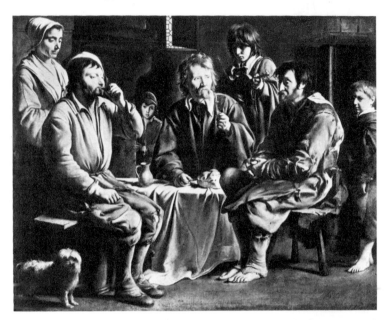

LOUIS LE NAIN. *Peasants at Supper*. 1641. The Louvre, Paris

There is a frozen, static quality about both groups of diners. The immobility of Le Nain's peasants is intended to suggest their fundamental dignity and self-respect. Segal's people, by contrast, are immobile because they seem to have nothing important to do.

of the dark clouds which frame the brightly illuminated forms in the center of the picture, the artist creates a dramatic, emotionally charged stage. Nature provides theatrical occasions, of course, but only because men see in them the working out of their own private dramas of menace and threat, fear and resistance, deliverance and jubilation. Thus, in this painting, the upraised arms of the trees and shrubs seem to be joined in a weird, natural imitation of primitive human sun worship.

An intriguing example of art as psychological expression is seen in George Segal's *The Dinner Table*. Mr. Segal (born 1924) makes sculptures by placing plaster-soaked rags on the bodies of his models. After the plaster sets, the rags are taken off the model and assembled into a single cast plaster figure. His final forms, therefore, are replicas of living forms without the exaggeration or simplification which would result if the sculpture were carved or modeled. The artist then installs his props to create a "real" environment. Segal seems to find his creative role in the identification and organization of commonplace people in commonplace situations; he does not display sculptural virtuosity. The whiteness of the plaster figures, which are quite naturalistic in all respects except color, is contrasted with the complete realism of the actual materials and objects used as props. This whiteness usually suggests the purity of form and idealization of type which we associate with classical Greek sculpture. Instead, we are presented with rather grubby, stolid, ungraceful figures. They are neither ugly nor handsome, strong nor weak; neither friendly, hostile, nor interesting. The artist's theme is *the ordinariness, the banality, the artlessness of our everyday environment* and of many of the people in it. His technique of using plaster-soaked cheesecloths as the actual surfaces of his figures results in a lumpy, torpid quality. The forms lack precision and distinctness, and we ascribe the lack of these qualities to the personalities of the people the artist represents. He expresses their lumpiness, indistinctness, colorlessness, and attitude of indifference; he reveals their placid, vegetable-like character.

Love, Sex, and Marriage

In addition to expressing the varieties of personality and the interaction of culture and personality, art also deals with the perennial themes of love and sex, marriage and procreation. The treatment of love varies from the physical embrace of Auguste Rodin's *The Kiss*, to the maternal affection conveyed by Mary Cassatt's painting *La Toilette*, to the motherly pride displayed in Jacob Epstein's *Madonna and Child*. Humane love is expressed by Pablo Picasso's sculpture *Shepherd Holding a Lamb*, and Aris-

tide Maillol proffers a classicized version of erotic attraction in his relief sculpture *Desire*.

The female figure is commonly used as a point of departure for the expression of a wide variety of personal feelings about love and sexuality. And the work of a single sculptor, Gaston Lachaise (1882–1935), illustrates two interesting variations on a sexual theme. In the *Standing Woman* of 1912–27, the elegance of the figure's hands and feet is combined with an idealization and exaggeration of

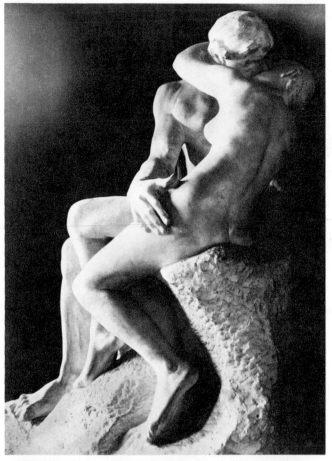

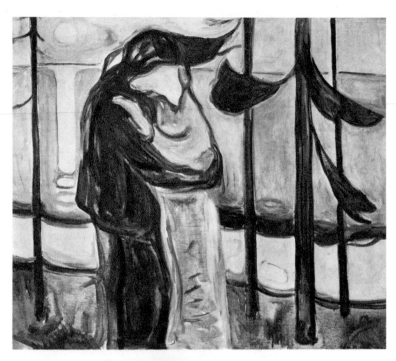

EDVARD MUNCH. *The Kiss*. 1921. Sarah Campbell Blaffer Foundation, Houston. Love as loss of personal identity.

AUGUSTE RODIN. *The Kiss*. 1886–98. Rodin Museum, Paris. Love as tender eroticism.

MARY CASSATT. *La Toilette*. c. 1891. The Art Institute of Chicago. Robert A. Waller Fund. Love as protective concern.

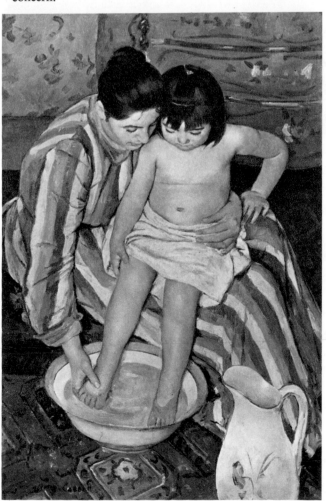

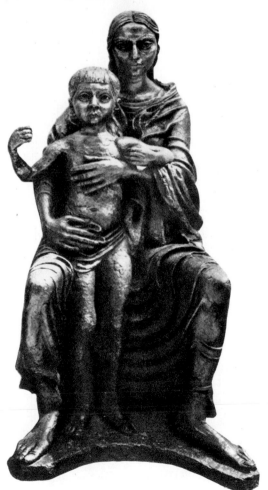

JACOB EPSTEIN. *Madonna and Child*. 1927. The Riverside Church, New York. Love as maternal pride.

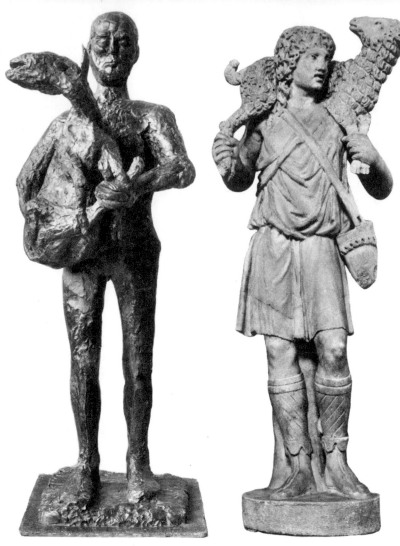

LOVE AS COMPASSION FOR LIVING CREATURES

far left:
PABLO PICASSO. *Shepherd Holding a Lamb.*
1944. Philadelphia Museum of Art. Gift of
R. Sturgis and Marion B. F. Ingersoll

left:
Christ as the Good Shepherd. c. 350 A.D.
Lateran Museum, Rome

LOVE AS THE IMPULSE TO POSSESS

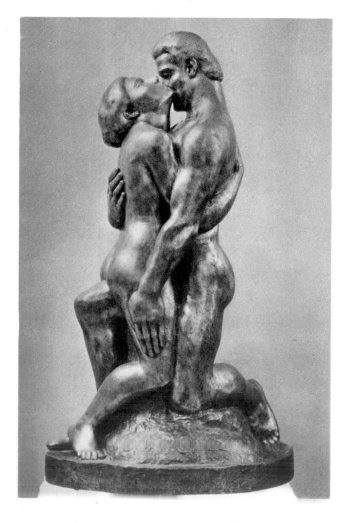

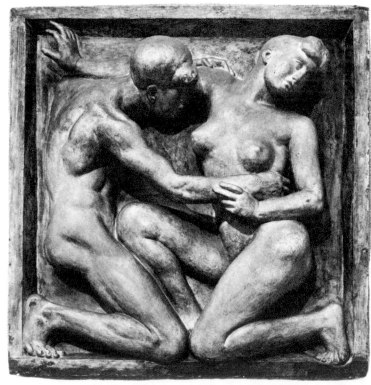

ARISTIDE MAILLOL. *Desire.* 1906–8. The Museum of
Modern Art, New York. Gift of the artist

WILLIAM ZORACH. *Embrace.* 1933. Estate of Wil-
liam Zorach. Courtesy Bernard Danenberg Gal-
leries, New York

the fleshy forms associated with procreation and maternity. The sexual theme is closely related to the maternal, but the eroticism of the whole is tempered by the lightness and terpsichorean agility of the feet and the buoyant grace of the hands. By contrast, the *Standing Woman* executed by the same artist in 1932 reveals a greater exaggeration and stylization of form, with almost athletic emphasis on childbearing and fecundity. The feet are solidly planted in the earth, and the muscles of the shoulders and abdomen constitute an aggressive assertion of the female biological role. With less gentleness in the transitions between forms than in the early bronze, the late figure expresses procreative arrogance, and this emphasis diminishes its ability to suggest any of the tender or romantic meanings of love. In *Reclining Nude*, by Amedeo Modigliani (1884–1920), we see, in contrast to the massive fleshiness of Lachaise, a sinuous and elongated version of the female. She is regarded here as an object of pleasure. Her very sleep is an expression of satiation, of sexual fulfillment, of the subordination of all functions and meanings to the erotic. Finally, we encounter the ultimate abstraction of the female form and function in *Torse Gerbe* by Jean Arp (1887–1966). In the sculpture of Arp, almost all aspects of personality are denied in favor of a kind of impersonal sexual or biological meaning. He carries abstraction of organic forms as far as one can go without losing contact with what is, biologically and psychologically, human.

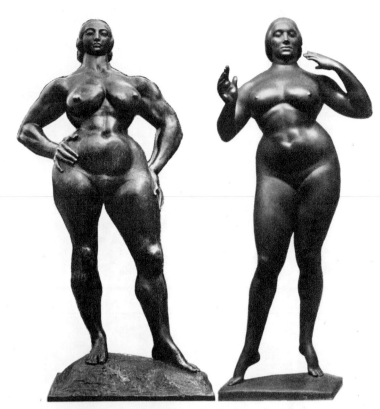

left: GASTON LACHAISE. *Standing Woman.* 1932. The Museum of Modern Art, New York. Mrs. Simon Guggenheim Fund

right: GASTON LACHAISE. *Standing Woman.* 1912–27. Whitney Museum of American Art, New York

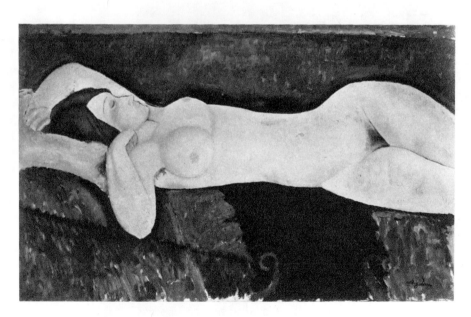

AMEDEO MODIGLIANI. *Reclining Nude.* c. 1919. The Museum of Modern Art, New York. Mrs. Simon Guggenheim Fund

JEAN ARP. *Torse Gerbe.* 1958. Collection Arthur and Molly Stern, Rochester, New York

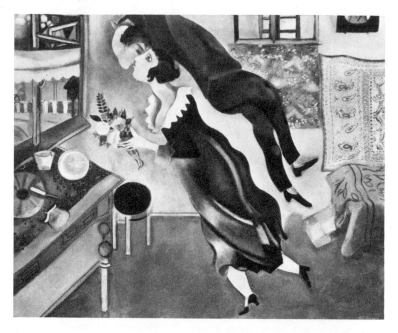

OSKAR KOKOSCHKA. *The Tempest (The Wind's Bride).* 1914. Kunstmuseum, Basel

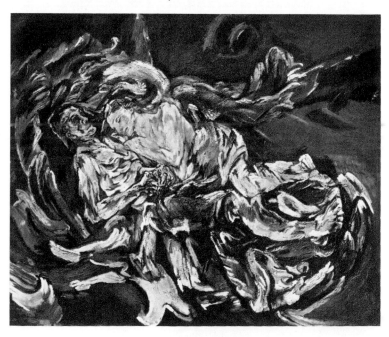

Our culture abounds with references to love in marriage, many of them attempts at cynical humor. A great deal of the humor about conjugal life revolves around the difficulty of sustaining the romantic meanings of love long after a married couple have come to know each other so well that they cannot easily hold on to the mystery and illusion that feed romance. Love as romantic transcendence is most popularly expressed in the work of Marc Chagall (born 1887), as in *Birthday*, which is, with its

childlike celebration by a couple, so much in the spirit of our notions of perpetual courtship: the exchange of gifts on anniversaries; the perpetuation of courtesies and gallantries practiced before marriage; the repeated protestations that romance has not fled. The charm and popularity of Chagall are in good measure traceable to our belief that the substance of love and marriage consists of just such rituals as the one celebrated in *Birthday*.

A somewhat more cynical view of the marital relation is expressed by Oskar Kokoschka (born 1886) in *The Tempest*, or *The Wind's Bride*. Here the pair is seen as swirling in space before a moonlit mountainscape in the background. Love for them, as for Chagall's couple, has performed the miracle of levitation. But while Chagall's people are magically lifted up, Kokoschka's are *swirled*. Words in both titles for the Kokoschka—"tempest" and "wind"—suggest the *sturm und drang*, the storm and stress, of a Germanic conception of human relations in general and of love in particular. As the bride sleeps, wrapped in tender and trusting emotions, the groom stares—starkly and stiffly awake. Although he is physically part of the situation and is also levitated and swirled by the power of romantic love, he remains incapable of suppressing feelings of gloomy foreboding.

Carl Hofer (1878–1955) in *Early Hour* carries the theme of *The Wind's Bride* one step further to disillusioned domesticity. The crisp morning light reveals the husband, already awake, dispassionately contemplating the sleeping form of his wife. The dog asleep at the foot of the bed completes the picture of familial routine. The face of the man is not one of anxiety or apprehension as in the Kokoschka; rather, its leanness, combined with the man's baldness, creates an ironic impression of asceticism, of intellectual resignation to the dilemma of marriage. It is interesting that in both Germanic works on marriage, the wife is shown in contented sleep, while the husband is apprehensively awake in the moonlight or skeptically contemplating the plain truths of domesticity in the clear light of morning. In the American conception of love and marriage, at least as expressed in films, the husband apparently suffers neither qualms nor regrets; neither does he indulge in dark speculation about the fate of his manhood under the constraints of domesticity. In painting, this attitude is expressed by the sophisticated realism of John Koch (born 1909) in *Siesta*. Unlike his continental counterpart, the American male apparently experiences marital love as a casual, uncomplicated episode in the normal routine of everyday life.

Another expression of the marital theme is seen in *Conjugal Life* by Roger de la Fresnaye (1885–1925). Here, in a work by an early follower of Cubism, the process of breaking up the figures and converting them into geometric forms has begun and is most visible in the treatment of the hands and faces. But correspondence to visual

CARL HOFER. *Early Hour*. 1935. Portland Art Museum, Portland, Oregon. Love as a domestic quandary.

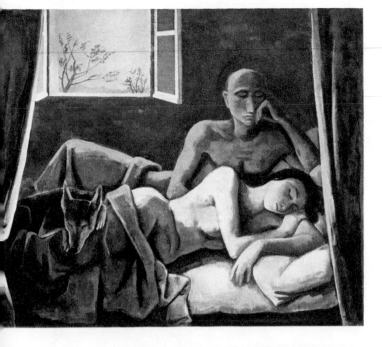

JOHN KOCH. *Siesta*. 1962. Private collection, Durham, North Carolina. Love as an extension of upper-class leisure.

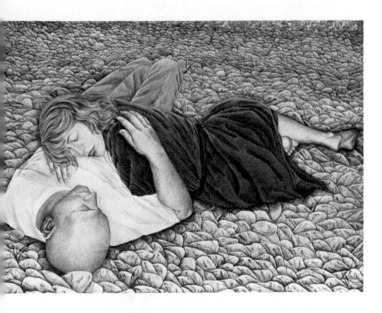

BARBARA ADRIAN. *Bed of Stones*. 1964. Collection Mrs. Alexander Rittmaster, Woodmere, New York

LOVE AS A PROLETARIAN TRIUMPH OVER THE REQUIREMENTS OF COMFORT

BURT GLINN. Photograph of Russian couple at Sputnik Beach on the Black Sea. 1967

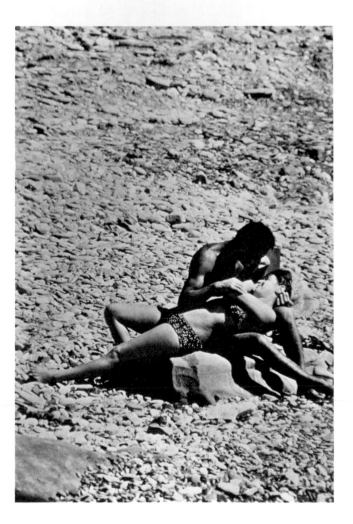

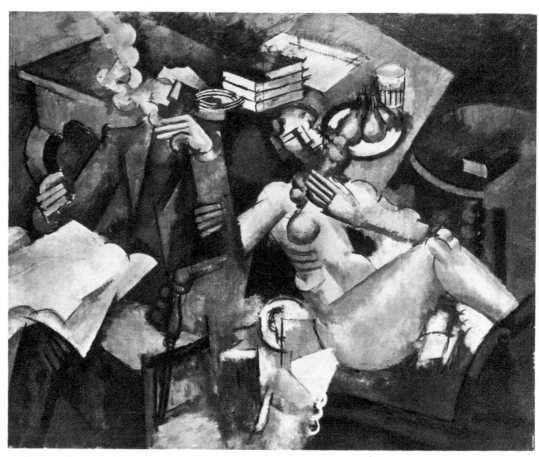

Roger de la Fresnaye. *Conjugal Life*. 1912. The Minneapolis Institute of Arts

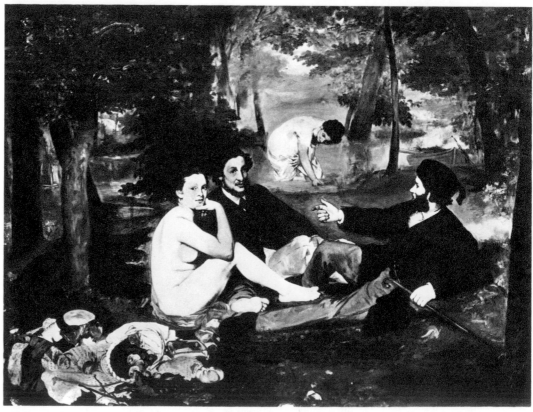

Edouard Manet. *Le Déjeuner sur l'herbe*. 1863. The Louvre, Paris

reality remains strong, sufficiently strong to resist the depersonalizing effects evident in fully developed Analytic Cubism. There is about this couple a casual, comradely quality which is accentuated by the matter-of-factness of the woman's being nude while her clothed husband reads the newspaper and enjoys his pipe. Their relationship seems to exhibit a kind of mutual indifference based on the familiarity and comfortable intimacy of the long-established marriage. The composition of the painting strengthens this idea through the manner in which the figures lean on each other, while the principal lines and masses tend to seek the center and to lock the figures into a tight formal structure. There is a slight resemblance between the female figure in this work and the one in *Le Déjeuner sur l'herbe (Luncheon on the Grass)* by Edouard Manet (1832–1883), where we also find a scene of relaxation in which clothed male figures are juxtaposed with the female nude. The Manet painting, executed in 1863, caused a great scandal because of this association and because of the contemporary, as opposed to classical or allegorical, treatment of the subject matter. However, the work of La Fresnaye is much less shocking since the subject is *conjugal* life and the Cubist style has shifted emphasis from any hint of eroticism to the manner of organizing forms in pictorial space.

Clearly, the many meanings of love find varied expression in contemporary art. If one quality can be said to characterize the modern approach to the subject, it is candor and, with notable exceptions like Chagall, a refusal to sentimentalize romance. On the contrary, a bitter comment on marriage, such as is seen in *Couple* by George Grosz, is probably a more accurate, if exaggerated, expression of contemporary feeling about the institution which St. Paul said was preferable to burning.

In summary, the attitudes which artists express toward women and marriage in their work can serve as an interesting index of values prevailing in their particular cultures. Such works also constitute evidence of the capacity of art to deal with intimate psychological themes in all their variety and subtlety. In Lachaise we found the sexual-reproductive attributes of woman glorified, but at the expense of her femininity and completeness of personality. And in Modigliani we saw frank admiration for the

GEORGE GROSZ. *Couple*. 1934. Whitney Museum of American Art, New York

sexual-hedonic qualities of woman: once again, she was a useful *thing*, but not a person. For Chagall she was a little girl; for Kokoschka and Hofer an enigma, a source of puzzlement; for La Fresnaye a comfortable article to have around the house. These themes and attitudes are not new; they confirm what men have always known—that the holy bond has its problematic aspects. The contemporary artist, however, has been candid enough, or perhaps tactless enough, to say so.

Death and Morbidity

Death has fascinated and frightened man from his earliest records to the present moment. He has never been able to solve to his emotional satisfaction the mystery of how vitality and personality inhabit matter during one instant and depart from it in another. From the paleolithic portrayal of dead animals in the dark recesses of caves to the primitive African sculptures of departed chiefs and ances-

tors (see the figure of a chief from the Belgian Congo), art has given form to man's attempt to understand, if not to master, the fear and enigma of death. While science advances in its ability to control the causes of death, art expresses the anxiety of contemporary man about the finality of death. Art has always done so. Indeed, sculpture, particularly, had its origins in ancient efforts to

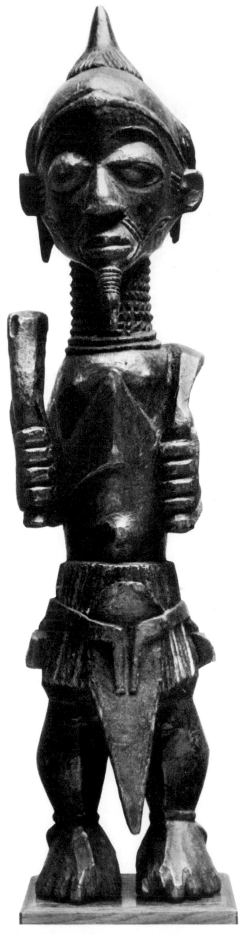

Figure of a chief, from Bena Lulua, Belgian Congo. 19th century. Copyright 1971 by The Barnes Foundation, Merion, Pennsylvania

provide a lifelike body for the departed soul to inhabit. The monuments of Egyptian art were, in their principal motivation, enormous state-supported enterprises aimed at overcoming the anxiety which attends the death of a king who is revered as a god. It might be said that the modern artistic treatment of mortality represents an extension of the anxiety and concern which everyone feels, but which in ancient times was given expression mainly for the benefit of chiefs and kings.

ARTISTIC EXPRESSIONS OF MORTALITY

A lithograph by Käthe Kollwitz (1867–1945), *Death and the Mother*, vividly expresses the almost insane terror which grips a mother whose child is about to be taken. The imagery gains some of its symbolic force from medieval personifications of the devil as the emissary of death. Notwithstanding our emergence from such superstitions, this work is deeply disturbing since it exploits fears which we find difficult to suppress. An impersonal phrase like "infant mortality" is here given powerful emotional content, so that one experiences dread and the impulse to strike out against the death symbol.

A strange portrayal of mortality or of fate occurs in *Death on a Pale Horse (The Race Track)* by the American painter Albert Pinkham Ryder (1847–1917). Here the symbol of death carries his conventional attribute, a scythe (to cut down lives), as he rides a white horse around a race track. No one is present to view the sinister race, which curiously involves no competitors. Like other paintings by Ryder, this work looks as if it were dreamed. (It *appears* to have been dreamed. Actually, the painting was created in response to the death of a waiter Ryder knew, a man who gambled his savings on a horse race, lost his money, and committed suicide. But we should not let the actual motivation for creating the painting interfere with any reasonable interpretation we can make of the final result.) See Chapter Sixteen for a discussion of interpretation. Although the figure is unmistakably the specter of death, the question remains, how does he accomplish his grim task? Perhaps the artist's mythic imagination is at work. The ancients, for example, believed in myths which described the world as being held by a thread, or as being supported by a brawny god condemned or tricked into taking it as his burden. Does Ryder's painting mean that death continues to take souls so long as his mysterious figure continues to race around the track with his scythe held aloft? Is the track a symbol of the *orbis terrarum*, the circle of the lands, the world? If so, we have a magical *explanation* of death, a primitive use of cause and effect which operates in dreams and in myth but which our waking minds will not accept. Unlike the Kollwitz, this work is not disturbing: it lacks her vivid realism, and the victims of death are not seen—they are an absent, abstract multitude. If this interpretation of the

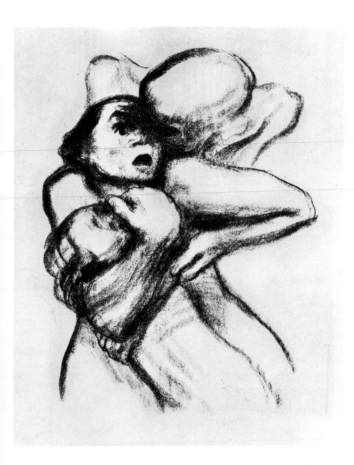

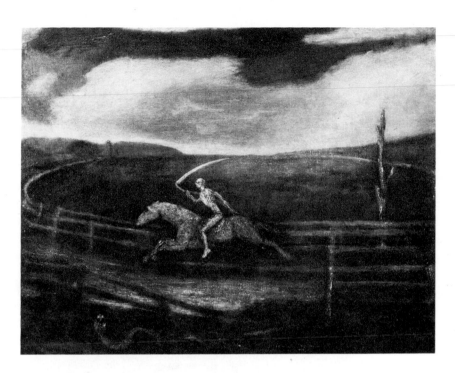

KÄTHE KOLLWITZ. *Death and the Mother*, 1934. Collection Erich Cohn, New York

ALBERT PINKHAM RYDER. *Death on a Pale Horse (The Race Track)*. c. 1910. The Cleveland Museum of Art. Purchase, J. H. Wade Fund

painting is correct, the rider, the horse, and the track represent the operation of an inevitable process—the universal, necessary passing away of lives contingent upon the race of Death around a magic circle.

The Dead Mother by Edvard Munch (1863–1944) is a work of infinite pathos in its feeling, not so much for the mother, who is beyond suffering, but for the child, who holds her hands to her ears as if to stop the *sound of death*. This is a work whose psychological realism is more thoroughgoing than that of Kollwitz, who employs conventional death symbols. Munch confronts the actual death scene and, in particular, studies its impact upon a child. The child is not too young to understand the full meaning of the event, yet she does not possess adult mechanisms for protecting herself, for softening the blow. The date of this painting is 1899–1900, a time when the confrontation of harsh reality and strong emotion was not encouraged in art, and was avoided, if possible, in life. In Edvard Munch we have a model of the heroic artist who is not afraid to employ his skill to examine real life, using the best available tools of psychological analysis and visual investigation to carry out the task.

The Passion of Sacco and Vanzetti by Ben Shahn (1898–1969) deals with the death by execution of two men convicted of participating in an anarchist bombing. The mourners are represented as "respectable" members of society who have somehow played a role in the miscar-

riage of justice leading to the execution of the men. The background shows the courthouse and a portrait of a jurist taking the oath. In a scene heavy with irony, lilies, symbols of resurrection, are carried over the open coffins of the dead men, illiterate but not ignorant immigrants who were unfairly tried by a highly prejudiced judge. Shahn reveals Sacco and Vanzetti in death as defenseless, foreign-looking, harmless. Their mourners look guilty and hypocritical. The picture is a work of moral and social indignation: outrage at the society which takes such cruel vengeance, and compassion for the two "little" men caught up in large events which destroyed them. In this work, death is not a mystery or an adversary to be overcome. Death is understood as the very matter-of-fact, logical consequence of man's mistreatment of man. Our emotions are mainly enlisted against the entire human and social apparatus which kills. But the fact of death itself is treated quite objectively and dispassionately.

In *Girl Before a Mirror*, Pablo Picasso (born 1881) represents some of the morbid anticipations of a young girl as she becomes aware of her impending biological role in womanhood. A kind of X-ray representation of the actual figure on the left and her reflection in the mirror on the right shows the spinal cord and the shapes of internal organs related to reproduction and the nurture of the young. The serene and innocent face of the girl is reflected in the mirror by a dark, hollow-eyed visage, surrounded

BEN SHAHN. *The Passion of Sacco and Vanzetti.*
1931–32. Whitney Museum of American Art,
New York. Gift of Edith and Milton Lowen-
thal in memory of Juliana Force

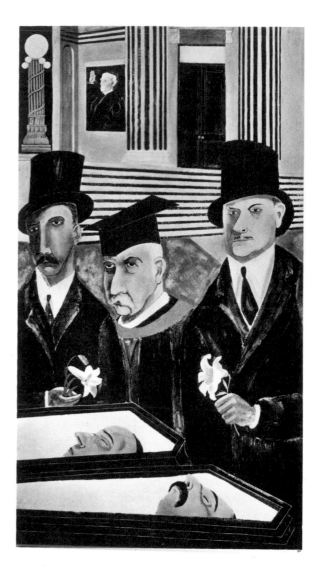

EDVARD MUNCH. *The Dead Mother.* 1899–1900.
Kunsthalle, Bremen

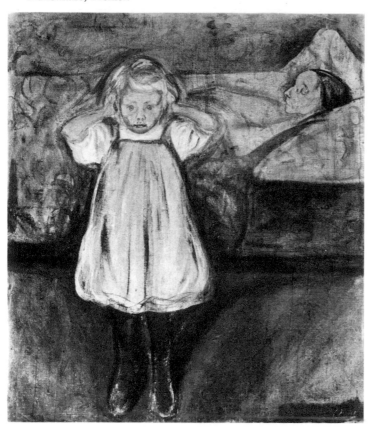

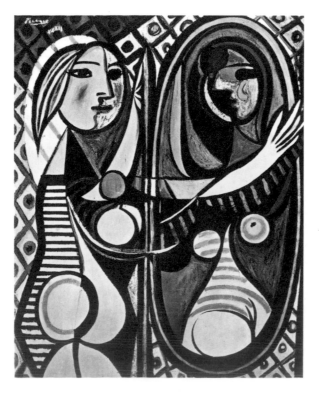

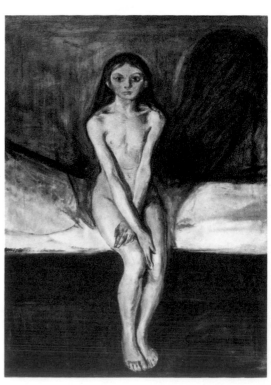

by black and blue moon-shaped crescents. The head on the left is partly surrounded by a bright halo, a sunny nimbus, with a bright yellow passage on the side where a shadow would be expected. This clear-eyed "sun-face" can be seen as a symbol of unclouded youth and vitality; the "moon-face" in the mirror presents the fearful aspect of death. The girl's arm is shown in motion, reaching across to the mirror and to the apparition which holds the image of her fears. Since the painting is divided vertically into two equal parts, the arm moving across the picture serves to unite the halves compositionally, and, which is more important, psychologically. It is a gesture which represents the end of innocence and a touching expression of sympathy for that other self—the self which may die in the act of bringing life into the world. The painting constitutes a remarkable achievement of sympathetic imagination and insight on the part of a man into the understandable apprehensions of a girl emerging from adolescence. It should be compared to the more naturalistic treatment of the same theme by Munch in *Puberty*, an equally haunting work, and to the lithograph *Adolescence* by the English artist Charles Brockhurst (born 1890).

ARTISTIC EXPRESSIONS OF ILLNESS

Just as the modern expression of love tends to be characterized by candor and a certain skepticism so far as marriage is concerned, the art of our time also confronts illness and disease frankly, almost clinically. The artist, of course, is not interested in pathology from a medical standpoint but only as part of the human condition. The artist is not fascinated with the details of morbidity for its own sake but rather refuses to ignore a whole dimension of experience which helps to define man.

One of the earliest nineteenth-century treatments of mental illness is seen in the *Madwoman* of Théodore Géricault (1791–1824). The artist scrutinizes the woman as carefully as she herself apparently examines some real or imagined threat. She seems to be terrified and deluded at once. But without our knowledge of the subject and title of the painting, would we not interpret this work as a shrewd study of character, as the portrait of a somewhat suspicious, possibly eccentric French peasant woman? The painting by Géricault should be compared with *The Madwoman* by Chaim Soutine (1894–1944), which was painted in 1920, approximately one hundred years later. Here the artist attempts to convey to the viewer the *experience* of the sick person. She is presented as trembling with fear, and there is no question in our minds that she is mentally ill. Although Géricault maintains his objectivity about the subject, Soutine employs his painterly technique to enter into the life of the subject. The earlier painter is usually classified as a Romantic because his choice of bizarre and emotionally laden subject matter constituted an effort to deal with the intensity of man's inner life by describing his abnormal behavior, his reactions in emergencies, his loss of rational control under stress. Soutine is called an Expressionist because of his subject matter and also because of the distorted, agitated style he used to render his theme. The Expressionists took the Romantic interest in violent and extreme themes and directed it toward the act of painting itself, which became a record of the convulsions of form. Its imagery reflected the artistic reaction to social injustice and personal struggle. The frightened eyes and tortured hands of Soutine's

opposite page left:
PABLO PICASSO. *Girl Before a Mirror*. 1932. The Museum of Modern Art, New York. Gift of Mrs. Simon Guggenheim. Anticipating her womanly role, a girl confronts a premonition of her own death.

opposite page right:
EDVARD MUNCH. *Puberty*. 1895. National Museum, Oslo. The crisis of adolescence experienced as biological dread.

left:
CHARLES BROCKHURST. *Adolescence*. 1932. Syracuse University Art Collection. The onset of womanhood is discovered in a magical awareness of the body's opulence.

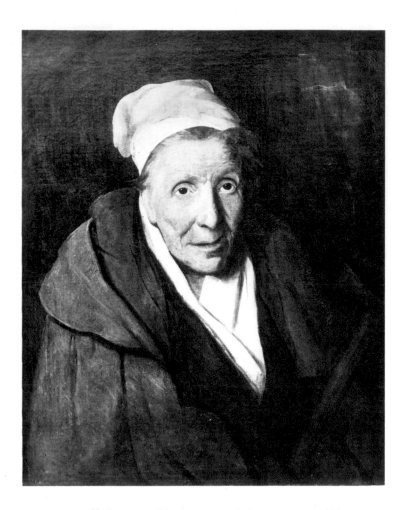

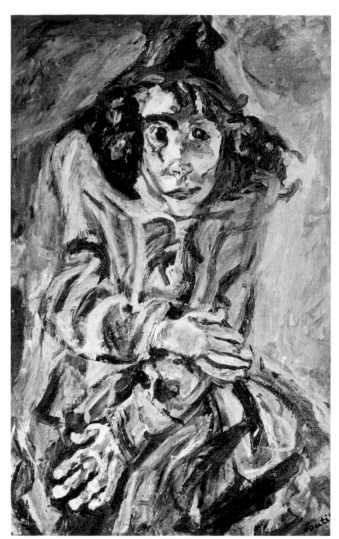

THÉODORE GÉRICAULT. *Madwoman*. c. 1821.
The Louvre, Paris

CHAIM SOUTINE. *The Madwoman*. 1920. The National
Museum of Western Art, Tokyo. Presented by Mr. Tai
Hayashi, 1960

woman bespeak her illness but also transcend it, as we recognize in her a fellow human being who suffers.

The Frugal Repast, an etching Picasso executed when he was himself young and very poor, portrays a gaunt, emaciated couple. The man is blind. The drawing emphasizes their almost starving condition and also offers the artist an opportunity to attenuate their hands and bodies, endowing them with a languid as well as skeletal quality. Although the man is afflicted and both are plainly undernourished, the couple seem resigned to their situation, and the artist does not attempt to tax our normal sympathies. They have some food and each other. Neither the handicap of blindness nor the condition of extreme poverty is regarded as a deterrent to enjoying the fullness of life. The etching is a highly civilized tribute to romantic love which does not degenerate into mawkish sentimentality. What appears at first to be a morbid interest in the effect of malnutrition upon lovers becomes a human triumph over serious deprivation. The weakness caused by hunger is converted into tenderness, as the artist discovers a peculiar kind of amorous beauty in their withered bodies.

Our political and social leadership has lately taken a serious interest in improving the lives of the poor, and consequently the nation as a whole has begun to study the details of social and personal pathology which flow from deprivation, especially when it extends over several generations. But it should not be thought that artists, in works such as *The Frugal Repast*, are attempting to gloss over the reality of poverty, to minimize the need for social and economic reforms by appearing to mitigate its consequences. Some artists, to be discussed subsequently, create works designed to *encourage* changes in social life. It is nevertheless an abiding trait of art, as opposed to politics, to reveal the values people can create in any situation or condition in which they happen to find themselves. Puccini's romantic opera *La Bohème* deals with a theme similar to Picasso's, the composer creating aesthetic values out of the love of a consumptive, dying girl for an impoverished poet. Picasso's etching, made in 1904 when

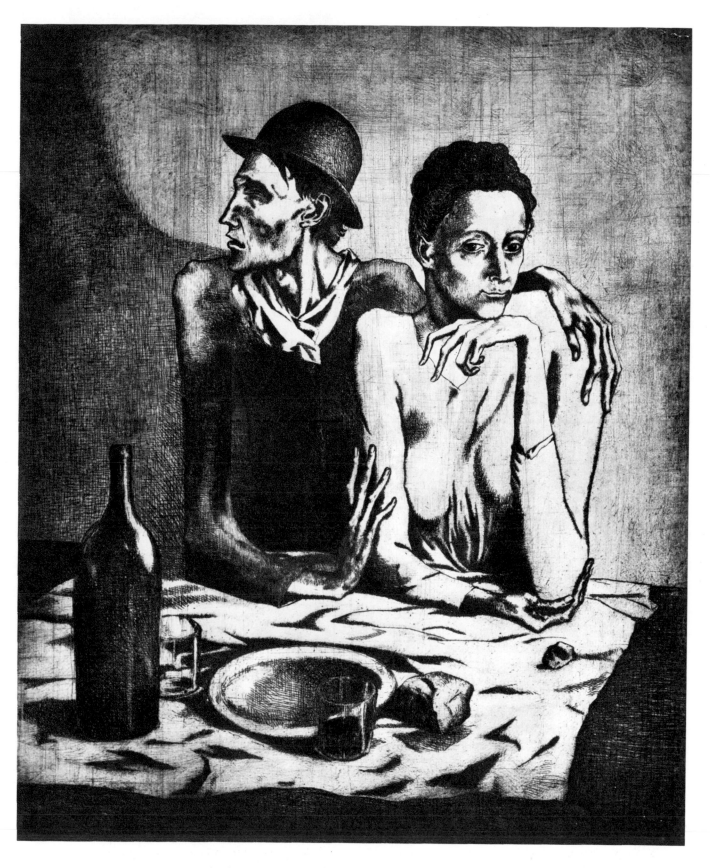

Pablo Picasso. *The Frugal Repast*. 1904. The Museum of Modern Art, New York.
Gift of Abby Aldrich Rockefeller

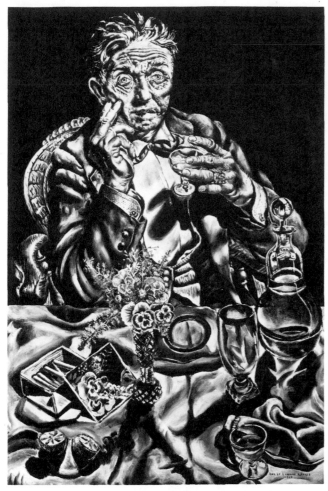

IVAN ALBRIGHT. *Self-Portrait*. 1935. Collection Earle Ludgin, Chicago

Photograph of Melvyn Douglas as he appeared in the CBS Television Network presentation "Do Not Go Gentle into that Good Night." 1967

The institutionalization of aging in our culture leads to a variety of indignities: segregation of old people, organized games for grandparents, and the horrid bureaucratic designation "senior citizen."

the artist was twenty-two and presumably as ardent a votary of tragic love as any hero of Puccini, followed by ten years the first performance of *La Bohème* in 1894. Both of these men succeeded in creating works which depend for their emotional effectiveness on the idea of love sustained and carried to intensity *because of* affliction and *in spite of* the world's opposition.

There is an aesthetic—which is to say, a system of ideas about art—based on the experience of illness and the general decline of vitality. In Géricault and Soutine, we saw this interest as part of a legitimate concern with the total human condition. In Munch, death constituted an omnipresent fact of life, although, in the judgment of some, his total artistic production may betray a neurotic obsession with the inevitability of death. In Shahn's *Passion*, the culmination of a whole series on Sacco and Vanzetti, we encounter death as part of a satiric-ironic statement about injustice. Although the work as a whole belongs to the tradition of social protest, it is also a personal expression of the pathetic death of two simple men.

In Picasso's etching we see the outcome of an aesthetic development in which the signs of affliction or deterioration have acquired a sympathetic, even erotic, significance. In Ivan Albright's *Self-Portrait* and Karl Zerbe's *Aging Harlequin*, decline and a certain ugliness associated with senescence (compare Ghirlandaio's *An Old Man and His Grandson*) are recorded in fascinating detail. Zerbe (born 1903) endeavors to enlist compassion for the harlequin and views him in a dignified light despite his ravaged countenance. Albright (born 1897) presents himself with familiar personal objects, drinking champagne and contemplating with equanimity the fate which is clearly detailed in his face. This artist portrays aging not so much as a psychological or spiritual condition but as a stage of life in which the processes of disease and deterioration have grown progressively stronger than the forces of vitality and renewal.

Perhaps the ultimate fascination with deterioration is

seen in the work of Hyman Bloom (born 1913) and of Alberto Burri (born 1915). Bloom, an American painter, reveals in *Corpse of an Elderly Female* a fascination with death and decay unmitigated by any artistic device which might soften its clinical accuracy. Bloom's interest in dissection and in cadavers can be interpreted as a reaction to the slaughter which took place during World War II. Thus, the carnage which characterizes our recent history, added to a fascination with the painting of flesh, as exemplified by Rembrandt's *Slaughtered Ox*, possibly accounts for Bloom's choice of theme. Working abstractly, but with a different clinical emphasis, is the Italian artist Alberto Burri. His *Sacco B.* is made of burlap sacking stretched and sewn around what appears to be an open wound or incision. Burri, who was a military doctor, creates compositions which seem to be visual variations based on surgical operations, the dramatic focus of which is the opening in the flesh. One can view them as organizations of gauze, burnt wood, burlap, and other materials,

but their arrangement seems to have a hidden purpose. When the rents in the sacking are seen as the result of some mysterious surgery, Burri's surfaces become animated with meaning: they are related to disease; wounds and surgery are presented as a kind of primitive handicraft; and a rather disorderly death seems to hover over the whole. It is a far cry from the Thomas Eakins painting of modern surgery in 1889, *The Agnew Clinic*, with its progressive and optimistic presentation of surgical technique.

Although examples could be multiplied, we have seen how one of the personal functions of art—in the modern era as in the past—is the confrontation of death and all its attendant events and feelings. If art does not help us postpone death or the decline of our powers, it *does* help us to face the experience, to see it as part of the gamut of living. Art expresses our fears, curiosities, and aversions concerning death, and in so doing adds to the interest and variety of life.

KARL ZERBE. *Aging Harlequin.* 1946. Collection Dr. Michael Watter, Washington, D.C.

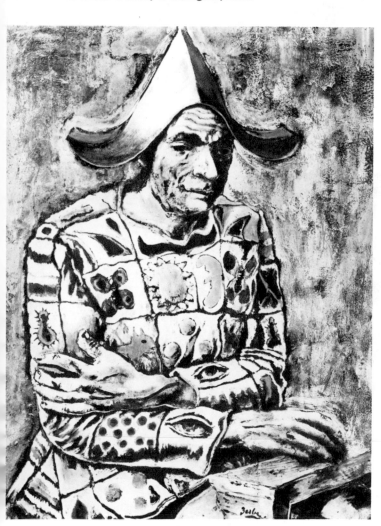

DOMENICO GHIRLANDAIO. *An Old Man and His Grandson.* c. 1480. The Louvre, Paris

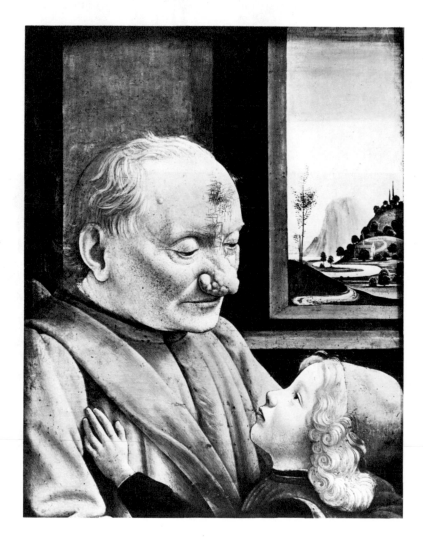

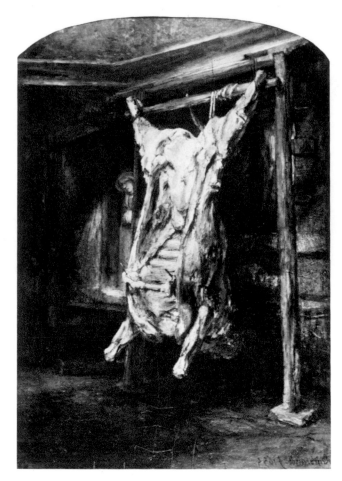

REMBRANDT VAN RIJN. *Slaughtered Ox*. c. 1655.
The Louvre, Paris

HYMAN BLOOM. *Corpse of an Elderly Female*. 1945.
Whereabouts unknown

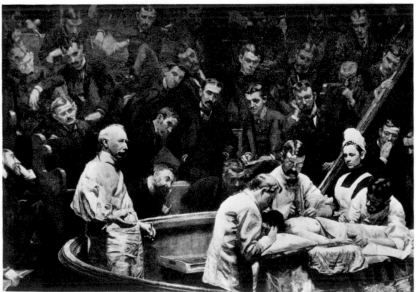

THOMAS EAKINS. *The Agnew Clinic*. 1889. The University of Pennsylvania,
Philadelphia. The ritual of surgery portrayed as a triumph of mind over flesh.

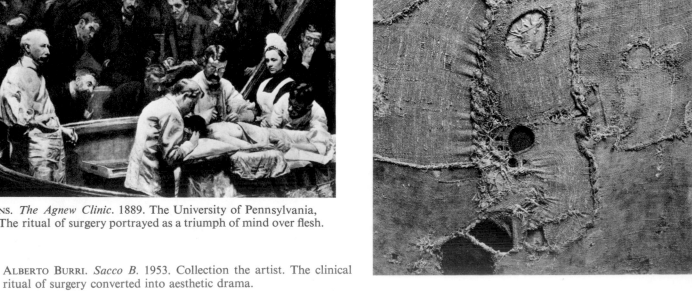

ALBERTO BURRI. *Sacco B*. 1953. Collection the artist. The clinical
ritual of surgery converted into aesthetic drama.

Spiritual Concern

We should distinguish between an art of spiritual concern and religious art. Usually, religious art is the expression of collective ideas about man in his relation to divinity. Sometimes it possesses spiritual qualities. But at other times, even when it is successful in its mission, it functions chiefly as education or history or as a kind of visual preaching. Nonreligious art may evince spiritual qualities, as in Van Gogh's *The Starry Night* (see p. 40); yet ostensibly religious art may have little spirituality, as in *Christ Preaching at Cookham Regatta* by Stanley Spencer (born 1891). Rouault's works, in contrast, possess spiritual content whether the subject matter is sacred as in *Christ* or secular as in *Three Clowns*.

What can account for this paradox? Religious art tells a sacred story, or enjoins right behavior, or endeavors to sustain faith. But spiritual art endeavors to be a revelation of the divine in human nature and in the world. That is to say, spiritual art tries to declare the immanence of the divine in the world, often finding it in unexpected places. But it does not come to us with appropriate labels, and its creators may not necessarily think of their work as having a spiritual quality. Furthermore, spiritual art expresses the *questions* an artist may have about man's place in the universe, whereas religious art tends to deal with the *answers* which have been institutionally established. We might define spiritual concern, so far as the present discussion is concerned, as *the personal search for ultimate values through art.*

For a certain kind of artist, work is an effort to discover meaning in the world through the materials, processes, and stylistic language of art. Particularly in the modern era, the artistic enterprise is identified with search, investigation, and inquiry. In the past, artists, like other men, were more certain about the meanings and purposes of life; hence, they tended to concentrate mainly on giving elegant and finished expression to the commonly accepted conceptions of man and existence. But the modern era has witnessed a profound change in the artistic expression of values. The industrial, scientific, and political revolutions of the eighteenth century ultimately caused an almost universal questioning of traditional dogmas and philosophies about the nature of man, the purposes of his existence, his relations to other men, and his relation to the divine. And although these dogmas and assumptions have been questioned or sometimes abandoned, our era has not been especially successful in providing alternative assumptions which remain tenable even for the period of one lifetime. In other words, the intellectual, spiritual, and artistic activity of our time has been devoted to questioning and searching. Consequently, works of art which deal with personal values are characterized more by the expression of doubt and

uncertainty than by conviction and the assumption that artist and public share some orthodoxy.

It is common to contrast the religiously centered art of the Middle Ages with the secular, "religiously indifferent" art of the present era. But this contrast is misleading. One could cite the considerable artistic effort which is expended today in the design of sacred buildings and in the

STANLEY SPENCER. *Christ Preaching at Cookham Regatta: Series No. VI: Four Girls Listening.* 1958. Arthur Tooth & Sons, Ltd., London

GEORGES ROUAULT. *Three Clowns.* 1917. Collection Joseph Pulitzer, Jr., St. Louis

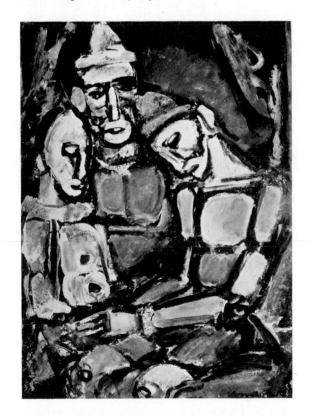

creation of liturgical art objects to enhance and facilitate religious worship. It is quite obvious, also, that Le Corbusier's chapel at Ronchamp and *Menorah* by Seymour Lipton (born 1903) constitute examples of religious art because of their use in worship. But it is less evident that works without plain religious utility and connotation are expressive of the artist's spiritual aspiration and concern.

The Starry Night of Vincent van Gogh (1853–1890) is evidently a picture of a village at night, with particularly prominent cypresses in the foreground and exaggerated concentric and spiral emanations of light from the stars and the moon. But the flamelike shapes of the trees and the brushwork in the hills and sky tend to animate the entire scene so that everything appears to be alive and in motion. Only the houses and the church are relatively at rest. The artist endows the common features of the landscape with a kind of life they do not normally seem to possess. This sense of the aliveness of all things, not excepting inanimate objects, characterizes Van Gogh's work even when he paints a chair or shoes. For him, the distinctions between organic and inorganic, animate and inanimate, or void and mass do not exist: all of creation

exhibits the divine presence. And for those of us who do not possess the spiritual gifts of Van Gogh, the experience of his paintings constitutes a glimpse into a hallowed world—an opportunity to share in his "God-intoxicated" perception.

In *Christ* by Georges Rouault (1871–1958), we have a religious subject which also exhibits the distinctive spirituality with which this artist endows all his work. It is noteworthy that there is very little iconographic material in the painting—no conventional symbols or gestures or details of dress which might clearly identify Jesus and two of his apostles. We have only the downcast countenance of Christ and the vaguely Middle Eastern head clothing of the disciples. As men, they are characterized by intensity and a certain plainness if not coarseness of feature. They are also crowded together very closely, as in the photographs one occasionally sees of very humble people. Rouault's use of heavy black lines serves not only to bind the composition together and strengthen the impact of the forms but also to emphasize the sorrowful quality of this close-knit group.

What qualities of the work account for its spiritual character? The first is the similarity, with minor differ-

The useful and the secular often converge in the spiritual: Van Gogh's painting begins with an everyday theme and culminates in a mystical statement; Lipton and Tinguely begin with liturgical function and end by expressing spiritual concern.

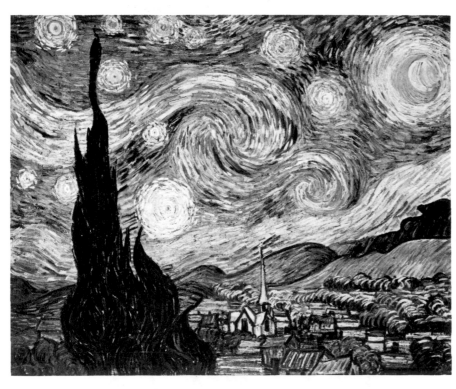

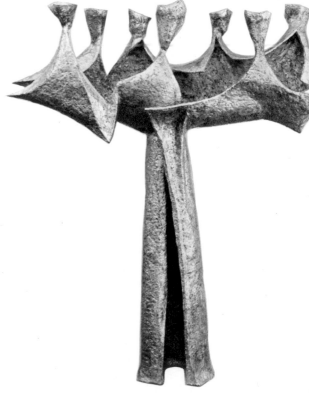

VINCENT VAN GOGH. *The Starry Night*. 1889. The Museum of Modern Art, New York. Lillie P. Bliss Bequest

SEYMOUR LIPTON. *Menorah*. 1953. Temple Israel, Tulsa, Oklahoma

entiations, of the three men. They are thus able, collectively, to symbolize all men, humanity. Although the Christ figure is the most highly individualized, we view the men as a group rather than as a series of distinct personalities. The second is the lack of refinement of the features, the deliberate avoidance of physical beauty. The result is an emphasis upon the nonmaterial, the nonhedonic. The colors are intense, the features are rough, and the transitions from light to dark are harsh; we are shocked out of our conventional, worldly expectations of harmony of color and elegance of shape and proportion. The third is the passive, accepting expression of the face of Jesus. This not only expresses the ethos of Christianity but also describes the body of humanity as suffering. The fourth is the huddled arrangement of the figures, as a consequence of which they symbolize the oppressed, frightened, and victimized condition of those who are weak.

These factors, working together, express the wretchedness of the human moral condition. Obviously, they do not describe the power and mastery of man, his technological brilliance, his commercial avidity and materialistic prowess. Certain themes at the heart of Christianity,

GEORGES ROUAULT. *Christ*. 1937. Private collection

such as the virtue of humility and the significance of suffering, are expressed so as to give them universal application. These ideas become descriptions of the spiritual condition of all men. Since the moral status of man, as seen in the work of Rouault, is substantially different from the condition of man as we commonly see him—in the midst of his prosperity, aggressiveness, and competition—we might properly conclude that the artist is attempting to reveal the authentic nature of human beings, what humanity is *really* like as opposed to what man thinks he is.

Whereas the spirituality of Rouault grows essentially out of one insight—the moral inadequacy of mankind—we have in the sculptor Henry Moore (born 1898) an artist who expresses spiritual affirmation and renewal. His UNESCO sculpture casts humanity in a monumental role. Monumental sculpture is usually employed to celebrate military triumphs, to idolize an emperor-god, a hero, or a general, and to commemorate victories of one sort or another. But Moore, if he celebrates any victory, celebrates the durability of man. The massiveness of the figure creates a powerful sense of stability, and the large forms he has abstracted from the thighs and torso are akin to the shapes of old hills and eroded mountains. The positive forms are punctuated, so to speak, with openings and hollows and surmounted by the head, which seems to symbolize the dominance of intelligence over matter. The openings and deep hollows are not merely "negative shapes" as we sometimes hear them spoken of. They are positively conceived and permit the environment to become a part of the sculpture and to interact with it. Moore's figures are meant to be installed out of doors, preferably in a natural setting, where they can most effectively stand for man and the man-made. Without dramat-

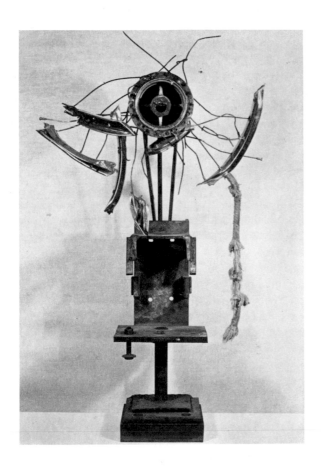

JEAN TINGUELY. *Monstranz*. 1960. Whereabouts unknown

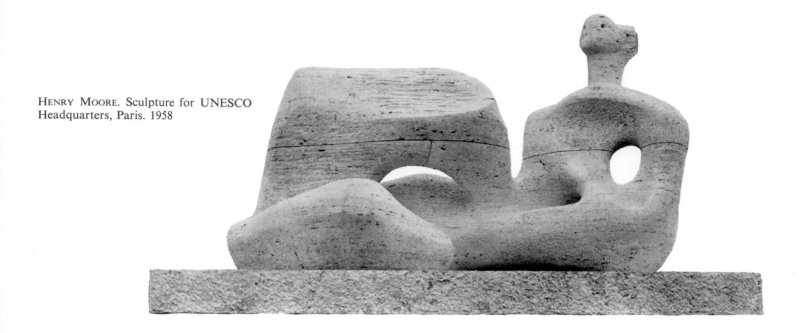

HENRY MOORE. Sculpture for UNESCO
Headquarters, Paris. 1958

ic devices or theatricality of any sort, this figure suggests resurgence, as if it had once been struck down, penetrated, submerged. The forms of the sculpture, although taken from nature, have a certain arbitrary quality. Thus, they represent the outcome of human will and intelligence working on the materials provided by art and by life. The image of man here is Promethean: man suffers and is defiant. He is not morally squalid, and although his reclining position can be taken as one of defeat, as in the *Dying Gaul*, he appears prepared for physical and spiritual renewal. Compared with Rouault, Moore seems less theological, less affected by knowledge of the sinfulness and corruptibility of man. Rather, the UNESCO sculpture expresses the forces of human defiance, of an earth creature which slowly rebuilds itself, whether it knows or not that the powers of the universe will strike it down again.

Since spiritual concern in our time is expressed through questioning, uncertainty, and restlessness, it is not surprising that *motion* and *agitation* should be characteristic of some contemporary works. Certainly Van Gogh used the motion implied by his patterned brushstrokes to express the aliveness of everything he saw. Rouault and Moore, on the contrary, employ stable forms, possibly because the image of man is for them less uncertain. However, in Umberto Boccioni (1882–1916), perhaps the best-known of the Italian Futurists, we see motion described as the essential characteristic of modern man. *Unique Forms of Continuity in Space*, executed in 1913, constituted both the culmination of many studies of the plastic representation of movement and Boccioni's personal adaptation of the lessons of Cubism. It is, of course, an optimistic work, and it possesses a gracefulness and

embellishment of form which was not evident in the more cerebral works of the French Cubists. This sculpture is perhaps not entirely successful in the expression of spirituality since it surrenders too readily to the desire to create surfaces of fascinating beauty. But the artist did aim at dematerialization; he sought to convey something of the spirit of man by identifying him as a being whose solidity and stability are an illusion—an illusion which, incidentally, this sculpture fails to break down. Hence, notwithstanding the facts that the figure is not enclosed by a single continuous skin and that the movements of muscles and tendons have been permitted to break through the skin, we have a work which remains whole and coherent, which refuses to dissolve at its boundaries and merge with the environment. Thus, despite his obsession with motion and dematerialization, Boccioni cannot escape the physical unity and corporeality of man.

A very different, if also more poignant, expression of the spiritual quandary of modern man is found in the work of Jackson Pollock (1912–1956). *Number 1* (1948) shows the typical paint surface of this artist's mature style: tangled skeins of pigment dripped and spattered on the canvas, creating a seemingly infinite labyrinth of pattern and movement. Seeing the work as a whole, one is aware of an overall texture as well as a repetition of black, somewhat calligraphic movements overlayed with splashes, unstructured white drippings, and knots and spots of color. Because it is a huge canvas, nine by seventeen feet, one is drawn into details of the maze; only in reproduction, which is to say in reduced size, can one see it whole. The impact of Pollock's work derives from the kinetic power of the paint application and is best experi-

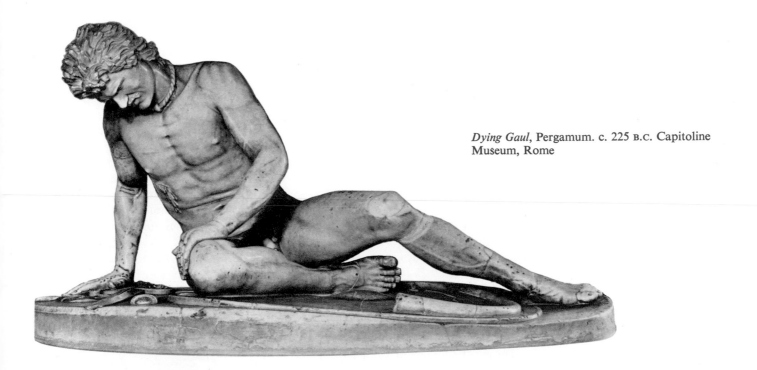

Dying Gaul, Pergamum. c. 225 B.C. Capitoline Museum, Rome

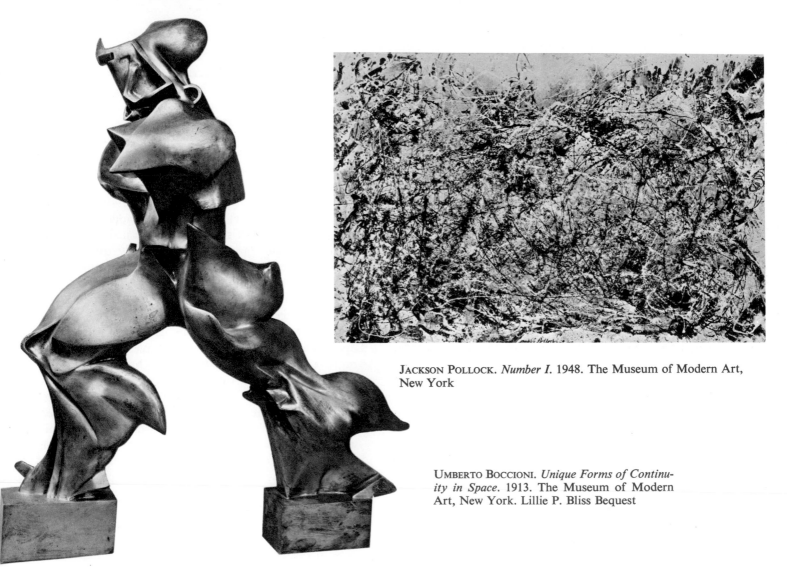

JACKSON POLLOCK. *Number I*. 1948. The Museum of Modern Art, New York

UMBERTO BOCCIONI. *Unique Forms of Continuity in Space*. 1913. The Museum of Modern Art, New York. Lillie P. Bliss Bequest

enced directly. Devoid of representational elements, the painting inevitably refers the viewer back to the artist's act of executing it. Its imagery is of paths of motion, at once dancelike and trancelike, more purposive in the blacks, spotted at random with some of the colors, and enmeshed and trapped with the whites. No single movement is fathomable in terms of an intentional origin, departure, journey, and return. We seem to be looking at a multitude of voyages amid various kinds of terrain and conflicting fields of force. The movements are attended by the expenditure of considerable energy but seem otherwise to be literally aimless. If the viewer sees beyond the picture as a continuous texture, he cannot fail to be excited by its release of energies and its uniquely repetitious, aimless, restless, antigraceful mode of movement. If he pursues particular passages, he cannot fail to feel himself entrapped, enmeshed. Summoned enthusiastically to a spectacle here or there, the viewer is shunted aside before arriving, cast into mazes and vortices from which he can be extricated only by turning away. The experience of the work, which begins as visually intriguing and exciting, may leave one frustrated and disturbed.

The disturbing features of Pollock's work would not have attracted such wide interest if they did not in themselves constitute so faithful a reproduction of the spiritual landscape of our time. Perhaps all fields of endeavor and all personal biographies would reveal similarities to Pollock's "voyages" if we could know the lives and adventures of others from the inside. There is, however, the possibility that the lack of culmination and coherence in Pollock is a feature of some but not *all* interior landscapes. That is, we may from time to time experience illusions, if only in dreams, that our own biographies contain small culminations, minor fruitions, and hints of fulfillment. But such intimations of value in our personal existence, combined with the record of social purpose and accomplishment in many public realms of endeavor, would not invalidate Pollock's relevance to the spiritual condition of modern man. He remains the painter of our energetic and industrious failures.

Aesthetic Expression

Aesthetic needs and impulses are not the specialized interest of a small group. Everyone seems to be concerned with what is beautiful, pleasing, or appropriate in the visual world. That is, we are interested in beauty wherever it may be found—in people, in nature, and in objects of daily use. Some artists do specialize, however, in making things which are beautiful or aesthetically satisfying *in themselves*, apart from any utility they may have. Objects created to be beautiful or intrinsically pleasing are nevertheless useful because they help to satisfy the aesthetic interests and requirements of modern men. In his earliest days, man may have been concerned about colors or shapes only to the extent that they were signs of danger or of opportunity. But since his life depended on how accurately and intelligently he could see, vision was a matter of supreme importance. We still possess remarkable visual equipment and outstanding capacity for interpreting our optical experience. However, the conditions of contemporary life do not seem to demand as much of our perceptual capacities as we are equipped to supply. Hence, some forms of visual art appear to have evolved in complex cultures as a means of engaging our unused perceptual capacity. Perhaps aesthetic pleasure is, in fact, the satisfaction experienced in employing to the full our innate capacities for perception.

An elementary aesthetic pleasure might be called "the thrill of recognition." Obviously, recognition has always played an important role in human survival. Its significant role in all human affairs accounts for the popularity of art which is easily recognized, which provides a multitude of cues to its origin in reality. When we *recognize* something in a work of art, we are in a sense rehearsing our survival technique, sharpening our capacity to distinguish between friend and foe. It is only a short step from the ability to perform such discriminations to the ability to enjoy perception itself, suspending all the while any impulse to fight or flee. Rather, we learn to linger over visual events and thus to maximize our delight in them.

An artist whose lifelong effort was devoted to making the art of painting a source of pure visual delight was Georges Braque (1882–1963). An early associate of Picasso in the creation of the intellectual austerities of Analytic Cubism, Braque employed the principles of Cubism to paint surfaces of immense sensuous appeal and decorative ingenuity. *The Round Table* shows his mastery with shape and texture and his droll wit in exploiting optical and pictorial conventions for pleasure and humor rather than reliable cognitive cues. One recognizes the room and the table easily enough, with the top tilted forward to reveal a multitude of ordinary objects: a mandolin, a knife, fruit, a magazine, a paper, a pipe, an open book, and so on. The objects in themselves are unimportant; they have shapes and colors and textures which Braque can rearrange. He can show the top and side view of an object at the same time; he can paint opaque objects as if they were transparent; he can reverse the expected convergence of lines in perspective; he can exaggerate ornament with white lines, arbitrarily exchange light areas with shadow areas, or paint shadows a lighter and brighter color than the objects which cast them. The purpose of

GEORGES BRAQUE. *The Round Table*. 1929. The Phillips Collection, Washington, D.C.

these "violations" and surprises is not to create a painting *of* something; rather the painting must *be* something, a kind of organism which lives according to its own law. And that law seems to state that any twisting, slicing, distortion, or reversal of shape, color, and texture is justified if it can increase our delight in looking. The logic of the painting is based on the obligation to surprise or please the eye rather than to reproduce a set of relatively innocuous objects.

But how does an artist please the eye? Once the logic of reproducing appearances is abandoned, the possibilities are infinite. The painter becomes a kind of intuitive investigator of the shapes and colors and textures which singly or in combination are somehow appealing. His artistic conscience does not permit him to exploit the literary associations one has with objects. Any satisfactions one takes in the work must derive from pictorial organization and painterly technique. He tries to arrive

at just the right quantity and shape of, say, dark brown imitation wood graining. He surrounds the table shapes with thick and thin white outlines: they flatten out the shape and destroy the illusion of deep space which has been mischievously suggested by shadows cast into the corner of the room. Three-dimensional effects are created and then flattened or penetrated, pressed into two dimensions. The viewer is forced to "read" the painting as if the walls and floor were in the same plane as the table base. There is a certain visual humor or, at least, trickery going on in Braque's painting—humor which, because it is very subtle, does not result in laughter, but which fully challenges our capacity to enjoy ourselves visually.

The development of abstract and nonobjective art has been almost identical to the development of an art of *purely* aesthetic purpose in the modern era. (Aesthetic impulses, of course, operated in the past—usually in the nonutilitarian decoration of useful objects. But *we* have

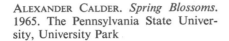

ALEXANDER CALDER. *Spring Blossoms.* 1965. The Pennsylvania State University, University Park

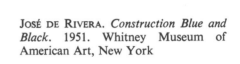

JOSÉ DE RIVERA. *Construction Blue and Black*. 1951. Whitney Museum of American Art, New York

made sensuous appeal and nonutility in art an end in itself.) As some painting and sculpture has departed (some would say it has been "liberated") from its historical and didactic functions, it has increasingly been devoted to the problems of creating new forms and experiences which would be valid in and of themselves. Thus, in the sculpture of José de Rivera (born 1904), *Construction Blue and Black*, we have a work of mathematical precision and geometric beauty. The sculpture "works" only in an aesthetic frame of reference. Practical objects may, of course, resemble the Rivera sculpture and even derive their design inspiration from it. But we have reached the point where it is not necessary to ask what this work *symbolizes;* the theme or subject matter of the sculpture is the formal organization of the thing itself.

Alexander Calder (born 1898) invented an entirely new sculptural genre—the mobile—which delights us with the variety of movement of its abstract shapes. His *Spring Blossoms* is a whimsical work, as are so many of his mobiles, in which the slightest movement of air in the space around it imparts a comic, rollicking motion to the intricately balanced parts. They shift into an infinite number of constellations, arriving at temporary periods of equipoise by wiggling, wriggling routes. Although mobiles do not obviously resemble people or trees, their movement sometimes suggests, for example, the sway of branches or the complex anatomical maneuvers of exotic dancers. But these are only associations of the viewer, stimulated if not encouraged by this truly original and

often comic artist. His art is highly intellectual and controlled, even in the latitude it provides for seemingly random motion. Moreover, it is sculpture which "uses" the atmosphere and light of the place in which it is located: the climate of the room collaborates with Calder, helping to carry out his compositional intention.

The *Juggler* by David Hare (born 1917) is another work in which a playful abstraction of motion is the principal theme. But motion is not intended here, as it was in Boccioni, to be a means of transcending man's physical being in order to reach a spiritual condition. Rather, the balance, grace, and skill of the juggler become an excuse to fashion a curious steel "thing." It is very important to understand this recurrent practice in contemporary art: unlike the arts of tradition, in which materials were fashioned so that they might imitate appearances or express known ideas about life, the contemporary arts often reverse the relationship. They endeavor to find phenomena in life which seem to suit what can be done with materials. Thus, the juggler provides the theme or the opportunity for making a welded steel construction. Our aesthetic pleasure is based on the tension between our idea of a juggler and what has happened to that idea in the course of its embodiment in steel. This latter point demonstrates how important the expectations of the viewer are in the total experience of art. *Your* idea of a juggler contends with the *artist's* idea, which is physically, palpably there to assert its validity. Perhaps you are convinced that David Hare's construction deserves to exist

independently, for its own sake. If so, you have probably gone through a process of reconciling your ideas of balance, motion, and form with the sensations you receive from the steel object before you.

Calder's mobiles show how a new sculptural type, or genre, was developed to give expression to the artist's interest in a particular kind of motion. Hare's sculpture is, very seriously, a "thing" which arouses the idea of a juggler. Neither of these works performs any of the world's work, from a practical standpoint. But they do something for us, as viewers: they afford pleasure or de-light based on our ability to follow the artist as he makes curious comparisons or metaphors connecting and relating ideas, objects, memories, and sensations. Since such works of art answer no practical need, it is necessary that we approach them with a different mental set, a different logic from the one with which we confront the everyday world. We are no longer trying to prove that we can recognize a juggler when we see one; we are rather interested in finding out what special entertainment is to be had in the *difference between* the sculpture and a juggler.

One of the most charming and personal developments

Like David Hare, Lanceley creates a metal metaphor —a comparison between a person and a machine.

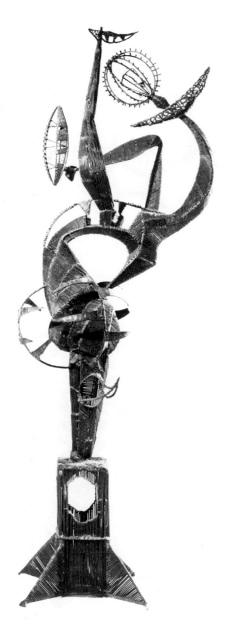

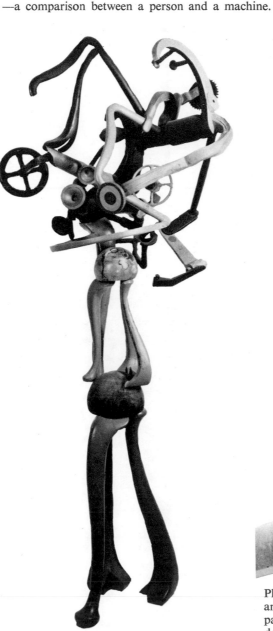

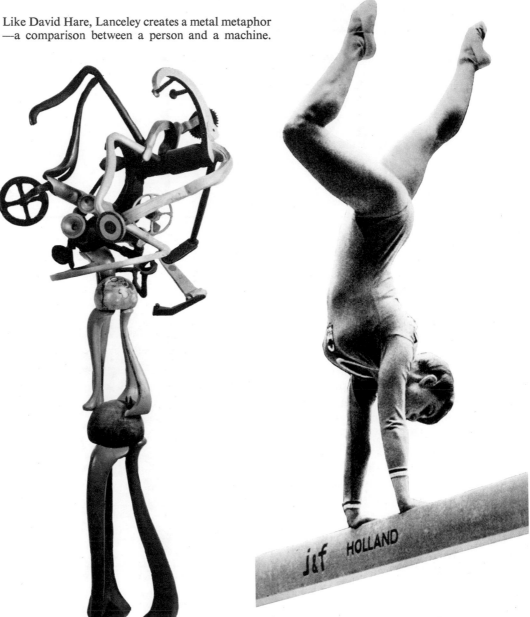

DAVID HARE. *Juggler*. 1950–51. Whitney Museum of American Art, New York

COLIN LANCELEY. *Inverted Personage*. 1965. Albion College, Albion, Michigan

Photograph of gymnast. The sculptures by Hare and Lanceley depend on our knowledge of a particular slice of reality. That is, our pleasure derives in part from perceiving differences between this kind of human figure and the metallic fantasies of the artist.

EDUARDO PAOLOZZI. *Medea*. 1964. Kröller–Müller
Museum, Otterlo, The Netherlands

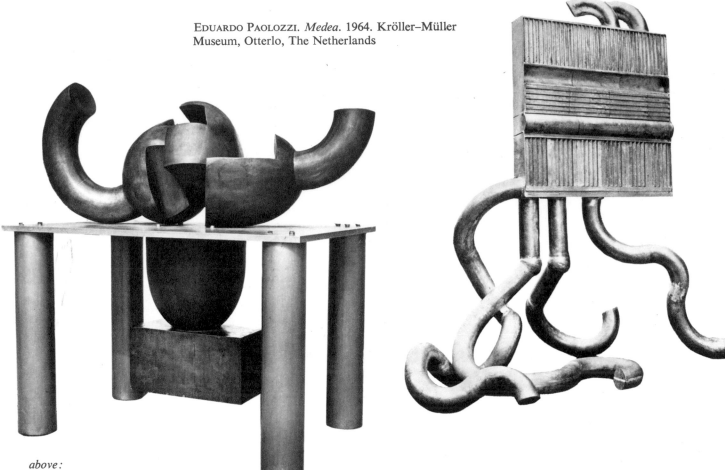

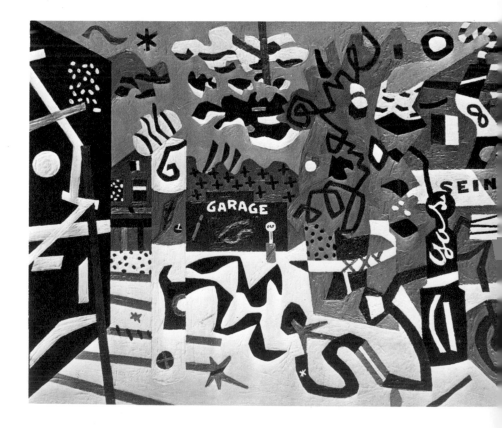

above:
PETER VOULKOS. *Firestone*. 1965. Los
Angeles County Museum of Art. Museum Purchase with Contemporary Art
Council Funds

The comic linear forms based on a gasoline pump and road signs in Stuart
Davis's 1940 painting become sinister
appendages of machine idols in the
sculptures of Paolozzi and Voulkos in
1964 and 1965.

right:
STUART DAVIS. *Report from Rockport*.
1940. Collection Mr. and Mrs. Milton
Lowenthal, New York

of Cubism was created by the late American painter Stuart Davis (1894–1964). In *Report from Rockport*, he used flat, geometric, wriggling forms to designate the features and qualities of American places he so enthusiastically enjoyed: street signs, billboards, gas pumps, lettering, the architecture of Main Street, noise, jazz, automobiles. The features of urban life which worry traffic engineers pleased Davis—the profusion and confusion of signs and lights which bedevil motorists; the gasoline gulches which spring up along the sides of every new highway; the dangerous speed of souped-up automobiles; the general lack of overall design and planning. He was an early and devoted follower of jazz as played in the saloons of Hoboken and Newark; this affinity is echoed in the dynamism and staccato rhythms of his paintings. Davis developed out of the pictorial devices of Cubism a personal style which could convey the impact of our distinctively American chaos in painterly terms. But he was neither an illustrator nor a social critic, although he could be satirical. In the main, his paintings accept the disorganization, noise, and commercial blatancy of our environment. He adds to our fund of aesthetic values because he teaches us to see the unique vulgarity of the American highway and the shopping district of Main Street as gloriously funny—confused, disordered, cacophonous, but healthy.

The varieties of aesthetic expression in contemporary art are far too many to discuss with any completeness. There are works which endeavor to appeal to all the senses through the visual; there are whimsical works which themselves contain motion and which act as modulators of light, galaxies of the near-at-hand; there are visual puns and metaphors, objects which, like café performers, impersonate and ridicule their models in life; there are works which celebrate the excitement and energy of places and events we might normally regard as chaotic. Beauty, defined as ideality of form—especially when based on the human figure—is not a common trait of the aesthetic expression of our time. When the figure does appear in art, it usually is revealed in unideal or ugly manifestations. We see the figure in paintings of Bacon, Dubuffet, Paolozzi, and De Kooning, but it is lonely, awkward, or repellent.

The reasons for this approach to so potent and significant a human symbol are complex and beyond the scope of this section. It is fair to say, however, that the aesthetic initiatives of artists and the aesthetic needs of viewers *do* meet in a variety of modes in contemporary art. Never before have the personal functions of art been so variously expressed. Perhaps the requisite attitude toward art in our time is not to deplore the fact that it is so profuse and difficult to understand but rather to rejoice in the large array of choices it affords for our every mood and impulse.

THE SOCIAL FUNCTIONS OF ART

In a sense, all works of art perform a social function, since they are created for an audience. Artists at times may claim that they work only for themselves, but they mean by this that they set their own standards. The artist always hopes, secretly perhaps, that there is a discriminating and perceptive public which will admire and prize his work. Consequently, works of art which have been created in response to the most private and personal impulses nevertheless function in a context which calls for a social response and, it is hoped, social acceptance.

There are, however, narrower and more specific meanings for the social function of art than the fact of its being created for the ultimate acceptance of audiences. These meanings have to do with the *social intention and the actual character of response* which works of art evoke from various publics. That is, art performs a social function when (1) it influences the collective behavior of people; (2) it is created to be seen or used primarily in public situations; and (3) it expresses or describes collective aspects of existence as opposed to individual and personal kinds of experience. In all three cases, the individual responds to art with the awareness that he is a member of a group, a group which is in some way characterized or urged to act by the works of art he is witnessing.

Many works of art are deliberately designed to influ-

far left:
SAMUEL LAROYE. Bicycle mask of the Gelede Secret Society, Yoruba tribe. 1958

left:
Ceremonial mask of the Gelede Secret Society, Yoruba, Nigeria. Not earlier than 1900. Webster Plass Collection, British Museum, London

Art as an agent of social change. By combining the traditional forms of Yoruba sculpture with contemporary thematic material, a western Nigerian sculptor participates in the transformation of African society and culture.

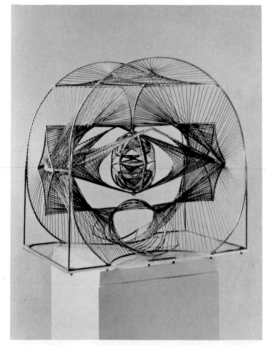

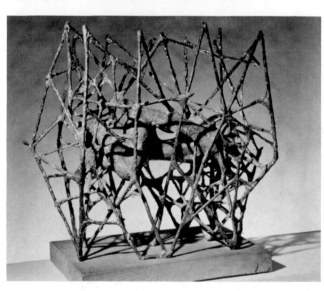

ISAMU NOGUCHI. *Monument to Heroes.* 1943. Collection the artist

The public monument is an art form through which a collective abstraction—society—acquires a memory and a conscience.

ence group thinking. Artists may try to make us laugh at the same phenomena; to accept economic, religious, or social ideologies; to identify with a class or ethnic interest; or to see our social situation in ways which had not previously been apparent. The visual arts, like the other arts, can function as languages of praise and celebration, anger and protest, satire and ridicule. In other words, art can influence the attitudes of people in groups, affecting the way they think or feel and, ultimately, the way they act. Advertising art is a common illustration: its purpose is to influence collective purchasing behavior. During a war, through posters, governments attempt to arouse hatred of the enemy, or to stimulate enlistments, or to increase production levels. In peacetime, art is used to affect almost every conceivable kind of group goal, attitude, or desire.

Some persons, including artists, regard art which influences social behavior as impure, as "mere" propaganda, as applied sociology, as debased art. And, given certain prior assumptions about the "appropriate" functions of art, they are right. Nevertheless, art has always influenced collective behavior; hence, we could not present art's complete role in contemporary culture if we ignored its social functions. Furthermore, the history of art appears to demonstrate that aesthetic excellence is unrelated to the functions which art performs: excellence is not a simple matter of serving noble purposes. In the final chapters, on art criticism, we shall discuss some of the determinants of excellence in art as well as the criteria for making judgments about aesthetic value. For now, we are chiefly interested in the connections between art and social affairs.

Political and Ideological Expression

Some artists are interested in the freedom to solve the special problems of style or technique which fascinate them. Others seek the freedom to use style and technique to express their views about society and political processes. Those in the latter group are sometimes inclined to speak about "artistic responsibility." For them, art does not exist merely to entertain and gratify the senses; it must edify. It must play a role in the improvement of our collective existence. So long as there are political wrongs to be righted and unjust or ugly social conditions requiring change, art must participate through visual education and persuasion in the development of popular attitudes which can lead eventually to a better society. This view of artistic responsibility is opposed, of course, by those creative persons who feel they serve society best when they concentrate on the discovery of new form, the creation of new beauty, and the free and honest expression of their personal experience.

Although the argument about the appropriate social role of the artist is not likely to end soon, it is worth observing that the politically uncommitted artist is as likely to create an art of clear social meaning as the artist who is passionately involved in ideology. The different kinds of artistic expression in our time of almost complete

creative freedom are more likely based on personality differences among artists than upon varying philosophical views about the proper role of art in society. Artists are, nevertheless, citizens who take an interest, as do other citizens, in the social and political issues of their time. Despite stereotypes about their romanticism and their irresponsibility or inability to function adequately in practical affairs, artists are as politically and socially mature as physicians, businessmen, accountants, or lawyers. But just as some lawyers devote their careers to advising clients on tax matters, property closings, and the merging of corporations, while others serve in public office or act as counsel for indigent persons, so also do some artists create paintings of flowers on tabletops while others portray people amid the struggles and disappointments of life in a complex civilization.

Although Cézanne, for example, could generate aesthetic emotion through his paintings of apples, other artists have required themes of more obvious human and social relevance to challenge their creative abilities. Eugène Delacroix (1798–1863) and the Romantics required enormous historical and political spectacles, as in the painting *Liberty Leading the People*, one of the early monuments of revolutionary art. In classical antiquity,

"VERY WELL, ALONE"

DAVID LOW. *Very Well, Alone.* c. 1940. Cartoon by permission of the David Low Trustees and the *London Evening Standard*

The cult of personality built around Mao-Tse-tung in China does not obscure powerful impulses toward Westernization, as in this patriotic poster which borrows heavily from the greatest political cartoonist of the West, David Low.

Maoist poster. Library, University of Georgia, Athens

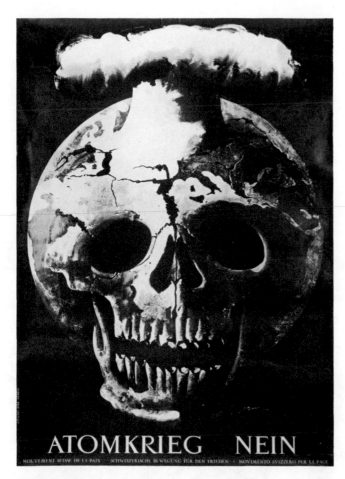

HANS ERNI. *Atomkrieg Nein (Atom War No)*. 1954. The Museum of Modern Art, New York. Gift of the designer

In this century, Mexico has produced three outstanding artists whose work has been, in the political sense, frankly revolutionary: Diego Rivera (1886–1957), José Clemente Orozco (1883–1949), and David Alfaro Siqueiros (born 1898). Their paintings, frequently in mural form, deal with themes like the poverty-stricken condition of the Mexican masses, the brutal conquest of Mexico by the Spanish invaders, and the exploitation of peasants by avaricious landowners. The paintings range from works of obvious political and ideological content to those in which an intense concern with human suffering is the dominant motive. *Echo of a Scream* by Siqueiros (compare this socially oriented work with a psychologically oriented work, *The Scream*, by Munch, p. 243) exhibits the emotional force of a fantastic, almost hallucinatory pictorial device employed to express the idea of poverty and deprivation. The word "echo" in the title and the repetition of the image of the screaming child, together with the anonymous, deserted industrial wasteland which is the setting, tend to generalize and extend the theme of the work to the entire body of humanity. Presumably the hunger, pain, and abandoned condition of all derelict children is symbolized here. The emotional strategy of such works is to arouse our normal feelings of shock and sympathy. We are forced to confront an unpleasant social reality. And although this painting has no specific political content, it does seize the imagination and enlist our feelings in favor of action which can relieve human suffering.

A particularly mordant social comment is seen in

the Greeks adorned their public buildings with sculptures depicting the military struggles connected with the mythic founding of their city-states. This was intended to inspire all citizens with civic virtue, which they saw as inseparable from a decent personal existence. Although the personal and aesthetic functions of art have always existed, therefore, they were never especially prominent in the totality of artistic creativity until the modern era. A career such as Cézanne's, devoted so unswervingly to the mastery of receding planes and the architectonics of pictorial space (see p. 329), is almost inconceivable before the nineteenth century. Consequently, even though contemporary civilization has brought about the cultivation and flourishing of art devoted to highly personal, very technical, or idiosyncratic tendencies, we should not forget the larger historical context: for the most part, art has been brought into being because of public needs, social necessities. And even when a society is wealthy and free enough to indulge individual artists in the expression of their private and possibly capricious impulses, we nevertheless have many artists who employ political and ideological themes in their work out of choice, because of their personal interests and preferences.

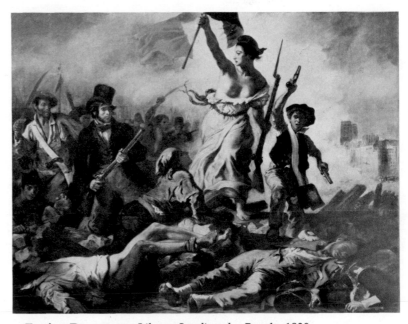

EUGÈNE DELACROIX. *Liberty Leading the People*. 1830. The Louvre, Paris. Much blood, gore, and commotion: all classes are involved in a highly "participatory" uprising. Still, in 1830 French revolutionaries required an allegorical figure to inspire and guide them.

With this denunciation of the university in 1932, Orozco anticipated many of today's bitter attacks on the "relevance" of academic study. Similarly, Siqueiros created in 1937 a hallucinatory image of poverty which might well apply today.

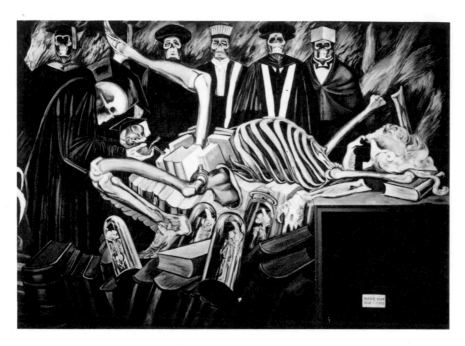

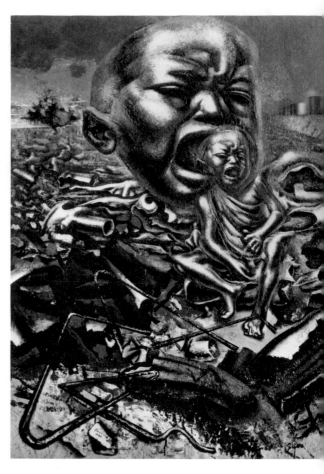

JOSÉ CLEMENTE OROZCO. *Gods of the Modern World.* 1932–34. Trustees of Dartmouth College, Hanover, New Hampshire

DAVID ALFARO SIQUEIROS. *Echo of a Scream.* 1937. The Museum of Modern Art, New York. Gift of Edward M. M. Warburg

Orozco's *Gods of the Modern World*, a portion of the fresco mural in the Baker Library at Dartmouth College. An almost completely dissected corpse is shown stretched on a pile of books, where it is attended by a deathly figure in academic costume. Presumably, the corpse has just given birth to an infant skeleton, also in academic cap, with the professorial skeleton acting as midwife. In the background stands a collection of dessicated academics wearing their regalia, which survives in universities today from the costumes worn by medieval professors. This work is an example of exceedingly gruesome humor, especially since it is in the library of a distinguished educational institution. The function of the university as preserver and mediator of ancient knowledge and tradition is presented here as a necrophilic ritual. Still, it is true that universities have often functioned as midwives at the birth of what the philosopher Alfred North Whitehead called "inert knowledge." At any rate, this portion of the mural illustrates the capacity of the artist to satirize bitterly a respectable institution like higher education in its very own house; it also expresses that revolutionary im-

patience and disgust with established convention which are traits of the satirist when he genuinely detests the subject he ridicules.

Diego Rivera's art has the same revolutionary commitment as Orozco's, but its formal organization is less violent. He is perhaps the best designer and artistically the most sophisticated of the Mexican artistic "troika." Nevertheless, he drives home his *political* message with an oversimple, unsubtle force. In *Night of the Rich* and *Night of the Poor* we have a morality play: the overindulgence and the corruption of the rich, engrossed in the pursuit of profit and joyless pleasures, are contrasted with the huddled, innocent sleep of the poor, some of whom industriously study at night to escape from illiteracy, while middle-class types in the background evince their disapproval. In these and many similar works, we have the stereotyped portrayal of classes and racial groups according to standard Marxist dogma. The ideas are tremendously simplified because they are intended for the instruction of the poor and uneducated. Needless to say, such simplifications lead to a heightening of emotion and

Photograph of professor wearing gas mask at 1967 commencement ceremonies at the University of Pennsylvania to protest research in chemical and biological warfare under a U. S. Department of Defense contract

dean Family by Hector Poleo (born 1918). The work exhibits a style of simplified, heightened realism and has the opulent color and clear, distinct forms associated with classicistic art. The figures are tall and idealized in their proportions. The artist has tried to present them in a very dignified, almost aristocratic manner. Yet they are humble, quiet people, possessed of an almost classical athletic grace. Indeed, they are somewhat reminiscent of the Spanish-grandee types Hollywood used to employ to play the roles of Mexican noblemen and lords of haciendas. Viewing this version of the family, gracefully gathered together on an elevated place among the Andean peaks, one feels remote from the class struggles of the proletarian masses in Rivera and Orozco, although such struggles constitute the ideological context of this work also.

ARTISTIC EXPRESSIONS OF HUMANITARIAN CONCERN

A modern industrial state contends with social and political problems radically different from those characteristic of a feudalistic, agrarian society. Problems associated with the modern administration of justice, the operation of democratic politics, and the regulation of a complex economy would seem unreal and remote to people living in a state of peonage. For modern Americans, the impersonality of government, for example, is a legitimate theme, well expressed by George Tooker (born 1920) in *Government Bureau*. Using repetition of figure and space, like the receding images in parallel mirrors, the artist endows a governmental building with a quality of Surrealist terror—the quality of an orderly, methodical, perfectly credible nightmare. Is this the image of government by federal bureaucracies which lies behind so many political attacks on "overcentralization" of power? The Jeffersonian idea of agrarian democracy was suspicious of concentration of authority in centers remote from organically functioning local communities. All men in general, and countrymen in particular, seem to dread any contact with government when it is represented by "strangers," especially if they are located in buildings not unlike prisons. But can modern, predominantly urban mass societies, as opposed to the scattered farming communities of Jefferson's day, function otherwise? Have the architectural forms been developed which can fittingly express the relation of government to people in a mass democracy? It would appear that modern banks and office buildings have done a better job of eliminating impersonal and authoritarian qualities in their interiors than have governmental buildings, which are, ironically enough, the creation and instrument of the people. What Tooker has done is to dramatize the loneliness and alienation felt by ordinary people when taken out of their living, organic setting and placed by necessity into the sterile, nightmarish interior of a typical administrative labyrinth.

Isaac Soyer (born 1907) in *Employment Agency* presents an aspect of the operation of our economy in human

a sharpening of ideological points at the expense of social accuracy; that is, the poor are not always virtuous and the rich are not always corrupt. But the principal social and political objective of the mural is here achieved—to endow masses of ignorant people with the consciousness of their belonging to an oppressed class and, further, to arouse their violent antipathy toward their oppressors. Just as early Christian and Romanesque artists confronted the problem of explaining in simple terms the fundamental concepts of good and evil, sin and expiation, deliverance and damnation, so Mexican revolutionary artists endeavored to explain the meanings of wealth and poverty, oppressors and victims, heroes and traitors, conquest and revolt. It is not surprising that Latin American artists, growing out of a tradition in which the influence of religion upon culture was very potent, should employ the arts in a manner similar to that of the Church, although, ironically, the doctrines of Rivera and his associates are violently hostile to organized religion.

In another Latin American work, a social and political message is carried without any overt ideology—*The An-*

DIEGO RIVERA. *Night of the Rich* and *Night of the Poor*. 1927–28. Whereabouts unknown. Mural art as an instrument for developing class consciousness.

below:
HECTOR POLEO. *The Andean Family*. 1944. Division of Visual Arts, OAS, Washington, D.C.

terms. When economists speak of different kinds of unemployment—of transitional unemployment, of the absorption of new workers by the labor market, of workers with obsolete skills, of displacement due to automation—we may not fully understand what these phrases mean in terms of the individuals affected and of their efforts to cope with an economy which seems to work against them. Many Americans have been fortunate enough never to experience unemployment. Others know what it is like to look for nonexistent jobs or to find that they are unqualified for the jobs that do exist. But in an economy which receives thousands of new workers each month, which is continuously changed by new technology, and which is variously affected by price, credit, interest, and tax policies, the experience of temporary unemployment, at least, with its psychological as well as economic overtones, is bound to be shared by millions of people. Soyer views the waiting room of an employment agency as a theater for the enactment of a psychological drama, as a revelation of the motivation and anxiety of individuals who are out of work. Unemployment translates itself, for some, into the feeling of being unwanted by the world,

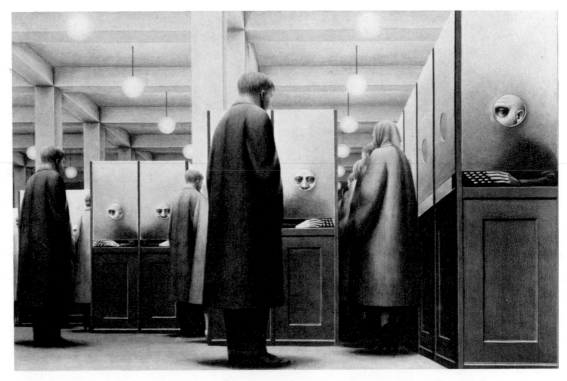

GEORGE TOOKER. *Government Bureau.* 1956. The Metropolitan Museum of Art, New York. George H. Hearn Fund, 1956

ISAAC SOYER. *Employment Agency.* 1937. Whitney Museum of American Art, New York

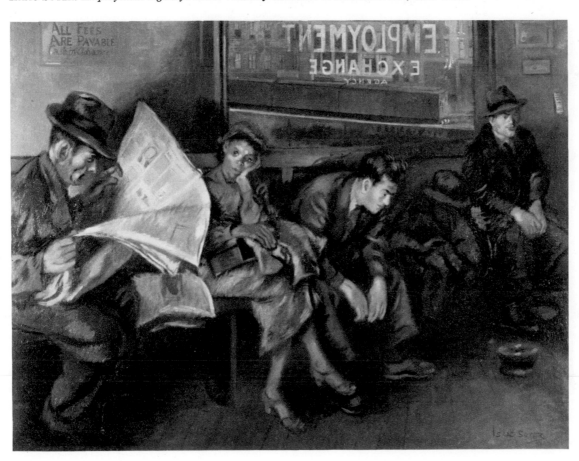

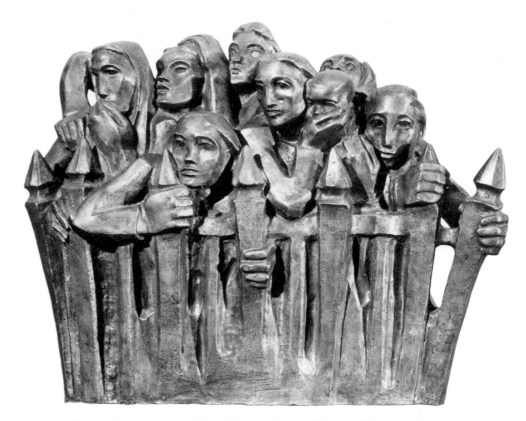

BERTA MARGOULIES. *Mine Disaster*. 1942. Whitney Museum of American Art, New York

Photograph of friends and relatives of men trapped in a West Virginia mine. 1968

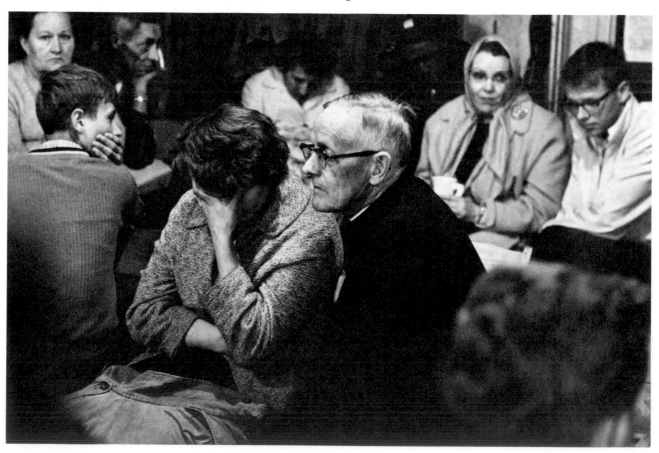

and it is one of the profoundest spiritual experiences of the modern era. As an artist, Soyer offers no economic solution (indeed, economists offer few viable solutions) but deals rather with the objective qualities of the experience itself.

A sculpture which deals with industrial phenomena in social terms is *Mine Disaster* by Berta Margoulies (born 1907). The work is a kind of memorial to the wives of men who are periodically trapped, even today, by some accident in an obsolescent mine far below the earth's surface. The social and psychological implications of the event are stressed here. These women cling to hope mingled with the expectation of disaster because they often know that proper safety precautions have not been taken or that agencies charged with enforcing safety regulations do not always carry out their responsibilities. In this sculpture, as in many other works of social protest, the device of huddling the figures is employed together with psychological analysis of the mixed emotions of hope, suspense, and despair in the faces.

In *McSorley's Bar* (1912), the American painter John Sloan carries on the tradition of vivid reporting and accurate social description which characterized the work of the so-called Ash Can School. Outstanding members of this school were Robert Henri (1865–1929), Maurice Prendergast (1861–1924), Arthur B. Davies (1862–1928), George Luks (1867–1933), William Glackens (1870–1938), John Sloan (1871–1951), Ernest Lawson (1873–1939), and Everett Shinn (1876–1953). These men organized themselves as "The Eight" in 1908. They were experienced as reporters and illustrators, their services being essential for the illustrated dailies and monthlies which flourished at the time, before the advent and full development of photojournalism. In rebellion against the salon art of Europe, they portrayed working-class themes without any hint of condescension or of discovering "picturesque" subjects in hitherto ignored environments. Henri, who exerted the strongest influence among The Eight, can be regarded as the mediator of the great European painting tradition stemming from Hals, Velázquez, and Manet. Emphasis was on truthful representation, dramatic lighting, spontaneous brushwork, and the capture of transient movement. Social themes, such as a workmen's bar, were not recorded from a particularly ideological or class-conscious point of view. In fact, Sloan was as concerned with paint and light quality as with any class or economic issues which might be exploited. Still, his choice of a proletarian subject represented an act of rebellion against the official art of the period, but the painting itself expresses a type of manly comradery rather than commitment to a political doctrine.

One of the great works of art that express humanitarian concern—one which is also an important historical document—is a photograph by Alfred Stieglitz (1864–1946), *The Steerage*. The picture was taken in 1907 during

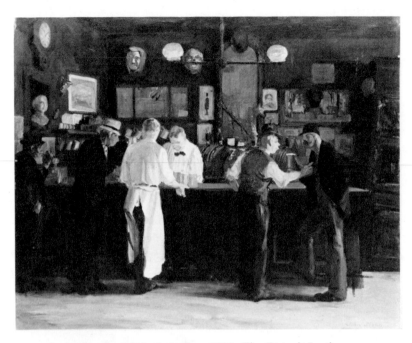

JOHN SLOAN. *McSorley's Bar*. 1912. The Detroit Institute of Arts. Purchase, General Membership Funds

the height of a massive migration of people from all parts of Europe to the United States. The steerage was the most uncomfortable part of the ship and was hence the cheapest way to cross the ocean for the desperately poor people who came to America seeking a new life. An excellent film, *America, America*, written and directed by Elia Kazan, vividly describes the adventures and the voyage of a Greek immigrant who so idealized life in America that he endured incredible hardship to get passage on one of these ships. The steerage photograph resembles a medieval cosmological painting in which condemned people wrapped in shrouds come out of some hellish place where they have been confined, as if in an oceangoing grave, to greet light and life. Perhaps only men who have been similarly carried in troop transport ships during the great wars have any conception of such voyages—often more than a month of living in crowded holds belowdecks. But troops traveled on different business. These people came, as did the waves of immigrants before them, to build an existence that was denied them in the rigid class societies of the Old World.

The German sculptor Ernst Barlach (1870–1938) typifies the artist whose work embodies universal, humanitarian concern although it grows out of particular, national stylistic roots. His sculpture derives in part from the medieval Gothic tradition of wood carving and has an affinity with the socially conscious themes of twentieth-century German Expressionism, although it is not agitated and tempestuous but quietly self-contained. In

ALFRED STIEGLITZ. *The Steerage*. 1907. Philadelphia
Museum of Art. Stieglitz Collection

right:
Film stills from *America, America*. Directed
by ELIA KAZAN. Copyright © 1963 by Warner
Bros.-Seven Arts, Inc. A young Greek living
in Turkey in 1896 determines to seek liberty in
America. He bids his mother good-bye (top)
and makes his way to Constantinople (center).
There he works as a porter, laboring so dili-
gently toward his goal that he is nicknamed
"America, America." At last, crammed into
steerage with hundreds of others (bottom), he
sails for America.

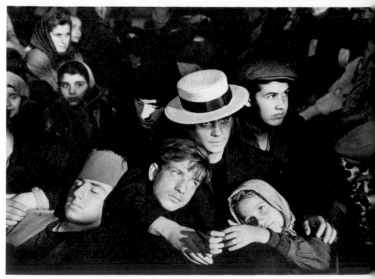

Veiled Beggar Woman, the theme of the begging woman is organized around one emotion—compassion. The individual identity of the woman is concealed by the cloak over her head, so that the main idea of the work is concentrated in the supplication of the hands. The anonymity of the subject helps us to see the sculpture as an example of social expression, specifically an expression of pity for the economic and human conditions which lead any person to beg.

The most monumental and celebrated work of social and political expression in our time is Picasso's *Guernica*. The painting, which is of mural size, was executed in 1937 to memorialize the frightful bombing of the Basque town of Guernica by Franco's forces during the Spanish Civil War. In it Picasso created the forms and imagery which have influenced an entire generation of artists, when their theme is violence, suffering, war, and chaos. Using black, white, and gray only, the artist tried to create a work which would simultaneously express multiple perceptions of a single catastrophic event: newspaper accounts of the bombing, the terror of victims, the symbols of civic disaster, the experience of laceration and pain, and the meanings of modern war as viewed from the standpoint of history. Images such as the fallen statue, the mother and dead child, the burning building, the shrieking horse, and the spectator bull function as actual descriptions of a civilian bombing at the same time that they symbolize a new concept of war compared to the traditional confrontation of armies. In Picasso's major works, there is frequently some reference to an antique conception of serenity and order. Here the classical image operates as a symbolic point of reference *against which* contemporary violence is portrayed. The drawing style of children is employed to express their presence and victimization as well as the violation of adult modes of seeing and thinking. For example, the outside of the face and the inside of the mouth are shown simultaneously. Adult modes of perception and conventional pictorial logic would have inhibited the artistic objective, which was the representation of the inner and outer meanings of a disaster. The opened mouth is a recurrent symbol in this work, standing for death, cries of insane fear, and pain. Only the dead child to the left has a closed mouth. The work is a terrifying document of the devastation of human values.

Picasso's painting was an artist's reaction of shock, his feeling of being personally wounded. But the bombing of the Spanish town in the 1930s was only an anticipation of the holocausts later suffered by many cities during World War II, culminating in the fire bombing of Dresden and the atom bombing of Hiroshima and Nagasaki. The painting was thus sadly prophetic, but its focus was mainly confined to the individual suffering caused by war. When it was executed, its imagery was adequate for the violence of the period, since more sophisticated concepts for thinking about large-scale human carnage—"overkill,"

ERNST BARLACH. *Veiled Beggar Woman.* 1919. Private collection

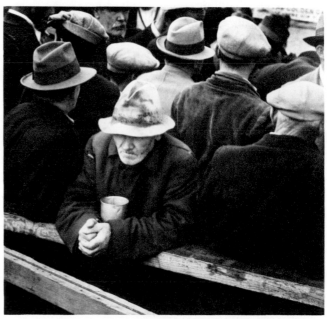

DOROTHEA LANGE. *White Angel Breadline, San Francisco.* 1933. The Oakland Museum, Oakland, California

Compare the photographic and sculptural versions of the same theme. Notice how the individuality of the person is suppressed in order to emphasize a generalized social symbol.

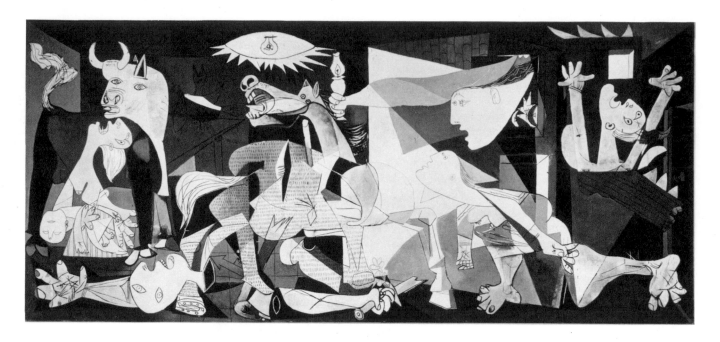

PABLO PICASSO. *Guernica*. 1937. On extended loan to the Museum of Modern Art, New York, from the artist

for example—did not yet require expression. Consequently, while this work of Picasso remains relevant to the contemporary problems of humanity, it exists within the same frame of reference as Goya's *Disasters of War* done in the nineteenth century; however, it is not equal to the conceptual challenge implied by calculations of the fifty or eighty million casualties which a society might sustain, according to some thinkers, in a first assault by modern weapons of destruction. The *Guernica* of 1937,

therefore, may be the last important work of art to deal with war as an enterprise carried on by semi-industrial but not automated methods. It was still possible for Picasso to think of war as a catastrophe which has *individual* consequences. Now its scale has been so enlarged and its methods so transformed that artists are compelled to use an abstract and dehumanized form language to cope with modern modes of obliteration (see Adolph Gottlieb, *Blast II*, 1957, p. 300).

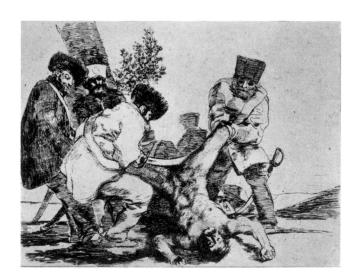

FRANCISCO GOYA. *"Nothing more to do."* From the series *The Disasters of War*. Issued 1810–63. The Hispanic Society of America, New York

Despite the mechanization and depersonalization of war in the modern era, the cruelty of individual executions has not greatly changed—from Goya's nineteenth-century etching to Segal's twentieth-century *tableau vivant*.

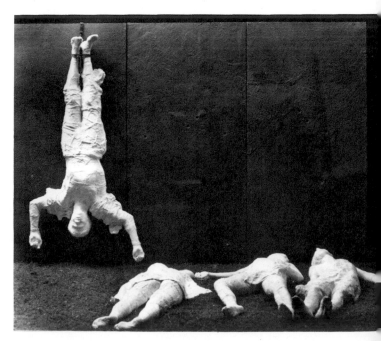

GEORGE SEGAL. *The Execution*. 1967. The Vancouver Art Gallery, British Columbia

Social Description

One of the social functions of art is performed by works which simply describe facets of life without necessarily implying that there is an urgent problem to be considered. The very act of selecting portions of ordinary existence for artistic treatment helps to focus our attention on the quality of daily life. Unless some dramatic incident takes place, we do not normally pay much attention to conventional places and events. Only when a "frame" is placed around them do we begin to discover their distinctive quality, or flavor, or meaning. The discovery of new values in common experience can lead to several results: it can heighten our insight into daily existence; it can help us compare the quality of contemporary social life with that of other places and periods; it can result in decisions to change the visual environment; it can lead to a new perception of ourselves as part of, and also apart from, contemporary social reality.

Some works attempt to govern the attitude of the viewer; others can be governed by the viewer's already formed attitudes. The *Pool Parlor* by Jacob Lawrence (born 1917) can be seen as a seriocomic portrayal of pool-hall drama, intensified by the almost macabre action of the figures, their flat patterning, and their deadly concentration on the game. The artist has exploited the attitudes commonly associated with life in the ghetto by creating mock-sinister silhouettes of black men's bodies, viewing them from above through the glaring lights which hover implacably over a group of pool sharks going about their business. If we regard the pool hall as a sordid place where criminal plots are hatched, then we are reacting to the work in humorless, legalistic, or moralistic terms and we miss its comedic point, its visual parody of the folklore about pool parlors—a parody that succeeds because the sinister action is exaggerated. In contrast to this quasi-humorous version of pool-hall emotion and acrobatics is the dramatic American film *The Hustler*, in which the actors, Paul Newman and Jackie Gleason, portray rival pool "artists" involved in a series of tense contests which express the obsessive character of the game practiced as an art, together with the heightened emotions of suspense and danger resulting from heavy gambling on that artistry. In the film and in Lawrence's painting, we see how urban patterns of male gregariousness, idleness, and leisure are given aesthetic form without direct political or ideological emphasis.

The cultural patterns of ethnic groups, particularly of the first and second generations in America, have been the subject of systematic study by sociologists. One of their findings is that while the first American-born generation is anxious to forget or conceal its inherited ethnic practices and rituals because of anxiety to become "acculturated," or Americanized, the next generation, feeling

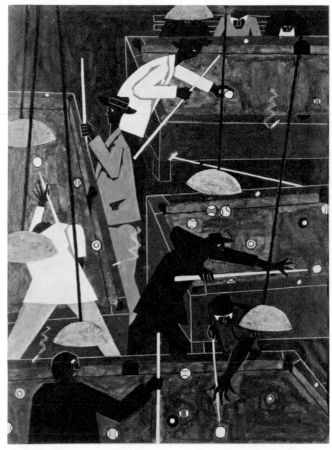

JACOB LAWRENCE. *Pool Parlor.* 1942. The Metropolitan Museum of Art, New York. Arthur H. Hearn Fund, 1942

Film still from *The Hustler.* Directed by ROBERT ROSSEN. © Rossen Enterprises, Inc., and Twentieth Century-Fox Film Corp., 1961

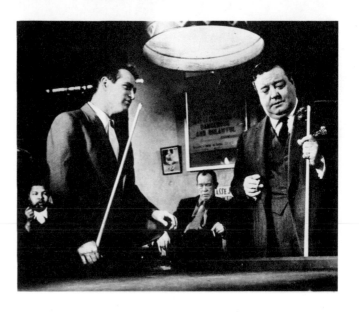

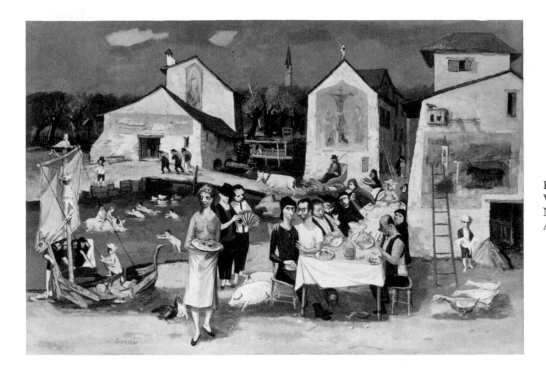

LOUIS BOSA. *My Family Reunion.*
Whitney Museum of American Art,
New York. Gift of Mr. and Mrs.
Alfred Jaretski, Jr.

JESSE TARBOX BEALS. Photograph of Italian children.
1900

more secure, is often proud of its inheritance and even
endeavors to revive the customs of its immigrant fore-
bears. Louis Bosa (born 1905) is an American painter
who has drawn primarily on the customs of immigrant
and first-generation Italian-American families as they try
to maintain some of their traditions, to transplant them
somehow in their new country. *My Family Reunion* shows
one of those old-country "tribal" feasts set in Italy but
seen through American eyes. Bosa's art relies substan-
tially on his appreciation of the incongruity of Mediter-
ranean customs viewed against the predominantly Anglo-
Saxon background of American culture. His people are
painted to reveal their feelings of awkwardness and also
their determination to conserve and perpetuate the
ancient festivals and family rituals which make life mean-
ingful for them. This painter is an excellent draftsman and
composer, and has a sharp eye for the gesture, the bodily
proportion, the clothing choice, and the characteristic
expression which reveal the southern European's personal
crisis of adaptation, of holding on and letting go. Now
that pizza pies, submarine sandwiches, and minestrone
have become part of the mainstream of contemporary
American culture, the rich, symbolic elements of the im-
migrant subculture celebrated by Louis Bosa may appear
increasingly remote, especially to that young third gener-
ation so thoroughly absorbed in baseball and the "top
twenty 'pop' tunes."

Portrayals of the landscape or the cityscape have their
social connotations whether or not people are visible in
them. We see the signs of human use: care or neglect,

AARON BOHROD. *Landscape near Chicago*. 1934. Whitney Museum of American Art, New York

affection or abandonment. The environments that men build influence their builders at the same time they reflect human choices and limitations of imagination. In the painting *Landscape near Chicago*, Aaron Bohrod (born 1907) offers an ironic comment on that halfway region—neither urban, suburban, nor rural—one sees on the outskirts of large American cities, with its homemade, cinder block architecture, accumulation of rusting equipment, and evidence of repairs begun but never completed. Bohrod's detailed naturalism is ideally suited to painting the portrait of a house—and, by implication, of its inhabitants, people who occupy the lonely, undefined space between country and city, who cannot quite mold their immediate environment into a convincing imitation of a human community. Edward Hopper (1882–1967) painted a related building portrait in *House by the Railroad*, although here it is the faded glory of a Victorian mansion which is portrayed, as opposed to the impoverished, anonymous style of building and living shown in the Bohrod painting. Hopper's house may now be a relic: perhaps it has become a rooming house whereas once it represented elegant domesticity; but it has its own wilted dignity, conferred by the artist's presentation of the forms as a unified, coherent, sculptural mass, isolated but wearing its dated architectural adornments with a certain forlorn pride.

Two versions of New York's "El," the almost extinct elevated railway, are seen (p. 66) in a watercolor by Dong Kingman (born 1911), *The 'El' and Snow*, and in *Third Avenue* by Franz Kline (1910–1962). Kingman's facility

with watercolor is challenged by the enormous variety of surface and material in the city. The artist seems to revel in the structural complexity and labyrinthine spaces and recesses everywhere one looks: he has deliberately selected an intricately built-up, virtually enclosed location, with its tangle of street signs, traffic signals, utility poles, overhead wires, and store-window displays. And in this overwhelmingly man-made situation, nature is modestly represented in the form of snow. Kingman's approach to social description is through the crisp representation of complex layers and levels, directions and labels, of the dense, tight environment in which urban man makes his home. Kline, on the other hand, is much more selective in approach and endeavors to describe less of what is objectively seen and more of what is subjectively felt. For him, the steel structural members of the elevated constitute an opportunity to paint large, black, powerful forms advancing toward the viewer and almost filling up the canvas. The effect upon the viewer is of shapes about to occupy his entire optical field: they loom up and press in upon him and seem capable of blotting out all light. Kline's image is sufficiently abstract and general to suggest any large-scale, structural element in the city. His execution is purposeful and decisive, carrying all the authority of engineering—its formidable, masculine power as well as its aura of menace.

The dramatic imagery of Kline consists essentially of a struggle between his black *shapes*, representing the struc-

EDWARD HOPPER. *House by the Railroad*. 1925. The Museum of Modern Art, New York

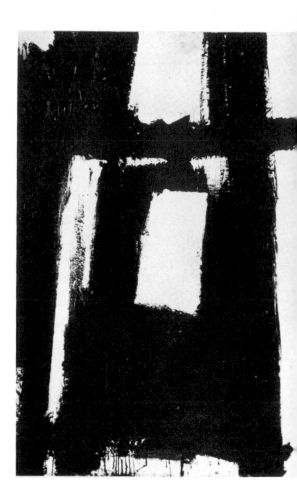

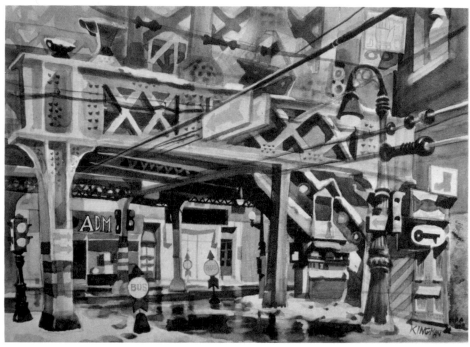

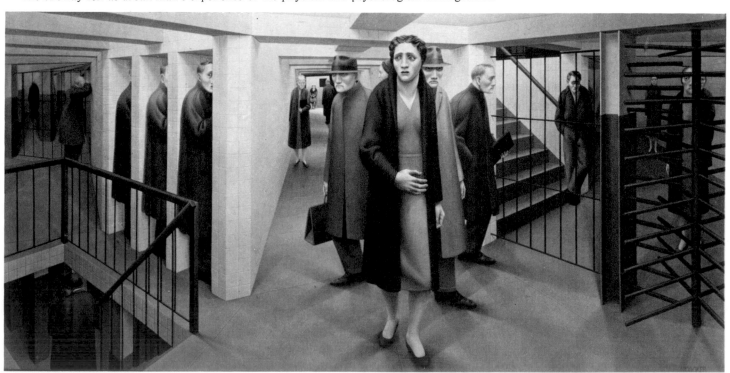

tural element, and his white *spaces*, representing the element of light. Each element endeavors to preempt the place of the other in a figure-and-ground contest, with the black asserting its role as figure first, and then yielding to the advancing, expanding white spaces, as the viewer is drawn into the conflict. This struggle to establish a *gestalt*, or pattern, within Kline's canvases is very well suited to the themes of urbanism and social description, since cities are indeed battlegrounds where contending demands for space and light are being fought out. In our cities, as in Kline's painting, the battle remains fluid, with temporary resolutions achieved intermittently, depending on the optical energy and social intelligence we bring to the contested arena.

The theme of urban struggle is quite explicitly treated in *Battle of Light, Coney Island* by Joseph Stella (1880–1946). In this work, the fascination with movement which Stella imported from Italian Futurism is given full scope by the systematic distractions and attention-getting devices of a famous American amusement park. For Stella, flickering neon signs, the amplified voices of barkers, the on-and-off patterns of colored light bulbs, and an authentically raucous, honky-tonk atmosphere epitomized the distinctive American harmony of sensuous and dynamic forces. This painting might be regarded as symbolizing the affirmation by a European (Stella was born in Italy and came to the United States when he was twenty) of the social achievement of our adolescent civilization: the synthesis of all the kinetic, unsophisticated, "hard-sell" elements of the culture into a glorious explosion of energy, color, and form.

Stella transmuted the cacophonous sounds and flashy

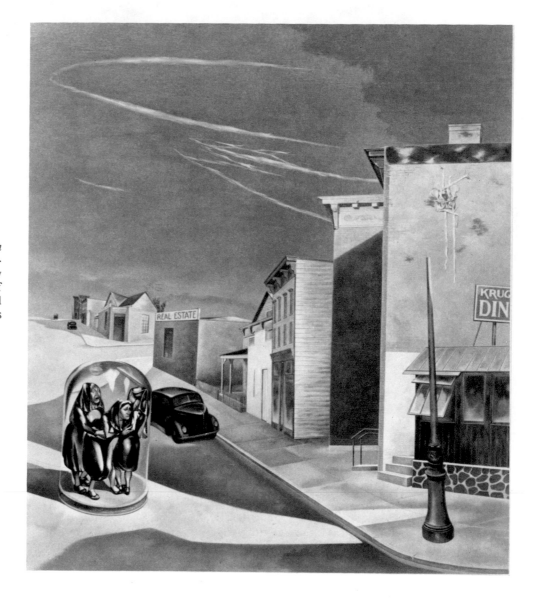

Louis Guglielmi. *Terror in Brooklyn*. 1941. Whitney Museum of American Art, New York. A Surrealist version of the sense of loneliness and menace which the city's streets can evoke.

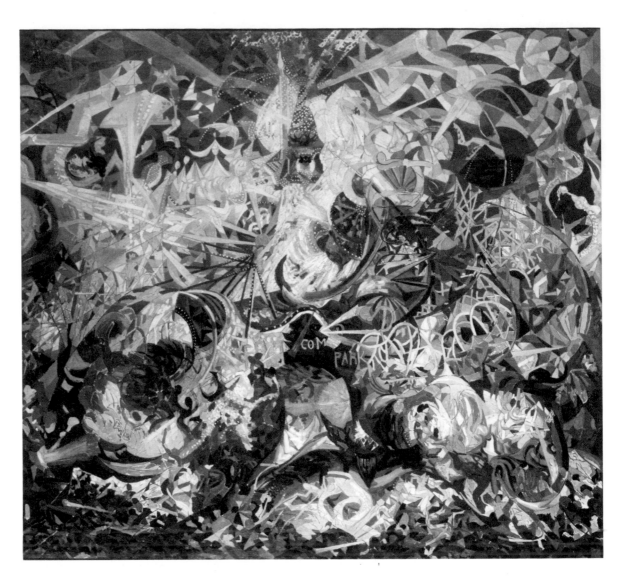

JOSEPH STELLA. *Battle of Light, Coney Island*. 1913. Yale University Art Gallery, New Haven, Connecticut. Gift of the Société Anonyme

illumination of Coney Island into an exciting spectacle of brassy exuberance in 1913; in 1936 Mark Tobey (born 1890) undertook a similar theme in *Broadway*. Tobey was equally fascinated by the light from a thousand signs and by its ability to express the frenetic search for fun by millions who are drawn like moths to the synthetic jubilee continuously on view in the center of Manhattan. Later, in 1942, Piet Mondrian (1872–1944), the almost monastic Dutch abstractionist, was to succumb to Broadway's glitter with a sparkling canvas, *Broadway Boogie-Woogie*. Tobey's tempera painting is "written" in light, a sort of neon script blurring into an incandescent haze in the center of the picture, where the scale grows smaller, the signs and people come closer together, and the motion of men and vehicles more nearly resembles the heat and commitment of battle. But Mondrian, as befits the artist

of ultimate abstraction and detachment, views the Great White Way as a musical composition. The restrictions imposed by his rectangular mode of composition do not allow the freedom and literalness of description we see in Tobey, or the spiral, radial compositional devices which Stella employs to suggest expansiveness and intersecting vectors. However, with dozens of little squares and abrupt changes of primary color, Mondrian could convey the flickering, dancelike quality of light and movement in the thoroughfare.

Whether or not Mondrian really knew the boogie-woogie, which involved a forward movement of the body and arms and then a reversal before the forward inertia was lost, his painting does express its short bursts of energy, the go and stop, the scurry and halt, of the Broadway "mell-o-dee."

The neon spectacle of Broadway can
be expressed as white writing, or as
little squares of alternating color, or
by shaping the neon tubes themselves
into an abstract simulation of the
whole glittering scene.

PIET MONDRIAN. *Broadway Boogie-
Woogie*. 1942–43. The Museum of
Modern Art, New York

below:
MARK TOBEY. *Broadway*. 1936. The
Metropolitan Museum of Art, New
York. Arthur H. Hearn Fund, 1942

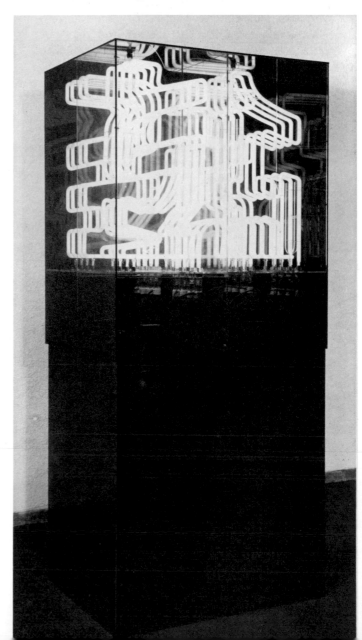

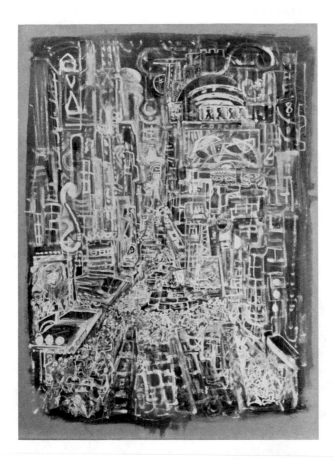

CHRYSSA. *Fragments for the Gates to
Times Square*. 1966. Whitney Muse-
um of American Art, New York.
Gift of the Howard and Jean Lipman
Foundation, Inc.

Satire

The social function of satire is to ridicule people and institutions so that they will change. As a type of humor, satire is not merely aimed at the feelings of relief and superiority we get from laughter; satire is also aggressive in intent. It makes fun of its object—sometimes bitter, derisive fun. Although laughter is involved, satire is a *serious* art form, serving to puncture pretension, to cut the mighty down to size, to dramatize the gap between official promises and actual performance.

Just as humor plays an important role in the psychological health of the individual, satire is vital for the healthy functioning of human communities. The capacity of responsible persons to accept satirical criticism gracefully and without efforts at suppression is probably a good index of their ability to exercise noncoercive leadership. And if our society as a whole cannot accept satirical comment and criticism in its stride, then our institutions and customs are fragile indeed. Often, individuals or groups that have been stung by satire question the legitimacy of the offending material by creating a casuistical distinction between constructive and destructive criticism. Naturally, an offended individual or group will feel itself the victim of destructive criticism. And it is possible to think of satirical material in literary or visual form which appears to have violated common notions of propriety in expressing criticism. But the impulse to suppress disagreement, whether it appears in satirical or other forms, can often be evidence of unwillingness to examine the causes which originally aroused the criticism. Certainly the autocrats of all times have been inhospitable to satire directed at themselves, and certainly the right to use humor in social and political criticism is indispensable, part of the fabric of freedom.

Democratic societies, too, go through solemn phases when satire is regarded as negative, uncooperative, and divisive, if not actually subversive. An administration's humorless image of itself may be caused by the personality traits of high officials, variations in their ability to "take it." In this connection, President Truman very aptly observed, "If you can't stand the heat, then get out of the kitchen." Yet is there any special trait of satire which makes its victims more uncomfortable than does conventional criticism, the complaints and comments found in the usual media of news and information? Furthermore, are there any characteristics of satire in the visual arts which are uniquely painful?

First, to be the object of ridicule is probably more difficult to bear than to be scolded. To be laughed at by a community or by substantial groups in the community is very much like being ostracized. It is an exceedingly severe kind of humiliation. Second, laughter is both a physiological and a psychological phenomenon; it involves the total organism and thus implicates an individual more completely in an act of ridicule. We are likely to remember a satirically comic reference to a public figure long after we have forgotten his specific acts and policies. Many American voters will not forget the damaging visual comparison of Thomas E. Dewey, twice an unsuccessful presidential candidate, to the groom on a wedding cake. Finally, the visual forms of satire often use caricature or some other means of exaggerating the physical shortcomings of their targets. Needless to say, we are, for the

LI'L ABNER The Champ **By Al Capp**

AL CAPP. Panels from *Li'l Abner* Ugly Woman Contest. 1946. Courtesy Al Capp and United Features Syndicate. Capp's professional interest in comic repulsiveness or ugliness was fully echoed by his readers, who generously contributed drawings of their candidates for the supreme ugliness accolade.

Leonardo da Vinci. *Caricature of an Ugly Old Woman*. Biblioteca Ambrosiana, Milan

When satire dwells on the ugly, it has a timeless and universal character; very little separates Al Capp's twentieth-century version of ugliness from the vividly repulsive countenance drawn by a Japanese artist twelve hundred years ago.

Caricature from the ceiling of Horyu-ji, Nara, Japan. 8th century A.D.

most part, very aware of our personal imperfections; to have them magnified and made to symbolize policies and attitudes which the community finds repulsive is very painful, especially if one's psychic defenses are not strong.

An observation about caricature needs to be made here: fashioning grotesque images of real or imagined people is a universal practice. All children are intrigued by the creation of fantastic, hideous, incredibly ugly faces. Leonardo da Vinci made many such grotesque heads, which he regarded as investigations of variations from the beautiful; but they were, from a psychological standpoint, similar to the images children and others create—explorations of the frontiers of the human. Such graphic images are comparable to the rich body of spoken and written material which exists for characterizing persons of ordinary appearance as ugly. Adolescents seem to be especially adept at the creation of derisive physical descriptions and comparisons. Further, popular comedians can convulse audiences for hours with detailed descriptions of the ugliness of their spouses and other female relatives. In short, fascination with ugliness is widespread; it is perhaps as pervasive as the interest in beauty. The interest may appear to be malicious, but more likely it grows out of anthropological and psychological inquiries which have little connection with malice. Whether or not

caricature is malicious, however, the visual forms of satire (which often employ caricature) *are* intentionally malicious. The malice is not a moral fault but a kind of civic virtue, since satire serves society by acting as a check on the excesses and misapplications of power. And satire serves culture by acting as a check on the excesses, foolishness, or grossness of current customs and tastes.

Perhaps the greatest political satirist of World War II, if not of the first half of the twentieth century, was the Briton David Low (1891–1963). His cartoons were in many respects visual counterparts to the speeches of Winston Churchill: he could ridicule the Fascist dictators, summon the courage of his countrymen when they were taking a terrible beating, express fierce defiance when Britain faced invasion, appeal for help from America, and grieve over the valorous dead. Every editorial cartoonist develops a pictorial formula for the portrayal of the world's political leaders, a formula which quickly identifies a personality physically and also stereotypes him with traits such as villainy, hypocrisy, courage, or madness. David Low, technically very able, was especially successful in his personality formulations, his characterizations of der Führer and Il Duce. At a time when their military and racial insanity, matched with total political power, had succeeded in bludgeoning and terrifying the civilized

DAVID LOW. *Rendezvous.* 1939. Cartoon by permission of the David Low Trustees and the *London Evening Standard*

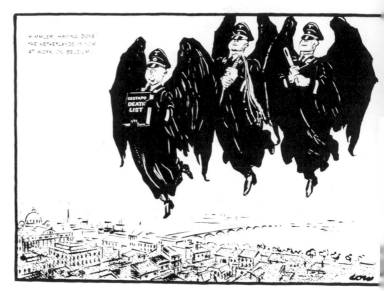

DAVID LOW. *The Angels of Peace Descend on Belgium.* 1940. Cartoon by permission of the David Low Trustees and the *London Evening Standard*

world, David Low shrewdly managed to identify Hitler and Mussolini as asses—dangerous, to be sure, but asses nevertheless, and thus hardly supermen. Low's assessment was not complete or entirely accurate (it may have been sound as far as it went), but it served to encourage the hard-pressed Britons; he used satire to reduce the dictators to less than invincible size.

The political satirist at his best is shown in Low's cartoon *Rendezvous*, which deals with one of the strange consequences of political expediency—the Russo-German nonaggression pact of 1939. The Russians hoped by the treaty to buy time to rearm against the expected invasion by Germany. And Germany hoped to secure the neutrality of Russia during its planned attack on Poland, France, and the remainder of the West. Hence, the mortal enemies, soon to be locked in the bitterest struggle of the war, greet each other with feigned and exaggerated gestures of courtesy while addressing each other with their customary rhetoric of insult.

Another powerful satiric thrust is seen in Low's cartoon *The Angels of Peace Descend on Belgium*. It deals with the brutality of Heinrich Himmler's Gestapo, or secret police, which followed the German armies into conquered countries, organized the looting, and tortured and murdered potential resistance leaders. Although Italy was a German ally, it too was a victim of the systematic Gestapo methods as the war began to turn against the Axis powers. The great Italian film *Open City* is a dramatic document of that

tragic period. But Low, in this cartoon, is a satirist rather than a tragedian. The symmetry of the figures, their military precision, even their identical dancelike foot positions serve to symbolize the mechanical, efficient, and highly organized character of Gestapo torture. Finally, the silhouettes of great black birds descending upon a city establish symbolic connections with vultures and medieval myths of death.

We expect satire in the graphic arts, especially in news media, but it also occurs, although less frequently, in "serious" painting. Most of the work of the American painter Jack Levine (born 1915) is satiric in intent, *The Feast of Pure Reason* constituting a typical example. The ironic point here obviously lies in the contrast between the title, which celebrates a rational, totally logical approach to human affairs, and the actualities of decision making in some communities—the secret meetings and negotiations of corrupt officials, politicians, and businessmen. Levine employs realistic caricature, tending to identify moral and civic corruption with physical grossness and ugliness. His people are meant to be detested rather than laughed at, his satire deriving mainly from the sarcasm of the title and the ponderous, bloated qualities of the social types he represents as occupying positions of influence and authority.

Woman, I by Willem de Kooning (born 1904) possesses satirical values, although the violent execution of the painting or the shock with which the viewer reacts to the

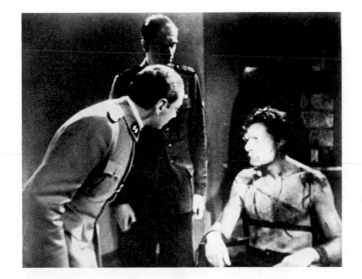

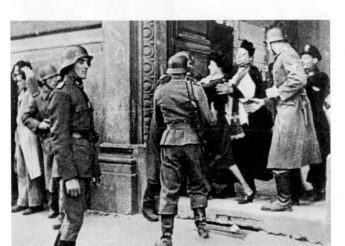

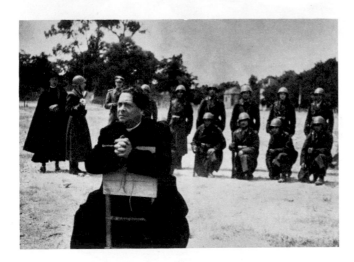

Film stills from *Open City*. Directed by ROBERTO ROSSELLINI. 1945. Courtesy Contemporary Films/ McGraw-Hill

JACK LEVINE. *The Feast of Pure Reason*. 1937. On extended loan to the Museum of Modern Art, New York, from the United States WPA Art Program

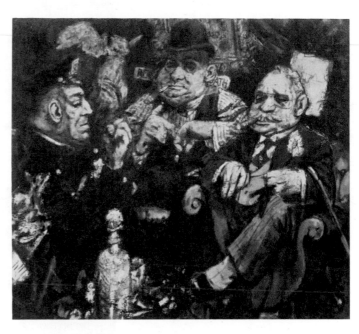

WILLEM DE KOONING. *Woman, I*. 1950–52. The Museum of Modern Art, New York

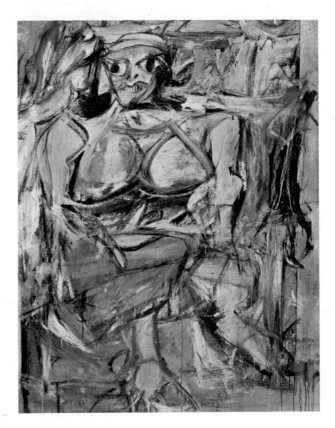

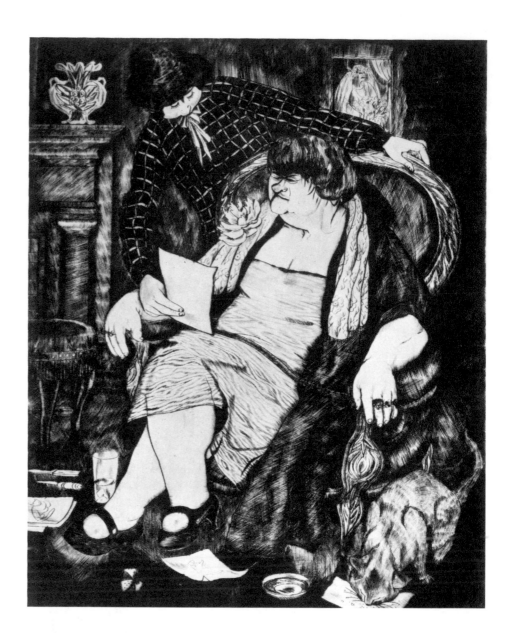

PEGGY BACON. *The Patroness*. 1927. The Museum of Modern Art, New York. Gift of Abby Aldrich Rockefeller

WILLIAM GROPPER. *Gourmet*. 1965. Associated American Artists, New York. A satirical thrust, in the manner of George Grosz, which, like Peggy Bacon's *The Patroness,* equates physical grossness with moral deficiency.

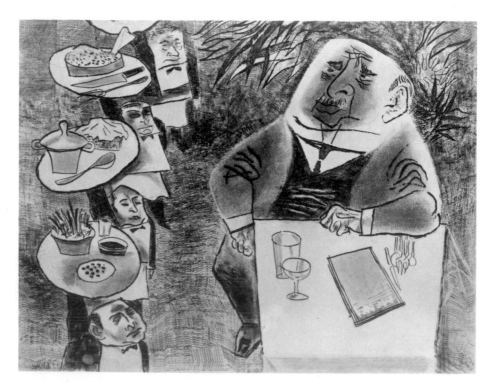

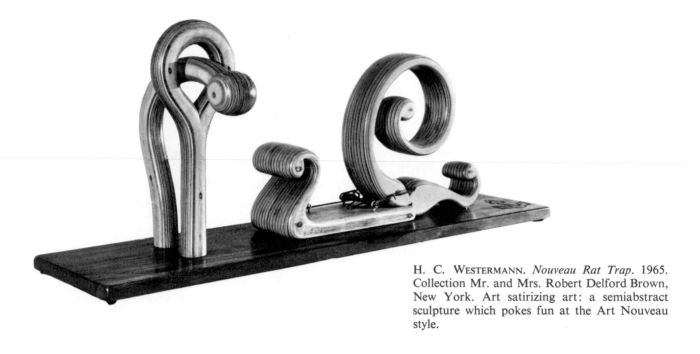

H. C. WESTERMANN. *Nouveau Rat Trap*. 1965. Collection Mr. and Mrs. Robert Delford Brown, New York. Art satirizing art: a semiabstract sculpture which pokes fun at the Art Nouveau style.

work may momentarily prevent his seeing its elements of burlesque. The artist presents an older woman, heavyset, wearing a light, flimsy shoe, overexposing her body in a scantily designed dress, and exhibiting a grimacing expression when she would doubtless wish to appear bewitching. The oversized eyes are probably the result of grossly overdone makeup, the horrible mouth expression probably the result of trying to fashion a fascinating smile through ill-fitting dentures. The tiny ankle and the swollen foot attempt to support a massive superstructure, and all, together, betray the fierce and pathetic exertions of a "mom" gone berserk. The artist presents *Woman, I* not merely as a single clinical study but as an authentic portrayal of the inner and outer condition of a sizable body of older women in our culture. The artist is plainly indignant, enraged to the point where he wants to make as horrible a contrast as he can between the woman's pretensions and the actual results we see. Jack Levine seems to dwell more lovingly upon the bloated surfaces of his people, but De Kooning barely establishes his forms before tearing into them with angry, slashing painterly attacks.

A work of similar satiric anger is the etching *The Patroness* by Peggy Bacon (born 1895). Here, too, the subject is corpulent and ham-handed; she is surrounded with furs which are of no help so far as allure is concerned. Her face is twisted and pinched in contrast to her bodily bulk—a symbol, no doubt, of her minuscule soul contrasted with her excessive wealth. The artist means to imply that large funds rather than sensitivity and connoisseurship enable this gross person to play the role of patron of art. It is perhaps a typical if exaggerated expression of the attitude of the artist toward his patron, a sort of compensatory act of derision toward the persons on whom he feels dependent, a malicious bite of the hand that feeds him.

Satire thrives in art whenever there is freedom from political or social repression. As the visual arts have embraced abstraction, however, there has been a lessening of artistic ridicule, of thrusts directed at the old familiar targets. Art seemingly withdrew from the social and political arena after 1946 and devoted itself more to the analysis of relatively private emotion and the refinement of the visual language used to express that emotion. A similar development has taken place in literature and in philosophy. Philosophers for some time now have been concerned with language—that is, with the analysis of linguistic structures as vehicles of meaning rather than with the content of philosophic propositions and systems of thought dealing with the human enterprise as a whole. Pop art, which was a relatively brief phenomenon, had satiric potential, although it lacked the sharpness and precision of genuine satire. Its target was very broad: all of modern culture. Nevertheless, its stance was mainly critical, although it is difficult to say whether some of the "Poppers" derided or celebrated the banalities of popular culture. Still, they seemed to be aware of the noise and commotion around us and busily engaged themselves in developing artistic weapons to cope with their noxious effects. These weapons were, for the most part, fragments of the environment itself (which is damning enough). In the future, we may confidently expect that artists will find some way of making significant statements about the physical environment—statements which deserve to be taken seriously as social criticism as well as art.

Graphic Communication

We are accustomed to think of visual art in terms of objects which are prized and admired. But, as we have already seen, visual art also constitutes a language—a language which is useful for a variety of social and institutional purposes. Forms and images can be organized so that they communicate with extraordinary persuasiveness, and, in conjunction with verbal language, their explicitness and precision of meaning is maximized. Understandably, our industrial civilization, which has developed mass production and mass distribution to a very high degree, employs the language of visual art extensively in its marketing operations. And graphic design, particularly of posters, packages, books, and other printed matter, is an indispensable tool of the communications industries and the so-called knowledge explosion. What is known today as advertising design, or graphic communication, used to be called commercial art. Although such labels are not very important, they call attention to the crucial function of art in conveying information from business and industry to the specific social groups they wish to influence.

Advertising design, however, is only a single, although prominent, instance of the social function of art as a communication medium. The purposes of graphic communication vary, and consequently the artistic organization of images, forms, words, and subject matter also varies. In general, the professional education of contemporary artist-designers prepares them to create and organize images which can serve a variety of information and communication objectives. That is, the artist who can design an advertisement to promote the sale of an automobile or a

MEL RAMOS. *Chiquita Banana.* 1964. Collection Ian W. Beck, New York. An example of the appropriation by a Pop artist of an ancient advertising device for selling anything.

lipstick may also be able to design a record album cover, a book jacket, an outdoor poster, or a package label. However, some designers restrict their efforts to particular communications media and particular kinds of products or information. Also, the arts of information and communications design are so specialized that very few advertisements, packages, posters, or labels are ever the work of a single person. Art which serves commerce and industry is *collective* art, just as almost all phases of industrial engineering, manufacture, and distribution are team enterprises.

Since we have been nurtured on fairly romantic ideas about *individual* artistic creativity, the collective character of modern communications design may be somewhat dismaying. But we should remember that most of the ambitious artistic projects and many of the minor artistic efforts up to the Renaissance were collectively created. Anonymous, collective creation typifies design today as in the medieval period: we seldom know who designed a particular Gothic cathedral, carved its stone sculptures, or executed its stained glass. Likewise, when a modern office building, hotel, or college dormitory is erected, we often cannot be certain of the personal origin of the design in the large architectural firm which carried out the commission. Even when we know who the senior design partners are in a prominent firm—for example, Skidmore, Owings and Merrill—the collaborative character of contemporary architectural practice does not permit the identification of a single designer in the same sense that we know Michelangelo created the original design for St. Peter's and Jefferson designed his home at Monticello. But notwithstanding certain modern and medieval similarities in the organization of the design process, we are inclined to regard collectively created works less seriously than works designed and executed by an individual. This is so because, since the Renaissance, we have worshiped individual genius, and the art object as an embodiment or reflection of genius. Even the cinema, a twentieth-century art-industry illustrating collective creativity to a high degree, was prolific with "geniuses" during its early Hollywood days. Today, the cinema industry centered in Hollywood must contend increasingly with low-budget "art" films created on a fairly individualistic basis by artist-director types in New York and elsewhere. Even so, the film-making process denies such directors the artistic autonomy enjoyed by easel painters, for example.

Although the collective or collaborative origin of art devoted to information and communication accounts for its minor status according to some persons, its connection with commerce is another source of detraction. Thus a poster which is designed to persuade or to sell is regarded as inferior, a priori, to a painting or sculpture which was

GEORGE APTECKER. Photograph of a wall at Coney Island. 1968. Communications design practiced as a folk art.

never soiled by commercial motivation (although the painter usually hopes to sell his pictures). In this period, we have come to believe that works of art created for no particular client and embodying no person's ideas other than those the artist freely chooses to express are superior to those commissioned by commerce or industry. Advertising art is especially suspect, as is advertising in general. We are all more or less convinced believers in the motto *caveat emptor*—"let the buyer beware"—because we do not in our hearts entirely trust salesmen, even if our society rewards them munificently. Art which persuades or sells is considered less pure, less idealistic, less *fine* than art which just is. Quite possibly, we expect the arts to perform certain religious and ethical functions exclusively, to appeal to our better nature, to enlighten us and elevate our moral character (which they may do) rather than to remind us of the getting and spending which occupies so much of daily life.

But an appeal to art history shows that artistic excellence is not necessarily related to the social or financial arrangements for bringing it into being. "Who pays the fiddler calls the tune." So far as artists are concerned, this proverb can be understood to mean that art will be paid for by kings and cardinals when they are powerful and possess large means, or by merchants and industrialists when they are rich and influential. The patronage of art and artists clearly reflects social and economic change. As a corollary, the uses and subject matter of art change because of the shifting requirements of the individuals and institutions that commission or patronize art. But artistic excellence is more likely related to the imagination and technical mastery of the artist (and his client's ability to recognize these traits) than to the moral status of commerce or the ethical level of advertising. Indeed, the history of art offers ample evidence of distinguished works created for relatively trivial purposes—Cellini's saltcellar, for example. We remember the artist now and prize the object, although many of us do not recall the patron and are not particularly interested in the cellar's effectiveness for holding salt.

THE PROBLEMS OF COMMUNICATION

What are the characteristic problems of information design which the artist must solve in carrying out the social function of this art form? First is the matter of arresting the attention of a portion of the public. This is a problem for all effective communication. Its challenge

varies from the five-second viewing limitation for an outdoor poster to the fifteen- or twenty-minute perusal of a magazine page. Second, and related to the difficulty of gaining attention, is the overall psychological and sociological strategy: identifying the particular group which is addressed and knowing its interests and motivations. Third is the problem of characterizing the use and meaning of the product, idea, or service which is to be sold or communicated. How can a complex new idea or product be presented quickly and memorably to a vast public which is under almost continuous visual assault from competing designs and media? Finally, there is the problem of the content and quantity of verbal material which may appear as a caption for a poster, as copy within an advertisement, as dialogue on television, or as the sole visual material on a book jacket. It should be stressed that the design and presentation of letter forms constitute a graphics problem which is often more significant than the verbal-literary problems of communication design. Increasingly, our learning in the realm of values and attitudes takes place under the auspices of nonverbal media. Accordingly, new problems are faced by graphic designers for films and television who must relate their imagery to unseen words or music—material which occupies aural but not optical "space." That is, although we do not employ our ears to see, the designer must know how the acuteness of visual perception is affected by the sensory and cognitive effects of words and sounds.

The Blues and Piano Artistry of Meade Lux Lewis. 1962. Riverside Records, New York. This record album cover, which presents a relatively simple image of high artistic quality, nevertheless entails the collaboration of several persons: the client, artist Peter Max, art director and designer Ken Deardoff, and a number of graphics specialists.

BRUNO MUNARI. *Campari.* 1965. The Museum of Modern Art, New York. Gift of the designer

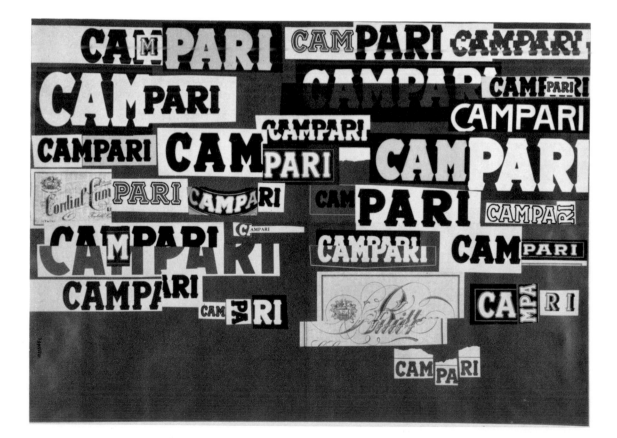

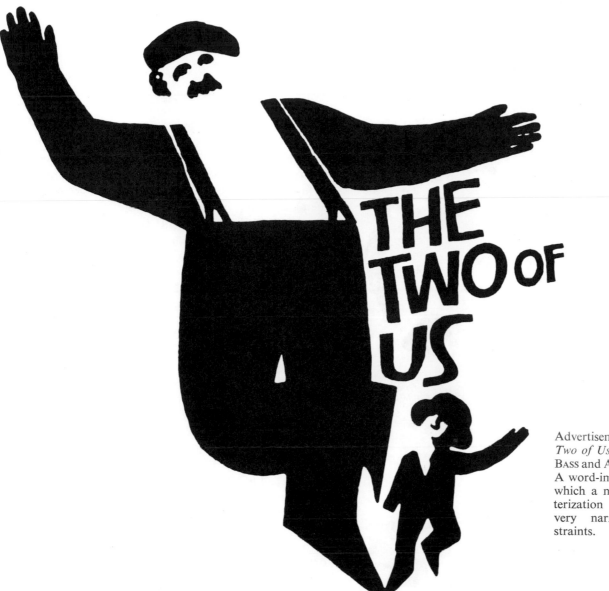

Advertisement for film *The Two of Us.* Designed by SAUL BASS and ART GOODMAN. 1968. A word-image combination in which a maximum of characterization is achieved within very narrow formal constraints.

These general problems of information design are closely related to more prosaic economic and technical matters. Processes of reproduction affect artistic techniques, which, in turn, affect graphic form and content. The size of final reproduction dictates the detail or simplicity of images and the choice of type faces. Some faces are highly legible at a distance or can be read easily when the viewer is rapidly moving. Available funds govern the media decisions of the designer: the use of color, of photographs, or of painted images; the amount of white space in a quarter page as opposed to a full page; the particular medium used—newspapers, posters, television, or magazines. Even the quality of paper affects decisions about color and design. All of these variables are comparable to those faced by an architect who must contend with a variety of cost, site, and functional factors. His task is to find an effective artistic solution within the practical limitations set for him.

Visual simplicity and logic are the dominant traits which emerge from the successful solution of problems in information design. Visual simplicity implies a bias in favor of open or white space and bold, abstract forms— forms which are easily seen, quickly identifiable, and capable of controlling a desired set of symbolic meanings. By logic I mean a sense of connectedness among the elements of a total design: the product or idea, the pictorial and other visual material, and the copy or other verbal material. It is interesting to observe how often graphic designers have drawn upon the stylistic innovations of contemporary painting in endeavoring to solve their problems of formal innovation and stimulation of interest. The following illustrations taken from the work of designers throughout the world demonstrate the not infrequent dependence of information design on the allegedly useless fine arts. While abstraction has followed its own internal development within painting, it has been indirectly the

SEGUNDO FREIRE. Carnival poster. 1957

PABLO PICASSO. *Design*. The Metropolitan Museum of Art, New York. Gift of Paul J. Sachs, 1922

most important reason for the effectiveness of modern graphic design.

SOLUTIONS

A Mexican carnival poster by Segundo Freire shows the unmistakable influence of Picasso's paintings of harlequins and musicians. The poster designer, however, retains only the flat patterning of Cubism and does not go so far as to slice the figure and recompose its elements to the point where his work would require too much intellectual effort of the viewer. It is not desirable to carry distortion and dismemberment of the human figure beyond a certain point, if quick communication is a primary objective. On the other hand, a certain amount of simplification and generalization of the figure is an aid to recognition and identification in advertising; hence, Cubist abstraction has been a fertile source of ideas for designers interested in graphic communication. The Italian designer Pino Tovaglia has created a striking railroad poster based largely on the painterly style of Fernand Léger. *Three Women* by Fernand Léger does not, of course, contain machinery, but it does reveal the artist's attempt to convert all visual material into mechanical equivalents. It is possible to think of this crisp, powerful poster design as a kind of artistic triple play—from Picasso and Braque, to Fernand Léger, to Tovaglia—an aesthetic equivalent of the baseball trio: Tinker to Evers to Chance.

A cover design for *Fortune* magazine by the late Alvin Lustig (1915–1955) reveals the influence of another facet of Cubism—collage, the creation of pictorial images and textures by pasting flat material, especially printed matter, on the picture's surface. Picasso and Braque combined

PINO TOVAGLIA. Railway poster. 1957. Courtesy the artist and Ferrovie Nord Milano

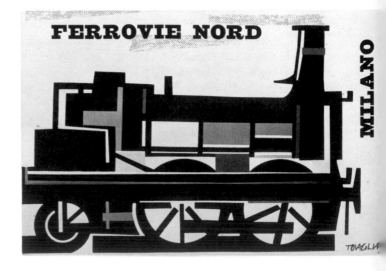

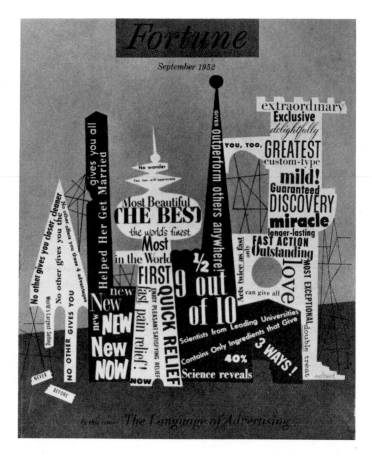

ALVIN LUSTIG. Cover design for *Fortune* magazine. 1952. Courtesy Time, Inc.

PABLO PICASSO. *Bottle of Suze*. 1912–13. Washington University, St. Louis

FERNAND LÉGER. *Three Women (Le Grand Déjeuner)*. 1921. The Museum of Modern Art, New York. Mrs. Simon Guggenheim Fund

the pasted material *(papier collé)* with drawn or painted forms, as in the Picasso collage *Bottle of Suze*, which contains pasted papers, newsprint, wallpaper, and the label from a liquor bottle. Although the original Cubists deliberately used papers whose printed material was unrelated to their aesthetic aims, Lustig has employed the words and type faces of the collage material to reinforce his theme—"the language of advertising." Furthermore, his shapes are those of television masts, billboards, and related display devices. Thus, designers try to increase effectiveness by stating their message two or three times simultaneously, and with varied formal devices. The Picasso collage, on the contrary, has no explicit message but rather communicates an aesthetic effect. Hence, the bottle and its label serve mainly as an excuse for organizing a series of forms: the print is not there to be read but to be experienced as texture and color.

An especially interesting example of what anthropologists call cultural diffusion is visible in a Japanese cosmetics poster by Tsuneji Fujiwara. The faces are remarkably similar to those painted by Amedeo Modigliani, an Italian-born artist who spent most of his working life in

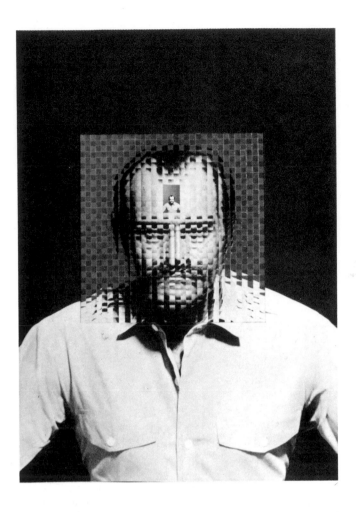

> The jacket designer has created a mysterious personality symbol through the photographic adaptation of geometric forms originally developed in Analytic Cubism.

France. Modigliani began his career as a sculptor and was especially influenced by African wood carving, as in the example illustrated, translating African forms into the small mouth, elongated ovoid head, and delicate, stylized arches over the eyes of the women in his paintings. Apparently, the Japanese designer found in Modigliani an ideal of female beauty which would appeal to the audience he was trying to reach. As a result, the feminine ideal which a painter in Paris distilled from African sculpture and his own sensibility and presented in the context of traditional easel painting finds itself utilized in a totally different context—advertising design.

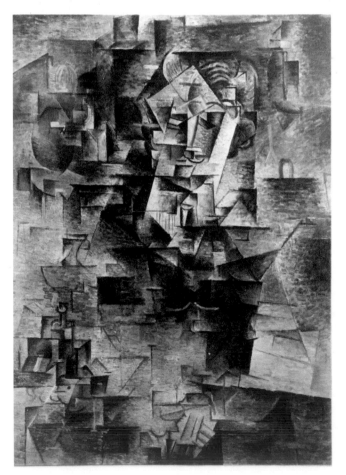

The English artist Ronald Searle places satirical gifts at the disposal of poster design in a drawing for the United Rum Merchants of London. Using humor to gain attention has obvious advantages provided the product emerges in a favorable light. From the standpoint of the designer's client, entertaining the public must also induce that public to notice the product, think well of it, and want to buy it. Solemn people always seem concerned that humor might divert interest from the message or create an unfortunate association of the product with laughter. Consequently, Searle's satirical drawing style had to be carefully employed. Fortunately, Searle specializes in caricature of distinctively English, mainly Victorian types, and seems to understand the varieties of British mustache as few others do. His viewpoint is that of a friendly critic of the establishment; hence, the ridiculous situation he portrays can be seen as an acceptable spoof, with its mock consternation, its irreverence for the genteel culture represented by serious musicians, and its feigned disapproval of the sly old gentleman whose absurd violation of the rules can be tolerated if he drinks Lemon Hart rum. It is worth noting that the abstract approach to poster design can be successfully abandoned in this case because there is a sure grasp of humor and a traditional product addressed to a tradition-oriented public—assets combined with the highly individual, quickly identified style of an artist whose employment by an advertiser itself constitutes an endorsement of the product.

The film illustration by Ted Hanke, *Oil Men Call This a Christmas Tree,* illustrates an intelligent use in industrial advertising of aesthetic discoveries made originally by

Mask, from Ivory Coast. Collection Peter Moeschlin, Basel

Amedeo Modigliani. Detail of *Anna de Zborowska*. 1917. The Museum of Modern Art, New York. Lillie P. Bliss Collection

Have a GOOD RUM for your money

RONALD SEARLE. Design for advertisement for Lemon Hart rum. 1957. Courtesy United Rum Merchants, Ltd., London

Because graphic designers work under the pressure of deadlines and in an intensely competitive environment, their profession is often characterized by obvious borrowing and quick adaptation.

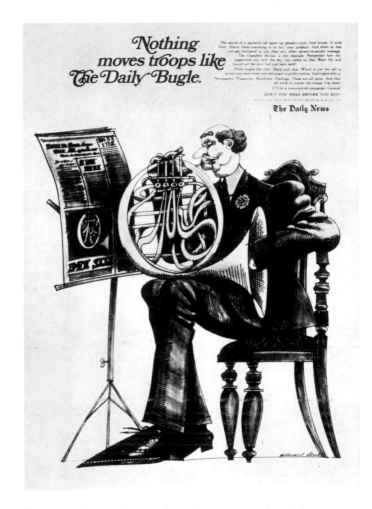

EDWARD SOREL. Design for advertisement for Print Advertising Association. 1968

artists who celebrate the machine: such painters as Léger, Duchamp, and Sheeler, along with a host of contemporary sculptors who weld together discarded metal scraps and machine parts. The painted illustration is obviously based on a photograph of something real, but, so far as the layman is concerned, this combination of valves, pipes, gauges, nuts, and bolts is an impressive mystery, a symbol of technological mastery. The angle of vision is from below, and since there are very few cues to the scale of the construction, we see it almost as a monument. In addition, the strong light-and-dark patterning, with some of the shapes almost in silhouette, simplifies and drama-

tizes the stark, mechanical forms. Graphic design often shows how the social intent of great corporations is similar in style to that of ancient kings and generals who erected heroic statuary, obelisks, and triumphal arches to celebrate victories or call attention to the extent of their power and achievement.

A medium of vast influence for graphic design lies in television. Its electronically reproduced announcements and title cards now tend to resemble the imagery employed in magazines and outdoor posters. Still, the poster has not been disdained by a number of masters, including Toulouse-Lautrec and Picasso, both of whom created

Information Design

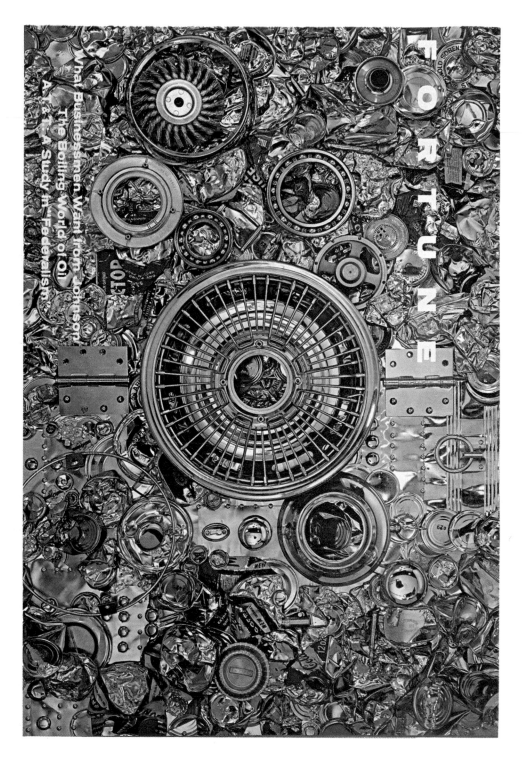

WALTER ALLNER. Cover design for *Fortune* magazine, February, 1965. Courtesy
Time, Inc. Here a graphic designer assumes the role of sculp-
tor. For an audience of industrial executives, he creates a
dazzling organization of old and new metallic objects based
on the wheel (big) and the circle (closed). The design tran-
scends its vehicle, a magazine cover, because photographic
imagery is now capable of eliciting tactile, as well as visual,
responses.

Die Komödie einer sensationellen Erfindung (The man in the white suit) Mit Joan Greenwood, Cecil Parker
Regie: Alexander MacKendrik Prädikat wertvoll Regiepreis Cannes 1956 Neue Filmkunst Walter Kirchner/

HANS HILLMANN. Poster for film *The Man in the White Suit*. 1966. Designed for Neue Filmkunst, Walter Kirchner. Courtesy the artist. For the graphic designer, concentric squares must go somewhere, must do a job, must mean something explicit.

HERBERT BAYER. Artwork for advertisement *"The art of progress is to preserve order amid change and to preserve change amid order"* (Alfred North Whitehead). 1966. Created for Container Corporation of America's *Great Ideas of Western Man* series. Courtesy Container Corporation of America, Chicago. Change visualized as an ascending process: transformation under the solemn governance of law. But there is some evolutionary experimentation going on too.

oil men
call this a
Christmas Tree

As painters and sculptors developed the aesthetic potentials of industrial machinery, it became possible for graphic designers to portray machines as symbols of economic growth and industrial efficiency.

TED HANKE. Film illustration for Diamox advertisement, Lederle Laboratories Division. 1957. Courtesy Lester Rossin Associates, Inc., New York

JULIUS SCHMIDT. *Iron Sculpture.* 1958. Nelson Gallery-Atkins Museum, Kansas City, Missouri. Gift of Mr. and Mrs. Herman Sutherland, Mr. W. T. Kemper, and the 8th Mid-America Annual Exhibition

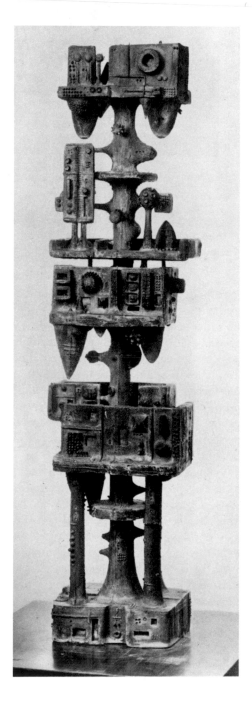

Advertisement for Southern Natural Gas Company, Birmingham, Alabama. 1967

THE ASPHALT JUNGLE

WITH JACK WARDEN, AECH JOHNSON, BILL SMITH / MGM TELEVISION

CURTIS LOWEY (art director) and ARNO STERNGLASS (illustrator). Advertisement for TV show "The Asphalt Jungle." Courtesy Ken Saco Associates, Inc., New York

works for reproduction. (Indeed, Lautrec is responsible for a body of poster work which holds an enduring place in the history of modern art.) The intimacy of the television image permits the medium to deal very frankly with a variety of social problems (when producers and sponsors possess the courage to undertake controversial or emotion-laden themes). Also, the continual improvement of the technical quality of broadcast and received images promises that as time passes fewer and fewer artistic values will be lost in transmission. As color television is perfected, we may confidently expect a substantial growth in the commissioning of visual art for TV reproduction, not only for advertising spots, title cards, and animated films but also as the primary material of regular broadcasts. They would correspond to books which today are published so we can examine at leisure works we may or may not have seen in museums. Such publications, being relatively inexpensive, have brought about a revolution in the artistic literacy of the world. However, books have also been published since the invention of movable type with visual material created for the book alone. So, also, will television commission works of art specifically for entertainment and educational purposes as the quality of visual reproduction improves.

The genealogy of the forms in the poster by Saul Bass (born 1920) for Pabco Paint Company would not be difficult to trace to Paul Klee or Joan Miró. What is interesting to the student of graphic design is the adaptation by the artist of Surrealist imagery to advertise house paint.

But the strategy of the imagery also makes marketing sense. The manufacturer has to interest housewives in his product, and a key problem of paint manufacturers and retailers lies in convincing women that house painting is not an arduous, dirty job—not, at least, with this product. Klee did, so to speak, considerable research into childlike imagery, while Miró has added to that research his own whimsical conceptions of a world inhabited by and perceived through the eyes of children, or of persons with childlike mentalities. Both artists succeeded in invading the carefree world of children, where adult notions of responsibility and fear of error have not yet penetrated. The forms which Saul Bass draws upon, in short, tend to express freedom from inhibition, a rollicking, neurosis-free approach to adventure and chance taking. The timid housewife, afraid lest she undertake a job beyond her powers or make a glorious mess of painting her kitchen, is encouraged to view the operation as a romp, easy enough for a child to accomplish. With these unconscious suggestions present in the imagery, the art of the designer carries the message further through the small photographic illustration of the happily employed *hausfrau*, bottom center, while the outline of the drawing itself is executed in bright, clean color. Thus, although the design is simple enough and easily and quickly perceived, it makes very sophisticated use of modern art history and of unconscious suggestion to advance the advertiser's objectives.

Color is so very personal. That's why Pabco gives you so many colors to choose from. match, blend or contrast any Pabco colors in any interior exterior finish. You'll get just the effect you want. Pabco goes on so easily, too Dries fast. smooth and even. Lasts longer for Pabco paint, roofing, siding, where you see this emblem.

LOOK AHEAD—
PAINT WITH
PABCO

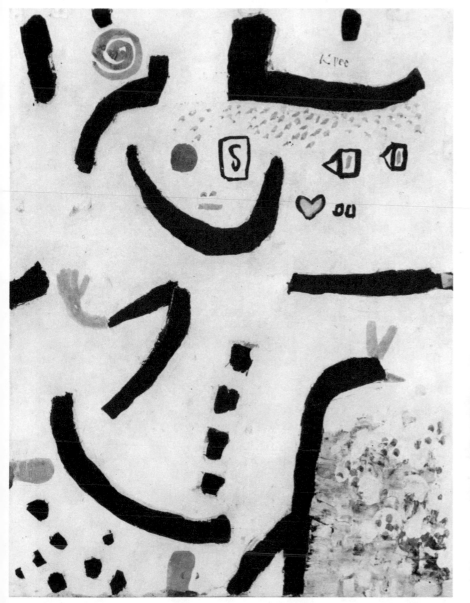

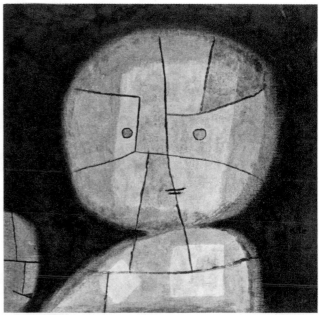

PAUL KLEE. *A Child's Game*. 1939. Collection
Felix Klee, Bern. Permission Cosmopress
Geneva, 1971

PAUL KLEE. *Bust of a Child*. 1933. Paul Klee
Foundation, Kunstmuseum, Bern

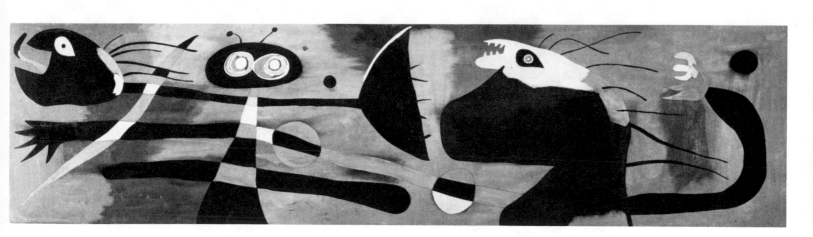

JOAN MIRÓ. *Nursery Decoration*. 1938. Collection Mr. and Mrs. Richard K. Weil, St. Louis

at left:
SAUL BASS. Poster for Pabco Paint Company.
1957. Courtesy Napko Corporation, Houston

A NEW RINEHART SUSPENSE NOVEL

By JUNE DRUMMOND

Murder on a Bad Trip

When a small town's reservoir is poisoned with LSD—and seven people die—the stage is set for this gripping new mystery by the author of *Cable Car* and *Welcome, Proud Lady*. "Miss Drummond writes expertly, incorporating the effects of . . . hallucinatory drugs into her story realistically."—*Publishers' Weekly*.

$3.95 from your bookseller
HOLT, RINEHART AND WINSTON, INC.

Advertisement for *Murder on a Bad Trip* by June Drummond. Holt, Rinehart and Winston, Inc., 1968. Courtesy Denhard & Stewart, Inc., New York

Since many viewers are disoriented by Op art, it seems logical to exploit Op art effects in the jacket design for a murder mystery dealing with hallucinatory drugs.

The foregoing examples have tended to emphasize the dependence of information design on the detached and seemingly autonomous fine arts; yet there is no reason why originality and excellence of a high order cannot occur in graphics. To be sure, the designer is usually under the pressure of deadlines, not to mention the demands of various employers and clients. Hence, the scientific model of pure research followed by technological application may be analogous to the situation of the designer, too. But great corporations in our society also *employ* pure scientists to carry on research for the ultimate benefit of their enterprises. Unfortunately, they do *not* find it necessary to employ painters and sculptors whose work they may apply for practical advantage. On the other hand, contemporary support of museums and foundations, patronage of artists, and gifts to institutions which educate artists come largely from corporations and individuals who must feel that they benefit aesthetically or practically from the innovations of fine art.

Apparently, relationships among artists, designers, and patrons in our society are very complex. As yet, most fine artists live and function in the time-honored tradition of economic malnutrition. Some are employed as designers; but few can flourish in both areas at a high level of performance, although the education of artists and designers is quite similar. Happily, we are beginning to witness an increase in the professionalism of designers for industry and commerce with a consequent growth in their artistic autonomy. That is, the design consultant or head of a design firm functions as a business or professional equal, rather than as an employee, in his relations with commercial and industrial clients. Purely artistic qualities have become prominent in graphic design as the designer's economic importance has been recognized and his professional status consolidated. We may eventually arrive at a condition like that of the Renaissance, when no line could be drawn between artists and designers since, with very few exceptions, they were the same men.

at left:
VICTOR VASARELY. *Vega.* 1957. Collection the artist

THE PHYSICAL FUNCTIONS OF ART

Both paintings and buildings can serve as symbols, but only buildings perform a physical function. By the physical function of art I mean the creation of objects which operate as containers and tools. By "container" we can designate a range of objects from a carton of milk to an office building. Both need to be shaped and constructed primarily according to the requirements of their contents (if people can be thought of as "contents"). Both are used as well as looked at. A tool can be a tablespoon or a locomotive. One is a simple, the other a complex, machine. Both need to be designed so that they operate efficiently. And one aspect of their operation is their appearance. Any tool or machine looks like something. The artistic problem is to make it look like what it does,

The careers of Michelangelo and Leonardo show that the design of anything—from fortifications to industrial machinery—was within the artist's province. But this work was done in their capacities as artists; the radical separation of the aesthetically meaningful from the useful had not yet taken place.

LEONARDO DA VINCI. *Plans for a Spinning Wheel.* c. 1490. Biblioteca Ambrosiana, Milan

while also making it look "good" to the persons who may use or buy the tool. Thus, the physical function of art or design is connected with the effective operation of objects according to criteria of usefulness and efficiency as well as those of appearance and appeal.

The difference between a painting and a building or a machine is that a painting is used *only* by looking at it, whereas a building or tool is used by doing something *in* it or *with* it, as well as by looking *at* it. It was formerly thought that art affected useful objects by adorning and embellishing them or by creating surfaces or skins which concealed their working parts. To some extent, this view survives in erroneous conceptions and applications of industrial or product design. Presumably, all the important problems of function are handled by engineers, while artists look after superficial beauty. But we are beginning to recognize that appearance and function are inextricably linked: engineers are more consciously aware of aesthetics, and artists are more knowledgeable about operational design. Many useful objects today are totally created by artist-designers because their education in production methods, engineering, and art equips them to exercise substantial responsibility for a product from its conception through its design prototype, manufacture, packaging, and sales promotion. The profession of in-dustrial design—or product design, as some call it—constitutes a new and fruitful synthesis of art, engineering, and marketing.

During the Renaissance, artists often served as architects and engineers simultaneously. But the Industrial Revolution of the eighteenth century was mainly responsible for the separation of art, as such, from the structural aspects of building and manufacture. Civil, industrial, and mechanical engineering developed as professions separate from art and architecture, and although their resulting specialization yielded many benefits, one of the disadvantages society has experienced during the past two hundred years or so has been the increased proliferation of ugliness in our large- and small-scale environment. Often engineers have been excellent designers, as in the cases of Paxton, Roebling, Nervi, and Maillart (see discussions in Chapter Thirteen on architecture), but increasing technical specialization, with its emphasis on a narrowly conceived utility, together with the indifference to aesthetic values of a society excessively oriented toward materialistic goals, led to the abundance of trashy design which characterized the early fruits of industrialism and mass production.

Between the eighteenth and the twentieth centuries, the handicrafts survived mainly as obsolescent vestiges of

MICHELANGELO. *Drawing for the Fortification of Florence.* c. 1529. Casa Buonarroti, Florence

BRUCE DAVIDSON. Photograph of people on East 100th Street. 1967. When thinking about buildings, we must think about the people who live in them. Architecture is above all a social art.

their role in preindustrial economies and more relevant to the requirements of men who have passed through the Industrial Revolution and now cope with an electronic revolution and its offspring, automation.

In addition to the design of small tools and large machines, private dwellings and great public structures, art is concerned with the design of the man-made environment. Through the professions of community planning and urban design, art contributes to the harmonious shaping of *all* the parts of the man-made environment *in healthy relation to each other*. Modern societies can no longer afford to have their communities develop on a piecemeal, fragmented, unrelated basis. Too many of the problems of urbanism have their origin in social failure to plan *comprehensively* and in advance of need. Here, as in the case of industrial design, art consists of more than the embellishment of outdoor spaces with parks, plazas, and monuments, although these are certainly elements which reveal the aesthetic concern of the community. But we realize that the best spatial organization of a community grows out of intelligent solutions to the functional and visual problems which any inhabited area creates. In a sense, the artistic problems involved in the design of containers or buildings are present on a vastly augmented scale in connection with organizing the masses, voids, and functional elements of the huge containers we call communities. Unlike product design, however, the process of community planning entails a number of complex relationships to sociology, law, and politics. The design of a community has to be undertaken in the light of a total philosophy of social and personal interaction.

The physical functions of art, therefore, affect us in our immediate and intimate lives as well as in our public role as citizens—as people who use and are used by the man-made organisms called communities. In the following sections we shall discuss some of the large and small structures created for practical use as well as the aesthetic and symbolic enrichment of our lives.

preindustrial modes of making, as status symbols for the few who could resist the inroads of engineer design, or as focal points of idealism for craftsmen like William Morris, who hoped to reverse the development of industrialization and capitalism through a revival of medieval artisanship. But the crafts have embraced new functions in the twentieth century—functions less related to nostalgia for

Architecture: The Dwelling

Of all the types of buildings—churches, schools, shops, palaces, castles, skyscrapers, airports, factories, and hockey rinks—the dwelling is the earliest, the closest to our daily lives, and perhaps the best illustration of the technological innovations and design philosophies which affect and afflict architecture. Architecture is a social art, and in the dwelling we see its most intimate effect upon that prime social institution, the family. It is worth our while, therefore, to look at some of the principal effects of families on home building and of domestic architecture on families.

If we approach the modern home as a social container,

our first observation concerns the implied purposes of its size and design: the home today is intended almost exclusively for the child-rearing family. It does not usually have sufficient room for the permanent residence of grandparents, maiden aunts, bachelor uncles, or assorted other relatives. Nor does it any longer have a parlor, library, pantry, or front porch. Instead, there may be new rooms or spaces—called the game room, patio, family room, carport, recreation room, bar, or solarium—where parents, children, and adolescents can entertain their friends and pursue their hobbies. A second observation is that, compared with the homes of a generation or two

VERNER PANTON. Living-Eating-Relaxing Tower. 1969

All of an individual's physical needs for domestic living are packaged in a single double-decker unit. Can these represent Le Corbusier's "machine for living"?

KENNETH ISAACS. Ultimate Living Structure. 1968

ago, there is less privacy, more open planning, and fewer single-purpose spaces in the contemporary dwelling. Partitions are either eliminated, or do not go from floor to ceiling, or do not really separate and insulate spaces and sounds from one another. Third, homes are increasingly built on one level or on split levels, but they seldom have two, three, or four distinct layers, one on top of the other. The one-level, or ranch-type, dwelling promotes mobility and the loss of privacy mentioned above. Fourth, multi-purpose rooms reduce the overall size of the house and cause intensive use of space and heavy wear of equipment. Fifth, but not least important, the mechanical services and labor-saving devices built into the home have absorbed a larger proportion of its total cost, and these have become for most people a principal index of its value—economic, aesthetic, and spiritual. That is, we probably love our dishwashers, rotisseries, air conditioners, automatic ovens, tile bathrooms, and built-in stereo equipment more than any of the amenities or spatial qualities which architectural design can bring to the home.

If these observations are correct, it would appear that Le Corbusier's old dictum about the dwelling—"The house is a machine to be lived in"—is accepted in practice if not in theory. However, what factors have made it possible for the modern dwelling to operate as an efficient machine while retaining some of the warmth and sentimental association of the old idea of home? Obviously, technology is an indispensable factor since it cuts down the space and time needed to perform the arduous tasks connected with food preparation and storage, laundering and house cleaning, heating and cooling, decoration and maintenance. Modern building materials and techniques have enlarged the possibilities open to the designer: light, strong structural elements, some of them metal and plastic instead of wood; plate glass; new insulation materials, adhesives, and fasteners; strong new surface materials—paints, plastics, metals; prefabricated units, especially for kitchens and bathrooms; and almost universal availability of low-cost electricity (until the 1930s many rural homes had no electric power). Other factors we might cite are the generally increased family incomes which permit us to purchase and operate the often costly tools and appliances needed in the modern home, and the industrialization, to a moderate extent, of home building. In addition, families purchase more than one home in a lifetime; they change and modernize its equipment frequently; and banking practices try to encourage the financing of new homes or the remodeling of existing dwellings.

The versatility of technology permits the inexpensive imitation of traditional handcrafted home furnishings, so that really "modern" appliances and materials are confined to the kitchen and bathroom. Thus, living rooms and bedrooms can appear untouched by technology and so retain their traditional sentiments and symbolic associations. Glass-fiber drapes, for example, can look like the finest handwoven Irish linen; pressed board can imitate any wood grain; industrially manufactured lighting fix-

PLASTIC as Plastic exhibition at the American Crafts Council's Museum of Contemporary Crafts, New York. 1968. By using plastic art objects, furniture, and appliances, combined with light from naked fixtures, designers achieve an environment of multiple reflection, highly regular smoothness, and transparency of objects. Such spaces and their contents seem designed to simulate trancelike and hallucinatory states: they act like the visual equivalents of drugs.

tures, floor coverings, furniture, bric-a-brac, knickknacks and whatnots, and even paintings can fairly well pretend to be handmade, and thus preserve our allegiance to former modes of making and former objects of cherished ownership.

Plate glass may be the single most influential material affecting the design of the dwelling. Ideal for warm climates, it is also used extensively in temperate and cold climates because we have enthusiastically accepted one of the main tenets of modern domestic architecture: the interpenetration of indoor and outdoor space. The contemporary house is designed so that its outer walls, or shell, constitute a screen rather than an impenetrable barrier. The one-level dwelling has many openings to the outdoors: its floor is close to ground level; it may have a patio as part of its integral design; it tries to locate its "lamp and picture window" opposite a vista more inspiring than the neighbor's back yard. The picture window and the patio are so essential to our way of life that even apartment dwellers have them, with a balcony substituting for the patio, although that balcony high above the traffic is rarely used; it is usually an architect's device for breaking up a monotonous exterior facade or a realtor's device for renting apartments. There are, however, technical and structural reasons for the widespread use of glass. (1) The walls of many modern buildings can be penetrated at almost any point because they do not bear weight; they serve as curtains. Post-and-beam construction permits glass walls in homes as the steel frame does in skyscrapers. (2) The loss of heat moving in either direction through glass has been greatly reduced through double paning, while the framing and walls around glass are tight and well-insulated (older homes had no insulation except air space or, sometimes, layers of brick). (3) Modern plate glass is strong and durable, even over relatively large areas. (4) Intelligent orientation of the house on its site and proper location of its windows admits the sun at the time of day when it is most desired. The architect who chooses to cooperate with nature can design eaves, overhangs, or sunbreaks so that the heat of the summer sun is blocked out while the warming winter sun is invited into the house.

Another device for control of interior climate is air conditioning, which is not only a form of technology but also a symbol of philosophic disagreement in modern architecture. We possess the technology and soon will be wealthy enough to air-condition all interior living space. (If Buckminster Fuller succeeds in throwing domes over our cities, we shall be able to air-condition or weather-condition the urban out-of-doors too. Victor Gruen, an architect and city planner, has already constructed some shopping centers whose outdoor areas are under transparent enclosures and are thoroughly air-conditioned.) Much of modern domestic architecture, especially under the influence of Frank Lloyd Wright, is based on the goal of continuity with nature—using advanced technology to build structures which seem to grow out of their surroundings. But the philosophy of the so-called International Style architects, exemplified best by Walter Gropius, Ludwig Mies van der Rohe, and Marcel Breuer, urges the conception of the dwelling—or, indeed, any building—as an interior environment which can be completely controlled by technology. Architects can and have designed buildings without windows, with no modification of their exterior form in response to climate, orientation, or prevailing winds. Since engineering can manage these problems, the architect presumably devotes his energies to designing beautiful spaces. And where the focus of activity is almost wholly internal—as in a museum, factory, department store, church, gymnasium, or laboratory—such buildings have been very successful. The high-speed elevator, the steel-frame skeleton, and light curtain-wall construction have enabled us to build almost as high as we wish, and to create a uniformly equable atmosphere throughout the structure. But there are some disturbing rumbles: when the technology is not working too well, uncomfortable temperature variations develop; where there are no windows, the inhabitants want to look out; where the air conditioning works well, the dwellers wish to sense the advent of spring, the odor of gasoline fumes and damp city streets, the sound of automobile horns, and the scuttle of pedestrians racing for cover. Such noises and waftings serve the urban office worker as the sound of the neighbor's gasoline lawn mower and the fragrance of burned barbecue serve the suburbanite. At any rate, they are among the real considerations of an art which, according to Vitruvius, the ancient Roman architect and theoretician, must satisfactorily afford firmness, commodity, and *delight* (strength, utility, and beauty).

FRANK LLOYD WRIGHT

The great artist-poet of the dwelling was Frank Lloyd Wright (1869–1959). In a long and controversial career—during which he designed skyscrapers, museums, housing developments, office buildings, shops, factories, college campuses, and hotels—he brought to the art of creating human shelter an original, pioneering, and distinctively American genius. He was independently ahead of European architects in many ways: in his understanding and exploitation of modern technology, in his revolt against the stultifying architectural baggage of the past, and in his aesthetic innovations—that is, his ability to deal with the dwelling as an art object, as something both beautiful to look at and a delight to live in. Wright's forays into social philosophy and community planning have not been as universally praised as his achievement in domestic architecture, although they are worth serious attention and have been provocative of healthy debate. But his houses are his chief monuments, and it is difficult, when

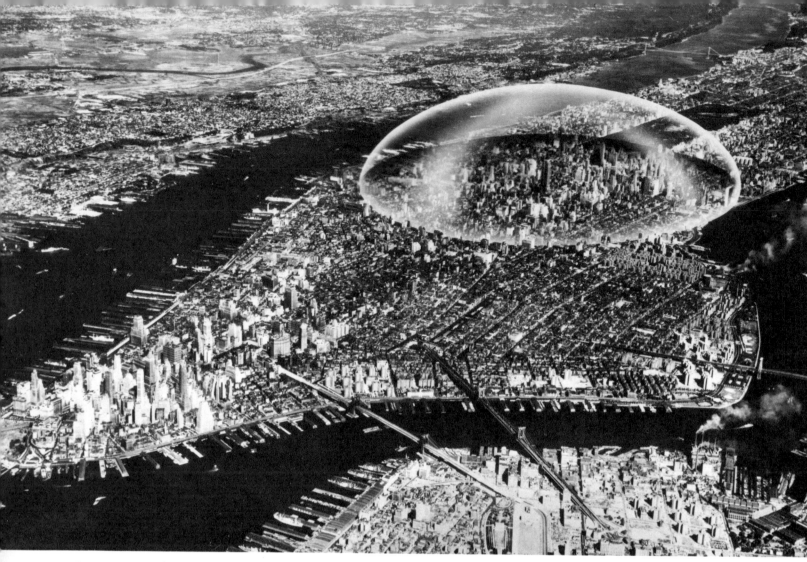

BUCKMINSTER FULLER. Proposed geodesic dome over New York City. 1961

BUCKMINSTER FULLER. Aerial view of sun garden in former United States Pavilion, EXPO 67, Montreal. 1967. Some of the human possibilities for living under a geodesic dome were realized by the citizens of Montreal when they replaced the exposition displays with formal gardens, graceful fountains, and free-flying birds.

we look at a building so sculpturally vital as the Robie House, to realize that it was built as early as 1909.

Perhaps the most widely cited and reproduced house by Wright is Fallingwater, built in 1936 for Edgar Kaufmann at Bear Run, Pennsylvania. It is at once a triumph of architectural romanticism and an example of the brilliant exploitation of technology. Only steel-and-concrete cantilever construction would permit the design of such graceful but massive overhanging slabs, which complement the rugged natural setting with their horizontal rectangular precision. There is an echo of International Style devotion to the unadorned cubical mass, but the overall conception is romantic. The heavily textured masonry of the vertical masses associates the building with the materials, shapes, and colors of the site, an association which is an axiom of the Wright philosophy of building. Wright did not disdain engineering—indeed, he was one of its most original exponents. But he did not see sound engineering as an end in itself: to him, engineering was a tool to be employed in the light of his guiding concept of what a shelter is, a dwelling organically related to nature.

Wright's ideas about the internal organization of the house still provoke controversy, although many of them have been widely accepted. He held that a massive fireplace and hearth should be the physical and psychological center of the house. He disapproved of basements and attics. Materials like paint, plaster, varnish, and wood trim were to be avoided or reduced to a minimum. Ornament was not to be *applied* to the structural elements but would result from the natural patterns *inherent* in building materials or grow logically out of the processes of forming and fabrication. Cooking and dining facilities should be adjacent to the living room, located in the center of the house, away from the exterior walls. The kitchen or "work area" should be a tall space behind the fireplace or adjacent to it so that cooking odors can flow up through it rather than into the house. The rooms seem to radiate from the fireplace core, so that Wright's houses tend to have a cross-shaped plan. The arms of the cross are thus open to the outdoors on three sides, with horizontal bands of windows or clerestories around them and very wide eaves which create porchlike spaces underneath.

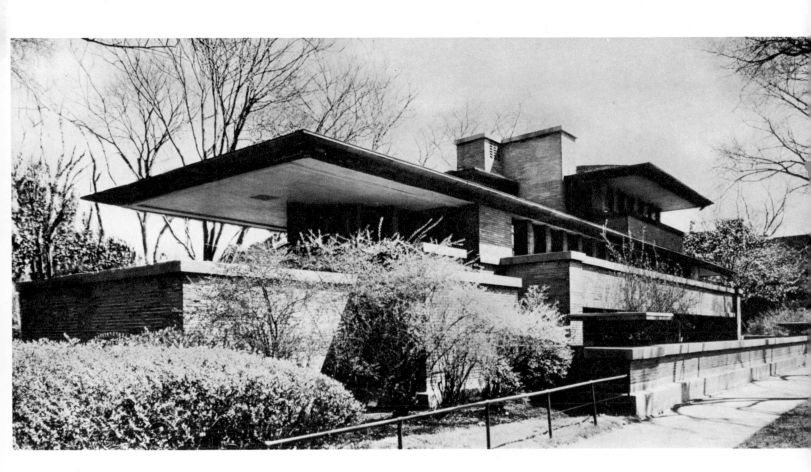

FRANK LLOYD WRIGHT. Robie House, Chicago. 1909

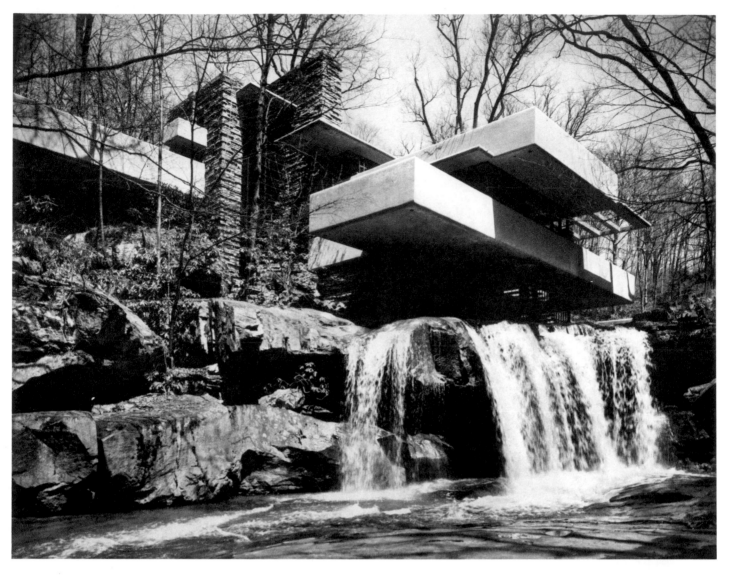

FRANK LLOYD WRIGHT. Fallingwater, Bear Run, Pennsylvania. 1936

FRANK LLOYD WRIGHT. Interior, Taliesin East, Spring Green, Wisconsin. 1925

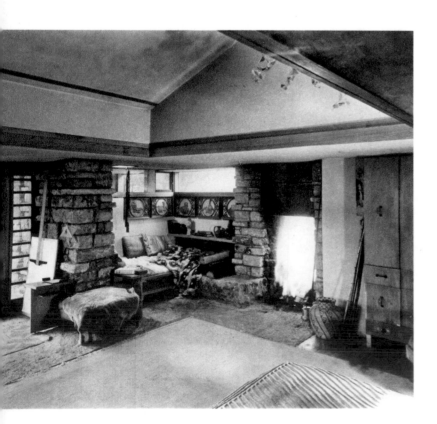

at right:
DER SCUTT. Conversation pit. 1967. Through a circular, multilevel conversation pit, a contemporary architect endeavors to elicit the feeling of warmth and protection which man first enjoyed when he sat near a fire in the mouth of a cave.

The interior of Mr. Wright's house, Taliesin East, located in Spring Green, Wisconsin, shows the inviting warmth and variety of surface, space, and light that Wright built into his famous prairie houses. Oriental rugs are used to break up the floor space and to define functional areas, while Japanese screens and Chinese figurines are located on ledges set at various heights so that the eye is encouraged to linger and refresh itself. Wright's interiors were sometimes criticized for being too dark. But it would appear that he took care to calculate the modulation of light more than designers who simply flood a room with light, obliging the occupants to install acres of drapery to gain a measure of privacy and control over outside illumination. For instance, the rough ashlar (stone) masonry at Taliesin requires slanting light to set off its texture. And to be intimate, a corner meant for informal conversation needs a modulated, blended light rather than the inhibiting glare of flood illumination. Of course, this room suggests the cave more than the tent or the metal cage. Perhaps we are drawn inward by our atavistic desires—deep, unconscious feelings of safety and comfort derived from the Paleolithic memories of the race. With respect to comfort, the architect was less successful; the furniture, which Mr. Wright insisted on designing himself, seems unintended for the human backbone: Wright's right-angled chairs and sofas refuse to accommodate the compound curves of the garden-variety spine. Cushions and upholstery might mitigate their discommoding effects, but these seating arrangements could never approach the comfort or the sculptural elegance of, say, a Hans Wegner chair (see p. 162). It was not as a furniture designer but as a master of space and light *modulation*, that Wright demonstrated his artistry.

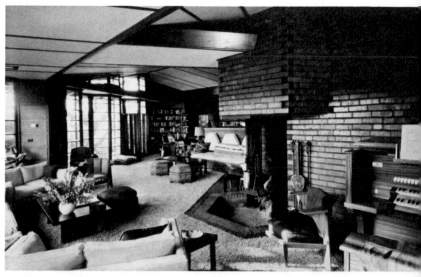

FRANK LLOYD WRIGHT. Interior, Hanna House, Palo Alto, California. 1937

The living room of the Paul Hanna House (1937) in Palo Alto, California, has a less cavelike quality than Taliesin and shows how important the pattern of light and cast shadow is in Wright's total conception. There are very few right angles in the room itself, with its gently slopping ceilings, the polygonal shapes of the furniture, and the powerful fireplace projections. Into this complex space direct sunlight is admitted, but it must pass through tree branches first, then through the small windowpanes and past the chairs until it reaches the brick fireplace wall and the sunken, stepped-down hearth, which makes its own shadow pattern. Thus, we have a marvelously rich and complex orchestration of the textures and colors of materials, with moving, patterned light working on them. It should be stressed that these interior effects are not the result of an unthinking, cluttered architectural design—a mere addiction to broken surfaces. Rather, they are the consequence of a fully developed philosophy of shelter combined with the design ability to create the spaces which that philosophy implies.

LUDWIG MIES VAN DER ROHE

Conceivably, the rectilinear austerities of International Style architecture can best be understood against the background of Art Nouveau, a manner of design and decoration which affected all the arts at the turn of the century. The subway, or Métro, station, one of several designed for the city of Paris by Hector Guimard (1867–1942), exhibits most of the typical features of an Art Nouveau structure about the size of a house: the generous use of exposed ornamental and structural elements of cast iron, the avoidance of right angles, the heavy reliance on a serpentine line, and the location of sinuous curves at every joint and change of direction. This style had a re-

HECTOR GUIMARD. Métropolitain station, Place de L'Etoile, Paris. 1900 (demolished)

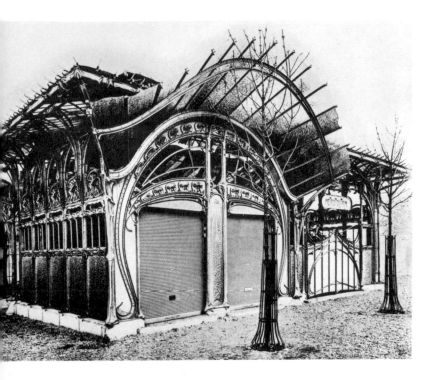

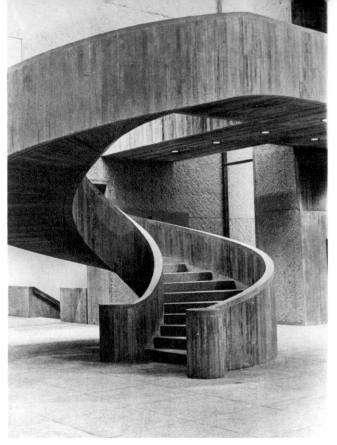

I. M. PEI. Circular stair, Everson Museum of Art, Syracuse, New York. 1968

The serpentine undulations of Art Nouveau in the 1890s, purged of their flowery ornamentation, reappear as complex geometric curves in an elegant contemporary museum staircase.

VICTOR HORTA. Stair hall, Tassel House, Brussels. 1892–93

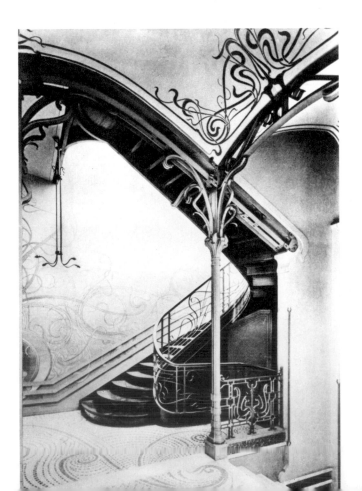

vival which started slowly after World War II (possibly as a reaction to the economic and aesthetic restraint imposed by wartime restrictions) and reached its peak in the early 1960s. Perhaps affluence encourages baroque impulses among the leaders of fashion and design. In prosperous times, the doctrine of Mies van der Rohe that "less is more" begins to seem unnecessarily ascetic; we grow interested in a kind of frivolous, lavish elegance. But Art Nouveau was not really elegant or grand in the classical manner (though it may have been exuberant); rather it sought to unite art and nature—nature conceived as a forest grove—through imitating organic forms, especially plant life. Wright, who was an active young architect in 1900, was also interested in the organic, but in a less derivative and more sophisticated manner than Guimard, Horta, Hoffmann, and the other central European designers working in this botanical mode. Later, Wright did not have to react against Art Nouveau, whereas Gropius, Breuer, Mies, Neutra, and Le Corbusier may have felt they did. At any rate, the International Style architects, strongly under the influence of the Bauhaus (see pp. 150–53, "The Emergence of Industrial Design"), seemed to have as doctrinaire a devotion to the right angle as did Art Nouveau adherents to the S curve. Hence, from the 1920s until about 1942, with the exception of Wright and his followers, avant-garde houses were austere white cubes, devoid of ornament, with extensive glass facades and no-nonsense flat roofs minus eaves. Small wonder that the popular reaction to these buildings was chilly and that, because of severe commercial or industrial versions of the style, it became known irreverently in some quarters as "gas-station moderne."

Of course, in the hands of a master the International Style had authentic elegance, as in the famous Tugendhat House in Czechoslovakia, which was designed in 1930 by Ludwig Mies van der Rohe (1886–1969). Floor-to-ceiling windows, black marble partitions, polished metal columns, silk curtains, and Oriental rugs created an atmosphere of restrained splendor, of sensuous appeal within a controlling intellectual framework. An exterior view of the house conveys no such sumptuous impression: the rear elevation reveals the debt of modern architecture to the asceticism of Mondrian. Mies appears to have been the most craftsman-like of the International Style designers in that he never abandoned an ideal of *beauty* achieved through well-made and well-proportioned parts, never became addicted to design as mere multiplication of standardized parts: he showed how to achieve a quiet, controlled splendor by attention to detail and without architectural histrionics.

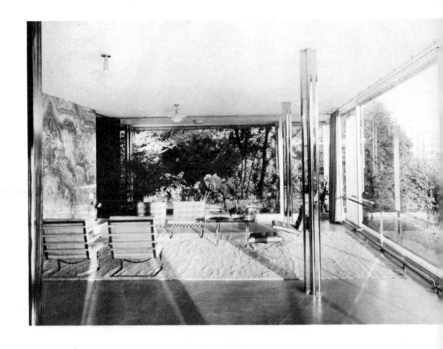

LUDWIG MIES VAN DER ROHE. Tugendhat House, Brno, Czechoslovakia. 1930

LUDWIG MIES VAN DER ROHE. Interior, Tugendhat House

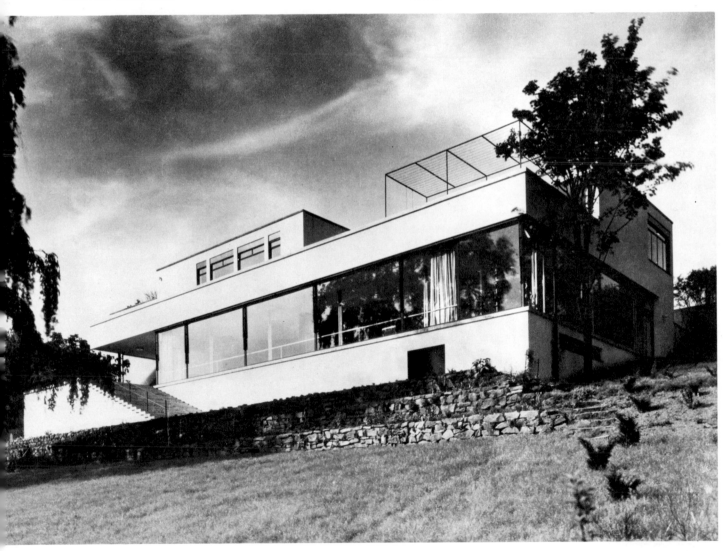

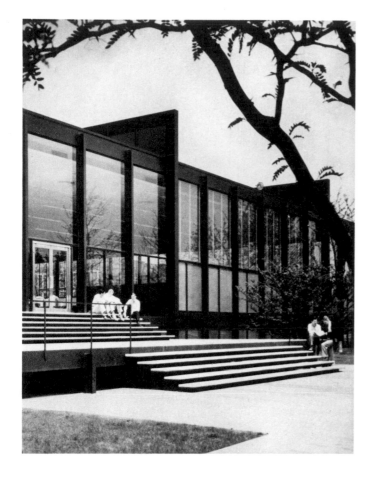

LUDWIG MIES VAN DER ROHE. Crown Hall, Illinois Institute of Technology, Chicago. 1952

LUDWIG MIES VAN DER ROHE. Floor plan of Farnsworth House

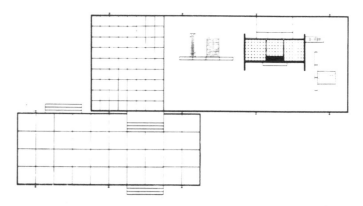

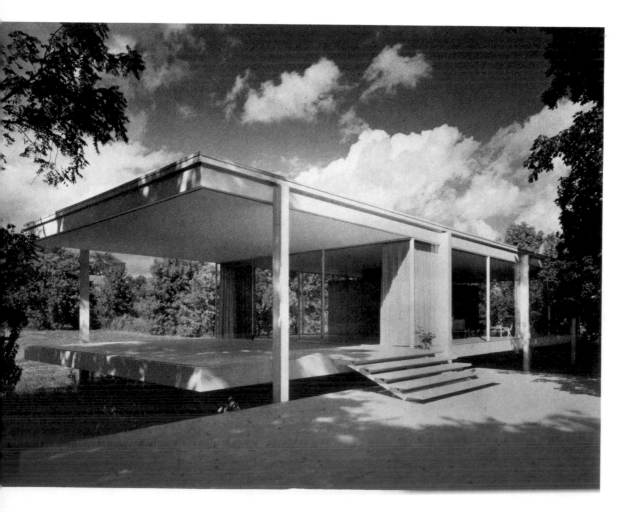

LUDWIG MIES VAN DER ROHE. Farnsworth House, Plano, Illinois. 1950

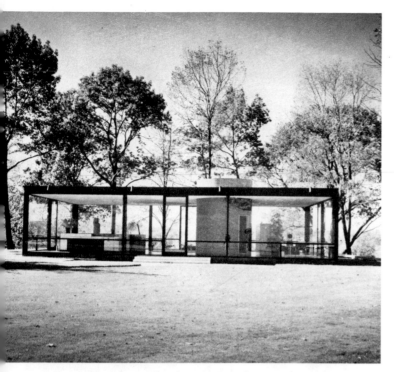

PHILIP JOHNSON. Glass house, New Canaan, Connecticut. 1949

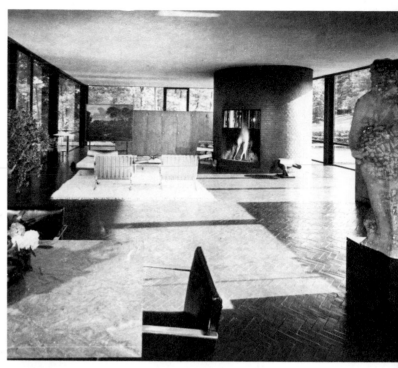

PHILIP JOHNSON. Interior, Glass house

In the Farnsworth House (1950) built in Plano, Illinois, Mies employed a formal vocabulary similar to one he was to use again in his School of Architecture for the Illinois Institute of Technology in 1952. Both structures are approached from a raised platform, and both make elegant use of a simple series of slablike steps as a transition from the ground level to the plane of the floor. The Farnsworth House consists of two connected rectangular boxes that are raised off the ground. Rather than exploit natural materials, Mies used large expanses of glass, which afford generous views and produce reflected images, to establish continuity with nature. Extreme simplification of form and function is seen in the use of pristine white posts to support the roof, to separate the large glass panes, and to act as stilts, raising the house off the ground. In the Illinois Tech building, Mies hung the ceiling from imposing steel girders stretching across the roof to black exterior steel columns which also function visually as satisfying vertical accents. The building is not raised off the ground as is the Farnsworth House, but the platform and two sets of gently ascending steps create the impression that it is. The repeated horizontals of the steps help to balance the vertical rhythm of the columns and the mullions (bars between the windows) and thus endow the structure with a classic dignity and repose.

A Miesian house is essentially *one* large cubical space in which functional space divisions and rooms are achieved by nonstructural partitions and by the location of utilities, closets, kitchens, and so on. For Mies, the real work of architecture lay in the creation of unencumbered interior space which the occupants could subdivide and use as they wished. These internal arrangements are, after all, a matter of private and temporary caprice, a matter of nterior decoration. Perhaps Philip Johnson's glass house in New Canaan, Connecticut (1949), expresses this Miesian point of view best, although it represents an obviously limited solution to the problem of shelter for a family. By refusing to be overly concerned about *who* used his buildings, or *how* they employed the interior vistas he created, Mies was able to concentrate on the design of what is becoming that rarest, most unobtainable commodity in the modern world—pure, unobstructed, undemanding, serene space.

LE CORBUSIER

Le Corbusier (Charles Edouard Jeanneret-Gris, 1887–1965), who began with assumptions similar to those of Mies, moved in a more sculptural direction as his career progressed; increasingly he employed poured-concrete forms and left the steel-glass vocabulary to Mies, Johnson, and their numerous imitators. (Ironically, Mies was apprenticed to a brick mason when a very young man.) In 1929, Le Corbusier's Villa Savoye exhibited the in-

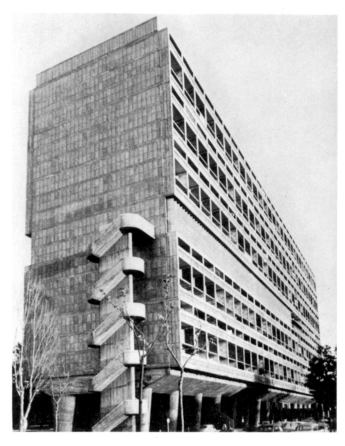

LE CORBUSIER. Unité d'Habitation, Marseilles. 1947–52

LE CORBUSIER. Villa Savoye, Poissy-sur-Seine, France.
1929–30

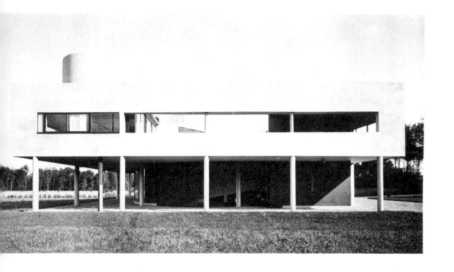

fluence of Cubist painting (he was himself an active abstract artist) and employed forms much as they were to be seen in the contemporaneous architecture of Mies, Gropius, and Breuer. But the house also shows an early use of his stilts, a brilliant structural device which has been widely adopted in apartment houses such as his Unité d'Habitation and in buildings designed by architects throughout the world. These reinforced columns of concrete, which the architect called *pilotis*, exploit the fact that steel-and-concrete construction has permanently freed architure from the requirements of earthbound compression construction (structures in which the building material is *squeezed* by the force of gravity). A structure can now be lifted into the air, freeing the space at ground level for a variety of practical functions. This open area also creates an appealing visual organization, with a strong shadow pattern at the building's base

crisply defining the concrete forms above it.

Wright, too, developed his own "mushroom" pillars (something like pilotis) in the Johnson Wax Building interior (1938), partly as a structural but mainly as a decorative device. Since his houses generally rose from a concrete pad, he employed cantilevered forms to open up ground space and also to provide an interesting light-and-shade pattern. But Wright was temperamentally attached to the earth. Le Corbusier and the Bauhaus designers had a better appreciation of the possibilities of suspension engineering; indeed, they developed several classic chairs based on suspension and tension principles. Houses on stilts were used as early as the Neolithic riverbank villages of about 12,000 B.C., but it remained for Le Corbusier to create a viable application of the same principle in the twentieth century.

The Villa Shodan, built for an Indian businessman in

LUDWIG MIES VAN DER ROHE.
Barcelona Chair. 1929

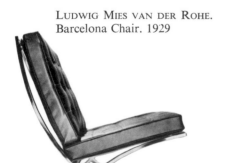

ALVAR AALTO. Armchair. 1934

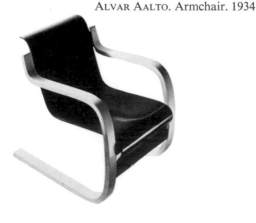

LE CORBUSIER. Chaise-longue
frame. 1927

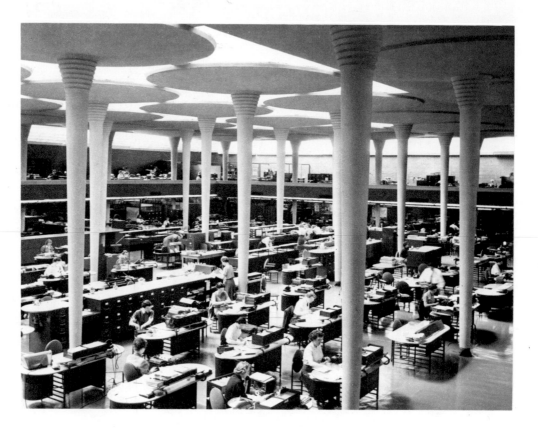

FRANK LLOYD WRIGHT. Interior, Johnson Wax Administration Building and Research Center, Racine, Wisconsin. 1938

1952 by Le Corbusier, shows the development of his style within the directions indicated by the Villa Savoye of 1929. The mastery of poured concrete is now well established, with the textures that are imprinted by the rough wooden formwork serving to overcome any unpleasant, mechanical slickness of surface. We also see the full development of Le Corbusier's invention, the *brise-soleil*, or sunbreak, a device which is especially useful in tropical countries but is also employed wherever the unobstructed sun would create interior problems of heat and glare. The occupants can look out, yet the exterior rooms are shaded against the steady beating down of the sun; and visually,

a delightful articulation of surface, of light and shadow, is achieved. The Brazilian Oscar Niemeyer (born 1907) has been much influenced by Le Corbusier, and throughout South America there are magnificent public and private buildings of poured concrete in which Niemeyer, and others, employ sunbreaks and pilotis.

It should be realized that the complicated wooden formwork required to build these virtually sculptured concrete structures is more feasible economically in countries which have abundant, inexpensive sources of hand labor. Thus, Le Corbusier could employ his structural vocabulary on a vast scale for the creation of an entire

LE CORBUSIER. Interior, Villa Shodan. In the interior of the Villa Shodan, Le Corbusier virtually paints with light through the design of the window perforations, much as in his chapel at Ronchamp.

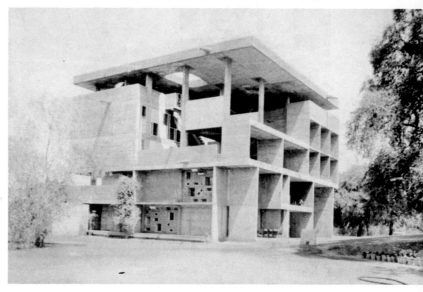

LE CORBUSIER. Villa Shodan, Ahmedabad, India. 1952

Le Corbusier. Wooden formwork used in construction at Chandigarh, India

Skidmore, Owings and Merrill. Steel-frame construction, Chase Manhattan Bank, New York

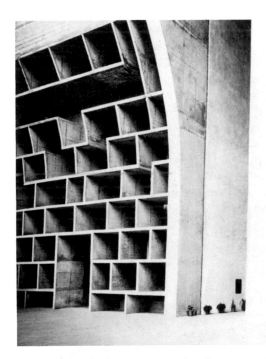

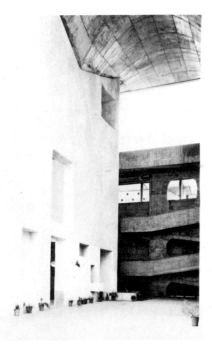

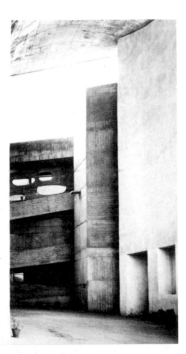

Le Corbusier. High Court Building, Chandigarh, India. 1955–56

national capital city, as at Chandigarh, India. And Niemeyer has been engaged on a project of similar size and scope, the building of a whole new capital, Brasilia, in the interior of Brazil. However, when reinforced concrete is employed in industrially advanced countries, especially in the United States where labor costs are high, construction time must be held to a minimum, and therefore variations in shape and space tend to be eliminated. A building vocabulary of steel frame, glass wall, and metal panel with some minor masonry trim is more suitable to our economy. And when concrete slab construction *is* used, building-code restrictions are so inhibiting that the visual results are very much like steel-frame structures. It would be difficult for the nonexpert to look at a row of glass boxes on Madison or Park Avenue in New York City and distinguish the steel-frame from the reinforced-concrete buildings. As for home construction, poured concrete is very rare; since it is quite expensive and mostly reserved

for clients who are friendly to experimentation. In the Yale art school, designed by Paul Rudolph (born 1918), we see a lavish and costly use of poured concrete containing a special aggregate which endows the building's surface with a coarse, rich texture; the texture was heightened by vertical striations imprinted by the formwork, after which the concrete surface was hand-hammered by the workmen. What is especially noteworthy is the courageous commissioning of so daring a structure by Yale's late President Griswold; he could easily have satisfied the practical requirements of the university with the usual glass-steel-and-masonry box.

If Wright was poet of the house, Le Corbusier was poet of the apartment and the multiple dwelling. His Unités d'Habitation (apartment houses) have been widely imitated, especially his building at Marseille (1947–52). The influence of his stilts, sunbreaks, roof sculptures, and rough concrete is particularly evident in several buildings by the brilliant Japanese designer Kenzo Tange (born 1913)—the Peace Museum at Hiroshima, his own residence, his Tokyo City Hall interior, and his Kurashiki City Hall. Tange's Imabari City Hall (1957) seems derived from the chapel at Ronchamp, just as his wall treatment in the Kurashiki City Hall derives from the chapel interior at Ronchamp. However, imitation of forms is one matter, the original conception of shelter another. Le Corbusier conceived of an apartment as a drawer sliding into a building skeleton; the whole might be compared to a chest of drawers. Being Swiss-French, he also used the analogy of a bottle and a bottle rack. In the Marseille building, each apartment is a self-contained unit of two levels which can slide into a standardized cavity in the "bottle rack," or building skeleton. If mass-production methods were fully extended to housing, these drawers or bottles could be completely fabricated in factories elsewhere, hoisted into place in the building skeleton, and plugged in. At Marseille, the apartments are sound-insulated from each other by lead sheets between the common walls, something modern apartment dwellers would appreciate, as there has been virtually no acoustical privacy in many of our costly new multiple dwellings. The kitchens are air-conditioned; living rooms are two stories high and give onto a balcony with sunbreak and magnificent view. On every third floor there is a corridor, called an "interior road," which runs the length of the building. The interior roads on floors seven and eight contain an indoor shopping center, with shops for fish, meat, dairy food, fruit and vegetables, and a bakery, liquor store, and drugstore. To complete its list of essential services, the Unité has a

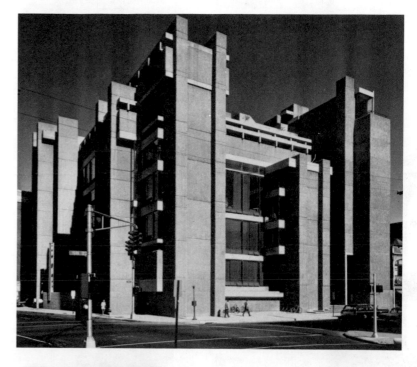

PAUL RUDOLPH. Art and Architecture Building, Yale University, New Haven, Connecticut. 1963

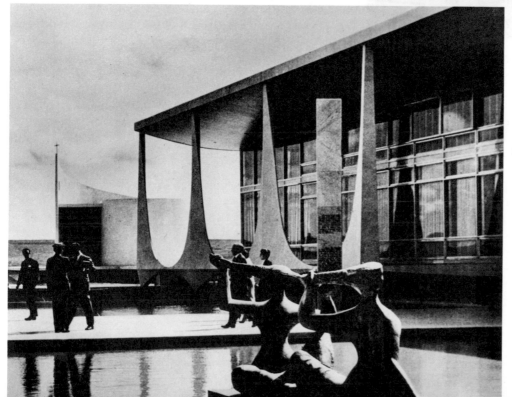

OSCAR NIEMEYER. President's residence, Brasilia. 1960

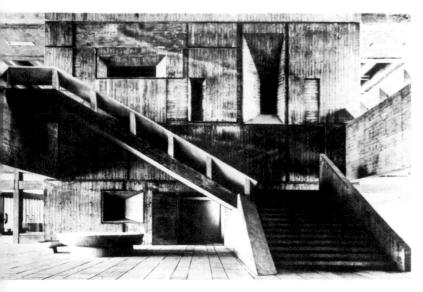

KENZO TANGE. City Hall, Kurashiki, Japan. 1960

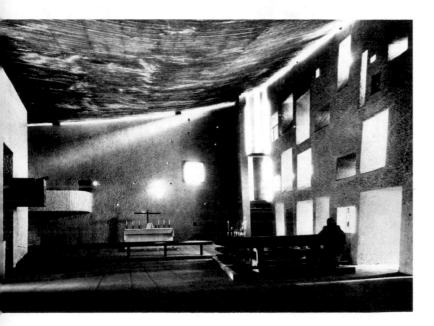

LE CORBUSIER. Interior, Notre Dame du Haut, Ronchamp, France. 1950–55

laundry, cleaning service, barber shop, and post office. It has many of the features of a resort hotel but is intended for *permanent* residents. The building holds 337 apartments of 23 different types, and thus can accommodate large families or unmarried individuals. The seventeenth floor has a kindergarten and nursery; and above it on the roof is a roof garden, children's swimming pool, gymausium, running track, solarium, and snack bar. The various roof structures for elevators, ventilation, and other utilities have been designed as playful sculptures, while the machinery for elevators, generators, and air

conditioning is tucked under the first floor above the stilts.

It should be stressed that the Marseille apartments were built by the city and were intended to be working-class dwellings. The building residents formed an association to secure social and cultural benefits for themselves and to administer their communal affairs. The only comparable social arrangement in the United States would be co-operative apartments and condominiums, though these are usually occupied by persons of substantial means.

It is clear that Le Corbusier intended to make urban residence a satisfying and rich experience, not merely a compromise painfully accepted by people who would rather live elsewhere. In this country, our population has become increasingly urbanized but, it seems, increasingly unhappy with urban living. We too have built immense multiple dwellings for persons of all economic levels, but however striking or "modern" these structures may appear to be from the outside, we do not seem to be able to develop satisfying patterns of life within. At least, those who can escape to suburbs or small towns continue to do so. What can the reason be for these costly failures? Is it that Le Corbusier's pattern does not work? Or is it inapplicable to the circumstances of American life? Do we design and build badly? Do our huge apartment houses constitute a *new conception* of social living carried out in new architectural terms in response to new conditions of urban life? Or do these structures represent the same old conceptions of urban life in multiple dwellings which have been given a spurious novelty by applications of the latest steel-glass technology?

THE MODERN DWELLING

Wright, Mies, and Le Corbusier, then, are the three acknowledged geniuses of modern architecture. Their contributions to the design of the dwelling—and, indeed, to the design of all structures—have been among the most original and influential features of our civilization. Many gifted designers have appeared among their followers, men who understood, adapted, and refined the language of form, the philosophy of shelter, or the utilization of technology inherited from the masters. But the genius of the "form givers," as they have been called, consisted of their ability to synthesize or create a new conception of dwelling space based on stubbornly held convictions about the nature of living together under one roof, the requirements of modern life, and the bewildering array of forms, processes, tools, and devices proffered by applied science. That is why these architects are honored above others, although other men have made distinguished contributions to architecture as builders, teachers, designers, engineers, and even clients.

Today the magazine racks of any drugstore display a staggering number of publications about home building,

CHARLES EAMES. Living room, Eames House, Santa Monica, California. 1949

RICHARD NEUTRA. Kaufmann House, Palm Springs, California. 1947

decorating, and remodeling. Their colored photographs, architectural renderings, and suggestions for decoration are often so glamorous and exciting (and expensive) that the individual is easily overwhelmed and confused. Once we have been liberated from the idea that the form of a house is something traditionally, naturally, and permanently set, like the shape of a tree or the color of snow, we are confronted with a bewildering array of choices even within a narrow economic range. That is, despite our talk about conformity, this civilization offers more options to the individual than any other in history, *provided that he is able and willing to exercise intelligent choice.* What are some of the principles or guiding ideas of domestic architecture which can be used by the well-intentioned citizen who feels at once liberated by contemporary design and perplexed by its infinite variety?

1. A house does not exist in a physical or social vacuum. It is set among other houses to which it must be harmoniously related. It is not primarily a form of self-expression. It is oriented on a specific site to which it should seem to belong and from which it should derive specific advantages. Increasingly, the house does not shut out the environment but rather chooses deliberately to include parts of the environment within itself—visually through its fenestration, and physically through its patterns of ingress and egress and traffic circulation between the house and grounds.

FRANK LLOYD WRIGHT. Living room, David Wright House, Phoenix, Arizona. 1952

2. The real substance of a dwelling is the shape of its space, not its kitchen and bathroom fixtures. Utilities change and can be replaced, but the spaces through which we move remain fairly constant, and they are the chief determinants of our psychic satisfaction in the dwelling. Surfaces and surface materials receive more attention than they deserve. Elegant paneling or papering cannot overcome badly shaped space, whereas a poor or unsuitable surface material *can* be changed. Space should be shaped around the requirements of a particular family rather than the supposed requirements of fashion or style. This calls for a certain amount of self-knowledge, a realistic assessment of one's present habits and anticipated needs. Since it is difficult to predict requirements and preferences with much accuracy, flexible or informal space arrangement is best for most people.

3. The outside of the dwelling is, in part, a membrane which selectively transmits light and heat for the comfort of its occupants and reflects the shape of the interior space. Traditional features of building—cornices, gables, entablatures, pediments, cupolas, and so on—tend to be survivals of obsolete building technologies. Their symbolic-expressive power is far less potent and dramatic than the forms which can be created with modern materials and structural devices. Unfortunately, some modern builders make eclectic use of materials, producing results which are frivolous or ostentatious. They may combine brickwork, stonework, wood, concrete, stucco, glass, marble, mosaic, asbestos, plastic, and metal in vulgar profusion in the same structure. Simplicity of material is a virtue in building, especially when the shape is complex. But the exterior is more than a membrane; it has a *pictorial* relationship to the site. The relationship is harmonious to the extent that indigenous materials and skillful landscaping are employed and the dominant lines and masses of the structure respond to the topography, that is, the shape of the land. (The urban dwelling is usually part of a multi-unit structure and thus does not *directly* confront the problem of relatedness to its environment. Perhaps that is the reason for the heavy emphasis on interior decoration as a mode of self-expression in some apartment dwellings.)

4. Interior decoration should not mean merely the application of ornament, the embellishment of surfaces, the collection and display of objects, or the selection of furniture. (Its most professional practitioners prefer the designation interior designer or interior architect.) Since the dwelling interior and its contents are experienced visually as well as used, their arrangement needs to be considered from an aesthetic as well as a practical standpoint. Rules, principles, and guides about the use of color, scale, textures, period styles, fabrics, and so on are easily obtained. Resourceful interior design is most needed in apartments, where architectural qualities are generally limited and where emphasis must be placed on furniture, color schemes, *objets d'art*, and lighting. For the private dwelling, built-in storage units often take the place of distinctive items of furniture. But for any dwelling, the problems of unity, focus, coherence, articulation, and expressiveness must be solved, regardless of furnishings and no matter how well the space was originally designed.

For most of us, the normal accretions of living, the gifts of well-meaning friends, the hand-me-downs of honored ancestors, combined with our everyday debris, constitute the decorative objects of our interior environment. The possessions we purposely acquire, like furniture and rugs, soon receive a patina of wear which makes them seem to belong with everything else, no matter how incongruous visually. A merciful psychological mechanism blots out any consciousness we may have of aesthetic or stylistic struggle among our possessions, and so we can live amid our clutter in relative equanimity. After some time, the hideous things we own may become positive necessities without which we could not comfortably endure. But at this point in architectural history, one can only observe that despite the best efforts of Mies, man is something of a squirrel, and he will continue to accumulate things he does not need and can find no place to store. The interior designer cannot very well change our squirrelly nature, and so he justifies his role by creating ingenious containers to store or display our possessions; he tries to endow them in the aggregate with unity, pattern, and coherence through arrangement or lighting; or he substitutes new fetish objects for the old ones if we can be persuaded to part with them.

5. Genuinely satisfactory architectural solutions to the problems of apartment dwelling are not too readily available except in the work of a few architects like Richard Neutra and Le Corbusier. Interior decoration seems to be largely a corrective effort, an endeavor to conceal bad design or make undistinguished design interesting. For example, the apartment houses of Mies van der Rohe are magnificent in their totality, but their individual cells appear neutral and impersonal. That is, they do not seem to create the positive excitement to be found in a Wright interior. (Yet there are those who prefer them to the sometimes forced rusticity of Wright.) Hence, Miesian spaces require the ministrations of an interior designer. Until truly original architectural and

PIERRE PAULIN. Undulating furniture. 1970. Designed for Artifort Holland. Distributed by Turner Ltd., New York

social thought is applied to the multiple dwelling in the United States, therefore, apartment dwelling will be attractive mainly for the accessibility and convenience of other urban attractions and services. Delight in a home remains largely the prerogative of the man who dwells in a single, mortgaged, detached dwelling.

CONCLUSION

Since the days when men lived in caves, tents, and huts, domestic dwellings have gone through immense transformations accompanied by equally radical changes in human personality. Now space exploration and scientific fantasy contemplate residence on distant planets in strange or nonexistent atmospheres. In the present era of innovation and experiment, the very idea of a shelter which assumes a hostile environment—a safe inside and

an unfriendly outside—may become obsolete. If climate is controlled, our only shelter might be our clothing, and that for privacy, not protection. Perhaps houses will only be storage places for certain private effects while the rest of life is carried on in specially designed structures for particular activities. There may even be distinct structures for the enjoyment of privacy, just as there now are special buildings to which we go for collective dreams—motion picture theaters. The line between the home and the community may substantially disappear. Perhaps families will live in disposable dwellings like the nests which birds build and discard each year. Architecture can accomplish such wonderful (or dreadful) ends now, if we wish. But do we wish? Look about, and see how the schemes of planners, the talent of designers, and the investments of capitalists give form and texture to the social and architectural fabric of the community.

Large-Scale Design: The Community

Everyone seems to be aware of our community problems of crowding, air pollution, traffic snarls, noise, pedestrian danger, visual chaos, and ugliness. We also know that communities are not always and inevitably afflicted by these problems. Communities are built by men, hence men are responsible for the predicament we are in. Only men

—not nature or the passage of time—will get us out of our difficulties. What are some of the remedies which have been tried or proposed to make human communities truly livable again? If communities are thought of as works of art—either well or badly executed—what are the elements of that art?

Traffic on Los Angeles Freeway

We know how to design and construct excellent build-ings and roadways of all types, but we do not seem to be able to put them together so that the results are anything short of lethal. Even if it is granted that the automobile is a deadly weapon and the source of many of our problems, do we not possess the design ingenuity to minimize its destructiveness? Can we build cities and towns which are not completely at the mercy of noxious exhausts and murderous fenders? Is peaceful coexistence possible? Or, stated more positively, since man is a social animal, can we create the physical arrangements which will allow him to enjoy social life?

Architects and planners, engineers and philosophers have thought about these problems and have made pro-posals ranging from extreme utopianism to modest and cautious reform. We shall examine a few of their ideas. Considering the growth of populations and the physical and aesthetic inadequacy of most communities, the design of cities and towns should be of vital concern to every citizen in a democratic society. If comprehensive ideas and designs exist which can help cure our various civic dis-eases, it is exceedingly important that citizens know about them, exercise informed judgment about them, and ulti-mately act to reshape the man-made environment.

EBENEZER HOWARD: THE GARDEN CITY

In the nineteenth century as today, people left farms in droves and added to the congestion of cities. The country-side was depopulated and the cities teemed. By 1898, Ebenezer Howard, an Englishman without architectural training, realized that the problem was not merely one of reversing the flow of migration: it was necessary to create communities that combine urban and rural features—communities not wholly engaged in industry or wholly devoted to rural or suburban life. His solution: "Town and country *must be married*, and out of this union will spring a new hope, a new life, a new civilization."[1] He wrote a book which advanced the concept of the "garden city," a community of concentric belts of land alternately used for commerce or manufacturing and "green" belts or park land. The greenbelts would insulate functional areas from each other while providing recreation space and that balance of rural and urban qualities needed for a healthy and aesthetically satisfying existence. He planned to have administrative and recreational buildings at the core of these communities—something like the squares and village greens which give emotional and visual focus to small towns and some city neighborhoods.

Land would not be individually owned but would be held and developed by a common body which would limit the growth of the community to about 30,000, thus preventing speculation and high density of habitation. Beyond this population, it would be necessary to start a new garden city. The outermost belt of each community might be used to grow food for local consumption or be

left uncultivated so that it could be used for recreation space and function as a natural defense against absorption by other towns. (Many of today's overpopulated urban districts were once lovely villages which were eventually surrounded and swallowed up.)

Howard hoped his plan would lead to the decentralization of London, an event which never took place. But it *was* translated into reality in several English and American suburbs. The *word* "greenbelt" has been widely adopted, but rarely have all of Howard's principles been applied in a single community: controlled growth; ownership of land by a common authority; and the systematic segregation rather than the indiscriminate mixing of residential, industrial, recreational, and administrative functions.

It should be stressed that Howard's garden city was to be a balanced community, with the activities of work, recreation, residence, and government contained within it. Today's suburbs or satellite towns are mainly one-function communities: they have been called "dormitory suburbs." Without an industrial base, the community of homeowners, heavily engaged in child rearing, is hard pressed to finance and maintain good school systems, not to mention other essential services: police and fire protection, street lighting, water supply and sewage disposal, road maintenance. As industries move or are lured into such communities, as the highways to the central city grow more crowded, as commercial and industrial facilities sprawl in unplanned profusion outside their corporate limits, the suburbs lose the advantages of decentralization which their residents presumably left the city to gain. Aside from the moral aspects of suburban parasitism—using and enjoying urban services without contributing to their maintenance and support—there are practical disadvantages in a living arrangement which grows increasingly insupportable from an economic standpoint and is

architecturally monotonous. One begins to learn painfully that no community is an island.

FRANK LLOYD WRIGHT: BROADACRE CITY

Of course, one way to deal with the problems of urbanism is to eliminate cities, to start all over again, in a sense, by reorganizing society into small, almost self-sufficient communities. Or, if cities cannot be dispensed with, and since their problems are too deep-seated to be solved, we can proceed to reform part of society by creating ideal communities outside the megalopolitan monsters. This might be called the Noah's Ark approach to urban redesign. If the ugliness as well as the social disorganization of the city is due to overcrowding, then decentralization—spreading out the population—overcomes the mechanical and space problems of urbanism. Also, it enables men to establish a better relationship to the land and to nature. In his Broadacre City plan of the 1930s, Frank Lloyd Wright proposed a decentralized solution: an acre of land for each person. (The United States population at the time could have been accommodated on the available acreage.) Farmers would have ten acres, but everyone would raise some of his own food, supplementing what full-time farmers could grow. This procedure might be less efficient from the standpoint of agricultural yield per acre, but Wright believed, as did Jefferson, that moral and educational benefits accrue to people who till the soil, at least part of the time. Today, some young people have taken to living in communes, as much concerned with the moral advantages of group living as with the evils of urbanism.

In a land area of four square miles, fourteen hundred families or six thousand people could live, produce some food, provide each other with a variety of personal services, and engage in some light manufacturing. Wright believed, quite correctly, that the automobile and heli-

EBENEZER HOWARD. Garden City plans. From *Garden Cities of Tomorrow,* London, 1898

CONKLIN and WITTLESEY. Town center, Reston, Virginia. 1961. Ebenezer Howard's Garden City concept is given contemporary expression in the town of Reston.

copter liberate men residentially. Unlike nineteenth- and early twentieth-century workers, we need not live immediately next to where we work. The telephone enables us to communicate easily with cities, if we need to; radio and television broadcast news and entertainment; and motion picture theaters are everywhere. Thus, we do not have to live *in* the city to use or enjoy some of the goods and services created there. (Some of us can live parasitically *off of* the city, however.)

But can communities of six thousand create the necessities of modern civilization? How many people are associated with a modern university? Fifteen thousand? Thirty-five thousand? How many are needed to support a first-class museum, hospital, theater, department store, school system, steel plant, state capitol?

Wright did not plan to dispense with cities at once, however. Eventually they would wither away. But the existence of the city was part of his plan (albeit grudgingly), since some of the residents of Broadacre would commute there to work. (Today commuters wonder whether two or three hours per day of boring, unproductive travel are sufficiently rewarded by character-building activities in the suburbs like raising tomatoes and mowing the lawn.) Still, contemporary suburban life is a caricature of the Wright idea. He genuinely wished men to raise their own food, to improve the land, to be substantially free of money and its associated evils. Their houses would be designed by architects like Wright, who would relate their dwellings to the shape of the land. The shape of city lots, which strongly governs the design and orientation of the houses on them, is based on the speculator's need to cut up land into standardized packages which can readily be sold. Wright believed that the operation of a money economy distorted the natural and proper architectural solution of man's problems of work and shelter. People would not own land in Broadacre City but would hold it so long as they could make productive use of it. The point is that land would not be a commodity which is traded for profit but rather a source of sustenance and delight for those who can live harmoniously and productively on it.

Americans believed, traditionally, that individualism and independence are the possessions of men who do not work for wages. Of course, when farmers produce so much that they depend on the income received from the sale of their surpluses, they become enmeshed in the money economy. It is difficult to think of our large-scale farmers, with their subsidies, price supports, and scientific assistance from the great land-grant universities, as independent yeomen, rugged individualists. That is why Wright and other utopians wished agriculture and light manufacture to be a sort of serious avocation—necessary to sustenance, but not so industrialized that it would become a business. When Mr. Wright was asked, "Can you produce U.S. Steel by decentralized methods?" he replied, "Yes, of course; more effectively, so far as human life is concerned and the benefit it derives from steel. . . . The Garys and the Pittsburghs have served their term. We do not need them now."[2] There speaks the authentic utopian, a sensitive man despite his aggressive tone, who had looked at Pittsburgh (before its rebirth in the 1950s) and decided it would be better to begin again in the uncorrupted countryside.

The principles on which Broadacre City would be organized are best summarized in the following list prepared by Wright himself:[3]

No private ownership.
No landlord and tenant.
No "housing." No subsistence homesteads.
No traffic problems. No back-and-forth haul.
No railroads. No streetcars.
No grade crossings.
No poles. No wires in sight.
No ditches alongside the roads.
No headlights. No light fixtures.
No glaring cement roads or walks.
No tall buildings except as isolated in parks.
No slum. No scum.
No public ownership of private needs.

LE CORBUSIER: LA VILLE RADIEUSE

The garden city is a suburb; the suburb is a tentacle of the city. According to Le Corbusier, it creates more problems than it solves: commuting, expensive installation of utilities from the central city, too many vehicles, costly maintenance. And eventually the garden city is absorbed by the spreading central city. The Ville Radieuse or its variants, proposed by Le Corbusier for several French cities in the 1920s, is a plan for as many as three million people. Unlike Wright the American, who generally detested skyscrapers, which are an American invention, Le Corbusier the Frenchman found them absolutely essential. He would create *vertical* garden cities. The Ville Radieuse paradoxically has a higher population density than present cities and yet *more* open space. The explanation lies in its huge but widely separated office buildings

and apartment houses. Instead of being clustered to form the well-known canyons of Manhattan, they are open to light and air, surrounded by park areas on all sides, and approached by unimpeded highways on several levels. The highways, subways, and trainways radiate outward from the center of the city, much as do the streets in Washington, D.C. At the outer rings of the city are located large apartment houses of the type at Marseille, fifteen or twenty stories in height, with some individual dwellings situated among them. Industry would be located still farther out from the city, but not very far from the apartments where workers live.

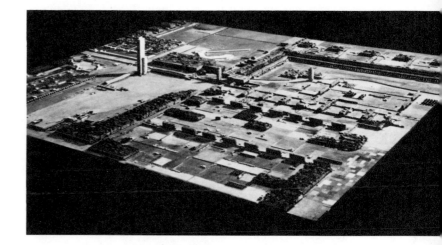

FRANK LLOYD WRIGHT. Broadacre City plan. 1933–40. Reprinted from Wright's *The Living City*, Horizon Press, New York, 1958

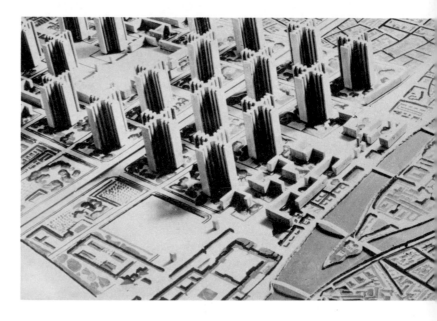

LE CORBUSIER. Ville Radieuse: Voisin Plan for Paris. 1925

The space opened up in the city by high-density sky-scrapers could be safely used by pedestrians since the different kinds of transportation would have their own levels. This is an ideal of today's city planners which we cannot seem to reach. Some of our most modern urban redevelopment schemes locate parking garages in the core of the city, thus drawing vehicles into the center city and forcing pedestrians to compete with them for space. Such an arrangement results in so much inconvenience and harassment for people who have come downtown to shop or dine that they are increasingly drawn to suburban shopping centers. As a consequence, shops and restaurants in downtown areas, even when abetted by low-cost parking garages, find it increasingly difficult to compete with decentralized shopping centers.

Le Corbusier was reconciled to the existence of the city and its unique culture. He did not seek to escape but to change the city. And the world seems to have accepted his commitment to high-rise structures but, until recently, has been unwilling to carry out radical surgery in the central part of the city necessary to rationalize its transport systems and admit light, sun, and air to downtown districts by opening up the space around skyscrapers. Also, when we tear down decaying urban areas in order to create the space for a new and comprehensive plan, we find ourselves faced with many painful decisions. Must everything go? Tearing down some areas involves the destruction of our visual history. Can some of the monuments of architecture be retained? Can the architectural "cure" of a city evolve gradually, incorporating the new with the old, or will such gradualism inevitably fail?

It should be pointed out, in fairness, that when an irreplaceable monument is torn down today, it is rarely because of large-scale urban redesign. Rather it is because our major cities do not have adequate legislation to protect these monuments. The pressure to wreck some of the great and expensively constructed buildings of the past comes from real estate and other interests that perceive larger revenues from new structures on the old sites. The cost of operating older hotels, train stations, and private mansions reduces profit margins to the point where it seems economically advantageous to replace them. Alas, their replacements are too often designed on the basis of maximum utilization of the site, maximum rentable space, and a minimum of architectural amenity. The architectural quality of much urban construction is based on investment considerations for the most part; hence, there is a great deal of demolition and new commercial construction in American cities.

In Europe, legislation, as well as a long tradition of profound reverence for artistic monuments, prevents the destruction of great structures. There cities seem to grow organically; the continuity of the past with the present is maintained. When drastic urban surgery is called for, it is usually undertaken to improve the visual organization of space, with full attention to the *total* context of buildings and open areas. War and bombing devastation, of course, make it possible to design and build from scratch. For instance, the opportunity for Le Corbusier's Marseille apartment house grew out of the need for housing following World War II. But a great deal of rebuilding in Europe has taken place since then; hence, the architectural crises of urbanism cannot be traced to the war but rather to the unsuitability of cities, as we knew them, to the conditions of modern life.

However, the Ville Radieuse was a plan dating from 1925. It sets ideals of efficiency—the rational use of energy, materials, and space—above all others. Order and beauty would result from the intelligent application of the Modulor to building and large-scale planning. Stripped of the Gallic enthusiasm with which Le Corbusier promoted the Modulor, it is a common-sense set of dimensions and ratios based on the parts and intervals of the human body. These dimensions help a designer plan

LE CORBUSIER. *Modulor*. 1947–52

a chair, ceiling height, or door opening; and multiples of the Modulor guide the architect in laying out gardens, parks, even whole cities. Through use of these fundamental ratios, all building and planning is presumably endowed with human scale. How French! How Cartesian! There may be some utility in employing a Modulor for various design problems. And since human perception *is* guided by a self-image of the body—its size and functioning—a certain harmony can result from the systematic use of a human canon of proportions. But the plastic qualities of Le Corbusier's buildings are more likely based on his artistic intuition and his experience as a painter than on the logical application of the Modulor system.

So much of architectural history depends on the emotional biases of its leading personalities. Le Corbusier, an active and tremendously productive person as writer, painter, sculptor, architect, and planner, feared boredom. According to him, the detached family dwelling in the suburbs is most efficiently and satisfactorily used for about twenty years, while a family is being raised. Then the children leave, and the parents, alone in a house larger than their needs require or their strength can maintain, are vulnerable to attacks of boredom. This would not happen in the Ville Radieuse. Instead of social isolation, there is the companionship of people in one's Unité d'Habitation. The residents are of all ages and family conditions, unlike the single-age-group environment of some American retirement communities. Apartments are not primarily for lifetime residence; one occupies them so long as they meet one's needs. As children leave or one's job changes, one moves to another suitable place. This part of his plan, then, conforms to the increased mobility of populations.

In addition to the human activity around one, in the Unité and in the city, there is the visual excitement of sculptural buildings and the sparkling silhouette formed by the skyscrapers which are visible from one's balcony. Le Corbusier admired the skyline of Manhattan, but only at a distance. He deplored the living and working arrangements which it implied: "Our American friends have erected skyscrapers and made them work. They are constructions of an astonishing technique, tangible proofs of present possibilities. But, from the planning point of view, their skyscrapers are tiresome and their towns wretched to live in (though vibrant and meriting the closest attention)." And he went on about single dwellings: "Instead of multiplying innumerable suburban houses let us equip ourselves with impeccable dwelling-units [that is, apartment houses] of an appropriate stature."[4]

An important facet of Le Corbusier's approach to community planning lies in his commitment to mass production of cells or dwelling units in his apartment houses. Most of us accept the benefits of mass production while at the same time we fear it lessens individualism. But Le Corbusier and his followers would cite the American

Photograph of a slum scene in Harlem

DAVIS, BRODY and ASSOCIATES. Riverbend Houses, New York. 1966–68. Good design in middle-income housing: private entrance to each duplex, floor-through living space, walled terrace, continuous outside gallery, spectacular views; a creative adaptation of Le Corbusier's *ville radieuse* philosophy on behalf of the black residents of Harlem's tenements.

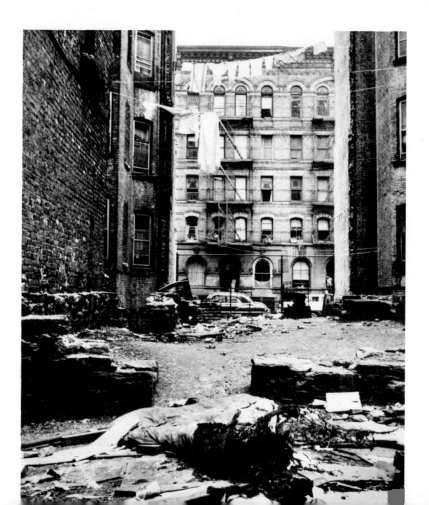

automobile as an example of a product which is mass produced and is offered in so many shapes and types that there is a wide range of choice for the individual. Individualism grows out of the way one uses mass-produced goods, not in their rarity, cost, uniqueness, or unavailability to others. To be sure, single dwellings, when mass produced and given superficial variety by the color of roof shingles or details of trim, make up dismal, monotonous streets and neighborhoods. Standardization is more acceptable in large apartment buildings because (1) there is variation in the types of units or cells; (2) an outsider sees, not the individual apartments, but the totality of the building, which can be architecturally impressive; (3) hence each cell need not indulge in architectural pretensions to uniqueness; (4) residents do not look out at dwellings identical to their own but instead they can enjoy the shifting patterns of sky, land, and cityscape.

Perhaps Le Corbusier's contribution to city planning can best be seen in his demonstration that, since urbanism is an inescapable fact of modern life, rational ordering of space can make urban life satisfying, even exciting. Great architecture is possible without atavistic return to the building techniques and living patterns of the past. Reinforced-concrete construction ("reconstituted stone," as he called it) can be spiritually satisfying, functionally adequate, durable, and reasonable in cost without surrender to the austerities of the steel-and-glass boxes which Wright so disliked. Finally, excellent community design results from artistic sensitivity wedded to a conception of man: his work, recreation, visual requirements, feelings about space, and need to move about freely on his own feet. Indeed, if Le Corbusier or any architect can devise ways for men to move on foot freely, safely, and with delight, in communities numbering in the millions, then the notion of individualism will have been greatly strengthened.

Following are the main principles of town planning advocated by Le Corbusier:

> The *keys* to town planning lie in designing for the four functions: Living, Working, Recreation, Circulation.
> The *materials* of town planning are sunlight, space, greenery, and steel-reinforced concrete.
> Enough dwellings should be concentrated in one building to liberate the space around it.
> Pedestrian routes and mechanized-transportation routes should be separated.
> Distance between home and work must be minimized.
> Living quarters should have the best urban sites.
> Pedestrian paths should not be obstructed by buildings, which should be elevated on stilts.
> Autos, buses, and other vehicles should travel on elevated roadways, beneath which are housed pipes and other utilities now buried below ground; easier repair and maintenance would result.
> Industrial areas must be separated from residential areas by greenery.
> Architectural monuments should be safeguarded.

ELEMENTS OF PLANNING: RESIDENTIAL GROUPING

Almost all community plans call for special areas set aside for residential purposes. With the exception of the large apartment houses of Le Corbusier, these residential areas are occupied chiefly by detached, single-family dwellings. They vary greatly in cost, quality of design, and orientation on their sites. They may have been built speculatively, in huge developments, or they may have been built on an individual, custom-made basis. Yet some developments may contain very costly dwellings, while some individually built houses may be relatively inexpensive. Cost and the organization of construction do not necessarily govern the patterning of home sites, roads, and open space in a residential area, although the designer of a large development has the best opportunity to make provisions for comprehensive design.

What personal and social objectives are sought in the grouping of houses, the design and location of roads, and the shaping of open space? The chief reason most persons choose to buy separate dwellings is to live in a quasi-rural setting, to capture, if possible, the charm of village life while enjoying the amenities and conveniences of modern suburbanism. Consequently, they hope their houses will blend gracefully with the landscape; afford convenient and safe access on foot to neighbors; provide roads nearby for reaching shops, schools, churches, recreation; and present a varied but unified visual appearance. Of course, these objectives are also accompanied by a host of other requirements (some not admirable) concerning the social status, ethnic origin, religious affiliation, and income of neighbors; preference for a particular architectural style; desire for more room and privacy than an apartment affords; and special space for hobbies, recreation, gardening, and so on. At a certain point, the individual has to make compromises, usually based on his available funds; or a contractor makes the compromises for him in a development already planned and built. Up to the point where it is necessary to compromise, however, what are the desirable features of residential groupings?

Curving roads are best for providing visual interest and variety; they permit more freedom for siting houses on different axes in relation to the road axis. Curved roads also tend to slow down motorists. Of course, a main thoroughfare should never pass through a residential area. Where straight roads are necessary, houses need not be set parallel to the road; all can be given a slight, consistent tilt to create more varied space intervals and to take advantage of the best orientation to sun and view. If every house in a group is independently tilted and sited on its lot, the result can be the creation of chaotic, jarring space areas. Some zoning ordinances attempt to prevent this through rules for uniform setbacks and minimum distances between houses. Very narrow lots, of course, impose severe design limitations unless they are developed

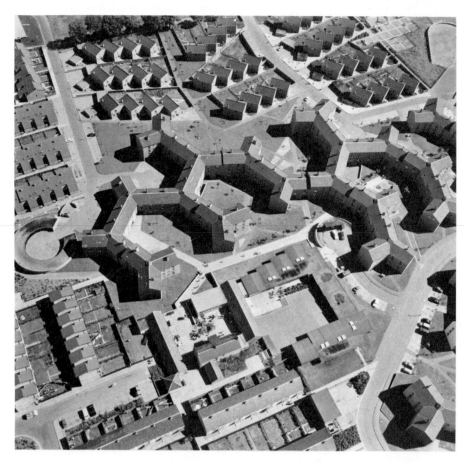

New town in Cumbernauld, Scotland. 1965

Sven Markelius. Vällingby, Sweden. Begun 1953

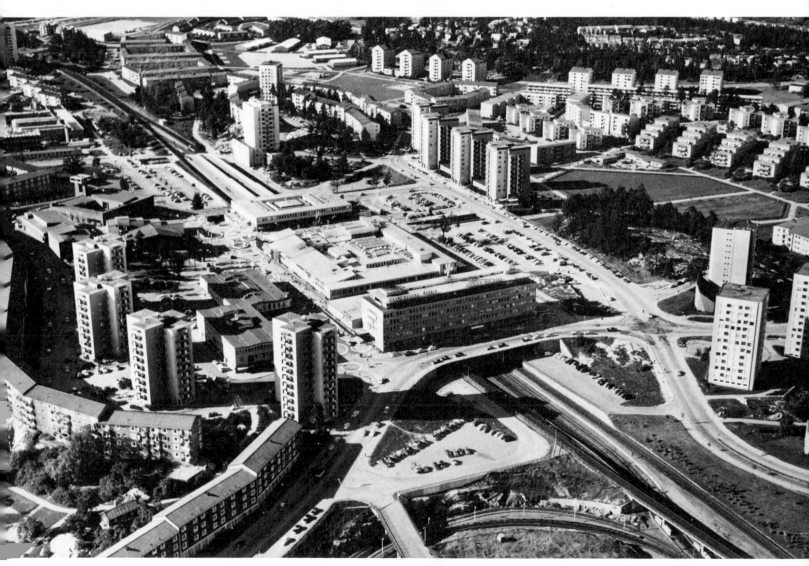

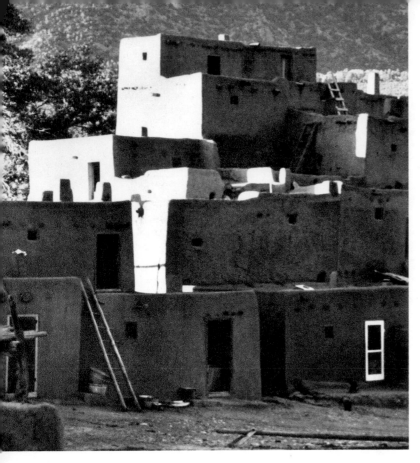

Indian village, Taos, New Mexico

ALFRED NEUMANN and ZVI HECKER. Apartment house, Ramat Gan, Israel. 1960–63. The sculptural excitement in this apartment building (below) proves that modern technology can generate the same feeling of community and human interdependence that we sense in the adobe pueblo, America's oldest highrise dwelling. (above)

as a group so that the designer can put together adjoining side spaces for maximum visual effect. So far as intersections are concerned, the four-corner intersection is usually best avoided, whether curved or straight roads are employed. The simple T intersection is best. A variety of road types can be employed to connect with larger arteries: the cul-de-sac, dead end, loop street, the collector road, rectangular grid, and their modifications and combinations. Hopefully, of course, the bulldozer will be used as sparingly as possible, natural contours will be respected, and good trees and interesting stone outcroppings will be permitted to stand. In general, it is best if houses are sited as well as possible in relation to the land and each other, with a minimum of road introduced to serve the houses. It often appears, however, that houses and lots are located to serve the road.

Flat terrain lends itself to any pattern, but good design tries to avoid the obvious, especially the unmodified rectangular grid; an effort should be made to introduce variety and a semblance of changing vista where nature has not been too generous with trees, rolling landscape, or other sources of visual interest. It has been found in highway design that a good view is enhanced if it is approached by a curved route rather than by a straight line. By this principle, even a fairly commonplace row of houses can be made more attractive if we do not see them all at once, as if they were lined up along a railroad track. In addition to the horizontal curve in the road, the vertical curve, the rise and dip of the road, can add interest to individual dwellings and to a group. But houses must be designed to take advantage of the changing levels of vision from which they will be seen. In general, it is best if the dominant roof lines follow the slope of the land. When houses are close together because of narrow lots, they harmonize well if there is some continuity among their roof lines: they should seem to flow together, and this effect can be enhanced through landscaping.

Unfortunately, one of the motives for residence in detached houses is a laudable but misunderstood individualism. To avoid the monotony of some mass-produced developments, designers, contractors, and homeowners indulge in orgies of spurious originality in their fencing, lampposts, planting, shutters, shingles, siding, mailboxes, garden sculpture, and so on. Horrors are perpetrated in an effort to deny that the houses carry approximately the same price charged by the same contractor, and contain about the same number of door knobs. But outrageous aesthetic efforts usually work against the intent of the homeowners who, to avoid the jarring visual discontinuities of the city, sought out the suburban development in the first place. Villages of the past achieved much of their harmony because there was very little variation in construction methods and building materials in any given area. The farmhouses of a region tended to be alike in construction, but farmers, because of their sensitivity to

the land, arrived at a subtle individuality; they knew how to site a house very well. This had nothing to do with the "rugged individualism" of the yeoman farmer; it was due to his common sense about wind direction, tree protection, commanding view, drainage, the flow of water on the surface, and the water table below ground. A knowledge of geology helps, especially if one must dig a well.

Our zoning laws and attitudes about property ownership make it very difficult to gain the design benefits of clustered houses and pooling of space for common amenities and services. Think of the space wasted in the thousands of developments with small lots where the legal minimum of a ten- or twelve-foot side yard is just barely maintained! Such amounts of space do very little visually or otherwise. They merely serve to separate. Consider also the space devoted to individual garaging. A variety of architectural services and design benefits would result from thinking of a cluster or group of houses as a single design problem rather than using the atomistic, single dwelling as design unit. Group garaging, fencing, and landscaping alone would vastly increase safe play space for children, reduce the amount and cost of roads and driveways, introduce handsome fencing where desirable (compare the solid, consistent stone walls of farm villages to the changing fences on every hundred feet of frontage in a typical suburban development), and extend the benefits of professional landscape architecture.

Richard Neutra has written very candidly about the problems and illusions of homeownership which so many dwellers in tract developments inherit. The freedom and independence that homeownership seems to imply is rarely exercised in any real sense by the time land developers, zoning boards, lending institutions, contractors, building trade unions, and public utilities have organized their various skills, assets, energies, and interests to produce the detached dwelling the citizen buys. Indeed, that citizen is not likely ever to *own* his house.

But it is his to use and pay for. And the detached dwelling, with its design atrocities and the illusions of individualism it confers, may yet constitute a better solution to the problems of shelter than the alternative—undistinguished boxes in urban apartment houses, dwellings increasingly reserved for the very rich or the very poor. Unfortunately, the poetic promise of the domestic dwelling we inherited from Frank Lloyd Wright has not been realized in housing for the millions. Perhaps it never can be. But it would seem that here architecture and community planning are ahead of society. We know how to design better communities than we are permitted to build, better indeed than most citizens realize is possible.

ELEMENTS OF PLANNING: THE HIGHWAY

Trains and buses are more efficient vehicles of transportation than automobiles. Nevertheless, if we have a choice, we prefer to drive an automobile to the same destination we could reach by bus. Why? There is the sense of freedom and personal control in a car. An auto trip has elements of the unexpected. If modern existence is increasingly mechanized and automated, the motor trip, at least, provides the opportunity to exercise skill and judgment—not merely to arrive at a destination point but to meet the challenges and overcome the problems of getting there. Doubtless, also, the automobile is felt as an extension of the driver's body: he wants to test it against the rigors of distance, the competition of other drivers, and the demands of the road. The auto voyage along with the shopping trip is one of the fundamental experiences of twentieth-century man. In the face of transportation alternatives, casualty statistics, and all the obstacles that hinder a painless approach to the highway, motorists surge toward the broad concrete strip like lemmings drawn to the sea.

What draws the motorist in addition to the need to get somewhere is the chance to feel the land moving under his vehicle, to view the changing sky and countryside at 70 mph, and to sense the response of the car to the shifting shape of the road. We have to acknowledge the fact that highways, parkways, bridges, and viaducts constitute art objects, sources of aesthetic experience for the millions.

Highways are man-made, they employ plastic materials, they affect our experience of space, and they consist of shapes and structures which could have been designed differently. The aesthetics of driving is partly based on the way our vehicle handles. But it is also based on the opportunities the road provides for the vehicle to work, and for us to see and respond to the spatial expanses hollowed out by the highway. The connection of the driver to the car and of the car to the road is part of a kinesthetic continuum of amazing complexity and varied occasion for pleasure.

Safety is, of course, a principal objective of the highway designer. But aesthetic considerations are intimately related to safety. The designer can shape a motorist's visual experience because he knows how far ahead a driver can see at given speeds, as well as his degree of peripheral vision and ability to discriminate objects. He knows how the banking and grading of the road and the transition to and from curves affect comfort and pleasure as well as safety. The architect Richard Neutra has brilliantly discussed the deep-seated human desire for precision—smoothness and regularity of surface and contour.[5]

For the motorist, this need for precision is satisfied in the pleasurable feelings experienced in smooth car maneuvers assisted by the shape of the highway and its access roads. The well-designed highway *leads* the eye of the driver, preparing him for certain operations while affording sufficient variation to avoid monotony. (In addition to the pleasure it affords, variety is desirable because of

Expressway through Lefrak City in Queens, New York. An automotive conveyor belt surrounded by an anonymous collection of boxes for middle-income apartment dwellers. The result of this architectural relationship of mutual indifference and disregard is ugliness.

Complex freeway interchange in Los Angeles

TR-4 sports car on the road

the dangers due to the hypnotic effects of monotonous highway design.)

The highway right-of-way ought to be chosen not only for economy of construction but also to exploit topographic and scenic advantages. Given any particular terrain, the designer should consider how its features are seen, not by a man on foot, but by a motorist. The problem becomes architectural: organizing and controlling the vision of an individual as he moves through a particular spatial sequence. Designers can go around a hill, over it, into it with a tunnel, or through it with an open cut. Funds will govern the decision to some extent. But, as aesthetic considerations apply increasingly, it becomes necessary to utilize the sensibility of the architect and sculptor as well as that of the engineer. Three-dimensional models should be used in planning much more than is now the practice. Sculptors and designers should be engaged as consultants so that qualities of color, shape, and texture will be properly exploited. Cinematic techniques combined with three-dimensional models of proposed highway constructions would immensely increase our knowledge of the psychoaesthetic factors of highway design. The cost of such studies would be minuscule in relation to the staggering sums we expend for highway engineering and construction. And some of our ugliest blunders might be avoided.

Today's wide interest in sport cars is partly to be explained as an interest in the aesthetics of driving, and particularly in the psychoaesthetic values of experiencing the machine for its own sake and as an extension of the body. For example, sport-car enthusiasts often prefer side roads with poor surfaces, bad turns, and no banking to the smoother pleasures of the highway. This preference can be understood, in part, as a reaction against the aesthetics of precision, regularity, and predictability. It also suggests that kinesthetic needs—for some motorists, at least—require satisfaction more urgently than visual needs. There appears to be a connection between the riding properties of the conventional automobile and the ratio of visual to kinesthetic values in the modern highway: as road design moves toward an increase in pictorial and architectural values, automobiles are designed like oceangoing ships. As roads become safer, the driver's reactions fall into a smoother, less erratic pattern: there

are surprises but he is prepared for them. His physical awareness of the machine diminishes. By contrast, the sport-car aesthetic of speed, surprise, unpredictability, danger, and death is quite understandably associated with romantic, death-defying figures like James Dean and Jackson Pollock, both of whom died in auto crashes. Romanticism thrives on the exaggerated expression of a single emotion, but if the human body and the machine must be joined together in order to experience the heightened feeling of accelerated motion through unpredictable space, the result is likely to be fatal.

The parklike character of highways has led some designers to rely too heavily on formal, regularly spaced planting of trees and shrubs. This approach may be acceptable for roads of relatively low speed, where the median strip is narrow. But for fast, large-scale roads, it is best to preserve the character of the countryside as much as possible, retaining local vegetation, selectively thinning wooded groups, and providing visual definition and accent through the road itself and its auxiliary structures. The design of viaducts, bridges, multilevel interchanges, side slopes, retaining walls, safety railings, embankments, and urban approaches presents difficult aesthetic problems as well as challenges to engineering ingenuity. For example, we are rarely able to bring a highway into or through a city harmoniously. How can major arteries be visually integrated with the various structures and facilities which surround them in the city? What are the best shape and scale relationships for the areas created by the crossing, paralleling, descending, or rising of freeway ramps and strips as they meet local traffic patterns?

And there are other questions. What can be done to minimize the number of signs posted by well-meaning highway departments? Can visual information be given more concisely, in more attractive and professional images, and sufficiently in advance of need? Can the right-of-way be somehow extended so that billboards will not invade the motorist's privacy or exploit the passage of citizens on thoroughfares built with public funds? One need not listen to radio and television commercials, but vision is essential to driving; hence, billboards cannot be "turned off." Obviously, the best efforts of architects, engineers, and planners will be frustrated if there is no appropriate legislation to protect the visual, structural,

and topographic relationships they are learning to create.

Although the automobile is the cause of much civic and social mischief, it is also the parent of the highway and parkway. These, in turn, have been carried to the point where they constitute exceedingly complex and monumental art forms. Given its most expensive and vastly organized expression in America, the modern highway illustrates our resemblance to the ancient Romans—solid builders and great administrators but not especially sensitive to the nuances of human or aesthetic relationships. Since 1946, Germany and Switzerland have demonstrated on a smaller scale a more advanced and comprehensive idea of the highway as a form of attenuated architecture. The world's greatest democracy has yet to accept the legitimacy of expending public funds for sculpture which might enliven a long and dull stretch of road. The pathos of Edward Hopper's *Gas* tells the story well. But we are learning that with our frontier gone and our natural resources limited, the spoliation of the landscape must cease. A well-designed highway may be the most effective instrument we have for educating the millions to enjoy the countryside and to preserve it unravaged.

Terracing along Highway 70 outside Denver, Colorado. Sound highway engineering here creates an impressive geologic display as well as an aesthetic effect appropriate to the grandeur of the Rocky Mountain setting.

ELEMENTS OF PLANNING: PLAZAS, MALLS, CIVIC CENTERS

The advent of television has made our public life a living-room experience. Momentous world events are witnessed from the same sofa which used to serve for courtship before automobiles overtook us. Indeed, many of the tragic events of our time, the deaths of presidents and charismatic public figures, are experienced over television

Garden State Parkway south of Raritan River crossing

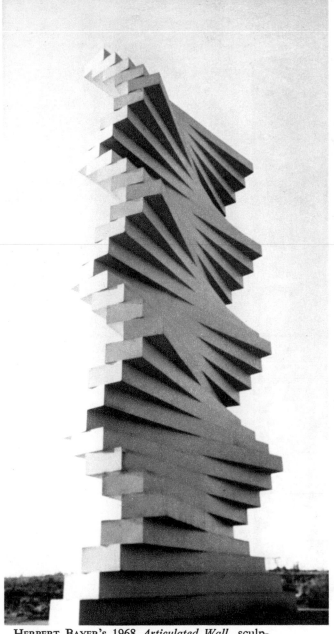

HERBERT BAYER's 1968 *Articulated Wall,* sculpture for Mexico City's Route of Friendship

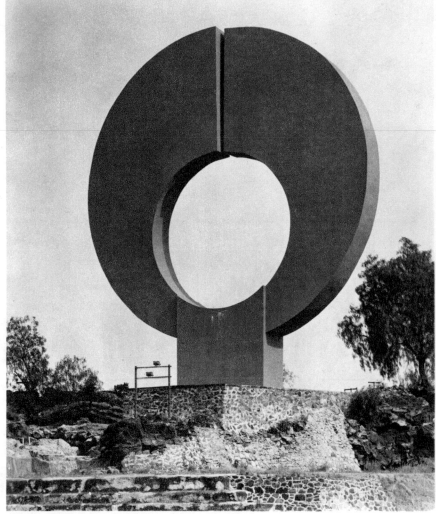

JACQUES MOESCHAL's 1968 sculpture for Mexico City's Route of Friendship

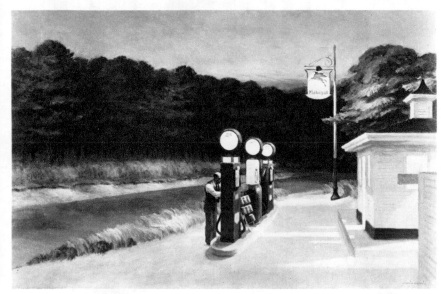

EDWARD HOPPER. *Gas.* 1940. The Museum of Modern Art, New York. Mrs. Simon Guggenheim Fund

Although massive painted sculptures punctuate the belt parkway around Mexico City, the typical Mexican citizen prefers figurative to abstract forms. North Americans, more accustomed to abstraction, must look at the figurative imagery on highway billboards—our contribution to monumental outdoor art.

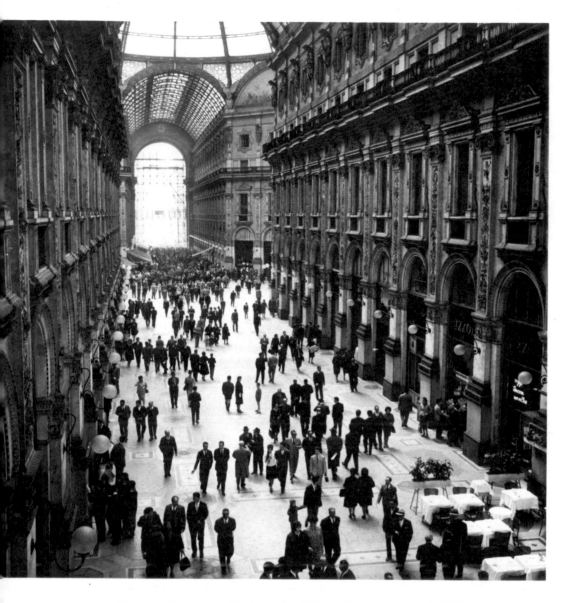

DONALD RAY CARTER. Photograph of Galleria Vittorio Emanuele, Milan

A city is not great unless it creates places where citizens can enjoy the variegated delights of a rich street life.

BERNARD RUDOFSKY. Photograph of Corso Vannucci, Perugia, Italy

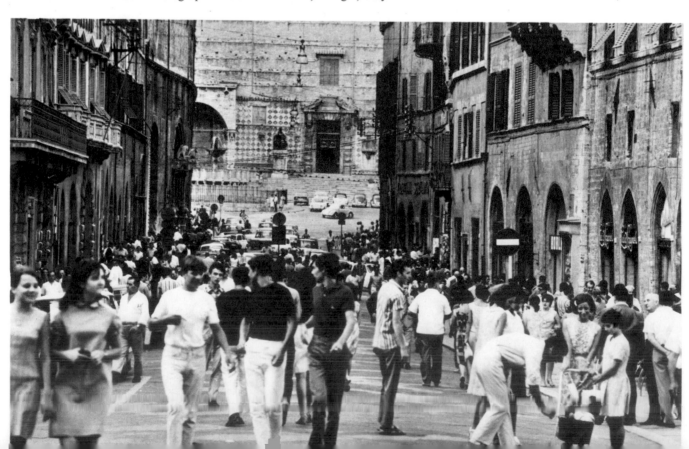

with all the immediacy and sense of personal distress that are felt by members of a single family. For a long time, this fact about political life has been apparent: we cannot, like the free citizens of a Greek *polis* or the inhabitants of a small New England town, gather together in a single square to hear issues debated and the people's business settled. But our communications media have only recently become effective and vivid enough to provide an alternative sense of community, since the old forms of physical community appear to have broken down. However, television, radio, and the journals and news magazines create only a community of mind and opinion, entertainment and information. We require physical and palpable symbols of community too—places in the open where we can come together out of the darkness of our TV dens to experience the exhilaration of *being with*, as opposed to *looking at* or *reading about*, people.

What are the places in the community which now bring large numbers of people together? They are shopping centers, parks, sports arenas, schools and universities, theaters, municipal and civic centers, hospitals and clinics, airports, bus and train terminals, skyscraper groups, hotels and museums, and combinations of these buildings and places. As individual structures, such buildings are designed with fairly clear and definite ideas about the way the interior space they create will be used. Consequently, even the office building of mediocre design works fairly well—as a technical if not an aesthetic entity. But the space *around* the building does *not* work very well, because it has rarely been planned: it is merely leftover space, occupied largely by the avenues and streets required to carry people. Sidewalks and pedestrian space in general are immensely crowded. The noise, jostling, auto fumes, and confusion of even the most distinguished thoroughfares are so disturbing to the pedestrian that he must flee indoors to hear himself think.

Yet we want to stroll, windowshop, sit on benches, watch the passing parade, and enjoy the visual qualities of structure and space under varying seasonal and light conditions. These are the traditional and deeply rooted desires of people who congregate in market places, church plazas, parks, and civic centers. Many Americans visit Europe for these reasons—so that they can browse in outdoor book stalls, shop in open markets, stroll along park lands, explore crooked little streets opening into enclosed squares where there might be a church, some statuary, a fountain, an outdoor restaurant, some children playing, or older people chatting in groups. Imagine that—people carrying on a conversation out of doors! American college students can do so on campus: they may even have some outdoor classes if the weather permits. But after graduation, daily life will be largely an indoor affair.

In 1945 Lewis Mumford wrote about the practice of removing shade trees from commercial areas: "The merchants' notion that the chopping down of shade trees on

GONZALO FONSECA. *Column with Objects.* 1969. Twentieth Century Fund, New York. A two-ton abstract sculpture—a kind of modern megalith—takes its place among the lampposts, mailboxes, and fire hydrants that have hitherto constituted the urban stroller's street furniture. Hollows and ledges provide resting places for anonymous ornamental objects, and a smooth marble surface invites people to inscribe graffiti.

business thoroughfares is a sign of progress or business efficiency is one of those blind superstitions that cannot be justified by sound business practice."[6] Largely due to the design ingenuity of Victor Gruen, shopping space has been recovered for pedestrians in centers created by his organization in Minneapolis, Minnesota (the Southdale Shopping Center); Cherry Hill, New Jersey; Rochester, New York (Midtown Plaza); and elsewhere. These shopping plazas or malls may be new, enclosed structures with natural light admitted at the top, generous and often exotic plantings (as at Cherry Hill and Minneapolis), and air conditioning throughout. Or the mall may be created by the closing off of downtown streets as in Rochester. Converting some of the streets of "center city" to pedestrian use can accomplish a great deal toward reclaiming the city for people: this move does not necessarily require that buildings be torn down; auto traffic can, of course, be rerouted and underground garages can be built. Although expensive, such measures are sometimes undertaken to counter the flow of retail business to outlying shopping areas. But as piecemeal efforts, they are not

VICTOR GRUEN ASSOCIATES. Cherry Hill Shopping Center, Cherry Hill, New Jersey. 1961

VICTOR GRUEN ASSOCIATES. Midtown Plaza, Rochester, New York. 1961–62

Parly II, an American-style shopping center between Paris and Versailles. The American cultural invasion of Europe continues. Here our design and technology enhance the traditional continental marketing experience: the pleasure of visiting dozens of little shops and vendors' stalls in comfort and on foot.

likely to succeed; they must be accompanied by large-scale redesign of the slums and obsolete structures which usually surround downtown areas.

Rockefeller Center in New York City, begun in 1931, provided the impetus for all subsequent design of public plazas and buildings in the high-density core of a modern metropolis. The center consists of sixteen buildings occupying fourteen acres of very choice real estate in Manhattan; the complex surrounds a pedestrian mall and a sunken plaza which is an ice-skating rink in the winter and an outdoor restaurant in the summer. The buildings, designed collectively by a team of architects under the leadership of Wallace K. Harrison (born 1895) (who subsequently headed the architectural team which designed the UN complex), are massive slabs which in their honesty and boldness represent the first significant departure in New York City from the idea of the skyscraper as a tower, as a sort of oversized church steeple. This group of buildings, built on costly land and requiring complex utilities and banks of elevators to service their tenants, embodies a frank if unspectacular solution to the problem of getting a maximum of light into the interior of very tall structures. No office is more than twenty-seven feet from an exterior wall; thus, all have light, fresh air, and a view. The clean plane of the walls of the RCA Building is given a pleasing surface texture by the vertical strips of light-colored stone facing; its profile departs only slightly from a perfect rectangle in staggered setbacks located where elevator shafts end. But the main advantage of the unbroken curtain-wall surfaces and the slablike quality of the structures lies in the sense of enclosure and protection they give to the plaza and mall on the ground. The popularity of this site grows out of the feeling it affords the pedestrian of being at the focal point of an energetic and exciting city, indeed of being at the center of civilization itself. The mall, which is quite small, has colorful, carefully tended, and frequently changed flowers and plantings. The sculpture is fairly undistinguished but is enhanced by the elegant setting provided by the fashionable shops which face the mall and the generally chic and cosmopolitan types who stroll in from Fifth Avenue. With its Gothic stonework, St. Patrick's Cathedral, across the avenue from one of the buildings in the complex, provides a very satisfying complementary architectural note and appears to be not diminished but rather enhanced by its contrast with the scale and structural massiveness of its neighbors. A fountain in the lower plaza, surmounted by a gilded sculpture of Prometheus visible from the entry to the mall, constitutes both a center of visual and ambulatory focus as well as a transition to the unadorned vertical plane of the RCA Building. The sense of space in the mall is reminiscent of the experience of moving down the center aisle of a high-naved cathedral (the space is squeezed at the sides and opened up at the top), and then one emerges as if released into the vast, bright opening at

St. Patrick's Cathedral, New York. 1858–79. View from Rockefeller Center

the transept; this promenade corresponds in Rockfeller Center to one's approach to the sunken plaza. Indeed, the outdoor space at the center is a modified mirror image of the indoor space at St. Patrick's Cathedral up the avenue.

Built during the heart of the Depression by a group with huge resources at its disposal, Rockfeller Center was intended to be a commercial as well as an architectural success. And it has achieved its objectives. It created jobs, it brought a good return to its investors, and it established a model for subsequent efforts. Indeed, the Rockefeller family has been the prime mover behind a huge philanthropic project for housing some of the principal cultural enterprises of New York City in the Lincoln Center for the Performing Arts.

Rockefeller Center, New York. 1931–37

Wall of RCA Building

Lincoln Center for the Performing Arts, New York

Theaters, opera houses, and office buildings, then, are the magnets which draw people together in great numbers: the art of large-scale design lies not only in attending to the mechanical needs of crowds with efficiency and dispatch—in other words, minimizing confusion, inconvenience, danger, and discomfort—but also in designing inspiring spaces, spaces which make them feel the community was created with human beings in mind. A great city is large and frustrating, at once exhilarating and depressing. The individual privately lost in its vast and often depersonalized routine needs to be publicly reminded of his participation in humanity, that is, of his capacity to experience emotions arising from large-scale, collective effort. Knowing that powerful persons and institutions have assembled vast resources and outstanding designers in order to please and impress him (as well as justify their power) has comforted the ordinary citizen from ancient times to the present. Even when we know

Piazza San Marco, Venice. Begun 1063

full well that a building has been endowed, or a vast project initiated, by men anxious to show they are worthy stewards of the world's wealth, the sense of satisfaction we experience in the presence of great public architecture is undeniable. So, passing over the inescapably ambiguous record of power, we honor the Medici of Florence, the doges of Venice, and the Renaissance popes for the monuments which they caused to be built and which stand after the economic and political histories of their builders have long been forgotten.

ELEMENTS OF PLANNING: INDUSTRIAL AND COMMERCIAL STRUCTURES

Not many years ago, a factory or warehouse was an ugly place—grimy, surrounded by refuse, clutter, and bad odors. Viewing the industrial sprawl from the train window as one crossed the New Jersey meadows, one wondered how workmen ever became accustomed to the sights and sounds once they had overcome their reactions to the stench. The same wonder arose in connection with steel-mill towns along the Ohio River, wood-pulp mills in the South, the slaughterhouses of Chicago and Kansas City, and the scarred mining towns of Pennsylvania and West Virginia. Their active and obsolete remains still mark the places where we live and work. From the standpoint of aesthetic detachment, they are often romantically picturesque or symbolically impressive: the open-hearth steel mills of Gary, Indiana, at night; the oil refineries of

Galveston and Bayonne; the railroad marshaling yards of Chicago or New York; the almost deserted textile factories of Utica and New England; the "gas-house" area of any large city hard by its abattoirs, produce wholesalers, and fish markets. But these romantic and/or malodorous places are disappearing, mainly because their operation has become uneconomic. They were in the wrong location; they were too costly to maintain; some of them could be automated; or their managements became concerned with public image. The Victorian notion that industrial manufacture was an inherently ugly process, even though its products were necessary, has given way to the idea that the rationality, order, precision, and planning which are essential for any successful industrial enterprise

The romantic and picturesque imagery associated with artfully photographed industrial structures is not always compatible with an aesthetically satisfying way of life for nearby residents.

Bayway Refinery, Linden, New Jersey

Steel mills, Pittsburgh

Freight yards, Salt Lake City, Utah

Cross-sectional drawing, Johnson Wax Research and Development Tower, Racine, Wisconsin. Completed 1950

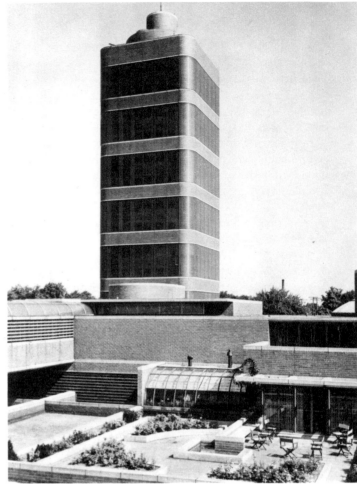

FRANK LLOYD WRIGHT. Johnson Wax Administration and Research Center, Racine, Wisconsin. 1936–39, 1946–49

FRANK LLOYD WRIGHT. Johnson Wax Administration and Research Center at night

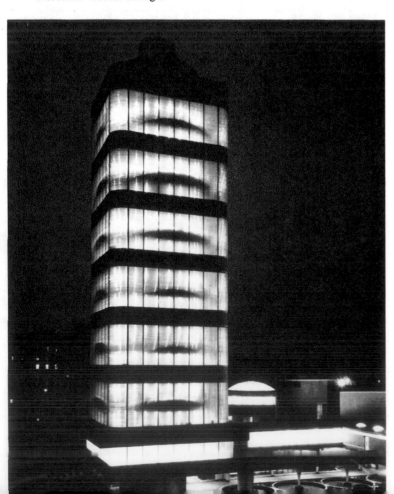

can also be visible in the places where that enterprise is carried on.

A pioneering industrial statement was made, once again, by Frank Lloyd Wright in his administration building (1936–39) and research tower (1946–49) for the Johnson Wax Company in Racine, Wisconsin. Some of its features appear dated now, and the structural vocabulary (with the exception of the tower) seems more related to the domestic dwelling than to business activity. But is that a fault? Should we criticize the many contemporary factories and research centers which look like collegiate buildings? Worker morale is improved and management is enabled to attract the scientific and technical personnel so essential for the survival of a modern industrial enterprise. The Johnson buildings are also located in the center city, where architectural quality and sculptural accents are a valued asset. A globe of the world, given a prominent location in a formal setting, is rather trite and somewhat reminiscent of exposition planning. (Planners and designers often succumb to the temptation to erect a massive "symbol," but the result is often too literal, while also dull as expressive form and boring or irrelevant as sculpture.) In the Johnson complex at Racine, the genuinely

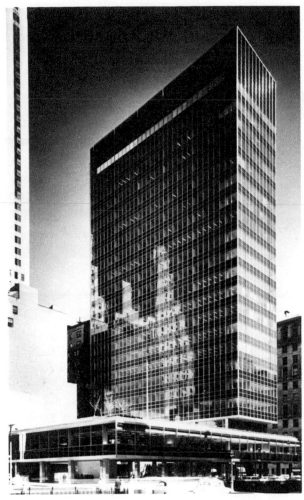

SKIDMORE, OWINGS and MERRILL. Lever House, New York. 1952.

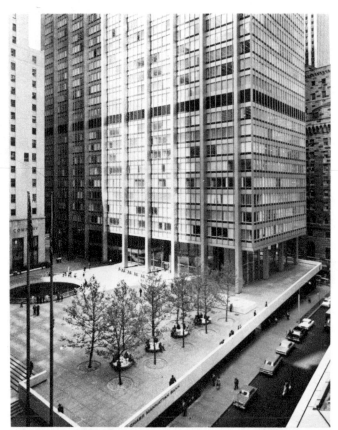

SKIDMORE, OWINGS and MERRILL. Chase Manhattan Plaza, New York. 1961

PAUL RUDOLPH. Endo Pharmaceutical Center, Garden City, New York. 1964

interesting forms inhere in the structures themselves and in the research tower, which rises dramatically from a seemingly hovering platform. Its horizontal bands repeat the emphasis of the administration buildings, and its circular roof turrets provide a note of variety for the tower while restating similar forms which appear elsewhere. The floors, or layers, of the tower are cantilevered from a central core which passes through the building and is visible as the turret on the roof. Night illumination reveals the structure very clearly and shows the Wrightian concept of a tall building as opposed to the Chicago and New York skyscraper conception. A high-rise structure resting on a platform is a design device which is increasingly used today, and with conspicuous success, as in Lever House (1952) and the Chase Manhattan building (1961), both designed by Skidmore, Owings and Merrill. This device unifies a site while creating a protected open space beneath the platform where a variety of practical activities can take place.

The extent to which modern industrial buildings have departed from the factory stereotypes of earlier days is seen in Paul Rudolph's Endo Pharmaceutical Center. The building vocabulary employed in Rudolph's Yale School

EPSTEIN & SONS. Kitchens of Sara Lee Administration Building, Deerfield, Illinois. 1964

ELIEL AND EERO SAARINEN. General Motors Styling Administration Building, Warren, Michigan. 1949–56

ANTOINE PEVSNER. *Bird in Flight*. General Motors Technical Center, Warren, Michigan. 1955–56

of Art and Architecture is repeated here, confirming the observation above that collegiate and industrial buildings now often look alike. Similarly, the Sara Lee bakery plant appears to have been influenced by the architecture building at Illinois Institute of Technology designed by Mies van der Rohe (see p. 106). These stylistic similarities show the interest of industry in seeking a level of architectural quality no less excellent than is sought in university buildings. Also, the distinctiveness of such industrial architecture provides a competitive advantage for firms engaged in retail operations.

The interior of the Administration Building in the General Motors Technical Center, designed by Eliel and Eero Saarinen (1873–1950; 1910–1961), shows the elegance and devotion to aesthetic effect which the modern giant corporation seeks for its administrative and research headquarters. The buildings of the center surround a man-made lake one-third of a mile long; hence the distances between them can only be negotiated, appropriately enough, by auto. The buildings are chiefly rectilinear structures, three or four stories high and spread out generously on a vast, flat site. Drama is not sought in sculptural treatment of the exterior, as in Rudolph's Endo Center; rather, a serene effect is pursued through quietly spacious interiors and lavish, uncluttered areas between the buildings, whose regularity can be viewed without obstruction across the lake expanse. Plantings soften the straight structural lines, and glazed-brick walls in primary colors enliven an otherwise sober complex of forms. The center undoubtedly impresses the viewer with the size and complexity of General Motors, but it would appear to be intended mainly as an ideal work setting: the promotion and sale of General Motors products is accomplished in other ways. A research-and-development campus is not a place meant to dazzle visitors or employees. Rather, it provides an environment in which people can function effectively at their jobs. Hence, the total organization of space does not promote the type of aimless strolling, sight-seeing, and visiting we want in urban neighborhoods

and plazas. Informal activity can occur on walks and verandas around individual buildings, but the focus of this architecture, notwithstanding excellent outdoor sculpture and water displays, is within the buildings, as it should be. A fine balance is struck between the pleasing but not distracting outdoor organization and the somewhat richer and more active interiors.

More dramatic industrial and commercial structures can be seen in Ely Kahn's (born 1884) Municipal Asphalt Plant in New York City, the St. Louis airport terminal by Minoru Yamasaki (born 1912), and the North Carolina State Fair Arena by Matthew Nowicki (1910–1949) and W. H. Deitrick (born 1905). The late Eero Saarinen, who collaborated with his father in the design of the classical, somewhat reserved General Motors Center, displayed his theatrical gifts in the TWA terminal at Kennedy International Airport. However, before congratulating ourselves on the drama and grandeur of contemporary architecture and planning, we might look at the interior of Pennsylvania Station, designed in 1906 by McKim, Mead and White, the classicizing old firm which based the main concourse of the terminal on the Roman baths of Caracalla. In the waiting room of the station, we could see drama in unadorned steel structure equal to the best modern work, or even to the Brooklyn Bridge. But we can see it no longer: the venerable landmark has been torn down to make way for a sports arena.

right:
MATTHEW NOWICKI and WILLIAM H. DEITRICK. J. S. Dorton Arena, Raleigh, North Carolina. 1953

E. J. KAHN. Municipal Asphalt Plant, New York. 1944

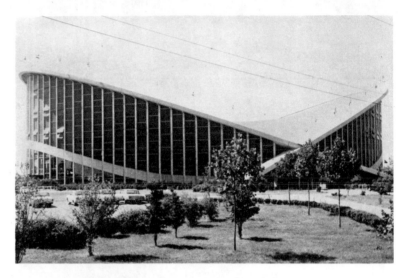

EERO SAARINEN. TWA Terminal, Kennedy International Airport, New York. 1962

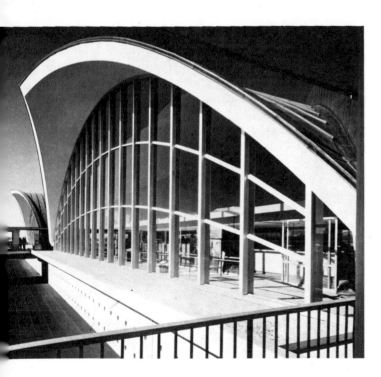

MINORU YAMASAKI. St. Louis Airport Terminal, 1954

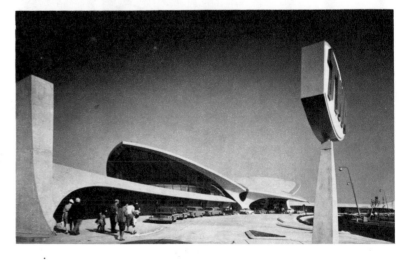

McKim, Mead and White. Main concourse, Pennsylvania Station, New York. 1906

McKim, Mead and White. Waiting room, Pennsylvania Station, New York. 1906

LARGE-SCALE DESIGN: CONCLUSION

The present time is one of frantic urban and regional transformation. The confluence of several forces has brought this about: (1) we realize that many social problems, now at the stage of crisis, partially originate in the physical design of the community; (2) we realize that our society is productive enough, rich enough, to undertake the massive design and architectural measures which are called for; (3) we realize that problems of health, transportation, recreation, commerce, and employment often transcend traditional political units: they embrace regions extending beyond towns, cities, counties, and states; (4) modern technology has provided the tools which make it practical to think in terms of large-scale, comprehensive design; (5) professional specialists—architects, engineers, sociologists, lawyers, administrators, land-use experts— have developed patterns of cooperation and unified action for community and regional design; (6) architectural education has evolved to the point where designers have a more sophisticated idea of comprehensive design than they formerly possessed.

Art participates in the physical evolution of the community in a narrow sense through the skills and ideals of those who practice the design professions. In a broad sense, art is the goal of all who are responsible for the shape of the large-scale environment—artists or not. One

left:
PAUL RUDOLPH. Southeastern Massachusetts Technological Institute, North Dartmouth, Massachusetts. 1966

below:
JOHN ANDREWS. Scarborough College, University of Toronto. 1966

bottom:
SAFDIE, DAVID, BAROTT, and BOULVA. Habitat, EXPO 67, Montreal. 1967

The "megastructure" approach to the architecture of great institutions and even of whole cities. Such continuous structures are open to social and technological change because they are designed to receive "add-on" or "clip-on" units which are mass produced by industrial methods instead of being custom-made on the site.

persuasive writer on the problems of cities, Jane Jacobs, says quite flatly: "A city cannot be a work of art."[7] She feels that architects and planners perpetrate ghastly urban errors by confusing art with life. By "life" she means the organic, creative social and economic activity of a city's neighoornoods.[8] But she may base her views on a definition of art as identical with sculpture or painting, both highly personal and individualistic types of expression in modern times. The fact is that some of our poorest architecture is too *im*personal, while industrial design is highly "other-directed." Often it is overinfluenced by what designers and businessmen believe will sell rather than what they know from professional experience to be excellent.

The cure for poor design is not "no design" but "better design." Truly professional designers know that communities are not merely oversized problems in abstract sculpture. They realize that the random impulses of people—their freedom and partial unpredictability—must be considered in any total plan. It is true that communities often grow unpredictably and that their districts are often creatively used for purposes not originally intended. Nevertheless, our knowledge of the inevitability of growth and change should not inhibit more deliberate efforts to create order and delight in communities, consistent with the freedom of their inhabitants and employing the best forms and ideas our feeble intelligence can devise.

The Crafts and Industrial Design

We have already observed that art performs a physical function through the designing and forming of all kinds of tools, implements, and containers. The important principle to stress is that art is not only decorative or symbolic: it is also utilitarian. There are significant differences between handmade objects and those which are produced by mechanical-industrial methods. But we should not forget the central idea that while methods, materials, and processes of making vary, the business of organizing them to satisfy human needs is an artistic problem.

In different historic eras, the individual responsible for the design or production of eating and cooking utensils has been called an artisan, a craftsman, an engineer, or

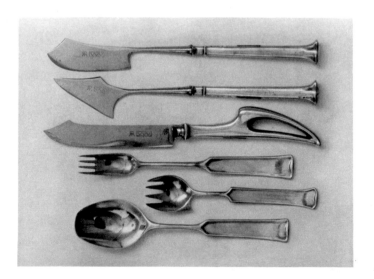

RICHARD RIEMERSCHMID, Table flatware. 1900. Landesgewerbemuseum, Stuttgart. As early as 1900, Richard Riemerschmid combined the rational analysis of function in useful objects with a sensitive and restrained adaptation of Art Nouveau forms.

a designer. And, indeed, the family itself has often produced its own food, clothing, shelter, and most of its tools and utensils. The hard-working housewife of American colonial days may not have regarded herself as a craftsman or designer, but she made her own cloth, cut and sewed clothes for her family, made blankets and rugs, painted and embroidered textiles, and worked at other crafts we would normally assign to specialists. When we study art, however, we are interested primarily in how a particular art object looks or operates and what it seems to mean. We care only secondarily about the fact that it was created by a colonial housewife or by a textile designer, a civil engineer, or an architect in the conventional sense. Our interest in the method of making an article or in the occupation of its maker derives from our curiosity about the form of the object itself and our effort to understand it.

The water jug made by a potter and the aluminum pitcher mass produced by machine are similar in shape and function. The art and fingers of the potter formed the clay jug. Forming the aluminum pitcher was a much more complex matter. But the pitcher—resulting from the collaboration of man and machine—has its own distinctive excellence: it too is an "art" object. It will be our task to examine some of the historical, technical, and psychological factors involved in the transition from clay pot to metal pitcher. The discussion will, in effect, ask the question, "Can men teach machines to create art?"

CHARACTERISTICS OF HANDCRAFT

Usually, a handmade object has been planned and executed by the same person. This is always true if the maker is what we call an artist-craftsman. But in the cottage and village crafts of many preindustrial economies, some division of labor occurs, so that artisans may execute the

The crafts tend to perpetuate tradition: we do not expect "originality" in the design of a violin.

designs created by others and employ members of the family to carry out minor operations repetitively. Nevertheless, there is a certain unity of control and execution in the handmade object. The excellent craftsman not only does all the work himself but also varies and adjusts his design according to the requirements of his client or customer. A tailor or seamstress or shoemaker who sets out to make an article for a customer also undertakes to satisfy the individual in terms of his personal measurements and requirements. Hence, the characteristics of handcraft include unified responsibility for the creation of the object and adjustment of design and execution to the customer's individual needs or caprice. The result of this process inevitably exhibits variation. We can speak of the craft object as "one of a kind," no matter how similar it is, in general, to other objects of its type. The uniqueness of the handcraft object may be based on idiosyncrasies of the craftsman's technique or the special desires of his patron. In any event, that uniqueness is identified by many as being the essence of art. It pleases us to know that we own or are looking at an object which is absolutely singular, which cannot be found elsewhere.

Not all craftsmen create for a particular patron. The great violin makers of Cremona—Stradivari and Guarnieri—made some violins in advance of orders for them. Here uniqueness is not based on the individual requirements of a customer so much as on the craftsman's progressive mastery of his art and his drive toward perfection. Modern artist-craftsmen—potters, enamelists, jewelers, glassmakers, furniture makers, and weavers—also endeavor to operate on this basis. However, their economic situation is precarious because they must compete with mass-produced articles. The Cremona violin makers were not threatened by mass production. They

could have been threatened by the work of inferior craftsmen, except that violinists are good judges of excellence in violins.

Another feature of handcraft in preindustrial cultures is, paradoxically, its relative sameness. Variations in detail occur because absolute duplication is not possible in handmade articles. But the people and the craftsmen living within a so-called folk tradition do not regard change for its own sake as a value. They change their modes of making, thinking, and behaving very slowly and only because of stimulation from the outside. Peasants and people remote from urban centers of ferment and innovation are inclined to resist novelty. Consequently, craftsmen in these cultures are content to use formulas and patterns in their work which were inherited over the generations. For them, inherited practices constitute an honored tradition which they must pass on as closely as possible. Persian rug making is a good example. Traditions in the crafts promote the development of a high degree of technical skill, since the folk craftsman concentrates on mastery of skill more than originality of expression. The problems of design and of content have, in principle, been solved for him. It does not occur to him to change his designs, especially as life itself, in folk cultures, does not change very much. It has a timeless quality which fascinates and charms the visitor, even if the peasant may not think of his work as "charming."

Although the older craft tradition places no premium on change or novelty, it *does* stress the proper use of tools and materials and the importance of durability. "Proper" in this context means employing the "correct"—that is, inherited—technique, and also respecting the working properties of the leather, fiber, wood, metal, or stone being formed. Furthermore, it means producing long-wearing, durable objects. Since the craftsman-customer relationship is a close one, the craftsman cannot easily escape responsibility for what he has made and sold. In the modern setting, responsibility for performance is shared by manufacturers with a multitude of middlemen. Thus, we derive one of the fundamental meanings of craftsmanship: the patron values the handmade object because he knows and trusts the craftsman who made it. Modern manufacturers attempt to develop a similar trust and regard for their products among merchants and consumers, but as a rule the consumer can only depend on performance data and specifications of materials. Claims for workmanship—in a hand iron or a radio, for example—are not always reliable unless supported by government regulations or by independent testing and evaluation agencies.

One other trait of handcraft as contrasted with machine production may account for the survival of artist-craftsmen today, notwithstanding their struggle with the economic facts of life: it is difficult to produce a great many ugly products by hand. There are inferior craftsmen, of

course, but they are usually discouraged, weeded out by a poor reception of their work. Second, it is very difficult for any human being to make something badly over and over again. He inevitably improves a little bit. Indeed, the visible results of his efforts to overcome technical deficiencies often seem more attractive than the perfection of the mature and accomplished craftsman. This appeal is based on the relatively modern discovery and admiration of crude, untrained, or primitive artistic effort. We may, for example, prefer the early, unsophisticated pottery of Pre-Columbian Mexico to the highly perfected black-figured pottery of classical Greece. In other words, handwrought objects of less than perfect technical mastery seem to satisfy human interest and may even arouse admiration for the proficiency they *do* exhibit. But the machine can produce badly designed objects at a fantastic rate. The result improves only if the designer improves. In the meantime, a vast amount of trash can be manufactured. Then, if these products are profitably sold, it may be

thought undesirable to change their design. In an industrial civilization, excellence is often defined in terms of mass acceptance, an acceptance which may only reflect the absence of qualitatively superior alternatives.

During almost all of man's history, his utensils and objects of daily use have been made by hand, mostly with the aid of small hand tools which are virtually extensions of his fingers and senses. Consequently, we have been thoroughly habituated to the visual and tactile characteristics of handcraft. It is doubtful that we shall ever entirely escape our emotional attachment to the properties associated with material which has been worked by hand—not as long as we have our amazingly strong and versatile fingers and opposable thumbs. But civilization as we know it now depends on mechanical and automated forms of making. Since 1750, the world has been going through an often painful period caused by conflicts between our emotional attachment to handcraft culture and the new mechanical, automated basis of civilization. Now the conflict is almost over. That is, machine methods of making and machine-made products have been successfully absorbed into the ordinary routines of almost all societies. Those newly emerging nations which still subsist on the basis of a handcraft economy are rushing eagerly—foolishly in some instances—toward machine-based industrialism. Some states on gaining independence almost immediately begin to build skyscrapers and steel plants although they do not have the supporting service facilities for high-rise buildings and could buy steel more cheaply than they can manufacture it. Thus, mechanical-industrial

ROY LICHTENSTEIN. *Ceramic Sculpture I*. 1965. Private collection

MERET OPPENHEIM. *Object*. The Museum of Modern Art, New York

These works rely for their Surrealist impact on the deliberate violation of the craftsman's aesthetic: appropriateness of material, decoration, and mode of making to the form and function of the object.

Useful Objects Made by Hand and Machine

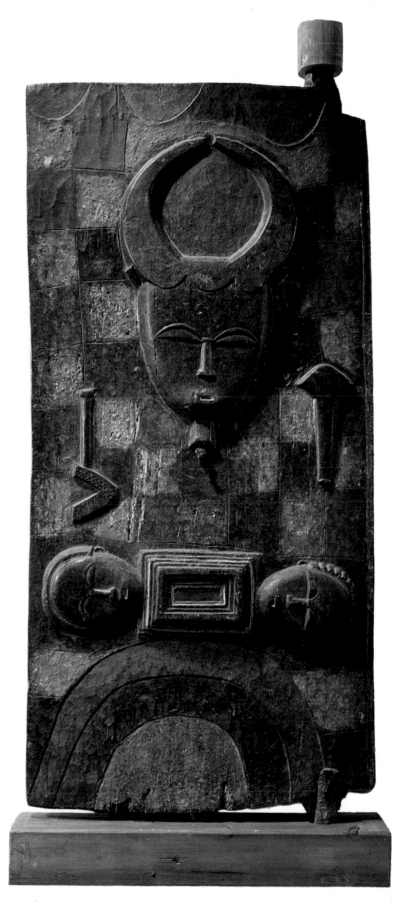

WOODEN DOOR WITH CARVING IN RELIEF, from
Baule, Ivory Coast. Rietberg Museum, Zurich.
Von der Heydt Collection. There is no differ-
ence between the fine and the applied in
African Negro art: utilitarian purpose and ex-
pressive form always coexist harmoniously.

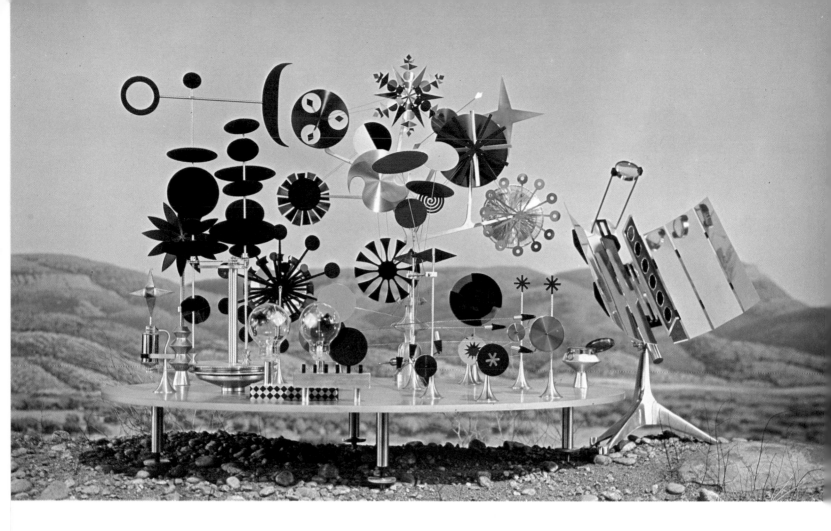

CHARLES EAMES. *Solar Toy (Do Nothing Machine)*. 1957 (destroyed). Designers like Eames have carried us across the threshold separating handcraft from machine technology; they create aesthetic delight out of the typical dynamics, shapes, materials, and processes associated with mechanization.

JACK BROUWER (art director). McGill engineered switches. Artwork for advertisement *How to Hatch More Eye Appeal.* Created for McGill Manufacturing Company, Inc., Electrical Division, Valparaiso, Indiana. Courtesy the Jaqua Company, Grand Rapids, Michigan. We reach the point where the design of unpretentious objects for mass production achieves the elegance and fitness of form to function that have characterized useful art in the great historic traditions.

production has become a symbol of national prestige while handcraft is regarded as a quaint survival of colonial dependence. It appears that experience with self-government and the operation of an industrial economy is needed to confer the breadth of view which perceives a healthy role in modern culture for the handcrafts together with mechanical production.

THE ORIGIN AND PRINCIPLES OF MASS PRODUCTION

To understand how industrial design functions in modern manufacture and to see the role of the machine as a tool of art, it is first necessary to describe the changes in methods of making brought about by mechanization. It would be a mistake to regard mass production as the result simply of the application of mechanical power to what were formerly handcraft processes.

The first principle of mass production is *duplication*, the second is *accuracy*, the third is *interchangeability*, and the fourth is *specialization*. The art of casting is the oldest method of duplication, one which goes back to Neolithic man. From this art, the enormous metal foundries of the present evolved. Today, there are very few manufactured products which do not contain some parts of cast metal or cast plastic. A second Neolithic invention, the potter's wheel, led to the wood lathe and then to the metal lathe, which is the basic machine tool of metalworking. Die stamping, another method of duplication, was used by Darius in the fifth century B.C. to manufacture coins. In duplication, then, we have the earliest attempt of man,

following emergence from a purely hunting economy, to satisfy his growing physical needs. Gutenberg's invention of movable type is the method of duplication most familiar to all of us, and perhaps the most far reaching in its effects. His movable type was a kind of interchangeability, too, since letters could be used over again in different combinations. But the tolerances of accuracy were quite wide, and the interchangeable principle was applied only on a two-dimensional surface without moving parts.

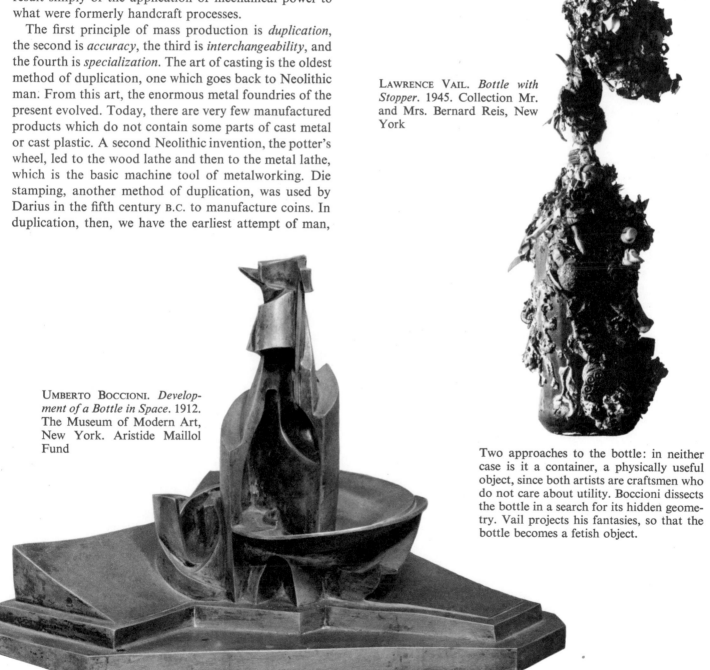

LAWRENCE VAIL. *Bottle with Stopper*. 1945. Collection Mr. and Mrs. Bernard Reis, New York

UMBERTO BOCCIONI. *Development of a Bottle in Space*. 1912. The Museum of Modern Art, New York. Aristide Maillol Fund

Two approaches to the bottle: in neither case is it a container, a physically useful object, since both artists are craftsmen who do not care about utility. Boccioni dissects the bottle in a search for its hidden geometry. Vail projects his fantasies, so that the bottle becomes a fetish object.

Micronesian stool for grating coconuts, from the Mariana Islands. In the folk tradition of handcraft, the analysis of function and the fitting of form to material and mode of making take place very slowly, almost imperceptibly, and often result in a magnificent sense of rightness.

Eventually, in the manufacture of steam engines or watches, a degree of accuracy was developed which not only improved efficiency of operation but also would permit interchangeability of parts: the stock of spare parts we now take for granted, and the possibility of manufacturing parts in one place and assembling them in another. These developments, in turn, depended on uniform standards of measure—that is, agreement about the meaning of dimensions—something handcraftsmen did not have because they did not need it.

Specialization in mass production refers not only to workmen but also to machine tools. The ideal manufacturing machine is one designed to carry out a single operation or set of operations simultaneously on a particular product. And the ideal factory consists of a series of such machines connected to each other, all electronically guided by instructions from a computer which has been programmed by men.

The assembly line is the modern, dramatic manufacturing device which fully employs duplication, accuracy, interchangeability, and specialization in machines and, to some extent, in men. It is associated with Henry Ford, although Eli Whitney set up an assembly line system to manufacture guns in the late eighteenth century.

In the early twentieth century, however, the point came when Ford, and other manufacturers, could tolerate no hand fitting because it was associated with inaccuracy and waste of time—an attitude completely contrary to that prevailing in the handicrafts! Quality and numbers had to be sought by eliminating the possibility of human error.

Human error could be reduced or eliminated only by making the human contribution as remote as possible from the process of making.

The germ of the idea embodied in mass production might be summarized as follows: the quality of a product can be improved, its price lowered, and much larger numbers produced if component parts are made accurately with specialized tools operated by workmen who could not otherwise make the whole product.

Modern manufacturing operations fall into three distinct phases: plant layout and tooling, duplication of parts, and assembly of mechanically duplicated units. These phases follow decisions by management to manufacture a new product or model—decisions that are guided by many considerations, including capitalization, research, engineering, marketing, and design. It is difficult to generalize about the role of design in relation to research, engineering, and marketing since it varies with the type of industry and the size of a particular enterprise. However, it is obvious that design or redesign involves enormously costly retooling operations in the automobile industry, for example, and evidently is a crucial factor in any company's prosperity. The practice of building clay and wooden models following marketing and engineering specifications might more accurately be designated "styling" than designing. Styling can be defined as that type of design which changes the superficial appearance of a product, often in response to marketing pressures. The role of styling in product design and some of the ethical and aesthetic questions it raises will be discussed below (pp. 153–55).

THE EMERGENCE OF INDUSTRIAL DESIGN

One of the consequences of the Industrial Revolution in the eighteenth century might be called "the replacement of the human hand." Until that time, no important changes in manufacture had taken place since the Bronze Age; tools were more refined, but principles of operation remained the same. Then a series of inventions, largely in the English textile industry, began to supplant the hand. Tools inherited from the Neolithic age—the axe, the hammer, the spade, the knife, the awl—had been hand-operated, but the new machine tools were set in motion by impersonal forces: water, wind, steam. A long process of depersonalization in manufacture began, culminating in modern mass production and the widespread belief that machine products cannot be art objects.

The economic principle of preindustrial manufacture assumes that the craftsman applies his skill and imagination to raw materials which, when formed into a finished product, have more value than they had formerly. After the Industrial Revolution, the workman's contributoin ceased to be skill and imagination. He offered labor, which became a commodity like wool, leather, metal, or

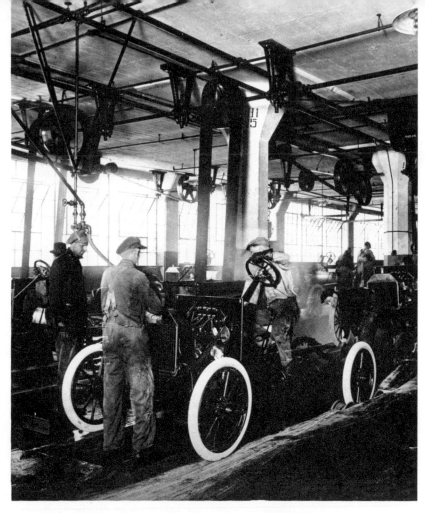

Ford Motor Company assembly line. Early 1900s

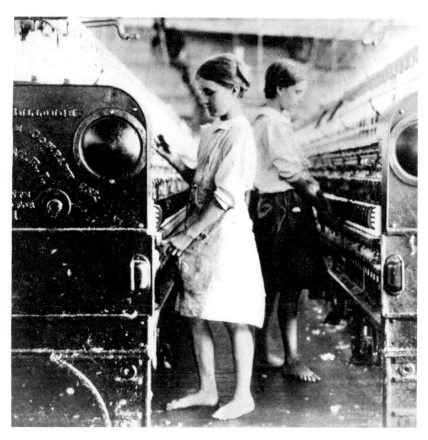

Child labor in a textile mill. 19th century

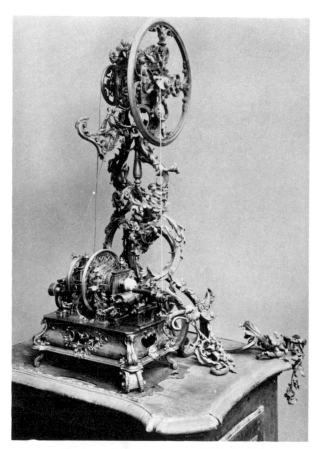

German Rose Engine. c. 1750. British Crown Copyright, Science Museum, London. How could the machine tool be humanized? By converting it into "art"—by covering all its exposed surfaces with ornament.

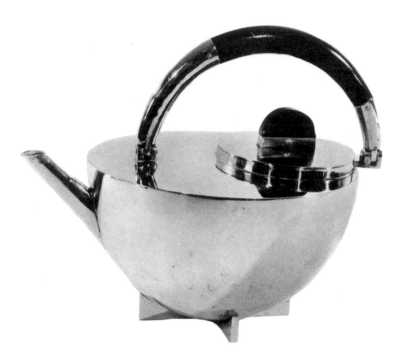

MARIANNE BRANDT. Teapot. 1924. The Museum of Modern Art, New York. Phyllis B. Lambert Fund

An ideological commitment to geometry and the machine is evident in the Bauhaus-inspired design of 1924. The contemporary craftsman John Prip, while the beneficiary of Bauhaus simplification of forms, feels free to express his feelings in organic terms as well.

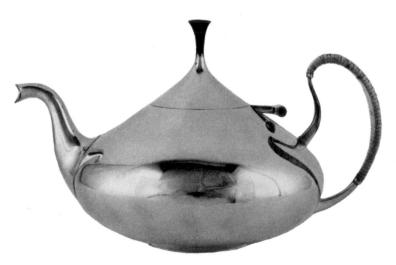

JOHN PRIP. Silver teapot. 1953. Museum of Contemporary Crafts, New York. Permanent Collection

wood. Machines integrated within the factory system accomplished the changes from raw material to finished product with results that were uniform and predictable. And so the craftsman ceased to be an important variable factor in production and instead became an anonymous constant factor.

The early social consequences of the Industrial Revolution were, from a human standpoint, disastrous. Human effort and skill having lost their unique value, work was turned into labor, a commodity. Women and children competed to sell their labor with steadily diminishing bargaining power; wages and living conditions were wretched. The machines which created more real wealth, and also more jobs, paradoxically brought poverty and lowered standards of living for those who tended them. Populations increased, and concentration into crowded urban industrial areas began—a concentration which survives to this day. But the hours of work were so long and the struggle to exist so critical that little energy remained for the workingman to cultivate leisure or to improve his natural capacities. Thus, the machine age, whose technological miracles revolutionized design and manufacture, brought in its wake poverty, degradation, overcrowded cities, ugly mass-produced objects, and the brutalization of human beings.

The sordidness of cities, the wretchedness of the working classes, and the deadly monotony of labor led to a romantic escapism in the arts, their divorcement from life's dismal reality. Sensitive people could not conceive of art as existing in a context which was so ruinous of human resources. And the early products of mechanization gave little contrary evidence. Since machine tools were not understood as having distinctive aesthetic possibilities, they were used to imitate handmade ornament, with results totally unsuited to the materials and processes used. Craft revivals were attempted in the nineteenth century, notably by William Morris, who was influenced by John Ruskin; but the artistic problems raised by machine mass production were not effectively faced until Walter Gropius established the Bauhaus in the twentieth century.

In 1890, the Belgian architect Henry van de Velde had proclaimed the engineer as the true architect of the times. Unlike architects, engineers were willing to break with older techniques and materials to serve contemporary needs with steel and reinforced concrete. They felt that mass production and the division of labor *could be made to serve quality*. Walter Gropius realized that the essential difference between craft and machine production was due not so much to the use of machine tools as to a basic difference in the *control* of the process of making: in one man in crafts but in a division of labor in industry. He had written a paper, "Industrial Prefabrication of Homes on a Unified Artistic Basis," which suggested the use of mass-production techniques for building and the pos-

sibility of achieving a high quality of product through large-scale industrial methods. The net result of these ideas was the opening of the Bauhaus at Weimar in 1919, with Gropius as its director. It was formed by the combination of a trade school with a school of fine arts. As an architect, Gropius shared with Morris a unified and comprehensive approach to the arts. It was an approach in diametrical opposition to that of "art for art's sake."

At first, each Bauhaus student had two teachers, one an artist and the other a master craftsman, because no individual instructors could be found who combined the appropriate qualities of both. It was necessary to produce students who had knowledge of and experience with the entire process of machine production and who could therefore provide manufacture with the integrated control which it lacked. Accordingly, the Bauhaus set about providing its students with a knowledge of science, economics, and craftsmanship as well as the fine-arts curriculum of drawing, composition, painting, sculpture, and art history. In this manner, industrial designers as we know them were first trained.

In 1925 the Bauhaus left the somewhat hostile atmosphere of Weimar and reestablished itself at Dessau, where a new faculty, now composed of Bauhaus graduates, combined the technician and artist in the same instructor. The school became an experimental workshop in which models for mass production were continually developed, revised, and improved. Some attempt was made to exploit the unique qualities of each type of machine; thus there was a beginning to the creation of a mechanical idiom or style, one which was distinctly different from handcraft forms and could make itself felt in furniture, pottery, textiles, typography, layout, and architecture. And, of particular importance, the invidious distinctions formerly made among the skills of painters, sculptors, craftsmen, and architects were substantially abandoned, since the new artists and designers might employ any or all of these skills in the process of creating an object.

The Bauhaus was driven out of Germany in 1933 when the Nazis came to power, and subsequently one of its younger instructors, László Moholy-Nagy, established an American branch, the Institute of Design in Chicago, where it was eventually absorbed into the Illinois Institute of Technology. By the time of World War II, it was plain that the Bauhaus had done more than create a new profession, industrial design; the Bauhaus had permanently influenced the education of artists throughout the world. Most courses in design today are largely derived from the famous Bauhaus foundation course, although it is a sign of successful assimilation that students and even their instructors may not be aware of the fact.

The Bauhaus *had* to emerge because conventional academies of art had become inadequate. They had begun as places to train artists and craftsmen who would produce the art objects required by a wealthy and elegant aristocracy. But academically trained artists began to lose contact with modern life as the social classes for which they produced art disappeared. The academies served to shut off talented students from the realities of industrial production by machines and from social reality itself, inculcating ideals and methods which were often obsolete as they were being taught. Consequently, their graduates usually were forced into the poverty, the romantic Bohemianism, and the economic irrelevance with which artists became identified after the democratic revolutions of Europe and America in the late eighteenth century.

Today, industrial designers, design consultants, package designers, and stylists are firmly established in the worlds of commerce and industry. Manufacturers either employ their own designers on a continuing basis or retain the services of design firms and free-lance consultants. Almost all professional art schools and many university art departments offer curricula leading to degrees in industrial design, organizing their instruction very much like schools of architecture. No article, from a can of soup to a locomotive, goes out into the world without the ministrations of a designer. Of course, the spectacular success of the profession may have been achieved, in some cases, for the wrong—that is, superficial—reasons. However, if the services of industrial design are sought primarily to stimulate sales, we cannot deny that a desirable side effect has been the visual improvement of a multitude of large and small objects in our environment. Beyond that, where the truly professional designer has been given free rein, visual improvement has been accompanied by the dividend of better performance.

Advertisement for Hanes Hosiery. 1968. "Form follows function"—a provocative demonstration of mutual adaptation between a container and its contents.

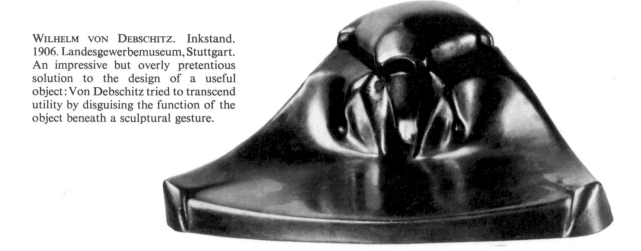

WILHELM VON DEBSCHITZ. Inkstand. 1906. Landesgewerbemuseum, Stuttgart. An impressive but overly pretentious solution to the design of a useful object: Von Debschitz tried to transcend utility by disguising the function of the object beneath a sculptural gesture.

FORM AND FUNCTION

It was Louis Sullivan (1856–1924), the Chicago architect and *lieber meister* of Wright, who originated the phrase "Form follows function." Applied to architecture or to manufactured objects, the phrase became an axiom, a first principle, for all modern design. It means that the outer shape and appearance of any designed object follows, or is a result of, its inner operation. From this postulate we can derive corollaries, as in plane geometry: the object should look like what it is and does; that is, there should be no deceptive appearance—metal should not imitate wood, plastic should not imitate marble, the small cottage should not imitate a palace or a castle. The design of buildings and useful objects before the modern period often began with the outer shell, the facade, and then proceeded to divide and arrange interior space. The essential problem had been to determine which period style to follow in building a library, a house, or a chair. Where the form of an object was functionally determined, ornament was applied to cover its nakedness, so to speak. Thus, architecture and design had become—especially in the late eighteenth and nineteenth centuries—increasingly decorative. Form did *not* follow function: it followed the prevailing taste in period styles and decorative ornament.

Industrial design, beginning with a body of liberating and idealistic axioms, was able to bring common sense and a distinctive excellence to machine-made objects. However, as the practice of industrial design evolved, it became subject to a variety of practically and aesthetically irrelevant pressures. Sophisticated and even misleading interpretations of form and function were invoked. Does "function" mean only the physical and utilitarian operation of an object? Is only one "form" possible in the correct solution to a design problem? Are alternative forms equally valid? Doesn't the appearance of an object also need to function by making the object appealing to consumers? If so, the form of an object is not merely the result of satisfying its internal operational requirements;

the form of a product and its outward appearance must enable it to compete commercially with similar products of other manufacturers.

Thus, we arrive at a type of design specialization, a child of industrial design—styling. Manufacturers discovered in the 1930s that the clean, functional lines of Bauhaus design stimulated sales. Hence, they employed industrial designers to redesign their traditionally styled merchandise. It was a simple step, then, to conclude that the periodic redesign of a product would increase its salability *whether or not* any significant changes in its physical functioning had taken place. In other words, redesign, or styling, created a new value for useful objects: new appearance. New appearance or novelty became for many products as important a factor in their salability as operational or utilitarian factors. A newly styled product had the effect of making older designs seem less valuable and out-of-date, although such products may have been no less useful to their owners. This cycle of design, redesign, and new styling of useful objects, leading to an apparent loss of value in older models of the product, has been called *planned obsolescence*.

Normally, we regard a useful object as obsolete if one of two conditions develops: (1) the product wears out, it no longer operates; or (2) the product operates, but a new model does the job better. When a new model of a product appears, newly styled or packaged, the consumer is led to believe that significant improvements in operation have been made. This may not, in fact, be the case, but consumers will discard the old and buy the new because novelty has become an important value in our culture. Furthermore, the quick obsolescence of useful objects has important economic implications. Industries need to use most of their productive capacity to keep their workers employed. They can operate profitably on less than full capacity for a time, but, obviously, unemployed workers cannot buy the automobiles, refrigerators, television sets, and other appliances produced by manufacturers if they are not earning wages. Hence, persuading the public to

use and discard goods more rapidly is vital to an expanding economy. For the same reason, the public is encouraged to buy *more than one* automobile, TV set, table service, or radio. We should own more than one home, keep a boat, build a ski lodge, take more vacations, and raise a second family when the first family has grown up. Without doubt, planned obsolescence has contributed to the steady raising of the American standard of living in the course of the general effort to use more of the productive capacity of industry.

However, our standard of living may be defined too exclusively in terms of the *number* of useful objects we own and the *frequency* with which we replace them. Durability, one of the chief traits of handcraft, becomes less prominent in machine production. We also increase each year the number of articles which are made to be used once and discarded. Package designers specialize in the creation of containers, most of which are disposable. Such package designs may be attractive from an aesthetic standpoint, yet their disposability somehow violates our emotional associations with art, which is expected to be

Automobile grilles. Courtesy *Design Quarterly* magazine. During the 1950s, American automobile designers embarked on a monumental "front-end" binge, which they followed, later in the decade, with a tailfin orgy. A true example of American Baroque, the phenomenon had an industrial father and a psychological mother: the manufacturer's need for exciting new salable packages mated with the stylist's need to express his stifled sculptural impulses.

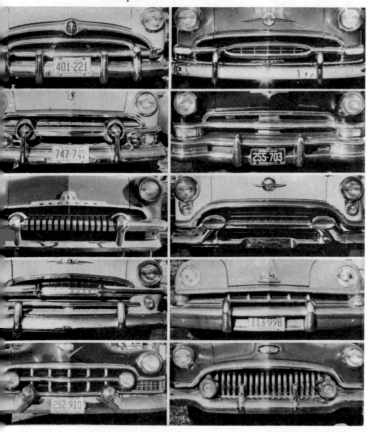

enduring. A country as rich in resources as the United States could afford, until recently, to employ its design skills in the creation of disposable packages and containers, while other societies, whether from cultural tradition or lack of resources, stressed reusable containers, durable products, and continuity of style. Today, planned obsolescence and disposability haunt us in the form of pollution and ruination of natural resources.

The industrial designer has been inescapably drawn into the world of economics and marketing. His training equips him to analyze the purpose and operation of a product and to find the best combination of form and materials to suit the product's function. His knowledge of production methods enables him to keep manufacturing costs to a minimum consistent with quality. He is trained to consider in his design the problems of packaging, shipment, and display of a product. Unfortunately, he is often obliged to fabricate a new "skin" for a product to create a deceptive appearance of uniqueness—to arrive at a result which is spuriously "different." Thus, we have come to a question which all artists, architects, and designers must ultimately answer: should a client be served with the solution which the designer deems best according to his professional standards, or does professionalism consist of finding the solution which best satisfies a client's marketing requirements? One could answer the question moralistically—in terms of designers who have integrity and those who do not. To be sure, the way a designer is employed affects the way he practices. It would appear that as commerce and industry grow more complex, the professions which serve them become more strongly and securely professionalized. The competitive forces which gave prominence to industrial design have inadvertently created the opportunity for ethical designers to survive and prosper. As design professionalism grows, we can expect an increasing number of designers and design firms to offer a quality and integrity of service such as one routinely expects from outstanding lawyers and surgeons.

INDUSTRIAL DESIGN: THE CHAIR

Until we sit on it, a chair is a work of abstract sculpture. It is also a complex engineering problem. The habit of sitting in chairs, which we take for granted in the Western world, is carried on in many positions, for different purposes, and with a wide variety of seating apparatus. We expect comfort, support, and stability from our seating equipment. And we should like to get into and out of a chair with a certain amount of dignity; but some chairs make acrobatic demands of middle-aged ladies and gentlemen. We want some chairs to be light and portable, others to be sturdy and resist abuse; some will be placed outdoors and must be weather-resistant. Generally, chairs should not be too bulky, for the contemporary home or apartment cannot afford to invest a great deal of space in

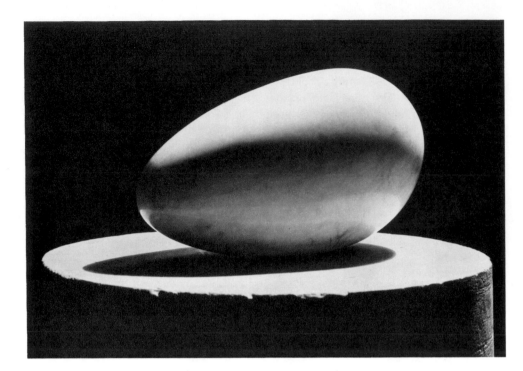

CONSTANTIN BRANCUSI. *Sculpture for the Blind.* 1924. Philadelphia Museum of Art. The Louise and Walter Arensberg Collection

The biomorphic perfection of the egg can be exploited at several design levels: it can yield practical dividends (the Aarnie chair); or it can be enlisted in the service of tactility (the Brancusi sculpture).

EERO AARNIE. Gyro Chair. c. 1965–66. Distributed by Stendig, Inc., New York

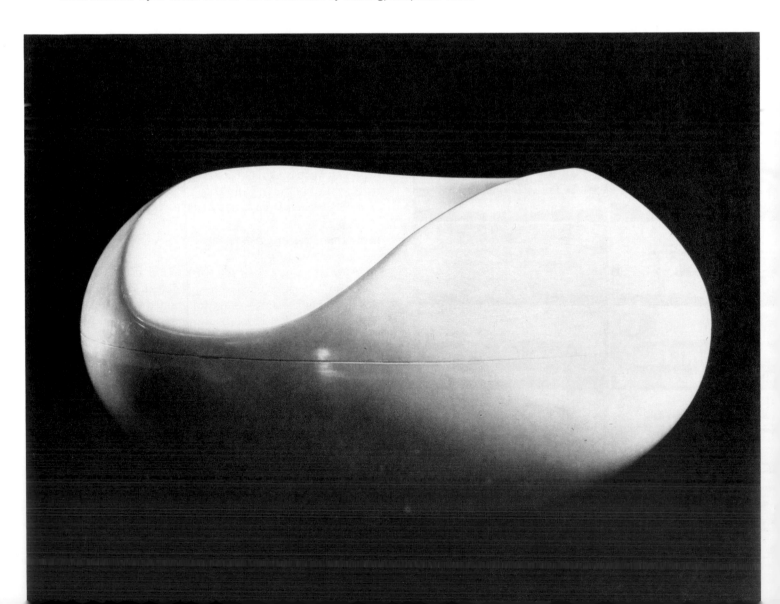

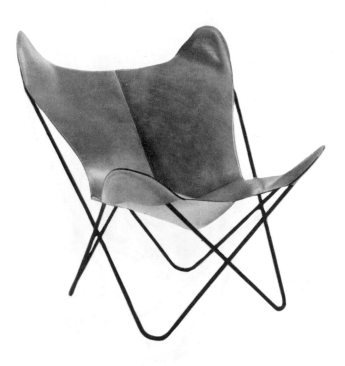

a chair which approaches the problem of comfort by assembling mattresses. As sculpture, chairs possess symbolic value: they designate the seat of a ruler, the throne of a king or bishop, or the inviolable perch on which the master of the house dines, reads his paper, or watches television. Chairs are feminine or masculine, juvenile or adult, alert or lazy, shy or assertive, austere or frivolous. To a crawling child or a kitten, the chairs in a room constitute a forest of legs. To a mother of small children, chairs may represent a series of nonwashable surfaces in which margarine and jam become too easily embedded.

A total design philosophy is revealed by a chair. The attitude of the designer toward comfort, toward the chair as architecture or decoration, toward exposure or concealment of the structural elements can be clearly expressed. For example, the famous Barcelona lounge chair by Mies van der Rohe is an eloquent demonstration of his architectural philosophy and style: less is more; simplicity of materials and form; careful attention to details ("God is in the details"), especially at intersections; absence of ornament; and elegance of proportion and scale. Technological innovation is also brilliantly in evidence. The cantilever principle (see pp. 560–62) is used in conjunction with the elasticity of metal. The same continuous metal bar serves as curved leg and back support while functioning visually in counterpoint to the metal element it crosses. Finally, the tufted leather cushions offer bulk, warmth, and color in contrast to the thin and

precise metal members. The spacing of the tufts and the webbing, visible at the front end of the seat, create rhythm and pattern through their repetitions so that a certain amount of visual variety and textural change can balance an otherwise austere effect. The chair is unquestionably a masterpiece, likely to endure as an active classic for many years to come. It is all the more remarkable when we consider its date, 1929, and the fact that interiors designed today still specify the Barcelona lounge chair.

The earlier armchair (1926) by Mies is interesting more as a revelation of the designer's thinking than as a completely successful work of art. The cantilever principle is again employed, along with continuity of structural elements—from back to seat to base. The armrest helps to strengthen the back support, but its joint at the base is not too satisfactorily accomplished. The chair is obviously influenced by the bentwood Thonet rocker of 1860, with polished metal tubing employed for its elastic properties as was the bentwood formerly. But the Barcelona chair is a more original and distinguished solution to the problem.

Marcel Breuer's tubular-steel-and-canvas chair of 1925 illustrates an early use of polished metal in furniture. The innovation provides great strength and stability with a minimum of weight and bulk. The result is a strong chair which is nevertheless portable, visually open, and harmoniously attuned to modern developments in steel-frame architecture and machine technology. Unlike the later Miesian chairs, there is a distinct separation between the supporting structure (two connected metal rectangles) and the seating itself. The seat is hung or suspended from the arms; *it is not in compression.* One sits on and rests

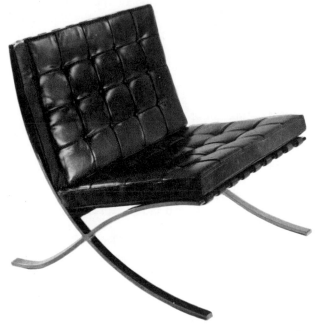

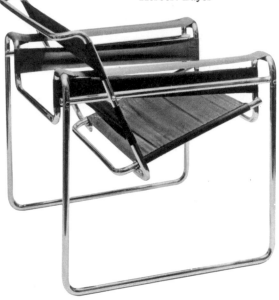

MARCEL BREUER. Armchair. 1925. The Museum of Modern Art, New York. Gift of Herbert Bayer

GEBRÜDER THONET. Rocking chair. 1860. The Museum of Modern Art, New York. Gift of Café Nicholson

against canvas which is stretched between metal-tube frames. Thus the suspension principle is used twice: in the framing and in the textile seating. Notice how Mies and Breuer arrive at design solutions by exploiting the inherent properties of materials: the relative resistance of canvas to stretching; the resistance of metal tubing to bending; the capacity of flat metal bars to bend and recover their original position—in short, their elasticity.

The painted wood armchair by Gerrit Rietveld, a Dutch designer, was made in 1917 as an experimental project. It is mainly interesting as a demonstration of the influence of painting upon utilitarian design. Here the rectilinear bias of Mondrian's work is clearly visible. We cannot say there is any innovation in structure or material, with the possible exception of the almost unsupported, almost cantilevered arms. Structurally, it is a compression-type of chair, built on post-and-lintel principles (see pp. 557–60). The chief effect sought is one of hovering planes, open structure, and avoidance of curves. Clearly, this project is designed to function primarily in visual terms, since it is the result neither of physiological analysis of sitting nor of structural analysis of materials. It is important as a reaction to the curvilinear extravagances of Art Nouveau, especially as seen in the furniture of Hector Guimard. Wright also reacted against Art Nouveau, as in the 1904 office chair of metal and oak for his Larkin Building in Buffalo. The curved and shaped seat and the slight tilt of the backrest represent an unusual concession on the part of Wright to the generally convex shape of the body, while the visual effect is somewhat more open than is usual in Wright's furniture, which would not be out of place in a Norman keep.

LUDWIG MIES VAN DER ROHE. Armchair. 1926. The Museum of Modern Art, New York. Gift of Edgar Kaufmann, Jr.

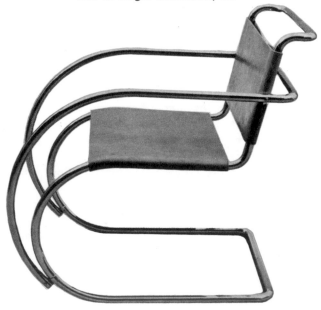

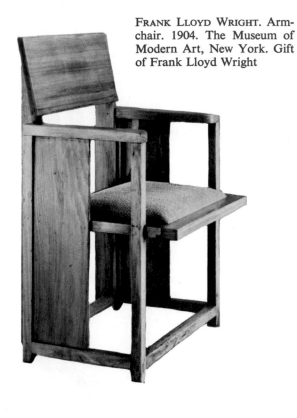

FRANK LLOYD WRIGHT. Armchair. 1904. The Museum of Modern Art, New York. Gift of Frank Lloyd Wright

FRANK LLOYD WRIGHT. Office armchair on swivel base. 1904. The Museum of Modern Art, New York. Gift of Edgar Kaufmann, Jr.

GERRIT REITVELD. Armchair. 1917. The Museum of Modern Art, New York. Gift of Philip Johnson

HECTOR GUIMARD. Side table. c. 1908. The Museum of Modern Art, New York. Gift of Mme Hector Guimard

The 1929 armchair by Le Corbusier shows some debt to the similar type by Breuer in 1925, although it contains a few refinements and structural changes. He has abandoned the side rectangular support and reverted to four straight legs, with the front pair ingeniously connected to the back pair through the seat and arms. While the sitter's weight rests on the canvas, it is less clear that the seat frame is suspended. It appears to be conventionally supported in compression at the front. But the back and rear portion of the seat may represent a better suspension design than Breuer's. Le Corbusier's adjustable chaise longue of 1927 is more original, more reminiscent of his architectural use of pilotis. The wooden base lifts the seating structure off the ground and possesses some quality of organic form in contrast to the mechanistic, tubular-steel frame. The separate seating and supporting structures permit a variety of reclining positions without the mechanical equipment we use in contemporary adjustable chairs which are less honest in the expression of their function. Furthermore, Le Corbusier has arrived at a comfortable position for the recliner—similar to that afforded by today's "tilt-back" lounge chairs, yet without bulky upholstery and concealed working parts.

Another classic armchair is by the Finnish architect Alvar Aalto. His bent plywood chair of 1934 carries out in wood the principles explored earlier by Breuer, Mies, and Le Corbusier in metal. Wood is a congenial material to the Scandinavians, and it imparts a warmth which polished, chrome-plated steel may lack. This chair, too, has a clear separation between the structure which supports and the structure which is supported. However, the single continuous bent plane of the seat does not possess the resilience of canvas or the suggestion of comfort and luxury of leather or conventional upholstery. The chair is notable for its clear statement of function, obvious stability, and its exploitation of the elasticity of wood in the seating. The curved and bent plane of the seat actually forms a modified coil spring at the front and rear points where it is anchored to the frame; thus the seat will give

Le Corbusier. Armchair with adjustable back. 1929. The Museum of Modern Art, New York. Gift of Thonet Industries, Inc.

Wendell Castle. Oak-and-leather chair. 1963. Castle is a contemporary craftsman who chooses to develop the sculptural possibilities of the Thonet furniture of the 1860s, the Art Nouveau swirls of the early 1900s, and the tubular-metal constructions of the 1920s.

Le Corbusier. Chaise longue. 1927. The Museum of Modern Art, New York. Gift of Thonet Industries, Inc.

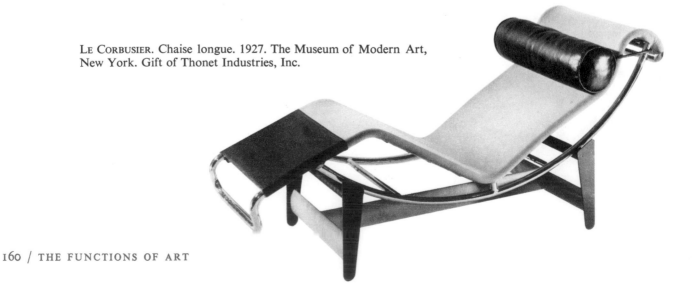

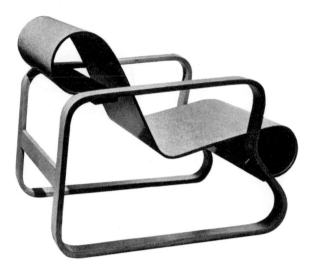

ALVAR AALTO. Lounge chair. 1934. The Museum of Modern Art, New York. Gift of Edgar Kaufmann, Jr.

BRUNO MATHSSON. Armchair. 1940. The Museum of Modern Art, New York. Edgar Kaufmann, Jr., Fund

CHARLES EAMES. Chaise longue. 1970. Designed for Herman Miller, Inc., New York

to the weight of the sitter. Although rather bulky (there is too much wasted volume inside the frame), the seating structure represented perhaps the best solution that could be achieved in 1934 with bent plywood, as opposed to modern "molded" plywood.

Bruno Mathsson used laminated plywood and fiber webbing in a 1940 armchair which requires much less floor space than Aalto's chair and yet provides equivalent opportunity to recline. The webbing has more resilience than bent plywood, of course, and also affords textural relief. By the shape and location of the seat, Mathsson is able to establish a low center of gravity well within the chair base; hence the seat back can extend well behind the base, unsupported, and without fear of tip-over. The curve in the seat, then, is not merely visual play or the result of conformation to the human posterior. It locates the weight of the sitter in the place where it will add to the stability of the chair.

The molded-walnut-plywood chair with metal-rod frame by Charles Eames dates from 1946 and has become an American, even a worldwide, classic. Molded-plywood technology was substantially perfected during World War II: British De Havilland bombers were made of this material. And Eames has solved the problem of making wood comfortable by (1) imparting to the plane a complex, biomorphic shape; (2) permitting the sitter to change position easily; (3) using open space at the lumbar base of the back to free rather than restrict the sitter; (4) providing support for the back exactly where it is needed; and (5) creating a brilliant system of articulation among the seating elements. Thus, while the elasticity of metal and wood are exploited, a small rubber cushion between the backrest and its metal support permits further independent lateral movement without strain to the structure. Also, the seat is anchored firmly to the front legs just behind the knees, while the rubber pad farther back beneath the seat permits it to give and to rotate slightly in

The 1970 chaise by Charles Eames builds on Le Corbusier's architectural solution to the reclining chair (1927). But Eames has new materials to work with: foam-rubber cushions, zippered pillows, and a cast-aluminum frame covered with dark nylon.

response to the weight and movement of the sitter. As a result, a remarkable amount of comfort is achieved in a mass-produced chair which is light, inexpensive, easily stored, and very durable. As the legs are splayed, the chair increases in stability when it supports weight. The sitter feels he is very securely connected to the chair and is able to maintain an excellent posture while seated and as he gets in or out of the sitting position.

A recent development in furniture design is seen in the armchair by Eero Saarinen. The cast-aluminum pedestal base represents an effort to avoid the forest-of-legs effect created in any furniture-filled room. And the molded plastic seat affords the maximum of continuity among the structural elements. The plastic material, reinforced with Fiberglas, permits the entire shell to perform a load-bearing function at the same time that a sculptural, biomorphic form is achieved. The fabric seat pad could be eliminated if desired, but it helps to add a note of textural and color variety. Such pedestal bases have hitherto been used in commercial settings, as bases for restaurant tables and ice-cream-counter stools. In addition to good stability, they offer room for one's feet, eliminating the uncomfortable leg straddling we must often endure around a dining table. Although this chair and coordinated furniture dates from 1958, it has not had a huge reception from consumers, despite its practical advantages. Three-legged chairs have not done well either. Perhaps the zoomorphic associations of four-legged chairs remain too precious, as yet, to be surrendered.

Charles Eames has designed a modified pedestal-based lounge chair (1958) which has legs and thus avoids the comparisons with a dental chair which a molded-plastic pedestal might suggest. The anodyzed-aluminum frame has a thick-and-thin sculptural shape which overcomes

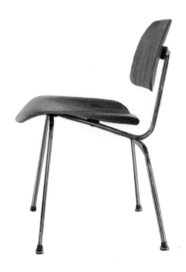

CHARLES EAMES. Dining chair. 1946. The Museum of Modern Art, New York. Gift of Herman Miller Furniture Company

many of the objections the public had to the tubular-steel-frame furniture of the Bauhaus designers in the 1920s. And the flexible plastic seat and back offer a rich and comfortable textural contrast to the polished metal. The chair is an exciting solution to the problem of carrying the sitter's weight down to the floor. At first, the sitter is suspended on the plastic within the metal frame. Then his entire weight is clearly received at two points and transferred to, and concentrated in, the post of the pedestal, from whence it is distributed among the legs. Very rarely do we see a structural function carried out with such clarity and precision. A similar visual effect occurs when we see the huge weight of a bridge truss concentrated at one small pivot on top of the pier which carries the load to earth. This dramatization of the load-transferring function, as carried out by Eames, is very satisfying: an unusual visual gratification is generated as we can almost see the weight traveling to points where it is collected, concentrated into a core, distributed to the legs, and then safely dispersed. In the connection between the

HANS WEGNER. Armchair. 1949. The Museum of Modern Art, New York. Gift of Georg Jensen

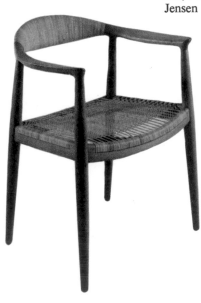

FINN JUHL. Leather-and-teak armchair. 1949

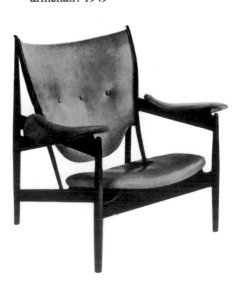

EERO SAARINEN. Armchair. 1957. The Museum of Modern Art, New York. Gift of Knoll Associates, Inc.

seat and base, there is a remote analogy to a waiter supporting a tray, its weight carried down via his upturned fingers and thumb, through his wrist, and into his arm. Such design is deceptively simple; in fact, the chair is a very sophisticated work: it clearly demonstrates that the materials and techniques of the machine age have arrived at the condition of art.

The Scandinavian approach to the chair has been structurally correct but conservative, and very single-minded in its pursuit of simplified sculptural form. The handcraft tradition there is strong, and hand-formed wood is the admired structural material, together with fabric or leather as a covering. Conventionally sprung upholstery and thick slabs of foam rubber would amount to an admission of failure to the Scandinavian designer. He has studied the anatomy of sitting carefully, shapes his oak, birch, teak, or rosewood lovingly and with precision, and requires only a thin, coarse-textured fabric pad to achieve the firm seating comfort he wants. The famous Hans Wegner dining chair of 1949 in oak and cane is another international classic. Wegner, a Dane, is noted for his careful attention to the arm- and backrests, to the felicitous matching and flow of wood grains, and to the tactile appeal of his wood surfaces. Another Danish designer, Finn Juhl, exhibits a strong sculptural impulse in his chairs, with a beautiful separation between the bearing and the borne elements. The two rear legs receive the weight at the elbow of the armrest and use this function as an opportunity to create visual interest in the play of negative shapes—that is, air spaces—in the openings between the wooden members and the curved plane of the chair back. The form language of Finn Juhl's chairs belongs more to the craft tradition (with a strong influence from modern abstract sculpture) than to the ma-

chine. A leather-and-teak chair (1949) by Juhl is somewhat more flamboyant and zoomorphic and also reveals the two pronounced tendencies of this designer: clear separation of support*ing* and support*ed* elements and a sculptural attention to the play of negative shapes.

A dramatic and unconventional Danish chair is seen in the oak-and-leather armchair (1950) by Borge Mogensen. The wood framing has an aggressively rustic quality, enhanced by wide leather straps and buckles. The unsupported, upward-tilted arms counterbalance the massive, earthbound triangular support and rearward tilt of the back. The seat element seems to derive from a ladder. In a chair of this sort, the designer has found an almost theatrical solution to the structural problem, but one which is completely honest nevertheless.

I have not examined several varieties of collapsible chairs and stacking stools, nor have I explored thoroughly many interesting new combinations of wood, metal, plastic, fabric, and leather. In general, it is surprising how many of the genuinely original new ideas in chair design go back to the Bauhaus and, more recently, to Eames. Further developments have been essentially refinements based on improved production methods and more sophisticated technology. The great Scandinavians like Mathsson, Ekselius, Wegner, Juhl, and Klimt have grown out of their own folkcraft tradition and, while aware of the Bauhaus philosophy, have been more attracted by the sensuousness of their materials than by a primarily cere-

right:
BORGE MOGENSEN. Oak-and-leather armchair. 1950. Collection Cabinetmaker Erhard Rasmussen, Copenhagen

FINN JUHL. Teak armchair. 1945

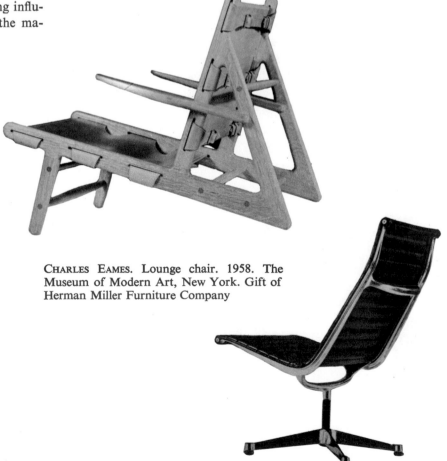

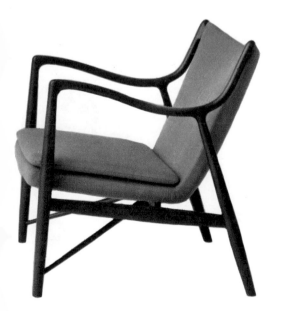

CHARLES EAMES. Lounge chair. 1958. The Museum of Modern Art, New York. Gift of Herman Miller Furniture Company

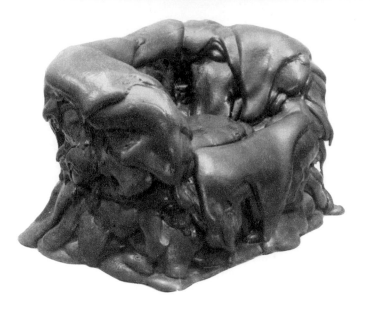

GUNNAR AAGAARD ANDERSON. Armchair. 1964. The Museum of Modern Art, New York. Gift of the designer. Ostensibly, this chair of poured urethane plastic represents the creative marriage of art and technology. But the object makes no real contribution to chair design: it functions chiefly as a fascinating demonstration of liquid tactility.

rials like chrome-steel tubing, plastic coverings, and cast-aluminum pedestal bases were introduced for domestic use and were by no means inexpensive. Still, a mass market and lowered unit cost are ideas built into the philosophy of modern product design. Expensive new designs are eventually "adapted," "styled," and brought to a large public at lower cost. In the United States, Charles Eames, George Nelson, Henry Dreyfuss, Russel Wright, and Raymond Loewy, among others, have brought design of good quality to American consumers at reasonable prices. Ironically, American manufacturers were better able to apply the design philosophy of the Bauhaus than the manufacturers of Europe, where capitalism, in general, has been less creative, more tradition-bound, and, until the Common Market, adjusted mainly to the requirements of national markets.

Today an enormous world market for good design has emerged. Production facilities are very widely dispersed, since they are no longer dependent on local water power and coal resources to the extent they were in the nineteenth century. Population increases imply that manufactured products do not need to be transported long distances to reach a good market. People in what were remote places are increasingly informed about new developments in consumer goods and have acquired appetites for quality in product design. We are entering an era in which the ownership of vast natural resources and elaborate production facilities will not be the exclusive basis of national eminence. Inexpensive atomic power will permit production to be carried on virtually anywhere. The tools of production will, no doubt, be radically transformed, many of them miniaturized, computerized, and electronically linked. In this not too distant future, design will be a crucial element for the capture and retention of markets, the conservation of raw materials, the discovery and satisfaction of subtle and evanescent human requirements, and the employment of men's energies and imagination to make beauty and utility synonymous.

bral approach to form and structure. Alvar Aalto, the Finnish architect, has been something of an exception among the Scandinavians, who, while maintaining their craft tradition, are now moving in more international directions, employing mechanically formed glass, polished metal, and plastics, and attacking the problems of mass-produced, inexpensive furniture, lighting, rugs, and tableware.

Where sturdy, inexpensive, easily stacked and transported seating has been required, especially for public uses, designers have been drawn to molded- and stamped-plastic forms with tubular- or rod-metal legs and supporting elements. Naturally, when cost is a factor, comfort tends to be pursued with molded plastics rather than with more expensive and destructible leather or fabric coverings. But it is interesting to observe that austere new mate-

OLIVIER MOURGUE. Chairs. 1965. The influence of painters Arp and Miro on contemporary French furniture design.

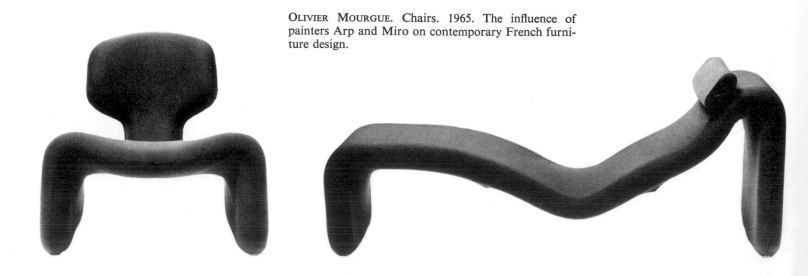

The Modern Chair As You Find It

(adapted from *Everyday Art Quarterly*, No. 20. Courtesy Walker Art Center, Minneapolis)

C O S T			
THE MATERIALS AND METHODS OF MANUFACTURE	THE DISTRIBUTION SYSTEM	CONSUMER NEEDS	THE DESIGNER
The size of manufacturing plants (most furniture factories are small) Manufacturers' prejudices and vested interests, as well as their insight Technical development and experimentation (the industry is not well organized for this) Wars, forest fires, taxes, and other natural and unnatural phenomena	A demand by retailers for "selling points" instead of problem solving, resulting in competing models rather than perfection of types A decorator's nightmare: a client who might like a chair indefinitely because it is well designed Retailer's conception of "what will sell" (this gets behind the times like anything else)	Convenience for: moving, cleaning, renovating, shipping, storing Economy in: initial investment, upkeep Comfort of: size, shape, proportion, resilience Durability to withstand: pets, time, children, shipping, back-tippers, elements Adaptability for: purpose, appearance, comfort	The designer's expressive needs —his whims, fantasies, and phobias The idiom of the times, or the character of contemporary human expression Painters: Miró, Mondrian, Arp Sculptors: Moore, Noguchi, Calder Architects: Breuer, Mies van der Rohe, Saarinen Schools and museums Critics and competitions

PART TWO

THE STYLES OF ART

INTRODUCTION TO *The Styles of Art*

THE CONCEPT OF STYLE IS INDISPENSABLE for the study of art, and yet it can be a source of confusion because the word has so many different meanings. Sometimes, style refers to the work of a particular historical period. It may refer to the art of a nation or several nations, or to the art of a region within a country. The growth and development of a single artist's way of working is often called "the evolution of his style." In addition, style can be a certain technical approach to the creation of art. The word "style" is also used as a term of approval, as recognition of a high level of accomplishment. In connection with the design of clothing or the changing appearance of appliances, "style" is equivalent to the latest fad or fashion. All the uses of the word and the concept, however, seem to have a single purpose—the classification or arrangement of a variety of seemingly unrelated works of art into categories which will make them easier to study, talk about, and understand. At the broadest and most general level, therefore, an art style is a grouping or classification of works of art (by time, region, appearance, technique, subject matter, and so on) which makes further study and analysis possible.

As with all scientific classification, the sorting of phenomena into categories is based on traits or qualities which the phenomena have in common. Styles of art, therefore, can be thought of as families. Just as members of a family have certain traits or features which give them what is called a "family resemblance," works of art can also resemble each other. They may have many differences, too, but they have at least *some* common traits which are discernible and hence make classification in a family or style possible. That common, uniting element may be directly visible in a particular use of color, shape, space, line, or texture; or it may be detected in a qualitative relationship among these elements. In other words, style may be discerned not only in what is visible on the surface of a work of art but also in the overall feeling or quality the work seems to express. This overall, or *pervasive*, quality of a work of art frequently constitutes the basis for its classification within a certain style. But it is not very helpful for students of art if the so-called style qualities are merely identified and classified. We need to know what traits or features of the work help to place it within a style. In other words, we must try to *explain* the

connection between the work and the style quality it seems to possess.

The reasons, then, for studying the styles of art might be summarized as follows:

(1) To acquire useful categories for thinking and talking about the common traits of works of art produced during various periods.

(2) To understand an artist, a period in history, a country, or a region in whose art a certain style seems to predominate.

(3) To compare intelligently (perhaps to judge) works of art which are stylistically related.

(4) To gain some idea of the connection between an artist's manner of working, the visible results, and our reactions to his work as a whole.

After we have some understanding of art styles, we are in a better position to read the so-called hidden language of art. An interest in style leads us to look for meanings beneath the subject matter and apparent purpose of a work of art. Just as handwriting, for the trained observer, conveys meanings which are not contained in the words themselves, a knowledge of style reveals much about an artist's way of thinking, about his environment, and about the society and culture in which his work is rooted. Archaeologists use the concept of style to help reconstruct past cultures on the basis of fragments of useful objects they discover. They put pieces of stylistic evidence together like a mosaic, to form an intelligible idea of the culture or civilization as a whole. Similarly, we study the styles of art—both past and present—as evidence for assembling in our own minds an idea of the changing condition of man. We are, in a sense, archaeologists of the artistic image of humanity.

At the present time, art is being created in many styles at once throughout the world. In previous epochs some variation existed, but there was less stylistic variety in any single place and hence less confusion for any given public about the purposes of art, the standards of artists, or the greatness or mediocrity of individual works. But modern styles vary greatly and change rapidly, and it is difficult to see in contemporary art the type of stylistic unity which persisted for long periods during the past. Therefore, instead of searching for a single common denominator for the art of our time, it might be better to describe the principal stylistic tendencies which appear to be operating simultaneously today. These tendencies can be seen as modern versions of styles which have persisted through the entire history of art. Fortunately, modern developments in the social sciences and the humanities permit an analysis of style based on our growing knowledge of the interactions among human behavior, personality, and artistic creation. As a result, we have better conceptual tools for the treatment of the diversity of modern styles than were available in the eighteenth century when this subject first began to be studied systematically.

STYLISTIC CHANGE

Although several art styles may coexist, especially in modern, complex cultures, there are periods of long or short duration when a single style predominates. But every dominant style is succeeded by another, and in recent years, styles (or stylistic fashions) have succeeded each other with increasing rapidity. For example, of all the styles described in art history, only the folk or peasant styles seem to persist regardless of cultural change—a phenomenon which is probably due to the isolation of folk culture, an isolation that can be traced back, in some cases, to Neolithic times. Today, however, it is difficult for any social group to be completely detached from the main currents of world culture, and consequently folk and peasant art is disappearing. This disappearance calls attention to the dynamic and transient character of artistic styles in the mainstream cultures. What accounts for stylistic change? Is it caused by changes in the way artists respond to social, economic, and class influences? Or do artists themselves initiate stylistic innovations which catch fire, so to speak, and grow into artistic conflagrations that eventually burn themselves out?

Scholarly answers to these questions tend to differ according to the discipline of the observer. Critics and art historians tend to attribute stylistic change to the creative inventions of particular artists or particular groups of artists working in well-defined times and places. The artist is someone who generates new ways of beholding—ways that subsequently enter the worlds of work, pleasure, commerce, property, and power. The critic's examination of specific works of art often permits him to identify with precision the works in which a new (and subsequently important) style feature originally appeared. Behavioral scientists, on the other hand, tend to attribute stylistic change to shifts in the way political, economic, religious, and ideological factors operate on the act of artistic creation. In other words, they see the artist as one who reacts more than he innovates, who, when he thinks he is innovating, is in fact reacting to extra-artistic qualities of his time and place—qualities or forces that are either so subtle, or so powerful and ubiquitous, that he is unaware of their existence as influences on his work.

Can the morbid qualities in Edvard Munch's painting be attributed to the long Scandinavian winters; or to the character of Protestantism in Norway; or to Munch's bachelorhood, bouts of alcoholism, and neurotic spells? In other words, should we seek a geographic, political, religious, technical, psychological, or even a medical ex-

planation of his style? If we choose a social or political explanation, then it follows that social and political changes account for stylistic change. If we choose a technical explanation, then such factors as innovation in pictorial composition, or the exploitation of new artistic materials, account for stylistic change.

The problem of stylistic change can often be solved with ease in the case of a specific artist. We can say, on the basis of what we know about him, whether shifts in his style were caused by shifts in social conditions, the evolution of his personality, his loss or gain of wealth and property, transformations in prevailing political and economic institutions, or by combinations of these. Indeed, a sound artistic biography may succeed in assigning a precise weight to each of these factors in an artist's total production as well as in particular works. But when an entire group or a generation of artists seems to move in an identifiable direction at about the same time, it is more difficult to ascertain the factors that have influenced all of them. Certainly we hesitate to use the word "cause" in connection with an extensive style movement. Yet, insofar as we feel obliged to discuss human behavior systematically, we often feel justified in using terms very much like "cause" to describe conditions antecedent to clearly visible, collective changes in the way artists work.

But why try to account for stylistic change among groups or generations of artists? Because we suspect that large-scale changes in art may portend changes in the general character of existence. Perhaps a style that many artists adopt at approximately the same time represents a type of adaptation to change by the entire social organism. In other words, artists may serve as society's antennae. Or artists may be even more influential: perhaps they *generate* rather than anticipate significant changes in the way people feel and know the world. During a time when a creative personality such as Picasso is the object of cult worship, it is possible that artists are perceived as the ship's rudder rather than its radar.

No matter how we account for stylistic change, however, and no matter how we relate it to civilized processes in general, we feel confident that we can recognize the emergence of new styles and the decline of old ones. Styles almost appear to possess living, organic traits; indeed, we speak of them in terms analogous to biological life cycles—the budding, blooming, and wilting of flowers; the childhood, adolescence, maturity, old age, and death of a person; or the regular changes in the weather following the succession of the seasons. To be sure, these analogies are inexact if not misleading. Still, they call attention to a phenomenon we are aware of in all human affairs, not only art, and therefore seem to hold a secret about fundamental human mysteries. When styles change, whole societies react as if they were early men witnessing climatic changes following the advance or retreat of a polar glacier. Clearly, style is an enormously potent symbol for civilized man. It replaces weather, the migrations of game, and the condition of animal entrails as a sign of impending change. Hence, we study style a little in the spirit of those ancient Roman augurs who counted the flights of birds or examined the organs of animals in order to guess what might happen in the world and in the lives of men.

THE STYLE OF OBJECTIVE ACCURACY

The style of objective accuracy pertains mainly to painting, drawing, and sculpture since these are the arts which often have a close connection with the imitation of visual phenomena. This is the style of art which is familiar to most people, whether they have studied art or not. It is also the style which many feel most confident in judging, since they can compare a painting or sculpture with what they believe is its original model in life. For many persons, accuracy, or closeness of resemblance to what is represented in life, is the principal means of determining the excellence of a work of art.

Other words, such as "realism" or "naturalism," are loosely used to designate the style of objective accuracy. Faithfulness to what is seen is a principal feature of this style, and since most of us have good vision, we feel we can judge an artist's fidelity to his model, or his skill in creating the *illusion* of reality. To create the *illusion* of reality, some artists painstakingly reproduce every visual detail of a model on the assumption that a convincingly real or accurate work is the sum of carefully observed and executed parts. Sometimes this kind of artistic approach is called "photographic realism." Of course, the invention of photography in the nineteenth century (and its continued perfection in the twentieth century) has made the style of photographic realism almost obsolete. The masters of the past knew how to create the *illusion* of reality without trying to reproduce everything the eye can see. And most artists today see no reason to compete with the camera in the pursuit of realism. Hence, the problem of many contemporary artists is to create the impression of reality through a selective use of the many available visual facts. Clearly, this artistic approach requires more than good eyesight in order to be successful. The simplification or the editing of nature, while creating the illusion of the *presence* of nature, calls for considerable judgment and skill in execution. Also, through his selection of certain details of visual reality and his omission of others, the artist can express his feelings about reality—which the viewer is encouraged to share.

In this chapter we shall discuss the varieties of expression which are possible within the style of objective accuracy. We shall mention some of the ways in which artists create the sense of reality without actually reproducing all the details of an object or place. Also, we shall

speculate about why some artists prefer accuracy of representation, or the illusion of the presence of nature, instead of abstraction or distortion of what the eye sees.

The student of art should learn that, although the style of objective accuracy has been in decline during the modern period, it is nevertheless a powerful means for the expression of ideas and feelings. Our problem is to learn how to distinguish between those works in which the artist slavishly imitates the details of visual reality and those in which he uses objective accuracy to imply much more than is seen. In our effort to investigate this problem, we shall examine the work of traditional and contemporary artists who create images that are very recognizable in terms of reality but who succeed in using visual facts to convey meanings beyond the visible.

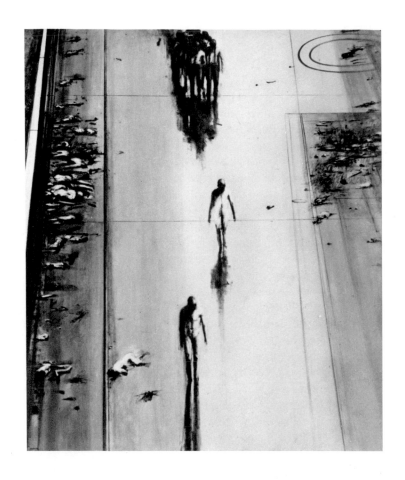

SIDNEY GOODMAN. *The Walk.* 1963. Collection Dr. and Mrs. Abraham Melamed, Milwaukee. A truthful visual account can generate its own peculiar sense of mystery. The strange angle of vision unnerves the viewer and leaves him open to any number of dark suggestions.

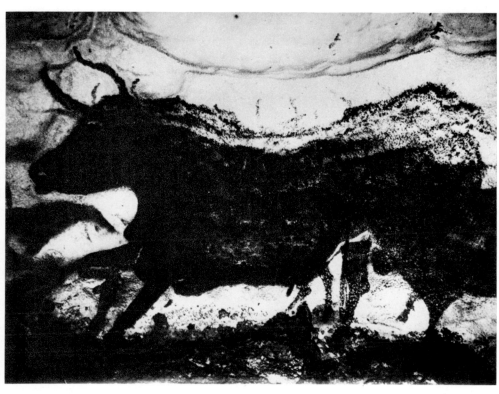

Black Bull (detail of a cave painting). c. 15,000–10,000 B.C. Lascaux (Dordogne), France

The Imitation of Appearances

Why does a painting or sculpture which looks convincingly like its model in reality fascinate us? Why do artists—modern and traditional, attempt to imitate what the eye can see or what the camera might record? These questions are fundamental, since almost everyone assumes that the accurate representation of reality is the basis of art—even art which is subsequently distorted or carried to a degree of abstraction where the original point of departure cannot be visually detected. Also, it is true that the earliest known art, the cave painting and engraving of Paleolithic man, is highly representational, beautifully accurate. Children, too, at a fairly early stage of their development, endeavor to represent real objects accurately, although they do not succeed from an adult standpoint. But when they are very young, children are not bothered by the requirements of visual logic as adults are; as they grow older, however, children *do* attempt to imitate the appearance of things as accurately as possible. Imitation for them is part of the process of coming to terms with the world in which they must live.

It is very likely that imitating the appearance of reality represents an effort to control reality. At very deep levels of awareness, our desire to paint a head, for example, so that it appears alive and capable of speech, is part of an effort to develop mastery over life. Drawing an object over and over again creates confidence in our ability to control it. Perhaps we think we are less likely to be vic-

tims of the seemingly capricious events of a world we do not understand if we can create images which are accurate and faithful enough to take the place of those portions of the world we must deal with.

For the artist, accurate drawing, painting, modeling, and carving are part of his repertory of skills, part of his development of craftsmanship, part of his training in learning to see and represent with fidelity, in the materials he has chosen, the objects of his vision. It is usually through drawing from reality—from the living figure, from nature, and from objects in the man-made world—that artists gain confidence in their powers of observation. It is also through drawing from reality that they often acquire ideas which can later be transformed into imaginative projects, far removed from empirical studies in observation and imitation of appearances.

For the viewer, a naturalistic work of art may be fascinating because admiration for the artist's skill is aroused. At another level, the viewer is attracted by the successful imitation of appearances on canvas, in stone, or in wood, because he knows that he is really looking at paint, stone, or wood—not at flesh, leaves, sky, cloth, and so on. Many of us enjoy so-called *trompe l'oeil*, or fool-the-eye, paintings for this reason. There are stories as far back as the Greeks about artists who could paint grapes so faithfully that birds were tempted to pick at them. The conflict between what a work of art looks like and what

ANDREW WYETH. *Christina's World*. 1948. The Museum of Modern Art, New York

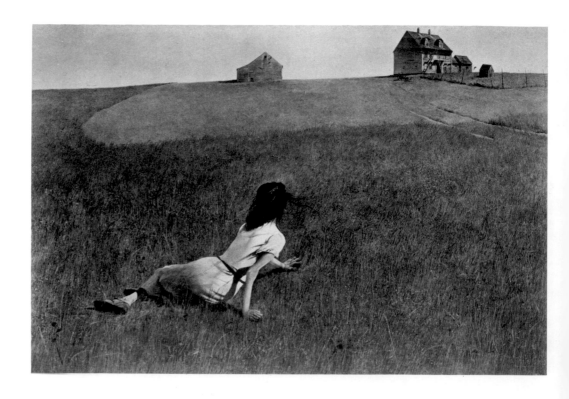

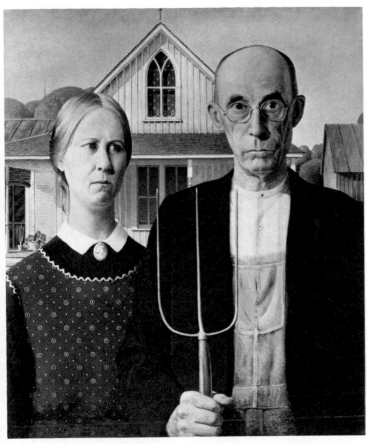

GRANT WOOD. *American Gothic*. 1930. The Art Institute of Chicago. Friends of American Art Collection

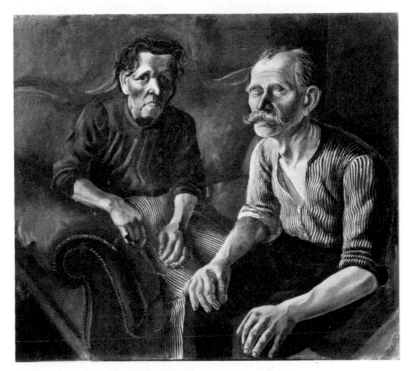

OTTO DIX. *My Parents*. 1921. Kunstmuseum, Basel

we know it is can be fascinating under certain circumstances and aesthetically pleasurable. Indeed, the appeal of a work executed in a style of objective accuracy always has at its base this fascination caused by the tension between appearance and reality.

Another reason for the interest in imitation of appearances lies in the artistic concern with narration—telling the viewer as clearly as possible what happened. From its beginning, visual art has played a role in the transmission of information. Although photojournalism has now largely supplanted the artist as a recorder of events, artists nevertheless continue to create works which not only inform the viewer through naturalistic description and representation but also depend for psychological effectiveness on very accurate rendering of visual details. Andrew Wyeth (born 1917) is an artist who uses a style of objective accuracy largely for narrative purposes, to convey moving, internal dramas about the lives of the people, objects, or places he represents. In *Christina's World*, we are aware of the struggle and loneliness in the inner life of a physically handicapped woman. Wyeth's attention to detail helps to establish the moods of harsh reality and pathos which are conveyed by the picture. His style also avoids excessive sentimentality. The tem-

pera medium gives the work a dry, matter-of-fact quality which heightens our awareness of Christina's difficult existence. Wyeth uses accuracy of representation, but location and selection of details are crucially important. Notice the high horizon and the low position of the figure. This serves to connect her more closely to the ground, as we see more of the earth than of the sky. Distances must be tremendous in her groping world; this impression is created by the skilled use of perspective—the small, distant house, the large expanse of field intervening between the figure and the house. It is exceedingly difficult to paint so large an area of relatively unimportant material—grass—and keep it interesting to the viewer. Yet Wyeth succeeds in giving the field a powerful psychological charge because of the tension created between the girl and the house: we view the grass as space which must be painfully traversed. The design of this picture combines with the artist's representational skill to make the work memorable.

There is a tendency in American art and thought to favor accurate, matter-of-fact representations of life. This may grow out of the traditional suspicion with which a frontier society views the customs and culture of the long-established Old World: older civilizations are associated,

perhaps wrongly, with the ornamental, the insincere, and the pompous; for example, *American Gothic* (1930) by Grant Wood (1892–1942) is a well-known work which celebrates the homely, simple, unadorned virtues of rural life. The picture and its title are intended, of course, to constitute an ironic comparison with the soaring, complex qualities of Gothic architecture. The pointed-arch window of the wood-frame dwelling in the background is an example of the so-called Carpenter Gothic style, the American version of the illustrious European style which is carved much more ornately in stone. But the ironic force of the work is based on the accurate and convincing likeness of a farm couple set in an environment of striving for Gothic style and splendor. Their plainness is severe, even pathetic, but authentic too.

An interesting comparison can be made between Grant Wood's solemn couple and the double portrait *My Parents* (1921) by the German artist Otto Dix (born 1891). We are confronted here with similar human types, but Dix departs further from naturalism, although he creates an overwhelming impression of realism. His enlargement of the hands and emphasis upon wrinkles, which are echoed in the rumpled clothing, convey the stiff and awkward characteristics which Europeans associate with the peasantry. Wood distorted his heads imperceptibly to stress their oval shape and to repeat the shape of the pitchfork. Otto Dix has employed somewhat more distortion and exaggeration. Does his work properly fit into the category of objective accuracy? Probably it does, because the narrative element, the purely reportorial, dominates the painting. The work is primarily responsive to what must have been the visual facts.

Grant Wood painted at a time when there was an attempt by some artists, particularly in the Midwest, to create a distinctive American style or several regional styles which would reflect native traditions, attitudes, and subject matter. The effort was in part a reaction against the sense of cultural inferiority which Americans felt in the 1930s (and perhaps still do) toward the artistic traditions and achievements of Europe. However, World War II, the second forceful reminder within twenty-five years of America's intimate involvement in world affairs, effectively ended the attempt to create art along nationalistic or regional patterns. While works of art with a strong local flavor continue to be created, they stand or fall on their artistic excellence and aesthetic expressiveness rather than their regional distinctiveness. Indeed, the communications media and the mass distribution of goods have tended to eliminate many of the pronounced local variations in customs which existed among people as recently as thirty years ago. Our myths and traditions today are largely manufactured by television and the films and then almost universally disseminated. Hence, provincial and regional differences in artistic expression have little foundation for existence.

The similarity in the paintings by Otto Dix and Grant Wood reflects a similarity of outlook in two artists separated by nationality and culture but united by a common interest in fidelity to optical evidence. It appears, therefore, that the style of objective accuracy is based on an artistic or human trait which is more fundamental than nationality or culture. In fact, a tremendous amount of artistic evidence can be gathered to show that the graphic or plastic imitation of appearances is universal. It may be a mistake to regard skill in imitation as the only criterion of artistic excellence. But it would be equally mistaken to ignore the large body of art which shows how men of all times and places have tried to create, first, actual models of what they see; second, symbolic representations of what they see; and third, credible imitations of visual appearances. In other words, as men become sophisticated, they realize that there is a difference between an actual object and its appearance to an observer. Certain types of artist create, knowingly or otherwise, on the basis of such a difference. In effect, they hope their imitations will succeed in convincing viewers that reality is also present in their art. A type of magical behavior is thus involved in artistic representation. This accounts for the fascination which the imitation of appearances holds for artist and viewer alike.

The Artist as Detached Observer

Another characteristic of the style of objective accuracy lies in the frequent concealment by the artist of the technique used to achieve his effects. It is as if he were trying to deny that his pictures are made of paint or his sculptures modeled in clay or carved from stone. The marks of his tools must not be visible in the final product. The artist wishes to focus the viewer's attention on his subject, not on the way the picture was put together. There is a certain artistic modesty implied by this approach, a self-effacement in the interest of heightening the illusion created by the image. Where a painter like Soutine was anxious to reveal his brushstrokes and the vigor and

sureness with which he applied paint, an artist like Charles Sheeler used a smooth, thinned-out, impersonal technique which seems highly appropriate to his machine-made industrial subject matter.

The attitude of the objective artist is one of detachment. He presents himself to his audience as a person who selects, arranges, and represents reality but suppresses his own personality in the process. If we are to learn anything about the artist as a person, it is through his choice of themes and organization of subject matter, not because of his individuality of vision or intensely personal manner of execution. There is something scientific in such an attitude. As we know, the scientist takes many precautions to be sure that his private feelings will not affect the observations and measurements he must make. He hopes

other investigators will come to the same conclusions as he has if they examine the same data. The artist interested in accuracy also wishes his results to have a validity independent of his personality: the work should appear to be almost anonymous; only the signature reveals the author.

The suppression of the personal in the artist's style is due to his desire to make vision, the act of seeing, the most important part of experiencing his work. In a sense, the Impressionists fit this description: they used scientific theories of color and optics; they freely exchanged technical "secrets"; they painted as accurately as possible the object seen quickly in a particular light. For example, in the Rouen Cathedral series of Claude Monet (1840–1926) we have a very single-minded effort to represent the

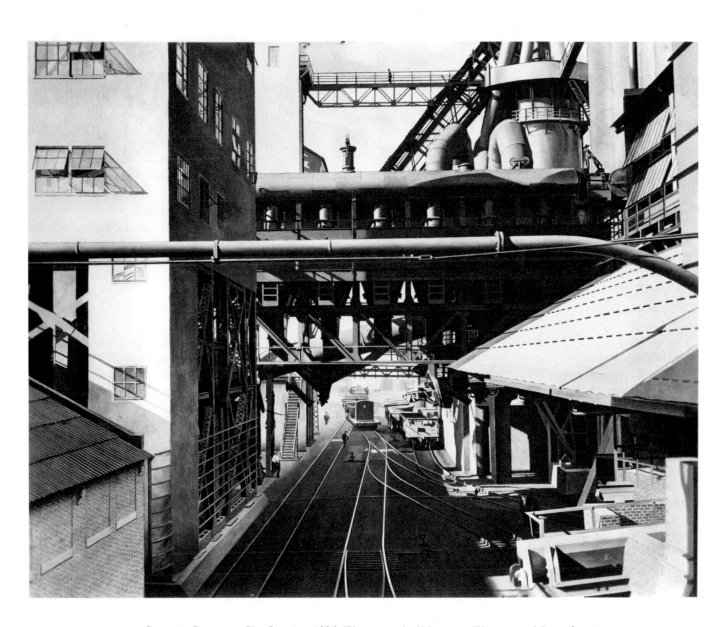

CHARLES SHEELER. *City Interior*. 1936. Worcester Art Museum, Worcester, Massachusetts

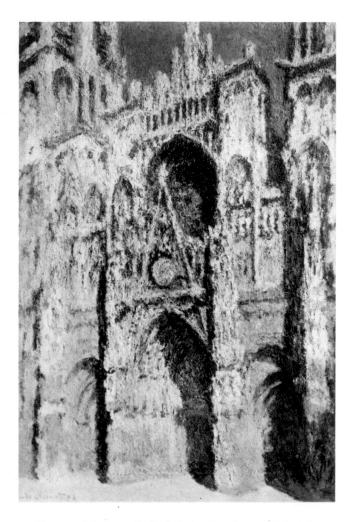

CLAUDE MONET. *Cathedral in Sunshine*. 1894. The Louvre, Paris

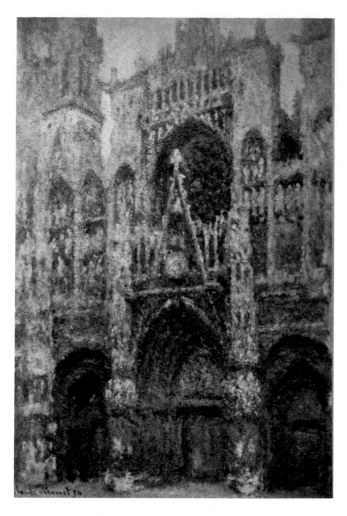

CLAUDE MONET. *Cathedral in Fog*. 1894. The Louvre, Paris

same building under varying light conditions according to a theory of color which was considered more "realistic"—that is, based on a firmer scientific foundation—than conventional techniques of applying color. It is quite correct to think of Impressionism as a style of objective accuracy, since it constituted a disciplined endeavor to use scientific discoveries about color and visual perception to present the object in its atmospheric setting with full fidelity. The genius of Impressionism lay in the realization that the object—a tree, a mountain, a still life—could not be seen or represented accurately without considering the character of the light and atmosphere around the object and the source and nature of the illumination which enables us to see the object in the first place.

As Impressionism evolved, its concern with the treatment of light became more intense, and the represented object tended to disappear; light itself, as in the late paintings of J. M. W. Turner (1775–1851), became the subject. At this point, the term "style of objective accu-

racy" could no longer be applied to Impressionism. The artist's fascination with light had become an emotional matter, strong enough to submerge the earlier concern for fidelity to the *object* in its environment. Although late Impressionism still deals with visual phenomena, the form of objects is almost completely dissolved in color: a virtually total abstraction is achieved. This is especially evident in Monet's water lilies (see pp. 412–14)—the forms of nature become inseparable from light and from brushstrokes of pure color. One cannot distinguish between shape, light, or color.

It appears that so long as an artist can deal with reality optically—through his eyes alone—he adheres to the style of objective reality. But when he allows himself to become emotionally involved with his subject, or with some personal feature of technique, he loses his detachment and his status as a "disinterested observer." Of course, this change of attitude and style may be a very logical and desirable development from the standpoint of aes-

thetic value. The change in the representation of reality, however, is caused by a fundamental change in attitude toward vision and the world on the part of the artist. He has placed a higher priority on the personal act of seeing than on the objective character of what is seen.

In the work of Edgar Degas (1834–1917), we see a style of supreme fidelity to optical and psychological reality at the same time that an Impressionist palette is employed. In *The Glass of Absinthe*, the artist plays the role of reporter, of detached observer of humanity. The drinkers are shown in clinically honest detail, with no preaching and very little dramatization of their condition. We can read for ourselves the dull, weary state of the woman and the mean, sodden look of the man. Degas seems to be a disinterested eye: he catches the couple casually, toward the side of the picture, as if he were using a candid camera. As a matter of fact, Degas was interested in the seemingly accidental compositions of photography and designed his pictures to look as if their subjects had been suddenly discovered. There is no obvious posing, no heroic or pathetic gesturing. As a result, his pictures of

ballet dancers, laundresses, women bathers, jockeys, and so on are exceedingly convincing because we sense an element of candid observation as opposed to the theatrical staging of the painters who preceded him. Later, Henri de Toulouse-Lautrec (1864–1901) would benefit from the compositional audacity and psychological honesty of Degas. His portrait composition *M. Boileau at the Café* (1893) employs the same diagonal treatment of the tables as the Degas, together with figures spilling out of the upper right-hand edge of the canvas. However, the central figure is more conventionally located than the Degas couple. Also, M. Boileau is hardly a derelict; he is the very solid embodiment of bourgeois comfort and self-satisfaction.

The art of Degas and Lautrec shows how Impressionist color, space representation borrowed from Japanese prints, and pictorial composition influenced by photography cannot obscure the fundamental psychological stance of the artist toward the world. Both men were tremendously interested in people; they were passionate observers of behavior; but they refrained from insinuat-

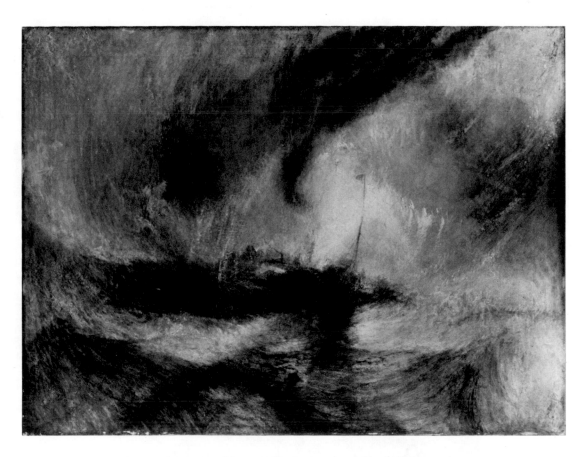

JOSEPH MALLORD WILLIAM TURNER. *Snow Storm: Steam-Boat off a Harbour's Mouth.* 1842. The Tate Gallery, London

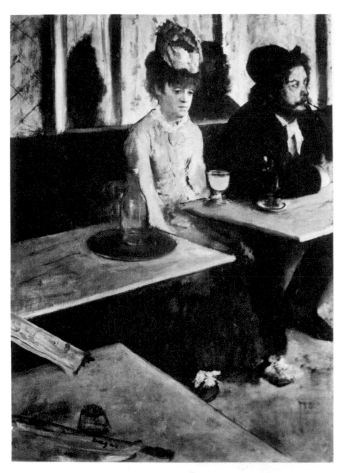

EDGAR DEGAS. *The Glass of Absinthe*. 1876. The Louvre, Paris

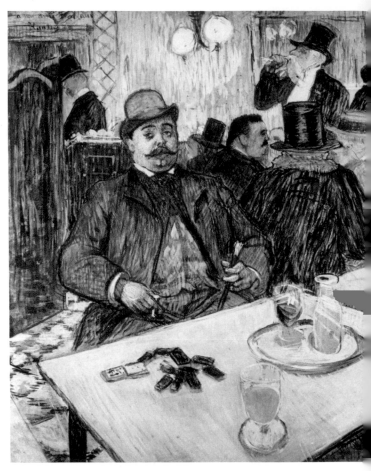

HENRI DE TOULOUSE-LAUTREC. *M. Boileau at the Café*. 1893. The Cleveland Museum of Art. Hinman B. Hurlbut Collection

THOMAS EAKINS. *The Agnew Clinic*. 1898. School of Medicine, The University of Pennsylvania, Philadelphia

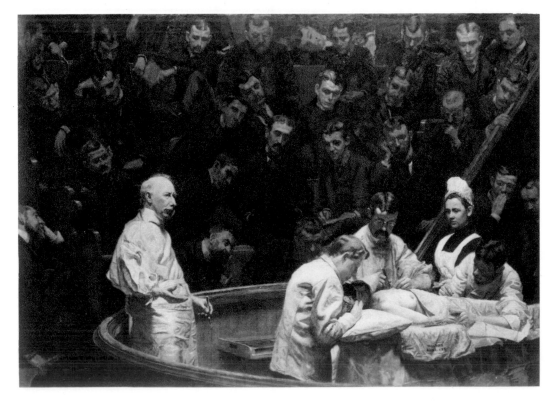

ing their own moral judgments. They were *detached observers*. This much we can conclude from their work, without looking into the biographies of the artists. They were, in a sense, the radical empiricists of painting: meaning, ideas, and knowledge arise from sensation, that is, from data based on observation of the real world. All other considerations must give way to the necessity of seeing clearly what is out there and reporting it—quickly and concisely—and without distortion of the visual facts.

For the detached observer, distortion is a type of artistic and moral vice. The Philadelphia painter Thomas Eakins (1844–1916) felt that distortion was ugliness, and his entire career as artist and as teacher seemed to be a single-minded and almost fanatical pursuit of the methods which would ensure the sort of accuracy which results from scientific knowledge of what the artist sees. He taught artists anatomy by dissecting cadavers and took an almost perverse delight in portraying the unvarnished facts of operating technique, as in *The Agnew Clinic* (1898). Dr. Agnew was not pleased to be shown with blood on his hands as he lectured, but Eakins was too stubborn a realist to compromise the facts. He had been similarly candid in 1875 when portraying a blood-spattered Dr. Gross and assistants in *The Gross Clinic*. By contrast, Rembrandt's *The Anatomy Lesson of Dr. Tulp* (1632) is a restrained and dignified tribute to the undeviating pursuit of learning on which the medical profession prided itself in the seventeenth century.

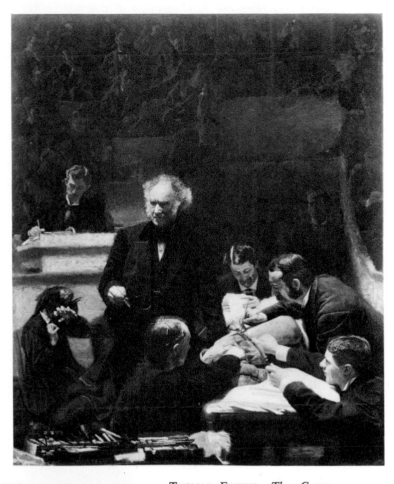

THOMAS EAKINS. *The Gross Clinic*. 1875. The Jefferson Medical College of Philadelphia

REMBRANDT VAN RIJN. *The Anatomy Lesson of Dr. Tulp.* 1632. Mauritshuis, The Hague, The Netherlands

The Artist as Selective Eye

The artistic concern with accuracy does not always result in photographic realism. Often the illusion of reality is created by elimination of details which the eye might see. At other times, there is a deliberate piling up of detail to create an impression of the complexity of the object. Some artists possess a technique which enables them to accumulate detail; and for some, an obsession with the subject may make it difficult to leave a work: such an artist will add to it, embellish it, and enrich its surface. Hence, the result may show the months or years of labor he has put into the execution of the work. Ivan Albright's painting is the result of years devoted to the amassing of detail. Appropriately enough, Albright was chosen to paint the portrait for the film of Oscar Wilde's *The Picture of Dorian Grey*. As in Wilde's story, Albright's paintings appear to have aged along with their subjects. Often the viewer is encouraged to examine a work of art so arduously produced with greater seriousness than if it seemed very spontaneously created. The visual evidence of long and sustained effort by the artist induces a type of empathy in the viewer: the respect for work, which is part of our heritage, is converted into respect for the painstakingly produced art object. Hence, by choosing

to show an abundance of visual facts—more than would be casually noted—the artist can govern, to some extent, the attitude of the viewer.

Among the artists who simplify—who eliminate detail —while maintaining the feeling of objective reality is Edward Hopper. In *Nighthawks*, for example, his picture is divided into quiet, simple, uncomplicated areas. The brushwork is hardly evident; we sense the materials of the place instead: bricks, stone, glass, and, of course, the people in the café. The mood of silence, of stillness, of a great city asleep, is accentuated by the small inactive figures, the emptiness of the street, the sharp, crisp shadows thrown by strong artificial light, the dominance of vertical and horizontal lines. Hopper shows just enough of a building or a person to enable the viewer to identify it; he is not a "tricky" or dexterous painter: each area of his picture seems to have been carefully and patiently pruned of nonessentials, reduced to the minimum needed for recognition. Like Andrew Wyeth, Hopper relies on placement for psychological emphasis, upon careful, undramatic execution of each part to create a cumulative effect which has a quiet drama of its own. His painted areas of light or of shadow tend to be flat and uncom-

EDWARD HOPPER. *Nighthawks*. 1942. The Art Institute of Chicago. Friends of American Art Collection

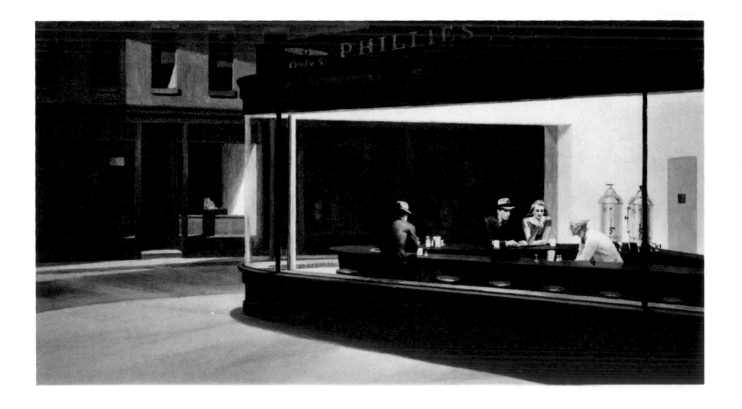

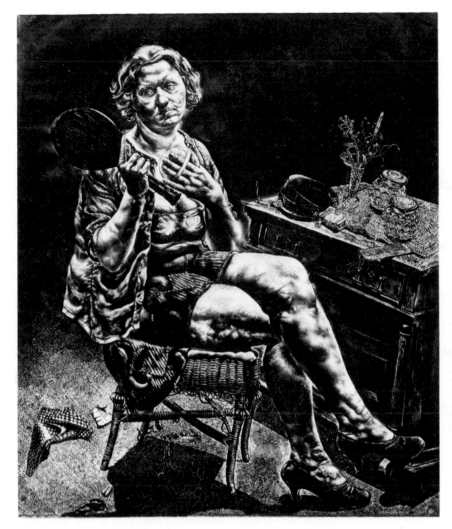

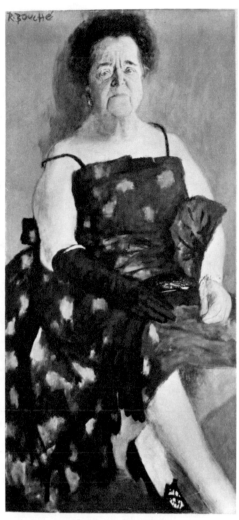

IVAN ALBRIGHT. *Into the World There Came a Soul Called Ida.* 1929–30. The Art Institute of Chicago. On permanent loan from the Collection of Mr. and Mrs. Ivan Albright

RENÉ BOUCHÉ. *Elsa Maxwell.* 1958–59. Collection Mrs. René Bouché, New York

plicated; he uses perspective and contrasts of illumination to suggest the solidity, the heaviness, of the objects and places he records.

Ivan Albright, who painted *Into the World There Came a Soul Called Ida,* relies on an accumulation of visual detail to suggest the process of human aging and deterioration. An almost pitiless observer, he brings out the evidence of sagging flesh at the same time that he reveals the woman's pathetic effort to reverse the aging process. But we are also made aware of the artist's compassion for his subject: her face, which is plain and homely, is also shown in a tragic light, as if she knows very well that cosmetics, clothes, and even hope will not restore the appearance of youth and, by implication, the unique enjoyments reserved to youth. Paintings of this sort encourage speculation by the observer—what is sometimes decried as literary association. It is important to remem-

ber, however, that in the well-executed work our speculation is encouraged in a particular direction—a direction which is intended by the design of the art object. In Albright's canvas, the details, which reveal so much, combine successfully to create a living organism—Ida, who appears very pathetically alive: she is both painted surface and human document. Albright's technique, which is tight and cumulative—suited to the visual exposition of facts—also suggests decay when he chooses; for example, he gives skin a leathery quality to suggest a drying-out process accompanied by the accumulation of unwanted flesh.

In the portrait of Elsa Maxwell by René Bouché (1896–1963), we see another work which in its accuracy and careful draftsmanship conveys some of the drama of aging. Mr. Bouché chose to view his subject from below her eye level, which, in an elderly and stout person, tends

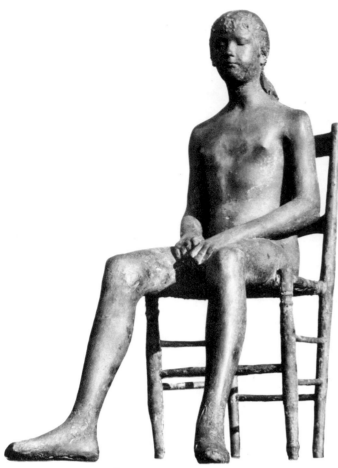

GIACOMO MANZÙ. *Girl in Chair*. 1955. The Joseph H. Hirshhorn Collection

WILHELM LEHMBRUCK. *Young Man Seated*. 1918. Wilhelm Lehmbruck Museum, Duisberg, Germany

to be unflattering. Indeed, there is a nervous, comic, but also oddly *dignified* quality about this portrait. Whenever a sitter is presented honestly by the artist, without any attempt at beautification or glossing over of unpleasant details, a certain measure of respect is earned by the subject. The lady, who exhibits a grossness in her person, retains a measure of human dignity through the artist's presentation of her in a hard, uncompromising light, from a bad view, and in a slightly uncomfortable pose.

Because of its frankness of observation and execution, Bouché's painting shares some of the journalistic flavor of the work of America's so-called Ash Can School, the group of eight painters who portrayed the unfashionable or seamy side of life during the early part of this century. The Bouché portrait also shares with Impressionism the unusual angle of vision which gives the painting a candid, spontaneous look. And the paint application has some of the movement and energy of the French artist Soutine, although it is not distorted or agitated. If it were, we should classify this picture within the style of emotion. As it is, Bouché stays with the visual facts, which convey a rumpled, stout old woman approaching her later years with some humor and a certain amount of self-acceptance.

Among sculptors, the contemporary Italian artist Giacomo Manzù (born 1908) exhibits a refined sort of realism which has roots in the Renaissance yet appeals

to modern tastes nourished on distortion and abstraction. *Girl in Chair* is an example of careful observation combined with elimination of detail so subtle that it is difficult to say where the simplification has taken place. The serenity of the figure results partly from the sculptor's ability to convince the viewer that a particular person has been represented at the same time that the basic forms have been stripped of all but their most essential qualities of shape and surface. The figure is simple and restrained, yet has extraordinary psychological presence. Even the chair has a curious perfection: it falls just short of a sculptor's abstraction (after all, a chair *is* an abstract object). Instead, its spare, open form serves to accent the solidity, the corporeality of the girl's slender body. In choosing a subject who is neither a child nor a woman, Manzù has undertaken a very difficult challenge for an artist working in an objective style: he must manage to imply her in-between and as yet uncertainly defined form and personality within a format of sound observation. Still, he must not fall into the trap of reproducing dimensions as if for a dressmaker's dummy. His solution appears to result from stressing accuracy in the overall dimensions of the figure combined with simplification in the modeling of subordinate forms: thus he approaches but does not quite touch abstraction, while retaining considerable naturalism in the total contour.

Manzù's girl could well be compared with *Young Man Seated* by Wilhelm Lehmbruck (1881–1919). Although the figure of the young man might be understood as conveying a mood of despondency or of fatigue in contrast to the more confident attitude of the girl, it also results from careful observation of the adolescent body together with subtle simplification of surfaces. Lehmbruck, however, goes beyond objective accuracy in his attenuation or elongation of forms. This "stretching" of the normal dimensions vividly presents to the viewer the idea of rapid growth in youth and the various kinds of physical unease and psychological tension which accompany such growth. Another reason for Lehmbruck's attenuation of forms may lie in his consciousness of being the inheritor of a Gothic tradition, that is, a tradition of building and carving which stresses tall, narrow solids and voids. At the same time, his Gothicism seeks a reconciliation with the classic, Mediterranean tradition of order and repose.

The suppression of detail without the loss of essential traits of form which make objects recognizable cannot succeed unless the artist has observed his subject very carefully. He must *know* the subject as well as *see* its surface characteristics; otherwise his work of simplification and elimination will fail: the result will be simple and empty rather than simple and significant. Every work of art within the style of objective accuracy represents the end result of a long process of observation and simplification. Even the work of Albright, with its elaboration of detail, represents a synthesis of many perceptions. Albright tells the viewer what he "knows" about the object by synthesizing many visual facts about it in a single painting. Manzù and Lehmbruck convey what they "know" by eliminating what they consider inessential. But Lehmbruck created new visual facts through distortion: to the extent that he distorts, the artist departs from absolute fidelity to the object. Clearly, this departure represents a decision about the priorities which shall be placed on visual fidelity relative to emotional evoca-

DIEGO VELÁZQUEZ. *Sebastian de Morra.* 1643–44. The Prado, Madrid. The tradition of visual candor reveals its capacity for moral sensitivity in Velázquez's dignified and compassionate portrayal of the dwarfs kept as living toys by the Spanish court.

tion. Art becomes a game played according to rules the artist recognizes: he may change the rules in the interests of a more effective work. One of the satisfactions in the study of art is finding out the rules which the artist appears to recognize and then deciding, if you wish, how well he has played the game.

Variations of the Style

Although many artists feel obliged to render very faithfully what is seen, and often try to suppress personal traits of execution in the process, they nevertheless achieve results which reveal their individual viewpoints. For example, Ben Shahn in his painting *Handball* gives us an exceedingly accurate and matter-of-fact image of city boys caught in somewhat awkward athletic and spectator poses, an image which is quite different in mood and feeling from the equally accurate Wyeth, *Christina's World*. Both pictures show isolated figures. In the wall of the handball court, Shahn, like Wyeth, shows a large

expanse of relatively uncluttered space. He uses some urban detail around the edges of his canvas to establish his setting, just as Wyeth silhouettes his small houses at the top of his canvas, against the horizon. Shahn freezes the action of his characters as does Wyeth. But note that Shahn deliberately draws his figures so that their clothes seem lumpy and rumpled, their bodies thick, stubby, and ungraceful. Their surroundings are drab, and they are trying to find some excitement in a place which appears indifferent if not hostile to outdoor recreation. If the painting of a group of awkward boys has elements of

BEN SHAHN. *Handball*. 1939. The Museum of Modern Art, New York. Abby Aldrich Rockefeller Fund

pathos, it is an impersonal, collective pathos. Christina's tragedy is individual and personal because Wyeth has painted her, not as an example of a type, but as a unique personality whom we feel we can know without seeing her face. Wyeth's drawing dwells on the contours of a particular person; Shahn's drawing dwells on the general characteristics of boys raised in a crowded city neighborhood. It is easy to conclude that Shahn is mainly interested here in the problems of people in the aggregate, whereas Wyeth concentrates on the private dramas of individuals.

John Kane (1860–1934) in his *Self-Portrait* shows how a primitive or relatively untrained artist approaches objective accuracy. Stripped to the waist, using a direct front view, he paints his hard, aging body, showing the muscles, veins, bones, and flesh as honestly as his command of technique will allow. He reveals a combination of pride in his strength and pugnacity, along with utter honesty about the kind of man he is Notice that the edges are

hard and sharp and that the modeling or shading is achieved with difficulty. The primitive artist usually tries for accuracy by the use of line and multiplication of detail. He rarely can use masses of rich pigment or intense color skillfully since these call for art-school training as a rule. Even if he is interested in concealment or evasion of truth, he usually does not possess the technique to heighten one area and suppress another. Furthermore, it is often a matter of principle with him to be scrupulously candid about what he sees and knows of his subject. Viewers admire so-called primitive art precisely for its sometimes brutal or sometimes naive candor. In a sense, we can only learn the truth about people and places through seeing them portrayed by an artist who does not care for dressing up reality or who has not received an education in the artistic traditions of representing reality in a prescribed way.

Charles Sheeler (1883–1965) is an artist whose work seems closely related to photography, and he was, indeed,

JOHN KANE. *Self-Portrait*. 1929. The Museum of Modern Art, New York. Abby Aldrich Rockefeller Fund

Although his painterly technique is far more accomplished, Spencer exhibits the same attitude toward the self—the same asceticism and absence of posturing—that we see in Kane's self-portrait.

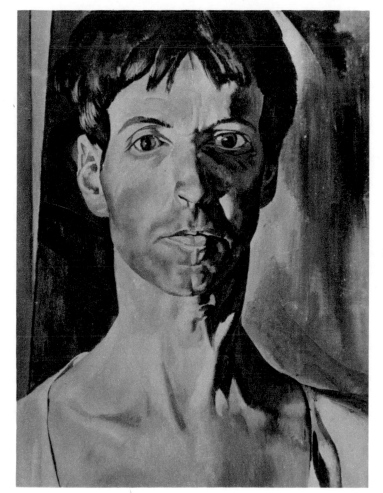

STANLEY SPENCER. *Self-Portrait*. 1936. Stedelijk Museum, Amsterdam

a distinguished photographer. However, his paintings of industrial subjects such as Ford's River Rouge plant, of grain elevators, or of machinery as in *Upper Deck*, reveal his interest in geometric purity of form rather than the real surfaces and objects which an industrial world creates. His pictures are characterized by immaculate whiteness, smoothness, regularity of shape, and absence of clutter or blemish. Although he is regarded as a realistic painter, he actually portrays a world in which noise, dirt, and confusion have been eliminated. In some ways, the atmosphere of his pictures is similar to that of Lyonel Feininger (1871–1956), whose art is classical and orderly but hardly an example of objective accuracy. Sheeler shows how accuracy of representation, if combined with a smooth, almost photographic technique and the suppression of chaotic detail, can create a highly convincing result which is nevertheless much idealized. His is an art which helps us to see some of the possibilities of formal beauty where it normally is not thought to exist.

There is another type of realism, sometimes called "magic realism," which falls within the style of objective accuracy. An example is *Old Models* by William M. Harnett (1848–1892). Such works, which have been widely admired because of their capacity to create convincing illusions, rely on a sort of photographic accuracy. That is, they re-create on canvas the retinal image of arranged objects. Also, the artist's juxtaposition of related still-life material (with an occasional ironic note from the insertion of a jarring object) provides a comfortable set of literary or practical associations. After the viewer has finished with checking the resemblance of the painting to reality, he can enjoy a moment of spurious philosophic

CHARLES SHEELER. *Upper Deck*. 1929. Fogg Art Museum, Harvard University, Cambridge, Massachusetts. Purchase, Louise E. Bettens Fund

LYONEL FEININGER. *The Steamer Odin, II*. 1927. The Museum of Modern Art, New York. Lillie P. Bliss Bequest

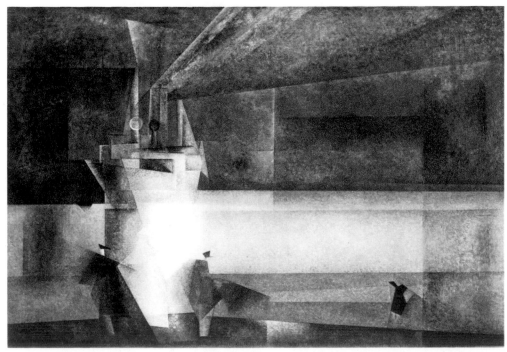

RICHARD LINDNER. *Hello*. 1966. The Harry N. Abrams Family Collection,
New York. The pose, the clothing, the low angle of vision, the space-age
rendering—all combine to create a fearful Amazonian creature.

MORRIS BRODERSON. *Good Morning, Starshine*. 1969. Collection
Naomi Hirshhorn, Hollywood. By combining his soft, pastel
technique with the accurate representation of arrested motion,
the artist achieves an eerie sensuality—a hint of terror beneath
the nubile forms.

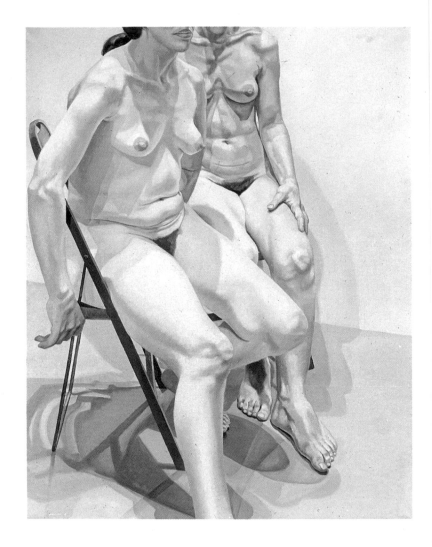

PHILIP PEARLSTEIN. *Two Seated Models*. 1968. Collection Mr. and Mrs. Gilbert Carpenter, Greensboro, North Carolina. Because the figures have been arbitrarily truncated and almost photographically rendered, the viewer perceives them as anonymous flesh. Hence, there is a strange tension between the realism of the forms and their human emptiness.

WILLEM DE KOONING. *Two Women*. 1952. The Art Institute of Chicago. Pastel again, but the color is richer and more aggressively applied. The signs of artistic outrage are everywhere but are most apparent in the treatment of the heads, hands, and feet.

CHAIM SOUTINE. *The Madwoman*. 1920. The National Museum of Western Art, Tokyo. Presented by Mr. Tai Hayashi, 1960. Although loaded-brush technique can well express an agitated or pathological state, it is not impossible for sympathy to enter the picture too.

MAX BECKMANN. *Columbine*. 1950. Collection Morton D. May, St. Louis. Another antifeminine version of woman, this time in a circus setting. Both Beckmann and Lindner revert to a Neolithic fertility image—the "displayed" or "shameless woman" motif—which originated long before Western conceptions of love or tenderness had developed.

De Heem's painting meticulously represents the domestic opulence prized by the seventeenth-century Dutch burghers, whose Calvinist consciences he simultaneously reminds—by those fragile and short-lived butterflies—that no matter how real and solid they appear, riches are an illusion and pleasures very fleeting. Harnett's work carries on the same tradition of visual accuracy, but with homely, useful objects and without such obvious moralizing.

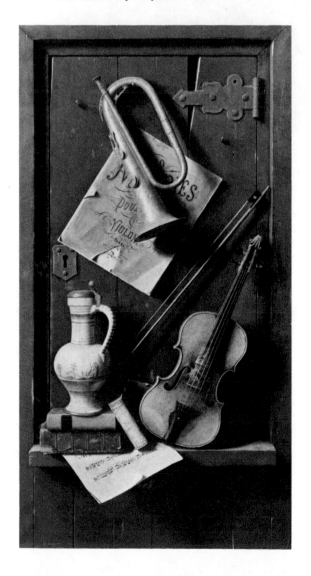

WILLIAM M. HARNETT. *Old Models*. 1892. Museum of Fine Arts, Boston. Charles Henry Hayden Fund

contemplation as he recognizes the relatedness of the objects, the beauty of commonplace things, the striving of art to capture reality and its inevitable failure, and the curious little visual thrills one experiences in seeing painted nails driven into painted wood, painted letters written on painted paper, and so on. Even though craftsmanship and accuracy of a high order are required, it must be remembered that such "realism" rarely dares to present what the artist knows or feels. His selection of detail is governed solely by the invocation of optical criteria, that is, by asking what elements of the object would be registered on the retina of a viewer with normal vision. Needless to say, comparable effects can be achieved by skilled color photography, and, indeed, the better women's magazines often present colorplates showing elaborate holiday table settings with similar results. The "magical" element in magic realism consists of the viewer's knowledge that he is examining a man-made object and that skillfully created illusions can *almost* convince him of their reality. But modern illusionism in photography, the cinema, and the electronic media is technically superior to painted illusionism and has, in addition, been developed into richer and more veritable art forms.

The principal difficulty of nineteenth-century *trompe l'oeil*, or magic-realist, art lay in its lack of humanistic ambition: it reduced the contribution to art from human personality to a decision about the faithfulness of painted surfaces to retinal images. But man knows, does, and feels more than can be accounted for by consulting the light-sensitive membranes of his eyes. Perhaps Harnett, John Peto, and the *petit maîtres* of seventeenth-century Holland, who were also magic realists, served, unwittingly, as precursors of Surrealism, which relied similarly

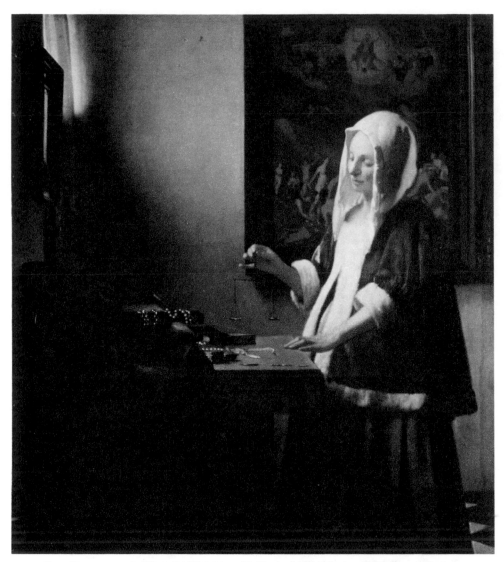

JAN VERMEER. *A Woman Weighing Gold.* c. 1657. National Gallery of Art, Washington, D.C. Widener Collection. Vermeer's subtle and sensuous representation of light—especially of the sparkling little *pointilles* one sees in his rendering of highlights—has been attributed to his use of the camera obscura. The image projected on the camera's translucent screen helped him to solve problems of perspective and also served as a reliable guide to the distribution and intensity of light. But the aid of this device notwithstanding, there remained the problem of execution, and in this regard Vermeer was a master.

on illusionistic portrayal of objects and spaces. Surrealists endeavored to excite emotion in the viewer by unusual juxtapositions of objects. But illusionists like Harnett do not appear to have had a strategy of psychological shock and restructuring of the imagination such as the Surrealists possessed. At most, fool-the-eye painters may have sought to undermine the viewer's reliance on the absolute validity of his optical experience. In this respect, they challenged the strict and occasionally naive empiricism of nineteenth-century American civilization. But mainly, *trompe l'oeil* engendered a popular confusion between objective accuracy and retinal illusionism. Ob-

jective accuracy means, among other things, fidelity to the visual facts. However, it also means fidelity to the kind of *truth* about objects which visual facts reveal. This latter definition, which fits most of the works discussed in the present chapter, makes the creation and study of art vastly more satisfying than a purely illusionistic idea of art. It has not been easy for many persons to understand the difference between art as the creation of illusions and art as the visual presentation of what someone knows about the world. Once the difference is learned, however, art becomes a highroad to knowledge that is not easily gained through other studies.

Devices of Objective Accuracy

We have already discussed some of the ways artists arrive at convincing representations of reality. Obviously, accuracy of size and shape relationships—in other words, "correct" drawing and modeling as traditionally understood—are the most common devices. This sort of mastery is not easily acquired, although the impression of accuracy can be fairly well achieved through painstaking attention to dimensions, through assistance from photographs, tracing, photographic projection, use of calipers, and other measuring and reproducing devices. But reliance on mechanical aids often implies an element of aesthetic dishonesty, although some artists use such devices without becoming excessively dependent on them. The viewer has been conditioned by the tradition of visual art to believe that artistic imagery has passed through and been affected by the personality of a very perceptive person, not a machine. In general, the well-trained artist abjures all but the simplest mechanical aids and can usually recognize when they have been used excessively to the detriment of expressive power. Commercial artists and illustrators, of course, freely use whatever mechanical devices they can, because they frequently work under the pressure of time, and because individuality of vision and style may not be their primary objectives. Normally, the attempt to draw an object accurately produces numerous variations from what a photograph would show, and yet a viewer can be equally impressed by the "reality" of several drawn versions. It is the drawing "error" due to the artist's age, sex, characteristic touch, attitude, training, and a host of other traits which creates interest and delight in the pursuit of objective accuracy.

In addition to accurate size and shape relationships, the artist's control and handling of illumination assists him in creating realistic images. The amount of light an object or place receives, the shapes of shadows, the transition from light to shadow, the portrayal of natural and artificial, direct and reflected light—these the artist learns to observe and control in the various media he uses. Through his mastery of represented light alone, he can model objects and spaces illusionistically quite apart from the use of line or contour. In sculpture, although the artist creates the actual forms the viewer will see, the control of light as it falls over the forms is very carefully considered.

Certainly Auguste Rodin (1840–1917) studied light as intently as the Impressionist painters, so that his surfaces are sensitively animated and varied at the same time that they describe large, three-dimensional forms in space. He attempted to create an activity of surface in sculpture such as painters were achieving through broken color and the use of short, heavily weighted touches of pigment. His

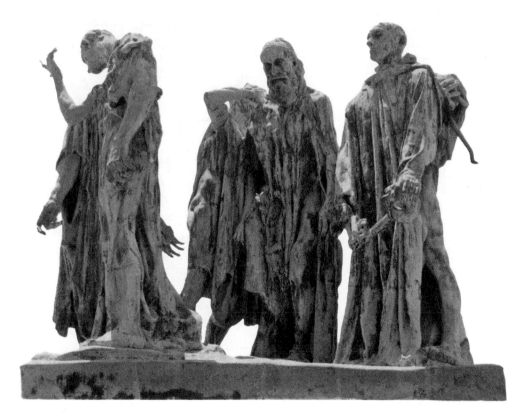

AUGUSTE RODIN.
The Burghers of Calais. 1889

head of Eustache de St. Pierre from *The Burghers of Calais* presents a good example of the sculptural surface which has an almost painterly effect while giving to bronze a soft, fleshlike quality.

Another device of the artist is focus: sharpness or softness, distinctness or vagueness, of form and contour. The rather elementary fact about optics—that objects lose distinctness at the periphery of our field of vision— becomes a device for the artist in his control of a viewer's examination of his work. The eye is drawn, of course, to the most distinctly represented form, other things being equal. As a painted form or object has its edge softened or blurred, we tend to view it as further away or withdrawn from the center of our field of vision. In drawing, forms in the same plane can be made to advance or recede depending on the "lose and find," "hard and soft," "light and dark" characteristics of the contour line. An artist like Léger deliberately uses a line of uniform weight, thickness, and color to prevent his forms from oscillating in space, since he wishes to press all forms forward into the surface plane of the picture. Masters of drawing from Holbein to Picasso, on the other hand, have varied the focal properties of line in order to move forms in and out, forward and back, when they sought objective accuracy.

In sculpture, forms may be sharply raised or softly melted within the same work, thus controlling the attention of the viewer. For the sculptor, the sharpness of focus, the degree to which a form emerges from sculptural relief into the "full round," becomes a tool of artistic expressiveness. Thus, in *L'Età d'Oro* by Medardo Rosso (1858–1928) we see soft focus used to create a very poetic and romantic impression, as of forms perceived through a haze. Aristide Maillol (1861–1944), the French master, avoided sharply undercut forms so that the unity and repose of the entire work, rather than the realism of any single part, is achieved. Yet Maillol's bronze sculptures seem to possess the weight and warmth of flesh and bone, much as Rodin's do, while using a different surface entirely. Jacob Epstein (1880–1959) produced portraits, executed in clay and cast in bronze, which are very sharply focused to heighten the sense of aliveness of his subjects. In his heads, the modeling is exaggerated—that is, the hollows of the eyes, cheekbones, and lips are deeper than would be the case in life. Also, the rough projections of clay catch the light and bring forms so sharply before our eyes that a powerfully vivid impression is created. It is interesting to compare the agitated surface of the head of Conrad by Epstein with the more melting forms on the equally agitated head of Eustache de St. Pierre by Rodin. Ernst Barlach (1870–1938), working mainly in wood, defines his forms less sharply than Epstein but nevertheless gives to wood the soft and hard properties of flesh, cloth, or bone as the subject requires. At the same time, he maintains our awareness of the material and the process of carving through which the forms were created.

AUGUSTE RODIN. Head of Eustache de St. Pierre (detail of *The Burghers of Calais*)

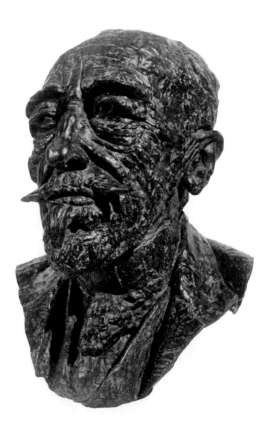

JACOB EPSTEIN. *Head of Joseph Conrad.* 1924–25. The Joseph H. Hirshhorn Collection

MEDARDO ROSSO, *L'Età d'Oro*. 1886. Collection Mr. and Mrs. William E. Loving, Jr., Columbus, Ohio

ERNST BARLACH. *Man Drawing Sword.* 1911. The Galleries, Cranbrook Academy of Art, Bloomfield Hills, Michigan

Color is, of course, a powerful instrument, if not the most important one, at the disposal of the artist—especially of the contemporary painter. Many painters try to create form by color alone, and if line or illumination is present in their work in a calculated way, it is managed solely through the manipulation of pigment. For the artist intent on objective accuracy, the use of color is mainly connected with the description of the colors—the so-called local colors—of the objects he represents. The color of these objects varies, of course, depending on the kind, amount, and source of light they receive, and the location of the objects in space. Just as we know that focus grows less distinct as objects recede in space, we also know—at least since Leonardo—that color becomes less intense as objects recede.

In *The Art of Painting* Leonardo says: "The principal colors, or those nearest to the eye, should be pure and simple; and the degree of their diminution should be in proportion to their distance."[9]

Conversely, intense or brightly colored forms appear to be closer to our eyes. Brilliance of color combined with sharpness of focus is consequently a powerful means of attracting visual attention and of defining forms so that they appear to be accurate and veritable.

Sometimes an artist uses color arbitrarily but combines it with precise drawing so that a style of accuracy is achieved while abstract elements are present. Even the most "realistic" artists may exaggerate color while they tend to remain faithful to the contours of the object in their drawing. It is as if the artistic conscience were willing to permit a certain amount of playfulness with color but would tolerate no deviations from objective reality so far as drawing is concerned. In Ben Shahn's work, we see color used in a fairly flat, poster-like manner; it is the authority of his line (a widely imitated line, incidentally) which establishes the concreteness and particularity of his people and places. Wyeth's color tends toward gray, although it possesses many subtle variations within its narrow range. It is a mistake to believe that only a painter who uses color riotously is truly a colorist. The commitment to intense color used only in bold contrasts may signify not only the absence of inhibitions about color but also the absence of sensitivity toward color. It is safe to say, however, that one of the most significant features of the modern movement in painting is a transition in the use of color from a purely descriptive function to an independent, expressive function. As a result, many artists feel liberated with respect to their use of color, but, as mentioned above, they feel varying degrees of attachment to objectively accurate contour drawing.

Perspective is the pictorial device (really a body of knowledge and devices) which most laymen know about and which a few have mastered in a rudimentary way. It is closely related to an artist's ability to create the illusion of deep space within his picture frame. The technical features of linear and aerial perspective—the perspective

ANDREA MANTEGNA. *The Lamentation.* c. 1490–1500. Pinacoteca di Brera, Milan

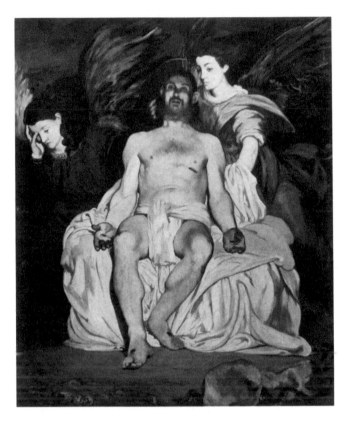

EDOUARD MANET. *The Dead Christ with Angels.* 1864. The Metropolitan Museum of Art, New York. The H. O. Havemeyer Collection. Bequest of Mrs. H. O. Havemeyer, 1929

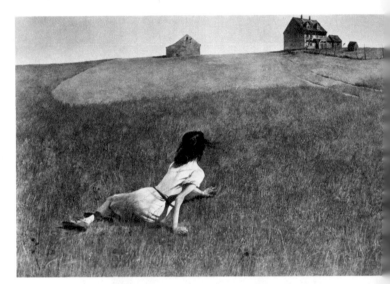

ANDREW WYETH. *Christina's World.* 1948. The Museum of Modern Art, New York

RENÉ MAGRITTE. *Personal Values.* 1952. Collection Harry Torczyner, New York. From Harnett's illusionism to Magritte's Surrealism is a philosophic rather than an optical journey. Now the artist ridicules our inherited notions of what is real, using the optical conventions of Western art to play his trick.

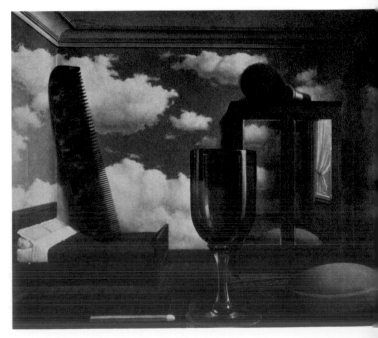

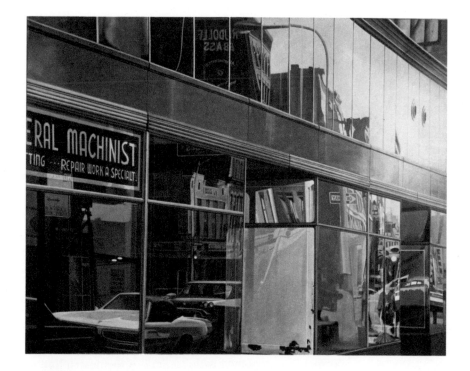

RICHARD ESTES. *Store Front.* 1967. Allan Stone Gallery, New York. Converging lines deny the planarity of the picture surface, and painted reflections deny they are pigment resting on canvas. The result convinces: an art of magical illusionism is created.

of shadows and reflections, of receding measured forms, of single-point and two-point perspective systems, of the interaction of perspective with color and illumination—are exceedingly complex. Suffice it to say that an understanding of at least the fundamentals of perspective enables the artist to simulate on a flat pictorial surface many of our optical experiences in the presence of nature or reality. Here again, the modern movement has first questioned and then largely abandoned the simulation of deep space in painting. The Surrealists have been the principal artists of the modern movement who have used perspective, and even then principally for the creation of fantastic illusions of infinitely receding space. In the Cubism of Picasso, Braque, and Gris, we see rather amusing and witty combinations of conventional perspective and other illusionistic devices along with arbitrary anti-illusionistic devices. Having learned, since the Renaissance, to "read" pictures in terms of the illusion of deep space, we have been taught by twentieth-century art to see pictures phenomenologically—as they actually are: flat surfaces with colored lines and shapes resting upon them.

There are many other devices of illusionism and objective accuracy in art, most of which are combinations of those mentioned above. One, for example, consists of juxtaposing two objects—let us say a hand and a figure—so that the hand is as large as or larger than the full figure. Since we know this cannot be objectively true, we "read" the relationship to mean that the hand is very close to our eye while the figure is at a considerable distance. Within the picture, this device creates the illusion of a vast space between the hand and the figure. It is called by the French a *repoussoir*, a setoff or foil. Of course, the device is based on the laws of perspective governing size relationships; and there are many others related to foreshortening, overlapping planes, distortions due to angle of vision, and so on. The illusions possible through play with the laws of perspective have been well explored by E. H. Gombrich.[10] For our purposes, it is well to know that perspective is an important tool for simulating optical effects, and it is employed most effectively, as in *Christina's World,* for dramatic and expressive purposes.

It seems likely that artists will always endeavor to master the devices which enable them to create illusions, to work in a style which makes possible an optical re-creation of reality. As they grow beyond the student stage, they may abandon some or all of these devices, or they may discover novel combinations and uses of the tools they have acquired. Certainly our principal masters have undergone the discipline of faithfully reporting their visual experience, and this discipline has served them well when they have sought "to render the invisible visible." But mastery of the techniques of accurate representation is not undertaken by artists merely to discard them later, or to possess the sort of confidence which is based on having endured a difficult discipline. As mentioned above, learning to draw accurately teaches the artist to see, that is, to *understand* what he is looking at. He must learn to distinguish between superficial imitation of surfaces and informed representation of visual phenomena. Similarly, viewers who are not artists can benefit from the artist's struggle to come to terms with visual reality if they learn to compare his rendering of reality with the world as they have come to know it. In the difference between the two lies the important body of meaning which the study of art endeavors to uncover.

THE STYLE OF FORMAL ORDER

The style of formal order expresses an artist's preference for balance and stability in his creative work and, by implication, in the world as a whole. To the extent that Western civilization bears the imprint of classical Greek thought, order has been its constant ideal—order in art, in politics, in religion, in the accumulation of knowledge, and in human behavior. The Greeks sought order through measure, proportion, or ratio—through the mathematical statement of relationships which would, they believed, produce harmony, balance, and beauty. That is why "formal" is combined with "order" in the description of a style whose most illustrious embodiment is Greek art of the fifth century B.C. *Formal order* is balance, harmony, or stability in art created through the methodical application of rules of measure. It is another term for Classicism —a Classicism found in all periods.

The immediate source of proportions for order and hence of beauty was, for the Greeks, the nude human figure. They made a momentous aesthetic discovery in concluding that what we call "beautiful" is the result of a harmonious relationship among the parts of any whole, and that a mathematical ratio based on the human figure lies behind every visual harmony. The human body is beautiful, they believed, because it is an expression of the order which can be found in the entire universe. The problem of the artist is to apply that universal order or measure to the design of buildings, the writing of music and poetry, and the fashioning of human images—images that are truthful representations of their models in reality and at the same time exemplars of perfect visual harmony. These human images were rarely drawn from specific personalities; rather they were "idealized" versions of the human—that is, they embodied a mathematical average of the best proportions encountered in the human category as the Greeks knew it. The Greek painter Zeuxis is supposed to have studied many beautiful women before he painted the portrait of Helen of Troy. Always, in classical art or the style of formal order, there is a rule of number or measure applied to the problems of artistic creation. Art is a search for the "right" proportions. A rule or canon guides the search.

The most conspicuous modern votaries of the classical commitment to measure are not artists but rather our social and physical scientists. Artists today tend to rely

LEONARDO DA VINCI. *Studio del Corpo Humano*. c. 1492. Leonardo tried to solve a problem of incredible difficulty: the determination of correct proportions in the human figure when it is at rest or in action. He sought to integrate these "objective" proportions into a scheme which accounted for changes due to the artist's angle of vision and psychological predisposition. Unlike the Greeks, who derived the figure from an a priori set of mathematical ratios, Leonardo—being an empiricist—was determined to discover ratios that would conform to his visual experience.

on intuition. But scientists depend on accurate measurement in empirical and experimental investigations, followed by statistical formulation of findings. The scientific pursuit of *truth* or *norms* through measurement of phenomena and abstract formulation of data—statistical analysis and mathematical statement—is comparable to the classical Greek pursuit of harmony through geometric measurement and arithmetic averaging. Presumably, the classical artist is engaged in discovering or creating forms which satisfy proportions, ratios, or norms already known to reflect the harmony of the universe.

But Western man has not been unswerving in his devotion to classical ideals of measure, order, and moderation. Periodically, he has been caught up in violent convulsions such as our own era has known too frequently. Even the classical Greek passion for formal order gave way to Hellenistic ideals of dynamic movement, ordinary naturalism, and unstable form. Similarly, today's art has been characterized by chaotic and violent style features as well as by rationality and order. Often, in the career of a single artist—Picasso, for instance—both the style of formal order and that of spontaneous emotional expression may be present. Apparently, Nietzsche was correct in his analysis of Greek culture into Apollonian and Dionysiac strains: the Apollonian strain is characterized by a *dream* of order and serenity; the Dionysiac strain is characterized by a *frenzy* of movement, an explosion of energy. In the past, one strain or the other may have dominated the artistic scene; today, both exist side by side.

The freedom and openness of modern culture (at least in the West) permits artists the almost totally unhampered expression of their Apollonian or Dionysiac impulses. The style of formal order, therefore, need not be the only artistic expression of a region, group, or nation. Nor does it necessarily represent the official taste of in-

POLYCLITUS. *Doryphorus (Spear Bearer)*. Roman copy after an original of c. 450–440 B.C. National Museum, Naples. Although Polyclitus designed his figures in strict conformity to a geometrical formula, he was the first of the Greek sculptors who possessed the genius for convincing the viewer of the natural grace as well as ideal perfection of his victorious young athletes.

fluential persons and institutions in the art world. Rather, it expresses the choice of creative individuals who feel an affinity for stable forms and balanced composition—men who possess a serene vision of the world. In other words, the style results from *personality* factors in the artist rather than *power* factors in the culture. We have to understand Classicism, or order, as a wish (felt by many persons but expressed only by the artist) that the world be governed by reason and logic. Whether the

artist admits it or not, his work has the effect of restricting the uninhibited rule of impulse. Through the visual evidence presented in his art, we see how deliberation and measure, calculation and the weighing of alternatives, have managed to overcome the spontaneous expression of feeling. Thus, we see Maillol instead of Rodin, Mondrian instead of De Kooning. We see man *measuring* the visual consequences of his planning and forming and building.

The Transient and the Permanent

If there is a single attitude or trait which characterizes an artist who employs the style of formal order, it is his interest in dealing with what is fixed and permanent or, at least, relatively unchanging. When such an artist works with a subject we know to be mainly dynamic and variable, he finds some way to stress its quiet or immutable qualities. With the human figure, he will select positions where it tends to be most stable, avoiding the suggestion that it is about to change attitude or location. One of the reasons Rodin's *St. John the Baptist Preaching* (1878) was criticized, at a time when critics preferred classical art,

was the impression the figure creates of walking off its pedestal. Sculpture, it was felt, belongs to architecture and should stand still. Furthermore, the French have always identified their culture very strongly with the classical Greek tradition; a statue which really seems to move would be in the nature of sacrilege. Jacob Epstein's *Madonna and Child* is a work of formal order because the composition is highly symmetrical, hence balanced and stable: wide at the base (like a triangle resting on its long side) and almost devoid of casual or incidental motion. The suggestion of movement, particularly of

JACOB EPSTEIN. *Madonna and Child*. 1927. The Riverside Church, New York

movement which would carry the viewer's eye beyond the art object, militates against the idea of permanence. All monuments which are created to express the durability of a person, event, or idea stress the motionless character of their forms; otherwise, they may amuse or entertain the viewer, but they will not persuade him to believe that the monument has succeeded in arresting the flow of time which governs the majority of mortals—those who are not heroes or kings.

Art instruction in the academic manner was largely biased in favor of formal order. It taught the student to recognize shapes which are relatively fixed and either to avoid the representation of changing shapes or to give changing shapes a permanent and classical quality. (Of course, the very act of drawing or painting from a rigidly posing model has the effect of freezing movement, a practice which permits visual study but which also appears somewhat unnatural as one carries it out.) The implicit purpose of such instruction was to teach students to create works of art which would seem resistant to all the forces of atrophy and change. It was as if the artist were asked to discover what it is that can survive amid all the things, including ourselves, which must die.

Students of philosophy will recognize as Platonic this academic approach to art instruction and creation, for it

Jockey. c. 150 B.C. National Archaeological Museum, Athens

at left:
AUGUSTE RODIN. *St. John the Baptist Preaching.* 1878. The Museum of Modern Art, New York. Mrs. Simon Guggenheim Fund

Arrested motion can be an eloquent device for the classicizing artist. By deliberately freezing the action of a highly animated subject, Manzù generates compelling aesthetic tension for the contemporary viewer—a tension he resolves by alluding obliquely to a style of the ancients, that of the Hellenistic Greeks.

GIACOMO MANZÙ. Detail of *Children's Games.* 1966. Collection Mr. and Mrs. W. B. Dixon Stroud, West Grove, Pennsylvania

The crystalline tower has been built or imagined by men of every time and place. At first a solid megalith, it dematerializes as it grows higher, a case of the convergence of optical law and spiritual striving.

LYONEL FEININGER. *Church of the Minorites (II)*. 1926. Walker Art Center, Minneapolis

LUDWIG MIES VAN DER ROHE. Seagram Building, New York. 1957

is related to Plato's interest in knowing the permanent forms of thought which lie behind the temporary and transient examples of acting and being we commonly see before us. The beautiful is the imitation, not of appearances, but of ideal and unchanging essences. Ideal essences must be known intellectually and mathematically before they can be imitated; hence, the artist must know the ideal dimensions and proportions of his subject before he attempts to imitate its form. Such knowledge will cause his work to be a closer approximation of the essential type it endeavors to represent. (It is interesting in this connection that casual conversation about men and women often begins with a description of their physical dimensions followed by a judgment of their proportions.) More important, however, than the philosophic origin of the attitude expressed in the style of formal order is the fact that artists probably work in this manner because of some inner necessity rather than because of any deliberate philosophic choice. That is, some artists find themselves creating forms which inevitably exhibit order and measured structure although they may have set out to work in a loose, spontaneous fashion. Other artists seem naturally to create forms which are characterized by indistinct shape and impulsive movement—forms which look as if

Mathias Goeritz, Luis Barragon, and Mario Pani. The Square of the Five Towers. 1957–58. Satellite City, Mexico City

of course, lend themselves to this treatment, but Feininger used this sharp-edged, geometric form language to represent growing things, the land, and even people. It was Cubism, with its tendency to convert all forms into geometric shapes, which created the breakthrough Feininger exploited in order to express the extraordinarily clear, serene, and restful qualities of the chapel and its setting. The subject and its world are not separated into solids and empty spaces. Instead, the air, the building, and the land are treated alike, as if they were facets of a remarkable gem. Feininger created a world of hieratic repose and fixed order; his work implies that our universe has an underlying structure which is also fixed, ordered, and, perhaps, divinely decreed.

It is not difficult to see that the style of formal order, in the hands of certain artists, has religious implications. This is understandable since the great protagonists of the style, the Greeks, had an almost mystical view of mathematics: it possessed a divine beauty for them; art created according to rules of proportion would therefore share the divinity of mathematics. Hence, the implication in Feininger's work that the universe is permanent and orderly is very much like saying that a divine being exists, has created the order reflected in the artist's painting, and wishes it to continue. At any rate, Feininger's painting represents one of the ways an artist would make such a statement, since he must use images rather than words to express his view of the universe.

Of course, another artist employing a different style may also express religious feelings, but the content of these feelings is less likely to be concerned with the changeless universe and the geometric order behind it. The style of formal order possesses a certain gravity and dignity by virtue of its emphasis on vertical and horizontal directions, measured intervals, and clarity of articulation. But it cannot cope well with feelings of agitation, demonic obsession, or Dionysiac transformations of personality. If an artist is interested in man's effort to unite himself with some transcendent idea or being, for example, his work is more likely to exhibit qualities of turbulence, of encounter and resistance, of endless space and shifting forms rather than contained space and measured forms. The paintings of Van Gogh well illustrate this way of expressing a man's mystical emotions—his striving for self-transcendence. He was an artist who could not find the style of formal order congenial, since the trees, flowers, people, and things he saw and painted appeared always to be in a state of agitation, always restlessly moving. One might say that his forms were seeking a consummation—a point of rest—which they could not find within his paintings; hence Van Gogh's style expresses a certain tension, even anxiety, which is foreign to the serenity of formal order. It is nevertheless a style which deals eloquently with the inner turmoil of certain kinds of religious struggle and aspiration. (See Van Gogh's *Starry Night*, p. 40.)

they are about to expand into the space around and beyond them. The artist who happens to prefer the sort of result he naturally and inevitably achieves is fortunate indeed. Often the chronic unhappiness of creative persons is due to the conflict they feel between what they like and the only work they are able to produce.

The painting *Church of the Minorites (II)* (1926) by Lyonel Feininger is an example of the style of formal order by an artist who was much influenced by Cubism. There is a quality in all of Feininger's work which suggests an effort to impose the geometric order of crystalline structures upon the visible world. Architectural forms,

Kinds of Formal Order

Although the style of formal order is associated in general with stability and permanence, there are also variations within the style—different ways of exhibiting the qualities of formal order. These variations I call *intellectual order, biomorphic order*, and *aesthetic order*. Of course, these categories are not absolutely distinct, but one or the other tends to predominate in given works or in the entire production of an artist.

INTELLECTUAL ORDER

Perhaps the best-known contemporary examples of *intellectual* order are to be found in the work of Piet Mondrian. In his *Composition with Red, Yellow, and Blue*, we see a

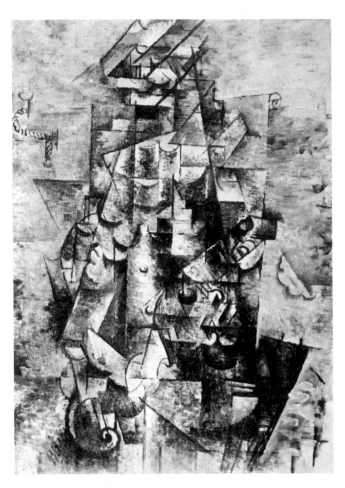

GEORGES BRAQUE. *Man with a Guitar*. 1911. The Museum of Modern Art, New York. Lillie P. Bliss Bequest

PIET MONDRIAN. *Composition with Red, Yellow, and Blue*. 1921. Gemeente Museum, The Hague, The Netherlands

picture which has been created entirely with vertical and horizontal lines, with areas of unvarying color, and with no representational elements whatever. The elimination of curves, of modeling, and of subject matter in the conventional sense obliges us to examine the work solely in terms of the restricted formal vocabulary the artist uses. He has employed only the type of pictorial device which can be completely controlled, which is to say, horizontal and vertical lines of equal thickness, measured rectangular shapes, and only three or four relatively unmixed colors. Yet within this deliberately narrow range of pictorial language the artist can produce considerable variety—in the shape of the rectangles (their ratios of length to width), in the length of lines considered by themselves, in the apparent "weight" and location of the colored areas, and in the spatial relationships among all these elements. Indeed, it is the interaction among the forms which suggests an intellectual order of mathematical complexity. If a viewer calculates visually how the balance of the total canvas has been achieved, he will see that the work reveals multiple balances or reconciliations

of horizontal and vertical movements and of light and heavy shapes—a series of large oppositions and small adjustments delicately related to each other. By reducing and refining his pictorial vocabulary, Mondrian tried to employ the pure activity of the viewer's eye to create impressions of motion, opposition of weight, and asymmetrical balance. The movements of our eyes, which are guided by the design of the canvas, initiate kinesthetic reactions in our total organism. The elements of the design are *intellectually* interpreted as weight, space, and motion since they do not look like or represent objects which possess mass, volume, and mobility. Hence, the balance we perceive can be regarded as a type of intellectual order—an order based on operations performed by our minds with our kinesthetic reactions, which have, in turn, been excited by the visual material organized by the artist.

One of the earliest twentieth-century forms of intellectual order appeared in Cubism, especially in the stage called Analytic Cubism (1910–12). Braque and Picasso worked together at this time (in close association with Juan Gris and Fernand Léger), and their work is so similar that it often appears that either one of them could have painted any given picture. The similarity suggests that a common *intellectual method* of analyzing form was employed by both painters; consequently, individuality was subordinated to the requirements of an agreement or convention about representing the surfaces and shapes of things. In Braque's *Man with a Guitar* (1911), straight lines, a narrow range of color, and a kind of slicing of the figure into geometric shapes suggest a highly impersonal and unemotional approach to the figure. We learn nothing about the age, personality, occupation, or appearance of the subject. The artist asserts, in effect, that painting pictures is no longer a narrative art. Instead, he presents a rather quiet arrangement of geometric forms which appear to be floating gently in the picture space. The figure's outline is indistinct; we see that the forms are denser toward the center and loosely distributed around the edges of the subject. No distinction is made between solid and void, hard and soft, skin and cloth. Indeed, it appears that we are dealing with an artistic approach to the nature of matter—the expression of the idea that, fundamentally, all substances have a common structure. The artist appears to be saying that all the variations we see in the visible world are superficial—shells, as it were, underneath which there is an order like the order of mathematics. Here again, the influence of Platonic thought is evident. Also, it is interesting to note that important theoretical developments in mathematics with implications for physics were being made at this time, notably by Einstein.

Cubism offered an analysis of form that artists could use in a variety of media and for many expressive purposes. In sculpture, *The Horse* (1914) by Raymond Duchamp-Villon (1876–1918) appears to be an attempt to translate an animal into mechanical equivalents, using the geometric format of Cubism. The painterly language of Cubism was enlarged by the incorporation of forms taken from machines or, quite possibly, from the working drawings of mechanical engineering. Although the artist attempts to visualize motion, the poise and stability of classical order predominate. Indeed, as we view the sculpture we are not so much impressed with the work's motion—actual or potential—as with the sculpture's *analysis* of motion in a "horse-machine." Consequently, it is the intellectual element, the process of taking apart the animal and reconstructing it along rational-mechanical lines, which characterizes this example of formal order. Compare this work with a mural detail by Orozco, *The Mechanical Horse*, which deals with the same subject, but in an emotional, nonintellectual style.

The processes of engineering and mechanization have been enormously fascinating to artists, whose reactions as expressed in their work have ranged from enthusiastic approval to contempt to violent revulsion. Classical artists, in general, tend to see their ideals of rationality, elimination of excess, efficient organization, and mathematical order realized in the machine. Accordingly, they borrow the forms developed by mechanical engineering and incorporate them into their work. But as soon as machine-made forms are taken out of their original contexts and exploited in art for their qualities of shape, surface, or movement, they begin to function as symbols.

As symbols, geometric-mechanical forms need not necessarily operate within the style of formal order. In the crisp, Euclidian shapes of *My Egypt* by Charles Demuth (1883–1935), formal order is clearly evident, much as in the work of Charles Sheeler and Lyonel Feininger. But in the *Eiffel Tower* (1914) by Robert Delaunay (1885–1941), the engineered forms are seen in a state of partial disintegration; instead of resting in classical repose, they appear to be exploding upward before coming down in a final collapse. Therefore, while the choice by an artist of geometric or biomorphic forms may offer a clue to his interests, it is their *organization* which establishes his style. And in the organization of forms, personality factors, such as the artist's characteristic way of feeling and seeing, are more determinative of style than the source in reality from which the forms were derived. Hence, Delaunay's Cubism does not prevent him from feeling and expressing a surging, explosive emotion as he views the Eiffel Tower. Mondrian, on the other hand, could paint living trees and yet endow their organic shapes with the fixed and measured character of plans made by a mechanical draftsman.

In architecture, the buildings of Ludwig Mies van der Rohe are considered classically simple and severely intellectual in conception and appearance. This may be due to the crucial importance the architect attached to purity of

JOSÉ CLEMENTE OROZCO. *The Mechanical Horse* (panel of mural). 1938–39. Hospicio Cabañas, Guadalajara, Mexico

RAYMOND DUCHAMP-VILLON. *The Horse*. 1914. The Museum of Modern Art, New York. Van Gogh Purchase Fund

CHARLES DEMUTH. *My Egypt*. 1927. Whitney Museum of American Art, New York

ROBERT DELAUNAY. *Eiffel Tower*. 1914. The Solomon R. Guggenheim Museum, New York

Geometrical forms can be used to express a restless, surging dynamism or, conversely, the order of forces that have been balanced and stabilized.

Abstract Modes of Order

ALEXEJ VON JAWLENSKY. *Still Life with Lamp.* 1913. Private collection, Hofheim/Taunus, Germany. The objects are barely identified—color striving to break loose. However, a stern linear structure holds everything together.

MAURICE ESTÈVE. *Rebecca.* 1952. Musée National d'Art Moderne, Paris. After establishing the huddled relationships typical among the objects in a still life and thus generating a conviction of real things in real space, the painter leaps boldly into pure color and texture. But the reality of the picture keeps in touch with the reality of the object.

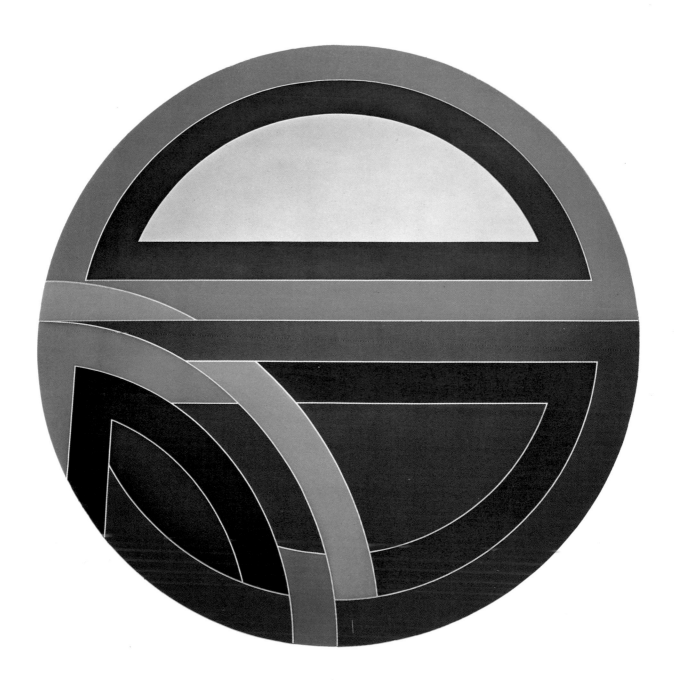

FRANK STELLA. *Sinjerli Variation I*. 1968. The Harry N. Abrams Family Collection, New York. The color wheel in a new guise— a set of intersecting protractors. There is no symbolic intent here; still, the image cannot escape its destiny: three rising suns whose radiation is intermixed.

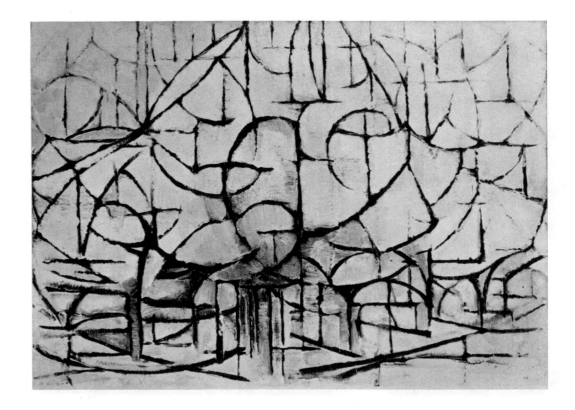

space and surface (as in the Seagram Building, p. 204), achieving his austere effects through restraint in the use of materials, careful attention to joints and change of plane, and a candid revelation of his structural method. There is no effort to use natural materials except in the planned landscaping around the building. There is no suggestion of handcraft or of the contribution of skill from the workmen who erected the structure. The result is a product of design—that is, of thought applied to the problem of using industrial materials fastidiously and with precision.

Mies, like Mondrian, restricted himself to a narrow building vocabulary; he gave up the suggestions and associations of natural materials as Mondrian eventually gave up the associations of curving lines and representational forms. Mies refused to explore the sculptural possibilities of reinforced concrete in his later work, although the virtuoso effects of the material had become increasingly apparent. He always disdained coarse, irregular textures: smooth materials, straight lines, clean planes, and regular intervals characterize his building surfaces. But, since he was a consummate classical artist, he introduced just enough variation in surface to avoid monotony.

The architectural style of Mies van der Rohe has been widely imitated, in part because it is admired for its elegance and classical perfection, but also because it fits so logically into a world of industry and technology. It has been equally well used for apartment houses, libraries, college buildings, skyscrapers, and domestic dwellings. Its flexibility of application combined with an essentially fixed identity relates the style to man's search for permanent and unvarying forms. Indeed, Mies stated his interest in creating structures and spaces which could be universally used. His buildings do not vary according to the local climate or the local availability of special materials. They do not reflect shifts in function and client or differences in emotional and symbolic meaning. But this lack of flexibility or adaptability is not to be regarded as a fault from the standpoint of classical order. Rather, it illustrates the victory of architecture over the limitations and restrictions of climate, handcraft, provincialism, and literary association. It is the visible evidence of man's effort to create something more durable than style regarded as the reflection of a personality.

BIOMORPHIC ORDER

While some artists achieve the quality of order by using forms derived from mathematics or engineering, others pursue order through the organization of shapes based on the biological world. The term "biomorphic" designates artistic forms which *look as if* they had developed in the same way that all living organisms develop: through the division of cells. An excellent example of biomorphic order is seen in Jean Arp's *Human Concretion*. Where some artists regard nature as fundamentally chaotic and therefore indifferent to the order of classical art, this artist

JACOB EPSTEIN. *Mother and Child*. 1913. The Museum of Modern Art, New York. Gift of A. Conger Goodyear

JEAN ARP. *Human Concretion*. 1935. The Museum of Modern Art, New York. Gift of the Advisory Committee

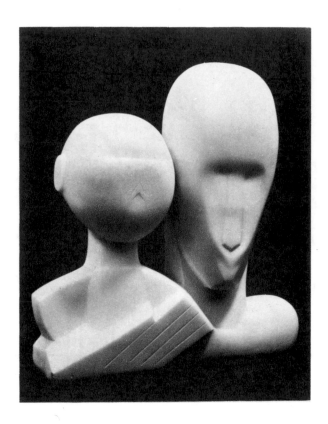

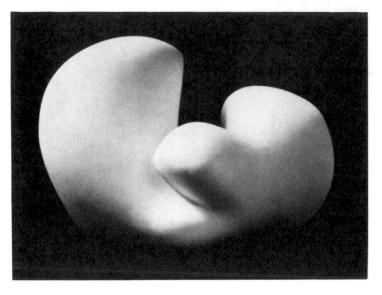

sees regularity and formal perfection even in organic life. The material of the sculpture is stone, and yet Arp has given it a soft, fleshlike quality. His title suggests that he was attempting to create simplified abstract forms derived from the human figure while avoiding any features which might identify arms, legs, torso, or head in a specific way. Thus, the connection with the distinctively human is somewhat remote, although the identification with the living and the organic is very strong. Nevertheless, these organic shapes exhibit unmistakably classical qualities of permanence and stability. In *Torso of a Young Man*, a polished brass sculpture by Constantin Brancusi (1876–1957), biological and geometric forms meet in the same work. There is no question of Brancusi's devotion to classical order—that is, to mathematical regularity, stability, and clear articulation. However, he is also determined not to let his Classicism sever the connection with organic life. He has therefore pressed geometry into the service of the biomorphic. The truncated cylinders which make up the torso stimulate memories of ancient figurative sculptures—the armless or headless gods and goddesses unearthed in Hellenistic ruins. At the same time, the long trunk and the distinct joints where the thighs meet the body recall the African sculpture which so obviously influenced Picasso, Marcel Gromaire (1892–1971), Modigliani, and others. It is possible to think of Brancusi's work as the result of a process of simplifying and generalizing *from* biological models or as the product of fundamental geometric units combined to suggest biological models. In any case, his work occupies a realm

CONSTANTIN BRANCUSI. *Torso of a Young Man*. 1924. The Joseph H. Hirshhorn Collection

at right:
MARCEL GROMAIRE. *Nu bras levé sur fond gris et or*. 1957. Galerie Leandro, Geneva

where geometry and living forms successfully meet. He and Arp demonstrate the compatibility of a style of formal order with rounded shapes and swelling curves.

The English sculptor Henry Moore is also a classical artist, but most of his work is less abstract than that of Arp or Brancusi, closer to the identifiably human. His reclining figures and family groups are monuments to vital repose, as in his bronze *Family Group* (1948–49). Moore stresses the roundedness of forms—even the bench on which the figures sit has no sharp angles. Nevertheless, his figures proclaim strength; clearly, biomorphic order need not result in a limp or structurally weak composition. An impression of strength is created because underneath Moore's smooth and rounded surfaces there is a forceful and virile understanding of skeletal structure, of a supporting system of bones and muscles which completely controls the massive weight of the figures. It is noteworthy also that Moore puts very small heads on his people, a proportional device which suggests great bulk and stability in the rest of the figure. Although this device produces a monumental effect, it also creates additional problems for the artist because he must control the resultant masses and weights if he is to achieve the effect of classical balance he apparently seeks.

Because Moore has successfully solved the artistic

OSKAR SCHLEMMER. *Abstract Figure*. 1962. Bronze copy after plaster original, 1921. Collection Frau Tut Schlemmer, Stuttgart.

Often the artist with an affinity for classical humanism feels the need to reach an accord with the machine. Thus, his work shows a struggle to reconcile the qualities of growing forms with those of precisely measured forms.

problems of the human and the abstract—of monumentality and control, of rounded form and structural power—we are privileged to see in his work one of the most affirmative artistic statements about man created in the twentieth century. These people, beset by the struggles, hopes, and fears common to all families, appear courageous enough to confront any challenge—from nature or from society. Perhaps Henry Moore's experience during the bombing of London in World War II, when he made hundreds of drawings of Londoners in their underground shelters, helped build his attitude of respect for human fortitude under extreme conditions. The attitude may have been inherited, since Moore's family had been

HENRY MOORE. *Family Group.* 1948–49. The Museum of Modern Art, New York. A. Conger Goodyear Fund

miners for generations and so knew the kind of labor which sends men deep into the earth to risk their lives daily.

It is important to recognize that a personal style such as Moore's grows out of his technical mastery; but we must also realize that it grows out of his experience both as a Briton at a crucial time in England's history and as a man who grew up in a harsh environment at a hard time. An interesting phenomenon of artistic style is that other artists can borrow from or be influenced by Moore's art without themselves having shared Moore's experience. And, as observers, we too can understand his work without having lived through the London blitz, without having been personally threatened by destruction from bombs and missiles.

Some of the range and variety within the biomorphic style can be seen in a painting by Joan Miró (born 1893), *Personnages Rythmiques.* This artist creates playful forms that are based on human figures but almost resemble the seal or walrus. The forms seem boneless, and they hardly describe visual reality. A crescent stands for the moon in one place, and in another it schematically represents the

arms across the torso, at the same time reminding us of a penguin. The breasts in the lower right portion repeat the same forms directly above, where they are greatly enlarged feet.

A number of absurd comparisons and connections of this kind are found in the work of Miró, and they account for his being associated with the Surrealists, although his fantasies tend to be childlike or whimsical rather than shocking. Surrealists as a group are fantasists—dealing with absurd, unconventional, and shocking combinations of subject matter. But the form language they use ranges widely—from the biomorphic of Miró to the almost photographic of Salvador Dali, to the osseous and geologic of Yves Tanguy, to the architectonic of Giorgio de Chirico. Surrealism, therefore, does not constitute a single style of execution so much as a distinctive way of confronting the viewer with fantastic subject matter. But some artists who have been grouped with the Surrealists —Miró, Chagall, Tanguy, and Paul Delvaux—seem more interested in dreams, trancelike states, and quiet fantasies than in shock or strenuous grotesquerie.

In Miró we have an artist who enjoys playing with the multiple associations of biological forms. To do this successfully, he has created shapes which look at once like images of living organisms seen through a microscope and like zoological or human shapes seen with the naked eye. In addition, the general atmosphere of his pictures is such that common sense or practical reality does not intrude. Hence, although the result might appear to reflect the thinking of a child, the development of these forms and their juxtaposition call for considerable adult wit and an imagination that is almost athletic in its ability to leap across categories and reality levels. The classical quality of *Personnages rythmiques* grows out of the predominantly vertical organization of the principal shapes and the clarity and distinctness of each form. Although the shapes seem to wriggle, they wriggle in an assigned area. Notwithstanding the suggested movement and playfulness of the forms, there is an overall sense of control, of fun in a universe designed according to rules devised by the artist.

The late William Baziotes (1912–1964) had a strong affinity with the biomorphic, as in the painting *Pompeii.* His work exhibits an extraordinarily sensitive perception of the quiet vitality to be found or imagined in all things: the rocks in a landscape or the cracks in a plaster wall. In Baziotes's pictures, as in dreams, inanimate objects acquire biological life. Although Baziotes was a superb colorist who could intrigue the eye with almost imperceptible changes of surface, of modeling, and of edge, the interest of his pictures does not cease with their surfaces: he animated the shapes in *Pompeii* by endowing them with the most subtle and gentle movement—an effect that calls for considerable craftsmanship in control of pigment and sensitivity to line. Such works speak very

JOAN MIRÓ. *Personnages rythmiques.* 1934. Kunstsammlung Nordrhein-Westfalen, Düsseldorf

WILLIAM BAZIOTES. *Pompeii.* 1955. The Museum of Modern Art, New York. Mrs. Bertram Smith Fund

VICTOR LUNDY. St. Paul's
Lutheran Church, Sarasota,
Florida. 1959

The visual analogy between Weston's artichoke and Lundy's church eloquently
demonstrates the biomorphic source of the feelings of security generated by the
man-made structure.

EDWARD WESTON. Photo-
graph of halved artichoke.
1930

quietly but may endure longer than more blatant painterly statements. It is the restraint and control of Baziotes's work which endow it with a classical quality: thus, we see formal order in the work of an artist who is an abstractionist, but who is nevertheless interested in living things, and who animates painted surfaces with gently controlled movement.

In architecture, biomorphic order has received fresh impetus from new materials and construction devices. Collapsible domes whose skins are curved metal hemispheres; shells made of concrete sprayed over inflated balloons; ribbed arena ceilings possessing an almost botanical delicacy and grace; and paraboloid roof structures combined with daring suspension systems—these have liberated designers from their agelong reliance on rectangular and triangular shapes (see Chapter Thirteen, especially pp. 578–83, 589–90). Of course, the dome, which has always expressed biomorphic impulses, is an ancient device going back to the early tumulus, or burial mound. It was never a frivolous form but rather a shape associated with man's wish to be inside a womblike enclosure: either the artificial grave mound uniting him with an all-embracing Earth Mother or the curved ceiling of his church, the dome of the heavens, symbolizing the encircling, benevolent, maternal universe. These structures combine formal order with symbolic meanings which are ultimately religious and biological.

Frank Lloyd Wright wrote about and practiced what he called an "organic" philosophy of architecture—one in which buildings assert their kinship with nature through their rugged materials and cavelike spaces. But only in the Guggenheim Museum did he base his design quite openly on the structure of a natural object: the building is like an enormous nautilus shell; within, the visitor easily descends a spiral ramp, building serried memories of nonobjective art at a somewhat faster rate than the sea creature builds its spiral chambers, one a year. The principle of development followed by the nautilus and the museum visitor is the same: each creature moves on when his physical or imaginative space has been fully occupied.

Wright's biomorphism is followed in other contexts. Just as the gently descending ramps of the Guggenheim manage the aesthetic transformation of today's "man on the go," the modern parking garage changes him from motorist to pedestrian, using the same architectural forms to create a niche for his gasoline-driven chariot. Such a garage is a sort of automotive Guggenheim whose outer skin has been stripped away. Progress along its ramps might be compared to the life journey of the nautilus through its shell; but here, as in the museum, it is a greatly accelerated journey. Nevertheless, the same biomorphism suffices. Man has created a gigantic, concrete sea shell, holding within its carved recesses thousands of nests for gasoline engines, temporarily still.

PIER LUIGI NERVI. Interior roof detail, Little Sports Palace, Rome. 1957

EERO SAARINEN. Ingalls Hockey Rink, Yale University, New Haven, Connecticut. 1958

Build thee more stately mansions, O my soul,
As the swift seasons roll!
Leave the low-vaulted past!
Let each new temple, nobler than the last,
Shut thee from heaven with a dome more vast,
Till Thou at length are free,
Leaving thine outgrown shell by life's unresting sea!

OLIVER WENDELL HOLMES,
"The Chambered Nautilus"

FRANK LLOYD WRIGHT. Interior, The Solomon R. Guggenheim Museum, New York. 1959

GEORGE A. APPLEGARTH. Downtown Center Garage, San Francisco. 1955

The nautilus image offers a strangely fitting description of biomorphic order and the use to which it is put by our civilization. The pedestrian emerges from the concrete shell, like a butterfly emerging from its chrysalis. But, to shift the metaphor slightly, the motorist is a moth, governed by lights, whereas the butterfly can wander about freely.

AESTHETIC ORDER

Aesthetic order is the style visible in works which achieve balance and stability mainly through the organization of their sensuous qualities. An artist can adjust the various surface appeals of a work so that we experience what is often called its "beauty." Aesthetic order does not rely on visual resemblance, truth, or symbolic power. Rather, it depends on the human capacity to prize and admire what is directly and immediately satisfying in itself and for no reason beyond itself. The simplest analogy is our satisfaction in the taste of food apart from considerations of nourishment or health. Such satisfactions do not occur because they mean something, look like something, or because they are particularly useful. They make an appeal to something within us which responds with the emotion of delight. Perhaps there is some optimal organization of perceptual energies which works of aesthetic order encourage, leading to an experience which leaves us gratified without knowing why.

The Breakfast Room by Pierre Bonnard (1867–1947), for example, is a work by a later Impressionist who relied on coloristic invention to orchestrate a symphony of quiet, chromatic delight. Although he benefited from the color experimentation of the Impressionists, Bonnard did not have their scientific motivation. He was more concerned with weaving a tapestry which was partly suggested by the color of the objects before him but more nearly created by his own imagination and painterly facility. The table and the objects on it, the window, the fragmented figure to the left, and the scene through the window are only nominally established. They constitute an opportunity for the artist to create a multitude of variations on yellow, yellow green, yellow orange, violet, blue violet, and so on. Deep space is only casually represented; the drawing is very perfunctory. Most of the color does not "move" in or out of the picture space; rather it tends to shimmer and coruscate on the surface of the canvas.

It is interesting that painters such as Bonnard do not especially attempt to remind us of the appearance of trees, sky, fruit, and tableware. The material we are chiefly aware of in their work is the material of which the work is made—in this case, oil paint. Bonnard and his great predecessors such as Monet, Renoir, and Degas educated us through our eyes to a delight in pigment and in color quite apart from what they represent.

The Appeal of Sensuous Surfaces

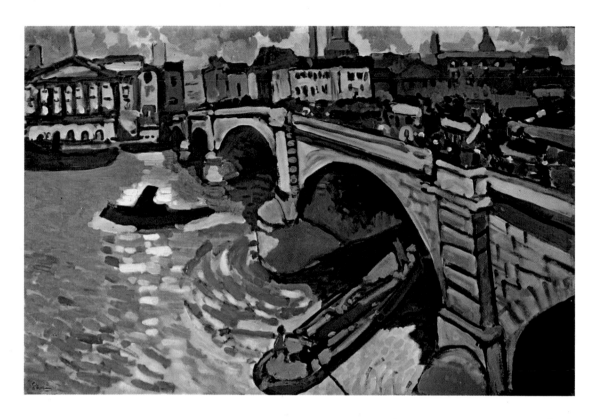

ANDRÉ DERAIN. *London Bridge*. 1906. The Museum of Modern Art, New York. Gift of Mr. and Mrs. Charles Zadok. There is an attempt here to separate color as a sensation from particular colored objects; color must convey the emotional truth of an experience, not merely its appearance.

PIERRE BONNARD. *Le Compotier blanc*. 1921. Acquavella Galleries, Inc., New York. If the viewer salivates, it is mainly because of the juicy colors, not the juicy fruit.

MORRIS LOUIS. *Moving In.* 1961. Private collection, New York. Through the management of fluid, overlapping stains on unprimed canvas, the characteristic mark of the brush—hence of the hand—is bypassed. We respond to a moist, multichrome mist, seemingly created by nature, not man.

PAUL JENKINS. *Phenomena in Heavenly Way.* 1967. Collection Mr. and Mrs. Jack Stupp, Don Mills, Ontario. Wetter than the Louis work, this has more puddle and flow. As the hand and brush become more remote, we enter a world of hydrodynamic engineering made gorgeously visible.

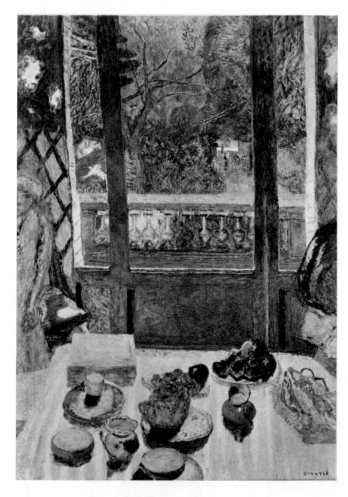

PIERRE BONNARD. *The Breakfast Room.* c. 1930–31. The Museum of Modern Art, New York

GEORGES BRAQUE. *Woman with a Mandolin.* 1937. The Museum of Modern Art, New York. Mrs. Simon Guggenheim Fund

Georges Braque, the early collaborator of Picasso, ultimately developed their common intellectual style into one of aesthetic order—an objective which occupied the greater part of his mature career. *Woman with a Mandolin* shows how the classical qualities of Cubism have been placed at the disposal of aesthetic pleasure. Compared with Bonnard, Braque is the greater designer: he more consciously and deliberately establishes shapes and areas; his organization of space is more inventive and varied. He also has a deeper interest in the differing textures of objects and surfaces; Bonnard suppresses all textures in the interest of *one* texture—one created by a single method of paint application. Braque adds sand, coffee grounds, crushed eggshells, etc., and otherwise manipulates his pigment to increase the variety of surface and tactile appeal of his canvases. He exaggerates the pattern of wallpaper, pressing it forward into the same plane as his figure, thus indicating that the sensuous qualities of the patterned wall are more important than its "correct" location in the picture space. He gives attention to the music stand almost equal to that given to the silhouette of the figure and mandolin, extracting the maximum decorative effect from each object, shape, or space presented for our vision. Notice that, as in Bonnard, we learn very little about the subject matter of the pictures: it is the opportunity subject matter creates for the artist to manipulate pattern, texture, and color which is important.

Perhaps the most elegant modern master of aesthetic order was Henri Matisse (1869–1954). His personal style was greatly enriched by the study of classical Persian art, which, as with much of Near Eastern art, emphasized opulence of color and surface and elaborate decorative detail. In painting like that of Matisse, Bonnard, or Braque, there is an almost Oriental emphasis on splendor, on subordination of expressive meaning in the interest of richness of aesthetic surface. The *Lady in Blue* by Matisse reveals the painter as a sophisticated European designer of patterns and decorative forms building on a Persian tradition. The artist's elegance derives from his ability to find precisely what he needs in the abundance before him: the ornamented furniture, the rich gown, the room interior, the lady casually sitting, a bouquet of flowers to frame her head, and pictures on the wall with somewhat classical evocations. These subject matters are present in highly simplified form; only shape has been taken from their total reality and then reassembled by the artist to create a new reality. The virtue which Matisse possesses preeminently is that of subordinating drawing, color, and design to a single pictorial effect which is meant to be pleasurable as a whole. Hence, in viewing his work, it is very important not to let the eye linger on any part of the picture by itself; one must attempt to see the entire canvas at once, to let it *fill the eye*, and then the effect of the carefully calculated quantities and intensities of color will be felt. Toward the end of his life, illness confined

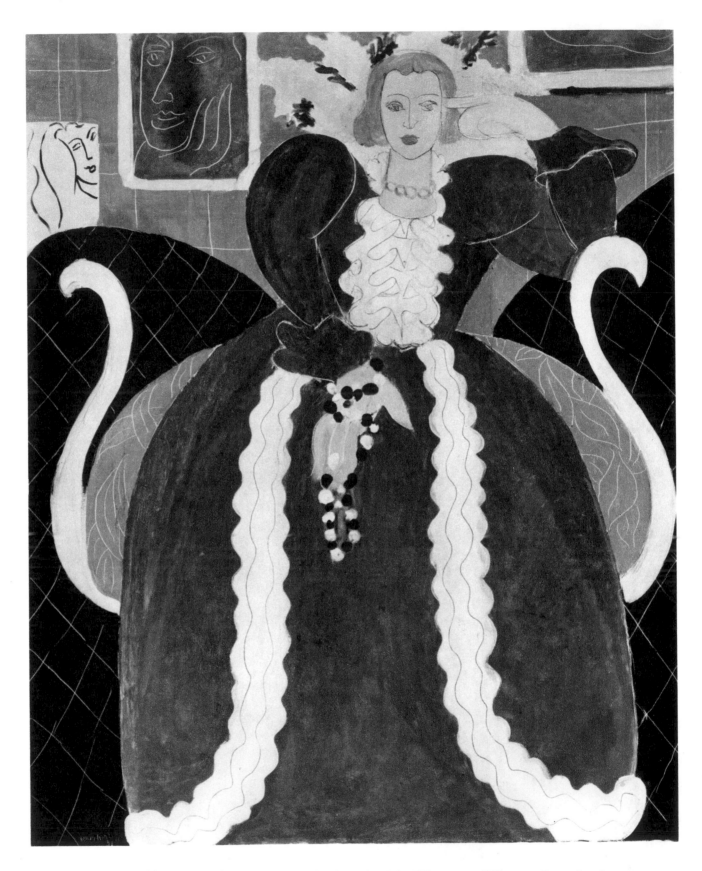

HENRI MATISSE. *Lady in Blue*. 1937. Collection Mrs. John Wintersteen, Villanova, Pennsylvania

Matisse to bed. But he continued to compose with scissors and colored paper, and in this way produced some of his most sophisticated work. This fact suggests that the artist did not rely on dexterity or sensitivity of touch, as did Degas, for example. Rather it is his calculation of quantities and shapes of intense color which is critical; likewise, his considerable experience with classical drawing enabled him to simplify, to suggest what the viewer needs to know about the subject, and to eliminate what is aesthetically irrelevant. Matisse never felt any obligation to prove that his representational powers were strong (although they were); hence he could subordinate representation and objective accuracy to the aesthetic requirements of each composition.

In sculpture, we may see aesthetic order as a primary consideration in the work of Richard Lippold (born 1915), such as *Variation Number 7: Full Moon*. In this work, the subject is light or light rays as represented by fine filaments of metal radiating from several centers, forming complex geometric shapes, and seemingly hanging suspended in space. The gold and silver filaments are so light that movements of air, or changing light in the room where the work is displayed, create delicate, shimmering effects and gentle vibrations which would seem to suggest outer space. But this construction has no scientific validity: we perceive it chiefly as an instance of aesthetic order. It has its own perfection based on precision, lightness, delicacy, and the ability to trap and distribute light harmoniously throughout its parts.

Another American sculptor, Harry Bertoia (born 1915), created for the Manufacturers Trust Company in New York City a metal screen which exploits the aesthetic possibilities of brass, copper, and nickel. Such a work departs from traditional wall-relief sculpture and more nearly approaches interior design or architecture. It serves, of course, as a partition and also as a fascinating plane against which the normal activity of a bank takes place. And because this screen wall has a primarily architectural function to perform, the sculptor has wisely decided to let the aesthetic properties of the materials dominate the space rather than create symbolic forms which would compete for the viewer's attention with the living persons and events in front of the screen. As a result, there is a mutually enhancing relation involving the room, its people, and the wall itself. Since passers-by and patrons are encouraged to see into the bank, an excellent architectural effect is achieved—the bank presents an image of openness and hospitality: its personnel and customers are complemented by the architectural space and the sculptural wall.

The concept of aesthetic order—of an art which appeals primarily to the senses without invoking ideas, symbols, or description—is closely tied to the main objectives of the abstract movement in modern art. Much of contemporary painting can be understood as an effort

RICHARD LIPPOLD. *Variation Number 7: Full Moon.* 1949–50. The Museum of Modern Art, New York. Mrs. Simon Guggenheim Fund

to develop a language which is purely visual, communicating qualities which belong to the world of line, light, shape, texture, and color alone. Painters and sculptors devoted a large part of their energies during the early twentieth century to pursuing the formal autonomy enjoyed by music and architecture. Now they have, to a considerable extent, succeeded.

In the work of such artists as Bradley Walker Tomlin, Mark Rothko, Ben Nicholson, Barnett Newman, Adolph Gottlieb, and Ad Reinhardt, a type of order has been

BRADLEY WALKER TOMLIN. *No. 10*. 1952–53. Munson-Williams-Proctor Institute, Utica, New York

HARRY BERTOIA. Screen for Manufacturers Hanover Trust Company, New York. 1954

achieved which is essentially in the tradition of Classicism—the Classicism of the Parthenon and J. S. Bach. See, for example, *No. 10* by Tomlin (1899–1953). The work of these men is almost totally abstract; its serenity is the product of calculation, simplification, and measurement. It departs from Mediterranean conceptions of order only in the absence of a canon of proportions based on the human figure. Unlike the Greeks, who required that mathematical perfection be embodied in the human form, or derivations of it, the modern followers of Classicism have put the human image aside. Instead, they rely on contemporary man's highly developed capacity to perceive abstract types of order: the order of ideas, or intellectual order; the order of living forms, or biomorphic order; and the order of sense data, or aesthetic order.

It is true that the pioneer efforts of Wassily Kandinsky (1866–1944) to develop a purely visual and abstract language of painting were Expressionistic in appearance. His swirling, amorphous colored areas could hardly be regarded as stabilized or measured approaches to formal order. But since 1912 (when Kandinsky published his book *Concerning the Spiritual in Art*), classical as well as Expressionistic developments have taken place in abstract painting. As a result, an Apollonian vision has emerged in modern painting. It is based on the perception of order in the sense data yielded by works of art which have been intentionally pruned of any other consideration. In the eighteenth and nineteenth centuries, discriminating viewers may have been instinctively aware of the order underlying the Neoclassic themes of masters such as David

and Ingres, just as seventeenth-century viewers perceived a refined structure beneath the allegories of Poussin. But not until the twentieth century did artists deliberately attempt to paint that underlying order, dispensing with objects and themes, employing only the purest data of visual perception which the art of painting could devise. It is this ambitious endeavor to create a classical style appealing directly to the visual sense which I have called an art of aesthetic order.

BEN NICHOLSON. *Painted Relief*. 1939. The Museum of Modern Art, New York. Gift of H. S. Ede and the artist

GIUSEPPE SACCONI. Victor Emmanuel II Monument, Rome. 1885–1911. An example of ponderous, overblown Classicism in a monument created to symbolize the unification of Italy.

Conclusion

Classical styles of art have been closely associated with measurement, calculation, mathematics, and geometry. But the use of geometrical shapes is not necessarily a sign of formal order. The essence of formal order lies not so much in the kinds of shapes and volumes employed but rather in an implicit attitude toward motion and stability. If forms seem to be at rest, they contribute to the sense of order; if forms appear to be moving, their motion is orderly only if it proceeds in a measured and predictable fashion. These assertions could be made about life as well as art. Parents usually learn to judge the activity of their children by the way they are moving: certain patterns of movement mean trouble; other patterns are reassuring. Of course, there are some parents for whom almost *any* movement by children signals danger and generates anxiety. According to our usual standards, such parents may be neurotic and are likely to raise neurotic children.

Extending this observation to art history, we find that in certain social and political climates there is a preference for absolute stability in the forms employed by the visual arts. The art of ancient Egypt and of Byzantium, for example, placed a premium on immobility. Should we then conclude that the art of these great civilizations reflected neurotic obsession with order? It is true that both civilizations resisted change and also managed to last as politically distinct empires for at least a thousand years. On the other hand, the sheer durability of a political state may not signify that most of its people are living what we, or they, would regard as the good life. Conceivably, the style of formal order—especially when it is an official and prescribed style—is an instrument of social control, a device for keeping the masses in awe of their

rulers. Modern dictatorships have shown a preference for a type of trite Classicism, possibly because they recognize the crucial role of order in Classicism and because they usually justify their absolute rule on the basis of society's need for discipline—a discipline imposed from above.

If the times are characterized by a great deal of confusion about standards and by individualistic behavior carried to what may be regarded as licentious extremes, then a style of formal order—in art, in manners, and in government—will seem attractive. It may even impress men as the only legitimate style. There are occasions in the lives of most people when stability seems more desirable than anything else. On other occasions, Classicism may strike them as painfully dull. From the standpoint of the health of a culture (assuming cultures can be sick or well), the opportunity for nonformal styles to flourish *along with* formal or classical styles seems vital. But in the modern world, it is not possible to decree the creation of art in *any* style with the confident expectation that the results will exhibit excellence or satisfy existing desires for something different. The underground hunger of Russian and Eastern European young people for American and Western European cultural products is a sign of the deadly boredom an official style of dated Classicism creates in that portion of a population which is most alive and hopeful of change. Sooner or later a stylistic reaction emerges—a reaction all the more extreme in its forms and ill-considered in its objectives because it has been so long repressed. The coexistence of divergent styles in free societies, then, appears to be one of the best signs, not only of a healthy culture but also of properly functioning social and political institutions.

THE STYLE
OF EMOTION

Many persons realize that the art of our time should not attempt to compete with the camera: handmade imitations of appearances have become obsolete. They also realize that most human beings have emotions and feelings they cannot or prefer not to express. Hence, they conclude that the chief function remaining for the visual arts is to create forms which a camera cannot record and to express feelings for which no other adequate language can be found. Certainly it is correct to believe that art is, among other things, a language of emotion. And usually, when we speak of art and emotion in this context, we mean strong, intensely felt emotion.

In the visual arts, certain traits commonly recur in works which stress the expression of feeling, and that is why we refer to a "style of emotion." Very often, the personality of an artist is such that he cannot "speak" in any language other than the language of feeling. Vincent van Gogh and Chaim Soutine were such men, and their paintings of people, flowers, trees, or even chairs seem to be bursting with intensity. For artists of this type, what matters most is not objective accuracy or the measured and balanced expression of order; rather, the expression of excitement, anxiety, pity, or rage—any emotion—takes precedence over all other considerations.

If we say that emotion is important to a certain kind of artist, however, do we refer to the emotion which the artist feels or to his arousal of emotion in others? Under certain circumstances, the reference might be to both. Usually, however, we have only a secondary interest in the artist's feelings; when studying art, we are mainly concerned with the way in which art *objects* are responsible for a viewer's responses. Sometimes the language used by critics to describe the emotional impact of a work may give the impression that the artist experienced the same feelings in advance of creating it. But, in fact, he may or may not have had such feelings. And it is not really our purpose to find out. Psychologists, of course, are interested in the connection between an individual's emotional life and his creative expression. Sigmund Freud's study of Leonardo da Vinci was, in part, an effort to explain the artist's work on the basis of psychoanalytic inferences about Leonardo's personality. In addition, certain theories of art criticism are based on the assumption that there is a close connection between artistic ex-

cellence and *genuineness* of emotional expression; that is, on whether the viewer is convinced that the artist truly experienced the emotions embodied in his work. The study of style, however, focuses more sharply on the art object than on the artist's behavior. When examining a work of art, the viewer ought to be somewhat selfish: he should be more interested in *his own* biography and *his own* emotions than in those of the artist. He should ask, "Does the work convince me of the reality of the world it attempts to create?" rather than, "Did the artist really undergo the emotions portrayed here?"

This latter observation raises an important question dealt with by aesthetics: Are emotions actually *portrayed* in a work of art, or do we merely project our personal feelings upon the art object? (The problem is dealt with in some detail in Chapter Ten, *Perceiving the Elements: Aesthetics*. However, a provisional answer is needed now if the discussion of an emotional style is to be understood.) There are, of course, differences of opinion about what constitutes the "expression of emotion" in art. The view taken here follows, in general, the position of the Gestalt psychologists: namely, that there are structural similarities between the neuromuscular behavior of a viewer and the physical features of the art object he is examining. Certain configurations of line, shape, and color induce corresponding kinesthetic reactions in perceiving organisms. Emotions are the names the viewer gives to his neuromuscular reactions—his feelings—which have been triggered by the organization of elements in the art object. The *energy* for such feelings or emotions comes chiefly from the viewer, but the feelings are given form, they are *organized*, by the work of art. Consequently, the answer to the question raised above is yes and no. In the sense that emotions are *caused* and *shaped* by the art object, they are *portrayed* in it. But, of course, only a living organism, specifically a person or a higher animal, can *experience* emotion.

Perhaps this theory of emotional perception in art accounts for the communication of feelings between an art object and a viewer. Yet what we are trying to discover is whether there is a *style* of emotion. Is there any difference, so far as aesthetic perception is concerned, between works belonging to this style and those in a style discussed earlier—the style of intellectual order, for example? The mechanisms of perception are the same, but there is a difference in the viewer's *disposition to behave* on the basis of his neuromuscular reactions. That is, a painting by Mondrian disposes him to stand still or sit, or to measure spatial intervals; a painting by Van Gogh disposes him to discharge energy through his limbs, to move toward the work, or perhaps to clutch at the air around him. Why does Van Gogh have this more massive, overt, and physical effect on the viewer? It is because Van Gogh's painting has structural similarities to the neuromuscular behavior which the human organism, going back to tis

primitive origins, has always regarded as a signal to move —to run, to leap, to dance, to bob and weave, and so on. The Mondrian stimulates behavior which is more recent in the development of the human organism—perhaps as recent as man's discovery of agriculture: the measurement of property, the laying out of fields for cultivation, the calculation of dates for planting, the estimation of weight and bulk with the eye. When the eye is used to measure, it performs a more intellectual task than when it signals the organism to run or fight. Consequently, the difference between an emotional and an intellectual style can be understood as: (1) a difference in the "signals" which the work of art transmits to the viewer; (2) a difference in the viewer's disposition or readiness to act on the basis of the "signals"; and (3) a difference in the type and magnitude of neuromuscular behavior induced in the viewer, behavior based on involuntary habits or reactions inherited from the development of the human species.

There are also differences *within* the style of emotion. That is, works of art have the capacity to arouse a *range* of feelings and dispositions in viewers—all of which are emotional but differing individually in their content. It is obvious that we can be elated by one work and depressed by another. Each particular emotional response may be caused by the subject matter or theme of the work; or it may be due to the type of aesthetic "signal" the work transmits. For example, abstract art often has no apparent subject matter, yet it can cause complex emotional responses. Something in the visual organization of abstract works must be responsible for the emotional reactions of viewers. Consequently, we shall be dealing, in the rest of this chapter, with *two* sources of emotion in works of art: thematic or subject-matter sources, and organizational or design sources.

The style of emotion properly designates works which rely on *any* means of arousing feelings in a viewer. Usually, its most stirring exemplars reveal the mutual influence of theme *and* design, resulting in a heightening or intensification of emotion. Examples might be observed in the *Side of Beef* by Chaim Soutine and *The Bat* by Germaine Richier (1904-1959). Both subjects are distasteful, and the organization of forms in each case reinforces our normal feelings of revulsion—feelings clustered around the idea of slaughter, or attack by a hideous creature. On the other hand, Henry Moore's *Falling Warrior* deals with killing, too, but his simplification of forms and his freezing of movement divests the sculpture of any gory or horrific qualities the theme might ordinarily have. In other words, what we know about Moore's theme does not interfere with the formal order of his sculpture. The warrior's limbs are posed in a type of classic ritual—a ritual which associated nobility with a valorous death on the battlefield. But the carcass by Soutine dramatizes the dumb, mutilated character of the eviscerated form which once housed organic life. The

GERMAINE RICHIER. *The Bat.* 1952. Whereabouts unknown

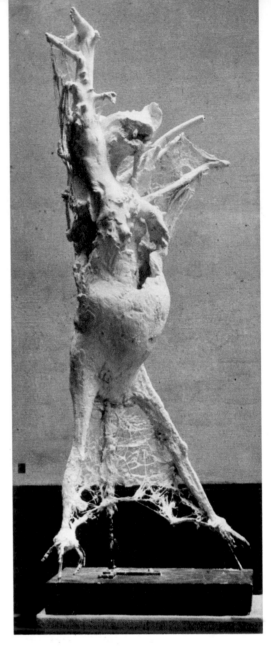

CHAIM SOUTINE. *Side of Beef.* c. 1925. Albright-Knox Art Gallery, Buffalo, New York

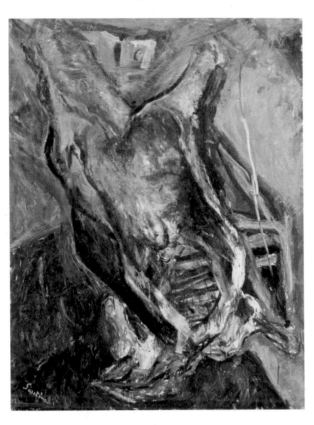

HENRY MOORE. *Falling Warrior.* 1955–56. The Joseph H. Hirshhorn Collection

carcass records the slaughter of a beast, not the slaying of a hero.

Richier's bat, with its webbed limbs radiating from a mammalian trunk, strikes a note of primeval terror because of some instinctive fear it arouses in humans. At the same time, its resemblance to the human is openly stressed by the artist to arouse mixed emotions in the viewer—emotions of dread and recognition. In this case, design is assisted by the *manipulation of symbolic meanings* to mount an assault on the viewer's feelings.

Themes of violence and an interest in mutilated forms are not uncommon features of the art of this century. However, we are not concerned merely with discovering whether we like or dislike these style features in contemporary art. Instead, we want to examine them to gain some insight into the kind of world we live in. If art reflects the times as well as the personalities of artists, it is worth serious attention whether we enjoy it or not. Certainly, our study of the style of emotion should help us to see what it is about life in the twentieth century which leads to the expression of terror and despair—or possibly even the expression of hope and joy.

Romanticism and Emotion

Although almost all works of art generate feelings in the viewer, whether intentionally or not, some appear to have been created largely *in response* to an artist's strong emotion, an emotion he was anxious to express. His attitude is unlike that of the artist working in an objectively accurate style: as a rule, the latter type of artist suppresses the revelation of personal feeling in his work and is indifferent to any emotion an audience may experience in its presence. A prominent feature of the style of emotion, however, is the apparent desire of the artist to *disclose*, even to *parade*, his feelings as frankly and as forcefully as possible.

The attitude of emotional candor, of giving primacy to the requirements of personal reactions, is also part of what is called Romanticism. The Romantic tends to believe that the important feature of any event, person, or place is *his* feeling about it. The claims of truth or of fact seem less urgent since his feelings are themselves facts: truths are emotions which are intensely felt or expressed. Many of us sometimes speak of individuals as "losing themselves" in some project or idea, and this ability to "lose" oneself is characteristic of the Romantic also. We may on occasion speak of such a person as losing his "sense of proportion." Looking at Romantic art, it is not difficult for the viewer to feel *lost* in the work, to lose his "sense of proportion," that is, the common-sense idea of the correctness or rightness of things. The paintings of Henry Mattson (born 1887), as in *Wings of the Morning*, encourage the viewer to feel drawn into the sea. He exhibits the typical Romantic reluctance to distinguish between subject and object, between the observer and observed. The ocean is shown not merely as a body of water but as a mysterious world in which we could somehow live. By contrast, Winslow Homer (1836–1910), who also painted the ocean with great power, did not try to convey an idea of the sea as a complete cosmos, a place in which the soul could wander endlessly.

Another feature of Romanticism is its interest in the exotic, the strange, and the dangerous. Romantic artists

HENRY E. MATTSON. *Wings of the Morning*. 1936. The Metropolitan Museum of Art, New York. Arthur H. Hearn Fund, 1937

WINSLOW HOMER. *Northeaster*. 1895. The Metropolitan Museum of Art, New York. Gift of George A. Hearn, 1910

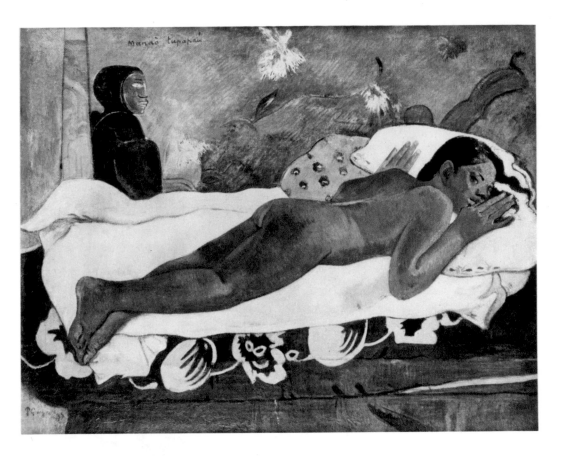

PAUL GAUGUIN. *The Spirit of the Dead Watching*. 1892. Albright-Knox Art Gallery, Buffalo, New York. A. Conger Goodyear Collection

have often been attracted to far-off lands, as Paul Gauguin (1848–1903) was to Tahiti. Unfamiliar places and customs create the opportunity for the artist, and for us as viewers, to forget our present lives and environments: we can *lose* ourselves in a distant place, at least imaginatively. The emotion of wonder or of amazement is deliberately encouraged. Gauguin's *The Spirit of the Dead Watching* (1892) perfectly fits the requirements of Romantic art: Tahiti is an exotic place; its people are simple and unsophisticated—especially to a European, a Parisian; fantastic flowers and a mysterious inscription, "Manao Tupapau ("The spirit of the dead remembers her")," occur in the background. Most important, an atmosphere of supernaturalism is an integral part of the picture. Yet the dark figure in the background resembles, as does indeed the entire composition, the very un-Romantic work by Manet, *Olympia* (1863), illustrated on page 309.

In contrast to the exoticism of Gauguin, there is the dreamlike and somewhat threatening world of the American painter Darrel Austin (born 1907). His work illustrates the fascination which the idea of violence has for the Romantic imagination. *The Black Beast* shows a fierce jungle cat at rest with a dead bird under her paws, both set in an eerie, marshy landscape. The animal seems to glow because the painter has illuminated her from below, creating a luminous, incandescent effect. Also, his paint is applied with a palette knife in thick ribbons of relatively unmixed color, so that the surface is exceed-

ingly active and exciting, in contrast to the serenity of the animal in the night landscape. The source of Romantic emotion in this picture lies in the juxtaposition of the beautiful but fearsome jungle cat with the mangled bird. Thus the artist suggests the duality of natural beauty: killing and suffering exist side by side with satiation and a type of majestic repose.

Another treatment of the Romantic theme of animal savagery lies in *Animals* by Rufino Tamayo (born 1899). Here there is no contrast between repose and killing: the animals are not satiated; a few bones of their victims are shown while they howl for new prey. The artist's manner is more primitive and at once more abstract than Austin's; indeed, the animal heads owe something to the images of destruction in Picasso's *Guernica* (p. 62). Tamayo's scene is more tropical than Austin's; he achieves his effects through large areas of flat, warm color set among menacing black shapes. We might contrast the essential attitudes of the two artists by saying that Tamayo is chiefly impressed with the pure, unalloyed savagery of his animals while Austin views the beast sentimentally although he knows she preys and kills.

In sculpture, a complex Romantic work exhibiting mixed emotions is seen in *Spectre of Kitty Hawk* by Theodore Roszak (born 1907). The artist has invented a frightening creature which we might regard as pure invention if we did not know of its origin in the pterodactyl, an extinct predatory bird. Using steel, bronze, and brass,

DARREL AUSTIN. *The Black Beast*. 1941. Smith College Museum of Art, Northampton, Massachusetts

RUFINO TAMAYO. *Animals*. 1941. The Museum of Modern Art, New York. Inter-American Fund

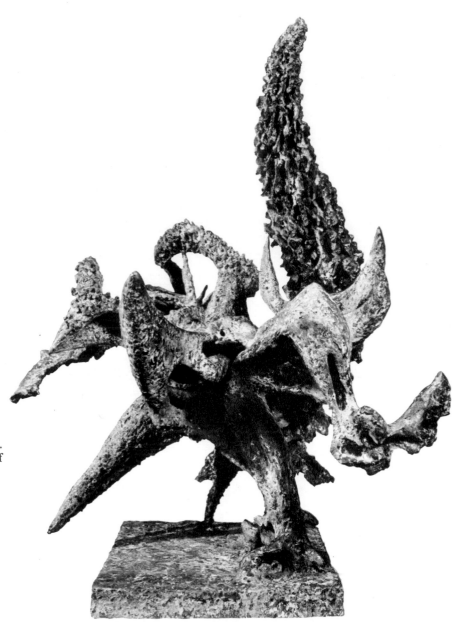

THEODORE J. ROSZAK.
Spectre of Kitty Hawk.
1946–47. The Museum of
Modern Art, New York

Roszak has built a flying monster which suggests the mixed consequences of the invention of flight at Kitty Hawk. Without the title and our knowledge of what the Wright brothers first achieved at Kitty Hawk, would this work hold its significance? Probably we should still experience a similar set of emotions since the idea of a predatory bird is strongly communicated through the head and claws; also, the wings, body, tail, and remaining anatomical features hint at the airplane—perhaps a crashed plane. Finally, the hard, refractory material, which is hammered and brazed, suggests the metallic glint of a flying bird-machine.

The use of a literary or historical title is also characteristic of Romantic art, since the intent of the artist is to heighten and intensify our emotional reactions to the forms with any assistance from mythology, history, or literature that he can legitimately include. Some artists of little creative power, craftsmanship, or formal invention may rely too heavily on titles, symbols, and literary

association to communicate with the public. In Roszak, however, we have a superb craftsman who works metal directly, achieving organic effects as easily as if he were modeling in clay. His forms—seen as a whole and apart from what they represent—possess an awesome, abstract power. Their jagged shapes, radiating out from the fuselage or body, imply danger and flight at the same time. This unity of form and meaning is what characterizes a successful work of art.

Because the Romantic artist deals with pure forms as well as with associations and symbols, he undertakes large risks as he attempts to control a complex vehicle of communication in the creative enterprise. The dangers of a trite or easily dated sentimentality are very great. For example, some works of the great Romantic masters, such as Delacroix and Géricault, may seem to us excessively melodramatic. However, *The Raft of the Medusa* by Géricault and the *Entrance of the Crusaders into Constantinople* by Delacroix survive as important works be-

THÉODORE GÉRICAULT. *The Raft of the Medusa*. 1818–19. The Louvre, Paris

EUGÈNE DELACROIX. *Entrance of the Crusaders into Constantinople*. 1841. The Louvre, Paris

cause of their magnificent formal organization and powerful execution. Their forms carry conviction long after their themes cease to be interesting.

Although Romantic art satisfies certain psychological needs of the artist and endeavors by any means to generate emotional reactions in the viewer, its genuinely great and enduring works survive only if they can make a contemporary sensory and formal appeal. That is why an emotional temperament or strongly held convictions

on the part of an artist will not by themselves guarantee artistic excellence. The general public can be fascinated, excited, or shocked into admiration of works which are merely sensational. That is, their symbolic or literary meanings may be so strong as to obscure weakness of organization, craftsmanship, and formal invention. With the passage of time, though, sensational effects diminish in power. Then a more just assessment of the artist's real achievement is possible.

The Role of Distortion

The style of emotion relies heavily on distortion because a viewer's feelings are readily aroused by any departure from what is considered "normal" or visually "correct." Particularly with respect to distortion of the human body, we find our attention arrested and our emotions immediately involved. But distortion of other themes— objects in the natural or man-made world—also arouses the viewer, since there is an inevitable tension between what we "know" to be the case and what we see represented as presumably faithful to reality. By "distortion"

we usually mean stretching, twisting, enlarging, or otherwise deforming the customary shape and size of things. But distortion may also refer to exaggerating color and illumination, increasing the contrast between light and dark, or overstating textural and surface qualities. Generally, the artistic choice of one or several of these types of distortion is not so much a calculation as a spontaneous and largely unconscious result of an artist's affective attitude toward his subject.

Because of his personality or because of his training,

Distorted photograph of a man

The high-speed camera reveals distortions we do not normally see, or it can be manipulated to create a distorted image. In either case, the viewer feels an impulse to imitate with his body what he sees. Thus, emotions that are based on visual signs are generated within him.

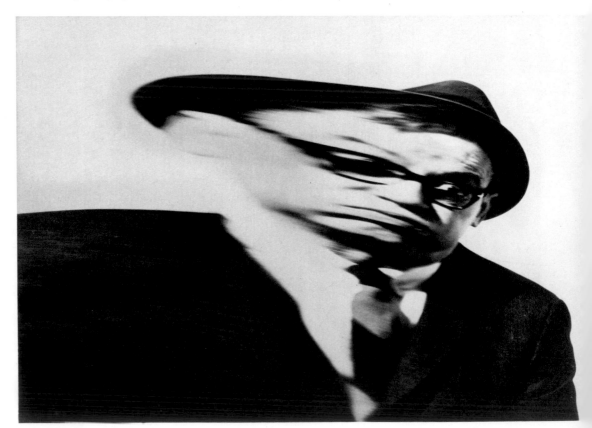

an artist may characteristically enlarge or suppress certain anatomical features; or he may prefer to view his subject when it *seems* agitated and deformed. Even a photograph can exhibit distortion if the subject is viewed at an atypical moment or from an unusual angle of vision. Michelangelo most notably portrayed the figure in writhing attitudes, employing particularly his famous *contrapposto*—an extreme twisting action through the trunk, shoulders, and pelvis. Some of the apocalyptic feeling of his *Last Judgment* fresco in the Sistine Chapel is due to the representation of muscles in tension. The viewer feels such tensions physically and emotionally. Michelangelo also tended to reduce the size of the head, except in his *David*, where the slightly oversized head and hands help describe the subject as an adolescent. Gauguin enlarged feet and drew their contours somewhat awkwardly so as to suggest the primitive quality in the people he represented. Toulouse-Lautrec, one of the great draftsmen of modern times, distorted his cabaret people with extraordinary wit and *accuracy*—accuracy because he approaches but does not fall into caricature: his delineations are truthful; his exaggerations are based on observation rather than the need to ridicule; they have a sure grasp of the characteristic forms that reveal character and type.

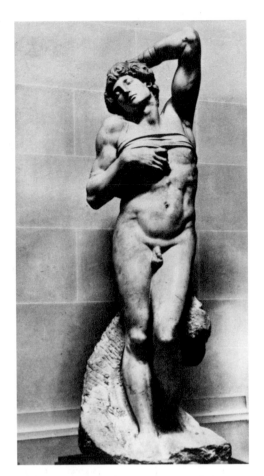

MICHELANGELO. *Heroic Captive*. 1514–16. The Louvre, Paris

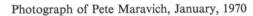

Photograph of Pete Maravich, January, 1970

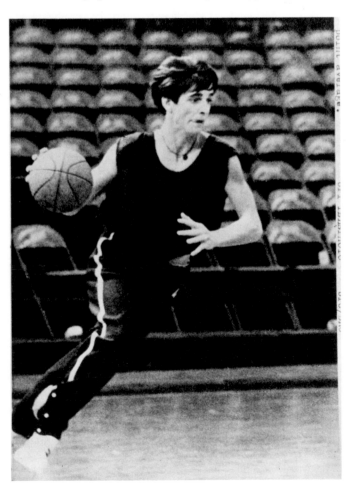

MICHELANGELO. Detail of *The Last Judgment*. 1534–41. Sistine Chapel, The Vatican, Rome. The flyed skin of St. Bartholomew provided Michelangelo with a plausible excuse for showing his own contorted face and what he felt to be his miserable and unworthy soul.

EDGAR DEGAS. *Pouting*.
1873–75. The Metropolitan
Museum of Art, New York.
Bequest of Mrs. H. O.
Havemeyer, 1929

Why does the Degas painting appear detached, matter-of-fact, and unemotional
compared to the Lautrec? Because Degas portrays optical effects while Lautrec,
also a keen observer, involves our feelings through more animated contours and
a more active paint surface.

HENRI DE TOULOUSE-LAU-
TREC. *À la Mie*. 1891.
Museum of Fine Arts,
Boston. Purchase, S. A.
Denio Fund and General
Income for 1940

Distortion has many purposes: it may be sardonic observation and pity in Lautrec, anxiety in Munch (p. 243) and Soutine (p. 34), and a kind of isolation and despair in Giacometti (p. 19). Van Gogh, as mentioned earlier, seems to have distorted unconsciously as a result of his intense preoccupation with color and pigment and because of an almost mystical projection of himself into the places and people he painted. The distortion of Francis Bacon (p. 244), the English painter, results in a macabre effect, suggesting that beneath man's civilized surface the mentality of a savage is in command. Some distortion is quite pleasant: the attenuated figures of the German sculptor Lehmbruck (p. 184) endow the adolescent form with gentle harmony and grace. Modigliani's stretching of the figure and simplification of contours (p. 25) results in a heightening of sensuous and pleasurable qualities. But it is interesting that both these artists would be described as Classicists. Distortion in their hands is mainly attenuation for the sake of refining form, the elimination of incidental detail which would oppose the sense of eternal stability and poise. Even Modigliani's erotic nudes are endowed with a certain dignity, a kind of aloofness, because of the purity of line and simplicity of the large forms he uses to describe them.

Caricature employs distortion, but it has a different purpose from that of other art genres. Caricature is mainly intent on ridicule of its object; consequently it subordinates artistic and factual considerations to the prime objective of making its target appear ugly, preposterous, hateful, or unnatural. (Indeed, the German word for ugly, *hässlich*, also means hateful.) In *The Senate* by William Gropper (born 1897), caricature is evident in the figure of the politician as exemplar of rant and bombast. We see gross exaggeration of gesture; an active, noisy figure juxtaposed with one asleep; a speaker with an overlarge mouth, large stomach, and bald head, self-important, but having no influence on his potential audience. The senator is a stereotype of the politician who persuades no one with his flatulent oratory—and yet his perception of the office and of his role seems to require the performance. The painting is a caricature since the situation is greatly oversimplified; it is an exaggeration of the truth because it is meant to arouse our derision and indignation. In Jack Levine's *Welcome Home* (1946), distortion is employed in a more artistically complex and thematically developed work. Here, too, the physical traits of the persons in the painting are held up to ridicule and contempt: we are encouraged to see their bodies as the physical containers of moral vices: pride and gluttony. At the same time, the artist makes sure that moral deformity is joined with social eminence. He lavishes attention on the details of the sumptuous meal; the obsequiousness of the waiter; the elegant dress of the diners; the female diner, upper left, who combines the signs of wealth and status with emaciated glamour. Noteworthy

WILLIAM GROPPER. *The Senate*. 1935. The Museum of Modern Art, New York. Gift of A. Conger Goodyear

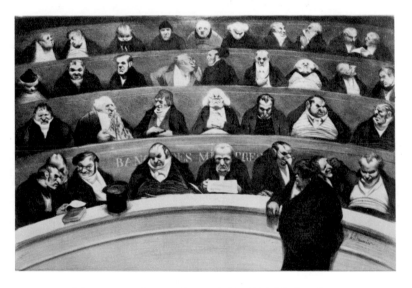

HONORÉ DAUMIER. *The Legislative Belly*. 1834. National Gallery of Art, Washington, D.C. Rosenwald Collection. Gropper's theme one hundred years earlier.

also is Levine's use of foreshortening and a distorting perspective to enlarge the heads; the view from above lets us "look down" on the celebrities and hence feel superior to them as they gorge themselves—middle-aged heroes celebrating a victory won with the lives of boys who lived on K rations. The kind of satire that Levine practices calls for a tremendous capacity for indignation and a willingness to deform his targets remorselessly. Oddly enough, corruption and hypocrisy must have a

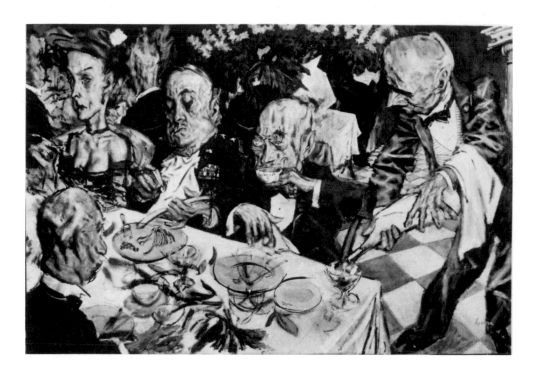

JACK LEVINE. *Welcome Home.* 1946. The Brooklyn Museum. J. B. Woodward Memorial Fund

To create satire, indignation is not enough: acute observation and intense, if hostile, analysis are also required.

JACK LEVINE. *The Banquet.* c. 1938–39. Addison Gallery of American Art, Phillips Academy, Andover, Massachusetts

certain fascination for the satirical artist, and he seems to love the signs of grossness and deterioration. Levine brings consummate painterliness—a Rembrandtian fascination with light and flesh—to the task.

Distortion, then, is among the most necessary artistic devices, playing an especially large role in satiric art as well as in the comic and grotesque. Among classical artists it is used for the refinement and purification of forms, as in Lehmbruck or Modigliani; among the Romantics, it is a means of intensifying emotional reactions. Many artists distort unconsciously because of a deeply personal manner of seeing and executing, or because their feelings toward a subject are exceedingly strong. Intense emotions such as love or indignation reduce anyone's capacity to express himself accurately. But objective accuracy is not a goal of Romantic art; passionate expression is. Consequently, if there is any single characteristic which is most commonly visible in the style of emotion, it is the liberal employment of distortion. Through distortion the artist shocks the viewer into a mode of perception different from his habitual mode of seeing. Distortion ensures that emotion rather than the "clear light of reason" will govern the transaction between an art object and the persons who examine it.

Anxiety and Despair

Because men in the twentieth century have known at least two terrible wars and live with the knowledge of their possible extermination in a third, it is not surprising that art has expressed their symptoms of fear and their feelings of hopelessness. The style of emotion also describes man's periodic lapses into depression, his feelings of doubt that the world can ever right itself. Artists, like philosophers, scientists, and theologians, try through their work to explain what is happening to the human species. Some condemn the social or economic conditions which make war possible; others look to the cause within man himself. Some artists do not attempt to explain the sources of their anxiety: instead they express its consequences. For example, they create images of struggle and slaughter; they stress the ugly features of human nature; they dwell on the persistent failures of civilization: poverty, injustice, and disease. They fashion works which express the difficulty of practicing love of mankind in a depersonalized society. For such artists, pictorial organization, design, and formal order seem less urgent than externalizing their inner crises.

There is an eloquent modern tradition of artistic protest against the inhumanity of war itself, from Goya's

EDVARD MUNCH. *The Scream.* 1893. National Gallery, Oslo

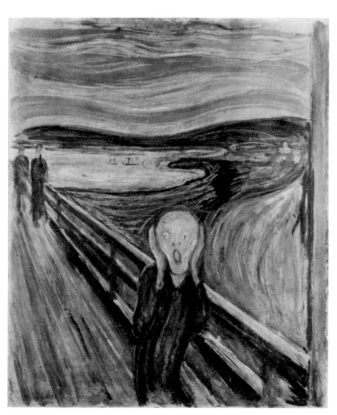

Disasters of War etchings to Picasso's *Guernica*. But beyond that, what might be called the side effects of war, or preparation for it, are felt in many unhappy ways, and these are inevitably present in visual art. In addition, there is a despairing art which is related only to personal grief or suffering without any apparent social or institutional connection. An example of this type of individual malaise or despair is *The Scream* (1893) by the Norwegian artist Edvard Munch. This painting shows a person on a bridge, hands held to the ears, with his mouth open in what seems to be a drawn-out scream or howl. We are uncertain of the age or sex of the person, and we do not know the reason for his grief. There is something deathly about the face, as is true of most of the people in pictures by Munch. The silhouettes of two anonymous figures on the bridge symbolize the indifference of the world to the private tragedy of the subject. The drawing is very generalized; the lines of sky and harbor seem to be echoes of the cry. Munch used the most economical means to describe what seemed to him the essential suffering and pain of life. He was an inventor of visual symbols for expressing the *inner* anguish of existence.

In sculpture, the figure *Cain* by Lu Duble (born 1896) constitutes an *external* image of torment in its extremely agonized portrayal of the Biblical personality who murdered his brother. The artist uses a powerful diagonal line to express the agitation of Cain, distorting the upturned head and out-thrust jaw to keep the diagonal force. The work is a good example of the way a dancer might use his body to express emotions of guilt and remorse. The body becomes the vehicle for externalizing the spiritual condition of its owner. There is very little subtlety in Biblical narrative; consequently this tense and dramatic portrayal seems appropriate to the moral scale of the crime and the severe character of the Biblical account.

In *Study for a Head*, the English painter Francis Bacon (born 1910) presents an image of terror—of a person on the edge of madness. Whereas the cry in the work by Munch suggests loneliness, suffering, and death, this scream is related to the savagery and pain of civilized life. The figure is displayed in the portrait format—a reasonably well-dressed man sitting in a chair. Our expectations in a picture in this kind of setting call for a study of character or the revelation of personality in repose. Instead, the connection between man and beast is emphasized. Of course, such a version of man is exceedingly disturbing; it certainly does not seem to tell the *whole* truth about the human condition. And yet Bacon has influenced many artists, even in the United States, where bitterness has not been a notable theme of artistic expression. In the so-called San Francisco school of painting, Richard Diebenkorn and Elmer Bischoff seem to have

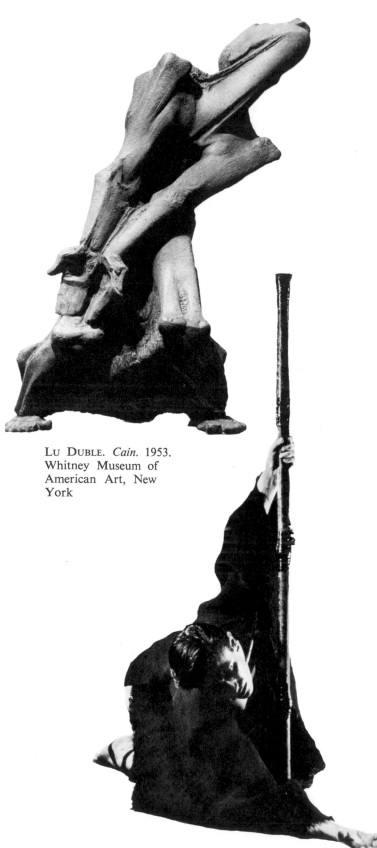

LU DUBLE. *Cain.* 1953. Whitney Museum of American Art, New York

Edward Villella in the title role of Prokofieff's *The Prodigal Son,* George Balanchine's production for the New York City Ballet Company

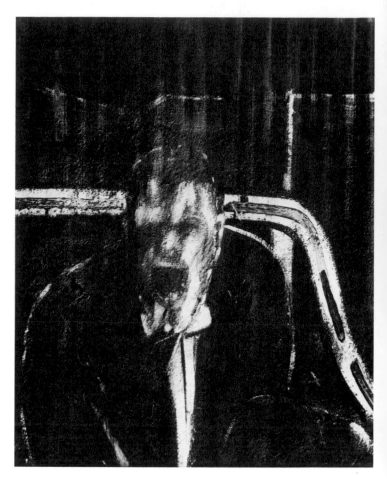

FRANCIS BACON. *Study for a Head.* 1952. Private collection

been particularly influenced by Bacon; outside the West Coast, Hiram Williams (born 1917) appears also to be attracted by the Baconian image of man. The blurring of the features and the apparently arrested movement—as in a photograph taken when the subject turns erratically—are characteristic of Bacon's work and the work of artists he has influenced. Bacon is not a particularly facile painter; he concentrates instead on the ungraceful creation of images which disturb any comfortable notions we may have about human dignity.

Rico Lebrun (1900–1964) in *Migration to Nowhere* deals with the effects of war by making a macabre dance out of the flight of its crippled victims. The artist's superb draftsmanship and theatrical imagination create a strangely ambiguous reaction in the viewer when we consider the grimness of his subject matter. Through distorted perspective he has emphasized the feet and hence the idea of flight. The distant, vacant horizon symbolizes the hopelessness of escape for these maimed figures, which lose their corporeality as they recede into the picture space. Yet there is a curious grace in their movement, in their billowing garments, in their use of crutches with the apparent skill of players in a horrible game. Compare them with the figure in a totally different

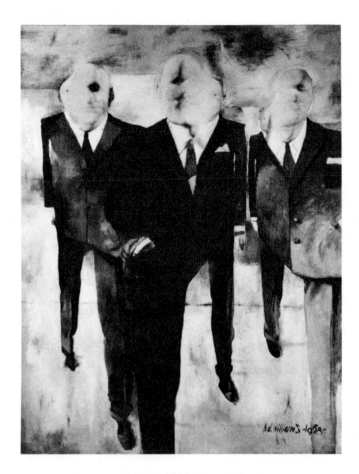

HIRAM WILLIAMS. *Guilty Men.* 1958. Collection Mr. and Mrs. Dalton Trumbo, Los Angeles

context: *See Hockey at the Garden*, a poster by Martin Glanzman for Madison Square Garden. The similarity of the figures in both works shows how danger, exertion, and grace are fused in the Romantic imagination, no matter what theme is being treated. The strategy of Lebrun's imagination ironically makes a desperate situation bearable by invoking the agility of the maimed; but Bacon finds nothing redeeming in the contemporary image of man: he wants to terrify us to the very marrow of our bones.

A subject similar to Lebrun's is treated by Ben Shahn in *Liberation*. But here, as in so much of Shahn's work, the figures are deliberately awkward; they seem maimed although they are not. Lebrun's figures, on the other hand, are graceful although they are crippled. Irony is a major quality in Shahn's work: the children play in a bombed-out setting; they pursue the normal pleasures of childhood under the most desperate circumstances conceivable. Just as Lebrun needed to discover a type of grace in deformity, Shahn gratified his aesthetic interest in design and texture through his slanting treatment of the sky, the leaning building, and the painstakingly rendered rubble. But in his drawing of the children—especially of the one full face we see—he has dwelt on hunger and pathos. By examining the children as silhouettes, noticing especially the foreshortening of the legs, we can grasp the full horror of the scene with its suggestions of broken cities and human dismemberment.

The recurrent agony of Europe during this century,

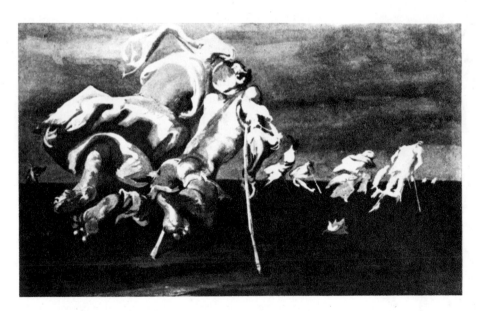

RICO LEBRUN. *Migration to Nowhere.* 1941. Whereabouts unknown

MARTIN GLANZMAN. *See Hockey at the Garden.* 1951. The Museum of Modern Art, New York. Study Collection

BEN SHAHN. *Liberation*. 1945. Collection James Thrall Soby, New Canaan, Connecticut

OSKAR KOKOSCHKA. *Self-Portrait*. 1913. The Museum of Modern Art, New York

especially in Germany, has contributed to a characteristic central European type of artistic anxiety, so well depicted in the style of Expressionism, particularly by Oskar Kokoschka (born 1886). His *Self-Portrait* (1913) reveals the typical distortions of Expressionist art: the large eyes and hand; gaunt, bony head; agitated paint application; flickering light; and a facial expression hovering between profound sadness and guilt. The hand seems to accuse the artist while his mouth endeavors to say what it is that assails and condemns him. The attenuation of the head and the restless contours of the face heighten the central idea of this work—that a man feels himself to be under a terrible judgment. Some of the same style features employed by El Greco to exalt the spirituality of the Counter Reformation in the sixteenth century become the means of expressing Kokoschka's anguish and self-doubt in the twentieth.

Perhaps Kokoschka in his self-portrait best expresses the theme of anxiety in modern man without venturing as far as Bacon. His subject remains capable of feeling responsible for, and hence guilty about, the world he lives in. One would find it difficult to attribute such feelings to Bacon's screaming man. However, the Bacon painting was created in the 1950s and Kokoschka's portrait was executed one year before World War I. Hence, on the evidence of these two works, there has been a considerable moral deterioration in our civilization; but, of course, such evidence is exceedingly incomplete and may reflect only the highly subjective opinions of two atypical observers of human nature in our time. It remains to be seen whether the expression of joy strikes as responsive a chord.

Joy and Celebration

It should not be surprising that the style characteristics which serve to express sadness and anxiety can also be employed to celebrate and to enjoy human experience. In the theater we find comic performers who also have ability as tragedians. Indeed, students of acting believe that great comedians such as Chaplin are masters of their art because they closely approach pathos and then swerve slightly to avoid it in an obvious way, meanwhile fully expressing the tragic dimensions of life. Celebration in art, however, is not *directly* related to the comic spirit; it deals rather with life's festive and exultant moments: victories over fear, consummations of love or ambition, affirmations of the goodness of being alive.

The indirect connection between celebration and the comic is visible in *Hassidic Dance* by Max Weber (1881–1961), where we see the members of a mystical Jewish sect who dance and sing to express their religious feelings of elation in the created universe. The dance is meant to be ecstatic, joyous, and genuinely reverent at the same time. And because the men wear high hats and long, almost funereal garments while dancing in a spirit of what is, for them, complete abandon, they create a somewhat comic effect. Weber has used twisted forms and a rather loose, sketchy drawing line to suggest the hectic movement, the spontaneous shouts, and the less than graceful figures of these religious enthusiasts. Much of the appeal of this work derives from the contrast between the plainness of the men, the formality and somberness of their dress, and the excitement and passion with which they throw themselves into the dance.

Using another technique to describe a totally different subject, John Marin (1870–1953) displays his typically vigorous, uncomplicated approach to the American scene. Marin worked mainly in watercolor, painting landscapes alive with movement, energy, and even the suggestion of noise. *Maine Islands* is characteristic of Marin's use of a few slashing, wet watercolor strokes to suggest the whole panorama of nature: air, sky, sun, water vegetation, and mountains. Although his style was highly individualistic, Marin's principal influence was Cubism. He used an abbreviated, notational, straight-line style which may derive ultimately from the carefully hatched planes of Cézanne. His pictures are carefully composed, although executed vigorously so that they create a slapdash impression. The generous use of the white paper and a rapid, wet brush gives his work considerable sparkle and freshness. Marin's world is a happy one: he painted a few sun rays almost as children do. His universe is untroubled, full of radiant energy; the motion and noise implied by his bright colors and active brushwork are friendly to man.

Marc Chagall is the chief modern exponent of romantic love. His paintings seem naive because they exhibit an almost childlike belief in love's power to remove anyone

MAX WEBER. *Hassidic Dance*. 1940. Collection Mr. and Mrs. Milton Lowenthal, New York

JOHN MARIN. *Maine Islands*. 1922. The Phillips Collection, Washington, D.C.

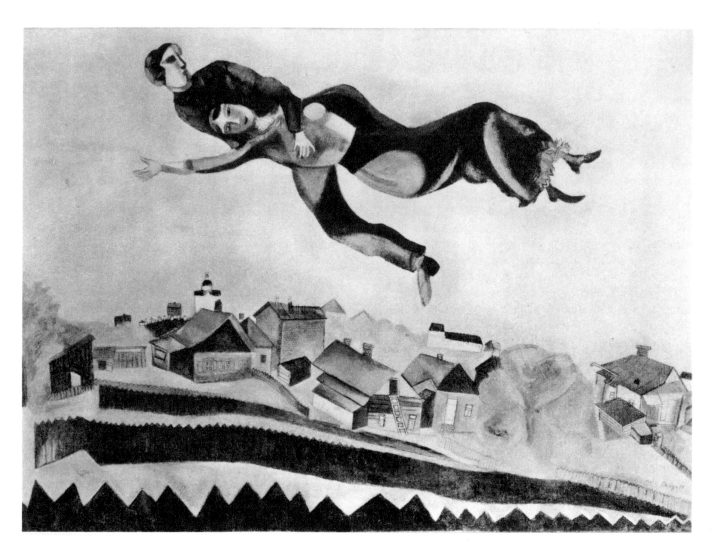

MARC CHAGALL. *Flying over the Town*. 1914. Collection Mrs. Mark C. Steinberg, St. Louis

beyond the "here and the now," the world of problems, obligations, and conflict. In *Flying over the Town* a couple floats above a village as if in a fairy tale or a dream. Chagall has been identified with Surrealism because of the fantastic and dreamlike elements in his work, but this label does not seem entirely accurate: he is not interested in shocking the viewer; his work grows out of the folk culture and the Hassidic legends absorbed during his youth in eastern Europe rather than the theoretical views developed by André Breton and his circle in Paris. He literally illustrates the beliefs of his childhood and his people: that love overcomes physical facts and mystically transports individuals despite the laws of gravity and aerodynamics. Chagall's work as a designer for the ballet also contributes to his interest in a world of fantasy and romance since the ballet is an art that is much devoted to the rituals of courtship and love. He is a joyous artist

because of his complete devotion to romantic love: its erotic aspects are very minor in his paintings although the color is rich, even sensuous. Even his portrayal of the female nude is devoid of suggestions of physical desire. Rather, his models appear to be women as conceived by the minds of children. Chagall's distinctive view of love is that it is a joy which people take in each other. It is so intense that they are liberated from terrestrial bounds: the world does not exist for them. This is an idea which anyone who has been in love can share, hence the popularity of this artist whose artistic forms are rather eclectic, deriving from Cubism, Orphism, Russian folk art, and, perhaps, individual painters like Redon and Ensor.

Eclecticism, the tendency to employ forms and stylistic devices from a variety of sources in the work of a single artist, is not necessarily a term of disapproval in connection with a personality like Chagall. His originality is

Emotion Generated by Symbols

JEAN DUBUFFET. *Leader in a Parade Uniform.* 1945. Collection Mr. and Mrs. Morton Neumann, Chicago. Dubuffet's imagery stands at the border where childhood, insanity, and hilarious burlesque meet.

PABLO PICASSO. *Fishing at Night off Antibes.* 1939. The Museum of Modern Art, New York. Mrs. Simon Guggenheim Fund. Two women casually watch the spear-killing of fish attracted to a boat by the light of the fishermen's lantern. It is a scene of rich color and dark irony: men are predators at work or play. The ladies—one executing a pirouette, the other holding her bike and eating a double ice cream cone—enjoy the spectacle.

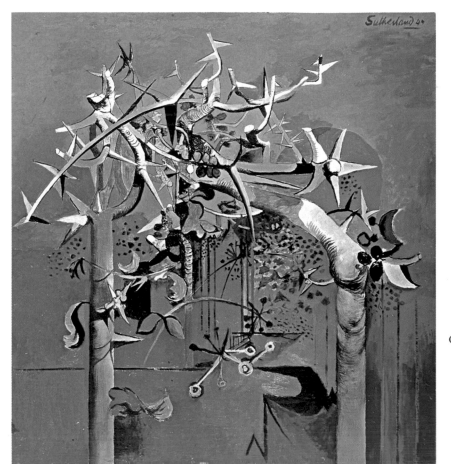

GRAHAM SUTHERLAND. *Thorn Trees.* 1945. Albright-Knox Art Gallery, Buffalo, New York. Room of Contemporary Art Fund. Sutherland has found in nature's thorns, prickles, and roots the metaphoric equivalents of what he sees as man's fundamental character: his capacity for inflicting many kinds of pain and his possession of a convoluted underground existence.

essentially poetic and literary, and consists of his highly individualistic vision of the world. All artists, of course, borrow in the process of arriving at their distinctive modes of expression. But it is important to recognize that originality of style or execution may seem less urgent to an artist than communicating effectively a certain kind of feeling or idea. The form language of Chagall is adequate for his theme since his dreamers and lovers are acceptable and credible to the viewer. Very rich color and a type of primitive drawing combined with associations of theatrical sets and lighting are probably the principal devices which encourage us to abandon our logical, "everyday-life" mode of seeing in the presence of his work.

How does architecture deal with the themes of joy and celebration? It is difficult for a building to illustrate dancing or flight since it must, before anything else, solve the problems of stability and safety. Yet the United States Pavilion at the World's Fair in Brussels (now destroyed) was a structure with a festive air about it. The architect, Edward Stone (born 1902), began with a round plan and with general proportions similar to those of a carousel, so that the association with an amusement park was quickly established. Using a large, circular reflecting pool before the building, he strove toward a sense of lightness. A perforated screen as opposed to a solid wall around the core of the building also contributed to the feeling of buoyancy. The columns which supported the shallow roof were as slim as possible. Modern materials and engineering reduce the size of the safety factors architects must use in designing their structures, so their forms need not be as massive as in the past. Fountains in the reflecting pool and generous use of flags around the building completed the holiday mood of the pavilion. From the standpoint of the interests of the American government, this was a most effective building, since a world's fair constitutes an occasion for projecting a favorable image as well as gaining customers for American manufactured goods. Clearly, a "happy" as opposed to a solemn or overdignified building can help overcome the impression of the United States as a colossus interested chiefly in money and power but indifferent to "little" countries and simple pleasures.

Another joyous building employing distinctive forms is Ordoñez's and Candela's Los Manantiales Restaurant in Xochimilco, Mexico (p. 254). Here the principal engineering device, thin-shell concrete shaped in the form of dramatic hyperbolic curves on a circular plan, solves the problem of structure and expression brilliantly. The thin-shell structure serves as roof, side wall, and window opening at the same time. While the shell is very strong, its visual effect suggests the delicacy and grace of artful paper folds. In contrast to the mathematical beauty of

EDWARD DURELL STONE. United States Pavilion, Brussels World's Fair. 1958

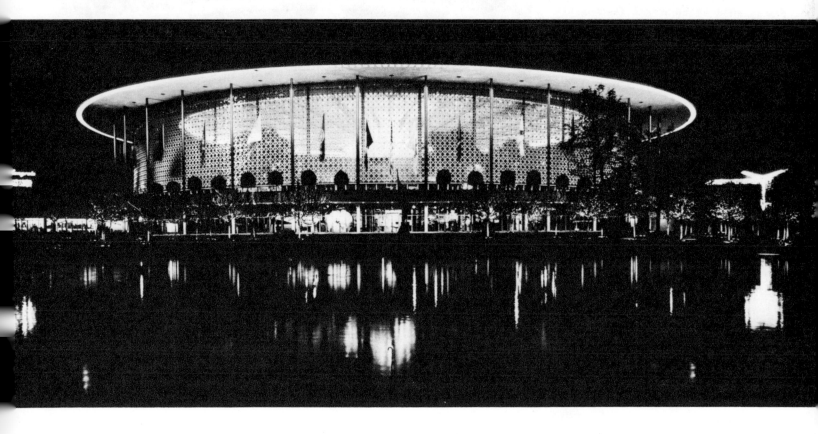

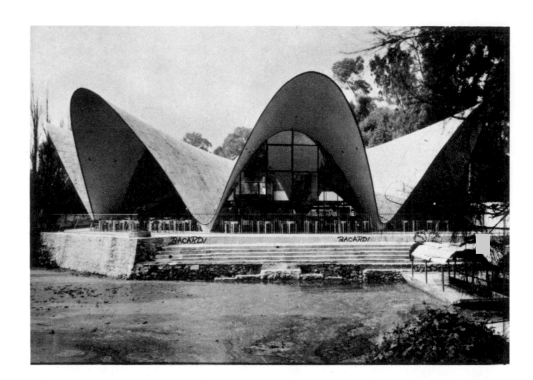

JOAQUÍN ALVARES ORDOÑEZ (architect) and FÉLIX CANDELA (structural designer). Los Manantiales Restaurant, Xochimilco, Mexico. 1958

VICTOR BISHARAT/JAMES A. EVANS and ASSOCIATES. General Time Building (now occupied by States Marine Line, Inc.), Stamford, Connecticut. 1968. With a circular plan on a masonry base, repeated inverted arches, and a reflecting pool, the General Time Building employs several of the devices used by Stone and Candela to arrive at a fresh and pleasing structural solution.

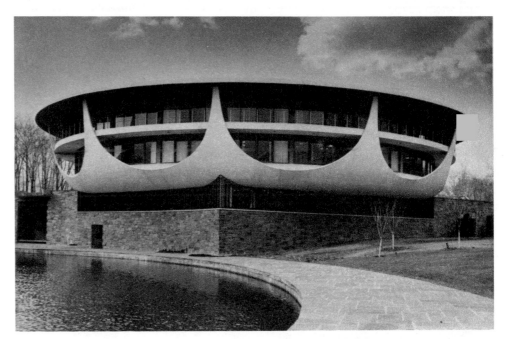

these curving shapes, the designers used a rugged, rubble masonry foundation and wide, gentle steps to create a powerful horizontal base for the soaring forms above. The large openings are inviting to the persons who approach the building, while, for those inside, they create a maximum opportunity for unobstructed vision so that nature and passing events can be enjoyed while eating.

In buildings such as those of Edward Stone and Félix Candela we discover what the art of architecture can mean when it is imaginatively applied to the solution

of practical problems. For them, it was not a matter of finding a standard, conventional, stereotyped building type and imposing it upon the unique requirements of a specific situation. They did not, to use an often cited example, adapt a Greek temple for use as a twentieth-century bank. Rather, they exploited modern technology and an understanding of the distinctive problems raised by their respective commissions to create architecture which is technically successful and visually appealing. Without the use of the human figure or the employment

of trite symbols, the inert materials of building, when skillfully organized, can become expressive of a wide range of human emotion. Here we see how architecture can meet the challenge of designing structures to express pleasure, elegance, lightness, and gaiety without becoming frivolous or sensational.

It appears that the choice of exhilarating or despairing themes in art is not entirely determined by materials, media, technology, or type of artistic genre. Rather, the attitude of the artist and the influence upon him of his culture also govern the ultimate meaning, the emotional content, of his work. We might imagine that architecture, because of its large scale and great cost, would be limited in its range of meaning. And often these factors *do* inhibit the architect. But a vast array of technology also serves to extend his expressive scope. Reinforced concrete, wide expanses of glass, and thin-shell structures can be employed equally well in the design of sacred buildings, domestic dwellings, or restaurants; the style and meaning of the structure, in each case, will depend on the way these elements are related to each other. Still, during the first half of the twentieth century, architecture mainly tended toward classicism and austerity (notwithstanding

exceptions like Gaudí, Wright, Stone, and Yamasaki), because powerful factors like mass production of building materials, increasing costs of labor, and the interest of financial backers in safe and predictable results influenced designers in the direction of highly rational, stereometric design. The style of emotion, therefore, is more prominent in those art forms (painting, sculpture, and printmaking) which use modern materials and techniques but are less inhibited by the costs of modern technology.

More recently, however, there has been an upsurge of experimentalism in the cinema and in architecture, both of which can be described as art *industries*. The opportunity to carry out daring and costly projects in these art forms suggests that our civilization is entering an era when *imagination rather than cost* may become the principal limitation felt by creative artists. And paucity of ideas, poverty of imagination, is an inner rather than an external restraint. But will a wealthier society in which there is a relaxation of economic inhibitions result in significant changes in the themes and styles of art? Will celebration tend to displace despair? The answer depends on how the creative imagination is influenced by culture as a whole—and art is one of the constituents of the culture.

THE STYLE
OF FANTASY

As artists become skilled in the manipulation of their materials, they often discover that they can invent forms which were never before seen or imagined. While one artist will not permit his work to stray from what is logical or probable—what is within the realm of common-sense reality—another may enjoy creating entirely new worlds. And most artists possess the skill to make such worlds seem real, however briefly. Ultimately, these fantastic creations reflect the artist's perception of his role as one who obeys the rules implicit in reality or as one whose mission is to *change* the rules. Either he deliberately creates strange new forms which are logical and credible or he *lets fantastic forms happen*, regarding himself as an instrument that cooperates with the processes of creation in the universe.

From a social standpoint, fantasy is the prerogative of children, since adults are not thought responsible or even entirely sane if they habitually disclose their dreams, much less take them seriously. Artists (and perhaps mathematicians) are among those privileged adults who seem to have the right to exhibit their fantasies openly without incurring disapproval. Perhaps society indulges artists and mathematicians because it regards them as fools or madmen, or as children whose active imaginations may be safely encouraged since they have no significant connection with reality. In that case society is mistaken, because every familiar reality in the man-made world almost surely had its origin in someone's fantastic imagination.

It is very likely that architects imagine spaces and shapes which would make wonderful buildings before they think of any practical purpose such buildings might serve. This would be especially true of those architects who have sculptural inclinations (see pp. 583–92, "Constructors and Sculptors"). But even engineers, as Arthur Drexler says, "have subjective, if not actually arbitrary, preferences for certain kinds of shapes."[11] Painters and sculptors, being even more liberated from practical necessity, can pursue their inner vision wherever it leads without any obligation to "make sense." The important point is that fantasy—the imagination of unreal forms, places, and events—is a universal human trait, and art is the principal means of giving it public expression.

Although children do not have a well-developed ability to distinguish between fantasy and reality, adults do, and

therein lies an important feature of the interest which a fantastic style arouses: our knowledge that a work has little or no basis in objective reality yet can convince us of its authenticity. Art exploits the will to fantasy in all men by improving on dreams, since the artist, by his craft, makes dreams tangible, substantial, and alive.

All man-made realities were once fantasies, but all fantasies do not necessarily become realities. Nor are they intended to. Chagall's people flying through the air are fantastic, but they do not anticipate general diffusion of the gift of levitation. In his case, fantastic imagery represents an emotional state rather than a technical advance in courtship. But some artistic fantasies have utopian implications. The architect who conjures up an ideal but fantastic city may be instrumental in converting dreams into reality, modified from his original conception perhaps, but real and socially useful. In fact, most of the major architects of this century have proposed utopian communities or single structures which constitute seemingly fantastic solutions to human problems. City planning, which is largely practiced by architects, might be regarded as the professionalization of the tendency to propose utopias. But the capacity of modern technology combined with human intelligence is so considerable that it is difficult to draw a sharp line between rationally organized planning and utopian fantasy. Certainly, many of the architectural fantasies of the 1920s and '30s are accomplished facts today. Private dreams *can* become public realities.

Some utopian fantasies deal with unreal spaces and flights of structural imagination; others deal with unprecedented personal and social relationships. The *Peaceable Kingdom* by Edward Hicks (1790–1849) is a fantasy based on the Biblical description of a world in which natural enemies have learned to live together without conflict and men (exemplified by William Penn and the Indians in the background) negotiate all their affairs harmoniously. The work fits into the category of fantastic art because the world it *realistically* portrays is not the one we live in, yet the meticulous technique of this primitive artist convinces us at least of the intensity with which he holds the ideal of peace. Such works may not succeed in overcoming some of our doubts, but they persuade us that the ideal they embody is real.

Because fantastic art originates in both logical and irrational mental processes, it presents no common set of visual qualities. Fantastic works may be objectively accurate or subjectively distorted, orderly or chaotic, rectilinear or curvilinear. We are justified in speaking of a fantastic *style*, then, only because certain works exhibit a logic based on hallucination, dreams, utopian hopes, and speculative vision. That is why, in the following sections, we will discuss fantastic art in relation to science as well as myth. So far as art is concerned, science and superstition are equally useful as sources of imagery. The cognitive claims of science afford material for the creation of art in the same manner as the magical practices of shamanism, the prophetic utterances of wise men, the redemptive hopes of religion, or the impersonal logic of geometry. Fantastic art demonstrates that it is very difficult for artists to know where reality ends and imagination begins.

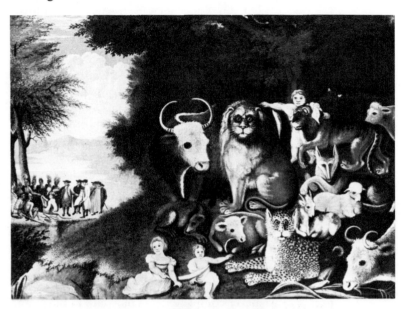

EDWARD HICKS. *Peaceable Kingdom.* c. 1848. Philadelphia Museum of Art. Bequest of Lisa Norris Elkins

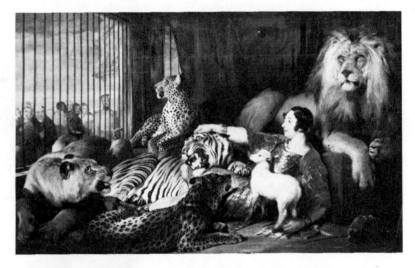

EDWIN LANDSEER. *Isaac van Amburgh with His Animals.* 1839. From Her Majesty's Collection, The Queen's Gallery, Buckingham Palace, London. Copyright reserved.

Landseer's Victorian melodrama, while executed with consummate skill and intended, no doubt, to make the same point as Hicks's painting, lacks the moral force of the primitive work: the mythopoeic power of Biblical prophecy is betrayed by a trite naturalism.

Myth

As children we read or listened to mythological narratives and usually accepted them without question: they were entertaining stories and seemed to explain the world in a manner which satisfied our curiosity and was adequate for the state of our knowledge. Subsequently, with increasing sophistication, myths or fairy tales were revealed to us as neither scientifically nor historically true. They remained entertaining as fiction but not as reliable accounts of real events or as accurate explanations of the way phenomena really "work." But some mythic material was not entirely abandoned: it was converted into folk wisdom to be ultimately enshrined in our mental lives in the form of unexamined beliefs and convictions. Officially, we think of myths, fairy tales, and nursery rhymes as the fantastic entertainments of a stage we have left behind; we try to forget that once we regarded them as truthful accounts of nature, man, and the world.

When an artist like Jean Cocteau (1891–1964) presents myth vividly and believably in a film—for example, *Beauty and the Beast*—the shock to adult sophistication combined with what remains of our childlike will to believe creates an aesthetic experience of enormous impact. For we never completely lose our faith in the power and validity of myth. Folk tales possess the capacity to stir our deepest selves long after we imagine that we are immune to superstition. The great Swedish film director Ingmar Bergman (born 1918) is fond of creating conflicts between characters representing the scientific, rational mind and the mythic, poetic, or religious mind. Often, he shows how the opposed tendencies are present in the same person, as in his film *The Magician*, in which a physician ultimately succumbs to fantastic fears—fears to which he believed himself immune because of his training as a scientist.

Why does myth have the capacity to move us, frighten us, or compel our belief? It is not that myths are true as science defines truth. Rather, myths establish connections with the way our minds grasp reality. Men are not completely civilized, completely rational, or completely evolved from their earlier physical and psychological selves. Myths are truthful accounts of the way men have seen themselves and the world for most of their life on earth, and in that sense of truth, they accurately explain a great deal about the way we think, feel, and behave. Hence, the serious study of myth is an important means of uncovering valuable material about man as he was in former epochs and as he is now.

In visual art, as in life, mythmaking goes on continually. Whereas narrative or poetic types of mythmaking are employed in literature, the visual arts use plastic fantasy—the invention of strange forms, or strange associations of known forms. These fantastic forms may

Film still from *Beauty and the Beast*. Directed by JEAN COCTEAU. 1945. Courtesy Janus Films, Inc.

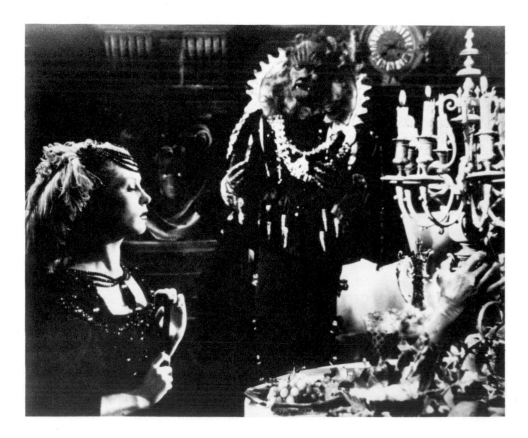

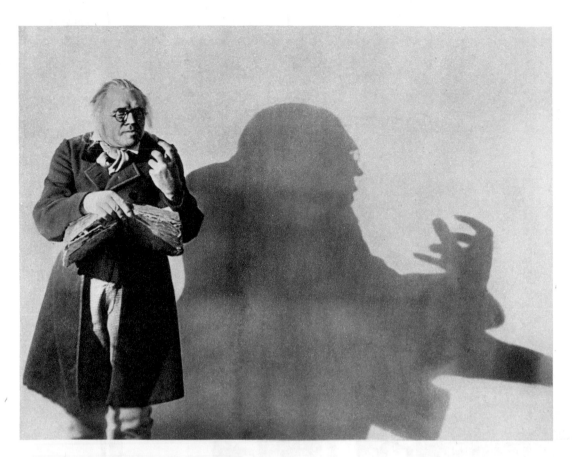

Film still from *The Cabinet of Dr. Caligari*.
Directed by ROBERT WIENE. 1920

Film still from *The Magician*. Directed by INGMAR
BERGMAN. 1958. Courtesy Janus Films, Inc.

be initially suggested by accidental technical effects, as in
the "planned accidents" of Max Ernst (see p. 409), but
the fact that they are permitted to stand, or are further
enhanced, suggests that the artist is willing to rely on
hidden, mysterious sources for the origin and partial
determination of his work. Some artists, in other words,
believe that the relatively uncontrolled creation of forms
will connect their work with the mythic components of
personality. For them, surrendering to fantasy is not
abandoning truth; it is a way of gaining access to *a type
of truth*—a type which our civilization does not value
very highly but which nevertheless explains a great deal
about our inner lives.

One of the best-known fantastic paintings showing the
mythic imagination at work is *Hide-and-Seek* by Pavel
Tchelitchew (1898–1957). On first examination the pic-
ture is of a tree, then of a hand, a foot, a system of nerves
and blood vessels, then of children, babies, and embryos.
Everywhere we look in the painting, passages of wet,
flowing color appear to merge with forms of biological
life. The artist's technique is at once loose yet remarkably
meticulous and accurate. The blood vessels appear to be
illustrations for a medical anatomy, and tiny lights occur
throughout to illuminate beautifully the exquisite render-
ing of an ear or the place where the veins of a leaf merge
with fine capillaries feeding a human embryo.

Of course, children do not grow on trees, and the sim-
ilarity between a hand and a tree is only superficial. But
for the mythic imagination, things that look alike, or can

GIORGIO DE CHIRICO. *The Great Metaphysician.* 1917. The Museum of Modern
Art, New York. The Philip L. Goodwin Collection. For De Chirico, a mythic
world—what he called a metaphysical world—exists all around us, but it usually
eludes our senses. His paintings give us a glimpse of captured moments when
metaphysical space and time intersect.

PAVEL TCHELITCHEW. Detail of *Hide-and-Seek*

PAVEL TCHELITCHEW. *Hide-and-Seek*. 1940–42. The Museum of Modern Art, New York. Mrs. Simon Guggenheim Fund

be made to look alike, are aspects of the same reality: men once worshiped trees. Children are the "fruit" of our bodies as the fruit is of a tree. To see the way blood is circulated to feed our bodies both frightens and fascinates us. Our arteries and nervous systems branch out like the limbs of a tree, the fingers of the hand, or the tendons of the foot. But the painting by Tchelitchew is not a treatise on biology or physiology; it *is*, however, a treatise about how the primitive portion of our personality confronts such themes as the life of the unborn, the drama of nourishment, the connection between plants and human beings, the tension between consciousness and unconsciousness, the teeming activity beneath the shell of a living thing.

In this same work, then, different types of imagery and different levels of observation tumble over one another. At once we have *both* the implied comparison between a hand and a tree—a plastic metaphor—and a directly observed and accurate rendition of a human embryo. *Hide-and-Seek* is thus a prime example of fantastic art which yet retains connections with empirically observed reality. It shows how the mythic imagination uses science and fantasy to deal with themes that are of monumental and absorbing human interest.

Dreams and Hallucinations

Our dreams are further examples of the connection between fantasy and the real world. They appear, however, to lack logical organization after we reflect upon them in the waking state. But while we sleep, they seem very real, sometimes frighteningly so. An artist employing vivid dream material can exploit irrational, disturbing qualities for the purpose of jarring people out of their habitual modes of perception. Such an art, using a realistic mode of representation, can employ images as they appear to us in dreams or in hallucinations, images similar to those caused, for example, by a high fever. Such an art was Surrealism, which was and to some extent persists as an artistic movement seeking to shock viewers by the employment of just such a strategy as is outlined above. As a formally organized artistic movement embracing the visual arts and literature, Surrealism is largely spent;

WILLEM DE KOONING. *Woman, II*. 1952. The Museum of Modern Art, New York. Gift of Mrs. John D. Rockefeller

gued that even the most rational of artistic approaches employs some kind of intuition, some reliance on sources of imagery hidden mysteriously in the self; otherwise, if artistic planning and execution were entirely a matter of the application of known principles to known objectives, artists could easily be replaced by computers programmed by technicians.

For their interest in dreams, the Surrealists were, of course, indebted to Sigmund Freud. From Freud they learned that dreams are only *seemingly* illogical, that they have important meanings if certain principles of interpretation are known. Not that Surrealist paintings necessarily constitute a puzzle, a collection of symbols requiring of the viewer a key for interpretation. Rather, Surrealism employs fantastic juxtapositions of images—combinations more like those seen in dreams than in waking life—to shock the viewer. Shock is believed to have an educational effect in that it obliges the viewer to reorganize his customary habits of perception in the act of experiencing the work. Behind this interest in shock is the conviction that man and society are hopelessly enmeshed in traditional, mainly wrong modes of thinking and acting. Presumably, fantastic art helps the individual to break away from inherited forms of thought and perception and opens him to the possibility of new kinds of behavior. Oddly enough, Surrealist and fantastic art can be regarded as having an educational purpose: it quite literally seeks to change behavior, a goal which is one of the fundamental objectives of any system of education.

Salvador Dali (born 1904) executed *Soft Construction*

but its influence is a permanent part of the creative approach of all artists who wish to make use of it. That is, an artist can deliberately create images which look as if they might have been dreamed; or he may endeavor to recollect his dreams and then represent them accurately; or he may employ the kind of creative strategy which eliminates preparatory plans and anticipation of the final product in favor of seeking to exploit spontaneous impulses during the process of execution. Abstract Expressionism constitutes an entire school of painting which stresses the impulsive and spontaneous character of execution. This school also tends to use the agitated paint quality developed by central European Expressionism, especially after World War I. Although it does not represent dreams or naturalistic images, Abstract Expressionism does owe to Surrealism the idea of reliance on unplanned or irrational impulses as an organizing principle for the creation of art.

It is easy to see that an artistic strategy which relies on dreams and the irrational and which encourages accidental technical effects would encounter considerable resistance from those who think of art as a planned and reasoned approach to creation. However, it can be ar-

MERET OPPENHEIM. *Object*. 1936. The Museum of Modern Art, New York. The idea of a fur-covered cup, saucer, and spoon is so fantastic, so repellent, that only a comic reaction can make the image bearable.

Art Nouveau chair. c. 1910. Collection Mr. and Mrs. Leo Castelli, New York. A chair that wants to be something else. Wavy plant stems and female heads combine to create an object that seems to be having a terrible dream.

ALBERTO GIACOMETTI. *Woman with Her Throat Cut.* 1932. The Museum of Modern Art, New York. A gruesome fantasy made all the more lurid because it is rendered with exquisite clarity and loving attention to form.

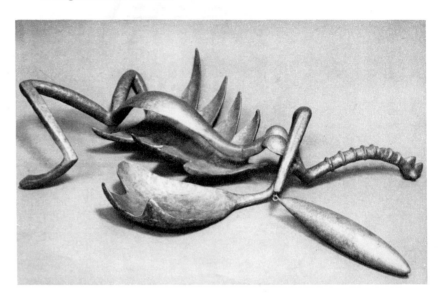

with Boiled Beans: Premonition of Civil War* in 1936 before he abandoned his serious artistic efforts in the interest of using his talent to illustrate the flamboyant aspects of his public personality. In it we see a highly naturalistic technique combined with truncation and distortion of the figure—devices which are characteristic of this painter. He also employs a Caravaggesque system of illumination: strong contrasts of light and shadow plus careful modeling to add to the illusionism of his fantastic forms. The sky and landscape are conventionally presented in hues which might be seen in a Technicolor travelogue. This almost banal naturalism increases the shock value of the figurative elements. A small figure in the lower left portion of the picture establishes the monstrous scale of the central subject. We recognize portions of female anatomy, stretched skeletal forms, and a horrible grimacing head attached to a breast that is being squeezed by a clawlike hand. A supporting element seems to be a tree trunk which merges into a foot. The melting of objects—the man-made into the natural, or the organic into the inorganic—is characteristic of Surrealist art in particular and of fantastic art in general. It is also a feature of dreams where persons and objects turn into something

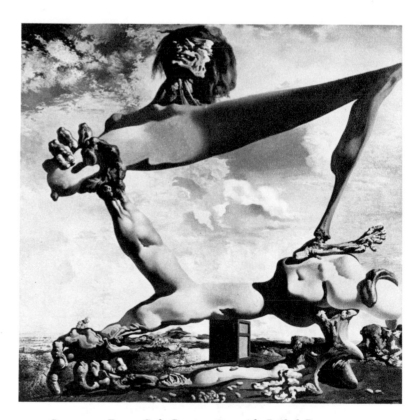

SALVADOR DALI. *Soft Construction with Boiled Beans: Premonition of Civil War.* 1936. Philadelphia Museum of Art. The Louise and Walter Arensberg Collection

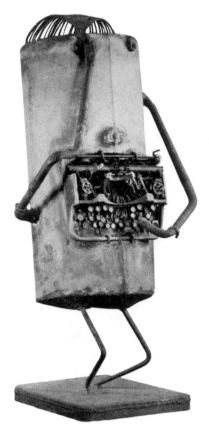

RICHARD STANKIE-
WICZ. *Secretary*.
1953. Whereabouts
unknown

Advertisement, *A
Christmas gift with
keys so lively, they can
go 115 words a min-
ute*. Courtesy Royal
Typewriter Company,
New York

else. It is noteworthy also that in mythology, metamor-
phosis is a common occurrence—persons and objects
change their identity readily. Dali relies a great deal on
the portrayal of plump, fleshy forms which he then
merges into dessicated forms or into stones, trees, and
manufactured objects. He has a characteristic Spanish
obsession with death and with love of the land, and to
the extent that these concerns are universal, his art pos-
sesses the power to hold our interest, notwithstanding
our knowledge that these fantasies are highly theatrical,
often seeming to be staged more to amaze us than to
express feelings sincerely held by the artist. Dali's literary
title, combining an absurd or flippant idea with a serious
reference to a historical event, is very much a part of the
total work. Thus, the attempt to shock is carried out in
the imagery of the work, in the title, and, as the artist's
biography reveals, in his behavior as well.

We see a sculptural fantasy in *Secretary* by Richard
Stankiewicz (born 1922), a work which also contains an
element of mordant humor. The torso consists mainly of
a cylinder with a typewriter embedded in the abdomen.
Pipe-stem arms seem to operate the typewriter, which is
also part of the secretary's body—an incongruous associa-
tion of the mechanical and the human. A large part of
contemporary art deals with the theme of the assimila-
tion of people by machines: here we see an only slightly
human figure as it absorbs a machine into itself and then
operates upon its own mechanical innards. Although
welded sculpture is now a well-accepted contemporary
medium, Stankiewicz was one of the first sculptors to use
machine parts which have not completely lost their orig-
inal identity. Thus he can manipulate meanings and as-
sociations at the same time that he manipulates the phys-
ical materials themselves.

This sculptor, like others who employ the same tech-
nique (see Chapter Twelve), runs the risk that his con-
structions will rely too heavily on the original meanings
of the parts and that the contribution of the artist will
not consist of much more than having brought the parts
together. The art of *assemblage*, as it has been called,
raises interesting problems in aesthetics and criticism
revolving around the role of the artist as discoverer of
form and as creator of form. Contemporary critical
opinion has frequently tended to de-emphasize the neces-
sity of *creating* form and meaning out of anonymous
materials, and has been willing to attribute artistic value
to works in which the artist's effort has been more nearly
akin to that of impresario than to that of craftsman.

A variation of the Stankiewicz fantasy placed at the
service of advertising art appears in an illustration for
the Royal typewriter. The idea of the typewriter emerging
organically from a French horn is at once whimsical and
absurd, so that the viewer's attention is arrested and the
chances that he will read the message below are increased.
Since the written copy makes no explanation of the in-

congruous combination of objects above, we assume at first that the purpose of the illustration is mainly to startle and demand attention. But the French horn is a beautiful instrument, the product of elaborate hand-craftsmanship. Hence, when we see it presenting the typewriter as if on a pedestal or, if you will, giving birth to the typewriter (which is carefully related to the horn in color and in some of its curvilinear features), we are encouraged to associate the grace and craftsmanship of the horn with the industrially produced commercial machine. Furthermore, the copy assumes that its idea of a beautiful machine has been communicated, hence stresses the speed, ease of operation, and *ruggedness* of the product.

Although the photographic image is visually pleasing while the typewriter possesses the clean sculptural lines of a sculpture by, say, Arp, the *art* of the advertisement consists of ingeniously assembling image and copy to produce a persuasive total idea: it is effective from a marketing standpoint without introducing considerations which might conflict with those of the product. In the Stankiewicz sculpture, the assembly of incongruous elements serves to heighten the characterization of the secretary, the person who assimilates, and is assimilated by, a machine. In the advertisement, on the contrary, the incongruous juxtaposition of elements serves to enrich and intensify the characterization of the machine.

One of the great monuments of modern fantastic art is Picasso's etching *Minotauromachy* (1935). The work embodies almost all the elements of fantastic art: myth, dream, history, sexual hallucination, incongruous juxtaposition, the literal versus the absurd, creatures part animal and part human. The artist deals with the Cretan myth of the Minotaur as well as with bullfighting today, and he refers obliquely to the ancient Greek legend in which Zeus, in the guise of a bull, carried off Europa. The horse, which carries a sleeping or unconscious female matador, is badly wounded, losing its entrails through its torn belly. But the violence of this scene is viewed calmly by faces of almost classical beauty. A flower girl holds a light against which the Minotaur, a symbol of erotic violence and civil chaos, shields himself. Like a dream, the work does not readily lend itself to a simple narrative explanation; yet it makes us symbolically aware of most of the elements of modern European history, and of the recurrence of the same themes in the art of Western civilization. For a Spaniard like Picasso, the tauromachy, the killing of a bull, is a dramatic reenactment not only of a pre-Christian sacrifice—possibly a fertility rite—but also of the structure of personal and collective life in the West. In other words, both the myth and the modern spectacle are short, concentrated versions of what our history has been. Picasso explores his Spanish heritage, his fascination with the ritual murder of the bull, his sexual fantasies, and his feelings about contemporary

PABLO PICASSO. *Baboon and Young.* 1951. The Museum of Modern Art, New York. Mrs. Simon Guggenheim Fund. Picasso's use of a toy automobile for the baboon's head well illustrates the Surrealist imagination at work. The visual resemblance is persuasive, but the logic of the relationship is so preposterous that we find pleasure in its very absurdity.

PABLO PICASSO. *Minotauromachy.* 1935. The Museum of Modern Art, New York

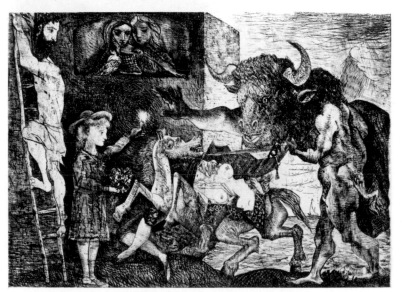

The theme of "Beauty and the Beast" lives perennially in the fantastic imagination, as exciting to the moviegoers of the 1930s as to the devotees of Picasso's inspired nightmares.

Film still from *King Kong:* Fay Wray. 1933. Directed by ERNEST SHOEDSACK and MERIAN COOPER. Courtesy RKO Pictures, a Division of RKO General, Inc.

HENRI ROUSSEAU. *The Dream.* 1910. The
Museum of Modern Art, New York. Gift
of Nelson A. Rockefeller

EDWARD KIENHOLZ. *The Friendly Grey
Computer—Star Gauge Model #54.* 1965.
The Museum of Modern Art, New York.
Gift of Jean and Howard Lipman. The
derisive personification of a computer in a
rocking chair: a visual version of the
sardonic jokes about electronic devices—
their strangely human mixture of ineffi-
ciency and omniscience.

MAX ERNST. *The Joy of Living*. 1936. Penrose Collection, London

Nature, whose fecundity Rousseau perceived as generous and benign, is seen by Ernst as an arena of cancerous growth, where plant and animal exchange identity and ceaseless reproduction spawns monsters that threaten to choke out the sky. As the horizon disappears, the artist's hallucinations become more and more credible, until the real and the nightmare worlds become one.

history to create a work which, as much as any, embodies the meaning of Western civilization from its Mediterranean origins through Greece to Europe and the modern crises of man. Two years later, in 1937, the artist created his famous *Guernica*, commemorating one of the cruelest events of the Spanish Civil War. He appears to have anticipated this work with *Minotauromachy*.

In *The Dream* by Henri Rousseau (1844–1910), we encounter the type of fantastic art that is based on the imagination of an unsophisticated or untrained artist—a so-called primitive artist—who takes up painting without formal instruction and, in faithfully reproducing his inner vision, arrives at a curious blend of heightened realism and pure dream. In this gentle work, Rousseau, a retired customs inspector, lovingly portrayed a dream about a naked woman on a couch, mysteriously located in the jungle with its wild animals and birds, exotic natives, and lavish natural growth. Not only is this the

dream of the woman in the picture, but also it must be the dream of the artist—naive and mildly erotic at once—in which the wealth of nature is arranged as a benevolent environment in which man can find food on the trees, visual delight in the natural forms, friendship from the animals and natives, and love from the naked woman. The artist achieves a magnificent decorative effect with his painting of foliage and flowers, and although his drawing of the nude is somewhat stiff, he has been able to dramatize her figure and make her credible through painstaking modeling and intense illumination. In painting this dream, Rousseau probably gave expression to the universal dream of male adolescence, an achievement made possible by his naiveté: he lacked the technique or the desire to conceal the literal presentation of his imaginative vision, and, as an adult seriously involved in the art of painting, he labored to give each detail an overwhelming veracity.

Scientific Fantasy

Because the character of our time is so much determined by science and its technological applications, it is not surprising that art has absorbed the common symbols and effects of science and technology. Science raises questions about the nature of outer space and of submicrocosmic matter—questions that fascinate the popular imagination and stimulate many sorts of speculation. Speculation and fantasy about technical questions by nonscientists is

part of a natural process of *humanizing* radically new concepts which may modify our conventional notions of space, time, matter, and energy. The characteristically human mode of dealing with ideas and events which promise to alter fundamentally our lives and our world is to talk and dream about them, incorporate them into jokes and tall stories, visualize them in astonishing contexts—in short, to anticipate the changes they may bring,

ROGER DE LA FRESNAYE. *The Conquest of the Air.* 1913. The Museum of Modern Art, New York. Mrs. Simon Guggenheim Fund

MATTA. *Here Sir Fire, Eat!* 1942. Collection James Thrall Soby, New Canaan, Connecticut

and attempt to adjust our typical ways of feeling and thinking to the new realities they imply.

Art does not merely illustrate—that is, make visual—the consequences of science and technology. Artists play symbolically and sensuously with new principles. They endeavor to discover whether novel ideas and materials can be harmoniously or expressively employed in their private worlds of feeling and intuition. They wonder whether physical discoveries about the motion and energy of subatomic particles can change the way they think about pictorial composition, the methods and techniques of sculpture, painterly conceptions of space and mass, the visual forms expressive of motion and repose, the structural relations between container and contained. And although artistic speculation and fantasy does not add to the common fund of knowledge regarded as scientific truth, it *does* add to our fund of humanistic knowledge—that is, knowledge about the effects of science on man's personal and social existence.

The Conquest of the Air by Roger de la Fresnaye, which was executed in 1913, seems a relatively tame work of scientific fantasy when compared with the actualities of space exploration today. It uses Cubistic forms with their geometric-mechanical associations to cope with the intellectual aspects of extraterrestrial travel. A balloon is shown in the distance, the French flag is prominent in the

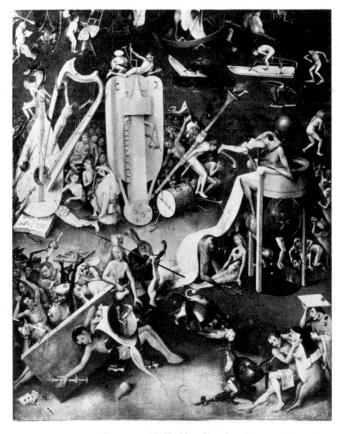

HIERONYMUS BOSCH. *Hell* (detail of *The Garden of Delights*). c. 1500. The Prado, Madrid

Mystical Transcendence Through Paint

MARK TOBEY. *Edge of August*. 1953. The Museum of Modern Art, New York. Tobey's pursuit of mystical oneness through art—of a visual union between man's inner and outer worlds—led to this synthesis of Western dynamism with the meditative scripts of Persia and China.

WILLIAM BAZIOTES. *The Sea.* 1959. Collection Mr. and Mrs. Morris H. Grossman, New York. For a certain kind of artist, the miraculous emerges in the discovery that the act of painting can evoke a natural world nature does not know.

MARK ROTHKO. *Earth and Green.* 1955. Galerie Beyeler, Basel. Through color sensation alone, virtually without the agency of shape, we become absorbed into the experience of vision.

sky, and a sailboat floats at the right. Presumably, the artist wished to symbolize the connections between sailing and flight and at the same time relate the scientific achievements in space travel to French nationalism. Any association between science and nationalism may seem naive to a world which has seen the international character of science and technology amply demonstrated in several world conflicts. However, we can regard this work, painted before the first twentieth-century war, as reflecting an optimistic, progressive, essentially nineteenth-century attitude toward science, notwithstanding its use of a form language which belongs to the present century.

In the work of Matta (Echaurren), we have a very frank effort to come to terms visually with the world revealed by modern physics. The foundation provided by Surrealism, particularly its invitation to the artist to surrender to his unconscious and automatic plastic impulses, enables the painter to create an autonomous universe of visionary forms. These forms seem to grow out of an interest in the problems of physics—problems dealing with electrical and magnetic energy, the motion of sub-atomic particles, their velocities, collisions, radiation, and brief life-spans. However, the Romantic heritage of Surrealism is also present in Matta's rich color, as in *Here Sir Fire, Eat!* in which a luminosity similar to Tanguy's moonscapes is visible in the general background (see *Infinite Divisibility* by Yves Tanguy, (p. 274), although Tanguy's silvery luminescence gives way here to a more tropical palette, possibly because Matta (born 1912) is of Chilean origin. As the orbits of the particles become more complex and begin to overlap and combine with one another freely, they seem to describe forms of almost

architectural meaning. Some of Matta's paintings are more austerely geometric, but he never totally suppresses an organic reference in his physical fantasies, so that a biological note, a humanistic idea, is always present. That is, we can sense ocean, air, sunlight, breeze, moonlight, stars, and all their romantic meanings behind the movements of the particles, which are so strange and yet so obviously guided by the laws which physics attempts to describe.

It should be stressed that Matta does not create models describing the physical properties of the universe. He *does* establish a setting that suggests a model of what might be seen by some superior eye which can translate the mathematical-symbolic formulations of science into visual images. However, such a setting is intended more to encourage the credence of the viewer than to manage physical phenomena with the kind of precision which could claim scientific validity. In short, we are dealing with art—that is, imagination—rather than with talented technical illustration. Perhaps the best analogy to Matta's effort can be seen in Hieronymus Bosch's paintings of the fantastic creatures supposed to inhabit Hell. Bosch represented in detailed, credible terms what no one had seen but what everyone speculated about—the tortures of the damned according to medieval notions of punishment within the framework of then current cosmology and theology. Just as medieval and sixteenth-century science and theology found their visual expression (devils, demons, tortures) in the art of Bosch, modern science and speculation about its characters and events (ions, mesons, antimatter, particle collisions) are given visual expression in the fantastic world of Matta.

Fantasy and Illusionism

In connection with the style of objective accuracy, we considered some of the devices used by artists to heighten the realistic or naturalistic impact of their works. Now we shall examine some works which employ traditional and new devices to create fantastic illusions, occasionally substituting the real object for the illusionistic treatment of it.

Infinite Divisibility by the American Surrealist Yves Tanguy (1900–1955) employs the naturalistic illumination and modeling we would expect in a conventional painting of still life. Light comes from a single source and causes the strange objects to cast sharp, distinct shadows which obey the laws of perspective as they move toward an infinitely receding horizon. In the distance are glowing light centers as if from strange suns, but their light comes to us through an atmosphere much as sunlight sometimes reaches us on earth—through a cloud (or pollution) haze. The forms of the objects themselves are arresting, appear-

ing to derive from a skeletal system—but whose? They imply organic origins along with mechanical origins. Also, they are painted to resemble stones and other geological forms. Yet a machine is distinctly suggested by the geometric arrangement of shapes at the left.

The infinite horizon so much employed by Surrealists helps create the mood of a dream and an atmosphere of silence. The deep space also supports these feelings. And the perspective effects are mainly those of converging lines, diminishing size of objects and shadows, increasing loss of focus in the distance, and sharp, almost photographic focus in the foreground. In Tanguy's world, everything tends to dissolve into a luminous haze in the distance after we have had the opportunity to examine highly detailed and carefully rendered fantastic forms in the foreground. Since Tanguy's color is usually a silvery gray, we easily associate this imagery with photographic realism.

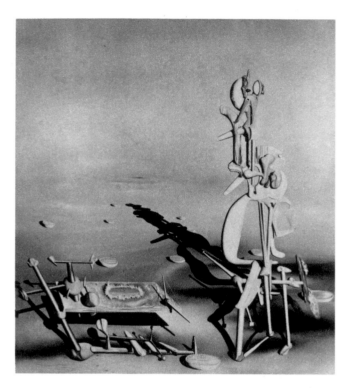

YVES TANGUY. *Infinite Divisibility*. 1942. Albright-Knox Art Gallery, Buffalo, New York

The effect of this work is not to shock but rather to induce a calm and serene acceptance of an environment which might be plausible to an astronaut. We can accept Tanguy's universe—so bare of the essentials needed to sustain human existence as we know it—because of its all-pervading atmosphere of emptiness and silence. There is no violence in Tanguy's "lunar" landscape; it seems to exist at a time *after* violence and passion have been spent. There is a sense of stillness, peace, and abstraction from human striving that we might associate with the fate of forms which are no longer alive. We may be witnessing, in other words, a calm, contemporary portrayal of the world as it would appear after we, and everything else alive, are dead.

A different kind of illusionism is seen in *The Bride* by Marcel Duchamp (1887–1963). Here we have the convincing representation of geometric solids connected by a kind of mechanical-biological plumbing system. The title assists the effect of Surrealistic irony as it contrasts the romantic-erotic meanings of the bride with a mechanical, quasi-Cubist representation of her person. We are shown what might be the interior of a complex mechanical system and are given visual hints of human internal organs, viscera, arteries, glands, and so on. The manner of representation is the same as would be employed to illustrate a catalogue for a manufacturer of equipment serving, let us say, a biological or medical laboratory. This theme, executed as a painting in 1912, would probably be carried out in three dimensions today.

The illusionistic devices of early Surrealist art relied on discoveries made as early as the Renaissance. However, many contemporary artists, eschewing illusionism, nevertheless pursue a kind of realism by employing the objects themselves which formerly would have been represented through a traditional artistic technique. That is, instead of representing the human figure with forms that show they were painted, modeled, hammered, cast, sawed, turned, or stamped, artists now assemble such objects *themselves* to create the figure. An example is *Masculine Presence* (1961) by Jason Seley (born 1919). The figure here consists of welded automobile bumpers and a grille. The result suggests the muscular and skeletal system of a man, with chromium finish and the convex forms of mechanical parts skillfully employed to achieve an organic effect. An interesting relationship between industrial design and sculpture is implied by this work: the purpose of automobile bumpers, as we know, is to provide a sturdy defense for the easily damaged metal skin of the car. However, over the years, designers have imposed a variety of curvilinear shapes upon the sturdy and serviceable bumper. That is, they have tended to

MARCEL DUCHAMP. *The Bride*. 1912. Philadelphia Museum of Art. The Louise and Walter Arensberg Collection

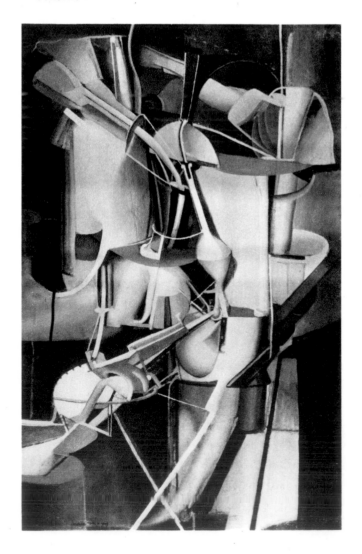

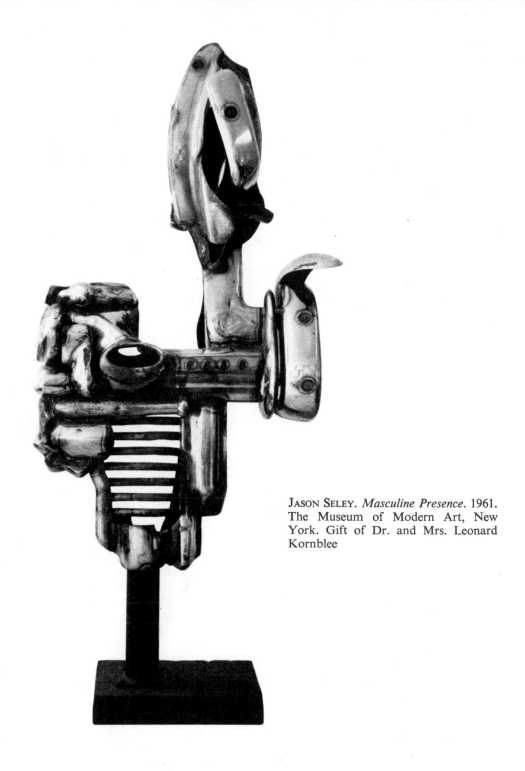

JASON SELEY. *Masculine Presence*. 1961.
The Museum of Modern Art, New
York. Gift of Dr. and Mrs. Leonard
Kornblee

treat it like sculpture, endowing it with the *qualities* of the human figure but avoiding "museum-art" representational effects. In reassembling these automobile parts, the artist has relocated their organic qualities in the place from which they were originally taken, and where, as sculpture, they appear perhaps more appropriate and authentic.

Marisol (Escobar) (born 1930) has fashioned a whimsical fantasy, *The Generals*, out of painted wood, plaster, and other common materials. We recognize what appears to be a barrel in the body of the horse and an ordinary table or bench in the legs. This construction moves among several modes of representation and meaning at once: there is a hobbyhorse quality to the whole, particularly in the neck and head; in their stiffness and boxlike construction, the two generals seated on the "barrel" suggest children's soldiers. But their painted faces have the rigidity of a Byzantine icon. Their boots—symbols of military command—are painted on the side of the barrel the way a uniform might be painted on a child's wooden soldier. Hence it is difficult to take their generalship seriously, notwithstanding the somber mien of their painted portraits. And for a heroic equestrian statue, the horse will not do.

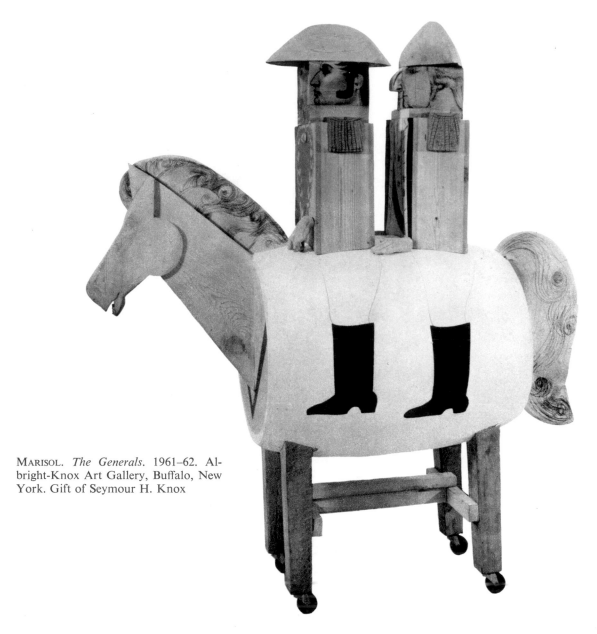

MARISOL. *The Generals*. 1961–62. Albright-Knox Art Gallery, Buffalo, New York. Gift of Seymour H. Knox

The illusionism of these latter two works lies in the employment of "real" materials or of materials we normally associate with other real contexts. The artist is the beneficiary of all the conventional associations we make with the objects he uses. His illusions are not of the "fool-the-eye" variety: no particular craftsmanship is required to mount boxes on a barrel; yet, with some visual hints, it is easy to imagine them as soldiers on horseback. The art here consists in using the viewer's *knowledge* that boxes are being represented as generals or that an automobile grille is a man's abdomen. Our *knowledge* that a horse's legs represented by table legs will not, therefore, carry the generals into any battle constitutes the distinctive aesthetic material in this kind of artistic effort. In conventional illusionistic sculpture, the artist labored to convince viewers that bronze or stone was in fact muscle

and sinew, and hence we could briefly disbelieve in the inertia of these materials. By his craftsmanship, the traditional artist "persuaded" paint, clay, or stone to look like flesh or cloth, for example. But the contemporary artist is more inclined to employ real objects or materials along with illusionistic fragments (as in the painted portraits of the generals) to create several levels of reality in a single work. Thus, an artist "plays with" the viewer's frame of reference, offering cues to reality at first, second, and third hand. The result might be a disorientation in our normal perception of objects, leading to the possibility of discovering new meanings in the reality of commonplace things. Fantastic art, then, through the manipulation of illusion and multiple levels of reality, moves beyond shock and disorientation of the senses to the creation of opportunities for new perceptions of the real world.

THE STRUCTURE OF ART

INTRODUCTION
TO *The Structure*
of Art

WHEN AS CHILDREN WE LEARNED TO TALK, we tried almost from the beginning to express ideas, desires, and feelings. Adults may have helped us to pronounce words, but they did not provide us with definitions of nouns, verbs, adjectives, and adverbs and then ask us to put them together to make language. We learned somehow to talk and to understand at the same time, and through trial and error, through successful or meaningful reactions to our speech, we learned to understand and use the language. It was not until some time later that teachers dissected the language for us, broke it down into its parts of speech and rules of usage. Before that, without knowing the rules, we had managed to understand meaning. Only when we grew older did we discover, like Molière's *Bourgeois Gentil-homme*, that we had been speaking prose all our lives.

So far in this book we have examined works of art comprehensively and have tried to understand them in terms of their functions and their styles. Such meaning as we have discovered has resulted first from seeing the art object *as a whole*. Later we may have looked within the object, into its parts, to find clues to its operation and purpose. But the meaning of the parts of a work of art is always governed by its meaning as a totality: in art, *the whole is greater than the sum of its parts*.

Now we are about to embark upon a study of the *structure* of art. Sometimes, art is thought of as a language, a visual language, which one learns to understand by studying how it is put together. But, as has been observed above, we first learned our spoken language as a whole *and then* were taught parts of speech, rules of usage, and the rest. Without knowing the definition of some noun or verb, we derived its meaning in particular contexts from the way people used it and reacted to our own speech. Consequently, it would appear that studying the *construction* of language or of art is not absolutely necessary for the apprehension of meaning. There must be some other good reason for studying the parts and structure of linguistic or artistic forms, or the effort might well be abandoned.

The point of view taken here is that the parts and organizational devices of a language have meanings of their own and are worth studying for their own sake. Words, and techniques for putting them together poetically, have inherent interest and beauty quite apart from

the comprehensive meaning of a poem. The values generated by word combinations in a poem or the organization of visual elements in a work of art are called formal or syntactical values, and they constitute an additional source of satisfaction and pleasure. Hence, my discussion of the visual elements and their organization in works of art is an effort to draw your attention to additional sources of aesthetic pleasure and meaning.

There is another reason for approaching the study of art by examining its fundamental units first and then proceeding to the way they are organized and perceived: works of art are created step by step and part by part. They do not spring into existence as finished wholes; it is doubtful that artists initially conceive of the finished work and then go on to execute its parts methodically. An artist may have a vague idea of what he is seeking at the outset, but he improvises, modifies, or even totally changes his original objective before he is finished. He is guided by goals, but the goals change as he works. We might say that the changing goals of the artist during the process of execution give *aesthetic form* to his use of materials. Otherwise the creative act would be mere manipulation, mere play. By studying the structure of art, we may not learn to be artists ourselves, but we can learn something about *the decisions* artists make in the light of their formal objectives.

The experience of art is not based entirely on what is objectively present in an art object. Even if viewers could agree on the objective existence of a red circle in a particular painting, its meaning would vary to some degree according to the personality of each observer and to a large degree in relation to his habits of seeing, his perception. Some works of art are deliberately created with the expectation that the viewer's perception, his act of seeing, will play a role in the meaning of the whole work. Such works are incomplete without the perceptual contribution of the viewer. Accordingly, we shall look into aesthetic perception as a constituent of the structure of art. We are primarily interested in perception not as physiologists and psychologists study it (although their researches are helpful) but as artists manipulate it. Painters, for example, may not understand color as physicists do, but they use it to affect the way people see their pictures. And we, in turn, try to discover what the painter seems to have done with our perception of color to complete his picture.

If the study of structure is carried out properly we should learn three things: (1) the nature of the constituents, or the elements of visual art; (2) the way these elements are organized, the so-called principles of design; and (3) the way people see and respond to what has been organized—that is, the viewer's contribution to the art experience.

THE VISUAL ELEMENTS: GRAMMAR

People see images, not things. Sensations of light falling on the retina are transmitted as energy impulses to the brain, where they are almost simultaneously translated into a meaningful entity called an image. Not that there is a picture, an optical projection, in the brain itself. The optical processes are in the eye, of course. But perception is a function of the mind. We cannot experience sensation without characterizing it in some way, giving it a label, loading it with meaning. An image, therefore, can be defined for our purposes as *the result of endowing optical sensations with meaning*.

For practical purposes, the common images we see have labels like house, tree, boy, and sky. But we can train our perception to identify the constituents, the elements, of ordinary images. That is, we can learn to focus our attention on the shape, color, texture, or light patterns which are parts of images. In fact, when we focus our attention on *part* of an image—its shape, for example—that part, that element, *becomes* the image because it becomes the meaningful locus of our interest.

Artists working in all media and styles have trained their perception so that they see more than the common images visible to everyone; they can also shift gears readily to see in terms of contrast, brightness, line, space, color, volume, and so on. The practice of fashioning images for others to see has accustomed them to think in terms of image constituents, the visual elements.

We are concerned, of course, with the visual elements of works of art: lines, shapes, and textures as they are employed by artists. After we have learned to see them in art, we may discover these same constituents in nature, although, obviously, no artist is responsible for the texture of trees or the linear properties of the veins in a leaf. To see the visual elements of art in the natural world is to project upon nature certain acquired habits of perception which we find pleasurable or useful. Consequently, one of the indirect dividends of studying art in general and the structure of art in particular is the added satisfaction we can get in ordinary perception of the world outside art.

When art was largely naturalistic, before the abstract and nonobjective became the central tendencies of painting and sculpture, the visual elements received little attention. Traditional painting and sculpture were studied

mainly in terms of their literary meanings, their narrative values, and the sentiments and emotions they aroused in viewers. Architecture and applied art were subjected at times to formal and structural analysis because of their nonrepresentational character. But even so, textures, shapes, spatial properties, and color as such received less attention than the meaning of allegorical figures, symbols, and naturalistic ornamentation applied to the basic structures. However, with the increased use of abstraction, it became necessary to find a language common to all modes of visual expression.

The labels used to designate the visual elements tend to vary according to the user, but what the labels denote in the art object is fairly consistent. It does not matter greatly if one authority uses "form," another "contour," and a third "shape." These terms are common and clear; and in any case they are defined by the contexts in which they occur. As synonyms, they are used fairly interchangeably, but precisely, in this book. What is important, however, is that you, the viewer, *understand* the real properties of the structure of art which these several words designate.

The discussion of the visual elements which follows does not constitute a grammar or set of rules which artists follow or disobey at their peril. Rather, I offer it as a visual grammar based on artistic *usage*—a *functional* explanation of the visual elements.

Line

SAUL STEINBERG. *Diploma.* 1955. Addison Gallery of American Art, Phillips Academy, Andover, Massachusetts. Although the writing on this diploma looks authentic, it cannot be read: the artist has exploited all the linear and compositional conventions of diploma art except those concerning correct letter form.

There is a difference between *a* line and *line-in-general*. *A* line, of course, is the path made by a pointed instrument: a pen, a pencil, a crayon, a stick. In geometry, a line is "an infinite series of points." This definition calls attention to a line as a dynamic entity; a line implies action because action was necessary to create it. Line-in-general suggests direction, orientation, motion, and energy. The effect of movement may be achieved by a series of shapes, none of which is thin, sharp, or linear but all of which collectively imply a direction. In other words, *a* line is an actual mark made by a sharp, moving instrument, whereas line-in-general is the result of a conclusion by the viewer that a particular set of forms has an orientation, a direction. For the most part, we shall be talking here about *a* line, the sharp, definite series of points.

Because we all have used lines to write, to make marks in the sand, in dirt, or on sidewalks, we know that a line

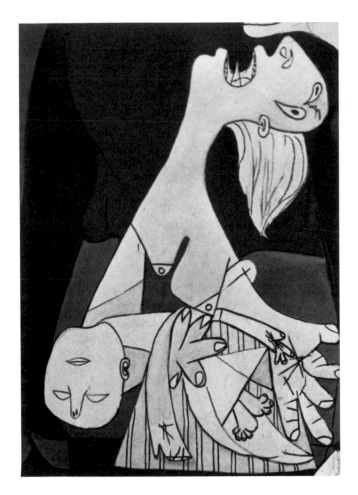

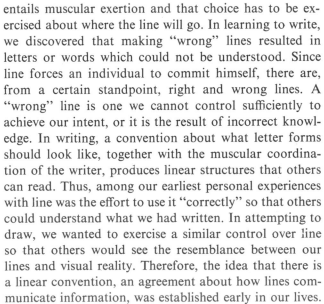

PABLO PICASSO. Detail of *Guernica*. 1937. On extended loan to the Museum of Modern Art, New York, from the artist

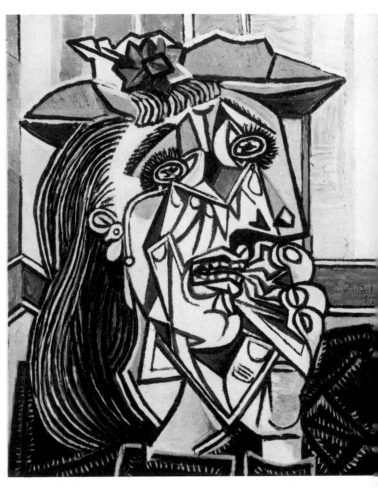

PABLO PICASSO. *Woman Weeping*. 1937. Penrose Collection, London

entails muscular exertion and that choice has to be exercised about where the line will go. In learning to write, we discovered that making "wrong" lines resulted in letters or words which could not be understood. Since line forces an individual to commit himself, there are, from a certain standpoint, right and wrong lines. A "wrong" line is one we cannot control sufficiently to achieve our intent, or it is the result of incorrect knowledge. In writing, a convention about what letter forms should look like, together with the muscular coordination of the writer, produces linear structures that others can read. Thus, among our earliest personal experiences with line was the effort to use it "correctly" so that others could understand what we had written. In attempting to draw, we wanted to exercise a similar control over line so that others would see the resemblance between our lines and visual reality. Therefore, the idea that there is a linear convention, an agreement about how lines communicate information, was established early in our lives.

We did not know the *basis* for the agreement about combinations of lines standing for certain sounds and

images, but we used the conventions and they worked. Line combinations acquired magical properties: a circle could be a letter, a ball, the sun, a face, the world. Line was thus alive with possibility, potent with meaning. In art, however, the agreements about the meanings of line operate differently from those in writing. The artist *goes behind* the conventions of writing to the magical-symbolic origins of linear properties. Indeed, the artistic employment of line, when it is very expressive and widely approved, can become the basis of new linear conventions which people recognize and understand almost immediately. This would seem to be the case with Picasso's linear formulations of the crying woman and the horse's head in *Guernica*.

THE MEANINGS OF LINE

We know that our present phonetic letters grew out of a pictographic language, letter forms being derived from pictures of oxen, ram's horns, the sun, people, agricultural tools, and so on. Over the centuries, pictographic

symbols became increasingly abstract, and in the form of alphabets have come to stand almost solely for sounds, although in China and Japan they continue to designate words and ideas nonphonetically. Although our Western letter forms may have lost their descriptive-pictorial function, we still recognize the relation of certain line combinations to fundamental physical conditions. Vertical lines look like trees in a windless landscape. They also look like erect men as opposed to running men, falling men, sleeping men, or dead men. Obviously, verticality stands for lack of movement, and it can symbolize life as opposed to death. The meaning of verticals can be extended, depending on context, to include dignity, resistance to change, timelessness, and so on. All the meanings are based ultimately on the fact that man is an erect, two-legged creature, who through the millennia of his evolution has developed reactions to verticality which are now part of his so-called human nature. It is doubtful that insects or fish or other creatures older than man would have similar reactions to verticality. If man's agelong associate, the dog, speculates about these matters, he must interpret verticality in some distinctively doglike way, since he is himself a horizontal creature.

The associations with horizontal lines are betrayed, of course, in the word itself. The mountain rising abruptly from a plain may be a dramatic focal point in the uninterrupted horizon, or it may be an obstruction to unimpeded movement as represented by the horizon. Turbulent wave forms break up the *horizontality*, the *calm*, of the

sea. They are also the probable origin in nature for many of the artistic forms employed in Romantic art to symbolize tempestuousness, *sturm und drang*. At six or seven years of age, children begin to employ a base line in their drawings—a horizontal line at the bottom of the sheet which stands for the ground plane we walk upon and, in a cosmological sense, for the *foundation* of the world or the basis of civilization.

The combination of vertical and horizontal lines provides us with the right angle, which is the foundation of the work of some artists—Cézanne, Seurat, Mondrian, Mies, Albers, and many others. The absolute, precise right angle introduces the man-made element into the natural world of irregular and approximate forms. Two verticals connected by a horizontal at the top indicate two posts and a lintel, or beam; hence, a doorway, a house, a building, and so a solid, safe place. To the simple repetition of the verticals is added the constructive horizontal member; thus man builds, putting things together

NORBERT KRICKE. *Raumplastik Kugel.* 1955. Collection Hertha Kricke, Düsseldorf. The complex linear system that Kricke builds with white wire no longer refers to an organic act—for example, the path of a man's hand as he writes cursive script; instead, it relates to subatomic particle trajectories, or to celestial motion, as in the paintings of Matta.

BILLY APPLE. *Untitled: Multiple Edition of 10.* 1967. Multiples, Inc., New York. The handwritten line has long been simulated by the ubiquitous neon sign. Now that same technology serves aesthetic ends—the linear impulses of abstract sculptors who wish to trace luminous paths in space.

VICTOR PASMORE. *Linear Development No. 6: Spiral.* 1964. Collection Mrs. John Weeks, London. A system of drawn lines serves as a visual analogy for a variety of processes in nature: growth, flow, resistance, and mutual adaptation.

so they will stand. A single vertical might be blown or pushed down; connected horizontally to other verticals, it has a better chance to remain upright. Note the stability of the letter H.

When applied to the human figure, the horizontal calm of the ocean, land, or sky means sleep or death, but death understood as the absence of strife, as man at one with Mother Earth. Danger is associated with diagonal lines —suggestive of man or the structures he has built *falling* to earth. Just as the right angle suggests stability, the diagonal suggests instability, loss of balance, uncontrolled motion. The two-legged creature fears a physical fall and in his religions translates that movement into a symbol for a moral fall. Only when the diagonal forms a triangle resting on its base (△) or when it connects the corners of a rectangle (▱) can it be regarded as safe. In the latter it forms a truss, strengthening the rectangle against any force that would make it an unstable parallelogram (▱). To these engineering associations of man the builder we can add the catastrophic meanings seen in lightning, a jagged, diagonal line (⟋⟍). Splits and cracks in stone or wood also take a jagged, diagonal path. Hence, in man's works and in nature, such lines symbolize breakdown and destruction.

Circular, ovoid, and curved lines are exceedingly complex in their meaning because they are less definite, predictable, or measurable than straight lines. These qualities alone are enough to connect them with femininity.

Since so many of the meanings of lines derive from the human figure, it is obvious that curves describe the fleshier portions of the anatomy. Circular lines, then, are inevitably associated by men with the female bodily attributes which arouse their erotic interest and which are related to procreation and nurture. Because of what feminists regard as tyranny, these essentially masculine interpretations of curvilinear forms are shared in the main by both sexes. That is why rounded hills in nature or in art are rarely compared to a man's shoulders. On the other hand, active and inactive volcanos—Vesuvius, for instance—usually bear male appellations and male roles in folklore.

Curved lines also suggest the motion of certain natural phenomena. Light rays, of course, travel only in straight lines, but water flows *around* objects. Thus we speak of curved lines as *fluid* lines. Bodies of water contain eddies and whirlpools, or spirals and concentric circles. The human ear, too, is shaped like a helix, or spiral. So also is the ram's horn, the volutes of Ionic column capitals, and snail shells. When children are born they still maintain a spiral position; in some primitive cultures, therefore, spiral designs on amulets are considered effective in promoting female fertility. Some tribal peoples bury their dead in a crouched or spiral position so they will be ready to be born again. Women living in modern, mechanized cultures also wear spiral-formed jewelry, but doubtless they are unaware of the fertility implications. For us,

Radiograph of chambered nautilus

such forms have essentially technical-mechanical signifi-
cance; our daily lives may be too far removed from nat-
ural processes to sustain the meanings of early magical
forms.

This discussion of line has led inevitably to a discussion
of linear symbolic forms. We have mentioned only a few
of the many meanings associated with these basic motifs.
Moreover, the meanings and functions of the visual ele-
ments will vary greatly according to the context provided
by the artist. The combination of lines, angles, and curves
with shape, texture, and color complicates the aesthetic
situation immensely. We may examine particular works,
paying close attention to the operation of their linear
elements, but it should be plain from the discussion above
that no matter how finely we dissect a work of art, we
can never arrive at a line which is meaningless, purely
itself and nothing more. The problem is rather one of
selecting the best meaning among the many possible
meanings within a given context.

USES OF LINE IN WORKS OF ART

For a demonstration of line employed simply, powerfully,
and accurately, we can study Picasso's drawing of the bal-
let impresarios Diaghilev and Selisburg. The artist who
has given the world so many truncated and distorted
images of the figure here shows his mastery of drawing as
it was understood by the academic tradition. But he goes

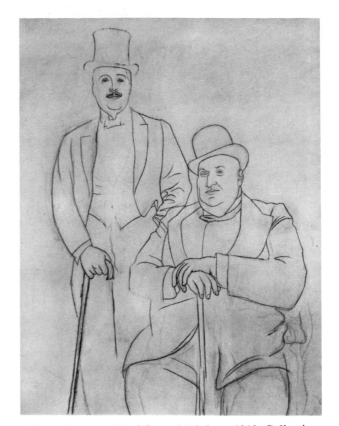

PABLO PICASSO. *Diaghilev and Selisburg*. 1919. Collection
the artist

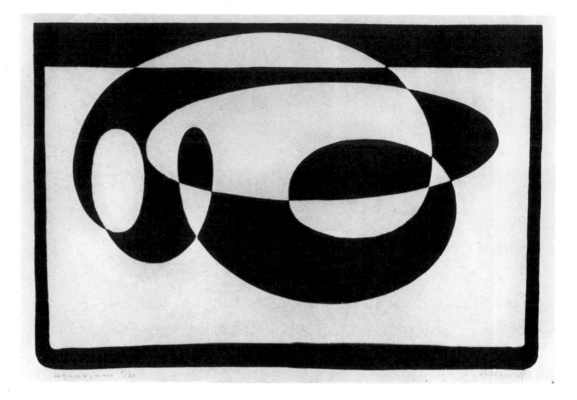

JOSEF ALBERS. *Aquarium.* 1934. Philadelphia Museum of Art. Print Club, Permanent Collection

beyond a simple display of representational skill and, dispensing with light-and-dark modeling, uses line darkened or accented by varying pencil pressure to describe the volume and movement of the forms enclosed. The lack of shading imparts a classical elegance to these already elegant, fashionable, and well-fed gentlemen. The hands of M. Selisburg constitute a set of complex, foreshortened, intermeshed forms and together with his fleshy face are executed with a line of dazzling precision and simplicity. Even in a naturalistic vein, Picasso knows how to use the power of abstract forms—underlying ovals, cones, and cylinders—to strengthen the work. In this case, the tilted bowler hat on Selisburg enhances the characterization of the face, just as the angular lines of Diaghilev's top hat help cancel the bulbous effect of a second chin.

Josef Albers (born 1888), known for his many variations of "homage" to the square, has created an ovoid composition within a rectangle in his woodcut *Aquarium* (1934). This work shows line produced indirectly—at the edges where flat, contrasting areas meet. The artist uses line and shape here to play with the viewer's perception: one sees alternately the *lines* created by the juxtaposed forms and the *shapes* contained by the ovoid lines. He opposes vertical ovals, at the left, to large horizontal ovals, center and right. Negative shapes—that is, shapes of nonsolids—and positive shapes exchange places. We can even see a fairly naturalistic fish if we try. The thickened black bar along the top defines the water surface, thus locating the figure as a floating form in the white rectangular space below, which then becomes water.

The artist has even managed to balance out two white triangles by having them point in opposite directions. Finally, the refusal of the figure-and-ground relationships to resolve themselves completely may be regarded by the viewer as a brilliant visual device for making the fish "swim."

The idea of a line going on a journey is well demonstrated in the work of Paul Klee (1879–1940). He continuously reminds us that line can be used not only to describe the shapes of things, as in conventional drawing, but also to call attention to the act of making the line itself. He indulges in a type of metaphysical wit, creating illusions of reality with drawn lines and then employing some device to let the viewer know he has been briefly deceived about the real existence of an image. Actually, Klee lets the viewer in on a private joke: the artist is not too sure whether the image he draws is "out there," somewhere inside him, or created by unseen hands. Thus, the play between the objectivity and the subjectivity of Klee's images becomes the real image the viewer sees. *Family Walk* is an example of Klee's wit which perfectly illustrates a discussion of line. In this abstract performance, a few geometric shapes and edges are sufficient to describe the characters, suggest their procession, evoke the family associations, and carry off the artistic point that reality can be described eloquently with line combinations which embody the structure and movement, but not the *appearance*, of people. In *Flight from Oneself*, Klee attempts a more serious and penetrating study: a visualization of alienation, or split personality. The repeated gestures appear to be decorative in purpose until we realize that

they represent the dual aspects of a single soul. The meandering line, apparently a disciplined scribble, turns out to be sufficiently controlled to repeat itself exactly in different scale. The figures are separate but joined, made of something like string, and attached to each other by the same "string" which accounts for their being. Klee, with great economy, portrays the reality of the psyche and the illusory character of the body at the same time.

His magical way with lines, his play with levels of reality, has been widely imitated—notably by Saul Steinberg (born 1914). No one, however, has approached Klee in the originality of his linear invention. And as a metaphysician who "happens to be" an artist, he ought to be ranked, perhaps, with professional philosophers who specialize in that branch of the discipline.

Line employed as in a map is visible in *Drawing in*

PAUL KLEE. *Family Walk.* 1930. Kunstmuseum, Bern. Permission Cosmopress Geneva, 1966

PAUL KLEE. *Flight from Oneself.* 1931. Kunstmuseum, Bern. Permission Cosmopress Geneva, 1966

CORNEILLE (CORNELIS VAN BEVERLOO). *Drawing in Color*. 1955. Collection the artist

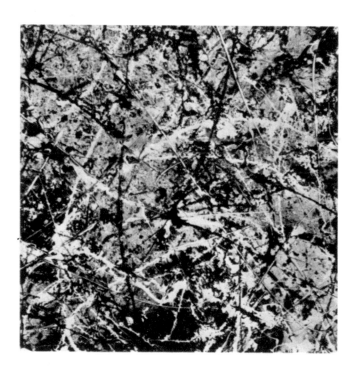

JACKSON POLLOCK. Detail of *Number I*. 1948. The Museum of Modern Art, New York

Color by the Belgian artist Corneille (Cornelis van Beverloo). This work can also be regarded as an aerial view of the varying densities of a populated area seen from a plane as it travels from the countryside to the tangled core of a city. It is not a real map; rather it imi-

tates and exploits the linear *qualities* of real maps. There are some black blots which, in a genuine map, might stand for bodies of water but which here function as do the knots in Jackson Pollock's paintings—as places where things get "tied up." Notice that the freer lines are ungraceful, their movement hesitant and awkward; in places they are childlike. The open blocks do not have the rhythmic, undulating qualities of nature; they suggest lots that formerly had buildings which have been torn down, while the neighboring areas await further "clearance." The awkward, scratchy line accompanied by blots here and there is an expressive comparison between bad pen writing and the urban experience. To make the metaphor more specific, the artist is probably comparing the frustrating act of writing with an old steel pen to one's movement—physically or visually—through the city.

Drawing lines occur in sculpture, too, except that they move in three rather than two dimensions. A good illustration is a humorous little work, *The Hostess*, by Alexander Calder. The penetration of formerly solid sculptural forms has encouraged linear tendencies, especially in welded sculpture, since iron and steel can obviously be employed in ways foreign to clay or stone. One of the first modern sculptors to exploit the linear properties of iron was Julio Gonzalez (1872–1942), who, logically enough, grew out of the rich Spanish tradition of decorative ironwork. His association with Picasso and Brancusi contributed to his adoption and personal assimilation of the form language of modernism. In *Grande Maternity* (1930–33) he employed welded iron rods combined with a late-Cubist approach to the figure to

create an aloof, stately, monumentally dignified version of a woman. The converging lines, which meet at the head and at the waist, represent her hair and the gathered folds of her skirt; yet they create just enough density to suggest the corporeality of the body. This sculpture eliminates a great deal, arriving at form by implication rather than addition of appendages. Squint your eyes in looking at the sculpture to gain some idea of the masses which are so sparingly suggested by the sweeping lines of the rods and the cagelike structure of the skirt.

A recent, more attenuated sculpture which builds on the pioneer work of Gonzalez is *Organic Form, I* (1951) by Joseph Goto (born 1920). Its symmetrical and delicate treatment of figurative forms carries the work to the edge of architecture, suggesting the linear tracery of a Gothic church spire. The fact that line is versatile aids the sculptor: he can use it as a drawing line, describing the contours of objective forms; or he can use it as the skeletal framework upon which a skin may or may not later be placed. Because line is precise and unambiguous in character, it well expresses systems—the nervous system, the skeletal system, wiring diagrams, maps and charts, even the structure of life itself, as in a two-dimensional model of the DNA molecule which carries genetic information in the cell. Line can give us a map of life's secret.

JULIO GONZALEZ. *Grande Maternity.* 1930–33. The Tate Gallery, London

JOSEPH GOTO. *Organic Form, I.* 1951. The Museum of Modern Art, New York

ALEXANDER CALDER. *The Hostess.* 1928. The Museum of Modern Art, New York. Gift of Edward M. Warburg

Model of the DNA molecule

Ironwork kitchen accessories. 1700–1825. The Henry Francis du Pont Winterthur Museum, Winterthur, Delaware. Skewer holder, gift of Charles K. Davis

American iron candlestands and rushlight holders. 18th century. The Art Institute of Chicago

The linear character of early American cooking accessories made of wrought iron derives ultimately from utilitarian considerations and the nature of the material itself. Some of the forms are not unlike those of Gonzalez and are strongly suggestive of the anthropomorphic candlesticks also made in colonial America. The late David Smith (1906–1965) plays a geometric game with eating utensils and tableware in *The Banquet*, using line to describe objects and also to locate them in relation to each other on the table. In *Royal Bird*, a biomorphic work, Smith employs a dominant horizontal line made of steel, bronze, and stainless steel parts. Here, as in Theodore Roszak's *Spectre of Kitty Hawk* (p. 236), visual metaphors based on the bird's skeleton are used as the primary sculptural forms. The calm associated with horizontals, however, is counteracted by the fierce beak-

and-jaw construction, the spikes darting out from the head, and what we know to be the aggressive stance of a fighting bird. The linear pattern of the rib cage, when translated into metal, recalls the intricate armor of medieval knights more than Thanksgiving leftovers. But if we can suppress our associations with the bird and see the horizontal pattern primarily as a cursive script with fascinating contrapuntal angles and curves, we can almost read the construction as a kind of metal calligraphy. There is no question that David Smith has been strongly influenced in his sculpture by the written line. In one sculptural landscape, he drew in space—combining descriptions of hills, rocks, and clouds with a mysterious, metallic penmanship.

Contrasting attitudes of the artist toward line can be seen in the *Nude with Face Half-Hidden* (1914) by Matisse

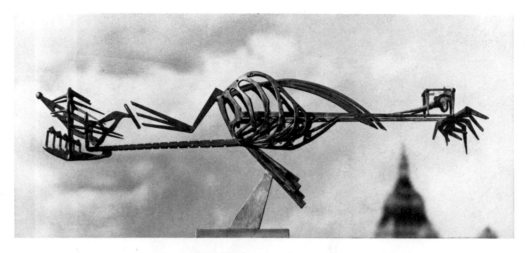

DAVID SMITH. *Royal Bird*. 1948. Walker Art Center, Minneapolis

young womanhood, a bicyclist who has created a new Christ out of sprockets, wheels, gears, and handlebars. and *La Grande Julie* (1945) by Fernand Léger (1881–1955). The line Matisse uses is firm, knowledgeable, and confident: when using it to represent the swelling curves of the figure, he does not lose sight of its independently abstract quality. It is both a drawing line and an ornamental arabesque. In the hand, he abandons a strict naturalism in favor of a semiabstract shape; he was apparently tempted by the sculptural possibilities of the hand and forearm thrust toward the viewer. Happily, the empty space in the left half of the print adequately balances the weight and thrust of the forms in the right half. Léger, in his painting of 1945, employs a heavy, mechanical line of unvarying weight and antinaturalistic intent throughout. Julie is perhaps a symbol of mechanized

DAVID SMITH. *The Banquet*. 1951. Private collection, New York

REMBRANDT VAN RIJN. *Woman Seated at a Window*. 1655–60. National Museum, Stockholm

Rembrandt's young woman, like Klee's, is lost in thought; but hers is not a neurotic or alienated inwardness. This healthier image is due, in part, to the decisiveness of Rembrandt's brushed lines in contrast to the deliberate "lostness" of Klee's line.

PAUL KLEE. *And I Shall Say*. 1934. Paul Klee Foundation, Kunstmuseum, Bern

In place of the sensuous and sophisticated linearity of Matisse, we are given blatant color, stark contrasts of light and dark, and a rigid line which could be made of cable. It is difficult to say whether Léger means simply to indict mechanization or whether, in his flight from sensitivity and sentiment, he is trying to prepare the way for a new world with a tough-minded, uncompromising presentation of the impending female type as she really will be. The painting is concerned more with the description of an idea than of an image; it has only an apparent relation to visual reality. Even its superficial rigidity is deceptive. It is not Julie who is rigid, mechanical, and depersonalized, but the *idea* she symbolizes.

A deployment of line by Klee which is difficult to place in any neat category appears in his drawing *And I Shall Say* (1934). The torso seems to have been executed with a slightly directed scribble. The hands and feet are good imitations of drawing by children. But the head could only have been done by a skillful draftsman. He has united all three modes of drawing in a single, psychologi-

cally convincing characterization. Once again we see the prototype of an approach to the visualization of personality employed by contemporary "cartoonists" like William Steig and Robert Osborn. But they are more literal than Klee in the portrayal of the "psychopathology of everyday life." Beyond the cryptic title, which laconically describes a practice we are all familiar with, Klee relies on linear invention to do the job for him. The figure's position, the device for showing the eyes directed inward, the immaturity of the hands, the uncertainty of the body—all combine to describe a person confidently but pathetically wrapped in fantasy. Her mouth is closed, her mind is speaking. She listens to herself making reply in an imaginary dialogue. The work is truly modern in that it is radically original, exhibits a twentieth-century type of psychological insight, and, like most masterpieces, is remarkably economical.

Line is perhaps the most crucial of the visual elements. The reasons for its importance might be summarized as follows: (I) Line is familiar to everyone because of our

WILLIAM STEIG. Drawing for an advertisement for the French Line. 1970. Courtesy N. W. Ayer & Son, Inc., New York

almost universal experience with writing and drawing. (2) Line is definite, assertive, intelligible (although its windings and patterning may be infinitely complex); it is precise and unambiguous; it commits the artist to a specific statement. (3) Line conveys meaning through its identification with fundamental natural phenomena. (4) Line leads the viewer's eye and involves him in its "destiny." (5) Line permits us to do with our eyes what we did as children in getting to know the world: we handled objects and felt their contours. By handling an ob-ject we trace its out*lines*, in effect, with our fingers. In our growth toward maturity, the outlines of things eventually became more important for identification than color, size, or texture.

The mention of *outline* immediately suggests shape, which is sometimes considered an extension of line. Shape seems to take priority over line, color, and texture in our recognition of phenomena. Hence, we shall devote the next section to an examination of shape as a crucial element of art and visual perception.

Shape

According to the purist philosopher in Molière's play *The Forced Marriage*, form is "the outward physical manifestation of an animate object," whereas shape is "the outward physical manifestation of an *in*animate object." One speaks of the *shape* of a hat, not its form. One speaks of the *form* of a lady, but reference to her shape is not quite proper. Clearly, the difference between form and shape hinges on whether or not the object is alive. For art, such distinctions are much too fine; in fact, they may constitute distinctions without a visual difference;

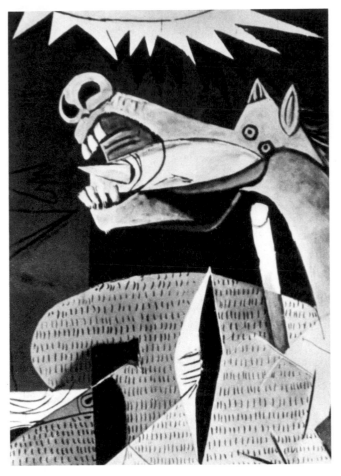

tool used to create them; there are also shapes which do not apparently occur in nature or the manufactured environment but are "invented" by the artist. However, a viewer cannot help seeing these shapes—no matter how abstract—in terms of his experience with reality. That is, he cannot see a triangle without regarding its corners as sharp and hence related, however remotely, to something which has a point, which can puncture, which is potentially dangerous. This does not mean that triangles are necessarily dangerous. A triangle resting on its base also suggests stability, like a football lineman crouched in a three-point stance. The meaning and operation of a triangular shape ultimately depend on which of the potential properties of a triangle the artist chooses to emphasize. If an artist uses a triangular shape to describe or embody something which in life is ovoid or curved, his departure from the expected provides an important clue to the meaning of the work as a whole. Why, for example, does the horse's tongue in Picasso's *Guernica* come to a sharp, dagger-like point?

Let us examine some of the fundamental shapes which occur in art or in reality and summarize their most obvious and common properties. We shall find, in examining specific works, that the artist often endeavors to *redefine* the conventional properties of shape through his total organization of the visual elements. His effort necessarily takes place, however, within the context of broad, common experience with the properties of shapes as man encounters them in life.

here the terms have been used interchangeably. We are interested in shape *or* form as one of the visual elements and in the manner of its operation in works of art.

Our discussion of line necessarily touched on shape since closed lines become the boundaries of shapes, such as triangles or circles. But shapes can be created without lines, as when a painter establishes an area of color or a sculptor creates a three-dimensional volume. Drawn lines need not be used in either case. The resultant shapes may have *linear* quality if our attention is drawn to their boundaries; but contours usually have the effect of making us aware of the *shape*, that is, they point to the silhouette of the area or space they enclose. We may, if we wish, think of *shape* merely as an extension of *line*, but that would be a quibble about categories. The important point is that shape is something we perceive as a distinct entity, something which supports meaning, something which operates structurally within art objects.

The shapes that artists create have a wide variety of sources: some are directly drawn from nature or the man-made world; others reflect the characteristic mark of the

Snow crystal. The crystalline world exhibits a regular geometry which is normally associated with man-made creations. Perhaps human egoism explains our tendency to attribute order to man and irregularity to nature.

Leonardo was supposed to have been able to draw a perfect circle freehand—that is, without any aid or tool. But whenever we encounter any perfect geometric shape, we are inclined to believe it was not made by hand. Perfect straightness and absolutely regular curvature in visual phenomena imply a mechanical origin. Recall that the characteristic beauty of machine-made objects, as opposed to handcraft, lies in their geometric precision and regularity of form. Irregularity and variation of shape characterize handmade forms. Hence, when we perceive works of art which contain shapes that appear to have been produced with a straightedge and compass curves, even though the artist has used his hands and hand tools to create such forms, we "read" them as mechanical forms. Machine forms, we realize, do not grow as natural objects do but are the result of human planning and design, activities which are essentially intellectual. Consequently, geometric shapes possess cerebral qualities, since, like mathematics, they appear to be pure products of the intellect. Geometry can be found in nature, of course, in the microscopic examination of crystals and snowflakes, for example, and even in certain geological formations; but nature confronts the unaided eye overwhelmingly in the form of irregular, asymmetrical, uneven shapes.

JEAN ARP. *Star*. 1939–60. Collection Edouard Loeb, Paris

Giant's Causeway, Northern Ireland

Our own bodies and the bodies of animals are a source of the irregular ovoid and curvilinear shapes which seem to have organic or biomorphic qualities. They are modeled ultimately on the pattern of organic growth through the division and integration of cells. What designers of coffee tables used to call "free form," and builders of outdoor swimming pools called "kidney-shaped," constitutes a correct although banal application of biomorphic form. Of course, crustaceans defy this principle since they are living creatures yet possess jagged, sharp, almost geometrically shaped armor. But their armor, which has been so suggestive to sculptors working with welded metal, is like our fingernails—lacking the nerves, muscles, blood vessels, and capacity for sensation of flesh and hence not "organic."

Star by Jean Arp (1887–1966) is a good example of organic shape given to a phenomenon traditionally conceived in geometric terms. A star is, after all, light from a distant body. We do not really see the source, just the light-wave emanations. But Arp has chosen to construct a biological model of the conventionally pointed diagram we use to symbolize a scientific concept. The star has lost its geometry, its absolute regularity, and its radiating points. It has gained skin and flesh, with bones implied

Spiny lobsters

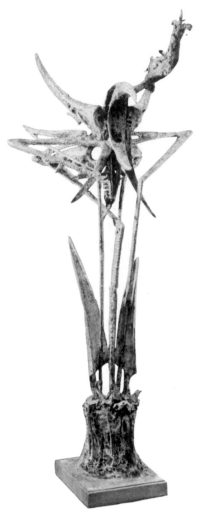

THEODORE ROSZAK. *Sea Sentinel*. 1956. Whitney Museum of American Art, New York

The weapons, sense apparatus, and armor of crustaceans offer a form language which has a curious fascination for contemporary painters and sculptors —Graham Sutherland and Theodore Roszak, for example.

GRAHAM SUTHERLAND. *Thorn Trees*. 1945. Albright-Knox Art Gallery, Buffalo, New York. Room of Contemporary Art Fund

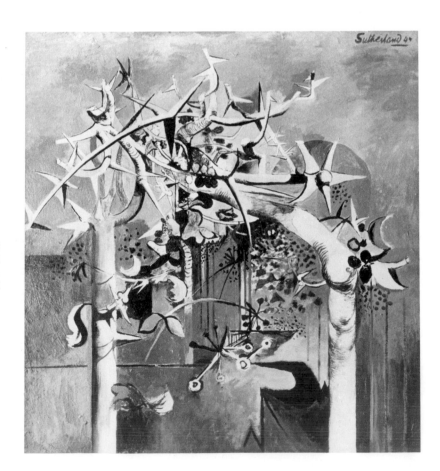

underneath, and an opening in the center which might be any bodily aperture. The contradiction between the standard idea of a star and its beautifully organic embodiment is no obstacle to enjoyment of the sculpture. In fact, its very freedom from the constraints of common sense and tradition is an asset.

Architecture seems to be an unlikely source of organic shapes since its fundamental structural devices are geometric in form. However, the modern development of plastics and reinforced concrete has vastly enlarged the vocabulary of forms available to the architect. Indeed, one of the commonly heard criticisms of some contemporary buildings is that their designers are too flamboyantly sculptural, seeking to create exciting shapes at the expense of functional efficiency. Le Corbusier's chapel at Ronchamp, however, satisfies structural and functional requirements while using shape to enhance the symbolic expressiveness of the chapel. The roof, particularly, resembles in profile a sculpture by Brancusi, the *Fish*. Although it might be forcing the comparison to suggest that Le Corbusier designed the roof as a literal image of the fish, which is a central symbol in Christian iconology, the biomorphic shapes in the building do increase its capacity to express the idea of the Church as a container, as the body of Christ.

Another instance of the architectural use of organic shapes is seen in the Casa Milá Apartment House in Barcelona. Antoni Gaudí (1852–1926), the architect, avoided geometric shapes wherever possible, and in the stone columns, particularly at the ground level, created the impression of dozens of elephants' legs. One would have to go back to Hindu-temple construction of the eighth century to find a comparable approach to architectural form. The entrance to the shrine at Elephanta, carved and excavated from solid rock, bears a singular resemblance to the Gaudí apartment house. In Gaudí's work and the Art Nouveau movement in general, organic shapes were employed consistently without regard to the function of the work, the character of its materials, or the processes employed in forming and fabricating the object. Hence, although the style often appears to be a triumph of the imagination over the obduracy of materials, it sometimes approaches the ludicrous because of its obsession with curves.

CONSTANTIN BRANCUSI. *Fish*. 1930. The Museum of Modern Art, New York. Lillie P. Bliss Bequest

LE CORBUSIER. Notre Dame du Haut, Ronchamp, France. 1950–55

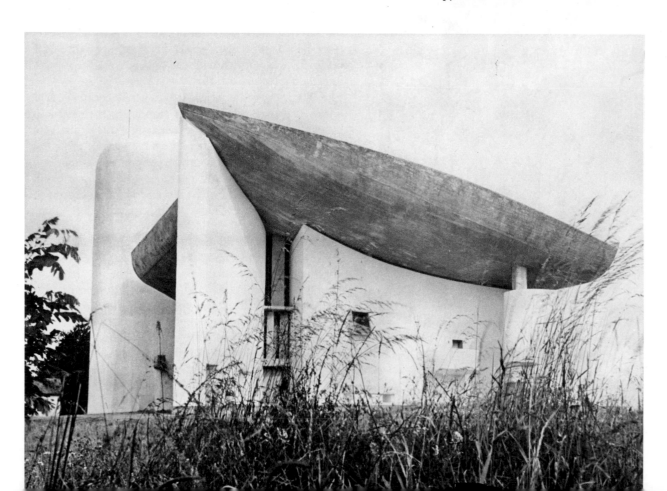

Entrance to the shrine, Cave No. 1, Elephanta, India

Antoni Gaudí. Casa Milá Apartment House, Barcelona. 1905–10

Arp's *Madame Torso with Wavy Hat* is clearly frivolous in shape and comic in purpose. We can readily identify the basic hourglass figure, while the head, hat, and hair develop into shapes like an Ionic capital, ocean waves, or an inverted handlebar mustache. The several convex, rounded forms are balanced by the negative, *concave* shapes located where the thighs would fit into the torso. And the raised relief of the figure casts shadows which strongly define the negative shapes, accenting the formal organization. But why are these forms frivolous? We might hazard a guess that organic shapes without a suggestion of structural firmness seem to wriggle, to describe a biological entity without bones (as in Miró's *Harlequinade*), implying the movement of a gelatin dessert. We have seen instances of excess flesh that develops a power of motion independent of its owner's wishes. The result, depending on the viewer's outlook, is ungraceful or lyrically pleasing, superabundant or enormously funny. The *Wavy Hat* is reminiscent of the curly, feathery shapes Miró is fond of using, as in his *Harlequinade*, a party of a picture, replete with squirmy, biomorphic shapes. Some of its fantastic insects would arouse the envy of that redoubtable illustrator of children's books, Dr. Seuss.

Adolph Gottlieb (born 1903) presents in *Blast II* a splendid laboratory demonstration of the properties of shape. The canvas is occupied by two forms of approximately the same area and mass, but the upper one is smoothly rounded whereas the lower one is ragged and chaotic, smeared at the edges, seething with conflict. The title and visual aspect suggest that the work is an abstract version of a nuclear explosion. A circular form above appears to represent the familiar mushroom cloud, while the agitated shape below designates the destructive process. The cloud possesses a serene, floating quality which heightens the contrast with the "noisy" chaos below. An interesting feature of the lower shape is the random, smeary quality of the brushstrokes at the periphery. They tell us that the artist does not emphasize the destructive force of a nuclear blast so much as its "dirty" character. And, since scientists and military men speak of "clean" bombs, the idea is appropriate. An *un*clean bomb is, of course, one which yields a large amount of radioactive fallout. Obviously, the artist has attempted to express this concept by the use of dark, smudged, disorderly shapes against an immaculate background above which floats a clean, bright, carefully brushed-out cloud form.

From the fertile imagination of Paul Klee comes a striking illustration of the two major types of shape—the biomorphic and the geometric. In addition to its visual interest, *The Great Dome* constitutes philosophic statement expressed through modest, unassuming lines and symbolic shapes in the guise of architectural description. The structure on the left represents the culmination of the agelong effort to bear the weight of a dome continu-

JEAN ARP. *Madame Torso with Wavy Hat*. 1916. Hermann and Margrit Rupf Foundation, Kunstmuseum, Bern

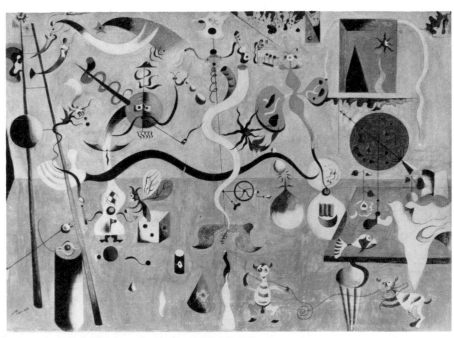

JOAN MIRÓ. *Harlequinade*. 1924–25. Albright-Knox Art Gallery, Buffalo, New York

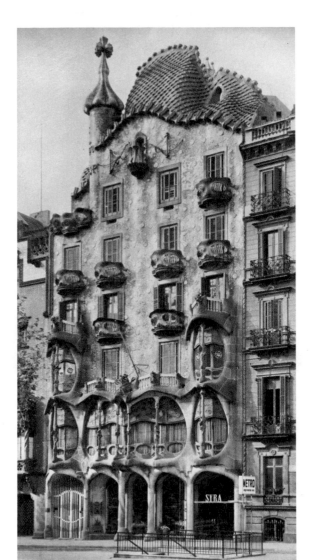

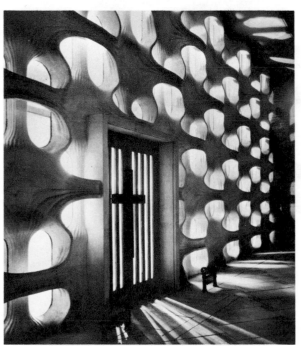

P. J. DARVALL. Screen for Upton Chapel, Christ Church, London. 1959

ANTONI GAUDÍ. Casa Batlló, Barcelona. 1905–7

The fleshy facade Gaudí designed for the Casa Batlló acquires strength and firmness through thin, bony columns which seem to be supporting enormous Surrealistic eyelids. These same highly expressive shape relationships are echoed, over fifty years later, in the architectural screen designed by P. J. Darvall.

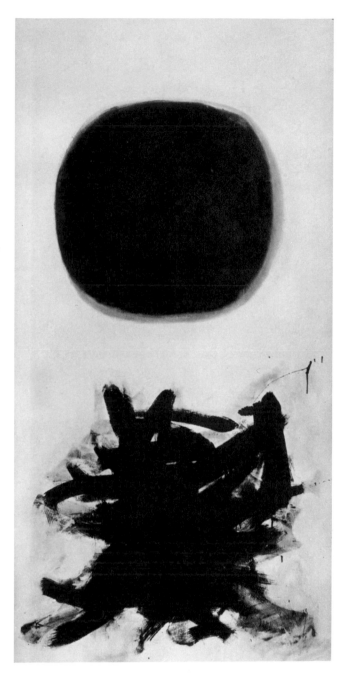

ADOLPH GOTTLIEB. *Blast II*. 1957. Joseph E. Seagram and Sons, Inc., New York

ously around its edge. At the same time, the dome is the architectural expression of the female breast, the symbol of maternal nurture. In the right half of the picture, Klee portrays a tower, symbol of the male principle, which is essentially geometric, a system of triangles. These basic shapes are starkly presented, each occupying one-half of the picture space. They are connected somewhat (not really joined) at the base of both buildings, but it is worth noting that Klee employs no compositional device to harmonize the two shapes, to connect them visually, to

mitigate their fundamental opposition. Furthermore, in his title he ignores the tower. If we may permit ourselves some amateur psychologizing, Klee here is expressing (a) the eternal war between the sexes and (b) his admiration, as a man, for woman. As in his *Flight from Oneself,* the artist shows his interest in the duality of all unities. Just as human personality struggles with itself and sometimes succeeds in becoming alienated, the sexes, which must unite to be creative, are nevertheless opposed to each other in the very nature of their appearances. This dichotomy is expressed through the contrasting monuments that represent the sexual polarities.

Perhaps an extreme example of the employment of geometric shapes to represent human beings is seen in *Composition: The Cardplayers* (1917) by Theo van Doesburg (1883–1931). Did *The Card Players* by Cézanne of 1890–92 anticipate, with its hint of Cubism, the complete dematerialization of the innocuous gamesters in Van Doesburg's work? We are aware of progressively smaller forms, more densely packed at the center of the picture, where hands and cards and a drink, perhaps, may come together. A few large, right-angle shapes suggest the location of shoulders, knees, chairs maybe. Surface organization takes precedence over representation, and much of its interest stems from our knowledge that this organization is based upon, is abstracted from, something real. The movement, the recession in space, and the interlocking character of visual forms are represented.

PAUL KLEE. *The Great Dome*. 1927. Paul Klee Foundation, Kunstmuseum, Bern

Billowing spinnakers. Shapes also possess volumetric meanings; we can perceive them as the containers of dynamic forces. The beauty of a sailing vessel (as well as its female associations) is based on the container idea, here expressed in the spinnakers of the sloops.

ELLSWORTH KELLY. *Aubade.* 1957. Museum of Art, Carnegie Institute, Pittsburgh. Through the scale and location of his positive convex shapes, Kelly manages to generate sensations of expansion and contraction of the visual field.

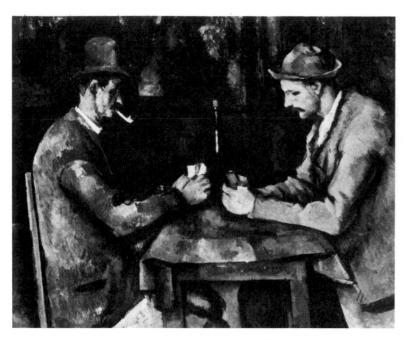

PAUL CÉZANNE. *The Card Players*. 1890–92.
The Louvre, Paris

THEO VAN DOESBURG. *Composition: The Card-
players*. 1917. Gemeente Museum, The Hague,
The Netherlands

Only the imitation of appearances is absent. The organic shapes of reality have been converted into the geometric shapes of a mechanized, completely rationalized art. Consequently, it is not surprising that a modern device now exists which can create patterns representing the electronic circuitry of computers, patterns which bear a remarkable resemblance to Van Doesburg's painting. The electronic patterns are made by a technician using an instrument called a "coordinatograph." Did Van Doesburg unwittingly anticipate printed electronic circuits? Will more sophisticated coordinatographs supplant painters? Do electronic engineers create art?

Technician using coordinatograph to prepare pattern for microelectric circuit

One of our operating assumptions about shape has been that geometric forms suggest machine technology whereas irregular, curvilinear, and ovoid forms have biological origins. Now this assumption is refuted by a printed circuit for a television set which is not only devoid of geometry but which could have been drawn by Arp, Dubuffet, or Henry Moore. Some of the forms have figurative connotations, although they are only the result of translating the functions of resistors, condensers, and electronic tubes into two-dimensional patterns. If such quasi-artistic phenomena are unintentionally created by engineers in the course of designing a television set, perhaps we might insert Douglas Pickering's drawing *Pomegranate* into a television circuit and watch the screen for the results.

The world has seen some curiously amusing shapes in the work of Arp and Miró. Now we look forward to new frontiers of shape organization as electronic engineers reveal their latent artistry in the design of circuits for television.

Light and Dark

Goethe on his deathbed is reported to have uttered the phrase, "More light." Rationalist philosophers of the En*light*enment spoke of "the light of reason." In this context, light means that which clarifies, that which dispels darkness. Darkness, by contrast, stands for ignorance and obscurity. In the humanist tradition, light is a symbol of the activity of mind operating to clear away and illuminate what is dark, hidden, and mysterious, to reveal the shining face of truth. It is also a masculine symbol; all the ancient sun gods were male: Apollo, Mithras, Mazda, and Horus. Such light symbolism, of course, bears a close relation to reality because, without light, we could not see. Our eyes are light-sensitive organs, equipped to receive stimuli caused by light energy falling upon objects—energy which is then absorbed, or reflected back to our eyes to form the sensory data of images. Darkness is not a positive phenomenon, it is the absence of light.

The world of art, however, is created by man, not by nature. Artists use darkness as a positive tool: they work with shadows to imply light. The light in Klee's *Self-Portrait* is the absence of shadow; the exposed paper is seen as light because of its *contrast* with the black areas painted in by the artist. Without *some* contrast, we would have the sensation of light but would be unable to perceive line and shape. The famous *Suprematist Composition: White on White* painted by Kasimir Malevich (1878–1935) shows how the virtual elimination of light-dark contrast almost results in the inability to discriminate any form. Actually, Malevich used two kinds of white—warm and cool—so that perception is possible on the basis of a subtle color or "thermal" difference rather than light-dark contrast. But for the most part, artists employ distinct contrasts of light and dark or of hue to delineate form.

A drawn line is visible because of contrast, whether a dark line on a light ground or a white line on a dark ground. Since colors, even when pure, differ in degree of lightness or darkness, they can be used to establish light-dark differences and thus visible form. As pure pigment, yellow is lighter than red, blue is darker than green. Sometimes, however, colors are mixed to the same degree of lightness or darkness, and then the eye is obliged to discriminate between them on the basis of their chromatic

H. DOUGLAS PICKERING. *Pomegranate*. 1955. Collection the artist

Printed circuit (used in television sets). The Museum of Modern Art, New York. Gift of Warwick Manufacturing Company, U.S.A.

PAUL KLEE. *Self-Portrait. Drawing for a Woodcut.* 1909.
Collection Felix Klee, Bern

KASIMIR MALEVICH. *Suprematist Composition: White on White.* c. 1918. The Museum of Modern Art, New York

quality alone—a matter we shall discuss later. I should point out that, although the works created by sculptors, architects, and craftsmen are seen in terms of light and dark, it is chiefly the two-dimensional media of painting and drawing which employ the device of light-dark contrast for the creation of form. Sculptors and architects build their forms directly. Painters create the *illusion* of forms in space, and light-dark contrast is one of their principal tools.

The simplest type of light-dark contrast is visible in the silhouette. Usually a solid black against a white ground, the silhouette provides a maximum of contrast and visibility. But it directs the viewer's eye to its shape as a source of information or identification. Its interior is uniform and flat; it has interest only by virtue of what can be implied through its contour. Silhouettes occur in nature, as when we see an object against the light. But usually, objects are illuminated by one or several light sources. The play of light over their forms, when imitated by an artist, results in a naturalistic appearance. Artistic manipulation of light and dark to reveal form or to create the illusion of volume on a two-dimensional surface is called "modeling"—a term borrowed from sculpture. An object can be "modeled" with only the stark contrast provided by two "values"—black and white. But a more convincing and subtle representation of natural appearance can be created by imitating a wider range of light intensities. This type of modeling, which was perfected during the Renaissance, notably by Leonardo da Vinci, is called *chiaroscuro.*

By taking great pains and introducing a wide range of gradation of shadow, an artist can almost simulate photographic naturalism. However, the eye can discriminate more degrees of light intensity than the skill or materials of the artist will permit. Consequently, artists do not usually attempt to compete with the camera, even when they are trying for objective accuracy. Instead, they look for *patterns* of light and dark which can reveal form effectively: they simplify and generalize shadows in some places and represent them with great accuracy in others. Thus, we can look at equally convincing representations of the form of the same object and find that they affect us differently, because of the varying emphasis placed on the patterning of light and dark. Chiaroscuro as a tool is subject to an almost infinite variety of uses: light-dark contrast can be exaggerated or underplayed; the artist may simplify shadow and accumulate detail in the light areas or vice versa; he may superimpose linear conventions upon forms modeled by chiaroscuro. And color and texture are inevitably involved in the representation of form. It is almost impossible for an artist to create forms by an absolutely mechanical imitation of the varying intensities of light and dark visible in the model he may be attempting to represent. Some process of selection, some evidence of emphasis, some sign of exaggeration by inclusion or suppression of visual facts will be apparent in the drawn or painted work. However, the evidence that an artist has *attempted* naturalistic imitation will have some bearing on our perception and critical interpretation of his work.

HENRI DE TOULOUSE-LAUTREC. *Maxime Dethomas*. 1896. National Gallery of Art, Washington, D.C. Chester Dale Collection. Silhouette used to create pictorial space and to direct the spectator's vision.

KÄTHE KOLLWITZ. *War Cycle: The Parents*. 1923. National Gallery of Art, Washington, D.C. Rosenwald Collection. Silhouette used to force the eye inward where it can locate details animating the total form.

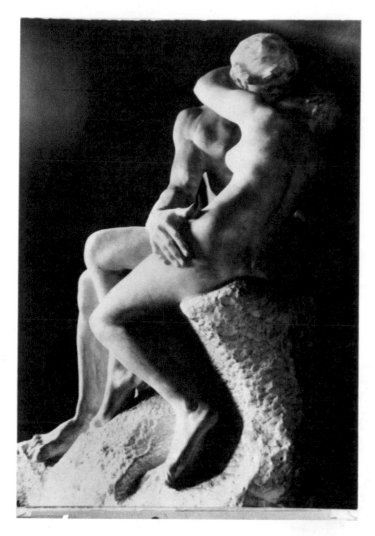

AUGUSTE RODIN. *The Kiss*. 1886–98. Rodin Museum, Paris

DAVID SMITH. *Drawing 1959—8*. 1959. Estate of David Smith. Courtesy Marlborough Gallery, New York

Much of the symbolism of light and dark is literary or mythic in character. Yet in the visual arts, the transitions from light to dark have meanings of their own—that is, distinctively aesthetic meanings—as do the shapes of shadows also. The gentleness or abruptness of halftones, or transitional areas, participates in the creation of emotional responses in the viewer. The type of illumination—from above or below, from one source or from many sources—affects our perception. The distinctness or indistinctness of shapes is controlled by line and also by the manipulation of light and dark. Some shadows appear to be empty or opaque; others are luminous and mysterious. They invite closer inspection for themselves, or they may direct our attention back to the light areas they define. We have already noted that some architects design interiors which are bathed in strong light while others create spaces and volumes which will cast shadows or break up the intensity of direct light. The sculptor Rodin was especially sensitive to the effect of light on viewers of his work. He would move a lighted candle along the contours of his figures to help him see transient light-and-

dark effects and thus control the animation of his sculptural surfaces. The welded sculptures we have seen by David Smith are highly effective in silhouette; indeed, some of his preparatory drawings show that he conceived his works largely in terms of their silhouettes.

As with the other visual elements, our perception of light and dark is guided by our experience of it in life. And in life we avoid too much of either: we can be as blinded by the absence of light as by light itself. Strong light-dark contrasts are equated with sharpness of focus, and since only near objects come into sharp focus, the degree of contrast in artistic forms provides information about their location in space. Once again, it was Leonardo who knew this first and advised painters to make distant objects less distinct than near ones—that is, less bright in color and less marked in contrast. The degree to which forms melt into one another or retain their separate identity is often a function of light-dark manipulation. The resulting distinctness or indistinctness of form is one of the important indices of style according to Heinrich Wölfflin;[12] we shall return to this subject in our discussion

of perception. At present, we may note one of the practical advantages of the eye's preference for avoiding the extremes of light or of darkness: so far as natural light is concerned, the late afternoon seems to afford, not the best visibility, but the most interesting shadows and halftones compatible with the pleasing delineation of form. Consequently, it is a good time for the conduct of social life. Ladies beyond the bloom of youth always seem to have known this important fact. Only American teenagers have the temerity to brave a Coke date at noon in the fluorescent glare of a modern soda-drug-and-pill emporium.

One of the consequences of the unrestrained use of color in modern painting has been the tendency to think of light and dark in terms of color. Even black-and-white prints have color and tonality. The paper has a certain color; hence, light areas may be slightly yellow or blue; and all black inks are not the same: students of painting are taught to describe forms not only by tonal painting (that is, by variations of one hue) but also by playing on the different colors which reside in the light, dark, and

halftone areas. Nevertheless, our perception of objects seems to be affected primarily by the distribution of light and dark on their surfaces. Only *after* we have identified objects in this manner do we go on to perceive their color qualities. And, as we know, some persons are color-blind in various degrees; this deprivation may handicap them in certain respects, but most of them function quite adequately. The primacy of form as determined by shape and by light and dark, therefore, accounts for the heavy reliance on these visual elements throughout the history of art. We shall discuss in the following pages some examples of the dramatic use of light and dark in traditional and modern art.

BAROQUE EXPERIMENTS WITH ILLUMINATION

After the masters of the Renaissance perfected chiaroscuro, the later Mannerist and Baroque painters went on to employ unusual illumination to dramatize their subjects. In Caravaggio's *The Calling of St. Matthew* (c. 1597–98) (p. 313), for example, the source of light from

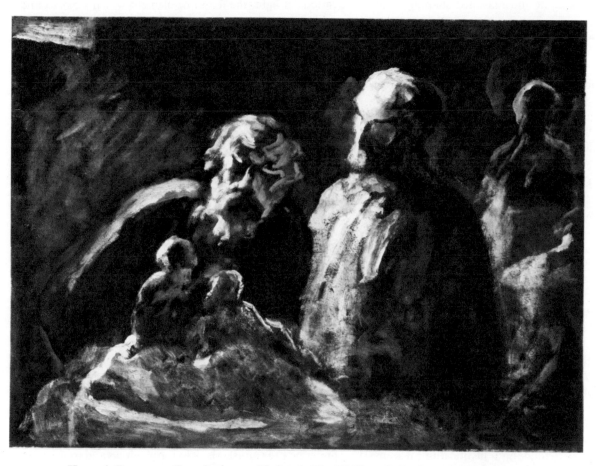

HONORÉ DAUMIER. *Two Sculptors*. Undated. The Phillips Collection, Washington, D.C. Daumier models with light almost as a sculptor does with clay. His pigment acquires a palpable plastic identity and thus helps usher in the modern notion that a picture is an object before it is a representation of something else.

the right—so clearly indicated by the modeling of the figures, the cast shadow on the wall, and the direction of Christ's hand—provides a means of endowing the event with a highly theatrical quality. About eighty percent of each figure is in shadow; bright light creeps around the edges of the forms to perform its descriptive function and also to seize the eye of the viewer. Study of the abstract patterning of the sharply defined light areas will reveal that they carry the real burden of the work. Georges de La Tour (1593–1652) went a step further, using *artificial* light to construct dramatic forms of classic simplicity. His *Saint Mary Magdalen with a Candle* (1625–33) (p. 313) shows the remarkable lengths to which the Baroque artist would go to create quiet pictorial drama through light-and-dark patterning while remaining within the confines of visual realism. The painting is very "modern" in its simplification of form, its deliberate pursuit of geometric shapes in anticipation of Cubism, and its manipulation of light to arrive at essentially abstract patterns. Distracting detail and a descriptive inventory are suppressed; the dark areas are handled so as to maximize their mystery. Although about three-quarters of the picture surface is in darkness, it is a very comfortable darkness, made so by the calm and reasoned shaping of the lights.

El Greco is known to us as a superb colorist, having carried the Venetian tradition of Titian and Tintoretto to Spain, yet he was also the master of a so-called flickering light—a light more animated than that of La Tour. Although both are Baroque painters, La Tour exhibits a formal order which relates him to modern classicists like Seurat and even Mondrian, while El Greco possesses an emotional, agitated style which may be felt in modern Expressionists like Munch, Kokoschka, and Soutine. His *The Agony in the Garden of Gethsemane* (c. 1580) (p. 316) appears to be artificially illuminated, especially in the Christ figure, in which the light-dark contrast is powerfully distinct. Of course, El Greco's technique of monochromatic underpainting followed by transparent overglazing (pp. 387–89) permits separation in the execution of two crucial phases of pictorial composition: light-dark modeling and color application. Contemporary painters attempt to deal with color and light and shape all at once: what is gained in spontaneity, though, is lost in the opportunity to calculate in advance the shape, color, and dramatic impact of the total composition. El Greco, too, seems very modern in that he did not feel obliged to be consistent or uniform in his light sources or in the naturalistic rendering of visual forms. The angel receives a different illumination from that of the Christ; the difference is partly explained by a shaft of light, but to modern eyes the lighting requires no natural justification; it seems entirely appropriate for the treatment of a mystical-religious theme.

In Rembrandt we encounter perhaps the most moving synthesis of Baroque experiments with dramatic light-and-dark illumination. The simplification of forms in the light, the cultivation of mystery in the darks, the buildup of pigment and opacity in areas of maximum illumination as in El Greco, and a variety of other technical and structural devices are readily at his disposal and are used with maximum eloquence and discrimination. Rembrandt underpaints and overglazes, but he is not averse to painting in spontaneous passages opaquely on top of transparent areas. His transitional tones bear the closest study because it is there that he departs from the abstract patterning of light and dark and reveals the distinctive insight into the human condition which raises his art above merely skillful pictorial organization. In *Man with a Magnifying Glass* (p. 314) the loss of light in the half-tones and shadows serves not only to model the forms but also to symbolize all that is human—that is, vulnerable—in his subject. The light areas consist of a vigorous, masculine impasto swimming among liquid, colored glazes which begin the transition to the luminous shadows. The light might be regarded as the virile, affirmative element—meeting our eyes first, establishing the shapes of the principal forms, struggling to expand and assert its dominance. The halftones represent the modifications of light, the feminine element which seeks to find an accommodation to the incursion of light through resistance, compromise, and yielding. Halftones operate in those areas which light cannot entirely occupy. In the shadows we see death and defeat, their luminosity being the visible record of invasions by light which failed. However, while the darks in Rembrandt allude to death, they do not symbolize the final frustration of life but merely a stage in an ongoing process. That is, the light is dynamic; it has been where the shadow is now, and one feels that it will return.

LIGHT AND DARK IN MODERN ART

The modern use of light and dark was most spectacularly inaugurated by Edouard Manet, especially in his "scandalous" painting *Le Déjeuner sur l'herbe*. But his *Olympia* (1863) may be an even more dramatic example of the use of flat lighting in figures set against a sharply contrasted dark background. It may have been this merciless flat light as much as his subject matter which aroused the indignation of the French public. That is, they may have believed they were objecting to his candid and highly individualized treatment of nakedness, but perhaps they were aesthetically offended by his realistic and unsentimental application of paint, his glaring treatment of light. Manet tended to eliminate halftones and subtle modeling effects. He painted directly, without glazes, but with a preference for bluish black in the shadows and transitions. The *Olympia* lighting has some of the quality of a candid camera photograph in which the flash bulb has flattened out the forms. This flattening was to influence the progress of subsequent painting in bringing all forms up to

FRANÇOIS BOUCHER. *Miss O'Murphy*. 1752. Alte Pinakothek, Munich

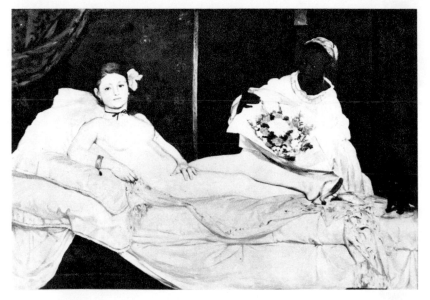

EDOUARD MANET. *Olympia*. 1863. The Louvre, Paris

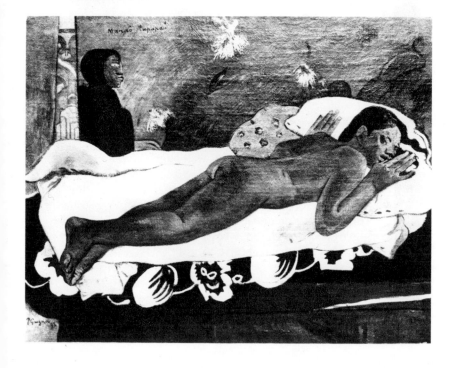

PAUL GAUGUIN. *The Spirit of the Dead Watching*. 1892. Albright-Knox Art Gallery, Buffalo, New York. A. Conger Goodyear Collection

From Boucher to Manet to Gauguin one travels through several distinct modes of viewing women. At first she is a delightful toy; then she becomes a more complete person—still used for pleasure, but humanized to the point where her frank stare is embarrassing; and finally she reverts to fearful adolescence as the child-woman imprisoned by the superstitions of an old witch.

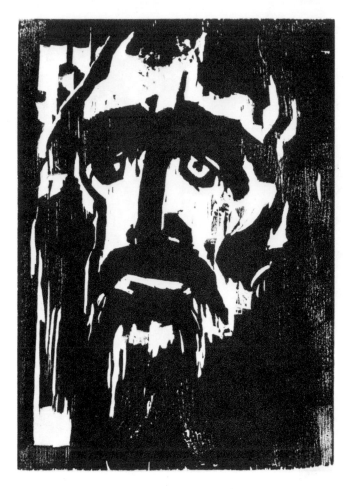

EMIL NOLDE. *Prophet*. 1912. National Gallery of Art, Washington, D.C. Rosenwald Collection

GEORGES ROUAULT. *Miserere: Dura Lex sed Lex*. 1926. Philadelphia Museum of Art. Purchase, Temple Fund

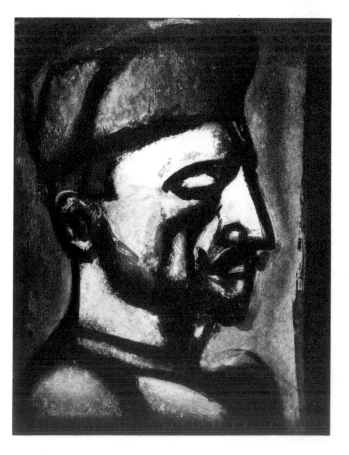

the picture plane. By 1892, Paul Gauguin, in *The Spirit of the Dead Watching*, could benefit from the innovations initiated by Manet in the flattening of forms and in stark light-and-dark contrasts. Gauguin was able to concentrate on symbolism and psychological expression while exploiting the compositional devices pioneered in Manet's *Olympia*.

The woodcut *Prophet* (1912) by Emil Nolde (1867–1956) shows how powerfully expressive the simple contrast of black and white can be when all middle tones are eliminated. Of course, the woodcut medium is highly suited to this treatment of light. But we would not accept it as readily as we do if it were not for the process of simplification of light and dark set in motion by Manet. The bridge of the nose and the nostrils in Nolde's *Prophet* are entirely dark, though the logic of illumination would dictate otherwise. But by 1912, an artist could mix abstract and descriptive elements almost arbitrarily, in this case producing a harrowing impact through the continuous pattern of darks connecting the brows, nose, and mustache. The light areas are not only patterns of light falling on the bony structure of the face and skull; they also become abstract forms which we read symbolically. The tool used in cutting the wood block imparts a characteristic shape to the forms; it does not change direction easily or gracefully because it must contend with the resistance of the wood grain. Consequently, the harshness of the shapes becomes an attribute of the subject: the prophet is ignored or despised because he declares truths the multitude does not wish to hear.

Rouault's *Dura Lex sed Lex (Harsh Law, but Law)* (1926) is a print very much in the spirit of Nolde's earlier woodcut. Here, too, the pictorial structure is basically an extreme light-and-dark contrast, with the inclusion of a few halftones which modulate the light intensity somewhat. The texture Rouault is able to achieve with the printing plate creates a painterly richness of surface, so that this work seems less obedient to the character of printmaking than the Nolde. But it is clearly the emotional expression of an idea which is paramount in Rouault, and he accomplishes his purpose mainly through an uncompromising use of the extremes of black and white combined with painfully astringent shapes.

As mentioned earlier, the modern movement has increasingly stressed the function of color as a determinant of form. Even architects have bravely incorporated bright primary colors into exterior wall panels. Painters, in their training and in their mature work, rarely devote their energies to consideration of problems of modeling by chiaroscuro, contrast by light and dark, or emotional impact through unusual illumination. Furthermore, technology has produced a large array of safe, durable, and brilliant colors which may be used without mastering the complex techniques of earlier eras. Consequently, limitations in the aesthetic potential of color will probably be

determined, not by the tools and techniques which technology can devise, but by the perceptual capacity of the human organism. However, it would appear that, although there is much that artists know about color, they presently know a great deal more about how to employ the expressive potential of light and its opposite, dark. It would be appropriate, therefore, to discuss the artistic use of color, which may be the visual element that holds the most promise for enlarging the realm of aesthetic effect.

Color

I shall discuss color *theory* in somewhat summary fashion because it is treated exhaustively and expertly in a number of specialized works on the subject. Besides, color theory provides speculative answers to questions which are not often asked in the course of examining works of art. Some color systems seem related to the physiology of perception more than to the aesthetics or psychology of perception. Others may have evolved from industrial needs for the classification and description of dyes, pigments, and colored objects. At any rate, artists work with color—pigment, to be exact—more on an intuitive than a scientific basis. The so-called Op artists may have a more sophisticated understanding of color and of perceptual theory than is usual among painters. But ultimately, even so knowledgeable a colorist as Josef Albers must paint his pictures by making intuitive adjustments to the organismic requirements of his own vision rather than by applying the data of color physics to the problems of pictorial organization. Even the French Impressionists, who were supposed to have been influenced by the color theory of Helmholtz, cannot be accused of knowing as much about color theory as today's high school student of physics. Their opportunity to see, in 1870, the work of Turner and Constable in England may have been a more potent influence on their subsequent painterly development. One might say that the aesthetic value of their painting transcends the discovery that objects *en plein air* have purple shadows. And teachers who have inflicted color wheels, color intermediates, and triads on generations of students appear divided about the ultimate effectiveness of this material for influencing the use of color by artists or the understanding of color by the public at large.

COLOR TERMINOLOGY

There is, nevertheless, a terminology of color based on scientific study and theoretical classification which facilitates discourse about it and permits orderly reference to the chromatic properties which we believe generate aesthetic emotion. Following are brief definitions of the terms most commonly used in connection with color, chiefly the effects attainable through the use of artists' pigments.

Hue is the quality we normally label by the names of the so-called primary colors: red, yellow, and blue. Note that these are different from the colors of the light spectrum as taught in physics: red, orange, yellow, green, blue, indigo, violet. The primary hues are theoretically the basis for mixtures resulting in orange, green, and violet; and, presumably, the primaries are *not* the result of a mixture. But in practice with artists' pigments, the most intense hues are achieved by mixture. The names given by manufacturers to colors are usually a form of proprietary advertising or labeling designed to distinguish a color from its almost identical cousins made or sold by other manufacturers. Thus we have "Mediterranean Gold," "Colonial Yellow," "Roman Bronze," "Canary Yellow." And finally we have the artists' pigments: yellow ocher, gamboge yellow, chrome yellow, and so on.

Value refers to the lightness or darkness of a color. As white is added, the color becomes "higher" in value until pure white is reached. Conversely, as black is added, or some other color which has a darkening effect, the value becomes "lower" until pure black is reached. As you approach pure white or pure black, you become less aware of the chromatic or color quality and more aware of the lightness or darkness, which is to say, the *value* of the color. Yellow is already high in value. It can be used to raise the value of colors darker than itself. Blue is already low in value. It can lower the value of lighter colors.

Intensity refers to the purity of a color, the absence of any visible admixture. As mentioned above, pigments are not often absolutely pure; thus they seldom present a hue at its fullest intensity. For example, the pigment called alizarin crimson can be made into a very intense red by the addition of a small amount of yellow or cadmium orange. Ultramarine blue is very dark as a pigment and becomes an intense blue hue only with the addition of white. Of course, too much white will kill its intensity and give it a faded appearance.

Local color is the color we know an object to be as opposed to the colors of the object we actually see. We know a fire engine is red, but depending on the light conditions when we see it, its distance, its reflective quality, and so on, it will appear red, violet, yellow, orange, and even green in some places. Its sparkling highlights might be

almost white. At least, a painter would use these colors in representing the "redness" of the fire engine. Similarly, distant mountains appear to be blue or violet although we know that the local color of their foliage is green. The blue or violet which the green becomes when it reaches an observer's eye is called *optical color*.

Complementary colors are opposites. They are opposite each other on a color wheel; more fundamentally, they are opposite in that the presence of one denotes the absence of the other. In this sense, no other color is as different from red as green. To the human eye, the afterimage of red is green; the afterimage of green is red. If red and green are placed side by side, the red looks redder and the green looks greener because the afterimage of each enhances the actual image of the other. If, instead of being juxtaposed, complementaries are mixed, they cancel each other out—that is, they produce a gray or, more likely, what painters call mud. Thus they neutralize each other. A small amount of red added to a large amount of green will gray the green; white added to the mixture will raise the value; and thus a variety of interesting grays can be mixed without the use of black.

Analogous colors are relatives, kinsmen, as opposed to strangers like complementaries. They are related because they share the same "blood lines"—red and orange, orange and yellow, green and blue, blue and violet, violet and red. Analogous colors are contiguous on the color wheel, so that families of color do not end distinctly at any point but seem to "intermarry" with their neighbors. Being relatives, they "get along," if that is true of relatives. They are harmonious next to each other; they mix with each other without becoming gray.

Warm and cool colors are so called perhaps because of our psychological associations with blood, fire, sky, and ice. Reds, yellows, and oranges are warm; blues, greens, and some violets are cool. But these "thermal" properties are relative. Yellow green would be cool next to orange but warm next to blue. Gainsborough introduced some purple into the shadows of his *Blue Boy* to warm up what would have otherwise been a chilly blue figure. Picasso did the same thing in his Blue Period paintings. Painters often create forms by contrasts of warm and cool rather than of light and dark. The warm colors seem to advance, the cool colors tend to recede. This illusion results not only because of association but also because the wave lengths at the warm end of the light spectrum are stronger —that is, more visible—than those at the blue-violet end. Ultraviolet, of course, cannot be seen at all.

Tonality refers to the generalized, overall color effect of a work of art when one color and variations of it, produced by admixtures of light or dark pigment, seem to predominate in our vision of the whole. Rousseau's *The Dream* (p. 266) has an essentially green tonality, for instance. At times we speak of warm or cool tones, which is a way of referring to variations of color built around a dominant warm or cool hue. A painting with a blue tonality may contain reds and yellows, but, because of the *quantity* and *distribution* of blue and its *tonal* variations, the single comprehensive effect is of the prevailing blue Tonality imposes at least a color unity upon a work, reducing and simplifying the problems of composition by reducing the number of color variables the artist must endeavor to harmonize. If he is particularly concerned with problems of shape, volume, or illumination, the artist may deliberately limit his range of colors, employing variations of one or two pigments plus black and white. Such a practice is called working with a *limited palette*. Yet great subtlety and expressiveness are possible while working within a single tonal range. The major works of Analytic Cubism were executed by Braque and Picasso with a limited palette, largely an umber, blue, and burnt sienna tonality. (Notice that it is easier to designate their prevailing color, or tonality, in terms of the painter's pigments than by the hues drawn from the light spectrum or the color wheel.)

COLOR AS LANGUAGE

It should be plain that very little can be asserted with certainty about colors in isolation. They always occur in a context or relationship—in art and in life. The *quantity* of a color in a particular context may overturn some of our assertions about advancing/receding, expanding/contracting, warm/cool relationships. And, of course, the *shape* of a color area affects its impact, as does the visible manner of its *application*. In addition to the optical properties of color, there are its symbolic properties to consider. Needless to say, there is an enormous accumulation of folklore about color as well as a theoretical and practical discipline called the psychology of color which endeavors to deal systematically with this material. Professionals called color consultants apply the body of knowledge about color to a variety of practical problems in manufacture, communication, safety, decoration, illumination, and so on.

One of the prominent goals of the modern movement in art has been the use of color as a direct and independent language of meaning and emotion. Abstract and nonobjective art liberated painters to the extent that they could abandon or minimize the use of the other visual elements and endeavor to communicate by color exclusively. The intention of some painters was to imitate music, which communicates feelings through "nonobjective" sound. There have even been attempts to combine painting and music through the invention of "color organs" which project colored light on a screen as one plays on a keyboard. The artist Wassily Kandinsky, who seemed to think of color in terms analogous to musical notes and of painting in terms of musical composition, is credited with the creation of the first nonobjective paintings, works which were not abstracted from anything,

Baroque Experiments with Illumination

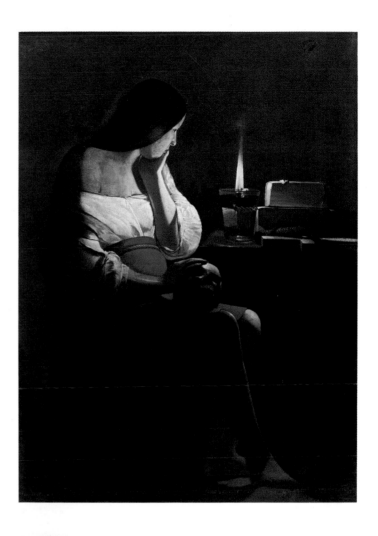

GEORGES DE LA TOUR. *Saint Mary Magdalen with a Candle.* 1625–33. The Louvre, Paris. La Tour's light represents the cleanliness of a spirit which has been washed and scrubbed by the effects of endless moral reflection.

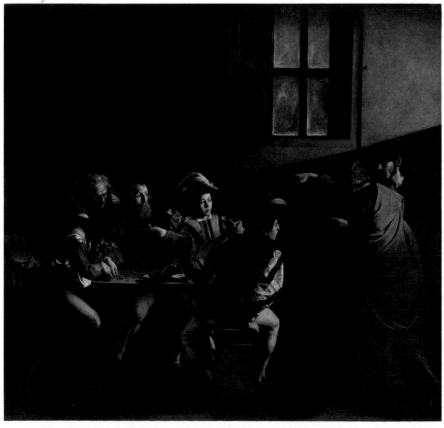

CARAVAGGIO. *The Calling of St. Matthew.* c. 1597–98. Contarelli Chapel, S. Luigi dei Francesi, Rome. For the sixteenth-century mystic, darkness was a spiritual opportunity—not merely the absence of light. In the shadows of Baroque painting, the substance of the soul made itself felt.

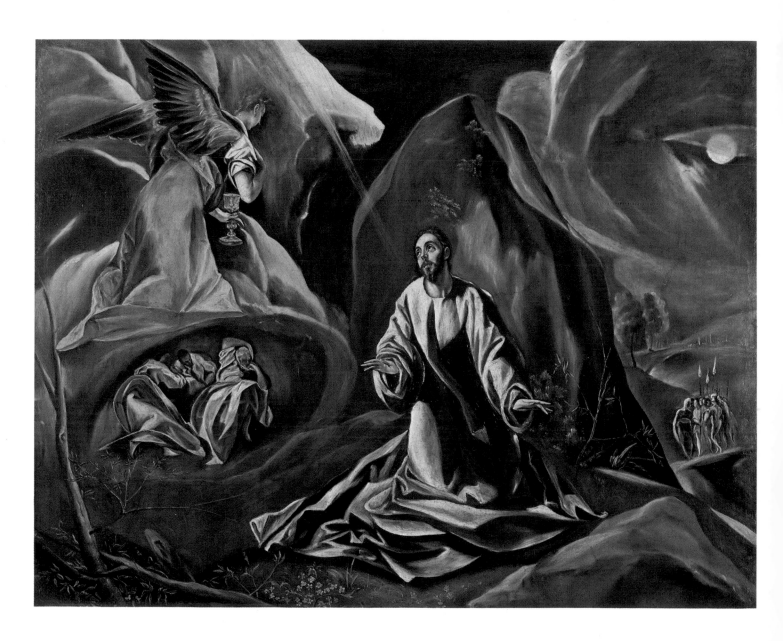

EL GRECO. *The Agony in the Garden of Gethsemane.* c. 1580. The National Gallery, London. El Greco's fundamental metaphor is of one flame beckoning to another. The visual image and the spiritual life complete themselves when all bodies are consumed in a single culminating blaze.

which set out to use color not literally or descriptively but symbolically, as a visual language of the emotions.

The Fauves ("Wild Beasts")—chief among them Matisse, Derain, Friesz, and Vlaminck—were responsible for carrying the coloristic advances of Impressionist painting into the realm of arbitrary color, making possible the conception of painting as an art of color solely, using line, shape, and symbol, if at all, in supportive roles. Several artistic movements during the first part of the century were concerned with carrying the color innovations of Post-Impressionism, especially of Cézanne, into new realms of expression. Among them were Synchromism (founded by two Americans, Stanton MacDonald-Wright—see his *Abstraction on Spectrum (Organization, 5)* p. 211—and Morgan Russell), Orphism, Die Brücke (The Bridge), Der Blaue Reiter (The Blue Rider), and Expressionism as a whole. Although it would be difficult to think of any modern painter or painterly movement that did not carry on serious experimentation with color, those mentioned gave strong emphasis to color as a nonverbal language. In the following pages we shall discuss the coloristic advances made by a few of the leading personalities of contemporary art.

London Bridge (p. 221) by André Derain (1880–1954) might be taken as a typical transitional work from Impressionism to Fauvism. Dated 1906, it has the crisp, bright touch characteristic of Impressionist paint application and the use of blue and blue violet in the shadow areas. But the blurring of edges and the pursuit of atmospheric effects by the admixture of white is absent. Black masses and outlines are used for emotional and visual shock, something the Impressionists would not have done because it would not have been optically "right." Intense yellow marks on the bridge do not locate themselves properly in space but jump out of their places and begin to function independently. Local color is exaggerated everywhere. The sky is vividly orange without any optical "explanation" of how that color was arrived at. Yellow and pink reflections in the water are theoretically possible, but not probable in the manner used by Derain. The drawing is adequate for identifying the site, but it is clearly subordinate to the activity of the brushwork and the dynamism of the pigment. At a time when the coloristic innovations of Impressionism were still controversial, it is understandable that the exaggerated color and departure from natural drawing by the Fauves would arouse violent reactions from conventional critics and the public in general.

Still Life with Lamp (p. 209) by Alexej von Jawlensky (1864–1941) (see also his *Self-Portrait*, p. 402) dates from the same time as *London Bridge*; it has moved still further in the direction of independent color while retaining only a nominal connection with its point of departure in visual reality. Although the structural organization of the painting is strong, it offers no particular eloquence in shape

or line. The design is simply a scaffold upon which to hang the intense, vigorously applied color. Jawlensky's subsequent Expressionist development is foreshadowed here in his rather coarse and unrefined design and execution. But he is well on the way in this work to a type of abstraction in which pictorial structure is based on color intensities; the drawing, illumination, subject matter, and spatial representation are fairly impersonal. It should be remembered that, at this time, French developments in abstraction were often monochromatic, since Cubism was chiefly concerned with the analysis of shape and space. Synthetic Cubism permitted itself the indulgence of arbitrary color and texture, but always within the framework of its own logic of shape and space. It is as if Gallic logic would not permit, for long, any thoroughly irrational development in pictorial composition. Yet Matisse, the informal leader of the Fauves, was thoroughly French. The apparent "wildness" of his color was inspired not by a desire to escape rationality but rather by an urge to discover color which could directly express emotions. He was fairly well convinced that color imitation or exactitude not only failed to convey the emotions felt by the artist but constituted in addition an impediment to successful expression.

The *Landscape with Houses* of 1909 (p. 222) by Wassily Kandinsky (1866–1944), although later than the Derain, is closer to Impressionism in its gradations of color and traces of color-vibration technique. His edges are not as harsh as Derain's, and the drawing is not as assertively rebellious in the Fauvist manner. But the spots of pure color in the roof tops begin to "jump out" of their spatial locations. The pictorial space is pressed forward, although Kandinsky has not reached the control of the picture plane which Cézanne had achieved in the 1890s. He never became as interested in pictorial architectonics as Cézanne and the French Cubists. For Kandinsky, the emotional and metaphysical possibilities of color were central. By 1910, Kandinsky had almost departed from subject matter in the traditional sense, as in his *Study for Composition No. 2* (p. 222). Landscape and figurative elements are present as well as conventional scale relationships, if we assume a traditional composition. But independent color now asserts itself in a picture which *does* seem to exhibit the visual equivalents of a musical composition—possibly the qualities of Slavonic dance music. We should not overlook the influence of Russian folk art on Kandinsky's work, even in his completely nonobjective paintings. Indeed, he shares with another Russian, Marc Chagall, an addiction to the same flying figures and folkloric elements we have come to associate exclusively with Chagall. Later in his career, Kandinsky was to develop a geometric style of painting in which mechanical shapes and straight edges shared with color the burden of expression. His Fauvist phase (until about 1914) appears to have been the period of his most vigor-

ous and painterly experiments with color. At this time he produced the paintings which have been so influential in the evolution of contemporary Abstract Expressionism. His subsequent geometric style has also affected abstraction through its "hard-edge" line of descent. Compared to Matisse, there is a certain naivete in Kandinsky, particularly with reference to the drawn line, but he was strikingly original and single-minded in his pursuit of one goal, a goal which has been of immense historical value for the subsequent development of painting: he separated color and paint from subject matter, thus giving abstract color an impetus which would be fabulously exploited by succeeding generations of painters.

In Mark Rothko (1903–1970) we have a modern painter who endeavored to employ color as if it were a mystical light which can surround the viewer and engulf his vision. *Earth and Green* (p. 272) consists of two unequal rectangles superimposed on a blue field. The pigment is applied to the canvas by staining it; hence we have no awareness of it as a brushed-on substance. It seems to be an integral part of the canvas which radiates a colored light. Within the rectangles there are subtle changes of tonality of the sort we have seen in the painting of Baziotes. The simplicity of Rothko's means recalls a similar quality in the *Blast* paintings by Gottlieb, but the expressive effects are quite different. It appears that Rothko was seeking a way of changing the viewer's mode of consciousness through color, an objective unlike that of Kandinsky, who sought to communicate emotions, while Gottlieb seeks to communicate an *idea* through form and color. Rothko, it seems, wanted painting to seize the consciousness, to get behind man's thought and feeling. This achievement would be comparable to affecting human experience through color in a manner which now is possible only through drugs or some mystical discipline. Since color is one of the most powerful instruments available to painting so far as its capacity to affect the nervous system is concerned, it is quite possible that Rothko introduced a revolutionary new idea into the history of painting. It is interesting that this ambitious goal for painting is expressed through works which are quiet, serene, deceptively simple, and very pleasing to the eye. Unlike Op art, which also endeavors to change or "shake up" consciousness through the eye, the art of Rothko does not involve pain, shock, dizziness, or any other threat to the viewer's poise and equanimity.

As we know, an earlier artistic movement seeking the alteration of consciousness was Surrealism. Its principal instrument was shock arising from the hallucinatory juxtaposition of incongruous material. Surrealism relied mainly on the cognitive meanings of subject matter; its approach was essentially literary. Hence, its capacity to shock, particularly to change seriously the viewer's frame of reference, diminished as the public grew familiar with the strategy and the devices which were meant to surprise. However, contemporary painters like Rothko seem to have found a way to create pictures which temporarily change one's sensuous—mainly color—environment, thus inducing a pleasant, contemplative state of being. Matisse was also interested in an art which would afford, through visual means, an opportunity for contemplation. We are perhaps about to enter an era when paintings, largely through color and shape, will carry out transactions directly with the nervous system, offering occasions for relaxation or stimulation—occasions from which the individual can emerge calmed or invigorated, his being having been quietly renewed.

Texture

We speak of getting "the feel of things" as if touching were the best way to know something in order to deal with it effectively. The fact is that touching or feeling things is our *earliest* way of dealing with objects. In the development of the individual, however, tactile sensation eventually gives way to visual sensation as the principal mode of knowing. Still, we regard touch as more authentic than vision in many situations that call for crucial decisions. If you have had a bad fall, you are very likely to *feel* your body—"looking" for breaks or bruises; a surface that looks all right may in fact conceal damage that has to be felt to be discovered. Babies, we know, examine objects by putting them in their mouths—feeling them with the lips, tongue, and inner surfaces of the mouth. To be sure, they have no teeth to get in the way. A time arrives, however, when learning to know the world by touching or tasting becomes dangerous; seeing is much safer.

Adults have learned to look at things before they touch them. But their looking is often undertaken as a tactile inquiry. That is, we use vision to find out what something would feel like if we touched it. This connection between visual and tactile sensation is so well developed in adults that we can fall in love with persons just by looking at them. Notice, however, that so far as physical love is concerned, looking contemplates tactility. Furthermore, physical love involves not only embracing but the touch or caress of the lips we call a kiss. In other words, we move back to some of our earliest sensory modes when seeking the total knowledge of a person implied by an act of love.

Unlike color and light, which can only be seen, a tex-

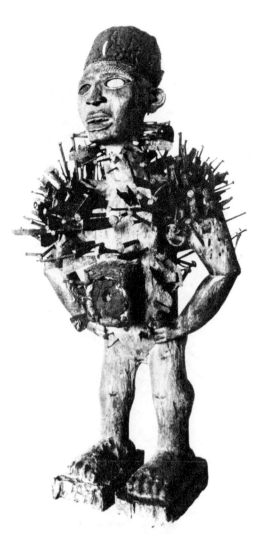

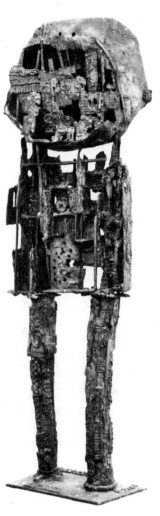

Nail fetish, from the Lower Congo. 1909. Museum für Völkerkunde, Basel

EDUARDO PAOLOZZI. *Saint Sebastian No. 2*. 1957. The Solomon R. Guggenheim Museum, New York

Nail fetish of Clous Yombe tribe, the Congo. 1878. Royal Museum of Central Africa, Tervuren, Belgium

Heavily textured surfaces have symbolic as well as sensory meaning. Very little semantic space separates the Congolese fetish figures from Paolozzi's St. Sebastian: the African tribal artist depicts his enemy with nails driven into him, while the contemporary sculptor shows his victim, mechanized man, lacerated with springs, wires, bolts, and gears.

ture can be felt as well. Hence, "seeing" a texture really means having a good idea about a particular surface quality. Much artistic representation consists of providing viewers with reliable visual cues about the surface qualities of real things.

What then are some of the properties of surfaces that can be rendered visually so that their textures are implied? Essentially, they are phenomena related to the light-absorbing and light-reflecting abilities of particular materials. These, in turn, are represented graphically in terms of light-and-dark patterning, light intensity (or value relationships), color relationships, and, to some extent, line and shape. In other words, texture must be represented in the graphic arts just as any visual phenomenon is represented—through manipulation of the other visual elements. In sculpture, of course, textures are *reproduced*,

not simulated, whereas in architecture they are *created*.

If texture can be represented through combinations of light-and-dark, color, shape, line, and so on, why do we regard it as one of the fundamental visual elements? Probably because the sense of touch has priority over the other senses in our development. Hence, we are ontogenetically "programmed" to attend to the textural qualities of objects as crucial attributes of their being. The work of art which is texturally ambiguous leaves a primal curiosity unsatisfied. We expect our eyes to tell us not only how an object is shaped, and where it is located in space, but also how it feels. That is, adults want to learn from texture what an object is made of, how it was formed, and whether it is safe to handle.

The early dependence on touch in human sensory development appears to be reflected also in the promi-

SEYMOUR AVIGDOR (designer). Interior with patterns. 1969. Material found at Vice Versa Fabrics, New York. The appeal of overall repetitive patterns is fundamentally tactile. The patterns become textures because we cannot deal visually with so many little images—they have to be perceived in the same way that we see grains of sand, beans in a pot, or bees in a hive.

nence of tactile qualities in the art of primitive peoples. Tribal art exhibits a textural force and vividness which is especially attractive to contemporary artists—notably those who have exchanged representational objectives in favor of making a direct sensory appeal. For the primitive artist, however, powerful textural effects are not primary aesthetic goals; they emerge as concomitants of his pursuit of ritualistic purposes: marking, scarifying, and smearing surfaces; embedding magical substances within a cult object; attaching charms and amulets to an effigy of a sorcerer or god.

In Western culture, our commerce with art has been substantially visual for at least five hundred years. In this connection, one can cite that redoubtable critic and connoisseur of Renaissance art Bernard Berenson, who made much of the centrality of tactile values in painting, by which he meant the capacity of pictures to convince viewers of the volumetric realities beneath depicted surfaces. In Western art, therefore, the emphasis until recently has been mainly on the volumetric or spatial persuasiveness of the visual transaction.

Today, there appears to be a powerful popular desire to return to tactility in the visual arts—to the primal foundations of sensory experience. It may be due to a surfeit of remote visual stimulation, as in reading, scanning, and watching. Or, at more fundamental levels, we may have developed a distrust of visual experience when it is not supported by tactile modes of examination. At any rate, the textural qualities we see in contemporary art have little to do with Berenson's more or less optical celebration of "tactile values." Instead, they reach back and down into the deepest strata of human personality and historical consciousness.

JEAN DUBUFFET. *The Sea of Skin*. 1959. Collection the artist. Dubuffet can organize the textures of century plants so that they make a statement about the aging of all organic materials.

LUCAS SAMARAS. *Box Number 3*. 1963. Whitney Museum of American Art, New York. Gift of the Howard and Jean Lipman Foundation, Inc.

CLAIRE FALKENSTEIN. *Point as a Set, No. 10*. 1962. Collection R. Stadler, Lausanne

We are curiously attracted by the threat of danger, even of mutilation. What accounts for the appeal of menacing textures? It is man's inability to resist any challenge to his manual dexterity. What is the best way to grasp a nettle, take hold of a cactus, or capture a porcupine?

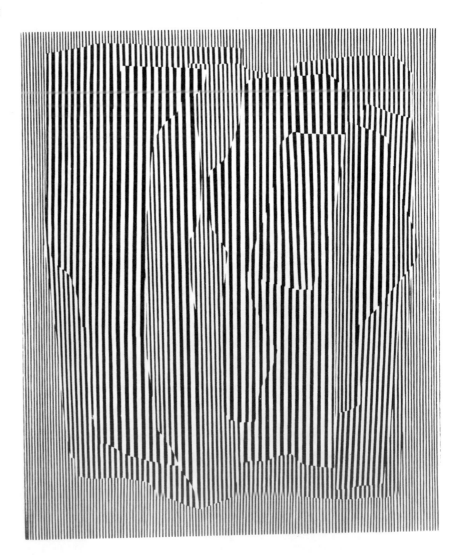

BRIDGET RILEY. *Current*. 1964. The Museum of Modern Art, New York. Philip Johnson Fund

THE OP(TICAL) PATHWAY TO THE NERVOUS SYSTEM

JULIAN STANCZAK. *Gossip*. 1964. Martha Jackson Gallery, New York

Conclusion

Because it is devoted to explaining the "parts of speech" in visual art, this chapter has been entitled "The Visual Elements: Grammar." Selected works, in which the performance of one of the elements was crucial for the total meaning have been examined. In attempting to concentrate on the role of line, light, shape, color, or texture, we found the function of an element to be invariably affected by the nature of its association with the other elements. In verbal language, the way parts of speech "associate" with each other is called syntax; hence the chapter touched briefly on what might analogously be called visual syntax.

But rules of syntax or usage do not operate in art (if they exist at all) as strictly as rules of usage in language. Nevertheless, there are principles of organization in art which seem to be employed consistently and which serve to maximize the effectiveness of a work of art, no matter what its function or purpose. Hence, we turn in the next chapter to these principles, which are sometimes called principles of design.

ORGANIZATION OF THE ELEMENTS: DESIGN

In the chapters dealing with the functions of art we discussed the variety of purposes for which works of art are created. But no matter what the function of a work of art, its parts or elements are organized to be seen. That is, the purpose of a chair is to support someone and *to be seen*. The purpose of a poster is to persuade someone and *to be seen*; indeed, to state it more accurately, a poster *must be seen first*, before it can be persuasive. Consequently, the organization of the elements of art has one common goal along with the variety of personal, social, and physical goals that are normally pursued. That common goal might be called *organization for visual effectiveness*.

A painting, which has no relation to physical utility, which functions by providing an opportunity for significant *seeing*, requires purposive design of its elements if it is to be effective. Now the term *design* has been substituted for *organization*. *Design* is a process which is common to the creation of all works of art. No essential distinction is made in this book between the design of paintings and the design of objects of daily use, such as chairs. According to another point of view, however, the word *design* should be confined to the organization of visual forms for creating utilitarian objects, while the organization of visual elements for creating "nonuseful" objects like paintings and sculpture is called *art*. However, that distinction is not used here for the following reasons:

1. The useful objects of the past frequently become the "use*less*" objects, the *fine art*, of the present. Although their status has changed, their visual organization, or design, remains the same.
2. So-called nonutilitarian objects *do* have a purpose, but not a physical one. They function by being seen, by arousing feelings, by "explaining" the world in visual terms.
3. The varied functions of works of art affect the way their visual elements are designed, but the need for design—that is, for organizing the elements so as to be visually effective—remains constant.

By insisting that design is a process common to the creation of all works of art, and by refusing to set up a

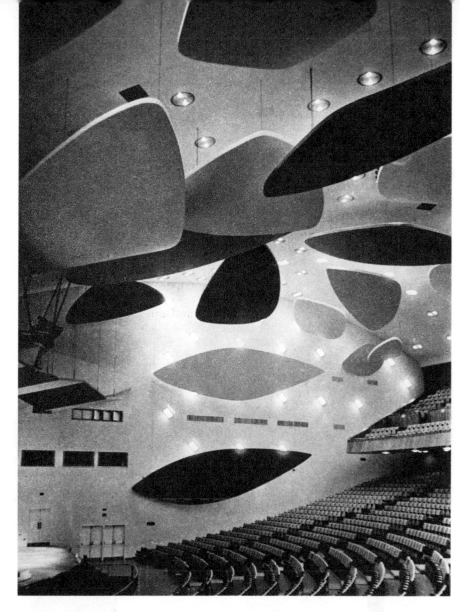

ALEXANDER CALDER. *Acoustical Ceiling.* 1952. Aula Magna, University City, Caracas. Calder's floating forms constitute an immense floating sculpture designed to improve the acoustical as well as the visual qualities of the architectural space. Aesthetic and practical values are thus united in the same construction. Should it be classified as art or as design?

hierarchy among art objects—designating some *art* and others *designed objects, applied art,* or *artifacts*—we gain certain theoretical advantages. We avoid being embarrassed by history, as when the magical—that is, useful—African fertility sculpture becomes a fine-art object in a culture which does not believe in certain kinds of ritual practices. We are not caught in classification dilemmas by having to make arbitrary distinctions, for example, about the physical utility or aesthetic value or psychological expressiveness of stained glass in Gothic cathedrals, of medieval tapestries hanging on damp castle walls, or of Romanesque sculpture telling Biblical stories to a populace that could not read. Is the Brooklyn Bridge symbolically less potent because it was *designed* to carry people across a river, as well as to perform its function with a maximum of visual and structural effectiveness? As we know from the example of stained glass, it is possible for a work of art to perform several functions at once, to be *designed* to operate at several levels, and to be apprehended by viewers at one or more levels according to their needs and interests.

As soon as materials are formed or assembled, they constitute a visual organization, an organization which

operates with greater or lesser effectiveness depending on how well its visual elements work together. Works of art of all kinds exhibit certain common patterns of "working together" that are called *principles of design.* These principles are ultimately based on the way people see most effectively and pleasurably and on the way materials can be formed most satisfactorily from the standpoint of their own nature and the effectiveness of visual communication. In a sense, the so-called principles of design are the result of long-term experimentation both empirical and intuitive. The history of art can be regarded, in part, as a revelation of the types of design or formal organization which have been found effective in different times and places.

It cannot be claimed that any single design precept—for instance, unity in variety—constitutes a "rule" for artistic and aesthetic effectiveness. Distinguished works can be found that defy the principles of design cited here or in other places. Furthermore, the capacity to experience unity in variety differs among cultures: the unity of a Hindu temple may be less apparent to Western than to Indian eyes; the unity of Gothic architecture was doubtless absent for persons habituated to classical Mediter-

Tovi's light fixture builds on the abstract sculptural tradition practiced by Brancusi. Maurer's Pop art lamp is, of course, a representational form: it looks like a light bulb. However, both fixtures reflect design decisions related to sculptural surface and volume, physical utility, and aesthetic expressiveness.

MURRAY TOVI. Tovibulb. 1969. Designed for Tovi & Perkins, Inc., New York

INGO MAURER. Giant bulb. 1967

ranean forms of artistic order—in fact, the term "Gothic" as applied to art originally meant something like "barbarian." Nevertheless, these variations aside, the principles of design are based on habits of visual perception which, in turn, are greatly influenced by the common physiological equipment of the human race.

The habit of reading from left to right, or top to bottom, or right to left, affects perception variably. But everyone has to measure size relationships, the rate of speed of moving objects, the distance of objects from the viewer. Binocular vision and perceptions of size, brightness, color, shape, texture, speed, and depth probably confer more uniformity than diversity on mankind's vision. And it is on the basis of similarities in vision and

perception that we dare to speak of design elements and principles as if they applied to everyone. In fact, as languages go, the language of vision may, like the languages of science and mathematics, tend to communicate the unity rather than the disunity of man. As Kepes says: "The visual language is capable of disseminating knowledge more effectively than almost any other vehicle of communication. With it, man can express and relay his experiences in object form. Visual communication is universal and international: it knows no limits of tongue, vocabulary, or grammar, and it can be perceived by the illiterate as well as by the literate. Visual language can convey facts and ideas in a wider and deeper range than almost any other means of communication."[13]

Unity

Perhaps unity is the only principle of visual organization, and the other principles merely different ways of achieving it. For unity may ultimately represent the desire of the individual viewer to relate the multitude of visual facts and events he witnesses to one person—himself. Therefore, no matter how well or badly an artist organizes the visual elements, *they will be seen as a whole.* As viewers we have to close or end our visual experience so that we can move on to other things which require attention. Moreover, closure is required to make sense of, to understand, what has been seen. If you leave the theater before a play or film has ended, your mind usually requires that you complete the performance yourself. You will recall what you saw and impose meaning on the truncated performance by adding something of your own to the material presented by the playwright or film maker.

But if the viewer requires unity in his visual experience and is capable of supplying it when it is absent, what is the purpose of deliberately trying to achieve unity in the art object? Our answer must be that the artist or designer is theoretically engaged in an effort to communicate *his* unity, that is, *his* vision of form, to the viewer. Ineffective design will result in an abrupt termination of the viewer's experience. In simple language, the viewer will stop looking. The act of "not looking" is a type of completion; it represents a critical judgment, made but not spoken.

We have seen works of art that appear to consist of only one of the visual elements—shape, for example, or color—and thus the problem of unity is substantially simplified, although the problem of sustaining interest becomes more difficult to solve. But usually, all the visual elements occur in a single work and in several manifestations: that is, there are many lines, shapes, colors, textures, and patterns of light and dark. Thus, a variety of visual events occurs within the type of organization we

call a work of art. One of the objectives of design, then, is to create some kind of order, or unity, among those events *before* they are seen by a viewer. (Of course, the artist himself acts as a sort of surrogate viewer for the public.) What are the principal devices of design for creating unity within the variety of visual events taking place in a work of art?

Dominance and *subordination* are the devices through which the artist attempts to control the *sequence* in which visual events are observed or the *amount of attention* which is paid to them. The dominant element of a work is the one on which all other elements depend for their meaning, or perceptual value. Dominance is achieved most easily by *size*, the largest form being seen first. Secondly it is achieved by *color intensity*. Other things being equal, an intense area of a warm color (which seems to advance) will dominate an intense cool area of the same size. A third way of achieving dominance is through *location*: the viewer's eye is usually drawn toward the center of any visual field; objects located there are more likely to receive earliest attention. That is why the head in most portraits is centered between left and right and above the midpoint of the canvas; it corresponds to the viewer's idea of the location of his own head when he looks at the picture. The *convergence* of lines and principal directions on a point in the visual field can impart dominance to that point without the aid of size and color. The eye finds it difficult to resist the point from which lines or strong light radiate or toward which they converge. For instance, we are tempted to look at the bright sun although we know it will hurt our eyes. Hence, a very light area will dominate its darker surroundings by analogy to the sun in the sky. Finally, dominance can be achieved by *difference* or *exception*. We know that nonconformity stands out. If an ovoid shape appears among

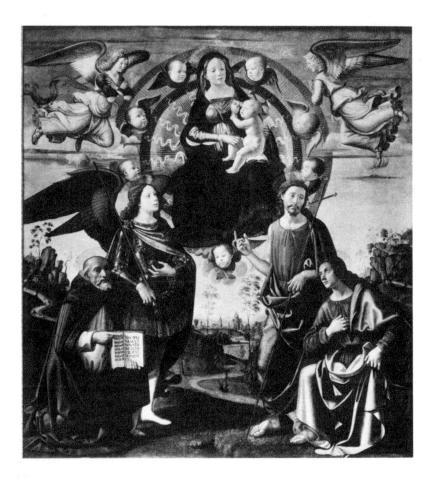

DOMENICO GHIRLANDAIO. *The Virgin and Child with Four Saints*. Undated. Alte Pinakothek, Munich

Unity can be achieved by a hierarchical design or by the manipulation of light. In the Ghirlandaio, each person is delineated with equal clarity, but rank and importance are determined by location on a pyramid of ascending majesty. In the Rembrandt etching, Christ occupies the central position and is slightly separated from, but little higher than, the others. His figure dominates by virtue of frontality, gesture, and its almost painterly modeling of form.

REMBRANDT VAN RIJN. *Christ Healing the Sick (The Hundred Guilder Print)*. c. 1648–50

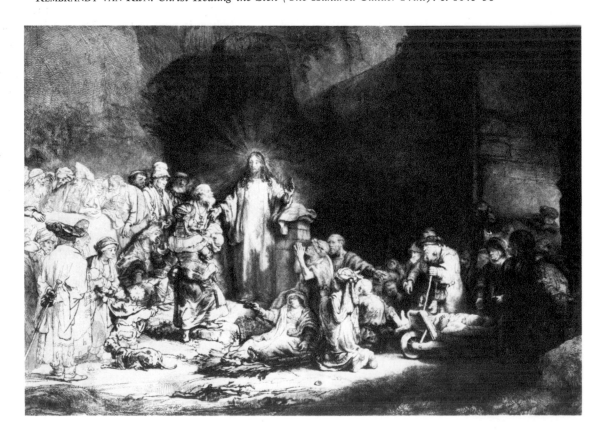

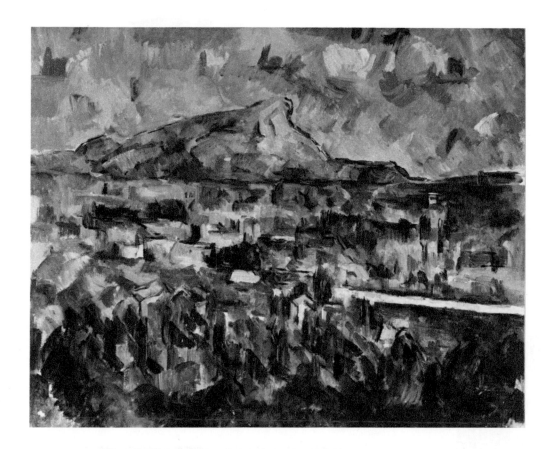

a number of squares, it will be seen as the exception; it will stick out like the proverbial sore thumb and thus seem to dominate the others. Similarly, in a field of similar shapes, the shape bearing a different color or texture will be able to assert its individuality. Subordination, as would be expected, results from the employment of devices opposite to those which create dominance: small size, peripheral location, dull or grayed color, remoteness from converging or radiating lines, and similarity to other forms in shape, color, and texture.

Coherence refers to the sense of *belonging together* that characterizes the components of a successfully unified work of art, one whose various parts have an independent existence but appear to have become what they are through harmonious adjustment to the requirements of each. When Paul Cézanne (1839–1906) painted a picture, changing the smallest area, he felt, would oblige him to reorganize the entire composition. All the parts were so adjusted to one another in color, shape, and size that they functioned organically; individual parts possessed their own character, but they were *interdependent* so far as aesthetic effect is concerned. If any visual organization is so carefully adjusted and harmonized that change in one of its parts ruins its effectiveness, we tend to respond to it as if we are in the presence of a living organism—man-made, to be sure, but alive and vital in the manner of all forms that exhibit aesthetic integration. Its unity is

based on the viewer's feeling that the organization as it stands is inevitable: it could not be otherwise and still exist. The apples, lemons, trees, or rocks of Cézanne must be precisely where and as they are.

Visual coherence or organic unity can be achieved, as mentioned earlier, through analogous color and color tonality—the prevalence of a single color or admixtures of it throughout a work. *Similarity* of any kind—of shape, color, size, illumination, character of line and edge, and texture—will also promote the impression of coherence and hence of unity. The use of this device has its perils, however, since sameness also leads to monotony. Any device for achieving unity runs the risk, if employed too mechanically, of losing the viewer's interest. Our tolerance for sameness is limited; we require variety to satisfy our visual appetites and yet not so much variety that the sense of wholeness is sacrificed.

Forms which are *dis*similar can be unified by the device of clustering. If they are unlike in shape, color, or texture, their *closeness* suggests coherence. In a sense, the eye is deceived by propinquity into accepting a relationship among incongruous forms. If they are surrounded by open space, dissimilar forms located near each other tend to be perceived as a unit. This principle of unity is frequently illustrated in the paintings of Braque following his Cubist period. *The Round Table* contains a variety of objects and shapes, no two of which are alike. But they

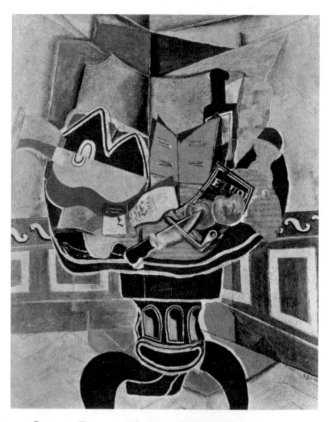

GEORGES BRAQUE. *The Round Table*. 1929. The Phillips Collection, Washington, D.C.

HERBERT FERBER. *"and the bush was not consumed."* 1951–52. B'nai Israel Synagogue, Millburn, New Jersey

RICHARD LIPPOLD. *Variation Number 7: Full Moon*. 1949–50. The Museum of Modern Art, New York. Mrs. Simon Guggenheim Fund

far left:
MARSDEN HARTLEY. *Smelt Brook Falls*. 1937. City Art Museum of St. Louis

left:
Nachi Waterfall. c. 1300. Nezu Museum, Tokyo

are held together by the dark, encircling form of the table top, which imposes the unity of a container upon the things contained.

Unity based on converging or radiating lines is quite common and fairly easily employed. The design problem in such cases is to avoid the obvious. We have seen this type of unity in an almost pure manifestation in the wire constructions of Richard Lippold. But Lippold creates subsidiary centers of interest at the periphery of the space under his control, and the color and shimmer of his fine metal lines appeal to the eye directly, thus mitigating what might be a too insistent stress on the radiant center. In "*and the bush was not consumed*," Herbert Ferber (born 1906) has created a radiating composition based on the V form; but although the directions converge at the point of the V, a number of minor variations in shape and direction serve to avoid a too obvious, hence tedious, reliance on the basic organization.

A classic instance of unity by central location occurs in *Nachi Waterfall*, a silk scroll painting of the Kamakura period of Japanese art (1185–1333). Although paintings of this type had a mystical-religious function in medieval Japan, they can be perceived by modern eyes largely in terms of their mastery of pictorial structure. In this case, the subordination of rich and complex landscape forms to the waterfall is superbly accomplished. The dead-center location of the water could easily lead to monotony if it were not for the sensitive adjustment of dark weights, left and right, top and bottom. A rugged,

rocky profile is dramatized at the point where the eye is led by the falling water, enabling the artist to introduce several diagonals to modify the dominant verticals. He also reserves his strongest light-and-dark contrasts for the spot where the water crashes against the rocks, after which it trickles away to a different tune. As the eye penetrates the darks, it grows aware of rhythmic vertical repetitions in the rock forms of the cliff as they support the dominant central waterfall, while balancing horizontal shapes are found in the tree foliage and the mysterious mountain forms across the top. The great virtue of this work is that, although an obvious, almost mechanical device for the achievement of unity has been chosen, the artist has managed to sustain the viewer's interest by ingenious use of subordinate measures for creating variety without in any way detracting from the principal dramatic event.

The problem of artistic unity might be compared to the dilemma of Scheherazade, the Persian princess who had to entertain her sultan with a different story each night for a thousand and one nights. If the sultan were not amused, the princess would lose her head. The recurrent element in the situation, the potentially deadly unity of the thousand and one nights, lay in the fact that the same narrator was engaged in a sustained effort to divert the same listener. Scheherazade managed to keep her head by introducing sufficient variety into her stories to obscure the fact that the same situation experienced a thousand times can become exceedingly dull.

Astarte figurine. Late Ca-
naanite period (1550–1200
B.C.). Israel Department of
Antiquities and Museums,
Jerusalem

Statuette from Tell Jedei-
deh (found in northwest-
ern Syria, part of present-
day Turkey). c. 2900 B.C.
The Oriental Institute,
University of Chicago

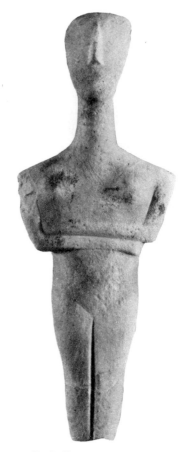

Cycladic sculpture of a
woman. Early Hellenic pe-
riod (4000–3000 B.C.). City
Art Museum of St. Louis

The symmetry of the human
figure is so inescapable, and is
felt so powerfully, that men
have always perceived it as a
divine force. Even in Pevsner's
concavities, the symmetrical
idea makes itself felt, as it did
six millennia ago.

right:.
Snake Goddess. c. 1600 B.C.
Heraklion Museum, Crete

far right:
ANTOINE PEVSNER. *Torso.*
1924–26. The Museum of
Modern Art, New York.
Katherine S. Dreier Bequest

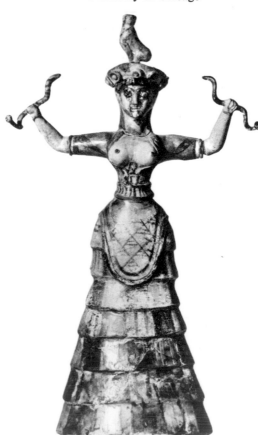

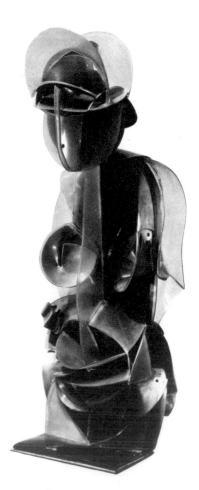

Balance

Aside from the legend that Galileo dropped unequal weights from it, the reason why the Leaning Tower of Pisa is popularly renowned is that it is out of balance yet manages to stand. The building is a worldwide curiosity. Our normal expectation is that the gravitational and engineering forces at work in the structure will be resolved —one way or the other. The building will either "balance itself" or fall. That it does neither is visually disturbing. Balance is the resolution of all forces in a structure leading to equilibrium or equipoise. It is evident in nature, in man, and in the man-made world.

Balance in the structural world is largely a matter of the reconciliation of weights and stresses leading to stability. It may be a chemical process in the biological world without which life itself could not be supported. In art, balance is, of course, an optical condition, and terms like weight, stress, tension, and stability, which are borrowed from physics and engineering, take on perceptual meanings. It would not be surprising if the parallelogram-of-forces problems that students of mathematics and physics solve are intuitively solved by artists and viewers as they calculate whether certain visual forms are pleasing. One thing is certain: having gone through a period of instability during infancy, we are very sensitive to signs of imbalance in all visual phenomena.

Architectural and sculptural structures must be in balance or they will not stand. The earliest cantilevered structures created some unease among persons accustomed to buildings whose support was visible, for the cantilever is a form of *hidden* balance. If we cannot intellectually imagine the balance of forces that provides its strength, we are likely to feel endangered when walking under a canopy which is unsupported by posts. The imbalance of graphic or painted forms does not endanger us physically but is nevertheless disturbing. Hence, several design devices are employed to create for viewers the experience of optical balance which they seem to require.

The simplest and least interesting type of balance is *symmetrical balance*, usually understood as bilateral symmetry. The left and right halves of the visual field are identical—mirror images of each other. This form of balance has a spontaneous appeal which may relate to the bilateral symmetry of the human body. Also, it requires a minimum of perceptual effort to understand. The elements in each half may be very complex and in themselves difficult to fathom, but as soon as they are recognized as echoes of each other, they acquire an interest which is curiously satisfying. Perhaps the pleasure which even children take in bilateral symmetry is related to the manner in which electrical charges are distributed over the hemispheres of the brain during perception. The other

HENRI MATISSE. *Carmelina*. 1903. Museum of Fine Arts, Boston. John T. Spaulding Fund

The centrally located figure, presented in a frontal pose, creates a problem in pictorial architecture which only the best designers can solve. These solutions are formal but also achieve a visual balance or reconciliation of all pictorial issues and appeals—sensory, thematic, spatial, psychological, and intellectual.

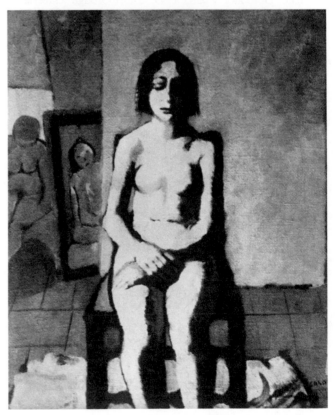

FELICE CASORATI. *Seated Girl*. 1933. Whereabouts unknown

JEAN ARP. *Olympia.* 1955. Private collection, Switzerland

Balance exemplified by Janus, the two-headed Roman deity, and Olympia, the reclining lady made famous by Manet. Dorazio's composition is almost symmetrical, but color and value differences seem to require small adjustments in the placement and direction of subordinate forms. Arp balances his work by exploiting the viewer's interest in the pair of small forms at the left; they manage to counteract the massive torso form occupying most of the picture space.

PIERO DORAZIO. *Janus.* 1949. Marlborough Galleria d'Arte, Rome

main type of balance, *asymmetrical balance*, is more complex and interesting, although it may, by a more devious route, provide the viewer with the same pleasurable reaction he experiences in symmetrical balance.

Balance by weight (usually asymmetrical) suggests analogy to a lever and fulcrum, or a seesaw. It is assumed that the center of a picture, or of the visual field in the case of sculpture and architecture, corresponds to the fulcrum on which a lever or seesaw is poised. A heavy weight can be counterbalanced by a lighter weight which is located at a further distance from the center. Of course, we are dealing with visual weight rather than physical weight. However, although gravity does not *actually* operate on the objects in paintings, we *perceive them as if* it does. What, then, are the properties of the visual elements with respect to weight? Clearly, size is the first consideration. Other things being equal, the larger, more massive shape seems to be heavier. Color, too, is important, in that it occurs in *relationships* implying *weight*, as well as strength and location. In general, warm colors are heavier than cool colors; those of strong intensity heavier than those of weak or faded intensity. As between warm colors —for example, yellow and orange—an area of yellow would appear larger than an equal area of orange, because yellow is higher in value; but orange has a stronger wave length than yellow and so would advance before it; their apparent weights, therefore, might be equal. Coarsely textured surfaces appear to be heavier than smooth surfaces, perhaps because the tactile feeling excited by coarseness alerts the organism to the possibility of cutting or abrasion if the surface were handled. In this case, weight is associated with concern about danger. The *location* of forms also affects visual weight. Above the midpoint on a vertical axis, they appear lighter than they do below. We can only speculate that this is due to the viewer's assumption of a horizon at the midpoint, forms above it being seen as if in the air, in defiance of gravity. In most pictorial traditions, "up" is interpreted as "in"; the top of the picture recedes while the bottom advances. Gravitational "thinking" inevitably affects perception; the bottom is where heavy objects appear to have landed. Also, the unusual excites interest, and interest confers weight. Peripheral position was noted in connection with unity as a type of subordinate location. For purposes of balance, however, a small object at the left or right edge of a field can cancel the weight of a larger object closer to the center—if the artist has stimulated the awareness of lever action in the pictorial field.

The "action" in most contemporary painting takes place on the picture plane itself. However, even when the principal conventions of depth representation have not been employed, we have been conditioned by life to "read" the forms as if the existence of deep space were implied. This results in a certain amount of ambiguity regarding the visual weight of objects that have been

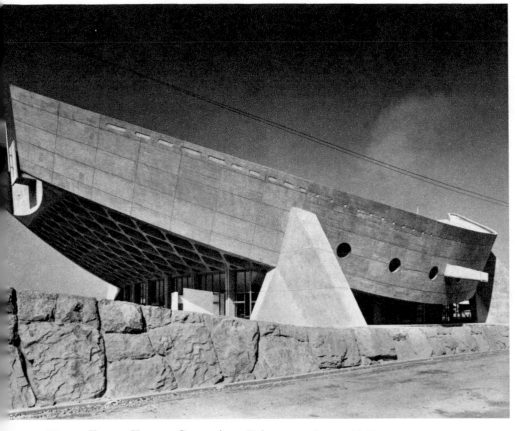

Drawing of side section, Kagawa Gymnasium. From *Art Today* by Ray Faulkner and Edwin Ziegfeld. 5th ed. All rights reserved. Reprinted by permission of Holt, Rinehart and Winston, Inc.

KENZO TANGE. Kagawa Gymnasium, Takamatsu, Japan. 1966

BEN NICHOLSON. *Painted Relief.* 1939. The Museum of Modern Art, New York. Gift of H. S. Ede and the artist

JEAN GORIN. *Composition No. 9.* 1934. Private collection

ADOLPH GOTTLIEB. *The Frozen Sounds, Number 1*. Whitney Museum of American Art, New York. Gift of Mr. and Mrs. Samuel M. Kootz

WILLIAM BAZIOTES. *Dusk*. 1958. The Solomon R. Guggenheim Museum, New York. Balance by interest. Two delicate forms at the right are unequal to the task of counteracting the heavier, more structural form at the left, but a strange, snaky line, not heavy at all, arouses enough curiosity to bring the entire composition into equilibrium.

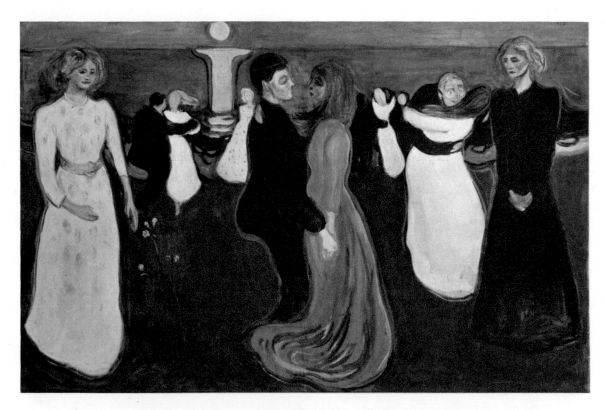

EDVARD MUNCH. *The Dance of Life*. 1899–1900. National Gallery, Oslo. Balance by contrast.
This almost completely symmetrical composition employs balancing figures at both extremes
to symbolize the opposed notions of joy and sorrow, vitality and death.

reduced in size because of what appears to be their location *back* in the implied picture space. The viewer can only look for other structural cues to guide him to the "correct" reading of the visual weights and the pictorial location of the forms he is examining. Or he can abandon the effort to locate objects in pictorial space. Cézanne is perhaps the painter who has addressed himself most impressively to the location of forms in pictorial space (although his spatial intelligence fails him when he portrays the unclothed human figure). From the standpoint of critical judgment, it seems to me (see p. 650) that the failure to resolve the spatial location of forms or to balance visual weights leads to an unfavorable estimate of the work as a whole—whether the work is executed in a naturalistic or abstract style.

Balance by interest is another asymmetrical device. It is based on the excitation of the viewer's *curiosity*, perhaps to counteract the impression of weight caused by size, color, or location. The idea that psychological interest adds weight may be open to question. Still, it is very clear that artists have long employed interest to balance shapes of obviously greater mass. In visual perception, psychological interest operates *as if* it possesses weight. Psychological interest, in turn, is generated by formal

complexity. Therefore, a simple, large, brightly colored form can be balanced by a small, neutrally colored form if the latter's shape or texture is complex. Interest is related to the whole realm of psychological affect, and therefore it can upset the logical operation of structural forces in visual art. That is, once symbols and explicit signs are employed in a work of art, they arouse complex emotions and associations; they can influence perception in ways which are irrelevant to formal structure. For example, it is difficult to perceive Surrealist works apart from their symbolic meanings. Many viewers say they enjoy the color of Chagall's paintings, but it is quite likely that they are chiefly attracted by his romantic and poetic imagery. Perhaps they really enjoy their *feelings* about his images and *believe* the color causes their feelings. At any rate, the pictorial structures of Chagall owe their unity, and appeal, to the *interest* he creates through symbolic and narrative modes. They are not balanced or unified by visual weight, which is to say they do not possess *formal* balance.

Balance by contrast might also be called balance by difference or opposition. It is a type of asymmetrical, dynamic balance which is most difficult for the artist to achieve because it involves calculating the visual demands

of varying quantities of unlike elements. It includes not only oppositions between colors (as in warm vs. cool) or between shapes (as in geometric vs. organic) or between light intensities (as in light vs. dark) but also oppositions between color and shape, between size and texture, or between shape and illumination. Although the balancing of weights is difficult, it is not overwhelmingly complex. Indeed, it is implied in the elementary design problems given art students, who are asked to find the "best" arrangement of black or of black and gray rectangles on a white field. It turns out that there are several good solutions, and also some that do not work very well. However, balance of interest by shape and color begins to approximate the complexity of art beyond that of a student exercise. The selection of one solution among others (none of which can be known in advance) transcends more or less skillful but mechanical manipulation of the visual elements and approaches the intricacy of mature artistic expression.

It is possible that balance by contrast is the closest visual analogue to musical harmony. That is, in both musical and visual structures there is a unified effect which is pursued through the combination of dissimilar elements. In each case, the work increases in interest when two dissimilar elements combine to create something new, for example, a third voice. Most of us recognize that the consonance created by playing or singing the same melody at the same time in a different octave is rather insipid. Dissonance is favored by some modern composers to avoid the monotony resulting from the reiteration of consonant harmonies. In visual art, the unities based on similarity and likeness are most common and most predictable. Perhaps the reason we admire the skylines of New York or Chicago (although we *know* that those cities are chaotic when seen up close) lies in the vigor of their unity wrested from so many dissimilar elements.

Balance of weight by interest is very conveniently illustrated in Joan Miró's *Maternity*, in which the artist virtually sets up a laboratory experiment for us. Two straight lines cross in the center of the picture, forming an X. The point where they cross acts as a fulcrum. A large form at one end shaped like a wedge of pie is balanced by a small, insect-like form at the other end. A worm shape

FRANZ KLINE. *Painting No. 7.* 1952. The Solomon R. Guggenheim Museum, New York. Balance by contrast. The open rectangular spaces at the right contend with the densely packed verticals at the left; each half of the picture opposes the other in the direction of its main forces and in its conception of occupying space.

PAUL KLEE. *Daringly Poised.* 1930. Paul Klee Foundation, Kunstmuseum, Bern. The irregular dark shape (lower right) far outweighs the smaller, lighter circle (upper left) until we realize that the circle may be an eye. In that case, the rectangles at the left form a head, acquiring increments of psychological value and optical weight in the process.

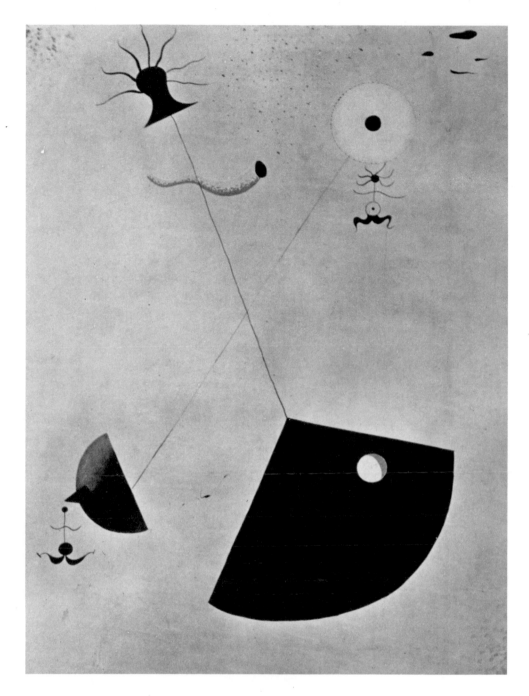

JOAN MIRÓ. *Maternity*. 1924. Penrose Collection, London. Balance of weight by interest.

also joins the insect, although it does not seem attached to the lever arm. The heavy shape is closer to the center, so that the moment of its forces (distance times weight) is about equal to the moment of forces created by the insect which is farther from the center of the fulcrum. This element in its entirety stands for the male, the hole in the wedge serving to characterize it as the eye of a cockscomb, while the wormlike shape symbolizes the spermatozoon seeking the ovum. The other arm of the X is, of course, the female, divided by the fulcrum point into two equal segments, one presumably internal, where the ovum is located, and the other external, where we see a hemispherical shape suggesting a breast. The feathered

little creatures at both ends, which look like the female biological symbol, ♀, seem to be engaged in a seesaw game wherein the ovum may swing closer to or farther away from the sperm. The position of the ovum and the title of the picture suggest that they will meet. In addition to the principles of balance, this work exemplifies the highly personal and whimsical mode of Surrealism developed by Miró. He has created a playful enactment of the biological drama of human conception and divested the process of much of its dark, clinical mystery, presenting insemination as a slightly comic natural event in which delicate timing and physical engineering play a crucial role.

Rhythm

The term "rhythm" applies basically to poetry and music, and relates to measures of time. But seeing also takes time, and, from the standpoint of the viewer, it is most efficiently and pleasurably done in a rhythmic way. Therefore, events or works of art that aid and abet the rhythmic tendencies of seeing are likely to promote a satisfying reaction when the total organism concentrates on vision. Some examples from athletics may make this clear. Tennis is a pleasurable game to watch, in part because of the rhythmic alternation of long volleys. A service ace is dramatic, but less gratifying to the rhythmic sense. American football seems rhythmically more satisfying than its English ancestors, Rugby and soccer, because football has distinct, alternating rhythms of attack and defense, like fencing, whereas the rhythms of soccer or Rugby are more difficult to perceive.[14] The action in the British games is more continuous and to American eyes at least, less distinct in structure.

In the visual arts, rhythm is the *ordered or regular recurrence of an element or elements*. The main types of rhythm can be labeled *repetitive, alternative, progressive*, and *flowing*. The repetition of the same or almost the same shape, color, line, or direction would constitute rhythm. The recurrence of similarly shaped spaces between lines, and the recurrence of colors or of positive shapes, are also rhythmic. In architecture, the rhythmic progression of interior spaces is essential, possibly more important than the organized appearance of the external

MU CH'I. *Six Persimmons.* c. 1270. Daitoku-ji, Kyoto, Japan

Rhythm accomplished through the repetition of shape, while variations in tonal value and spacing are subtly introduced.

WAYNE THIEBAUD. *Seven Jellied Apples.* 1963. Allan Stone Gallery, New York

forms enclosing an interior. Ideally, rhythm should characterize enclosing and enclosed forms through correspondence between inside and outside. But medieval building technology, for example, did not permit such a relationship; hence, the cathedral, with its complex skeleton on the outside, afforded little insight into the character of the spaces within. Nevertheless, the exterior membranes and buttressing exhibit a rhythm of their own which is fascinating as sculpture, apart from the interest based upon structural performance.

We know that men march, lift, or pull together with more effectiveness if their effort is regulated by a recurrent, rhythmic stress or beat. They tire less easily, too. In performing repetitive tasks, people try to find a comfortable rhythm. Up to a certain point, *repetitive* rhythm helps to sustain attention, to reduce weariness, to maximize efficiency. But early experimenters in industrial psychology discovered that operators performing repetitive tasks on dangerous machinery—such as punch presses, stamping machines, and sawing machinery—tended eventually to suffer injuries. Injuries could be reduced (aside from the use of safety equipment) by rotating operators after a certain length of time. Apparently, the human organism finds repetitive motion boring if experienced for too long, and resists by breaking the rhythm.

Visual repetition such as we encounter in fabric patterns can be very monotonous. Of course, allover repeat designs in fabrics are rarely perceived in a simple, flat plane: we see them broken up, draped, and in association with the movement of the shapes or volumes they cover. Some Op art is more tolerable in the form of fabrics

Model in paper dress of Op design. Dress, courtesy Scott Paper Company, New York

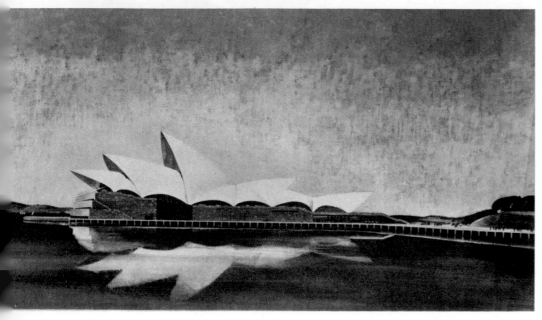

JOERN UTZON. Model of Sydney Opera House. Bennelong Point, Sydney Harbor, Australia. 1957. To be completed in 1973

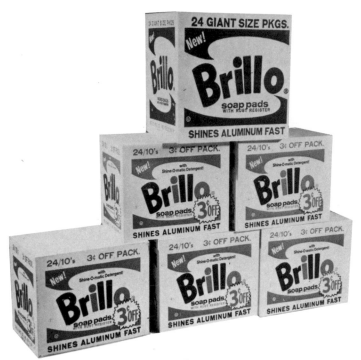

ANDY WARHOL. *Brillo Boxes*. 1964. Leo Castelli Gallery, New York. Repetitive rhythm.

draped over attractive human models than it is when seen as a flat plane. Op is a style which uses repetitive rhythm very effectively so far as physiological impact is concerned. Its practitioners introduce sequences of subtle variation after setting up a strong pattern of visual expectation. These variations have a rhythm of their own while participating in the rhythm of the primary pattern. As a result, the viewer is disoriented by the deliberate ambiguities of competing rhythmic optical patterns: his eye finds it impossible to integrate the stimuli it receives into any single, consistent image, or *gestalt*. This lack of integration has been variously described as exhilarating, confusing, exhausting, and pleasurably exciting.

The usual objective of artists and designers is to exploit the comfortable qualities of repetitive rhythm without incurring tedium. Hence, they employ repetition with variation, comparable to theme and variation in music. Simple *alternations* between black and white, solid and void, warm and cool, for instance, can be varied by the introduction of an unexpected element, a slight change in emphasis that does not destroy the rhythmic pattern of the whole. Rhythm, therefore, exploits the viewer's expectation of regularity. It can achieve variety within unity by frustrating expectation temporarily—in other words, by an occasional surprise. But it must ultimately satisfy the expectations it originally aroused.

The establishment of a rhythmic sequence in art does not occur as the result of accident: it has to be planned and calculated. Such calculations can easily become mechanical patterns requiring not artistry but the capacity

to follow directions. But when the viewer senses the non-creative character of rhythms so achieved, his experience of the work tends to be wearisome. Some Pop art works by Andy Warhol seem to fit this category. We can think of many examples from painting, sculpture, architecture, and industrial design which exhibit a deadly, unrelieved sameness. Art seems to consist of the saving variation which enlivens the rhythmic whole.

Progressive rhythm involves the repetition of an element with a consistently repeated change leading from one color, shape, or type of illumination to another. The expectation of the viewer is aroused in terms of a goal, a culmination. It is exploited in architecture very often by the order of the steps or setbacks of tall buildings. Or, as one moves through a building's interior, one may experience a sequence of progressively enlarged or diminished volumes, thereby arousing the expectation of a certain kind of volume, shape, or type of illumination at the conclusion. The architect may choose to satisfy this expectation, or he may work for a dramatic effect through surprise. But an architectural surprise that is totally unrelated to what precedes it would sacrifice the unity of the whole. Some qualities of the introductory sequence must be present in the dramatic climax. In other words, there are good surprises and bad surprises.

Rhythm as continuous flow is suggested by the movement of waves: the regular recurrence of curvilinear shapes; emphasis or stress at the crests and pause in the troughs;

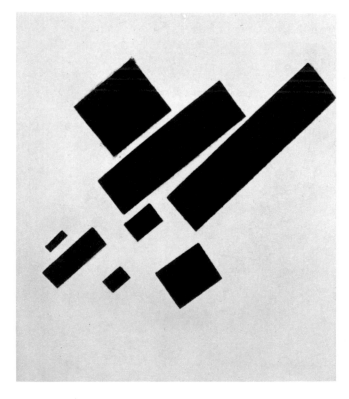

KASIMIR MALEVICH. *Eight Red Rectangles*. 1915. Stedelijk Museum, Amsterdam. Progressive rhythm.

measured, periodic intervals; and smooth transitions from one wave form to the next. The crucial feature of this type of rhythm is the transition between forms. The eye is arrested at various points of interest in the visual field: how is the movement of the eye form one nodal point to the next accomplished? We feel that when the eye is encouraged to move along a curvilinear path which is punctuated by undulating swells (waves again) with no breaks or sudden changes of direction, it describes rhythmic or continuous flow. There are, of course, staccato rhythms imitated by the movement of the eye or head. We see them in the paintings of Stuart Davis, Bradley Walker Tomlin, and John Marin. Flowing rhythm, on the contrary, is associated with sculptors like Jean Arp, Aristide Maillol, and Henry Moore; painters such as Georgia O'Keeffe, David Siqueiros, and Amedeo Modigliani. In architecture, fluid rhythms are more difficult to achieve, although, as we know, the Art Nouveau designers carried curvilinear forms to a possibly exuberant extreme. The late Eero Saarinen (1919–1961) employed fluid rhythmic lines in his TWA terminal building at Kennedy Airport as he did also in the Administration Building lobby for the General Motors Technical Center. And the principal structural element of Wright's Guggenheim Museum interior is the continuous spiral flow of the ramp following the curved inside walls of the building, which resembles the shell of a huge crustacean. Aalto's bentwood experiment ultimately seeks a practical application in chair design, but it is also a good abstract illustration of flowing rhythm based on human contours. Plowed fields photographed from the air illustrate flowing rhythm; they also exhibit the moiré effect now employed by Op artists. (Moiré

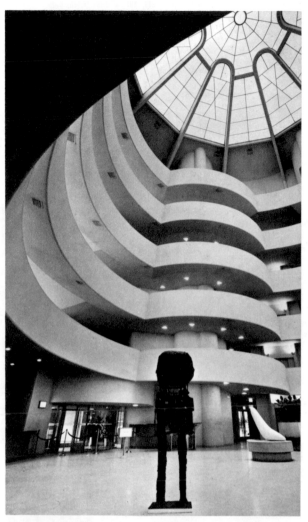

FRANK LLOYD WRIGHT. The Solomon R. Guggenheim Museum, New York. 1959

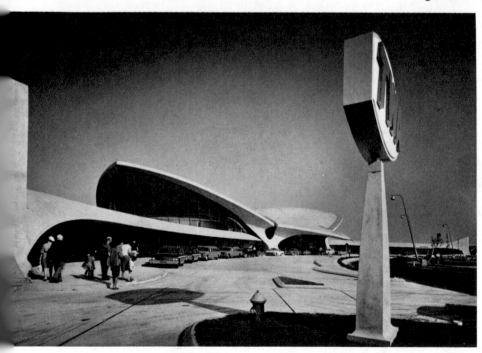

EERO SAARINEN. TWA Terminal, Kennedy International Airport, New York. 1962

ALVAR AALTO. Experiment with bentwood. 1929. Courtesy Artek, Helsinki

MARCEL DUCHAMP. *Nude Descending a Staircase, No. 2.* 1912. Philadelphia Museum of Art. The Louise and Walter Arensberg Collection

THOMAS EAKINS. *Multiple Exposure Photograph of George Reynolds, Pole Vaulting.* 1884–85. The Metropolitan Museum of Art, New York. Gift of Charles Bregler, 1941

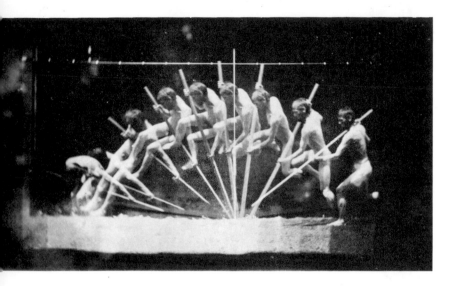

GINO SEVERINI. *Dynamic Hieroglyphic of the Bal Tabarin.* 1912. The Museum of Modern Art, New York. Lillie P. Bliss Bequest

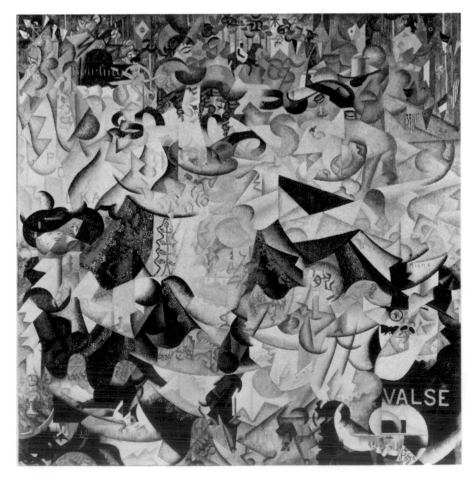

fabrics, usually silk, have been watered to create a pattern of wavy lines which shift and shimmer as the light changes or the fabric moves.)

The photograph of a pole vaulter by the painter Thomas Eakins illustrates repetitive rhythm. Eakins, a serious student of anatomy, shared with the photographer Eadweard Muybridge a scientific interest in motion, and the results of his investigations happily exemplify the design principle of rhythm. In painting, *Nude Descending a Staircase, No. 2* by Marcel Duchamp makes the same point, as do those Futurist works which give to dynamic movement the central place in art. A variety of rhythmic qualities is evident in Boccioni's *Unique Continuity* sculpture (p. 43), while the *Dynamic Hieroglyphic of the Bal Tabarin* of Gino Severini (1883–1966) is possibly the best single example in modern painting of rhythm in its repetitive, alternating, progressive, and flowing varieties. It contains color, line, and shape repetitions and progressions which can occupy the eye endlessly. The painting also has the quality of an organized explosion; it is similar to, but less raucous than, Joseph Stella's *Battle of Light, Coney Island* (p. 68). The Futurists, fascinated by mechanization and motion, clearly made rhythmic capital out of the austere Cubist analysis of form.

Notwithstanding the outstanding examples of rhythm in painting, sculpture, and architecture, the most spectacular manifestations today are very likely visible in motion picture imagery and the animated film. Certainly, continuous-flow rhythm is one of the main objectives of film cutting. As the time needed to see a work of art increases (in the film, in murals, in Happenings and Environments, in vast architectural projects), the principle of rhythm requires more attention. Because it is essentially a temporal concept, rhythm becomes increasingly crucial for the visual arts as duration becomes a ponderable factor in their perception.

Proportion

Proportion refers to the *size* relationships of parts to a whole and to one another. The particular visual context determines whether size is read as area, volume, or dimensions of width, height, and depth. The size of a shape in itself has no proportional meaning: it must enter into a relationship with other shapes before we can be aware of proportion. It should be understood at the beginning of any discussion of the subject that there seem to be no permanently valid *rules* fixing "correct" or harmonious proportions. True, in criticism of representational art, the phrase "out of proportion" may be used, but it means that the proportions of a represented image do not correspond to the proportions of the actual model being drawn, painted, or shaped.

There have been attempts to set up a canon or rule of perfect proportion, one that would automatically confer pleasing intervals on all artistic structures.[15] (The Vitruvian man, discussed earlier, p. 200, attempted to derive architectural proportions from the human figure.) The most enduring has been the so-called Golden Section. It divides a line into two segments so that the smaller has the same ratio to the larger as the larger has to the whole. The algebraic formula for the Golden Section is: $a/b = b/(a+b)$ where $b = a/2(\sqrt{5} + 1)$.

Another attempt, the Module, or Modulor, devised by Le Corbusier, was mentioned on page 120. The Golden Section has been used in many works of art and in many periods, but there seems to be nothing remarkable about it as a formula beyond its indirect recognition that a line divided in half makes a dull pair of intervals. Nor are segments of thirds much better than halves. Efforts to discover a magical geometric ratio that underlies all pleasing or beautiful proportion will no doubt persist. But the history of art will in all likelihood continue to afford examples of great works that do not conform to the canon. Of course, the validity of a rule of proportion can be "proved" consistently if one takes measurements at points convenient for the purpose of demonstrating the rule. But modern aesthetics has been greatly influenced by the *perceptual-field theory* of Gestalt psychology, and the perceptual field of an art object is not easily reduced to a set of dimensions (although it is not independent of the dimensions of forms, either).

The lack of eternally valid rules for perfect proportion does not, however, mean that we recoil from making judgments about proportion. In any given era, people seem to have fairly common conceptions about what constitutes good proportion in buildings, pictures, sculpture, useful objects, and even in people. We are taller and larger today than the men who wore medieval armor, so it is likely that our conceptions of pleasing height, if not width, in men and women have changed. But if there has been a change in proportional preference since the Middle Ages, it has been caused not by a rule of geometrical ratio but by better nutrition.

The figures in contemporary fashion illustrations are some ten or twelve heads high, although this ratio changes from time to time. Art students used to be taught that seven and a half heads was the correct measure for men, and six and a half for women. If a model did not conform, the head was drawn larger or smaller according to need. Aside from the ratio of head to height, it is probable that the average, or presumed average, size of the human figure, and the relationships among its parts, constitute the model for *thinking about proportion* for most visual phenomena. *We tend to perceive sizes, dimensions,*

and proportional ratios in terms of multiples of the human figure as a whole and in terms of proportional ratios within the human figure. In other words, we see a doorway or ceiling height as providing so much open space above the height of a man. Drivers may perceive in terms of car lengths and widths. But when we see only for the sake of seeing—when vision is self-conscious, so to speak—the referent is the dimensional self-image, the human figure.

According to this view, people are continuously if unconsciously engaged in making visual calculations and comparisons. They may use a scale of feet and inches, as when the say, "That man is six foot two." They may also say, "She is about my height, but a little stouter." In the latter statement, there would be a hint of proportional judgment. We may visit friends in a new apartment and feel uncomfortable during the visit without knowing why. Did the builder skimp on the ceiling height, so that we felt squeezed? A proportional feeling was experienced

here although unexpressed. We walk along the downtown canyons of a large city and feel depressed for no apparent reason. Are the buildings so high that we cannot perceive them as multiples of the human figure? There is nothing wrong with height in itself. If we approach a tall building from sufficient distance, it begins by occupying a small area of the retina; we see it in relation to other visual phenomena with which we have already established a proportional understanding. We can gradually advance toward the building, accumulating and enriching our perceptions of its size relationships through other cues in the visual field. The space around the building, which corresponds to the area of the retina the building does not occupy, is necessary for the establishment of a proportional understanding. But few skyscrapers are situated so that we can see them at a distance, especially on foot. Rarely can we see a tall building continuously as we advance toward it. In summary, it is very difficult for con-

ALBRECHT DÜRER. Study for Adam. c. 1507. The Albertina, Vienna

LE CORBUSIER. Modulor. 1951

Female figure. Photograph of Debbie Drake from the jacket of her *Easy Way to a Perfect Figure and Glowing Health*, Prentice-Hall, Inc., 1961

WALTER GROPIUS and others. Pan Am Building, New York. 1963

Fashion drawing

RICHARD UPJOHN. Trinity Church, New York. 1846

Trinity Church is magnificently situated at the culmination of a long canyon-like street, seemingly protected by walls of hovering skyscrapers. The Pan Am Building ignores the dignified old structure—Grand Central Station—at its base, dominates the buildings around it, and depersonalizes Park Avenue, once the handsomest thoroughfare in New York City.

temporary tall buildings to have what is called "human scale." The fault does not necessarily lie in their design, or their proportions, but in the insufficiency of optical space around them.

The function of design, however, is to manage proportion so that the disadvantages of the *spatial envelope* and inherent problems of shape can be minimized or overcome. Manipulation of the visual elements can create "adjustments" in the ratio of width to height, for example. Isolating a large shape makes it appear smaller. Horizontal patterning and segmentation of a tall shape reduce its apparent height. The size of repeat designs in a fabric affects its advancing/receding qualities: a large motif brings the pattern closer. Coarseness and fineness of texture too can be regarded as a dimension of proportion, coarseness tending to approximate the large motif, which advances relative to the small figure or the fine texture.

Any large, immeasurable form, when represented graphically, needs some familiar object or shape to give it scale. We have only a vague understanding of the proportions of a landscape painting unless we are granted a human or architectural cue. Knowing the size of a man or a barn, we can calculate ratios visually and then understand how high, distant, or menacing the mountain is. In abstract works, the viewer's knowledge of the size of real objects is not exploited, although his experience with size relationships in life *is* used. For example, in Matta's painting *Disasters of Mysticism* (1942) we cannot know whether the work is structured according to the scale of a conventional landscape, a situation in outer space, or an event seen under the microscope. But we are inclined

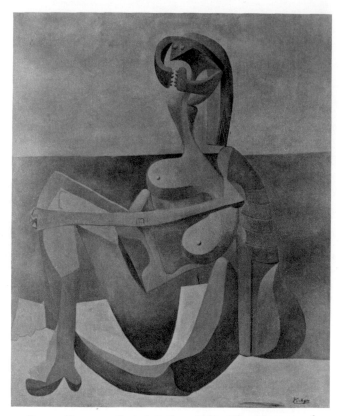

PABLO PICASSO. *Seated Bather*. 1930. The Museum of Modern Art, New York. Mrs. Simon Guggenheim Fund

MATTA. *Disasters of Mysticism*. 1942. Collection James Thrall Soby, New Canaan, Connecticut

Buttress of the State Capitol, Lincoln, Nebraska

to perceive motion, direction, light, shape, and size relationships in terms of our ordinary terrestrial experience. The same observation can be made in connection with nonobjective works by Kandinsky, Malevich, or Ellsworth Kelly.

A final point needs to be made about the exploitation of conventional norms in proportion: since we tend to perceive variations from these norms as distortion, proportion can be used for expressive effect. We are familiar with the effects of attenuation in the sculpture of Lehmbruck and Giacometti; and in their paintings, Modigliani and Picasso have placed small heads on large bodies to convey qualities of stability or monumental calm. Viewers see not only the head size but also, more importantly, the proportional *relationship* between the size of the head and the bulk of the body: it is the *proportion* which carries the expressive burden. Monumentality is a matter of proportion and of generous spacing rather than mere height and magnitude.

In architecture, viewers have been habituated for centuries to the intervals found in classical Greek and Roman buildings. As we know, modern buildings, even tall office buildings, have been adorned with miniature Greek temples at the ground level and even on their roofs. Aside from offering an obeisance to tradition, this practice represented a recognition of the fact that the classical civilizations solved the problem of proportion while we have not yet been able to do so. The severe flat roof of International Style architecture in the 1930s seemed dreadfully stark, naked, and arbitrarily cut off. Viewers required psychological interest at the top of a building as

well as at its entrance—whether overhanging eaves, entablatures, and triangular pediments were functional or not. Apparently, the earliest skyscrapers were perceived by designers as structures requiring a capital, a "head." It was felt that a building had to be "topped off" by something that would endow it with "good" proportion, that is, with a complete *body*. The designer's "block" in this case was his inability to free himself from the idea of the building as a symbol of the human figure. This idea is expressed quite literally in the buttresses of the Nebraska State Capitol in Lincoln. The structure is dated 1922. Only nine years later, however, the Radio City complex was begun by Harrison and others (see pp. 132–33). Its proportions expressed the technology of modern construction and the solution of contemporary functional problems. The vocabulary of form and proportion was now based on the abstract creations of the machine rather than figurative symbols and analogies retained from the past. But figurative relief sculptures over the entrances to several of the buildings in Radio City now seem to be quaint survivals. This does not mean that architecture and sculpture are permanently divorced: but the means of reconciling them is still in the process of being discovered. Humanistic interest has shifted to the spaces between buildings and the people moving through those spaces, the quality of their movement and their visual opportunities reflecting the designer's approach to the enclosure of outdoor areas. Thus, we gain some hint of a new, *kinesthetic* approach to form and proportion: the shaping of space to be seen and felt by people as they move in horizontal and vertical dimensions.

Conclusion

Although unity, balance, rhythm, and proportion have been treated mainly as objectives of the designer, we found it necessary to discuss the contribution of the viewer to the achievement of these goals. That is, in addition to knowing some of the devices artists use to reach their design objectives, we need to know why viewers are interested in them. To some extent, an artist's effectiveness depends on his understanding of the way people respond to his organization of the visual elements. But as we know, he is mainly guided by his own responses to his work in estimating its visual effectiveness for others. The principles or goals of design we have discussed are rarely the *conscious* aims of artistic creation: from the artist's standpoint they are labels that viewers give to his often intuitive efforts to discover form, express meaning, organize materials, and solve problems.

Such "labels" should help us as viewers to understand the underlying principles of visual organization which seem to make works of art effective. There may be a temptation to set up the principles of design as standards of

excellence against which specific works can be measured. But that would be a mistaken employment of them. Their use should be limited to *explaining* the organization of visual events in works of art. The problems of judgment and art criticism, discussed in Chapters Fifteen and Sixteen, are more complex because they involve philosophic as well as structural considerations. Notice that in the chapters on structure we have talked chiefly about the effectiveness of visual organization; and in the earlier chapters on function we discussed the *uses* of art. But we said less about the *value* of the uses or purposes which art serves. That is a question for the philosophy of art; determination of meaning and excellence is a problem of art criticism. However, we have been acquiring the tools which should help in the performance of critical tasks. As for a philosophy of art, it must be founded on knowledge of real works of art—what they mean and how they work. Then *informed* persons can begin to build a philosophy; and, hopefully, you have been encouraged in that undertaking by the material presented thus far.

PERCEIVING THE ELEMENTS: AESTHETICS

We have examined the visual elements and the principles of their organization, design. Now we are about to examine the principles which account for our perception of what has been organized. Before doing so, we should make an important distinction between *visual form* and *aesthetic structure* to avoid confusion in the discussion that follows. "Visual form" refers to the features of a work of art which are responsible for its organization—its existence as a coherent, perceptible whole. In other words, form designates whatever it is in the object that holds the work together. I like the statement about form which Vivas and Krieger use to describe the views of Isenberg and Bradley: ". . . they see form as the manner in which everything that is to be found in the object is put together, as the total interrelation of whatever is discriminable (the expressive as well as the formal elements) in the object."[16] "Aesthetic structure" refers to those features of the act of perception which give wholeness and coherence to the experience of a work of art. From this definition you can see that I intend to treat aesthetic structure as a psychological problem. It might be said that aesthetic structure exists *inside* the viewer, but only because the potential for visual form already exists *outside* him in the art object. Both form and structure are primarily caused by the art object, but, to oversimplify, "visual form" is used as an objective term and "aesthetic structure" is used as a subjective term.

What is the purpose of making this distinction? It allows us to recognize the contributions of the viewer to the "creation" of a work of art without ignoring the responsibility of the artist for determining the crucial events that underlie the structure of the aesthetic experience. It helps to account for the fact that different viewers perceive the same work differently, and that even a single viewer perceives a work differently at different times. It maintains the integrity of the objective existence of the work of art, a point which has some philosophic value. If we did not define visual form in terms of an objectively existing organization, we might find ourselves in the embarrassing position of ascribing the aesthetic experience almost wholly to the effort of the viewer. The artist would be credited only with some minor physical activity in providing raw materials for the experience. But he would not be regarded as the person responsible for the im-

mensely complex organizational effort which results ultimately in visual form.

At the other extreme, if viewers saw *only* what is physically present in the work of art—the colored patches of pigment on a canvas, for example—all experiences of art would be identical, assuming all viewers had normal vision. It would be unnecessary to instruct them in how to examine works of art. There would be no variation in perception based on the maturity, culture, or interests of different viewers. But clearly, viewers *do* vary in personality and background, they *do* see differently, they *do* have varying capacities for understanding or enjoying what they see. We know that perception is not merely a passive activity, that it requires work—the *active* organization of psychological energies. In other words, perception is a *creative* process. The perception of works of art entails the *creative integration of sensory excitations and psychological expectations aroused in a viewer by the organization of elements embodied in visual form.*

It might be helpful at this point to summarize the steps in the discussion which have led to the present position about the structure of art as a whole:

1. The *visual elements* are constituents of perception which have been fashioned by an artist. They are not materials like paint, concrete, and clay: the elements represent perceptible and intelligible qualities and relationships—line, shape, and so on—*resulting from* the handling of materials like paint, concrete, and clay.

2. *Design* is the organization of the visual elements for the sake of objectives such as unity, balance, or rhythm. *Designing* is not painting or drawing: it is an intellectual and controlling activity; it is *thinking about* how to paint or draw or model to achieve certain ends.

3. The *art object* is the physical result of artistic execution with materials such as paint, concrete, or clay. It has a similar meaning to "artifact," the kind of man-made physical object which an archaeologist

might dig up. An art object *possesses the potential* for visual form; it is the repository where form lies waiting to be discovered.

4. *Visual form* is the *perceived* result of artistic execution which has been undertaken in the light of design objectives. When someone looks at an art object, its *potential* for visual form becomes *actual*. The *viewer* brings its latent potential to life.

5. *Perception* is the viewer's act of seeing and attempting to understand visual form. It is more than an optical process since it also involves what the viewer's brain and nervous system do with the sensory data they receive.

6. *Aesthetic experience* is the vividly apprehended sum of a viewer's perceptions of visual form on any given occasion. Individual perceptions are very brief because of limitations in our nervous and physiological equipment. *Funded perception* is the accumulation and integration of perceptions which are separate in time. Funded perception becomes *aesthetic experience* when it occurs in connection with the unifying quality of visual form.

7. *Aesthetic structure* designates the forces at work in the aesthetic experience which bind our separate perceptions together. Aesthetic structure does not designate the *content* of aesthetic experience. It designates the psychological operations in a viewer which account for his *awareness* of the content or substance of a work of art.

The term "aesthetics," as used in the title of this chapter, is not intended to be confused with the philosophy of art, which deals with the questions surrounding the meaning, creation, and purposes of art, its relation to society and history, its role in the lives of individuals and communities, its character as knowledge, pleasure, expression, and so forth. The treatment of aesthetics is here confined to questions about the way perception occurs and is organized in the experience of art.

Empathy

We can gain a general idea of what empathy is by recalling our reactions during a play or film. As the narrative unfolds, we become acquainted with the characters, and we also grow *concerned* about them. We may dislike some of the characters (not the actors, but the characters they impersonate) and admire others. The play seems to encourage us to become personally *involved* in what happens to the people in it. We worry and rejoice *with* them. Then we even forget that they are performers and we are in the

audience: we *identify with* the characters and actually feel the emotions they express on the stage. No doubt measurements of our blood pressure, pulse, and breathing rate would indicate changes associated with our experience of emotions in "real life."

At the beginning of the play we had a very clear idea of the separate identities of the performers and ourselves. Yet at several points during the play that clear idea was lost. Why? Further, what is the connection between wit-

nessing a dramatic performance and looking at a painting or a building? We identified with the characters in the play because, according to theories of empathy, watching and listening are themselves forms of mimicry, forms of imitation. The only way we can "see" the emotion of fear expressed by an actor is by summoning up that same emotion in ourselves. Fundamentally, we cannot understand or perceive an emotion felt by another person unless we feel it ourselves. The more skillful the actor, the more intense will be our effort to imitate the feelings he is pretending to have. All the circumstances surrounding the performance are designed to encourage our effort to "suspend disbelief," to identify, to become a participant in the events we witness.

Empathy is, in part, a motor response. That is, one way we endeavor to imitate what we identify with is by setting our muscular equipment into motion. We clench our fists, draw our lips back, and bare our teeth. (Is this the part where John Wayne confronts his antagonist or grimly rides into the face of a howling gale?) We tap our feet or rock our bodies in time to music because it is the only way we can imitate regular intervals of sound with our muscular-skeletal systems. These motor activities are not the *result* of felt emotion, they *cause* emotion to be felt. Actors realize that an audience is watching them closely for motor cues; hence, actors learn how to use their bodies, voices, and facial muscles to signal the audience about which motor activity to imitate in order to experience the appropriate feelings. In the theater, actors must "telegraph" their cues very broadly. On the huge cinema screen, with its enormous close-ups, the merest twitch on an actor's face can send oceans of feeling through the sensorimotor apparatus of the audience.

However, if it is possible to imitate a performer with our bodies and thus feel the same emotions he is "acting out," how is it possible to imitate a bowl of apples painted by Cézanne, a building by Le Corbusier, or an abstract work by Mondrian? It is understandable that human beings imitate other humans in order to share feelings, but how do we imitate, empathize with, "feel into" objects, some of which are inanimate? The answer lies in the fact that perception is accompanied by physiological movements and kinesthetic feelings of which we may or may not be aware. We know that looking at a church steeple involves an up-and-down movement of the head. The feeling of being "squeezed" in a low-ceilinged apartment, as mentioned earlier, is based on the restricted physiological movements which accompany perception in that apartment. Conversely, we are familiar with the open, expansive feelings we have when walking into a great hall. In addition to these rather obvious, large-scale movements, of which we are often well aware, there are also minute movements of the eye and associated activities of the nervous system, breathing apparatus, indeed of the whole organism, which we do not consciously feel or

know about. Nevertheless, such activity causes an individual to experience feelings and sensations which he attributes to the visual forms he is examining. The retinal image is not the only factor affecting perception. We know, of course, that the muscles which move the eyeballs as well as the muscles which regulate the opening and contraction of the pupils are continuously active in vision, and that the design of the forms we see affects their activity.

In addition, the viewer is unconsciously engaged in summoning up the feelings and ideas which have been previously experienced in association with neuromuscular

ISAMU NOGUCHI. *Cube.* 1969. Collection Helmsley-Spear, Inc., New York

These environmental sculptures achieve a precarious balance. Why is that balance pleasurable to the viewer? Because of inner mimicry—kinesthetic imitation. We seek balance in our physical and psychological existence, hence we enjoy seeing models of hard-won balance. They recall our own early victories over disequilibrium.

sensations similar to those taking place as he perceives a work of art—whether naturalistic or abstract. The organism does this work, without the viewer's conscious awareness, because of what the psychologist Karl Groos[17] called "inner mimicry." We see and think with our physiological equipment, particularly with our muscular, skeletal, neural, circulatory, glandular, and cutaneous systems. Consequently, seeing abstract colors, shapes, lines, and patterns of light and dark opens up or closes neural pathways which were *previously* affected in a similar way by similar patterns of motor activity. For example, circular shapes may have been experienced in

<small>BARNETT NEWMAN. *Broken Obelisk*. 1966</small>

a thousand different contexts in life. When those shapes are experienced abstractly in art, the organism tends to *relate* and to *fuse* those earlier meanings of circularity with the present experience of it. The perceptual context and the cues provided by the work of art help the organism select from many previous encounters with circularity those feelings, meanings, or "traces" which are most appropriate—that is, most related to the character of the present stimulus. Because the viewer is not consciously aware of these processes taking place within him as he looks at a work of art, he attributes the feelings and sensations he is experiencing to the objective forms he sees. And the viewer is right to do this, since his "inner mimicry" is indeed a response, a creative response, to the visual material before him.

You will recognize that many of the observations made earlier about the visual elements, their organization and meaning, were based essentially on an empathic understanding of perception. There is a considerable amount of experimental evidence to support theories of perception as empathy. However, the version of empathy advanced by one of its earliest advocates, Theodor Lipps (1851–1941), includes elaborations which cannot be experimentally verified. Lipps believed that in the process of "feeling into" the work of art, an individual *identifies* with the work and its constituents by projecting his ego into it. Through this "projection" the viewer takes hold of the feelings and ideas embodied in the forms. Lipps recognized that motor sensations, which he called "sense feelings," are often aroused by the contemplation of works of art. But, he felt, to the extent one is aware of these bodily feelings one cannot regard them as properties of the art object. He argued that enjoyment of one's bodily feelings is not enjoyment of art. Unfortunately, Lipps's idea, the "projection of the ego," is not very satisfactory as an explanation of aesthetic perception. The phrase adequately describes the *results* of perception, our sense of identification and empathy, but it does not explain the process, the inner mimicry, the subliminal awareness of feelings which are experienced as qualities not of one's own constitution but of the work of art itself.

What emerges from the discussion is a convincing argument that empathy exists, that it is empirically observable in others and in ourselves, and that it originates in a motor response to perceived phenomena. There is no debate about that. The questions of whether ego projection is a sound concept, whether bodily awareness interferes with aesthetic experience, and whether perception involves organismic imitation—these remain open. It is interesting to note that the concept of empathy applies not only to the visual arts but also to music, drama, and literature. We can accordingly feel confident that the idea constitutes a useful instrument for understanding and probing further into the nature of our reactions to art.

Psychic Distance

As was just mentioned, Theodor Lipps, the early advocate of empathy as projection of the self into the object, found serious difficulties in a viewer's awareness of bodily sensations during aesthetic perception. Such awareness, according to Lipps, prevented the viewer from perceiving the qualities of the art object: he would be too involved with his own kinaesthetic reactions. Lipps's objection to this type of self-involvement is an approach, of a sort, to the concept of "psychical distance" as developed by the British psychologist Edward Bullough (1880–1934).

According to Bullough, psychic distance (I prefer "psychic" to "psychical") does not refer to physical space; it is not a spatial or temporal concept, although, obviously, there is a physical separation between the viewer and a work of art, and time is required to see or listen to a work of art. By psychic distance, however, he means the *degree of personal involvement* of a viewer in a work of art. In other words, psychic distance begins with the assumption of empathy: there *is* identification or projection or "feeling into" the work. The important question for Bullough is: How much personal identification with the work of art is desirable?

Before proceeding to Bullough's answer, we should look further into what he means by "distance." Distance is a matter of attitude or outlook. We do not approach art in practical terms, as we approach ordinary experience. We seek no personal advantage or useful knowledge. Bullough shares with the philosopher Kant the view that aesthetic pleasure is "disinterested" or detached. The attitude of the viewer is contemplative, reflective, not oriented toward action. Any motive beyond disinterested satisfaction would be regarded as placing the everyday, practical goals of the viewer ahead of the proper perception of the work for its own sake. It is easy to see the influence of Kant upon Lipps, who was also concerned with "disinterested" perception. According to him, the viewer would not be capable of seeing the work authentically if his perceptions were focused on his bodily sensations.

In order to escape practical involvement in a work of art, then, the viewer must suppress his customary habits of seeing. An effort is required to hold in abeyance those normal attitudes and interests which characterize our daily perception. When viewing films or plays, for example, we sometimes have to remind ourselves that what we are seeing is unreal. Consider children. They identify so readily, and have so indistinct an idea of the separation of the identities of others from themselves, that we must deliberately develop in them the concept of psychic distance. Otherwise, they may have nightmares and periods of unexplained depression. Although Bullough does not mention it, the concept of *aesthetic frame* helps to establish distance, or the attitude of

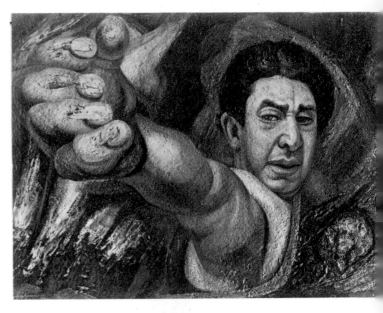

DAVID ALFARO SIQUEIROS. *Self-Portrait*. 1943. Instituto Nacional de Bellas Artes, Mexico City. By thrusting his fist toward the viewer, as if to annihilate the intervening space, Siqueiros makes it impossible for us to view his self-portrait with detachment. We see not so much a picture as a person whom we instantly fear or admire. The revolutionary artist deliberately eliminates distance: for him, the response to art must be a response to life itself.

disinterest. The frame around a picture, or, for that matter, the proscenium arch around the stage, serves to distinguish the events taking place within a work of art from those in the ordinary world around it. Of course, when distance is lost, when complete identification occurs, we lose "sight" of the frame. (In this connection, it is worth noting that older works of art usually had massive frames around them, whereas modern paintings increasingly employ thin wooden or metal strips, or no frame at all. Should we conclude that contemporary artists increasingly seek to eliminate the separation of art from life?) In addition to isolating the work of art from the rest of the world, the frame serves to remind us that the work contains material intentionally organized for aesthetic as opposed to practical perception.

At this point we can define psychic distance as *any awareness* by a viewer that there is a separation between the reality of his own life and the reality of the feelings he experiences in connection with a work of art. The viewer is *desirous* of having feelings through art; he *does* "cooperate" with the work of art by trying to believe in its reality. But he recognizes that these feelings do not belong

JACQUES VILLON. *Portrait of the Artist's Father*. 1924. The Solomon R. Guggenheim Museum, New York. Compared to Siqueiros, Villon is as detached from his subject as a stoneworker carving a granite monument. If the head is handsome, this is because of the way light falls on a series of crisp planes—planes that might belong to the drapery in a still life by Cézanne.

to his day-to-day "practical" existence. He understands that there is or must be a separation between art and life. Like a scientist, he realizes that he must be objective about gathering data and making measurements at the same time that he has a strong *personal* interest in the fruitful outcome of his experiments and measurements.

Loss of distance can be defined as complete involvement or identification with the realities present in the work of art. It occurs, according to Bullough, when perception becomes *practical* as opposed to *aesthetic*. At the other extreme, there is *excessive distance*, not caused primarily by the attitude of the viewer but by the work of art. Its lack of concreteness, credibility, or relevance to the life of the viewer does not permit *any empathy*, as we might say, to take place. This *overdistancing* is not only a trait of perception but is also traceable to qualities in the design and execution of the art object. Excessive distance, the inability of a viewer to develop any interest in the work, thus becomes one of the factors in critical judgment. That is, while one "sees" the work, one cannot become sufficiently involved to experience its formal, expressive, and other relationships. The situation is com-

parable to attending a party where you do not know any of the other guests. In the same vein, it is difficult to enjoy certain sports events unless you know the players or root for one of the teams. Some identification is necessary.

In discussing psychic distance, Bullough speaks of it as being operative in artistic production as well as aesthetic perception. He recognizes that the artist must detach himself to some extent, even from an experience which has affected him deeply, if he is to express himself effectively. An actor who portrays a mad man must be quite sane and very much in control of his own mental and histrionic equipment. The Romantic view of the artist as achieving excellence entirely because of the depth and intensity of his inspiration is rejected. Loss of distance would interfere with his intelligent and skillful employment of the techniques he possesses. This point is illustrated in life by the fact that when we are deeply moved by an emotion, it is difficult to speak about it coherently. Do good actors learn how to *simulate* emotions or do they find it necessary to *experience* the emotions they are called upon to portray? This seems to be the question which divides proponents of "classical" acting and advocates of so-called method acting, followers of Konstantin Stanislavsky and Lee Strasberg. Our discussion of empathy suggests that good actors express or project emotion by knowing how to create motor signals which the audience can simulate. Perhaps they undergo genuine and exhausting emotional experiences during training and rehearsals, acquiring the technique they can exhibit in a calculated manner during actual performances.

Bullough's understanding of the distance factor in the creation of visual form as well as in aesthetic perception leads him to propound what we might call the *law of psychic distance:* the most desirable degree of empathy or identification with the work of art "is the utmost decrease of Distance without its disappearance." At one extreme lies apathy, at the other lies the confusion of art and life. A moderate degree of disinterestedness results in a moderate degree of pleasure for the viewer. But vividness and intensity of perception require as much involvement as possible without actual loss of personal identity.

Having established what he considers the ideal psychic distance for aesthetic perception, Bullough goes on to classify the arts according to their tendencies toward overdistancing or underdistancing. The dramatic arts, as we know, run the risk of underdistancing. Bullough suggests that problems of censorship arise, particularly in connection with theater, because people lose their distance too readily when they witness real human beings undergoing all the emotions of real life. It is also difficult to maintain any distance toward the dance because, as with theater, the human figure is so prominent in the medium. And sculpture, insofar as it uses the figure, is close to the dance. Although the figure is not actually alive in sculpture, our attitudes toward its corporeality

and its frequent nudity cause distance to be kept with effort. (The mythical sculptor Pygmalion fell in love with his statue, Galatea.) Painting as an art most nearly approaches ideal specifications for distance: its reduction of lifesize scale and its stylization of visual phenomena render it the least subject to confusion with reality; hence, the proper degree of distance is more easily attained. Music, especially "serious" music, tends to be over-distanced, and architecture is most distant of all.

These observations by Bullough, made in 1912, may seem somewhat quaint today. For example, he could not have anticipated the nonfigurative character of much contemporary sculpture. Both classic ballet and, to a lesser extent, modern dance employ the figure in a formal and stylized manner; still, it is not difficult to maintain psychic distance from these art forms. Architecture is far from inducing apathy, even without the aid of such distance-decreasing factors as figurative ornamentation and the appeal of utilitarian function. Painting in its abstract examples has similar distance-potential to that of architecture. Despite these particulars, though, the principle which Bullough employed in making his distance classification seems to have continued validity: naturalism in art, whatever the particular medium, tends to encourage loss of distance and identification; stylization and abstraction promote overdistancing and apathy.

It does seem necessary, however, to take exception to Bullough's radical separation of *practical* and *aesthetic* concerns. Although he is in honorable company when he stresses the *disinterestedness* of aesthetic perception, the *definition* of disinterestedness he used—nonpractical, nonutilitarian concern—is too negative. He and philosophers who share his view tell us what aesthetic perception is not, but they do not tell us what it is. Their difficulty may be due to an effort to establish the existence of emotions and ideas which are purely aesthetic, unmixed with crass, workaday motives. Such thinking may betray the sociological frame of reference in which it was conceived: a leisure class can perceive pure beauty, merchants can only perceive money, and workmen only see things. Or it may represent an idealistic or religious world view which assumes within men hierarchic levels of experience similar to differences of rank and ambition which exist in the world men have created. Nevertheless, a psychologist operating on scientific foundations would be hard put to demonstrate experimentally the existence of interests, values, or concerns which are detached from biological survival, social utility, or practical function. Bullough tried to deal with these problems by asserting that men seek satisfaction in art by suspending any interest in practical advantage from it. However, he does not make his case. One's motive *in advance* of perception may be as detached and nonpractical as one would wish. (Even then, self-deception is possible.) But the meanings one attributes to perceptions are based on the practical experience, the concrete interactions, of the organism with life. In seeing, there is no escape from the memory of our visual progress through the world.

JEAN TINGUELY. *Rotozara.* 1967. Alexander Iolas Gallery, Paris. Increasingly, contemporary artists encourage the public to engage in a physical —rather than a visual and intellectual—exchange with art objects. The aesthetic experience becomes a public performance in which art objects and viewers interact. But this sort of commerce between persons and objects is not new; it goes back to the ritualistic and cultic origins of art during the long tribal incubation of modern man.

Fusion and Funding

The concept of funding in the perception of art was originally employed by John Dewey and was further developed and refined by the aesthetician Stephen Pepper. In acknowledging Dewey's interest in fusion and in bringing the concept more emphatically to our attention, Pepper has occasion to say: "He [Dewey] has much, of course, to say about quality, but never, so far as I have found, does he stop to write on the topic of fusion or funding. He used the concepts all the time but never held them up for long and careful scrutiny."[18]

Although the terms "funding" and "fusion" are used almost interchangeably, we can think of funding as including remembered perceptions and the accumulation of separate perceptions of the same work, and of fusion as the process of integrating those perceptions into a whole so that the work is characterized by a single dominant quality.

I have already asserted that people tend to perceive the "whole" of a work of art before they become aware of its parts. That seems to be a paradox, since we know that, in theory, the whole work, at least the *physical* whole, is the sum of its parts. But during any given perceptual opportunity, we do not see *all* of the work which is there to see. Almost any art object is capable of yielding far more sensory data than we are capable of perceiving on a particular aesthetic occasion. In the world outside of art, we do not wait to see the color of an automobile's license plates when it is bearing down on us. We are satisfied to identify the existence of a car moving at a certain speed along a certain path—and we get out of the way. The perception of events, in other words, is perception *infused* with a primary quality which makes meaningful action of some kind possible—a process of a few seconds, at most. In the case of a moving object, action is embodied in a "decision" by the whole organism to change its distribution of energy: to relocate itself. In the case of fine art, action consists of an immediate and vivid intuition of the quality which pervades the whole object, a quality which is simultaneously felt as pleasing or displeasing. Here we can spell out what Gestaltists and others mean about perceiving the "wholeness" of an object or event before perceiving its parts. That "wholeness" is qualitative or "fused"—the result of a completed electrochemical pattern or circuit in the perceiver's brain. Such a pattern or *gestalt* does not, however, take account of all the objective traits or parts of the perceived object.

Although a situation may not be urgent, perception is nevertheless hastily integrated; this process of integration does not last long enough to exhaust all the sensory possibilities within the situation. But we cannot claim that the habits of perception drawn from daily life do not also carry over into the experience of art. Hence, a person tends to perceive the whole work quite rapidly and, if more time is available, forms several qualitative perceptions of the work.

This tendency of the perceiver to jump to conclusions is apparent if we think of our behavior when reading a mystery novel. At any number of points before the end, we assemble the evidence for the detective and decide who the culprit is and how he committed the foul deed. If the mystery is well written, we turn out to be wrong, intentionally led astray by the author. The skillful writer of mysteries exploits the tendency of readers *to form a comprehensive perception of the quality of the whole before all the potential meanings of the material have been experienced.*

Theoretically, a work of art that is complex beyond the most rudimentary level can never be perceived completely, totally, finally, once and for all. We know that the plays of Shakespeare, for example, seem inexhaustible to the people who know the most about them. At least one reason why an excellent work continues to be rewarding after we have experienced it several times lies in the fact that we, the perceivers, have changed and hence view the same organization of forms differently. But on a single aesthetic occasion, our perceptions of the whole change because the later perceptions or "evidence" change the meaning or import of the earlier "evidence." And the changed earlier evidence affects the meaning of the later evidence, so that collectively they change the significance of the whole work that we are engaged in examining. Because perception of visual form takes time, just as does the perception of musical form, there is a rich and complex interaction among our separate successive perceptions of that form. (One of the functions of art criticism is to form an interpretation, that is, a statement about the single quality or idea which best accounts for our several successive perceptions—the aesthetic evidence—of a work of art.)

When we examine *A Sunday Afternoon on the Island of La Grande Jatte* by Georges Seurat (1859–1891), a number of expectations are aroused by our initial perceptions of the work. As the examination proceeds, these expectations are confirmed, disappointed, or modified. We may have expected social description and encountered instead a treatise on sunlight and cast shadows. Our perception of sunlight and shadow was transmuted into a perception of the Pointillist treatment of surfaces under varying conditions of illumination and distance from the viewer; the perception of light and distance gives way to a perception of colored pigment resting on a flat picture plane. The perception of the picture plane yields to an apparently opposed perception of the figures as sculp-

GEORGES SEURAT. *A Sunday Afternoon on the Island of La Grande Jatte.* 1884–86. The Art Institute of Chicago. Helen Birch Bartlett Memorial Collection

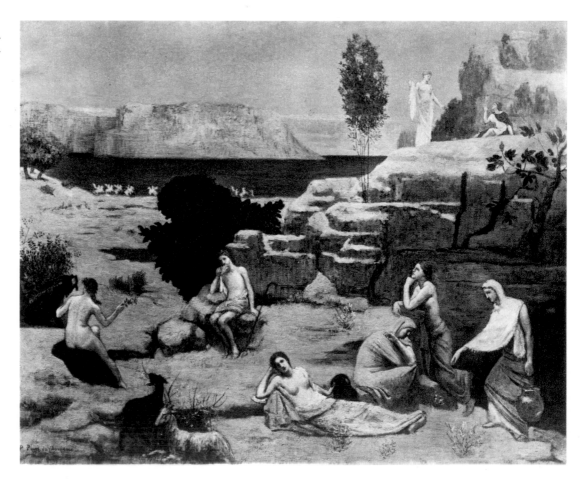

PIERRE PUVIS DE CHAVANNES. *A Vision of Antiquity—Symbol of Form.* c. 1885. Museum of Art, Carnegie Institute, Pittsburgh

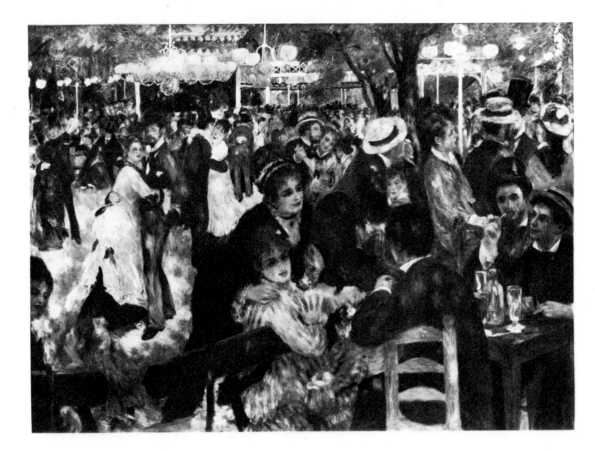

AUGUSTE RENOIR. *Moulin de la Galette*. 1876. The Louvre, Paris

tural solids floating in real space. Furthermore, perceptions of form mingle with perceptions of the thematic material. Our personal experience with similar events may affect the way we see the somewhat stately and dignified visual organization. Previous experience with art—say, *Moulin de la Galette* (1876) by Auguste Renoir (1841–1919)—may suggest contrasting ideas about the material which Seurat presents. In recollection, other works of art which seem to deal with related forms or themes introduce new perceptions at the same time that they color those we have already made. For example, *A Vision of Antiquity—Symbol of Form* by Pierre Puvis de Chavannes (1824–1898) exhibits a similar, slightly anemic devotion to Classicism but with less painterly control of space relationships.

Clearly, a multitude of qualitative perceptions—consistent with each other, building upon each other, or opposed to each other—can be formed by a single viewer in the presence of a work which possesses the formal organization to sustain his interest. Now arises the problem of how they are funded or fused into a unified experience.

Perhaps the discussion of the different ways in which the same work can be understood has obscured the fact of the technical unity and the design unity of the art object itself. First, it is we, the viewers, who have the capacity for "reading" the same work variably. Second, we are aware as we look that our several perceptions of a work are caused by the same organization of visual forms. Third, and most important, fusion designates a *qualitative*

unity in aesthetic perception rather than a logical or thematic unity. In other words, at any given moment during our examination of a work of art, we have a dominant, controlling impression of all the elements of visual form we have seen in the work. That controlling impression, or fused perception, is of the pervasive quality which seems to characterize the various parts of the work, no matter what its official title or theme. With respect to the Seurat, at a given moment all the parts seem to be permeated by a single feeling, which might be poorly verbalized as a *sense of controlled relaxation*. This fusion or qualitative perception of the whole having been made, our more analytic reading of *parts* of the work becomes *qualitatively* consistent. The motion of the sailboat and of the bandleader seems to be arrested. The cast shadows do not shift or flicker: they are fixed. Even our recollections of related themes are governed by the quality of this controlling perception. The informality of Renoir's dancers and diners will now appear extraordinarily intimate and flirtatious by comparison with Seurat's sedate parade; we are made aware of an almost Surrealist quality in the airless landscape of Puvis de Chavannes because of the masterful control of atmosphere and edge in Seurat's painting. For the time being, at least, everything we perceive in the work, or relate to it from the outside, is understood in the light of a *controlling quality* which is seen as the unifying element of the work under scrutiny. Renoir's painting may not be noisy when seen for itself on another occasion, but it seems so *now* in the light of our perception of the Seurat.

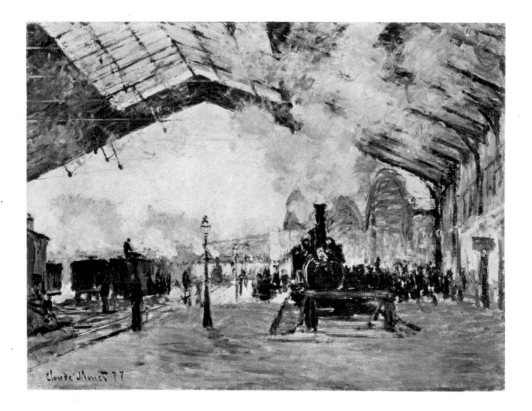

CLAUDE MONET. *Old St. Lazare Station, Paris.* 1877. The Art Institute of Chicago. Mr. and Mrs. Martin A. Ryerson Collection. Monet may well have been interested in painting only the visual effect of smoke dissolving the structural forms in the great train shed. But our perception of the painting could include hissing engine sounds, excited crowd noises, a clanging train bell, the smell of smoke, the screech of steel rails, and a slight shudder of the passenger platform as the train begins to move. These are not merely "literary" associations; they are real perceptions fused into a single dominant experience by the design and execution of the work.

Incidentally, this capacity of aesthetic perception to color the experience of other places and events which are not presently the focus of attention can lead ultimately to a romanticism of the Wildean sort (nature imitates art): *all* experience is regarded in terms of its effect on one's aesthetic perception. Thus, taking a train trip might be felt in terms of its influence on one's perception of Monet's *Old St. Lazare Station, Paris.* As such an attitude grows, life is experienced *only* in terms of its influence on the perception of works of art: human relationships cease to be felt directly but only as they might be felt if one were a character in a film, novel, play, or in history. When ordinary life is dull, or seemingly so, it is exciting to perceive daily events and one's role in them as part of a comprehensive pattern infused with the qualities we first came to know through art. Extreme forms of this sort of romanticism may not lead to madness, but they do diminish one's ability to deal effectively

with real life. To be sure, the qualitative perceptions we experience in art are too uncommon in our perceptions of daily life, work, and personal and social relationships.

Still, confusing the categories *art* and *life*, while often endearing, may be comparable to wearing rose-colored glasses: the things we see refuse to act as though they are rose-colored.

Even if the concept of fusion is fairly well accepted as the binding factor in the qualitative perception of form, the descriptions by Dewey and Pepper do not explain, from an experimental standpoint, the operation or the causes of fusion, although their discussion is very suggestive. Consequently, we shall turn to the Gestalt psychologists and their concept of closure and "good *gestalt*" (which is not unlike the concept of fusion) for what might prove to be an explanation of aesthetic fusion from another angle of attack.

Closure and "Good Gestalt"

"Closure" is the term the Gestalt psychologists use to explain the tendency in all human perception to seek completeness of structure and meaning. So long as the perception of wholeness is denied to a viewer, he experiences tension, discomfort, suspense. Forms which are in some way incomplete are therefore regarded as unstable by Gestalt psychologists. The perceptual energies of a viewer

are always organized to endow unstable forms with stability—that is, to complete them, to bring about *closure* —because only then can his discomfort and tension be dissipated. Gestaltists hold, therefore, that perception is always of wholes, of total *gestalten*, or configurations. They deny that the perception of a whole configuration is the sum of sense impressions of component parts. In this

contention, they are supported by Dewey and Pepper in their concept of fusion. Dewey maintained, as we know, that the fused quality of the whole work of art is immediately grasped—"seized," he said—by the viewer. Only *after* perceiving the quality of the whole does the viewer become aware of separate sensations and perceptions. These separate perceptions are bound or fused together by the original perception of overall quality, but neither Dewey nor Pepper explains how this comes about.

In Gestalt psychology, closure is a single instance of the operation of the *Law of Prägnanz*, other instances being unity, uniformity, good continuation, and simple shape. According to this law, the viewer's organization of his perceptual field will always be complete and as "good" as possible, "good" in this case meaning as good a *gestalt* as possible given the objective character of the stimulus. The viewer, furthermore, will always seek the route of maximum simplicity to arrive at closure of his perception. However, closure does not result from the recollection of similar unities previously encountered by the viewer. Neither does Gestalt theory accept the empathic theory of perception in which the viewer is engaged in kinesthetic or sensorimotor imitation of what he perceives, thus arousing in himself emotions corresponding to those expressed in the work of art. Gestaltists maintain that there are independent physical laws which govern the organization of psychological energies during perception, and that the organization of energies in perception approximates but does not replicate the organization of energies in the stimulus object.

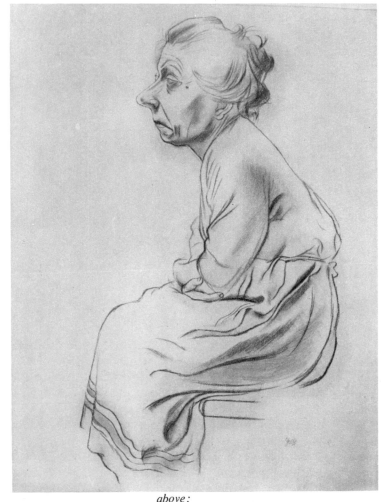

above:
PAUL KLEE. *Portrait of a Pregnant Woman.* 1907. The Brooklyn Museum

What accounts for the similarity of these two drawings? The models must have looked alike. But what does that mean? According to Gestalt theory, we grasp with our eyes their common structural qualities: sharp-nosedness, turned-down-mouthness, and small, squinty-eyeness. That is, in the act of seeing we make qualitative judgments. These judgments are based on only part of the visual evidence, but they control our perception and characterization of the whole work of art.

GEORGE GROSZ. *Charwoman.* 1924. The Brooklyn Museum

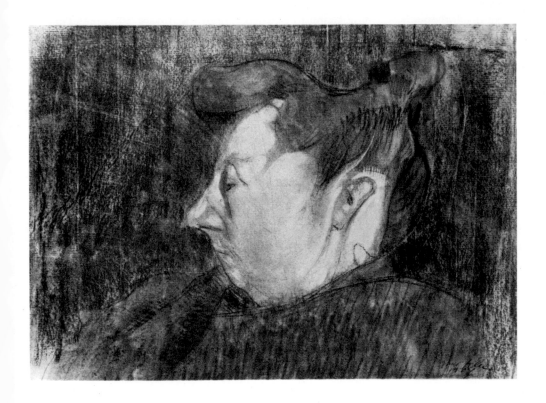

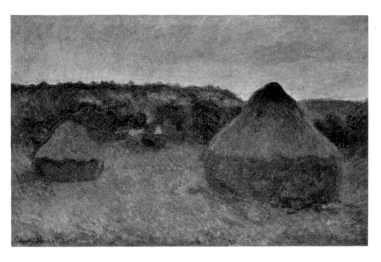

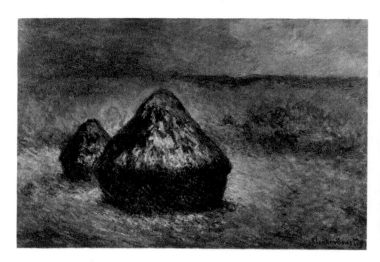

CLAUDE MONET. *Two Haystacks*. 1891. The Art Institute of Chicago. Mr. and Mrs. L. L. Coburn Memorial Collection

CLAUDE MONET. *Haystacks in Setting Sun*. 1891. The Art Institute of Chicago. Potter Palmer Collection

Gestaltists make a distinction about sensory stimulation which is important for psychology *and* aesthetics. They speak of the *distant*, or geographical, stimulus as the object which receives energy from the sun or elsewhere, absorbing some of it and reflecting some of it back to a perceiving organism. The energy from the *distant stimulus* excites our sense organs and sets up a new pattern of local, or *proximal, stimuli* which become the objects of perception. We do not, according to Gestalt psychology, perceive the *distant stimulus*, although the retina does receive its reflected light energy. What we perceive are proximal stimuli. While the distant stimuli —a tree, a face, a picture—may vary considerably, the proximal stimuli often tend to remain the same. Perhaps we can understand Claude Monet's numerous paintings of haystacks as his effort to represent only the distant stimuli and to ignore the tendencies of the organism to perceive them as unchanged even under new light, color, and atmospheric conditions. This distinction should not be particularly difficult for us to understand when we consider that something like it is incorporated into every schoolchild's study of the stars. In the fifth or sixth grade, children learn that in looking at the stars, they do not in fact see the stars but light which left the stars perhaps millions of years ago. Gestaltists maintain that they do not even see the light but rather their own local sensory excitations which have been stimulated by light (now much diminished) from the distant bodies. Impressionists first tried to paint the light emitted from objects rather than *a priori* or *received ideas* about the forms of those objects.

Consequently, we have a fundamental split affecting aesthetic theory: some aestheticians believe that perception replicates, or reenacts, the processes of organization

which were involved in the creation of the work of art. Others believe that aesthetic perception proceeds according to independently operating processes of the organism. Lipps and Dewey would be in the first category and Gestalt psychologists in the second. According to the Gestalt view, the energy or fuel for the conduct of perception comes mainly from within the perceiving organism. The art object *ignites* the fuel and sets the energies into motion. In that sense, the art object is the *cause*, the event prior to perception as well as the focus of visual interest. But our *experience* of the art object does not correspond to the structure of the distant stimulus. The perception of a shape or color in no way resembles the objective shape or color itself. In other words, there is no blue color or triangular shape to be found in the brain of a perceiving organism.

If perception does not involve replication, or reenactment by the sensorimotor system of events perceived in the object, how do we learn anything *about* it? Also, how does the organism bring about closure or "good *gestalt*" when confronted by unstable or ambiguous forms? In partial answer to the first question, Gestalt psychology advances the concept of *isomorphism*, which maintains that there is a correspondence between physiological processes and consciousness in the organism. That is, thoughts and feelings are the activity of atoms and molecules in the brain. But how is such activity in the brain initiated? It is "ignited," as mentioned above, by the "distant" stimulus of the art object. As Kurt Koffka says, "We see, not stimuli—a phrase often used—but on account of, because of, stimuli."[19] The proximal stimuli (the sense excitations in the organism caused by the "distant" stimulus, the art object) take the form of combinations of the conventional visual elements we have discussed

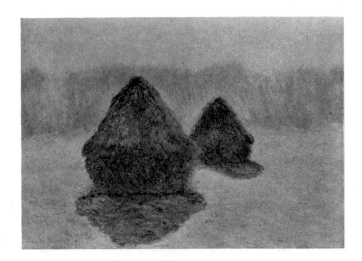

CLAUDE MONET. *Haystacks in Snow*. 1891. The Metropolitan Museum of Art. The H. O. Havemeyer Collection. Bequest of Mrs. H. O. Havemeyer, 1929

earlier: line, shape, color, and so on. Then the specific character of the visual elements in combination causes the viewer to integrate them in a *gestalt*, or configuration, according to one or more illustrations of the Law of Prägnanz: regularity, simplicity, and so forth. We have discussed some of these laws indirectly in Chapters Eight and Nine when speaking of the properties of the visual elements in isolation and the properties of the elements when designed to achieve, say, rhythm or balance. Our discussion, however, included recollected and symbolic qualities of the elements in addition to those properties which, according to Gestalt psychology, are independently determined by the organization of energies in the visual field. For example, Gestaltists maintain, on the basis of scientific experiment, that the space *inside* a closed shape is perceived as a different, denser substance than the space *around* the shape, although we know the space to be the same substance—for instance, ordinary paper. The Gestalt psychologists have developed a considerable body of such material, so that they feel confident in propounding "laws" of sensory organization about the perception of the main types of visual forms. They would claim that their laws describe physiological processes in the viewer which cause corresponding mental states (the patterned activity of atoms and molecules in the brain) or "experiences," as we might say.

You may recall that in Chapter Eight, in describing the visual elements, we spoke of them as "image constituents." Images, we said, were "the result of endowing optical sensations with meaning." In the light of the Gestalt distinction between distant and proximal stimuli, we can identify the visual elements with proximal stimuli. That is, they are *local* organizations of sense data which might be called *percepts of the visual elements*. The prob-

lem raised by our earlier question (If perception does not involve replication or reenactment, how do we learn—that is, know—anything about the object?) becomes for Gestaltists a question as to how the many percepts based on local stimuli relate or correspond to a "real," or *distant*, stimulus. Their answer is equivocal. They introduce the concept of constancy in *size, shape, color*, and *brightness*, and carry out experiments which show that perceived images remain unchanged despite experimental changes in the distant stimulus and the retinal image. Clearly, psychological factors are at work which govern *constancy* of percept despite the fact that a retinal image has been distorted by the experimenter's manipulation of a distant stimulus. Certain forces tend to prevent distortion of the percept despite objective changes in the stimulus. But Gestalt psychologists are unwilling to explain the stability or constancy of percepts in terms of previous experience with the stimulus object. They state one hypothesis to the effect that "the percept depending upon the *proximal* stimulus approaches the properties of the distant one."[20] Köhler says: "In this respect [the preservation of the 'right organization'] the stimuli copy corresponding formal relations among the surface elements of the physical objects."[21] In addition, "central factors" cause proximal stimuli to remain similar to distant stimuli. But this is what we would suspect from common sense and from the traditional psychologies which Gestalt rejects. Elsewhere, Koffka suggests that strong stimulus forces tend to produce a retinal shape which resists distortion, resulting, in turn, in a percept which corresponds closely to the retinal shape. The "stimulus forces" he refers to are within the organism—that is, they result from the organization of local or proximal stimuli. (By biological memory? By heredity? By learning?) Those who have no doctrinaire commitment to Gestalt psychology might aver that the "central factors" mentioned above and the local stimulus forces, which resist distortion, which cause the viewer's percept to approach the distant stimulus, are affected by something called *previous experience*. In other words, granting that perception is the organization of energies under conditions set by the organism and the field with which it interacts, our seeing is strongly influenced by experiential cues (*umstandsdaten*). Gestalt psychology rejects the concept of fusion but reintroduces it in terms of forces tending to maintain the constancies, or as "phenomenal regression to the real object."[22]

Let us return to the second question propounded above: How does the organism bring about closure? The best answer we can get from Gestalt relies again on the Law of Prägnanz, which appears to be a psychological version of principles derived from physics, notably Kirchkoff's Law. Applied to perceptual organization, Kirchkoff's Law would assert that the current intensities in a system of circuits (the perceptual forces within the organism) will be distributed in a pattern which generates

and uses a minimum of energy while functioning as a system. This amounts to asserting, as we have above, that the organism tends to seek the route of maximum simplicity (the least expenditure of energy) to achieve closure. A common illustration of this physical law is the shape of a soap bubble or a raindrop. The spherical shape of the soap bubble represents the best and smallest surface area for containing its volume. The raindrop arrives at a shape which is most efficient for carrying out its function: maintaining its volume against the resistance of its environment while falling as quickly as possible. The shape of the bubble or of the raindrop performs a function; it does a job; it is not the result of irrational forces. Likewise, closure in human experience performs a function: it permits perception to take place according to the most economical expenditure of energies.

The Law of Prägnanz, which we can understand as a requirement that perceptual energies be organized in "good" *gestalten*—that is, in patterns of maximum efficiency—further implies that such patterns must contain three properties: regularity, symmetry, and simplicity. You will readily note that these properties have been discussed in Chapter Nine as *principles of organization* under the headings, respectively, of *Rhythm, Balance,* and *Unity*. According to the Gestalt principle of isomorphism (see above), rhythm, balance, and unity are actually physiological processes which give rise to corresponding conscious processes during perception. Thus, Gestalt completes the circle in its presentation of solutions to the problem of how perception takes place, how characteristics of the art object are communicated to the perceiver, and how the organism is enabled to experience feelings and thoughts.

Since the Gestalt theory of perception is very important for aesthetics, but also quite difficult, I shall summarize its main contentions below without, it is hoped, doing them violence through oversimplification.

1. Perception is of whole *gestalten*, or configurations of sense data; these configurations are the fundamental units of experience.

2. The organism imposes wholeness upon its perception because of the way psychological energies are organized by the nervous system during the perceptual process.

3. If visual forms are unstable or incomplete (and they always are, in some sense), the human organism completes them according to psychophysical laws governing its perceptual behavior. Such completion is called *closure*.

4. Closure is required to form a *gestalt* because the organism cannot tolerate instability in its perception.

5. The completion of the *gestalt* takes place according to the Law of Prägnanz, which maintains that the resulting configuration will be as "good"—as unified, balanced, and constant—as objective conditions (visual forms and constitutional factors) permit.

6. The Law of Prägnanz is a psychological application of the physical principle that forces distribute themselves in a system according to a pattern of minimal energy production to maintain a maximum of stable, systemic function.

7. Regularity, symmetry, simplicity, and closure are characteristics of energy distributions during perception. These psychophysical terms correspond to the aesthetic terms *rhythm, balance, unity*, and *coherence*.

8. *Isomorphism* is the principle which asserts that consciousness corresponds (has structural affinities with) physiological processes, especially the molecular and atomic activity of the brain and nervous system.

9. Perception results from physiological processes in two ways: (a) through sensory activity caused by energy received from a *distant* stimulus (the art object); (b) through neural and other somatic activity caused by the organization of energies *within* the viewer following "ignition" by the *proximal* stimulus.

10. The organism perceives, *is conscious of*, qualities and properties of a work of art because the physiological processes of perception induce states of consciousness in the brain that correspond to functional activities of the body. These physiological processes are organized during perception along patterns of symmetry, simplicity, and so on. They do the work of forming a "good *gestalt,*" using the material provided by the distant and proximal stimuli.

It appears, then, that the principle of isomorphism, propounded by Köhler, is not radically different from the empathy theories of Lipps, Groos, and Vernon Lee. The *correspondence* between physiological and mental or psychological states is not substantially at odds with "inner mimicry"—the induction of thoughts and feelings through motor imitation, that is, physiological processes. There is, however, a conflict in the Gestaltists' unwillingness to employ voluntary imitation, association, and recollection as an explanatory factor in the perception of qualities. Gestalt theory will not rely on previous experience as a source of meaning and emotion during present perception; it must derive meanings and feelings from the patterns of energy distribution in the organism

triggered by the proximal stimuli. The result is an ahistorical explanation of perception, a description of vision without memory which seems to fly in the face of common sense. (Of course, science often conflicts with common sense.) In reacting against the excesses of associationism, stimulus-response bonds, nerve-synapse theory, and atomistic sense perception, Gestalt psychologists may ultimately arrive at another extreme, namely, a rather impoverished description of aesthetic perception in terms of the distribution of electrical energy in the brain and neural network. Such an analysis may be truthful so far as it goes, but it leaves out much that seems to present itself to consciousness in aesthetic experience.

Nevertheless, we are indebted to Gestalt psychology for its key concept of the total configuration as the fundamental unit of perception, its important distinction between distant and proximal stimuli, the concept of isomorphism, and especially its rigorous experiments in perception. The last have been particularly welcome to artists, since they tend to confirm scientifically the validity of artistic knowledge and practice which have been intuitively or empirically gained.

Artistic Perception: Wölfflin's Categories

The discussion of perception has been thus far conducted mainly from the standpoint of the person who views works which others—artists—have created. It may be useful to change our perspective and examine perception from another vantage point—that of the artist. I do not wish to assert that artists perceive differently from others. Indeed, it is possible that they best illustrate how *everyone* perceives at a given time. It is instructive, however, to draw inferences about perception in general from the evidence of visual art. Fortunately, a systematic approach to the study of such evidence is available in the influential book *Principles of Art History* by the art historian Heinrich Wölfflin. His categories of visual analysis, which will be discussed in this section, deal with characteristic "forms of beholding," as manifested in drawing, painting, sculpture, and architecture.

Wölfflin attempted to show that variations in the media and subject matter of art conceal underlying commonalities in style and that style results from a way of perceiving, an outlook or mode of imagination, which characterizes individuals, nations, and races at certain stages of their development. We have also studied style in Part Two, but the discussion there was conducted largely along the lines of *style as expression*—the ideas or emotions typically conveyed by recurrent modes of organizing form. Wölfflin's approach to visual style is psychological or perceptual. For him, style results almost inevitably from an artist's mode of seeing—a mode he cannot escape. The perceptual approach has the advantage of avoiding the excesses of literary, moral, and social association to which expressivistic theories of art are vulnerable. It is also obviously well suited to the visual arts. Wölfflin said he believed that the discussion of style as the *expression* of a school, a country, or a period could not deal with the unique qualities of works of art. Hence, he saw his task as an art historian to be the exposition and analysis of the history of vision and the description of necessary stages in the visual development of mankind as revealed in art.

It is likely that Wölfflin thought of himself as a psychologist of style as well as a historian of style. Although he recognized that there is more to art than the artist's eye, he relied heavily on a *psychology* of vision. Despite his distaste for the analysis of art as expression, he was nevertheless prone to draw racial and nationalistic inferences from the modes of perception he found embodied in art. But we can ignore this material, which seems, in any event, to be superimposed upon essentially sound observation of artistic modes of beholding. We can make use of his visual categories while passing over his "blood-and-soil" psychologizing. ("It has long been realized that every painter paints 'with his blood.' " "Different times give birth to different art. Epoch and race interact." "The linearity of the Latin race was apt to look cold to Germanic feeling." And so on.) It might be said that Wölfflin diluted the value of his excellent eye for style and technique by rather second-rate ethnic and racial explanations of the visual differences he perceived and taught others to see.

He understood the history of art as the history of modes of representation which, in turn, are based on a characteristic or typical mode of perception at a certain time and place. These modes of perception are broken down into five categories. There are two poles in each category, and development is from the first pole to the second. For example, the first category deals with the development from a linear style of art to a painterly style. This means that when we encounter a painterly style of art, it is the creation of an artist who has already passed through the linear stage: he has made the transition as an individual, or it has been made for him by the group or tradition to which he belongs. Nations and schools of art pass through the developments at different historical times. Thus, one country may be arrested at the linear stage while another has arrived at the painterly. Wölfflin occasionally suggests that ethnic and other factors may predispose artists, because of their heritage, to prefer the earlier phase of a stylistic category to the more highly evolved phase of

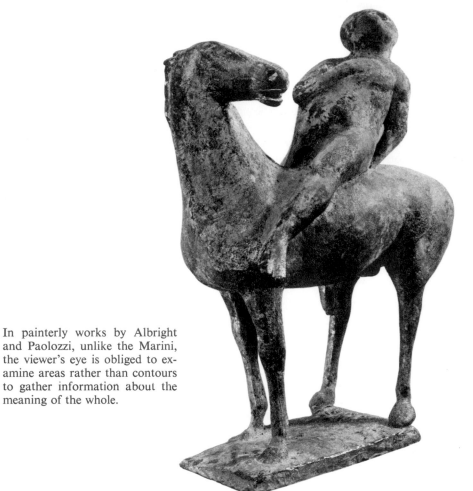

MARINO MARINI. *Horse and Rider*. 1947–48. The Museum of Modern Art, New York. Lillie P. Bliss Bequest

In painterly works by Albright and Paolozzi, unlike the Marini, the viewer's eye is obliged to examine areas rather than contours to gather information about the meaning of the whole.

IVAN ALBRIGHT. *That which I should have done I did not do*. 1931–41. The Art Institute of Chicago

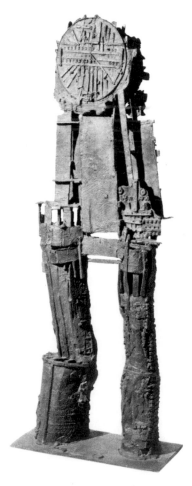

EDUARDO PAOLOZZI. *Japanese War God*. 1958. Albright-Knox Art Gallery, Buffalo, New York. Gift of Seymour H. Knox

development, but he stresses that neither pole is inherently—that is, aesthetically—superior to the other.

The five categories of stylistic development are:

1. From a linear mode to a painterly mode.
2. From plane to recession.
3. From closed form to open form.
4. From multiplicity to unity.
5. From absolute clarity to relative clarity.

As the first concept of representation in a category yields to the second, new possibilities of visual satisfaction become available. Although these concepts serve as ways of representing or imitating visual reality, they also perform a "decorative" function: they have the capacity to afford aesthetic pleasure as well as to describe the objects of perception. In other words, any artistic style, based on any concept of perception, is quite capable of carrying out the usual artistic functions of representation or imitation, decoration or aesthetic enhancement, personal and social expression, and so on. However, stylistic change offers new ways to perform these functions and makes it impossible, according to Wölfflin, to regress, to turn back to a previous stage. This is so because *psychological laws* govern the changes in perception which ultimately manifest themselves in art forms. We are therefore interested in Wölfflin's psychological explanation of the changes in perception from the first to the second concept in each of the five categories.

FROM A LINEAR TO A PAINTERLY MODE

First, what is a *linear* mode of perception? It is a style of seeing which, as the term would imply, stresses the contours or outlines of things. In addition, it is concerned with the tangible (that is, the grasp-able), or material, qualities of things. This is not to be confused with an exclusive interest in texture. Rather it is the opposite of any nonmaterial, spiritual, or idealistic view of the physical world. Emphasis is on boundaries, on definite separations between things. The drawings of children sometimes reveal this kind of linearity: they are afraid to permit objects to touch because that would interfere with or confuse the sovereignties among people and things. Although color and chiaroscuro are employed in linear works, the eye of the viewer finds the edges to be the principle source of information about form.

On the other hand, a *painterly* mode (*malerisch* in German) stresses the masses and volumes of things in the perception and representation of their forms. Because boundaries and limits are of secondary importance, objects can and do merge. Perception is of the continuities among objects rather than of their differences. Instead of perceiving things in isolation, one sees them in relationship. With the linear mode one is impressed with the stability and fixity of objects, while with the painterly mode one is aware of their shifting quality, their refusal to remain stationary.

Now, these modes of perception apply to architecture and sculpture as well as drawing and painting. For example, a sculpture by Eduardo Paolozzi (born 1924), *Japanese War God*, is clearly a painterly work. Its contour is not particularly interesting: the eye is drawn to the interior of the shape. Emphasis is on light and dark as the delineator of form. By contrast, *Horse and Rider* by Marino Marini (born 1901) is a distinctly linear work. The eye of the viewer is drawn to its contours first, and then it moves inward. Even when perceiving the interior of the forms, one is aware of the clarity and distinctness with which they present themselves: their flow into each other is precisely and logically articulated.

It is apparent that the concepts of linear and painterly style correspond to what we have earlier described as the style of formal order and of emotion respectively. Now, however, we are concerned with linearity as an attitude toward perception. It represents a total *weltanschauûng* (world view). Wölfflin's categories have the value of demonstrating that what is seen and artistically portrayed is not what is objectively available to perception (in this respect he anticipates Gestalt psychology) but is rather the result of a choice by the artist from available modes of perceiving what is objectively present. Wölfflin adds that at certain times and places the perceptual alternatives are very limited. That is why art history classifies art according to geographic and chronological categories. The student of art history needs to know what perceptual options were available at a particular time and place. Wölfflin wrote primarily of the transition of Renaissance to Baroque art in the countries of northern and southern Europe. For contemporary art, however, nationality and geography tend to mean less, although psychological differences in perception remain useful tools for the analysis of style.

FROM PLANE TO RECESSION

The second pair of concepts deals with the development from *plane* to *recession*. The artist employing a planar style sees action occurring not only on the picture plane but also on a succession of planes *parallel to* the picture plane. In other words, the movement implied among his forms is from side to side and up and down. But it is not *recessional* movement, which is to say, in and out. As far as painting is concerned, the illusion of depth can be managed through both modes. However, only the recessional mode conceives of balance through angular movement *forward and backward* in the visual field. In painting, a classic instance of the planar would be, once again, the *Grande Jatte* by Seurat (p. 358). Although many levels of pictorial depth are represented, each level occurs on a

HERBERT FERBER. *Homage to Piranesi, I.* 1962–63.
The Museum of Modern Art, New York

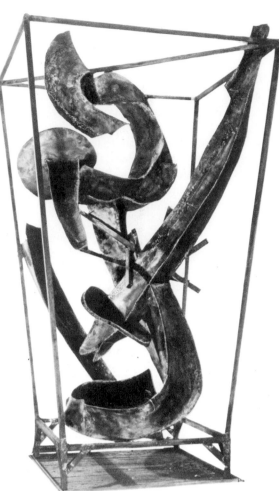

Franz Marc. *Blue Horses.* c. 1911. Walker Art Center, Minneapolis

JOSÉ DE RIVERA. *Construction Blue and Black.* 1951. Whitney Museum of American Art, New York

plane which is parallel to the picture plane itself. A good case of recessional movement is seen in *Blue Horses* by Franz Marc (1880–1916). The manes of the horses, particularly, describe curvilinear movements back into the picture and forward to the frontal plane. Foreshortening of the forms is obviously an important recessional device in painting. Sculpture, on the other hand, which need not employ illusionistic devices, nevertheless shows recessional movement as in the constructions of José de Rivera

and the work by Herbert Ferber, *Homage to Piranesi, I.* Ibram Lassaw (born 1913), by contrast, is a planar sculptor. All the movements of line are rectilinear and parallel to the frontal plane, from which the work is clearly intended to be seen. The sculptures of Lassaw also have a planarity similar to the early Analytic Cubist paintings of Braque and Picasso.

FROM CLOSED TO OPEN FORM

Wölfflin calls closed form "tectonic" and open form "a-tectonic." It is a subtle pair of concepts, dealing with the sense of confinement in *closed form* and of freedom to move infinitely in any direction in *open form*. Once again, the notion of boundaries and delimitation occurs, this time in connection with the volumetric space in which artistic forms are located and in which they have the opportunity to move. In general, Renaissance art was tectonic; it did not permit the eye to wander freely but restricted it within carefully designed enclosures—either real space as in architecture or virtual space as in painting. Baroque art tended to be a-tectonic: the space it represented was endless; it valued movement above stability. Obviously, the space in Philip Johnson's living room is a-tectonic since it tends to merge with the space around it. But Paul Rudolph's Yale School of Art and Architecture is distinctly tectonic or closed: it has a powerful,

Ibram Lassaw. *Sirius*. 1951. Private collection

Paul Rudolph. Art and Architecture Building, Yale University, New Haven, Connecticut. 1963

Philip Johnson. Interior, glass house, New Canaan, Connecticut. 1949

fortress-like quality which leaves no uncertainty about the distinction between indoors and outdoors. The pair of concepts is clearly architectural; how does it apply to painting? Certainly, Cézanne's pictorial space is closed and tectonic. Impressionism in general is open. Kandinsky is open. But Expressionists vary: Soutine and Van Gogh present open space; Rouault is planar and tectonic; while in Max Beckmann there is a struggle between tectonic and a-tectonic forces. Abstract Expressionist painting of the 1950s could be regarded as the modern continuation of Baroque recessional, a-tectonic movement. It represented a breaking away from the tectonic restraints of the School of Paris when it was dominated by such masters as Matisse, Picasso, and Braque.

FROM MULTIPLICITY TO UNITY

The fourth category deals with multiplicity and unity. Although some type of unity is the aim of all artistic effort, it is achieved in one case by the balancing of individual coequal parts, that is, by unity through *multiplicity*. In the second case, it is achieved through dominance and subordination, through a principle of hierarchic order among parts. A style of multiplicity approaches unity as a problem in the addition and subtraction of known and distinct parts or quantities. It is opposed by a style of unity based on accent, emphasis, domination, subordination, and building to a climax. Naturally, the mode of perception which stresses the separate identity of things will pursue unity in the form of many "checks and bal-

ances." It does, indeed, resemble one philosophy behind our system of government: unity as the symbiosis, the living together, of *independent*, sovereign states, a confederacy; the emphasis is on multiplicity. The opposed philosophy, that of the government as a federal union, stresses the sovereignty of the whole in which subordinate centers of interest play various dependent roles producing a single harmony. (According to Wölfflin, the sovereignty of independent parts evolves into a federal type of unity.)

Miró certainly represents the point of view of multiplicity. Mondrian, however, is an interesting case: his is an art of carefully calculated balance among independently existing elements. Yet his verticals and horizontals quickly enter into relationship so that the viewer becomes aware that the objects of his perception are the areas and visual weights established by the related lines. But, on balance, he is a classical artist, hence a "confederate" rather than a "federalist."

Among contemporary artists, the style of unity in multiplicity is evident in Jackson Pollock, Mark Tobey, and Louise Nevelson, while the style of unity through subordination is visible in Richard Diebenkorn, De Kooning, and Giacometti. Ben Nicholson's (born 1894) *Still Life* (1929–35) presents an intriguing instance of unity through repetition of shape and dominant color. Since he employs sharp edges to describe his shapes, one would expect him to be a linear painter who is intent on establishing the separate identity of the parts in his pictures. But his use of line is misleading. The forms, in fact, merge and overlap. They fuse. The objects are united, as in Braque, by the container which encloses them and by the

BEN NICHOLSON. *Still Life*. 1929–35.
Private collection

RAYMOND HOOD and JOHN MEAD HOWELLS. Chicago Tribune Building. 1924

RAYMOND HOOD and JOHN MEAD HOWELLS. Daily News Building, New York. 1930

white color tonality. The fine line Nicholson employs is a decorative or sensuous element rather than a device for establishing limits. Indeed, the only firmly delimited form, which is of the table top, employs no outline but achieves its edge by contrast in color and value. Hence, applying Wölfflin's categories to this work, we would find some puzzling departures from any consistent pattern: it is painterly, not linear; planar, not recessional; closed in form rather than open; in the style of unity rather than multiplicity; and relatively clear rather than absolutely clear or distinct.

FROM ABSOLUTE TO RELATIVE CLARITY

Wölfflin's final category, from absolute to relative clarity, constitutes a summary, perhaps, of his entire argument concerning the development of artistic perception. By *absolute clarity* he means "the exhaustive revelation of form." The artist feels that everything known about a form must be told. The view of it which best explains its character should be chosen. Coloristic considerations or dramatic treatment of illumination must not be permitted to obscure the clear, objective, and complete account of what is there to be seen. Thus, linearity is regarded as an instrument of greater precision than painterliness. Planarity shows what is "going on," while recessional movement is devious. From the standpoint of absolute clarity, the unity achieved through dominance and subordination

involves the suppression of visual truths. Relative clarity, then, represents a somewhat sophisticated artistic attitude.

As Wölfflin observes, Impressionism is the natural and logical outcome of this point of view. It employs suggestion instead of exposition, mystery instead of revelation. Forms which in the past had been delineated in an even, clear light are half-covered in shadow or lost in a haze. The viewer must participate more actively in the "creation" of the work of relative clarity, whereas, formerly, he could view absolutely distinct forms with a detached, relaxed eye. Instead of *taking in* the visual experience, he must actively *inquire after* it with his eye.

In architecture, two buildings by the same firm illustrate the styles of absolute and relative clarity. However, the direction of development is the reverse of that described by Wölfflin. Howells and Hood designed the Chicago Tribune Building in 1924, and they designed the Daily News Building in New York in 1930. The Tribune tower is, of course, Gothic in inspiration; hence it is a "painterly" structure, its parts tending to fuse and merge into the impression of the whole. The Daily News tower, on the contrary, is made up of clear, distinct cubical volumes. The reverse development by Howells and Hood does not necessarily invalidate Wölfflin's scheme of visual evolution; it merely illustrates the emergence in modern times of "synthetic" developments in style. That is, stylistic development does not grow "naturally" out of a

WILLEM DE KOONING. *Woman, IV.*
1952–53. Nelson Gallery-Atkins
Museum, Kansas City, Missouri.
Gift of Mr. William Inge

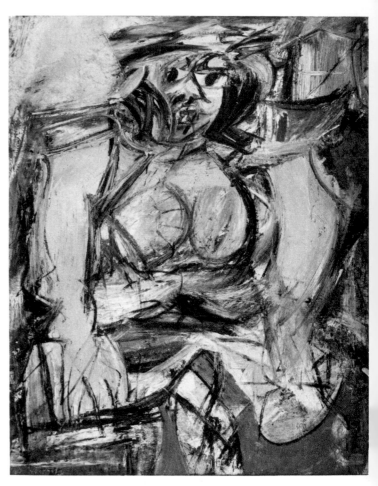

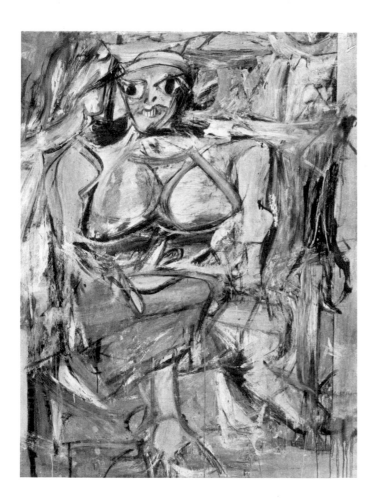

WILLEM DE KOONING. *Woman, I.* 1950–52.
The Museum of Modern Art, New York

WILLEM DE KOONING. *Woman, VI.*
1963. Museum of Art, Carnegie
Institute, Pittsburgh

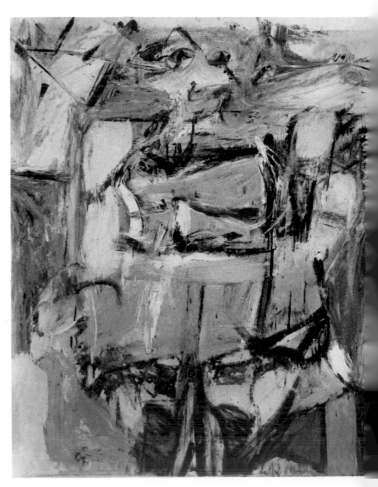

change in the outlook of artists and designers. Instead, it is "other-directed," to use the terminology of David Riesman. Style is responsive to shifts in technology, client preference, and, of course, the character of patronage and the freedom of artists. Thus, we find modern revivals of planarity, multiplicity, or closed form, although these are, according to Wölfflin, the earlier stages of development to which it is impossible to return once they have been thoroughly explored and understood.

Given these exceptions to Wölfflin's theories of perceptual development, what is the value of his system? First, we must think of his categories in psychological rather than historical or nationalistic terms. Second, we should consider that one or the other of his pairs of concepts is remarkably suitable for the explanation and description of art he could not have seen or known about. For example, Willem de Kooning's *Woman* series is very adequately described in terms of relative clarity. Third, we are assisted by Wölfflin in seeing the connection between an artist's perception of the world as a whole and his presentation of visual form. (But this is what I would call "expression.") Wölfflin helps explain why details are suppressed or obsessively recounted, why the viewer's eye is

drawn to the contour or the interior of a shape. Such explanations are made without the benefit of scientific experimentation and yet are not inconsistent with Gestaltist studies of the outline as being (a) *part of* the figure or (b) the boundary between the figure and its ground.

In his *History of Art Criticism*, Lionello Venturi takes Wölfflin to task, as I have, for insisting on the necessary succession from closed form to open form. But he grants the usefulness of Wölfflin's "schemes of visibility" for interpreting works of art.[23] (Remember that Wölfflin does not favor the analysis of the *expression* of art.) Innovations in expressive meaning, such as might be seen in the work of Picasso or Klee, are not easily explained with Wölfflin's categories. Perhaps this is due to a defect of the purely perceptual approach to art, or perhaps it means that we should refine the approach to the perceptual study of artistic form. At the present time, therefore, it seems likely that experimentation and empirical research into the perception of visual art forms can be carried out with the expectation of making many useful discoveries. However, such findings will probably supplement rather than displace humanistic models for analyzing the structure of art.

INTRODUCTION
TO *The Interaction*
of Medium and Meaning

WHAT ARE THE DIFFERENCES among these three terms: material, medium, and technique? We should have a clear idea about them before investigating the interactions between artistic expression and the various media. *Material* causes no difficulty: it designates the *physical elements* of art, such as paint, stone, glass, clay, and metal. They are available to the artist or designer in a variety of manufactured or natural forms, and he either works with them directly or supervises workmen in shaping and assembling them according to his intent.

Medium is a more difficult term. In the dictionary definition it is the "substance through which a force acts or an effect is transmitted." In other words, it is the vehicle by which materials are converted into artistic form. In painting, there is also a narrower, technical meaning of medium: it is the liquid in which pigment is suspended—linseed oil, casein glue, egg yolk, varnish, synthetic resin, and so on. But that definition would not apply to architecture, sculpture, and film. A definition of *medium* that can apply to all the arts is as follows: a medium is a characteristic use of particular materials for an artistic purpose. Architecture is not a medium, it is an art. Cast concrete, however, is a medium employed in architecture. Sculpture is an art, not a medium. But metal which is welded, hammered, or cast constitutes a sculptural medium.

Technique and medium tend to overlap in ordinary usage, but we can define *technique* with more precision here: *technique is an individual or personal way of using a medium*. For example, many artists employ the medium of oil paint in their work. But Jackson Pollock developed a highly *personal technique* in his employment of the medium. Ibram Lassaw has a different technique from that of Richard Stankiewicz, although both employ the medium of welded metal. Le Corbusier, Nervi, and Candela employ personal techniques in the cast-concrete medium. Incidentally, their use of building *technology* may be similar, but a personal technique is clearly evident in their individual results.

Our problem in the following chapters is to show how the nature of a medium influences what is done *with* it and what is expressed *through* it. Each medium has inherent possibilities and limitations. Some artists submit to the limitations and achieve a distinctive excellence through their sensitive awareness of what can or cannot be accomplished within them. Other artists choose to ignore the known limitations and either fail or succeed in extending the range of the medium. *Craftmanship* can be understood as the *knowledge* of what can be done in a

medium and the *ability* to do it. But all the possibilities of a medium are never known in advance. Hence, any artistic medium, whether of ancient vintage or recent invention, holds out a challenge to the skill and judgment of the person who uses it.

Art, however, is not identical with technology, which continually develops new ways to perform existing tasks, because in art, skills and technical mastery are not pursued as ends in themselves. Although technical skill is necessary and admirable, it is a *means* to an end. In art criticism, we often find ourselves judging the suitability of ends and means, that is, of the *quality of interaction between medium and meaning*. We try to discover, in our examination of a work, how the medium has influenced what appears to be expressed. At the same time, we are interested in how the expressive content has affected the employment of the medium. It goes without saying that viewers must have experience with many works in various media; otherwise, they will not be able to tell in what ways the medium and its meaning have interacted. Some even believe that personal experience with artistic creation is necessary if these relationships are to be fully understood. (This view is further discussed in Chapter Fifteen, under "The Tools of Art Criticism.") The purpose of the following chapters, therefore, is to provide information about medium-meaning interactions in the principal art forms. This is a difficult objective because we are attempting to communicate in verbal form the sort of knowledge which is normally gained by direct observation or practical experience. Furthermore, technology or artistic ingenuity can render obsolete any pat generalizations about media. However, if we make observations about medium and content on the basis of specific works of art, they, at least, will stay put. You may extend these observations, or *extrapolate*, as the scientists say, to other artistic phenomena at your own risk.

PAINTING

Of all the visual arts, painting is the most widely practiced. Children and grandparents, lifelong professionals and the rankest of amateurs, physicians and prizefighters, sick people and well—all paint, apparently with considerable satisfaction to themselves if not always to others. Is there any reason why this art form should have attracted so many more devotees than sculpture, for example? There are, of course, several reasons, but one of them concerns us especially: the flexibility and versatility of painting, particularly in oil.

The discovery of oil painting, allegedly by the Flemish painter Jan van Eyck in the fifteenth century, opened up a pictorial realm which could not have been conceived, much less exploited, before then. The suspension of pigment in linseed oil was the type of technological innovation which exemplifies our theme: the interaction of medium and meaning. Oil paint has blending and modeling qualities unobtainable with the earlier tempera paint. Its drying time is much longer; hence "wet-in-wet" effects are possible, effects which the quick-drying tempera would not permit. The slow-drying oil vehicle permits the artist to modify a still-wet paint film by adding paint, wiping it out, introducing darker or lighter tones, adding lines, scraping out lines, and even manipulating the paint with his fingers. Yet the paint film will dry as a single "skin" in which all of these applications and afterthoughts are physically united. Since oil paint dries to a fairly elastic film (years ago our kitchen floor covering, linoleum, was made of a coarse fabric impregnated with the same tough, durable linseed oil which is the vehicle of oil paint), it can be applied to canvas without great danger of cracking when the canvas buckles a bit. Large areas of canvas can be painted as opposed to the small wooden panels required for tempera, although prepared wooden panels continued to be preferred for oil painting until the end of the Renaissance. Before the perfection of painting in oil, mural-size works had to be executed in fresco—which is to say, fresh plaster—and on the site of the wall itself. It was much later that artists took advantage of the possibility of executing mural-size canvases in their studios, transferring the canvas afterward to the building for which it was intended. Michelangelo still painted the Sistine ceiling on his back, supported by scaffolding under the ceiling. (He gained no particular advantage by

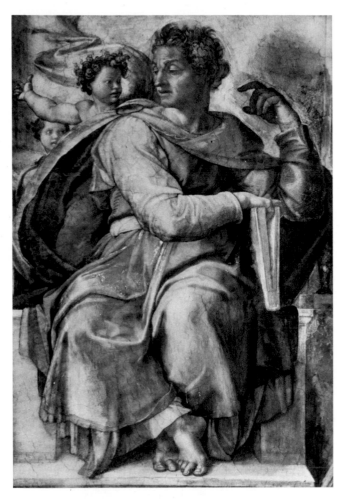

MICHELANGELO. *Isaiah* (detail from the ceiling of the Sistine Chapel). 1508–12. The Vatican, Rome. The good physical condition of Michelangelo's Sistine Ceiling paintings makes us wish that Leonardo had used the same fresco technique in his *Last Supper*. The color in a fresco does not *rest* on the surface; it sinks into and becomes part of the wall. Thus a fresco can withstand a great deal of punishment.

modern synthetic variants, which preserve the advantages of oil and extend its permanence, stability, and strength still further). Consequently, we can understand why painting is attractive to persons varying greatly in skill and sophistication, while sculpture appears to be an art for the hardy few. But more important then ease is the limitation of subject matter and treatment in sculpture as compared to painting. To be sure, Bernini could execute lace in stone and fashion sculptural shafts of light behind his St. Theresa, but such effects seem inappropriate to contemporary taste. Indeed, they appear to be painterly effects, an observation which brings us to another of the distinctive qualities of painting—its capacity to create *veritable illusions*. Sculptors who sought naturalism had to build replicas of actuality, going so far in the ancient and medieval worlds as to *paint* their figures in order to close the gap between reality and its representation. But key inventions in painting—linear perspective, chiaroscuro, oil painting, foreshortening, aerial perspective, glazing, color complementarity, and color vibration—opened up immense potentials for naturalistic portrayal,

Photograph of prospective buyers at an art auction

painting on the site. The individual panels are composed as wall paintings rather than ceiling decorations, the ceiling is poorly lit, and if the viewer wishes to see the entire sequence he must lie on his back as Michelangelo did. We see the Sistine ceiling frescoes more clearly in reproductions than on the site.) Even so, fresco did not afford the sharpness of delineation he wanted, so he also used *fresco secco* (which is really a type of egg tempera), applying it over the fresco to bring out the forms. But oil paint permits huge canvases—canvases which can include dozens of lifesize figures; vast landscape effects and bright, fresh color; liquid, bravura passages; ample detail where desired; and all integrated within a paint film which can look as if it were executed "in one skin" a few weeks ago.

Painting is about as old as sculpture, but it is difficult to think of any sculptural medium with the permanence, flexibility, and easy working qualities of oil paint (or its

fool-the-eye illusionism, the representation of depth, the capture of fleeting impressions, and the creation of elaborate but credible fantasies. Finally, in comparing painting to sculpture or architecture, we should observe that poorly executed sculpture cannot easily conceal its lack of craftsmanship, and poorly designed buildings are at least inconvenient and at most dangerous. Bad paintings, however, survive physically in spite of their craftsmanship. Painting possesses no "built-in" characteristics which might discourage ineptness in technique or lack of invention. Everything survives. As a result, there is a wide range of quality and expression in painting; individuals who as playwrights or architects might never have seen their plays performed, or their buildings constructed, manage to persist in this art until a few, at least, make some contribution of value.

Because the media of painting are versatile, flexible, durable, and also inexpensive; because human temperaments in wide variety are attracted to painting; because almost any theme can be treated in the art; and because works of modest imagination and indifferent technique survive physically as well as masterpieces do—painting is one of the most popular, perplexing, and exciting of the visual arts. Exhibitions of painting are held in museums, universities, and shopping centers, where they constitute cultural and social events comparable, let us say, to attendance at a Puccini performance in a middle-sized Italian city. The point to be stressed is that the popularity and accessibility of painting is a result, in part, of the distinctive qualities of the painting medium. Oil paint is mainly responsible for the size and character of the public which sees paintings and of the public (there is no better word) which creates paintings.

Having noted the social climate in which painting exists today—a climate resulting substantially from the character of the painting medium—we can discuss the technical and expressive qualities of painting itself. But with regard to the art as a whole, it would be wrong to succumb to technological determinism. No matter how revolutionary the invention of oil painting or fixed-point perspective appears to be, remember that these developments grew out of a search for color luminosity and control of space because aesthetic and cultural factors rendered such objectives important.

The Fugitive and the Permanent

It is readily apparent how architectural form grows out of structural requirements. In a well-designed building we quickly see that a truss, an arch, a dome, a post-and-beam, or a cantilever is *doing the work* of supporting weight and enclosing space. Although the forms can be appreciated for their decorative or expressive role, they are also felt as a physical system which is or is not likely to hold together as we live in and use it. No such consideration, however, enters into the perception of painting. Nevertheless, the art of painting has a physical basis which, like architecture, is concerned with durability. In this connection, Edward Hill calls attention to the structural character of painting: "A painting represents a fragile surface of pigments of various chemical origins suspended in an aqueous, unctuous, or synthetic resin binder, adhering to a plane support. With poor science, cracking, yellowing, bleeding, deterioration of ground can seriously alter the painting image and thereby the artistic intention."[24]

The stone vaults of Gothic churches were developed because fires were so common in the medieval world that wooden-roofed churches burned down repeatedly. We can be sure, therefore, that the physical survival of man-made structures was one of the most important practical goals of medieval communities. This interest in durability also reflected a concern with the timeless and eternal in social, philosophical, and theological systems. For the art of painting, physically considered, durability meant permanence—resistance to fading, peeling, cracking, warping, and splitting. Consequently, since painting was regarded not only as a means of communication, but also as a valuable material commodity, questions of permanence led to the study of "correct"—that is, permanent—technique. So-called fugitive colors could fade, especially the blues and violets. Others might turn black or "bleed through" (that is, show through superimposed layers of paint). Colors applied to a ground that was too absorbent would "sink in," especially if the color were too lean (that is, mixed with insufficient binder or excessively diluted with a thinner, for when dry it might present a dead, grayed appearance). A thousand perils hovered over every painter's brush.

Artists were members of the goldsmiths' guild during the Renaissance, and although masters like Leonardo, Titian, and Michelangelo had risen socially above the artisan class, they were nevertheless deeply immersed in problems of craftsmanship. Their training and professional roots were in artisanship and the guild system. (Unfortunately, a number of works by Leonardo, who was an inveterate experimenter, have not survived because he often did not follow the standard technical recipes of his day.) Leonardo and Cennino Cennini wrote treatises on the art of painting which contain lengthy discussions of technical methods. Cennino's, however, is more like a cookbook, while Leonardo's penetrates be-

LEONARDO DA VINCI. Detail of *The Last Supper*. c. 1495–98. Sta. Maria delle Grazie, Milan. Instead of the time-honored fresco technique, Leonardo used tempera on a masonry wall dubiously sealed with a varnish of pitch and resin. (He may also have applied an oil glaze over the tempera painting.) Soon after completion, *The Last Supper*'s paint film must have begun to peel off the wall, thus leaving Leonardo's most magnificent conception to the ministrations of a succession of more-or-less inept restorers.

yond cookery into psychology, anatomy, composition, and philosophy.

But whereas permanent painting technique began as an interest in physical durability, it ends as an aesthetic requirement. What began as a concern about *means* concludes as a concern about *ends*. In artists' contracts with their medieval patrons, specifications were stipulated for the amount and quality of lapis lazuli (the semiprecious source of blue pigment), gold leaf, and other costly materials, much as architectural specifications today require a particular brand of a product or materials with certain performance ratings. Later contracts were more likely to specify the size of the canvas, the number of figures (whether full-length or three-quarter-length), the visibility of hands, type of costume, and so on. But with the social and professional status of the painter more firmly established, the intangible qualities of his art were primarily sought, and although sound technique was assumed, it was realized that genius consisted of more than the use of costly materials. As the architect Filarete wrote in the fifteenth century, "The knowledge of painting is a fine and worthy thing, and really an art for a gentleman."

Nevertheless, the grace, subtlety, and inventiveness of painterly forms were surely perceived as triumphs of technique as well as imagination. The modeling of Leonardo and Raphael was based not only on a good understanding of illumination and anatomy, but also on the artist's capacity to force paint to resemble light and shadow, skin and bone.

For the contemporary student of art, it is important to know that technical methods inherited from the medieval past, with its pronounced interest in sound workmanship, survive as aesthetic goals in the present. For example, blues were used sparingly, because good blue was expensive, and others faded or turned green. Paint was applied thinly in the shadows, more heavily in the lights, for several reasons: tempera underpainting was often preceeded by a thinned-out drawing of ink washes which took care of the shadows; dark pigments tended to peel if applied heavily; and illusionistic effects were defeated by raised ridges of paint in the shadow areas. But modern colors resist fading and peeling, illusionism is not often pursued, and glazing over a tempera underpainting is uncommon. Nevertheless, one can find many contemporary

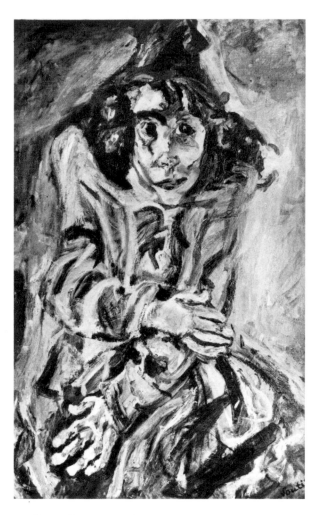

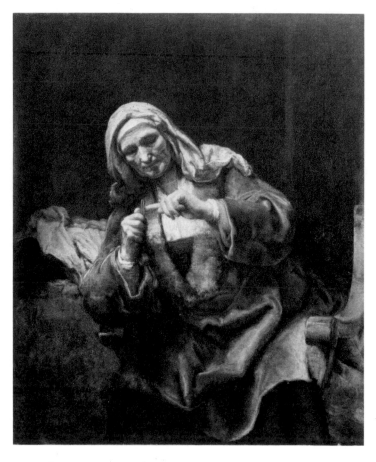

REMBRANDT VAN RIJN. *Old Woman Cutting Her Nails.*
1648. The Metropolitan Museum of Art, New York.
Bequest of Benjamin Altman, 1913

CHAIM SOUTINE. *The Madwoman.* 1920.
The National Museum of Western Art,
Tokyo. Presented by Mr. Tai Hayashi,
1960

EL GRECO. *The Agony in the Garden of
Gethsemane.* c. 1580. The National Gal-
lery, London

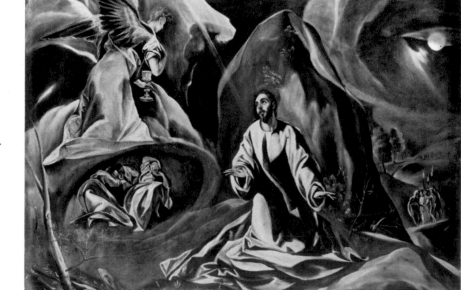

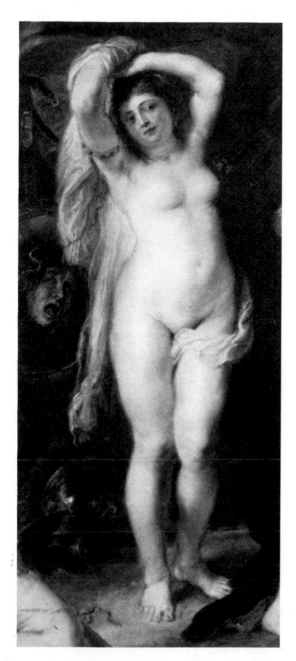

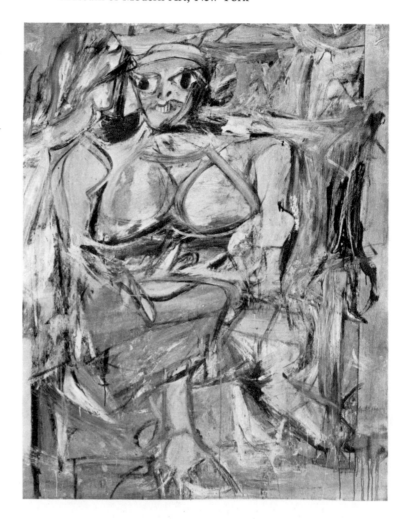

PETER PAUL RUBENS. Detail of *The Judgment of Paris*. 1638–39. The National Gallery, London

WILLEM DE KOONING. *Woman, I.* 1950–52. The Museum of Modern Art, New York

paintings which observe the ancient painterly traditions because they seem to afford aesthetic gratification even though they have no foundation in the current requirements of permanence.

The resemblance of Jack Levine's technique to Rembrandt's has been mentioned. The same can be said of Soutine. *The Madwoman* by Soutine, however, exhibits more direct brushwork in the darks than Rembrandt would have used. The brilliant cadmium reds, alizarins, and madders used by Soutine were not available to Rembrandt and El Greco, for example. Or perhaps, it would be better to say they were not available in such stable, light-proof colors as are now readily and cheaply at hand. Hence, the masters used a reddish glaze over a greenish tempera underpainting which itself rested on a luminous white ground. Soutine used opaque reds and

alizarins mixed with umber applied directly to the primed canvas. The colors retain their brilliance because they are almost chemically inert compared to the colors available to Rembrandt. Consequently, Soutine could paint his twisting shadows with loaded brush quite spontaneously; the agitation of the result owes a great deal to this direct execution. El Greco's turbulent and flickering effects had to be planned in advance and can be partly attributed to direct painting into his wet glazes. But laying opaque paint crisply into a wet, transparent glaze, which itself rests on a modeled monochrome underpainting, calls for sureness of hand and a clear idea of the effect desired in the outcome. Today Willem de Kooning, who is more influenced by Rubens than El Greco, is especially prominent among those painters who practice loaded-brush, wet-in-wet painting technique.

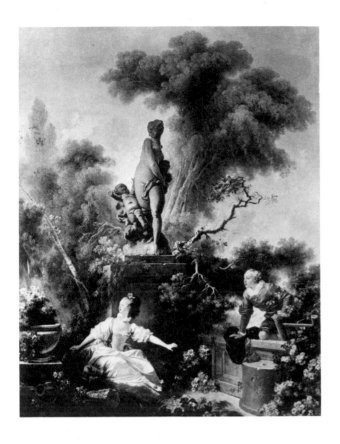

JEAN-HONORÉ FRAGONARD. *The Meeting.* 1773. Copyright The Frick Collection, New York

HANS HOFMANN. *Number 21.* 1962. Whereabouts unknown

GEORGES MATHIEU. *La Mort d'Attila.* 1961. Collection Jean Larcade, Paris

There has been an important change in the contemporary attitude toward permanence, one that inevitably influences any examination of modern painting. Just as scarcity characterized the economies of all societies in the past, affluence characterizes the economies of the industrially advanced nations today, particularly that of the United States. And, as John Kenneth Galbraith noted in *The Affluent Society*, a disproportionate effort of the economy is devoted to its private sector, that is, to the production and distribution of goods and services for individual consumption. He argued that insufficient economic effort has been devoted to the maintenance and expansion of publicly owned instrumentalities like schools, transport systems, hospitals, recreation facilities, and so on. As a result of personal prosperity and freedom to make ever-increasing expenditures in the private sector of the economy, individuals find that they can buy more consumer goods, replace possessions more frequently, and discard their possessions before they are "worn out." The process of quick obsolescence has already been discussed (p. 154) in connection with industrial design. It would be strange, indeed, if the idea of quick obsolescence in manufactured goods did not also affect our notions of permanence in works of art.

The medieval idea of craftsmanship and durability was based ultimately on economic scarcity: there were not enough of life's necessities, not to mention its luxuries, to go around. The lives of kings and nobles in the Middle Ages were unspeakably crude and primitive when compared with the life styles of our citizens of even modest means. Human labor was abundant and social techniques existed to extract the maximum of effort from it. By contrast, the modern idea of craftsmanship has to be related to economic abundance and an increasing *scarcity* of labor. Today, the prosperous nations of western Europe have labor shortages and must import workers to supply the needs of their expanding economies, just as the United States did during the first quarter of the twentieth century. Furthermore, the actual manufacture of goods is done increasingly by machines, with human labor employed to direct and operate them. Hence, we have an abundance of goods, a growing value set upon human labor in nations with advanced economies, and a reduction of human participation in the direct forming and fabrication of goods.

Inevitably, the durability and permanence of goods has a different meaning in an economy such as ours compared to its meaning in the scarcity economies of the past. Although some of us may have experienced scarcity, an enormous number of citizens, perhaps the majority, is unaware of any obligation to make things last or to acquire only those goods which seem durable. Instead of fixing a broken part, we replace it. And this practice makes economic sense, since the labor cost of repairs is often greater than the purchase cost of a replacement. (Of course, we rarely calculate the ecological costs of rapid obsolescence, of discarding used goods, collecting and relocating trash, of polluting water, land, and air with the wastes created by accelerated consumption.) In such a context, an artistic concern with permanent technique can seem to be an anachronism. Furthermore, as was observed, technology has created new painting media which are durable no matter how they are used. Consequently, the *fact of permanence*, the physical durability of the art object, ceases to be a crucial problem.

Since we are reasonably assured of the physical survival of a painting, our concern shifts to its durability as a significant statement in the medium. We want to know whether it will continue to live as a vehicle of sustained aesthetic interest. Our interest in this kind of survival is not rooted in an artist's technique so much as in his capacity to make original statements *through* his medium and personal technique which can survive changing standards of taste. As George Moore said, "It does not matter how badly you paint, so long as you don't paint badly like other people." The traditional artistic effort to master technical methods which would insure physical survival often led to the creation of such values indirectly —ideas about man and the universe which emerged because of the artist's search for enduring technique, sound principles of composition, and significant subject matter.

The *time* required to execute a work by traditional methods militated against a casual approach toward theme and technique. As the oil-painting medium was perfected, however, as painters used it with increasing facility, accomplished technical skills were often devoted to insignificant themes. For example, the subject matter of Jean-Honoré Fragonard (1732–1806)—courts of love, and the general foppishness of French aristocratic life before the Revolution—seems trivial and saccharine in the extreme, especially for modern, democratic taste. However, the fluid, almost Rubensian execution of *The Meeting* is a triumph of painterly virtuosity. Beyond the affected theatrics of the situation, we can see drawing, composition, space, color, and texture managed with a high degree of artistry. Some contemporary painters, on the other hand, undertake themes of portentous import or of utmost solemnity while employing a technical approach which seems rather casual and offhand. *La Mort d'Attila* by Georges Mathieu (born 1921) is such a work. *Number 21* by Hans Hofmann (1880–1966), executed in oil on paper, is another. Hofmann's work appears to have been created by a combination of liquid paint spatters and blobs. (Oil on paper is not, of course, a permanent technique. If the paper is unsized, the acids in the linseed-oil medium will cause it to rot eventually.) But physical permanence ceases to be a consideration. The value of painting has been relocated: *it now lies in the act of execution*. For the viewer or the collector, value lies in his immediate experience. Modern man does not look at a painting as medieval man did, making visual inquiry into its craftsmanship, its likelihood of surviving through

MICHELANGELO. Studies for *The Libyan Sibyl*. The Metropolitan Museum of Art, New York. Joseph Pulitzer Bequest, 1924

The drawings are more detailed than the final fresco painting because they truly are "studies"—devices for knowing a phenomenon visually and intellectually.

MICHELANGELO. *The Libyan Sibyl* (detail from the ceiling of the Sistine Chapel). 1511. The Vatican, Rome

eternity. The contemporary collector is aware of the work as a possession which he may eventually sell if it ceases to interest him or if its market value increases. But, more importantly, modern men have a *different sense of time*. Under the impact of rapid social change, and particularly of cultural relativism, confidence in eternal values and in fixed systems of thought has broken down. The idea that man-made structures can or should survive forever now seems slightly absurd, just as it would have seemed absurd to medieval men that anything be made *not* to last.

We know that the physical permanence of painting is a relative matter. Although scientific methods of conservation are highly advanced, we are acutely aware of the transience of taste: works of art may cease to be interesting long before they have decayed, their decay being a matter of certitude. Considerations of this sort account for the indifference to craftsmanship as it was traditionally understood. Consequently, contemporary painting rarely exhibits painstaking technique, fastidious attention to detail, and a meticulous quality of "finish." That is why a painter like Andrew Wyeth is unusual: his distinction is not that he employs the traditional egg-tempera medium, but that his use of the medium evinces an *attitude toward time* which most of us thought had disappeared.

If the decline of older ideas of permanence has cost us the loss of certain artistic values, there have also been compensations. Experimentation with design, materials, and the themes of pictorial expression has generated dividends in visual variety. Painting is perhaps more entertaining than it was formerly. At the same time, it has not ceased to be concerned with serious issues. Although the perfection of still photography and motion pictures during this century poses a serious threat to the survival of picture making as a handcraft, painting appears to be responding to the challenge with vitality. Indeed, the art is more widely practiced and exhibited than ever before; it has extended the range of social and personal functions it performs; and, as will be seen in the following discussions, painting has acquired many of the characteristics of sculpture, architecture, and even of drama.

If it were not for the museums and libraries which remind us of what painting has been, we might not be so acutely aware of the revolutionary changes the art is now undergoing. But the purpose of retrospective vision is not to compare the present invidiously. It is rather to see the technical and aesthetic achievements of modern painting in a different light.

Direct and Indirect Techniques

Simply stated, direct painting involves the pursuit of the final effect immediately, or *alla prima*. Indirect painting calls for a stage-by-stage approach to the final effect. These two approaches represent fundamental contrasts in technique, in artistic psychology, and in style. In general, traditional methods are indirect and systematically planned in advance. Modern approaches tend to be more direct and spontaneous.

So long as painting is regarded as the elaboration of drawing, the indirect method prevails. That is, if painting is seen as the application of color to a scheme which has already been worked out, it clearly makes sense to employ the indirect method. The choice amounts to a problem in the logical division of labor. First comes the conception of the general idea of the work, its theme, its specific content, its overall setting, and so on. Next, drawings can be undertaken to explore the spatial representation, the disposition of landscape and architectural features, and the figures. For the Renaissance artist, drawing was not only a way of making visual notations, as it is for the contemporary architect or designer; it was also a means of *studying* the things he would later paint. Indeed, we refer to such drawings as "studies." As mentioned in our discussion of line (p. 293), drawing obliges the artist to

commit himself, and commitment of this sort cannot be undertaken without knowledge. The Renaissance artist regarded drawing *primarily* as a mode of investigation and only secondarily as a display of facility. It is the modern era which has made drawing an end rather than a means.

Studies of drapery, of hands, of facial expressions, of the anatomy of a figure (which may not be seen finally because it is covered by clothing)—these were undertaken by the artist so that he could be assured of his intellectual and visual grasp of the subject matter. Then he felt ready to transfer his drawings to a prepared surface. Following transfer to the scale of the final work, the artist could begin painterly execution according to his inherited technique or his personal variation of it. If the work were to be completed in oil or varnish glazes, the preliminary painting in tempera would be monochromatic or limited in color. Division of labor extended to separation of drawing from painting; and within painting, coloring was separated from modeling. The monochromatic underpainting served as a guide for translating the drawing into paint, establishing the compositional scheme, placing lights and darks, modeling large forms, and solving any unanticipated problems which might arise. Because tem-

LEONARDO DA VINCI. Study for *Adoration of the Magi.* c. 1481. Uffizi Gallery, Florence

GENTILE DA FABRIANO. Detail of *The Adoration of the Magi.* 1423. Uffizi Gallery, Florence

Van Eyck's use of oil paint permits a much wider range of color and tonal values than the egg-tempera medium employed by Gentile da Fabriano only ten years earlier.

JAN VAN EYCK. *A Man in a Red Turban.* 1433. The National Gallery, London

pera paint dries quickly, and because it is very opaque, corrections which cover mistakes can easily be made. Oil paint dries more slowly, and becomes more transparent as it grows older; hence passages which have been painted out or blended over tend to show through eventually. However, tempera does not blend easily; consequently it is difficult to conceal any uncertainty on the artist's part by a wide, blended passage. Egg tempera, especially, is difficult to spread on in large areas. Large forms have to be built up by "hatching" (creating a small *area* of color or tone by a series of lines painted close together) and with small washes: it is a linear technique.

When the indirect method is employed, underpainted shadows can be executed in cool tones if warm-tone glazes will be applied over them at the end. Then, by glaze manipulation, the painter will be able to achieve a warm-cool balance as well as a quasi-Impressionist color vibration as he models and "drowns" some of the light with his glazes. The light areas are usually painted "higher" or "chalkier" than they will finally appear because over-painting and glazing will lower their value. In traditional painting techniques, it was assumed that white pigment (usually white lead), together with final varnishing, would tend to yellow the painting. That tendency constituted another reason for favoring a cool tonality in the under-painting. Some painters added a little blue to their white pigment to compensate for subsequent yellowing.

At this point, mention should be made of the mischief created for painting and aesthetics by final varnishes. Varnishes served primarily to protect the paint surface from impurities in the air—smoke, sulphur, carbon, and so on—which menaced painting before the development of modern heating systems. These impurities became embedded in the cracks and crevices of older works, especially those with an irregular surface, or those having impasto passages (thick, rough-textured paint surfaces). In the nineteenth century especially, dealers would apply a toned varnish to endow paintings with an antique, glossy appearance. Rarely did they give the painting a thorough cleaning or remove the old varnish before applying a new coat. As a consequence, old paintings acquired a soupy brown patina which could not be attributed entirely to the darkening of their colors. They were, in a sense, too old for their years. Rembrandts suffered in this manner, notably the famous *Night Watch*, which upon being cleaned was revealed as a "day" watch. With regard to the formation of taste among art students and collectors, a "museum brown" convention came to be operative, so that the appearance of numerous coats of varnish over a dirt-embedded paint surface was sought from the outset. Since glazes are mixtures of varnish or thickened oil with pigment, it is possible to confuse a glazed surface with one which merely has a final varnish applied over a direct painting. Perhaps that is why frequent coats of varnish were applied by dealers. Titian claimed to use as many as eighty glazes in a single painting. Such pains and

craftsmanship might be simulated for the unwary by several varnishings, but a conscientious examination of Rubens, Rembrandt, and El Greco should enable the viewer to recognize the difference between underpainted monochromatic passages which have colored glazes resting over them and canvases whose colored pigment has been laid on directly, followed by clear varnish on top. It should be added that very glossy color reproductions in artbooks sometimes create a spurious impression of glazing where it does not exist. You can be reasonably certain, for instance, that a glossy reproduction of a Van Gogh or a Cézanne is misleading.

Before the discovery and wide use of oil painting—either in the form of glazes over tempera or in direct application of oil paint to a primed canvas—most paintings were completely executed in tempera (the other principal forms were encaustic, which is a wax-based medium, and fresco, which employs water, lime, and plaster as its medium). Tempera is usually understood as any painting medium based on a glue. Older glues came from cooked animal skins—rabbit skin, for instance. As you may know from scraping breakfast frying pans, eggs act as a powerful adhesive. Casein, a milk derivative, is a modern glue, one that makes an excellent tempera. Polymer tempera comes close to being an ideal medium since it possesses all the assets and none of the liabilities of the traditional tempera and oil media. However, tempera paintings until the 1940s were mostly executed with the traditional egg-yolk medium which was often diluted with water. Today, for example, Wyeth employs the classic egg-tempera medium.

Many painters presently active were taught Cennino's recipes for preparing a gesso ground (thin, white plaster-of-Paris layers usually applied over a coating of size) on a wood panel (today Masonite hardboard is usually employed), and learned how to puncture the egg yolk sac, "cook up" an egg-and-water or egg-and-oil emulsion, and then mix the emulsion with powdered dry pigment. The pure egg-tempera medium is permanent, does not darken with age, and provides clean, bright color. But it usually calls for a rigid support and, as mentioned above, is not well suited for covering large areas. Furthermore, it virtually dictates a slowly built-up, step-by-step mode of execution. It tends to force a linear conception upon the artist; the style Wölfflin calls "painterly" is possible but difficult for the artist working in egg tempera. It is interesting to note that Shahn and Wyeth both tend toward the linear and distinct as opposed to the painterly and undistinct poles of the stylistic categories.

Direct painting begins when the artist starts to load his glazes with more "body" pigment. The Venetians are credited with introducing loaded-brush technique (instead of being used to spread a thin, liquid paint film, the brush is loaded with paint of a pasty, viscous consistency which is then applied in short "touches" rather than evenly brushed out). The technique is accompanied by

AGNOLO BRONZINO. Detail of *Portrait of a Young Man.* c. 1535–40. The Metropolitan Museum of Art, New York. The H. O. Havemeyer Collection. Bequest of Mrs. H. O. Havemeyer, 1929

Like most of the Venetian painters, Veronese worked on a coarse canvas over a dark ground. His lights are "lifted out," leaving the ground to describe the shadows; hence, we perceive an almost gritty texture in the flesh tones due to the dark intervals between the points of pigment. The Florentine Bronzino painted on a smooth support prepared with a light ground which he covered completely, achieving an enamellike quality in the flesh tones. These contrasting techniques have expressive consequences: robustness and masculine vigor in the Venetians; elegance and aristocratic reserve in the Florentines.

PAOLO VERONESE. *St. Mennas* (detail of organ shutter from San Gemigniano, Venice). c. 1560. Estense Gallery, Modena

Portrait of a Man, from the Faiyum, Upper Egypt. 2nd century A.D. The Metropolitan Museum of Art, New York. Rogers Fund, 1909. Encaustic on wood.

free departures from the controlling tempera underpainting. There is a line of development in the use of the oil medium from Titian to Rubens to Delacroix to Monet. Delacroix, perhaps, represents the critical departure from reliance on the underpainting; with him, spontaneous execution begins to assert itself forcefully. His contemporary, the classicizing Jean-August-Dominique Ingres, practiced an impeccably indirect method of painting with nowhere a brushstroke evident. But Eugène Delacroix consciously and effectively exploited the emotive possibilities of brushwork. His oil sketch for *The Lion Hunt*, excuted in about 1860–61, shows how the artist created forms directly with the brush. Drawing is felt or understood, but it is distinctly subordinate to the painterly

EUGÈNE DELACROIX. Sketch for *The Lion Hunt*. 1860–61. Private collection

EUGÈNE DELACROIX. *The Lion Hunt*. 1861. The Art Institute of Chicago. Potter Palmer Collection

establishment of form. Brushwork as the artist's handwriting now begins to be a prominent feature of painting. The dynamism of this composition derives basically from its underlying pattern of whirling forms which appear to have radiated from the center and then begun to rotate in a clockwise direction. But Delacroix is not content to rely on the dynamics of the compositional arrangement: he supports its movement with writhing brushstrokes which

have a life of their own. It is interesting to compare this oil sketch with the final work, which is much modified in composition and, of course, more "finished" in execution. From the standpoint of contemporary taste, the sketch is more abstract, less finicky, and fresher in its use of paint. The contemporary quality of the Delacroix oil sketch is vividly brought home when we examine a painting by a young American artist, Richard Lytle (born

1935), *The Possessed*. Lytle is clearly the beneficiary of Delacroix's form language, as was Jon Corbino (1905–1964) in his painting *Stampeding Bulls*. The antecedent of these works, both in subject matter and in painterly execution, is Peter Paul Rubens's *Lion Hunt* (1616–21). Although Rubens employed a preliminary underpainting, he clearly relied on a direct type of overpainting executed in what appears to be a very spontaneous fashion. Hence,

notwithstanding the many innovations introduced into painting through the ages, there is considerable continuity of outlook and of method, from Rubens in 1616 to Delacroix in 1861 to Richard Lytle in 1959.

The connection between brushwork and emotional expression has been mentioned several times. Now the question arises as to *how* brushwork performs an emotional function. Furthermore, how is this function related

RICHARD LYTLE. *The Possessed*. 1959. Collection the artist

JOHN CORBINO. *Stampeding Bulls*. 1937. The Toledo Museum of Art, Toledo, Ohio

PETER PAUL RUBENS. *Lion Hunt*. 1616–21. Alte Pinakothek, Munich

The Human Image in Traditional Painting

JAN VAN EYCK. Detail of *The Virgin and the Canon Van der Paele*. 1436. Groeningemuseum, Bruges

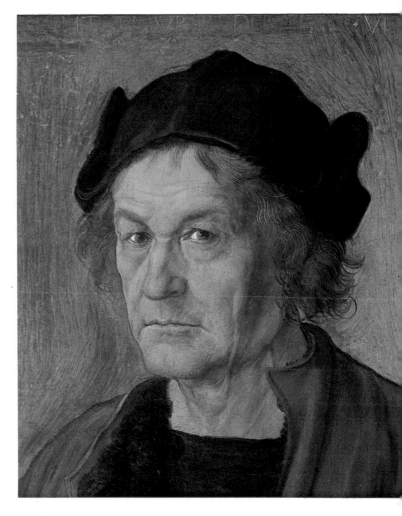

ALBRECHT DÜRER. Detail of *The Painter's Father*. 1497. The National Gallery, London

These are stubborn men. So are the men who painted them—stubborn, that is, about telling the whole truth.

LEONARDO DA VINCI. Detail of *Portrait of a Musician*. 1490. Biblioteca Ambrosiana, Milan

What generous expressions! How intelligent the eyes! The noses and chins are constructed as nobly as Greek temples. Even if idealized in these versions, such men *should* have existed.

MICHELANGELO. Detail of *The Prophet Joel*. 1509. Ceiling of the Sistine Chapel, The Vatican, Rome

EL GRECO. Detail of *Fray Felix Hortensio Paravicino*. c. 1605. Museum of Fine Arts, Boston. Behind those penetrating eyes, which seem to take one's full measure, the viewer senses the controlled intensity of a totally dedicated man, a "true believer."

PETER PAUL RUBENS. Detail of *Self-Portrait*. 1638–40. Kunsthistorisches Museum, Vienna. The self-assurance of an older man who has been very successful. An intellectual as well as a highly physical person, Rubens was never assailed by doubts about the ultimate unity of spirit and flesh.

REMBRANDT VAN RIJN. Detail of *Head of Christ*. c. 1650. The Metropolitan Museum of Art, New York. The Mr. and Mrs. Isaac D. Fletcher Collection. Bequest of Isaac D. Fletcher, 1917. For Rembrandt, the image of Christ posed a special problem: the dominant Catholic tradition of the Baroque called for an idealized, somewhat mannered personification, but Rembrandt's painterly style and religious commitment had their roots in Protestant realism. His solution: a Jewish model in whose countenance we see a remarkably credible embodiment of manliness and compassion.

JACQUES-LOUIS DAVID. Detail of *Man with a Hat*. 1873. Royal Museum of Fine Arts, Antwerp. Even in the work of a classicist like David, the force of a private personality asserts itself—especially in this candid portrait. A new cult of individualism is emerging— casual, studied, confident. The manner of aristocrats is now enjoyed by a wealthy bourgeoisie.

THÉODORE GÉRICAULT. Detail of *The Homicidal Maniac*. 1821–24. Musée des Beaux Arts, Ghent. Pursuing the varieties and extremes of individualism, the Romantic must inevitably examine one of the most tragic forms of human suffering and alienation: madness.

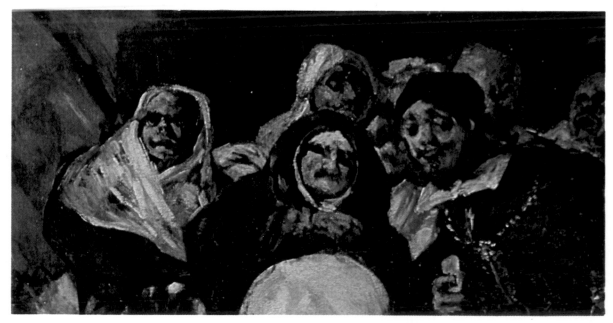

FRANCISCO GOYA. Detail of *Pilgrimage to the Fountain of San Isidro*. 1820–22. The Prado, Madrid. Goya painted best what he liked least. Because his commitment to reason was deeply offended by any individual or collective form of lunacy, he was continually enraged with the behavior of nineteenth-century mobocratic men.

EUGÈNE DELACROIX. Detail of *Portrait of Chopin*. 1838. The Louvre, Paris. The painter grows interested in the correspondence between heightened emotion, color, form, and brushwork; he suspects that turbulent feeling generates a unique visual resonance.

DIEGO VELÁZQUEZ. Detail of *Pope Innocent X*. 1650. Doria-Pamphili Gallery, Rome. A work of the seventeenth century, but thoroughly modern in its approach to painting and personality. Its optical realism anticipates Impressionism and photography. The only barrier between the viewer and a complete disclosure of Innocent's character is the aristocratic reserve of the artist.

EDOUARD MANET. Detail of *The Luncheon in the Studio*. 1869. Neue Pinakothek, Munich. The self-assurance and absolute openness to experience of this young man correspond to certain arrogant qualities in Manet's style: a frontality based on exceedingly flat lighting, a refusal to tamper with or idealize visual facts, a determination to set the painterly act above pictorial convention.

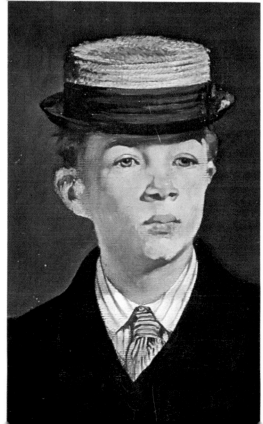

HENRI MATISSE. *Green Stripe (Madame Matisse)*. 1905. Statens Museum for Kunst, Copenhagen. Rump Collection

ALEXEJ VON JAWLENSKY. *Self-Portrait*. 1912. Collection Andreas Jawlensky, Locarno, Switzerland

In a sense, Matisse, during his Fauvist period, was responsible for the development of all these artists—even the Germans and Slavs. While pursuing his fundamentally serene pictorial objectives through a system of color more consciously arbitrary than his system of form, he opened up a new set of emotional options for figural representation—options that were eagerly seized by men of restless disposition everywhere. Although Matisse moved ahead logically, concerned with man's image only as a motif in a grand scheme of light, movement, decoration, and pleasure, these Expressionists followed a different path—a path of agonizing self-examination and private anguish.

 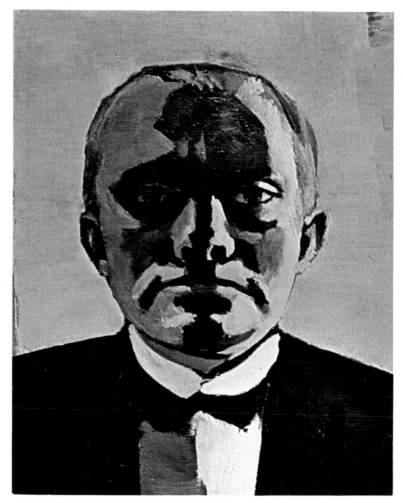

LUDWIG KIRCHNER. Detail of *Portrait of Gräf*. 1924. Kunstmuseum der Stadt, Düsseldorf

MAX BECKMANN. Detail of *Self-Portrait in a Tuxedo*. 1927. Busch-Reisinger Museum, Harvard University, Cambridge, Massachusetts

KAREL APPEL. Detail of *Crying Nude*. 1956. Collection Mr. and
Mrs. Alan Fidler, Willowdale, Ontario

ANTONIO SAURA. *Imaginary Portrait of Goya*. 1963. Museum
of Art, Carnegie Institute, Pittsburgh

LARRY RIVERS. *Celebrating Shakespeare's 400th Birthday (Titus
Andronicus)*. 1963. Collection Clarice Rivers, New York

RICHARD HAMILTON. *Fashion-plate study (a) self-portrait*. 1969.
Collection Rita Donagh, London.

To the extent that the human image survives in recent painting, it is either mutilated or
derided. Appel and Saura carry the Expressionist idiom to the limits of personal abuse,
trying to find mythic power through intoxicated painterly tirades. Rivers and Hamilton are
cooler; they play allusive Pop art games with drawn, pasted, and painted human images. But
they refuse to take these images seriously as symbols of human beings, which suggests that
the idea of man is a source of genuine embarrassment to many contemporary painters.

JEAN-AUGUSTE-DOMINIQUE INGRES.
Madame Moitessier Seated. 1851.
The National Gallery, London

to direct oil-painting technique? Perhaps the earlier discussion of empathy (p. 351) may help to explain the role of brushwork. Fundamentally, a viewer's perception of the artist's brushwork involves an internal "acting out" of the process of wielding the brush and applying the paint. It is for this reason that the term "action painting," coined by the critic, Harold Rosenberg, is so appropriate a designation for the work of the so-called New York School of painters—the Abstract Expressionists of the 1950s. Most viewers have had experience with the use of brushes, either in art instruction or in some other, more prosaic connection. Hence, it is relatively easy for them to identify with and to simulate inwardly the motions implied by the brushwork they see. This does not mean, of course, that viewers perform a series of gymnastic

maneuvers before a painting which has a rather active surface. But it does mean that a variety of physiological reactions are set in motion within the viewer by such a work and that these reactions produce feelings in the manner described by the Gestalt principle of isomorphism (p. 362). Such feelings are similar to kinaesthetic emotion; that is, emotion felt in association with bodily movement.

Indirect technique, for the most part, does not rely on brushwork to express emotion. Because indirect paintings are executed in separate layers, or "skins," distinct marks of the brush tend to be lost. If pronounced ridges of paint are employed in the underpainting, they will, of course, show through as textures; hence they must be anticipated, or the final effect may be spoiled or at least confused. The element of planning tends to reduce the appearance of

FRANS HALS. *Governors of the Old Men's Almshouse, Haarlem.* 1664. Frans Hals Museum, Haarlem, The Netherlands

FRANS HALS. Detail of *Governors of the Old Men's Almshouse, Haarlem*

The impression of swiftness and spontaneity in direct painting technique calls for considerable assurance on the part of the artist—assurance based on solid knowledge, power of observation, and shrewd grasp of character.

spontaneous execution, which is one important means of arousing empathy in the viewer. Masters of indirect painting technique such as Ingres and David brushed out their paint, leaving no surface sign of the process of execution; any empathic response of the viewer to their works had to be based on subject matter and on the design of the forms rather than their technical execution. For artists who favored historical themes and allegorical compositions, however, such a response was intended. Clearly, then, indirect technique draws attention to the subject matter of the picture whereas direct technique emphasizes the way it was painted.

Although indirect painting involves a division of labor in the process of execution, direct painting combines almost all the crucial decisions in the single act of applying paint. The artist may make preliminary sketches and he may transfer his general idea of the drawing and composition to the canvas before beginning to paint. But the final effect is not built up: color, drawing, value, shape, weight of pigment, and paint quality are decided at once as the paint is laid on. A spontaneous appearance is usually sought even if the painter works slowly and deliberately, calculating his brushwork in advance. If he does not achieve the desired effect at once, he is likely to scrape the paint off until he succeeds. Oil paint, of course, is ideal for this sort of trial-and-error execution. When an artist does not succeed in his first attempt but continues to paint over his earlier efforts rather than scrape them off, a labored, rather tortured paint surface often results. Direct technique, therefore, is not well suited to frequent "overpaints." The color, being largely opaque, tends to become muddy; it begins to look tormented, as if it had

been "pushed around" too much; clarity of color and crispness of brushwork are lost.

Since direct technique usually emphasizes the performing aspect of painting, the attention of the viewer is drawn to the visual evidence of paint mixing and application, because they constitute an integral part of the artist's performance. Cézanne and Van Gogh are both instructive performers to watch. There is more building up of planes in Cézanne, but his "touch," while careful, is rarely hesitant. He does not push the paint around indecisively.

EUGÈNE DELACROIX. *A Mounted Arab Attacking a Panther*. 1854. Fogg Art Museum, Harvard University, Cambridge, Massachusetts. Bequest of Meta and Paul J. Sachs. A painterly approach to drawing. The artist does not use line to establish contours so much as to anticipate paint application, the direction of brushstrokes, and the dominant rhythms of his composition.

PAUL CÉZANNE. *Aix: Rocky Landscape.* 1885–87. The National Gallery, London

VINCENT VAN GOGH. *The Ravine.* 1889. Museum of Fine Arts, Boston. Bequest of Keith McLeod

but seems to know the color and value of each stroke or series of strokes before he commits himself. Frequently, Cézanne's canvas shows through as the white paper does in some watercolor paintings. Consequently, his paint surfaces have a freshness and sparkle which a more labored technique would not yield. Certainly glazing would sacrifice the vividness of directly applied opaque color. The luminosity of glazed painting depends on light striking through to the whitish underpainting (which acts like a mirror) and then bouncing back in modified form through the translucent colored glaze to the viewer's eye. Thus, the light by which the viewer sees becomes an ally of the indirect painter. But the artist who employs direct technique cannot rely on such refractive effects: he must usually mix and apply any color effect he expects the viewer to see. However, with Impressionist painting (which is executed in direct technique), the artist relies on the viewer's eye to "mix" new colors optically, using the pigments the painter has *actually* applied to the canvas. The color vibrations of Van Gogh's *The Ravine* might be regarded as a demonstration of Gestalt principles of perception: the blues and yellows are juxtaposed, for example, so that they "complete" each other by forming greens. But they are also what they are—blue and yellow. Hence, the viewer's energies are organized to perceive the colors alternately as blue and yellow, or as green. It is the *alternation* of perceptual organizations which causes the experience of color vibration. In addition, Van Gogh's short, distinct brushstrokes set up staccato rhythms which reinforce the impact of the vibrating color. Thus, the colors of the paint, as well as its application, contribute to the tormented motion one "feels" in the water. A brushed-out technique or a luminous glaze in the traditional manner would surely ruin this effect. The flickering light of El Greco's *The Agony in the Garden of Gethsemane* (p. 316) is a different phenomenon entirely; it was achieved by the *shape* of the light and dark patterns. El Greco came as close as one could to conveying an agitated movement of light and form while using indirect painting technique.

If we trace direct painting technique from its beginnings among the Venetians during the fifteenth century to its full development in our own time, it seems that the method has paralleled the growth of individualism among men in general and of autonomy among artists in particular. Since direct technique emphasizes the uniqueness of the painter's execution, it is best suited to individuals who set a premium on the expression of their personalities no matter who their patron may be or what the theme of their work is. Indirect technique has served painters with lofty and ambitious aims, but it has best suited artists who did not wish to display their "handwriting," their technical idiosyncrasies. In recent work, these two contrasting attitudes toward the disclosure of technique remain visible although almost all artists paint directly. The so-called "hard-edge" and geometric painters employ an anony-

WILLEM DE KOONING. *Woman, II*. 1952. The Museum of Modern Art, New York. Gift of Mrs. John D. Rockefeller

Employing direct technique, modern painters use pigment as a vehicle of candid self-revelation (De Kooning) or as an anonymous element subordinated to the requirements of the total design (Glarner).

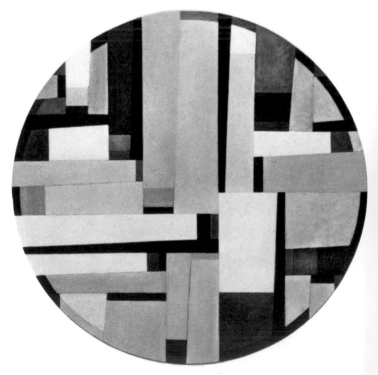

FRITZ GLARNER. *Tondo No. 54*. 1960. Collection Richard S. Zeisler, New York

mous technique, relying on design and the optical effects of color quantity and shape to carry the burden of the work. For the "action" painters, the execution of the painting, the path of the painter as he travels across the canvas with loaded brush, is often the theme of the work. Such paintings constitute evidence of the extraordinary development of personal freedom in the present era. Indeed, this emphasis upon individual personality to the exclusion of other values has aroused the hostility of some observers. Perhaps they are offended by such forceful assertions of freedom; or perhaps they cherish classical ideals of moderation and balance—of a mean between the extremes of "inner-directedness" and "other-directedness." But such Aristotelian counsels are rarely heeded in contemporary art: media and techniques serve to celebrate the individual—his freedom, his anxiety, his indifference to the form and content of yesterday's masters, and his search for new structures of meaning.

Frottage, Grattage, and Decalcomania

The spontaneous application of paint with a loaded brush was one type of liberation from the methodical approach to painting as it was traditionally practiced. In this technique, the artist recognizes and exploits the fact that the *marks of the tool*—the brush marks—are expressive in themselves, apart from the import of representational forms and the ostensible subject matter of a work. Once this type of expressiveness was discovered, it was a simple step to the realization that changing the tools of painting results in new possibilities of signification. Although painting remained an art of fashioning images, some artists devised new techniques for manipulating the paint, which *itself* became the source and subject of their imagery. Among the most inventive of these innovators has been Max Ernst (born 1891), an artist who has been a prolific creator of nonpainterly pictorial devices. In this section, however, we are concerned only with the application of his techniques to painting because they have been so influential in the work of other artists.

For most of his career, Ernst has been associated with the Dadaist and Surrealist movements. Hence, obedience to irrational impulse has played a major role in his art. *Chance arrangement* is a principle of Dadaist composition, while the juxtaposition of unrelated images is a principle of Surrealism: clearly, the movements are closely linked in their creative approaches. Ernst's technical discoveries can be seen as the result of a search for sources of imagery which are not known in advance, which cannot be calculated consciously, but which must be developed in response to "accidents" caused by interactions between paint and process. Still, although the resulting images appear to be irrational and unplanned, the artist works hard at a conscious level to create the accidental situations which, in turn, establish the basis for his adventitious forms.

Frottage is the best-known of Ernst's techniques. You may be familiar with it as the popular art of making rubbings: pencil or crayon rubbed over paper placed on a textured or relief surface transfers to the paper a negative image of the texture underneath. Archaeologists use rubbings to make transportable copies of stone or metal reliefs. Children use the technique on coins or whatever else comes to hand. Purely abstract patterns such as wood grains can be transferred, and then, because of their suggestiveness, worked up into recognizable images. Frottage, then, is a technique which has a practical, record-keeping value, and which also can be used to stimulate the creation of fantastic forms. For Ernst, it was a means of exploiting unplanned images of natural or accidental origin such as those one sees in clouds, wall stains, rock fissures, and so on. He found a way to use frottage in oil painting by placing a freshly painted canvas over a relief texture and then scraping away the paint. The unscraped paint remaining in the valleys and crevices of the canvas creates a pattern corresponding to the texture below. The process really does not involve rubbing, but it results nevertheless in a transfer of the pattern underneath by a technique

MAX ERNST. *The Eye of Silence*. 1944. Washington University, St. Louis

The painter builds a surface which he then carves, scratches, and abrades; his picture is something "real" rather than a system of illusions.

MAX ERNST. *Swamp Angel.* 1940. Collection Kenneth MacPherson, Rome

ANTONI TÀPIES. *Campins Painting.* 1962. Collection Mr. and Mrs. Robert B. Mayer, Winnetka, Illinois

similar to frottage. As with *decalcomania* (see below), the key concept is *transfer*, or, in other words, *informal printing*. Another informal printing process involves the dipping of leaves, kitchen utensils, fabrics, or toy parts— virtually anything which can be held in the hand—into wet paint; then the object is used like a hand stamp to transfer the pattern to canvas. However, we must distinguish between printmaking, as the intentional contrivance of images on a wood, stone, or metal surface for the purpose of making many reproductions, and frottage, as the transfer of "found" textures and patterns for the purpose of enhancing them in the context of a single painting.

Grattage, another Ernst technique, is the grating or scratching of wet paint with any of a number of tools: a comb, a fork, a pen, a razor, an irregularly shaped piece of glass, a needle, and so on. Grattage takes advantage of the plastic character of wet oil paint just as the paintbrush does. But the brush is designed primarily to *apply* paint and to blend it—only secondarily to leave its mark. These other tools manipulate paint which is already applied. Grattage involves an almost sculptural or architectural working of paint, the pigment being regarded as a type of building material like concrete. (In this connection, it should be mentioned that Le Corbusier liked to "scratch" images into his poured-concrete wall surfaces. As would be expected in an architect who was a serious painter,

several of his buildings contain incised relief figures created by pouring concrete around a shallow mold incorporated into the wooden formwork for the wall.) The conception of paint as a material which can be scratched, modeled, abraded, or otherwise tortured, represents a significant departure from the idea of paint as a descriptive substance. In traditional painting, the pigment was not really "there." It always designated a substance different from itself, usually one occupying a spatial location different from the pictorial surface. In the terminology of aesthetics, it was *transparent* rather than opaque; it pointed to something beyond itself. Today, pigment with its various admixtures can function "transparently" *and* "opaquely": it can describe something else or it can designate itself because of the operations which have been performed—not *with* it, but *in* it. Clearly, this new role of pigment carries painting closer to sculpture.

Decalcomania is used by Ernst in a special way: wet blobs of paint are squeezed between two canvas surfaces which are then separated. Variations in motion and pressure force the paint into random patterns, forming crevices and rivulets which, when dry, can be worked on directly and exploited for their formal and thematic suggestions: fantastic geological structures; volcanoes, caves, and valleys; landscapes of unknown planets, of prenatal memories; and projections of the fevered imagination. It is, of course, the artist's imagination which acts

as creative instrument while decalcomania, frottage, and the rest serve as strategies of imaginative stimulation.

Another Ernstian technique, *éclaboussage*, has been widely practiced by painters. It involves the dropping of paint or turpentine from a height to a prepared canvas. Ernst dropped the paint from a perforated tin can which swung from a string suspended above the canvas. The paint splashes are used in the same manner as the squeezed pigment in decalcomania. Turpentine dropped on a freshly painted canvas is also used to create splash patterns which expose the bare canvas or dilute the wet paint partially, depending on the force of the drop and whether the turpentine is blotted up or permitted to stand, puddle, or run in random paths. There is only a short step from dropping paint to throwing paint from a brush or dripping it from a stick in the manner of Jackson Pollock.

It is interesting that when these techniques are employed the connection between the artist and the canvas becomes mechanically more indirect and spatially more distant. For centuries, the brush was an extension of the painter's hand, but when used to spatter paint it is a different tool. Among the more bizarre methods of distributing paint on a surface is the technique of a young woman, Niki de Saint-Phalle (born 1930), who would fire a rifle at bags of paint suspended before a wall covered with random relief sculptures. The explosion of the gun and of the bag of paint created two dramatic events—the performance itself and the record of its violence on the paint-bespattered wall. As compared with the Ernstian technique of stimulating the imagination, this latter method shifts attention from the *result* of the creative process to the act of execution, which becomes the primary focus of interest. Another bizarre technique consists of driving an automobile back and forth over a prepared canvas laid on the road. This performance represents the interposition of a very complex machine between the artist and his working surface. Aside from its theatricality, however, it is no more absurd than composing music with a computer (which is a complex machine) or employing the coordinatograph (see p. 302) to create abstract pictures.

Once the brush lost its central position in painting and pigment could be combined with new admixtures held together with new glues and binders—once, indeed, that pigment was abandoned altogether—then the tools and materials of painting became capable of almost infinite extension. If an automobile could be substituted for a paintbrush, then a bulldozer might logically be employed as a sculptor's carving tool. César (Baldaccini)(born 1921) has in fact created objects in collaboration with the powerful hydraulic press used to squeeze junked automobiles into compact cubes of anonymous metal. He calls the method "governed compression." His relief is a good example of the combination of painting and sculpture in a crushed automobile. One cannot escape the impression, once again, that so theatrical a gesture represents a shift

Photograph of Niki de Saint-Phalle about to paint with a rifle

of focus from the object to the symbolic meaning of the act of creating it. In such "sculpture" and in the "paintings" of Miss de Saint-Phalle, we see the crossing of the line from plastic art to dramatic art: the object is of relatively minor importance, serving to remind the viewer of a previous *dramatic enactment*.

The tendency of painting to seek assimilation by the dramatic arts will be discussed in further detail in a following section. But with reference to the technical and imaginative innovations of painters like Klee, Ernst, Duchamp, and Dubuffet, I want to stress that these men have been engaged in devising strategies for the *artistic* imagination. These strategies remain tools whose major goal is the creation of art objects. It would appear, however, that another generation of artists has been impressed by painterly strategy for its own sake. The *process* of throwing, dripping, or exploding paint opens up possibilities which are felt to have aesthetic value apart from the outcome embodied in a conventional art object. In a subsequent section of this chapter, "Beyond Collage: Assemblage, Environment, Happenings," we shall analyze these more recent developments in painting and/or drama.

CÉSAR. *Portrait of Patrick Waldberg.* 1961. Collection the artist

The Picture and the Wall

Abstract Expressionist painting, which dominated the international art scene from 1946 until approximately 1960, reintroduced the huge canvas of Baroque and Neoclassic vintage, an innovation which has been retained by succeeding styles such as Pop art and Op art. Canvases having dimensions of up to sixteen feet are not unusual today. However, they represent a departure from the preceding easel-painting styles in more than dimension; the new scale of painting signifies a fundamental change in the way painting is intended to operate in its setting and for its public.

Critics at first questioned the huge scale of the post–World War II works which seemed to contain visual ideas that could be comfortably accommodated within much smaller dimensions. Habituation to small-scale painting had been abetted by an increase in the publication of art volumes of good quality after the war, resulting in the wide dissemination of reproductions of contemporary

CLAUDE MONET. *Water Lilies.* c. 1920. The Museum of Modern Art, New York. Mrs. Simon Guggenheim Fund

painting. But reproductions create a homogenized scale, and, for persons who have not seen the originals, they convey a misleading impression of the "authentic" experience of the work. "Action painting" was dependent for its effectiveness upon the communication of the artist's brushing gestures—gestures accomplished mainly through the movements of the large muscle groups of the body. This point is obvious in a work such as De Kooning's *Black and White, Rome D.* The viewer's reaction must be kinaesthetic as well as optical if he is to appreciate the painting. The same composition executed on a small scale, or the reproduction of the work in a book, will not succeed in stimulating the appropriate bodily responses.

Large pictures have been created, of course, during almost all periods of art history. However, their large size was based on the need to accommodate many figures, buildings, landscape details, and so on. Figures rarely exceeded life size: the fundamental scale and format were keyed to the imitation of visual reality. Hence, pictorial perception was easily related to a close or distant view of the same material seen in reality. Only with Impressionist painting did the distance of the viewer from the picture— the *size* of the area occupied by the image on his retina— become crucial for the understanding of the work. At one distance, perception would be mainly of fragments of the work, of color patches and color vibrations. At a greater distance, the color areas and fragments would come into *focus*, yielding a relatively stable image of the whole comparable to conventional representations of similar subject matter.

Paintings executed in direct technique had always exhibited indistinctness when seen up close. But the vital discovery brought about by the color divisionism of Impressionist painting was that unfocused color areas sustained interest as images in themselves. As mentioned earlier, (p. 312) the full expressive potential of color could be exploited only after it was substantially detached from a descriptive function. Such a development appears in the

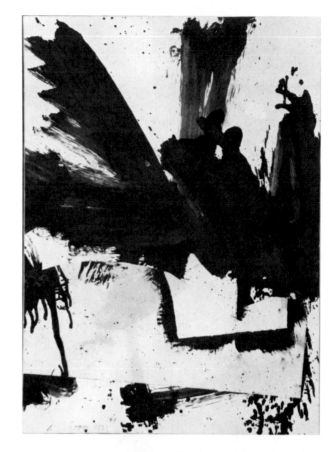

WILLEM DE KOONING. *Black and White, Rome D.* 1959. Collection Taya Thurman, New York

combination of almost free color, active brushwork, and large-scale abstract design in a huge canvas mural, *Water Lilies*, painted by Monet in about 1920. The work is over eighteen feet wide and is executed in large, loosely brushed color areas. Although the overall design is somewhat governed by the requirements of the natural setting, it is difficult to see the entire canvas at once because of its size. Hence, one views only a succession of parts, and these are quite abstract, the color and pigment taking precedence over description. As with Delacroix, the

CLAUDE MONET. Detail of *Water Lilies*

drama of the painting performance is heightened in Monet. But in the *Water Lilies* canvas, the *scale* of the work becomes as significant as the dexterity of the brush-work. Therefore, aside from its inherent visual appeal and demonstration of mastery in color and paint application, this work constitutes an important monument of large-scale abstract painting.

The large scale of modern works has several important implications for contemporary painting. The first is that passages of color and texture are frequently larger than the viewer, making it difficult to maintain an attitude of detachment and objectivity during perception. (Traditional aesthetics is based on detached perception, disinterestedness. Contemporary art, in general, militates against the maintenance of distance or detachment.) Areas and shapes in a painting become not so much the objects of perception as *part of the environment* in which perception takes place. A color area, in other words, surrounds the viewer. Mark Rothko made especially effective use of this factor. There is an analogy between the relation of the new to the old scale of painting and the relation of the wide-screen motion picture image to the television image. Empathy is easier to achieve with the motion picture image than with the home screen; psychic distance is lost more readily. The large motion picture image communicates meaning visually, while the small television image seems more like an extension of radio, of sound, of the spoken word. The small-scale image in television or painting, in other words, bears a closer relation to literature than does the painted or cinematic large image.

A second implication of large-scale painting lies in the tendency of the picture to merge with the wall and so to become an architectural element rather than a separate work of art *attached to* a wall. In this development, painting is, of course, returning to a condition enjoyed by its mosaic and stained-glass antecedents. The modern development began with the flattening of space by Cézanne and the Cubists. Illusionistic effects—the creation of pictorial space through perspective and chiaroscuro devices—were regarded as violations of the integrity of the wall and the reality of architectural space. Now the imagery of painting, in the work of artists as different as Antoni Tàpies, Jean Dubuffet, and Ellsworth Kelly, rests on the surface; it makes no claim to occupy space other than what it needs for two-dimensional support. If texture or depth is desired, it is built in sculpturally rather than created illusionistically as in traditional painting. Because it does not conflict with the spatial identity of the wall and may have almost the same dimensions as the wall, the large painting—in visual terms, at least—*is* the wall.

The return of painting to architecture is part of a general development, already noted, to create environments. In this tendency, painters have been encouraged by modern architectural practice. Some architects, of course, see their role as extending beyond the creation of space: they endeavor to control not only the location of the elements which articulate space, but also the character of surface on interior and exterior wall structures. To the extent that they design wall *surfaces*, architects perform a painterly function. Certainly Wright and Le Corbusier designed surfaces as well as volumes. As we know, Le Corbusier was a painter, and it would not be wrong to say that Wright composed like a painter. Consequently, buildings by Wright and Le Corbusier seem satisfactory without painting and sculpture (although painting and sculpture can be and have been added). Some painters feel that Wright's Guggenheim Museum dominates the pictures displayed in it: Wright's interior design satisfies the visual and plastic requirements of viewers; hence paintings may be superfluous. Buildings by Mies van der Rohe, on the contrary, seem to welcome painting and sculpture. Perhaps that is why his former colleague, Philip Johnson, has become the leading designer of new museums in the United States.

Since Miesian architecture is by far the most common influence on the construction of new buildings in this country, there is an abundance of anonymous space and plain wall surfaces in American building. Perhaps the lack of decoration and the absence of drama in much of our public architecture helps to create a vacuum which painters instinctively endeavor to fill. Furthermore, the large scale of modern painting has fairly effectively re-

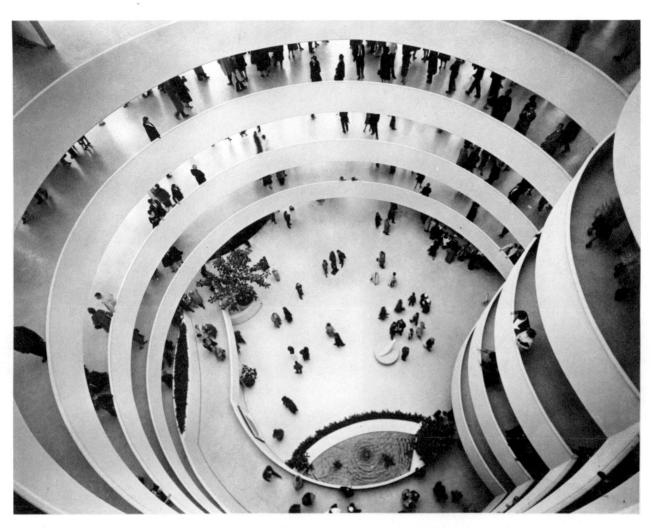

FRANK LLOYD WRIGHT. Interior ramps, The Solomon R. Guggenheim Museum, New York. 1959

Office of David Rockefeller, Chase Manhattan Bank, New York. 1961

HONORÉ DAUMIER. *Connoisseurs.* c. 1862–64. The
Cleveland Museum of Art. Dudley P. Allen Fund

DAVID TENIERS. *The Picture Gallery of Archduke
Leopold Wilhelm.* c. 1650. The Prado, Madrid

moved it from the domestic dwelling so that public build-
ings are becoming its natural habitat. Increasingly, the
new painting is intended for the spacious walls of galleries
and museums (designed by Philip Johnson) or for the
corridors and executive suites of banks and public build-
ings (designed by Skidmore, Owings and Merrill or by
Philip Johnson).

Small works are still created for homes and apartments,
but usually they are minor efforts by major artists, pre-
liminary studies, drawings, or works by amateurs. Very
few major works by "important" modern painters can
fit into the homes of even the affluent middle class. Col-
lectors of means are obliged to design special facilities to
exhibit their collections. Clearly, painting has departed
from the category of Victorian knickknacks. It is too
insistent, too large, too bright, too disturbing to rest
quietly against the wallpaper, surrounded by an ornate
frame, sharing soft light from a table lamp with a collec-
tion of china, family photographs, and travel souvenirs.
Painting has become an art of public statement and public
performance. Increasingly, public and quasi-public insti-

tutions support artists and pay for paintings. The eco-
nomics of art is such that even private collecting requires
the existence of public museums and government tax
policies which are politically determined.

Although a novel represents a private statement by a
writer, it would be absurd to think of publishing it for
one person, no matter what his means. Perhaps the major
works which painters create are approaching the condi-
tion of the novel. At any rate, it is difficult to believe that
large-scale paintings are created without any awareness
that they are destined ultimately for public ownership and
display. The small picture, the easel painting, is diminish-
ing in importance. Happenings and Environments have
become possible as the dimensions of the canvas approx-
imate the dimensions of the wall in a room. And the flat-
tening of space and the elimination of figurative subject
matter have conspired to identify the painted canvas with
the wall. Hence, pictures as wall ornaments, traded like
furniture or related household items, may continue to be
created; but they are not likely to occupy a position that
is very close to the heart of painting as an art form.

Mixed Media

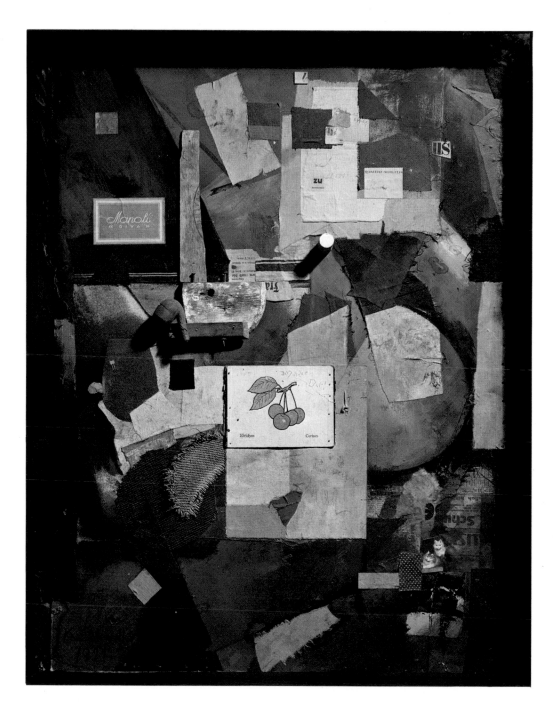

KURT SCHWITTERS. *Cherry Picture.* 1921. The Museum of Modern Art, New York. Mr. and Mrs. A. Atwater Kent, Jr., Fund. Collage and assemblage constitute an unconscious return to tribal modes of artistry, particularly in the equation of the tactile with the visual. But instead of using seeds, shells, stones, and fiber as raw material for his imagery, the modern artist employs commercial rubbish—especially the abundant rubbish of the textile and print industries.

From a certain standpoint, both works can be seen as elaborate displays of the taxidermist's art: stuffed pedestals for stuffed birds. However, the purposes they serve are internal to art: to get away from abstraction, calculation, deliberate design, and cerebral form—to reestablish the status of things as things.

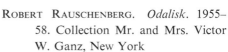

JOAN MIRÓ. *Poetic Object*. 1936. The Museum of Modern Art, New York. Gift of Mr. and Mrs. Pierre Matisse

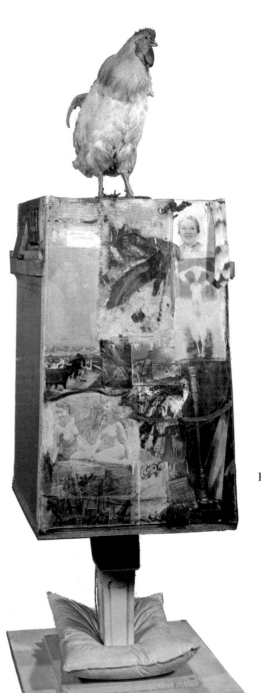

ROBERT RAUSCHENBERG. *Odalisk*. 1955–58. Collection Mr. and Mrs. Victor W. Ganz, New York

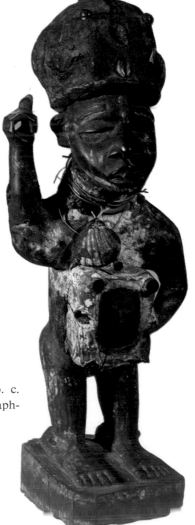

MIRROR FETISH, from the Lower Congo. c. late 19th–early 20th century. Ethnographical Museum, Antwerp

The fetish figure is inevitably a "mixed-media" construction since it functions as a container or dwelling place for magical substances embedded in its abdominal cavity. In the Congolese fetish, a mirror serves to frighten off demons or forces a criminal to identify himself. In the contemporary "fetish" by Arman, tubes of paint embedded in a female torso pour ribbons of color into her polyester belly and womb.

EDWARD KIENHOLZ. *The State Hospital.* 1964–66. Moderna Museet, Stockholm. As mixed-media impresario, Kienholz bears a curious resemblance to the Baroque sculptor Bernini: the theatrical requirements of the spectacle take precedence over inherited rules about the separation of painting, sculpture, and architecture. But this spectacle celebrates misery, not mystical transcendence. In his main departure from unalloyed realism—the goldfish bowl where the face should be—Kienholz offers a symbol of human alienation as painful as the whole gruesome tableau.

ARMAN. *La Couleur de mon amour.* 1966. Collection Mr. and Mrs. Philippe Durand-Ruel, Buzenvale, France

ANTONI GAUDÍ. Detail of spire, Church of the Sagrada
Familia, Barcelona. 1883–1926

SIMON RODIA. Detail of Watts Towers, Los Angeles.
1921–1954

GAUDÍ and Rodia both conceived of architecture as the
creation of expressive forms that appear to have grown by
natural accretion. This view demanded labyrinthine pas-
sages, surfaces like tribal fetish sculptures, and coloristic
effects of Byzantine brilliance. A mixed-media approach
to architecture is almost inevitable when the designer feels
that every part of the structure is magically alive.

Beyond Collage: Assemblage, Environments, Happenings

In every generation, painters feel that their elders have carried the medium as far as it can go in its prevailing direction and that they must strike out in radically new directions—in theme, in technique, in materials, and in creative approach. The feeling that inherited methods and media are at the stage of exhaustion has been especially intense among painters of the twentieth century. One reason, conceivably, for their sense of dissatisfaction with conventional materials and imagery has been the powerful attraction of the film—an attraction which is quite understandable, since motion pictures are a modern technological extension of the art of creating images which has been practiced by artists since Paleolithic times. Today many painters are strongly drawn to cinema, either as spectators or as film makers themselves. Others have felt, perhaps unconsciously, the need to change the fundamental painting situation. Spurred by the need to compete effectively with the new media of communication, painters have crossed the line separating their art from sculpture. They have abandoned the representation of objects and have created works which are made of "real" objects. They have fashioned works which disintegrate or destroy themselves as one views them. They have created works which spectators do not merely observe, but which they enter into, which they participate in physically, as actors in a drama. Such innovations may be regarded as acts of desperation intended to retain the interest of a public which was beginning to seek visual satisfactions elsewhere. On the other hand, they may be understood as the logical and inevitable adjustment of the art of image-making to available new materials and the visual challenges and opportunities of the contemporary world.

Assemblage, as the word implies, is the creation of art objects by putting things together—usually by taking them from their accustomed environments and combining them in a new context. There is also a type of three-dimensional assemblage—in other words, sculpture. But as was mentioned above, painting has "crossed the line," and it is very difficult to say when a work ceases to be pictorial and becomes either relief sculpture or sculpture in-the-round. Such classifications, at any rate, do not seem to be important. Outstanding painters, from Picasso and Braque forward, have employed assemblage of one sort or another. What is important is that a pictorial manner of seeing and organizing is evident in works of assemblage. Painters seem to think of the debris and the found objects they incorporate into their works in terms of the customary visual elements: line, shape, texture, color, light, and so on. Instead of simulating these qualities of objects with brush and paint, the artist employs the object itself. It might be argued that this procedure relieves the painter of the obligation to employ skill and imagination in the *re*-presentation of reality, that he may be concealing his ineptitude in the handling of paint. There are several answers to this charge. First, representational skills, even if not of so low an order as is frequently maintained, have grown progressively less vital to painting as photography and the film have advanced. Secondly, the display of skill in imitation of appearances seems to be one of those achievements of the past which contemporary artists feel cannot be surpassed. Finally, we cannot claim to judge a work of art properly in terms of the skills its maker does *not* seem to have: we must examine it on it own terms, seeing the materials the artist *has* used and the techniques he *has* employed in an effort to endow the materials with significant meaning.

In addition to the psychological and cultural conditions which led to the emergence of assemblage, the technical ground for assemblage was prepared by *collage*. The media are similar except that collage, as the term implies, (the French verb *coller* means "to paste, to glue"), calls for the gluing of materials to a surface. Assemblage employs *any* method of joining or fastening: nailing, gluing, stapling, riveting, screwing, welding, soldering, and so on. The latter methods carry it into sculpture,

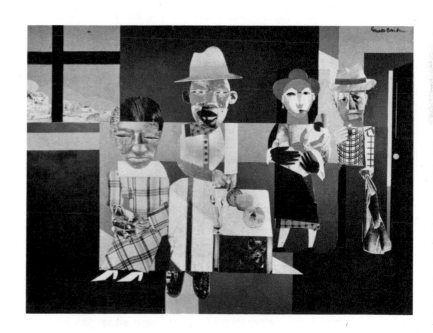

ROMARE BEARDEN. *Family Group.* 1969. Private collection, New Jersey. Here the collagist employs fragments of reproduced photographic imagery for their cognitive meanings as well as for their textures and colors; he operates simultaneously from narrative and painterly sensibilities.

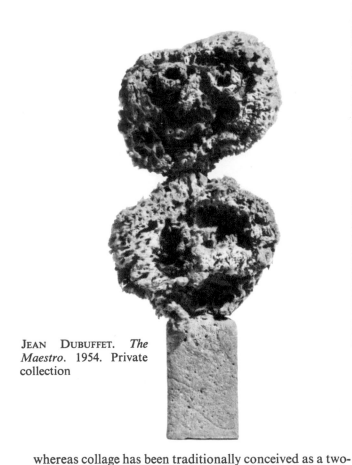

JEAN DUBUFFET. *The Maestro*. 1954. Private collection

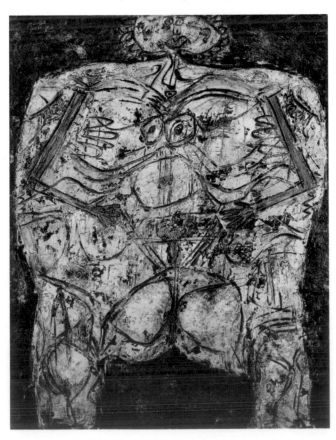

GEORGES ROUAULT. *Fleurs du Mal*. 1945. Collection Isabelle Rouault, Paris. The coarse, heavily textured surface of Rouault's painting is an additional weapon in his arsenal of savage characterization; furthermore, he anticipates the incised, scratched, and tormented surfaces of later artists such as Dubuffet and Tàpies.

JEAN DUBUFFET. *Corps de Dame*. 1950. Collection Alfonso A. Ossorio, East Hampton, New York

whereas collage has been traditionally conceived as a two-dimensional medium. For a long time, entry into the third dimension was a formidable barrier for painters. Although many practiced sculpture, they restricted their three-dimensional explorations, as painters, to textural elaboration and the creation of *illusions* of depth. But such fastidiousness about categories began to break down under the assaults of Dada artists such as Kurt Schwitters, Jean Arp, Max Ernst, and Marcel Duchamp. Today, artists do not seem to be particularly inhibited about working in any dimension they can penetrate. The old distinctions still survive somewhat in the education of artists. That is, separate courses in two-dimensional design, three-dimensional design, painting, and sculpture are still taught. But painting studios in college and university art departments display almost as much three-dimensional work as do sculpture studios. The principal difference seems to be the relative absence of paint among the sculptors. Unlike their painterly brothers, they are less inclined to "cross the line."

Among practitioners of collage and assemblage today, the French artist Jean Dubuffet (born 1904) can be compared to Ernst in imaginative and technical fertility. Although he too has abandoned the paintbrush in his later work, Dubuffet has a more authoritative command of pigment and color than Ernst. No matter how much he experiments with discarded materials as sources of imagery, his work grows out of an authentic "feeling for paint," something one misses in the elaborate technical

JEAN DUBUFFET. *My Cart, My Garden*. 1955. Collection James Thrall Soby, New Canaan, Connecticut

fancies of Max Ernst. Indeed, Dubuffet's preparations of pigment, asphalt, tar, cement, varnish, glue, sand, and so on seem to be efforts to convert the artist's canvas into a *wall* which can be scratched, modeled, and then painted. He appears to be creating a contemporary kind of fresco or wall painting, inspired by *graffiti*, the wall and sidewalk markings found in all human communities. Perhaps writing or drawing on walls is a primitive expression of primitive personalities; or it may be the universal manifestation of that fear of empty spaces which has been the origin of so much decorative and magical art in the past. In our own time, graffiti may symbolize the remoteness of the dominant "museum" art from the lives and interests of the people as well as an expression of displeasure with the austerities of metal-skinned architecture. At any rate, Dubuffet has been powerfully attracted to graffiti as a source of imagery and to debris as a source of materials. He has created works out of butterfly wings, tobacco leaves, papier-mâché, metal foil, driftwood, banana peels, fruit rinds, coal clinkers, and dirt. In his art we see a special case of the general interest among artists in discarded and worthless materials.

The refuse of an industrial civilization strongly oriented to the production of consumer goods is, of course, enormous in amount and variety. Moreover, it possesses a built-in visual history: we can see what it set out to be, how it was used, and how it came to be discarded. For an artist like Dubuffet, there seems to be an obsessive delight in employing garbage of one sort or another *in place of* conventional oil paint or in conjunction with it. Like so many contemporary artists, he seems to be anxious to demonstrate that the excellence of a civilization is not measured by its rate of consumption; that values can be created out of apparently insignificant materials; that the human contribution is the most important ingredient of all.

Industrial debris, garbage, botanical fragments, and the earth itself—stones, minerals, dirt—provide the materials of "painting" now that the brush and pigment are being either displaced or combined with refuse. In many respects, they are more difficult to work with than paint. Inventing problems with materials—problems which must be overcome in order to reach some significant level of artistic statement—may be an unconscious expression of the burdens and frustrations of painterly freedom. The constraints of indirect technique are gone. There is no hierarchy of subject matter: any theme is as good as any other. The hostility of the art-interested public toward experimental art has all but evaporated. Moving from a social position of alienation, painters are often celebrated personages—culture heroes who are supported by foundations, employed as "stars" by universities, and encouraged to exhibit their work in the new museums and cultural centers springing up each month. This combination of social acceptance and absence of technical restraint seems unnatural, not only to the older artists who remember the years in the wilderness, but also to younger performers who have not known any other creative environment. Their uneasiness stems from the nature of artistic effort, which seems to require some kind of resistance—the recalcitrance of materials; the limitations and requirements of sound technique; the Philistinism of

TOM WESSELMANN. *Still Life No. 15*. 1962. On permanent loan to the University of Nebraska Art Galleries, Lincoln, from Mrs. Adams Bromley Sheldon

we do not see this imagery, we hear it described for us through other media. To carry on our normal lives, we have become *adjusted* to the world of public images; that is to say, we do not really see them, or we learn to see them selectively. Pop (for popular) artists have chosen this world as the source of their *own imagery*, and appear determined to make us see what our nervous systems have mercifully managed to suppress.

Large scale is an important part of the strategy of Pop. An enormous slice of pie by Claes Oldenburg; a magnified comic strip by Roy Lichtenstein (born 1923); a bread-and-catsup ad by Tom Wesselmann—these drive home with all the subtlety of a hard-sell radio commercial the blatancy of our visual environment. A second feature of Pop is repetition, mechanical repetition, as in *Marilyn Monroe* by Andy Warhol (born 1931). One persuasion technique of radio and television spot commercials is constant repetition—a device which eventually overcomes indifference or resistance. Warhol uses visual repetition without variation in his painting and in his three-dimensional "sculptures"—reproductions of containers for soap, soup, breakfast foods, and so on. Obviously, he is not selling the product, he is pointing out the fact of visual repetition.

the public; poverty; outrage; indifference. When these elements are absent, the artist contrives somehow to reintroduce them into his technical procedures, or his subject matter, or both. Such an explanation would help to account for the extraordinary variety of materials in assemblage and the pronounced interest in themes which might shock the apparently unshockable middle classes of the mid-twentieth century.

POP ART AND COMBINE PAINTINGS

We know that everything in the man-made environment has been designed, given an appearance to help it perform some function. In much of the environment, design is commonly used to communicate, to persuade, to entertain, to sell, or to decorate. An enormous amount of visual material is produced and reproduced in the carrying out of these functions. Not only are signs, labels, posters, and packages designed, but the products they advertise are also designed. Hamburgers and hot dogs, soft drinks and bathing suits, automobiles and rocking chairs—all have shape and color more or less arbitrarily given them by designers; and their images saturate our surroundings, greeting us on television, jumping out from road signs, enveloping the reading matter in newspapers and periodicals, and mounted on groceries in supermarkets. When

ANDY WARHOL. *Marilyn Monroe*. 1962. Collection Vernon Nikkel, Clovis, New Mexico

CHARLES MCGOWEN. Photograph of raindrop reflections in a screen door. 1970. We can see a marvelous repetitive order in the chance interaction of natural and man-made structures. But nature is less resolute than man: given the slightest opportunity by the shape or dimension of the wire mesh, nature affords variety, or, at least, relief.

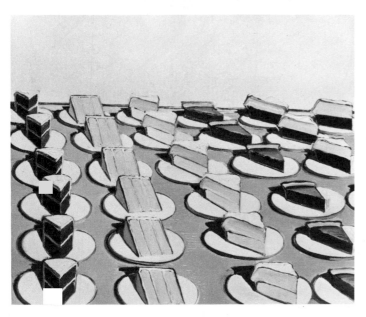

WAYNE THIEBAUD. *Pie Counter*. 1963. Whitney Museum of American Art, New York. Gift of the Larry Aldrich Foundation Fund

Anonymity is another feature of Pop. Robert Indiana's paintings of stenciled signs betray nothing of the personality of the artist except his lettering skills and determination to paint the sign. Warhol's Campbell's Soup labels—hundreds of them—might have been painted by some other, equally meticulous, painter; Lichtenstein's choice of a comic strip image may be his, but we see little in its execution which refers to the artist except that he created the work. Some thought, skill, and effort are visible, but they do not seem to belong to any particular artist. In this respect, Pop echoes the homogenized character of the designed environment as contrasted with the highly individualized, egoistic creations of contemporary fine art. Some of the Pop artists seem to be saying that the way to be truly original is to suppress all visual evidence of originality.

Other Pop artists, such as Robert Rauschenberg, Jasper Johns, and James Rosenquist, betray a more personal approach to painting while still drawing on popular imagery with varying degrees of literalness. Rauschenberg (born 1925) appears to control his material more as a conventional painter of "pictures" does,

KURT SCHWITTERS. *For Kate*. 1947. Collection Kate T. Steinitz, Los Angeles

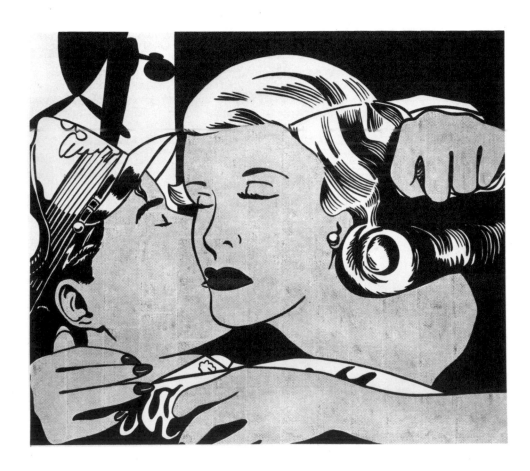

ROY LICHTENSTEIN. *The Kiss*. 1962. Private collection. Does this enlargement of the comic-strip version of romance constitute a critique of our mores, or is it a search for significance in the meticulous rendering of the banal?

ROBERT RAUSCHENBERG. *Canyon.* 1959. Collection Mr. and Mrs. Sonnabend, Paris

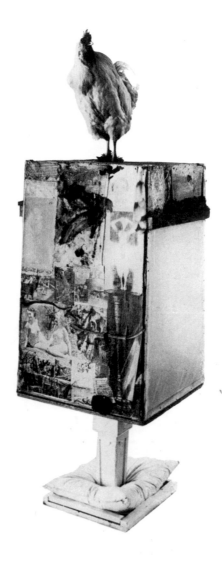

ROBERT RAUSCHENBERG. *Odalisk.* 1955–58. Collection Mr. and Mrs. Victor W. Ganz, New York

using devices of visual dominance and subordination, as opposed to the "straight," unadorned presentations of Warhol and Lichtenstein. His work grows more organically out of Abstract Expressionism than that of his fellows. However, as compared with action painters in general, he is more inclined to paste up or silk-screen an image than to paint one. He applies paint and attaches objects to images already manufactured by the world of commerce, his vision being essentially that of the collagist. Perhaps the work of Rauschenberg and the other, less painterly Pop artists signifies that the "hand-painted" image is dead. Henceforth, imagery will be *confected* of interchangeable parts manufactured in many distant places and for purposes unrelated to art.

Rauschenberg's "combine" paintings exhibit the free association of many of the stylistic and technical developments of twentieth-century painting. In such a work as *Canyon* (1959), the principal ingredient is collage together with attached three-dimensional objects—a stuffed eagle and a suspended pillow—plus painted areas, paint drippings, and a stick nailed to the wooden picture support.

The work does not easily lend itself to interpretation in terms of any meaning or idea which the materials and their organization seem designed to embody. Like other examples of Pop art and of Dada art before it, the prevailing theme is nonmeaning, the absurd, or antiart. But the choice of poster fragments, of banal or sentimental photographs, and of material from the world of point-of-sale and window display provides some indication of the ideological realm in which the painting dwells: it is a world of simultaneous fascination and disgust with the visual environment, particularly as it is manifested in hard-sell advertising, packaging, labels, trademarks—in the printed forms of popular culture. The early use of printed matter by collagists like Picasso, Braque, and Gris was based on the color, texture, and "reality level" of these materials. Pop artists, however, appear to be interested in the *semantic content* of the material they paste up and assemble: they also seem determined to present its original purpose and meaning in the ugliest or silliest context. Rauschenberg has gone so far as to use paint smears and drippings which simulate mud or other

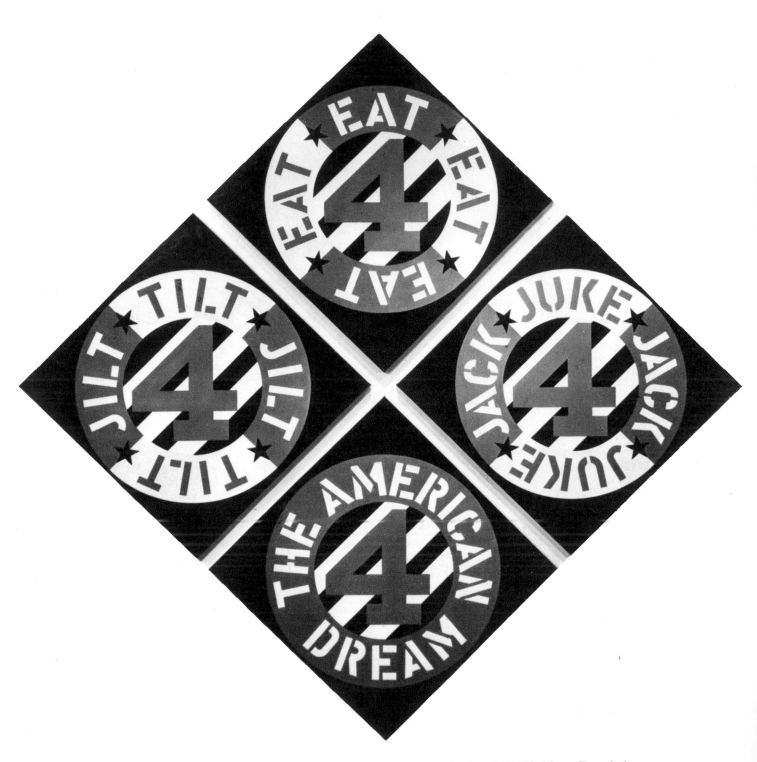

ROBERT INDIANA. *The Beware-Danger American Dream #4.* 1963. The Joseph H. Hirshhorn Foundation

substances thrown at a wall. The "splatter" idea is pervasive in modern painting—from Ernst, to Hofmann, to Pollock, to action painters, to Niki de Saint-Phalle. It may be the most graphic symbol of defiance and contempt which can be applied to a flat surface. In the work of Rauschenberg, however, the splattered paint is more nearly a gesture of annoyance—with the subject? With the viewer who persists in trying to discover a message? With himself for approaching a pretty surface too closely? We are not likely to find out.

A principal problem of some Pop artists lies in their inability to decide what stance to take toward visual phenomena. It is difficult when viewing works of Andy Warhol, Robert Indiana, or Roy Lichtenstein to discover whether they are repelled by the "ordinariness" and commercialism of the environment or whether they are endeavoring to *embrace* the environment, accepting it uncritically, and seeking to merge with it. One looks for signs of a point of view, an artistic statement of approval or aversion. But we seem to receive only an exclamation point. It is fairly clear that Pop offers no new "internal" developments for painting; its more-or-less Cubist formal language is not original. It is a thematic art; hence it raises questions of attitude and value orientation. Perhaps the movement will produce significant statements of an aesthetic, social, or formal character as its adherents develop and gain insight as artists and human beings. But since styles of painting succeed each other rapidly in the present artistic climate, a new style is given wide exposure and acceptance somewhat prematurely; then it is displaced quickly by another vogue before, it would seem, there has been enough time (for Pop, or Op, or Minimal) to exploit its distinctive vision of the world.

HAPPENINGS

Architecture has traditionally been the art of creating a physical environment in which people can live or work. Painting and sculpture were originally *part* of architecture: they were features, focal points, of the architectural environment. Now some painters are involved in an endeavor to go beyond architecture, to create a living environment which changes while it exists in space and time. Instead of being a statement *about* life, painting becomes an activity which is coextensive *with* life, *which is lived as it is created*. Unlike ordinary pictures, the new "paintings" are not perceived from the outside, but are created from within by the spectators who move through them (in collaboration with the artist who prepares the setting). Such works have been designated by their inventor, Allen Kaprow, as "surrounding[s] to be entered into" or "Happenings" and "Environments."

The Happening grows out of collage and the type of Environment created by the Dadaist Kurt Schwitters (1887–1948) in his famous Merzbau constructions of the

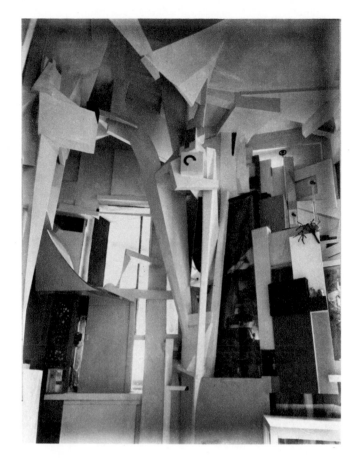

KURT SCHWITTERS. *Merzbau*, Hanover. 1924–37 (destroyed)

1920s. Built in Schwitters's home in Hanover, the earliest Merzbau might be described as an architectural collage, a division and modulation of interior space using refuse and found objects as structural and decorative elements. Schwitters worked on it for several years, bringing it to completion around 1924 and giving it the title *Cathedral of Erotic Misery*. A subsequent Merzbau (*Merz* may be an abbreviation of *Kommerz*, commerce, or of *Schmerz*, pain; *bau* means construction or building), dated about 1933, is more architectonic, less reminiscent of collage techniques. It appears to bear the influence of the design experiments conducted by the De Stijl group, especially by Van Doesburg. Schwitters built little grottoes into his constructions, dedicated them to friends, and incorporated in them discarded clothing and similar "nonart" items, much as Robert Rauschenberg includes old socks in his paintings, or as James Dine (born 1939) makes bronze casts of light bulbs. Schwitters is quoted as having said, "Anything the artist spits is art." The aesthetic outcome of such a viewpoint is the glorification of scabrous materials and unimportant objects which have nonart or antiart connotations.

Schwitters had conventional academic training and painted conventional portraits to earn his living. His collages and Merzbau constructions stemmed partly from his rejection of traditional painting as a serious form of

expression and the generally nihilistic climate of Europe in the 1920s—a climate which accounts for the strange humor of Dadaism, its inversion of all established values, its peculiarly negative wit. On the positive side, however, Schwitters was attempting through collage and his constructions to arrive at a synthesis of the arts of poetry, architecture, painting, and drama. He was apparently a versatile and spectacular personality. But his creativity flourished in the generally disillusioned environment of Central Europe after World War I—an environment characterized by disastrous inflation and economic decline, and by the rise of Fascism. These conditions combined to create a watershed in history for many artists and intellectuals. The end of the war initiated a new mode of feeling which was taken up by many Europeans who felt trapped by the war and betrayed by their civilization. For them, the forms, values, and institutions that had

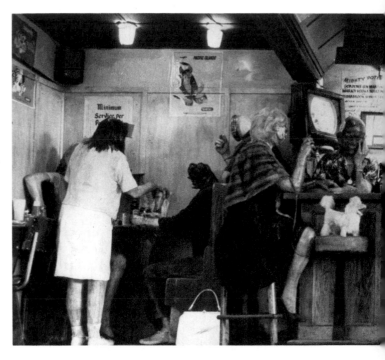

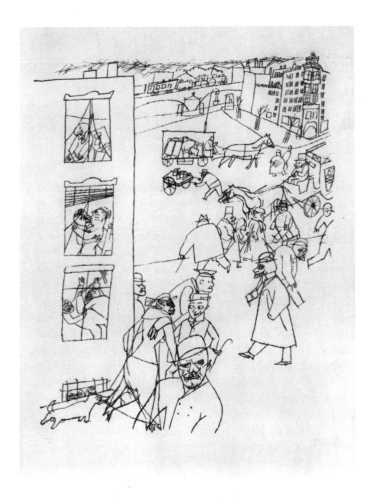

George Grosz. *Street Scene*. Date unknown. Philadelphia Museum of Art. Purchase, Harrison Fund. Perhaps the most cynical and contemptuous version of postwar German life is found in the painfully satirical drawings of George Grosz.

existed up to and through World War I were associated with systems of thought and behavior which had failed miserably. It is against this background that Dadaism and its products must be seen.

The Happenings and Environments of the contemporary painting scene may be regarded in part as more formalized and ritualized versions of the Dadaist events and antiart of the 1920s. In one reported incident, Schwitters took the discarded socks of a friend, cast them in plaster, and incorporated the casting into one of his Merzbau grottoes. Such gestures, which are repeated in contemporary art with or without knowledge of their earlier occurrence, exhibit features common to other expressions of revolt in the visual art of the twentieth century. (1) As already mentioned, discarded materials and debris are preferred to traditional media. (2) There is a deliberate avoidance of "beauty," especially of Mediterranean conventions of form. (3) The gesture of creation is perceived as more important than its outcome. (4) Humor results from the defiance of authority, of established norms, or of the values authorities admire. (5) Only absurdity is meaningful. (6) The gap between art and life is reduced as much as possible. (7) Caves and grottoes proliferate—both Happenings and Merzbau constructions are explorations and decorations of interior, womblike spaces.

A relatively little-known American primitive artist, Clarence Schmidt, has created a series of grottoes within his winding, cavelike house on a hill in Woodstock, New York. Schmidt, who has general carpentry and building skills, has had no formal artistic training, and is almost certainly unaware of the Dada art of the 1920s, much less

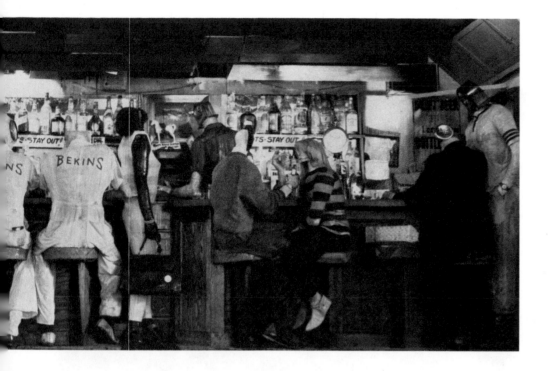

of Schwitters. Yet his fantastic house can be compared in all important respects with the Merzbau constructions. Like Schwitters, he also recites poems of his own composition, but probably thinks of them and of himself as following in the tradition of Walt Whitman. The Happenings of Allan Kaprow and his group (the principal Happening impresarios are Kaprow, Claes Oldenburg, Jim Dine, Red Grooms, and Robert Whitman) are also a synthesis of poetry and space organization. Apparently the primitive artist and the sophisticated artist are equally stirred to recite, perform, gesture, and *live* in their own constructions. Schwitters's Merzbau was located in the basement of his house and grew by accretion until an attic tenant had to be evicted. Schmidt lives in his "house" and adds to it continuously, so that on the inside it resembles a "many-chambered nautilus," with new rooms and grottoes emerging almost organically as the construction winds down the hill or burrows into the earth.

The Happenings of Allan Kaprow are more formally staged. They call for a script or scenario which serves to articulate the time element, while people, as spectators or actors, move through the garage or gallery where the event takes place. Kaprow says that these events grew out of his work in collage and assemblage, and he lists the typical collage materials used: "painted paper, cloth and photos, as well as mirrors, electric lights, plastic film, aluminum foil, ropes, straw; objects that could be attached to, or hung in front of, the canvas along with various sounds and odors. These materials multiplied in number and density, extending away from the flat canvas surface, until that pictorial point of departure was eliminated entirely and the whole gallery was filled. I termed this an environment." As the two-dimensional confines of the canvas were left behind, real environments were simulated: "a subway station, penny-arcade, forest, kitchen, etc." The gallery gave way as a place for staging Happen-

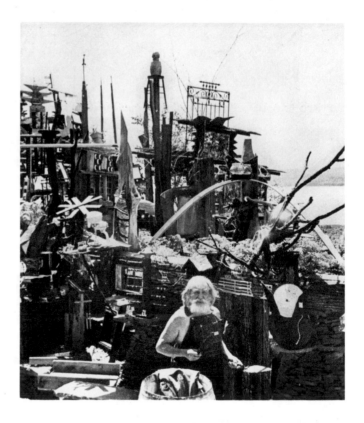

Photograph of Clarence Schmidt in residence, 1964

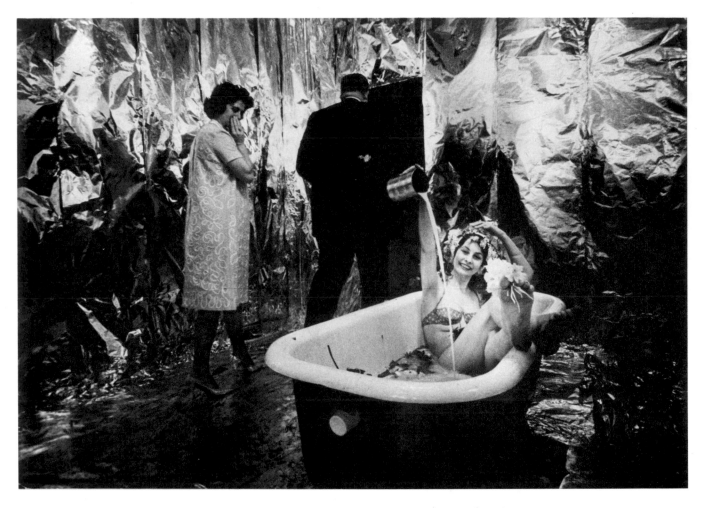

ALLEN KAPROW. From *Orange*. Happening. 1964

A form of expression that wants to escape framing, geometric positioning, specific location in time or space. Art without limits cannot be exclusive; everyone gets into the act.

RED GROOMS. From *The Burning Building*. Happening. 1959

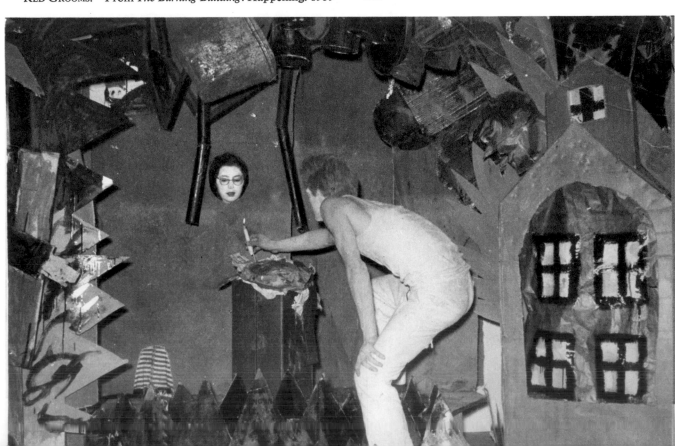

ings to "a craggy canyon, an old abandoned factory, a railroad yard, or the ocean side."[25]

Unlike conventional theatrical performances, Happenings do not have a developed dramatic structure—that is, a beginning, a middle, and an end; plot and character development; climax and denouement. They retain their connections with assemblage as orchestrations of the visual elements with new elements introduced from other art forms and areas of human experience—movement, sound, speech, and odors. They are, in short, paintings or assemblages moving in space, with the addition of nonpainterly elements which function as extensions of shape, color, texture, and light. Kaprow defines his Environments as "slowed-down, quieter, happening[s]"—as large-scale dioramas which can last for several weeks, while the Happenings compress time and last for only a few hours. Of course, motion pictures have not only better technical devices for the compression or expansion of time but also the further advantage of being reproducible many times; in contrast, the Happening contains so many spontaneous elements that it is confined to a single viewing and enactment. However, the impermanent character of Happenings is intentional. Happenings deliberately stress the transient nature of what man creates and anticipate the ultimate obsolescence of any work of art by causing themselves to disintegrate almost immediately as objects and events.

What is the future of the Happening and what is its meaning for painting? The Happening bears a superficial resemblance to theatre, but is dramaturgically clumsy because complex spatial-temporal events cannot be structured with sufficient precision to maintain control of its form. Only in the film, with its cutting, montage, and flashback techniques, can one manipulate the time dimension without losing pictorial control. As sculpture or as painting, the Happening surrenders the monumental and durable character of these art forms, their capacity to linger before our vision, for a while at least, and thus to permit the kind of visual exploration which the human organism seems to require and to enjoy. Yet the collage and assemblage antecedents of Happenings and Environments suggest different objectives. Happenings by Kaprow and Environments-plus-Sculpture, like those George Segal creates, appear to be efforts to discover the hidden ritual—that is, the sacred ceremonial element—which lies just beneath the surface of ordinary events in everyday life. Like Schwitters and Dubuffet, these younger men are trying to find the meaningful in what is apparently worthless and meaningless. In this respect, they are following the honorable tradition of Chardin, who painted common kitchen utensils, and of Courbet, who painted ordinary men performing menial tasks. Art has always tried to redeem the world by finding significance in rejected elements of experience.

The Happening, however, would not appear to constitute a vehicle of major aesthetic value. It serves better as a type of creative discipline for the artist, as a means of stimulating and focusing his perceptual energies on realms of experience which must eventually find their way into painting and sculpture. Some art forms and some artistic operations perform an instrumental function for the creation of other works of art. (Jim Dine, who no longer creates Happenings, says of his work in that mode: "I do not feel that there was enough of a perspective between art and life in them. . . . And I also felt that it was taking too much from my painting, which I really wanted to do.")[26]

Painters, for example, are often stimulated by literature, music, the dance, and film. Drawing and collage serve to collect a variety of sensations and experience on two-dimensional surfaces where they may be conveniently exploited by the painter or sculptor. But the kinds of experience which drawing and collage can compress into manageable and useful form appear to be too limited for many contemporary painters and sculptors. They require an instrument which does more than reflect what is seen in concise form. Like scientists, artists need a device which *interferes with* observed reality, which can take events apart and reveal their new or unsuspected meanings. It would appear that Happenings and other similarly bizarre manifestations of creativity constitute new artistic strategies—strategies which were foreshadowed in techniques like frottage, Merzbau constructions, Surrealist automatic writing, and in the nihilistic stunts and gestures of that troubled generation which lived between the two wars.

OP ART

In Op, or optical, art, which followed the premature decline of Pop art in 1964, painters attempted to construct works that would rely for their effectiveness solely on the physiology of the act of vision. In a sense, the color divisionism of Seurat (with its dependence on afterimages to create colors that were not present as pigment), and Joseph Albers's chromatic venerations of the square, were precursors of Op art. Its practitioners employ mechanical motion, artificial light filtered through prisms, images which shift depending on the viewer's angle of vision, and a variety of mechanical devices to produce optical sensations which conventionally painted canvases could never arouse. The sophisticated optical knowledge of modern physics was brought into the realm of aesthetics by Op; the sociological comments of Pop gave way to an art which bypassed the mind and imagination of the viewer, appealing to him as a physiological entity. And the effectiveness of Op on its own terms is undeniable; it produces feelings of disorientation or exhilaration purely by visual means, without recourse to alcohol or drugs.

The desire to transform the physical basis of consciousness has always been latent in painting, and in Mark Rothko's work, as was mentioned earlier, it has become

an explicit objective. Op art appears to be a systematic attempt to take hold of the human organism through its visual sense and to change first its somatic, and then its psychic, state.

The similarity of Op's objectives to those of modern biochemistry may be only coincidental. (Control of attitudes and emotions now seems within the grasp of biochemistry; hence the current interest in an information-and-education approach to attitude-formation that is supplemented by drugs and chemicals.) Nevertheless, Op has brought about the discovery of new powers in painting; and painting, as a result, has found a new *raison d'être*, a new claim on human attention. Now art can compete with tranquilizers and "pep" pills as a depressant or a stimulant. Even Matisse said he dreamed of an art "which might be for every mental worker . . . like an appeasing influence, like a mental soother, something like a good armchair in which to rest from physical fatigue." For the present, Op seems more effective as a stimulant than as a pacifier. Psychoanalyst Anton Ehrenzweig has compared it to a plunge into a cold shower. But surely an art capable of producing such physical effects will also be able to induce the soothing feelings Matisse longed for.

As objects of aesthetic value, Op works are not easy to judge. They cause precisely the difficulty which Professor Lipps (p. 353) regarded as an obstacle to aesthetic

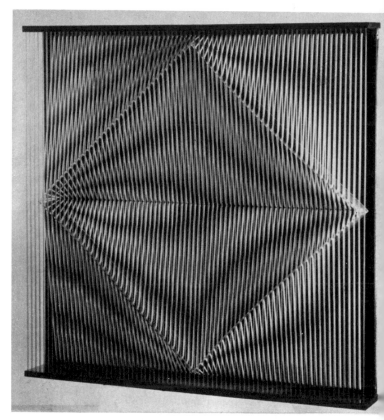

YVARAL. *Acceleration 19, Series B.* 1962 The Museum of Modern Art, New York. Gift of Philip C. Johnson

BRIDGET RILEY. *Blaze I.* 1962. Collection Louise Riley, London

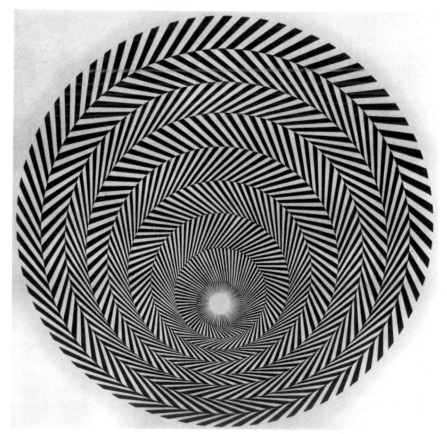

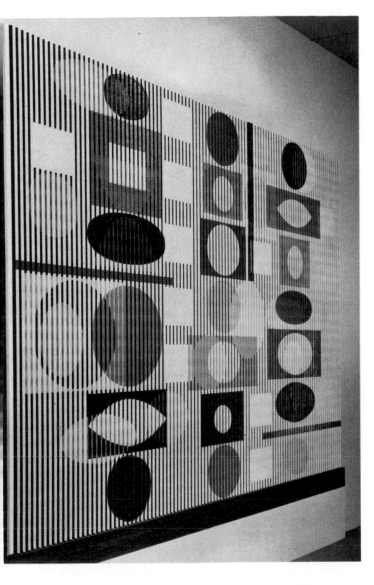

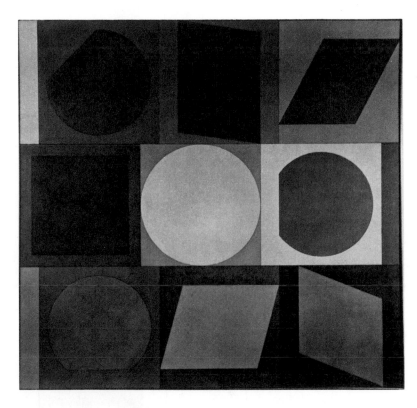

response—awareness of one's bodily feelings. Also, the single-minded pursuit of purely optical responses results in an experience of impoverishment for those who expect more explicit emotional, intellectual, or formal nourishment from art. West Coast painter Jesse Reichek comments: "The question seems to be whether optical tricks that massage the eyeball, and result, in some cases, in physiological effects, provide a sufficient task for painting. I don't believe such tricks are sufficient."[27]

Compared to the Neo-Plastic art of Mondrian and the De Stijl group, Op art arouses reactions which are quicker, easier, more physical, and less intellectual. But it is doubtful that Op will have the sustained influence on product design which Mondrian's Neo-Plasticism had. Moreover, the movement has not articulated a philosophic rationale, which would have been needed to guide its further evolution. Therefore, it appears to have been arrested at a stage more related to physics than aesthetics —a stage where its discoveries are not convincingly integrated within the humanistic mainstream of art.

Minimal and Color-Field Painting

Reductionism and retrenchment are persistent tendencies in recent art. If painting can cast off some of its inherited baggage, some artists feel it will have a better chance of being itself. Of course, painters differ about what is essential and what is expendable in their patrimony. They need to redefine their art periodically, to breathe and work in an aesthetic environment unconstrained by the aims of their predecessors. For minimal and color field painters, these inherited aims are emotional expression, symbol making, social comment, and deliberate disclosure of the self through visual imagery. Their art reacts against styles allied to history, literature,

JOSEF ALBERS. *Homage to the Square: Red Series—Untitled III.* 1968. Pasadena Art Museum, Pasadena, California. Albers established an important precedent for minimalist painters by showing that pictorial values can be generated almost solely through the color interactions of simple geometric forms.

AD REINHARDT. *Abstract Painting Black.* 1960. Whereabouts unknown. Reinhardt's goal was to create paintings which would be something while closely approaching nothing.

politics, psychology, and religion. What is left? Perhaps beauty.

The seeds of this art may have been sown by such pioneers as Malevich, Kandinsky, Mondrian, and, more recently, Albers. A forceful polemicist was the late Ad Reinhardt (1913–1967), who said: "Art-as-art is a concentration on Art's essential nature. The nature of art has not to do with the nature of perception or with the nature of light or with the nature of space or with the nature of time or with the nature of mankind or with the nature of society."[28] Art's modernist practitioners want to create forms meaningful in themselves, perfect to behold and unsullied by contact with the flawed and mutable world most of us occupy much of the time. This is not to say that minimal art is necessarily classical in style; rather, it aspires to the status of ultimate form, behind which there is nothing more, less, better, worse, or the same as.

In appearance, minimalist canvases are large, abstract, bright, often hard-edged, and highly simplified or flat in color. They tend to suppress figure-ground relationships created through overlapping, color value differentials, and perspectival devices; and, most particularly, they eschew the "handwriting" of the painter, as in Abstract Expressionism. Hence, there is a certain anonymity about their forms and painted surfaces (although not in their overall design) which leads the viewer to feel he is in the presence of a mass-produced industrial object. We shall

ROBERT MOTHERWELL. *Open No. 20.* 1968. Marlborough Gallery, New York. The issue raised here is almost wholly metaphysical: does the upper framing edge of the canvas constitute the fourth side of the window shown in the painting? If so, how, and if not, why not?

PATERSON EWEN. *Life Strewn with Time Intervals No. 8.* 1968. Dunkelman Gallery, Toronto. In the restrained vocabulary of minimal painting, Ewen's diagonal broken line functions as a gesture —not of a person, but of an idea.

Both Rothko and Olitski use shaping devices very sparingly—just enough to define vast fields of color which then acquire the traits of total atmospheres.

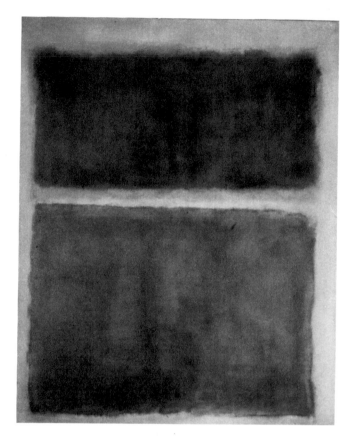

MARK ROTHKO. *Earth and Green*. 1954–55. Galerie Beyeler, Basel

JULES OLITSKI. *Prinkep*. 1966. Collection Kenneth Noland, New York

see the same result in minimal and serial sculpture, which is often manufactured industrially according to specifications written or telephoned by the artist.

Color-field painting is flexible enough to permit considerable variation—from floating mists to hard-edge geometry. It employs techniques such as staining unprimed canvas (which tends to hide signs of the brushed gesture); applying pigment with a squeegee, spatter device, paint roller, or airbrush; or flowing very diluted paint onto an unstretched canvas which is turned and

tipped to create form through controlled puddles, streams, and spills. Although these techniques afford much variety of edge and a wide range of depth, transparency, melting, and interpenetrative illusion, they consistently avoid the brushed look, the drawn line, and the painterly marks of wrist, fingers, and thumb. We are given to understand that it is the medium itself which does the job, combined with human intelligence, to be sure, but without those manipulative skills originated and nurtured by the tradition of handmade, mimetic imagery.

The Shaped Canvas

The rectangular canvas is one of many possible shapes. But it dominates all others mainly because of the Renaissance convention that a picture is a window opened on a world chosen or imagined by an artist and then painted illusionistically. The convention has been so thoroughly

absorbed by our culture that we are hardly aware of it, but it crops up in popular architecture as the "picture window." The design of a wall around a scenic or pictorial opening is a strange reversal of history, because pictorial imagery has usually been *subordinated* to archi-

tecture—in mosaics, stained glass, murals, and large-scale tapestries. Painting tends to "obey" externally determined formats; exceptions would be Baroque illusionistic ceilings and the portraits painted on Graeco-Egyptian mummy cases, where the painted image functions like a "picture window"—an opening that seems to show the deceased alive and well inside. This device derives ultimately from the even older tradition of painted effigies.

Obviously, the modern painter does not function within a tradition of effigy painting, of strict obedience to architectural surfaces, of illustration and decoration for the furniture of the Church, of fashioning theatrical illusions for stage scenery, or of simulating the world seen through an elaborately framed window. Accordingly, as the painted image ceases to decorate or symbolize something else, the shape of its container tends to be determined by necessities internal to the visual image or the processes of visual perception. The *shape* of the canvas becomes one of the expressive elements of the total work, but it does not act as a container, and is not part of the wall.

Having said what the shaped canvas is not, how can we explain what it is? It would appear that the virtual, or effective, image has become more important than formerly; the actual object on the wall is incomplete in itself. This is because the image, or "picture," is not consummated until it has organized the visual forces within the viewer's optical apparatus. The picture has shifted from the wall to the viewer's eye. The shaped canvas is a device for announcing the freedom of painting from

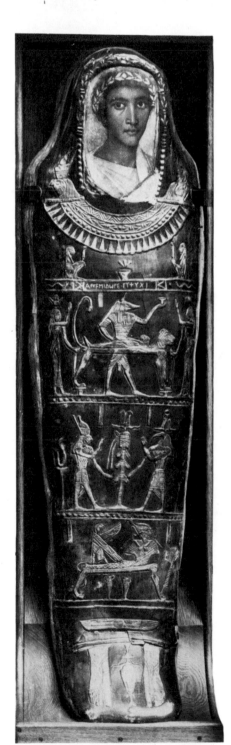

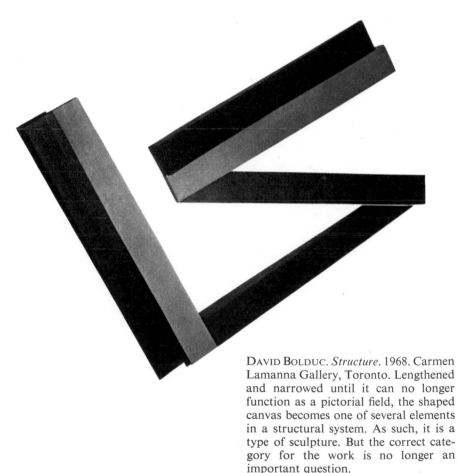

DAVID BOLDUC. *Structure*. 1968. Carmen Lamanna Gallery, Toronto. Lengthened and narrowed until it can no longer function as a pictorial field, the shaped canvas becomes one of several elements in a structural system. As such, it is a type of sculpture. But the correct category for the work is no longer an important question.

Egyptian mummy case with portrait of Artemidonis. 2nd century A.D. The British Museum, London

CHARLES HINMAN. *Red/Black*. 1964. Krannert Art Museum, University of Illinois, Champaign. New visual problems are raised for the painter who applies color to a surface of bent and curved planes. In addition, the irregular contour of the canvas sets up tensions that threaten to run away with the image.

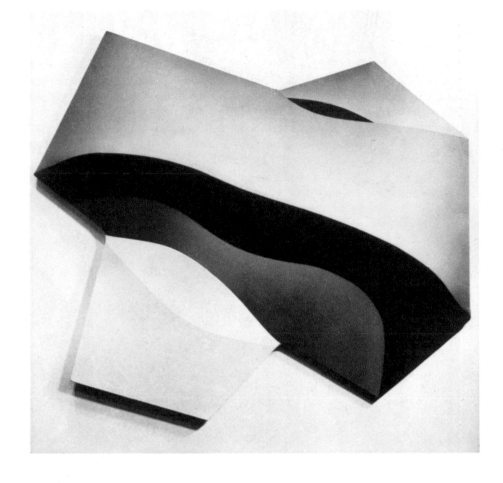

FRANK STELLA. *Sangre de Cristo*. 1967. Collection Dr. and Mrs. Charles Hendrickson, Newport Beach, California. A purely retinal "theology" is, of course, inconsistent with the theology of a man-god sacrifice. The title of this work functions as a device for deflating the viewer's conventional humanistic expectations.

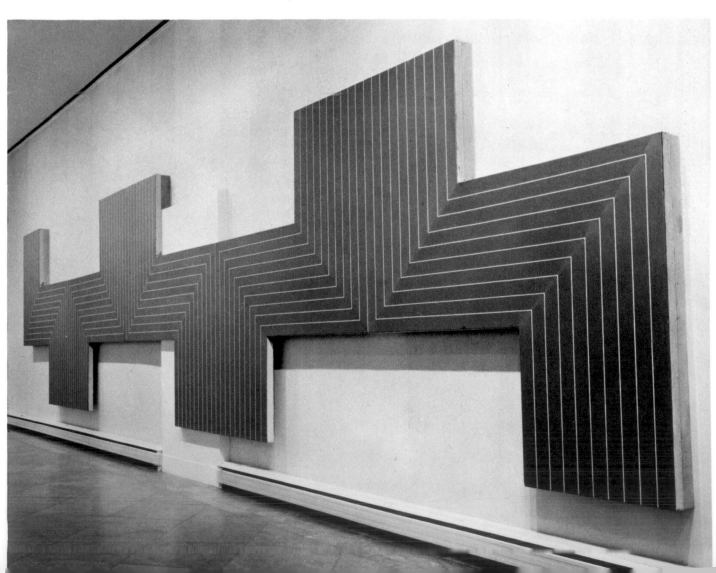

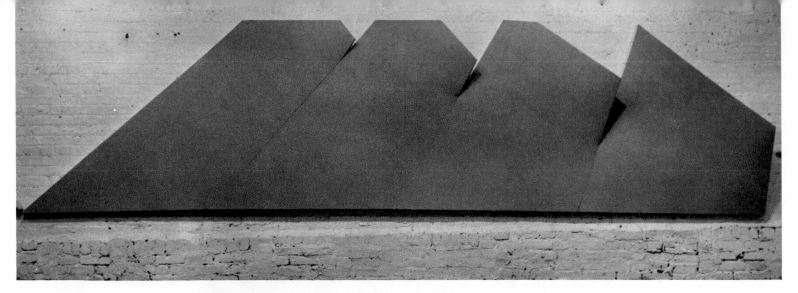

RICHARD SMITH. *Parking Lot.* 1967. Richard Feigen Gallery, New York. A series of notched triangular spaces grows progressively until it escapes its container, a quasi-rhomboid derived from the familiar pattern of diagonal parking. Fittingly for a shaped-canvas work, the significant action takes place at the edges.

the constraints of walls—of architecture. Unlike Op art, which employs more-or-less conventional picture-frame formats, the shaped canvas endeavors to organize the forces within the viewer's perceptual field by manipulating the outer edges of an image and introducing a variety of projections from its internal surface. Literally, of course, the shaped canvas hangs on a wall, it has three-dimensional properties, and it has to be perceived within a two-dimensional field. But we seriously underestimate the ambition of the shaped canvas if we think it is a type of painted sculpture affixed to a flat surface. Still, the strategy and tactics of this sort of painting have to be essentially planar—pictorial without being illusionistic. One cannot, as with sculpture, walk around a shaped canvas. So, if the painting has been liberated from architecture and yet falls short of free-standing sculpture, the only space it can effectively occupy is within the eye—retinal space. That is where this new kind of pictorial experience is designed to begin and end.

The older painting traditions endeavored to enlist the total apparatus of vision, not the optical organ alone. Humanists, especially, were concerned about the career of the image *after* it ceased to be a retinal projection. Now,

however, much is known about the physics and biochemistry of vision. Artists do not necessarily share in this knowledge, but they do know that the retina is an arena where complex, dynamic forces interact. This knowledge has created the possibility of an art whose ambition is almost exclusively retinal—an art which defies interpretation along symbolic, cognitive, and affective lines. As Frank Stella comments: "I always get into arguments with people who want to retain the old values in painting, the humanistic values that they always find on the canvas. My painting is based on the fact that only what can be seen there is there. It really is an object."[29]

The painters who want to execute maneuvers to affect the retina, primarily, deem it best to *begin* with the shaped canvas. Without the distractions caused by the old picture-frame conventions, they can more readily succeed in stimulating new sensations of space on the retina. Necessarily, their goals entail geometric forms, hard edges, flat surfaces, and more-or-less uniform coloration—which is to say, an absolute minimum of tonal variation. Only this stringent discipline, it seems, will succeed in carrying out the shaped canvas agenda: the creation of an art that ends within the eye.

Erotic and Obscene Art

One of the earliest functions of visual art was the stimulation of sexual feeling, if only to encourage human reproduction during the struggle of the species to survive the attrition of nature, war, and disease. But erotic art continues to be created in societies that have passed beyond the nomadic and tribal stages of culture. In the present day, when human overpopulation is an urgent concern, there has nevertheless been a pronounced

increase in the creation of works devoted to sexual themes. Some persons react with a sense of being liberated from what they feel are repressive and unjustified inhibitions on the expression of healthy erotic feelings. Others are deeply offended: they perceive erotic art as pornographic or obscene and fear that necessary restraints on the expression of human sexuality are breaking down in our civilization.

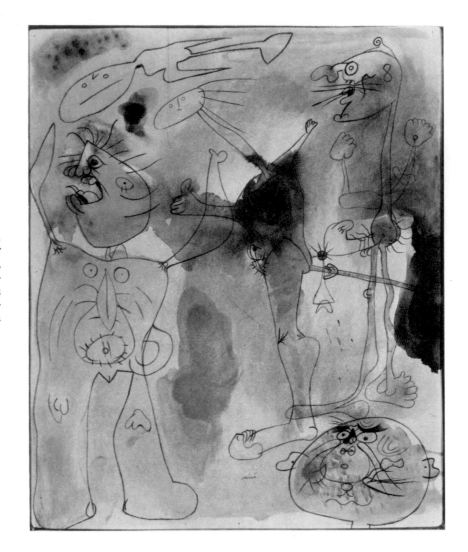

JOAN MIRÓ. *Persons Haunted by a Bird.*
1938. The Art Institute of Chicago. Peter
B. Bensinger Charitable Trust. In 1938,
Miró's phallic fantasies could be assimi-
lated by the Surrealist format of dream
symbolism and sexual horseplay. But be-
fore he was a Surrealist, Miró was a
humorist.

PAUL CÉZANNE. *The Bathers.*
1899. The Museum of Modern
Art, New York. Lillie P. Bliss
Bequest. The human figure
presented only pictorial and
"architectural" problems for
Cézanne; he could not see its
spiritual dimension—its role as
the subject and object of love.

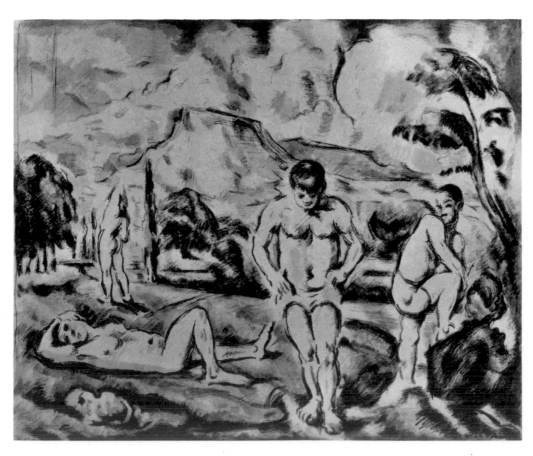

The public celebration of the human body, especially the female nude, constitutes a well-established tradition in Western art and culture. However, it has always been accompanied by a more-or-less clandestine art in which the human figure is shown in relation to explicit sexual practices. Now, in the permissive climate of contemporary culture, that formerly clandestine art is created and exhibited openly. The change we witness is not so much in the fact that erotic art exists but that it is abundantly visible; it is a transformation in popular attitudes toward the acceptability of an art whose theme is human sexual behavior in its many types and variations.

Without doubt, some erotic art is created as a mode of protesting against those institutions, values, and standards of behavior cherished by the so-called Establishment. As such, it is part of the intergenerational conflict which has grown so intense in all the industrial nations of the world. Viewed as a tactic in a generational struggle, its unlovely or obscene content becomes explainable: it deliberately endeavors to wound and offend by celebrating what an older society profoundly felt to be wrong, dirty, and ugly.

However, there are also art historical reasons for the flourishing of erotic and obscene art. For at least a half century, the artistic imagination has been fired by the innovations and opportunities for elaboration afforded by abstract and nonobjective art. Even in its quasi-figurative manifestations, abstraction tends to divert those impulses we associate with sexual longing and expression. Much of modernist painting, for example, stems from the initiatives of Cézanne (1839–1906), an artist whose genius was peculiarly inhibited in the presence of the unclothed human figure—male or female. This is not to say that Cézanne did not often execute nudes, especially during his early career when he intently pursued an erotic vision of the female figure. But it appears to have been a vision uncongenial to his inclination as a painter and, possibly, as a man. It is more a structural than a figural legacy that Cézanne left us. Understandably, his artistic descendants have excelled where the master excelled. To the extent that the example of a single personality can dominate conceptually the evolution of several artistic generations, Cézanne's oeuvre has done so. His work stands in relation to modern art almost as the Epistles of Paul do to the development of Christianity; writing in the mid-twenties, Vernon Blake said: "We are all willy-nilly, consciously or unconsciously, the artistic children of Cézanne."[30]

The emergence of obscene art, then, may be ascribed in part to the difficulty artists experienced for half a century in perceiving the human figure warmly and affectionately. They shied away from the banal voyeurism of a Gérôme or à Bouguereau, on the one hand, and away from the hothouse eroticism of a Modigliani, a Pascin, or a Balthus on the other. We may suppose that as a result many gifted personalities invested their ardor in the fascinating problems of space and object organization

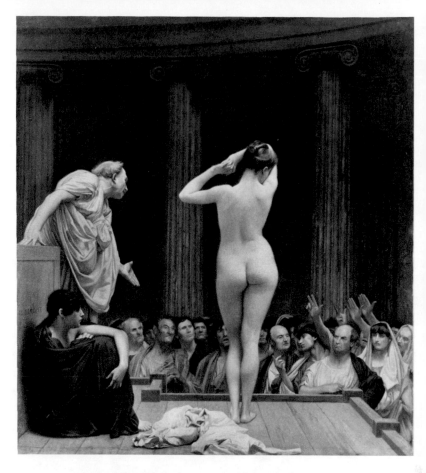

JEAN-LÉON GÉRÔME. *Roman Slave Market.* c. 1884. The Walters Art Gallery, Baltimore. The official art of the nineteenth century was often an exercise in disguised voyeurism. Under the pretext of teaching history visually, some painters catered to the prurient interests of the public.

BENNO FRIEDMAN. Buttocks photograph. 1969. Collection the artist

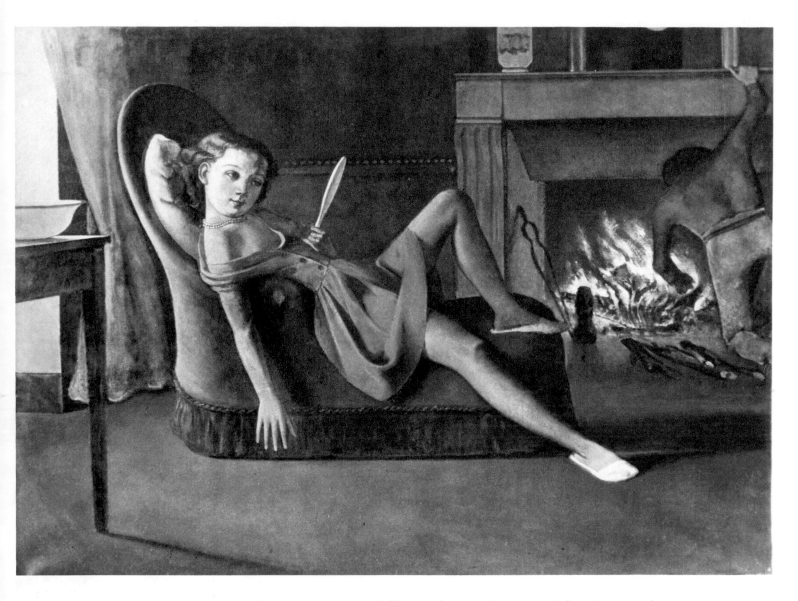

BALTHUS. *The Golden Days.* 1944–46. The Joseph H. Hirshhorn Foundation. The awakening sexuality of the girl adolescent has absorbed much of the career of Balthus. His art thrives on the conflict between bourgeois respectability, as represented by comfortable, well-appointed interiors, and the less-than-innocent reveries of good little girls.

TOM WESSELMANN. *Great American Nude No. 51.* 1963. Collection the artist. The reclining nude has a venerable history as a theme of Western painting. Thus Wesselmann presents the same subject but uses deliberate vulgarization, breaking with conventionalized treatment. As a result, the viewer is confronted with a type of nakedness to which he has not been habituated.

JEAN-AUGUSTE-DOMINIQUE INGRES. *Odalisque with a Slave.* 1840. Fogg Art Museum, Harvard University, Cambridge, Massachusetts. Bequest of Grenville L. Winthrop

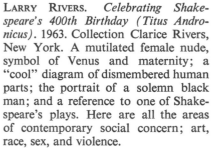

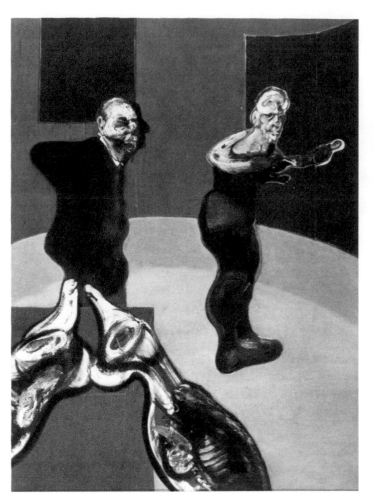

LARRY RIVERS. *Celebrating Shakespeare's 400th Birthday (Titus Andronicus)*. 1963. Collection Clarice Rivers, New York. A mutilated female nude, symbol of Venus and maternity; a "cool" diagram of dismembered human parts; the portrait of a solemn black man; and a reference to one of Shakespeare's plays. Here are all the areas of contemporary social concern; art, race, sex, and violence.

FRANCIS BACON. *Two Figures* (panel of a triptych, *Three Studies for a Crucifixion*). 1962. The Solomon R. Guggenheim Museum, New York. Today all the arts are free to deal with the theme of homosexuality. In Bacon's work, this motif is overshadowed by a consistently animalistic view of man—even in his efforts at love, which come to resemble the copulation of beasts.

opened up by the Post-Impressionists in the late nineteenth century and explored since then by the best talents of every artistic generation. But space is a medium in which human beings also move and encounter each other. A need is asserted, ultimately, to examine every kind of human encounter in all its figurative particularity. This assertion seems exaggerated and perverse when it appears in the form of erotic art, but it must be remembered that it has to contend with the expression of

anonymity on an enormous scale, as in minimal and serial art. To be sure, it is often prone to substitute lasciviousness and scatological shock for authentic erotic feeling, and at times it associates sexuality with pathological behavior, as in Rivers's *Titus Andronicus*. These are the excesses that accompany the easing of a long repression—societal as well as stylistic. But they will be moderated when the classical conventions for dealing with eroticism in art are rediscovered or reinvented.

Conclusion

The employment of trashcan contents in collage by Schwitters; the use of botanical materials, fruit rinds, and butterfly wings by Dubuffet; the incorporation of "real" objects in paintings by the Pop artists; and the Happen-

ings which create a fugitive art of short duration—these developments suggest new connections between painting and the culinary arts, gastronomy, spectator sports, psychodrama, and the theater. There is an analogy between

the machines fashioned for self-destruction by the Swiss artist Jean Tinguely and the elaborate dishes created by a chef to be eaten and visually destroyed in the act of consumption. The artistic element in food preparation and the aesthetic element in dining have often been the subject of discourse by philosophers; now the connection between a collage and a salad does not seem remote or absurd. There are works of art which seem to echo the processes of food preparation, eating, collecting the left-overs, discarding the refuse, and assembling it again. The ritual of dining is not very different from the ritualistic self-destruction of a machine or of a Happening which creates itself and is destroyed at the same time.

For many years, a popular act of the comedian Jimmy Durante was the tearing apart of a piano before a night-club audience. The process of decomposition possesses its own aesthetic fascination, as might be confirmed by anyone who has watched the wrecking of a building, a staged auto crash, or even a child knocking down a house of blocks he has laboriously built up. The "controlled compression" sculpture of César (p. 412) represents an effort to convert the ultimate destruction and transformation of an automobile into a constructive act. Thus, it constitutes a model for other artistic and quasi-artistic activities which have crushing, breaking, and dismemberment as their theme: they are efforts to discover an affirmative meaning in all the acts of needless destruction, senseless consumption, and nihilism which mark contemporary civilization.

Obviously, tearing down good buildings, ripping trees out of the landscape with bulldozers, scarring the earth with open-pit mining, disfiguring men's faces in prize-fights, producing goods which easily break, or testing thermonuclear bombs—these activities are strangely attractive to many of us; otherwise they would not be so widespread. Some artists, then, are engaged in seeking a constructive version of the all too human impulse to dis-member things.

Artists may not always know the import of their work; but civilization operates through them nevertheless, exploiting their fascination with materials and processes for what are, hopefully, humanizing ends.

SCULPTURE

Like painting, sculpture had its origin in the forming of figures for primitive magic and, later, for religious ritual. In viewing all subsequent sculptural developments, one should remember this early association of sculpture with magic. The ancient Greek myth of Pygmalion and Galatea symbolically expresses a number of fundamental insights into what sculpture is about. Pygmalion, a sculptor, fell in love with Aphrodite and, because she would not have him, made an ivory figure of the goddess and prayed to her. Eventually she took pity on the man and entered into the figure, giving it life as Galatea. Pygmalion then married Galatea, who bore him two sons.

All the essential ingredients of sculptural creation are present in the myth. The artist's motive for creating the work arises from an emotional crisis—a combination of personal yearning and cosmic anguish. The sculptor tries to control reality by fashioning an object that portrays the ideal outcome he desires. It is the pity of the goddess (a symbol of the magical power animating sculpture) which gives life to the artist's effort. He falls in love with an image he has created; hence art can acquire an autonomous life of its own. Out of the union of creator and created comes the continuation of his family line. That is, the somewhat morbid longing of a man for a goddess is converted into a healthy and living reality by his compelling skill with the palpable materials of sculpture. As always in magical art, there is an underlying assumption that materials cunningly wrought will oblige the gods to do what man wants.

Painting, too, has magical associations, but it requires the capacity to create and believe in airy illusions, whereas sculpture can give corporeal reality to man's hopes, memories, and fantasies. Consequently, sculptural works have served more prominently than painted images as vessels for the souls of departed chiefs and kings—as totems and cult objects among primitive men. The painted image seems to call for more capacity for symbolization than the sculptural image: viewers must be able to visualize the representation of space, volume, and texture in painting, whereas, for the primitive mind, sculpture does not represent or symbolize—it actually *is* what its maker says it is. Indeed, ancient sculpture was painted in order to fortify its claims to *be*, rather than represent, human personality.

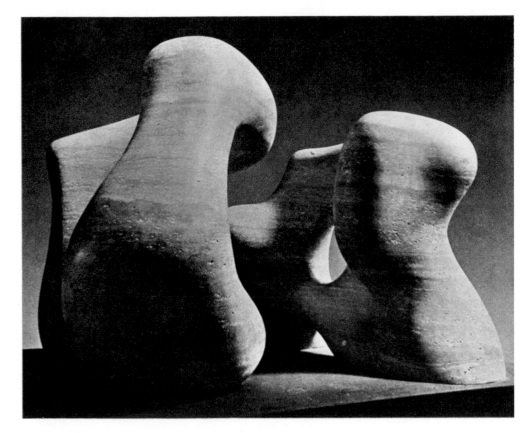

HENRY MOORE. *Two Forms*.
1966. Private collection, Zurich

The capacity of sculpture, no matter what its materials, to occupy real space and to compel belief in its claims to vitality, distinguishes it from painting and graphic art in general. Consequently, sculpture has remained, throughout its history of changing form, material, and social function, the same art which Pygmalion practiced—the art of making three-dimensional materials come alive in order to objectify human fantasies, record human personality and achievement, and satisfy human longings for perfection.

Modeling, Carving, and Casting

The sculptural processes are simply the most suitable ways of working available materials, and, where there is a choice of materials, the process chosen most likely reflects compatibility with the sculptor's personality. Obviously, stone can only be carved, drilled, abraded, and polished. It appeals to artists who are comfortable with highly resistant, obdurate materials. Wood lends itself to the same processes more easily; but in thin sheets it can be stamped, while modern technology permits it to be permanently bent and molded, as in Thonet and Eames chairs. Results come more easily here than with stone, but at the sacrifice of durability. Metals can be cast, cut, drilled, filed, extruded, polished, bent, forged, and stamped. More recently, powdered metals have been combined with plastic binders so that they can be modeled, almost like clay. They can be assembled durably by welding, soldering, and riveting, and with adhesives also. Plastics were brought prominently into sculpture by the Constructivists, although tasteless employment of plastics in imitation of other materials has created unfortunate associations which are only now being overcome. But there seems to be ready acceptance of metal sculpture no matter how it is fashioned. Metal is, after all, a plastic material which has had thousands of years of artistic use and visual familiarity.

It might be said that for traditional sculptors, mastery of the basic processes—modeling, carving, and casting—constituted the principal artistic challenges. Such mastery remains important, but it is not indispensable in today's sculptural expression because, as in painting, technology permits the forming and assembling of materials by other means. However, the modern sculptor confronts new problems of aesthetic choice due to greater variety and flexibility in the processes and materials available to him.

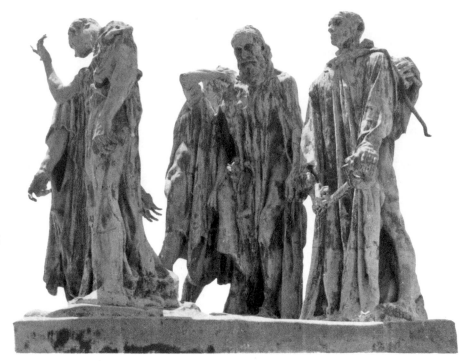

AUGUSTE RODIN. *Burghers of Calais.* 1886

WESSEL COUZIJN. Sculpture for Unilever Building, Rotterdam. 1963

When there are many alternatives, selection of material and process becomes a vital element in the meaning of the work. If the sculptor carves or casts, it is because these methods have a particular aesthetic significance, not because alternative processes are unavailable.

Monumental statuary has in the past been cast in bronze or carved in marble. Occasionally, concrete casting has been employed, but the material is suitable only for work which does not require subtle detail, which is to be incorporated into walls, or which is meant to be seen at a distance. Today, welded metal is growing more common in public sculpture, especially as the human figure recedes in importance and as abstract works gain acceptance. Naturalistic statuary, of course, must be modeled, then cast in bronze; or it must be carved in stone. Public buildings and parks still abound with statuary of this kind, and it continues to be commissioned by conservative patriotic groups and municipal bodies. But sculptors who can or will create such works are a diminishing minority. Contemporary buildings seem to be more friendly to sculpture which is, in general, more open, less monolithic in form than older works. Sculpture carved in marble, moreover, does not lend itself easily to the perforations, extensions, and surface qualities possible with forged, cast, or welded metal.

It is difficult, however, to conceive of a sculptural group like Rodin's *Burghers of Calais* being created through any process other than bronze casting. The psychological characterization of several figures; the naturalistic treatment of flesh, bone, and sinew; the range of surface subtlety in Rodin's group—these would be hard to achieve with modern welding or assemblage processes. Still, monumental work has been attempted by contemporary sculptors who have found an idiom which, while fulfilling the requirements of a monument, escapes, for example, the limitations of classical pediment sculpture, and its rather stuffy imitations. If the detail and nuance of modeling with clay or marble are sacrificed, still, a marvelous freedom of extension into space together with generous scale is now possible. Also, many of the techniques of industrial production and fabrication have been assimilated by sculptors today. The mallet and chisel have been joined by the acetylene torch, the hydraulic press, and the electronic welder.

The Greeks knew the art of bronze casting, and they also had an abundance of good white marble. They must have prized marble more for its durability than for its appearance, since their marble statuary was painted. It was not the stone's whiteness or texture they admired so much as its capacity to reveal their love of clear and stable forms, their understanding of the body and its anatomy in action or repose, and their conception of the ideal as embodied in the form of a surpassingly real and beautiful human figure. The Greek mode of thought and art constituted an effort to locate perfection in the here and now of men's vision and behavior. They chose marble to fix

POLYCLITUS. *Doryphorus (Spear Bearer)*. Roman copy after an original of c. 450–440 B.C. National Museum, Naples

MICHELANGELO. *Unfinished Slave.* 1513–16.
Tomb of Pope Julius II, Rome

the "now" forever, and they used a refined and calculated naturalism because they did not believe meanings or values should exist apart from men's bodies and actions. Sculpture for them was a means of demonstrating that perfection and reality could meet in forms which have human appearance and which can endure eternally. (It seems fairly clear that the Greek interest in permanence of form came from the Egyptian effort to preserve the soul through sculpture; in earlier cultures totemic figures were permitted to decay and were either forgotten or replaced.)

The greatest sculptor to follow the Greeks was Michelangelo, who believed his art was mainly one of releasing the forms and meanings hidden (perhaps imprisoned) within marble. Such an idea is not surprising in an artist influenced by Neoplatonic thought; it also typifies the sculptor who is a carver—one who begins with the stone block or the wood log and cuts away until the form in his mind's eye is revealed. Carving, a subtractive process, has always been considered the most difficult of sculptural processes because it calls for a well-defined conception of the result before the work of execution is begun. The carver subtracts the nonessential material in order to liberate the idea which already exists. And yet the grain of wood, ivory, or stone; their texture and density; their high compressive and low tensile strength—these significantly determine what forms will emerge and how they must be created. For example, diorite and basalt, used by the sculptors of ancient Egypt, are extremely hard granitic stones which resist detailed carving; consequently, Egyptian sculpture is characterized by large, simplified forms which adhere closely to the shape of the stone block as it was quarried. The well-defined prior conception of the work is therefore substantially at the mercy of the material when the actual carving takes place.

Michelangelo quarried his own marble and carved it himself directly. Subsequent carving practice allows the sculptor to make a small plaster model to serve as a guide for a pointing machine which enlarges and roughs out the major forms and dimensions accurately in marble or stone. Final, detailed carving and polishing can then be executed by the sculptor. This *indirect* method of execution guarantees a faithful and less laborious translation of the earlier conception to large scale. But it also creates aesthetic problems. The small plaster model is usually based on a clay original; that is, on forms which were built up by addition, not subtraction. And, of course, the working properties of clay are different from those of stone or marble. The sculptor may be able to anticipate the structural problems of enlargement and change of material. However, his original conception must necessarily be influenced by clay built around an armature (the wood or metal "skeleton" which supports the wet clay). As in translation from one language to another, some loss of meaning, or distortion of intent, inevitably occurs. Hence, the indirect method, which is also involved in any casting process, stands between the sculptor and the intimate contact with materials.

Casting, one of the great Neolithic inventions, accurately reproduces the forms and tool marks of an original clay or wax model. Its advantage lies in the translation of clay or wax into a material which is more durable than the original, which can be transported without danger of breakage, and which, of course, can also be duplicated. But durability and surface quality rather than duplication are the chief motives for the use of casting techniques in modern sculpture. Bronze, which is the most common casting material, also has surface and color characteristics that can be controlled for heightened sensuous satisfaction. The surface of a bronze casting develops a rich patina with age; it can also be burnished or treated with chemicals to produce a wide range of color from gold to deep brown or greenish black. Its surface can be dull or

The Ancestral Couple

ANCESTOR FIGURES OF THE DOGAN TRIBE, Mali. Reitberg Museum, Zurich. Von der Heydt Collection. As long as the original parents are perceived as the source of an awesome generative power—a power still active in tribal affairs —their effigies must be rigidly frontal, solemn, unmoved. The slightest deviation from verticality or horizontality is felt as the weakening of a force that must endure through eternity. What is remarkable is the variety of shaped forms and spaces that can be achieved within these constraints.

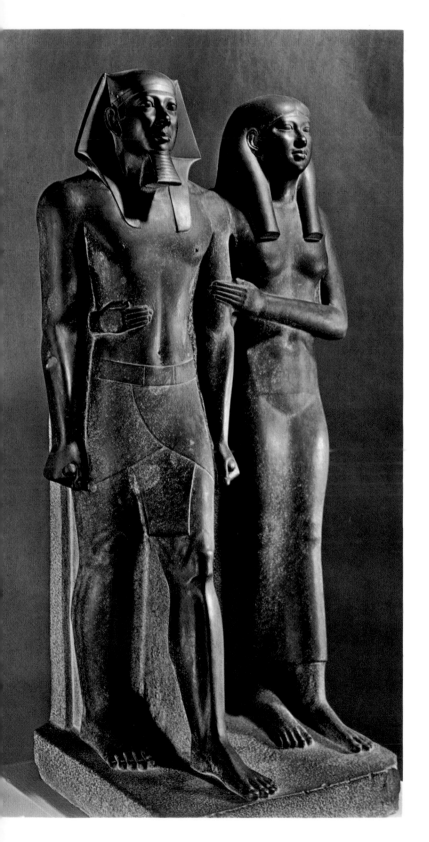

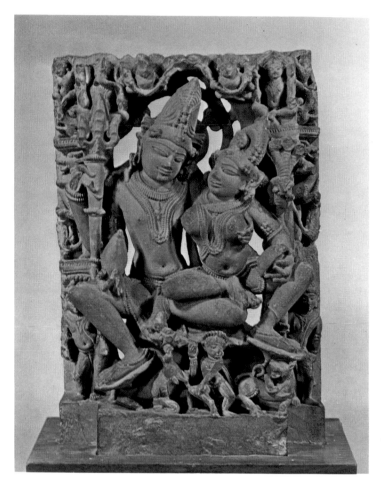

UMA-MAHESVARA MURTI (SIVA WITH PARVATI AND HOST), from Rajasthan or Kajuraho region, India. 10th–11th century A.D. Seattle Art Museum. In India the affection of the ancestral pair assumes an explicitly sexual character. Innocent of Western prudery, medieval Hindu temples were densely populated with "loving couples" in exuberant settings much like their teeming earthly communities.

KING MYCERINUS AND HIS QUEEN KHA-MERER-NEBTY, from Giza. 2599–2571 B.C. Museum of Fine Arts, Boston. Unswervingly pointed toward eternity, the royal pair now evidences an interest in the pleasures of marital intimacy. This interest is based on the discovery of the body as aesthetically pleasing and erotically exciting—ideas visible in the figures' contrasted forms: his—athletic and virile; hers—rounded and soft.

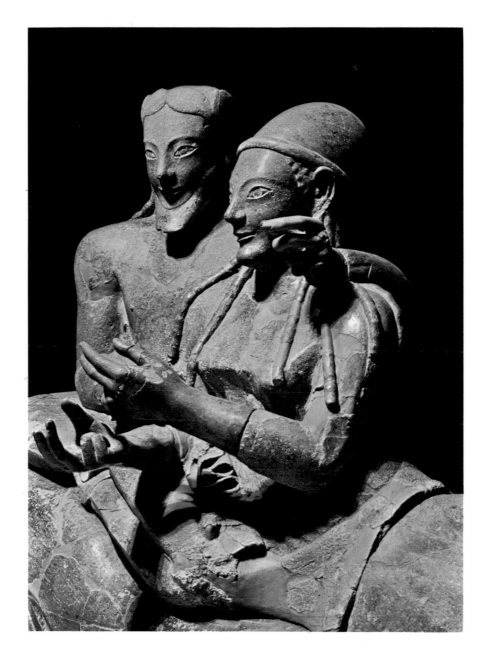

DETAIL OF SARCOPHAGUS, from Cerveteri. c. 520 B.C.
Museo Nazionale di Villa Giulia, Rome. To
preserve the alive quality of this couple, the
Etruscan sculptor depicted them with their hands
arrested, as if caught in a moment of animated
conversation. Also, vividly painted eyes, hair, and
skin must have compensated somewhat for the
archaic stiffness of the heads.

CRUSADER AND HIS WIFE. c. 1163. Chapel of the Grey Friars Monastery, Nancy, France. A touching wifely loyalty and devotion struggle to emerge from this rude Romanesque carving; nevertheless, the stone image more truly discloses a barbarian couple whose human awareness of each other has not yet been quickened by a Christianity they profess but do not understand.

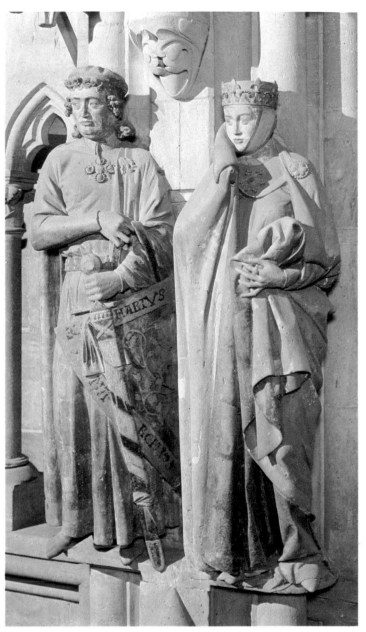

EKKEHARD AND UTA. Naumburg Cathedral, Germany. 1250–60. Conjectural portraits of the founders of the Cathedral, one hardly doubts they are a contemporary, that is, a Gothic, couple. Their relationship—more realistic than romantic—seems based on a "sensible" arrangement: the alliance of an influential, somewhat cynical German margrave with a stylish and elegant Polish princess.

Centaur and Man, from Olympia? 8th century B.C. The Metropolitan Museum of Art, New York. Gift of J. Pierpont Morgan

glossy, depending on the sculptor's intent. Similar surface possibilities are available with other metals, such as copper, brass, gold, lead, steel, and the new alloys. Clearly what is involved is direct work on the metal surface in a manner which is almost painterly. But it should be remembered that the earliest sculpture—whether of wood, stone metal, or clay—was painted, glazed, or inlaid with gems and other materials, in an effort to create convincing and vivid effigies. Terra-cotta sculpture was frequently polychromed—that is, it was glazed in the manner of modern colored ceramics—and achieved thereby a considerable degree of naturalism. (Polychromed terra cotta was carried to a high art by the Della Robbia family of Florence during the fifteenth and sixteenth centuries.) Today, a similar degree of naturalism might be achieved, if desired, with the use of plastics. For example, Frank Gallo's *Swimmer*, executed in polyester (a plastic also employed in painting) reinforced with Fiberglas and wood, offers a conventional range of form in an uncon-

LUCA DELLA ROBBIA. Detail of *Madonna and Angels*. c. 1460. National Museum, Florence. Polychromed terra cotta.

REUBEN NAKIAN. *Voyage to Crete*. 1963. New York State Theater, Lincoln Center for the Performing Arts, New York. Bronze casting.

The Lady Nofret. c. 2650 B.C. Egyptian Museum, Cairo. Painted stone.

JŌKEI. *Shō-Kannon.* Kamakura period (1185–1333). The Kurama Temple, Kyoto, Japan. Painted wood.

FRANK GALLO. *Swimmer.* 1964. Whitney Museum of American Art, New York. Gift of the Friends of the Whitney. Colored polyester, Fiberglas, and wood.

ventional material. The work is painted and is deliberately "pretty" in the Pop style. This sculptor often seats his figures in real chairs, thus juxtaposing a sculptural effigy with a "real" object made anonymously by industry. Gallo (born 1933) is here similar to George Segal, although his figures are more sculpturally described, modeled, and "prettified" than Segal's. Perhaps the closest modern counterparts to ancient painted sculpture may be found in store-window manikins, which are made of painted papier-mâché or plastic. Synthetic hair and eyelashes are attached, and the figures are then decorated by an assemblage technique known to window dressers. The manikins' parts appear to be interchangeable. But, like their ancient predecessors, they have a certain cultic significance.

Unlike Michelangelo, Rodin defined sculpture as "the art of the hole and the lump." Although he produced many carved marble works, Rodin's statement is characteristic of the sculptor who models to achieve form, who builds a surface additively. Clay is more immediately responsive than wood or stone, and it requires few tools. The sculptor's hand creates the forms and leaves the marks of thumb and figures in the soft, pliable material. Nothing is so personal and direct as clay; painters need a brush, and even those who abandon the brush must substitute some other tool or process. Yet even if clay offers little resistance to the sculptor and permits him to give form to the most transient impulse, it has distinct limitations when compared to wood or stone. It possesses little strength in tension or compression and hence requires an armature for support, as mentioned above. The building of an armature already commits the

PAUL VAN HOEYDONCK. *The Couple.*
1963 (destroyed)

PAUL VAN HOEYDONCK.
Space-Boys. 1963.
Whereabouts unknown

Utilitarian function united with realistic portraiture seemed entirely plausible to ancient sculptors. These commemorative or effigy vessels evolved from an early belief in the soul as a liquid substance, hence the combined pottery-portrait form.

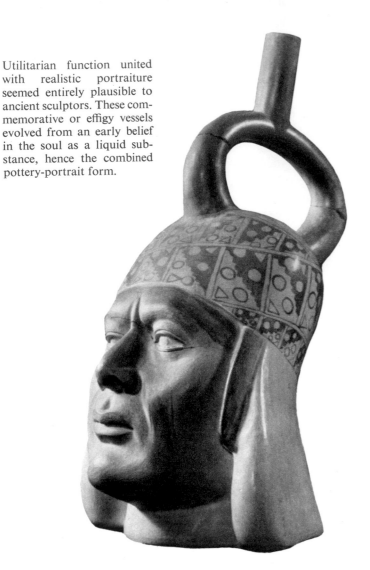

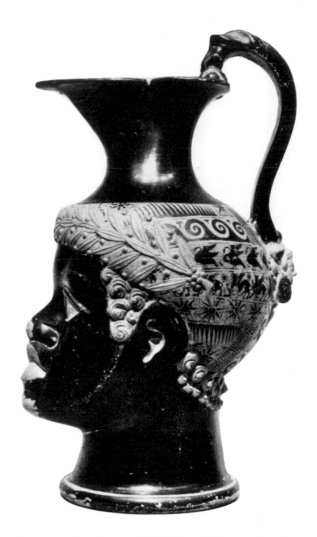

Portrait jar, from the Chicama Valley, Peru. 400–600 A.D. The Art Institute of Chicago. Painted clay.

Etruscan wine pitcher. 420–410 B.C. Private collection, Switzerland. Colored bronze.

sculptor to a certain type of result. Clay is not itself a permanent material. If it is to be fired as a ceramic sculpture, it is subject to the size limitations of a kiln and a variety of engineering considerations: it must be constructed to withstand high heat, complex internal stresses based on the weight of its projections, wall thicknesses, shifts in dimension during firing, and so on. Hence, clay is generally used to make preparatory "sketches" for sculpture to be executed in other materials, or for casting in metal. As ceramic sculpture, however, it is cheap, durable, and reproducible. It can be given a wide range of glossy or matte color, has many textural possibilities, and very honestly reflects the marks of the tool used to give it shape.

One of the subtle satisfactions of viewing bronze sculpture by Epstein or Giacometti, for example, arises from our knowledge that we see a soft, plastic material which has been "frozen" into a hard, highly resistant material. Bronze castings are, of course, hollow, with rather thin walls. But they *look* solid and massive; they often manage to retain the earthy quality of clay or rock. Cast iron, on

the other hand, is usually too coarse and granular to reflect the nuances of clay. It has its own character and does not simulate other surfaces and materials as well as bronze, copper, or brass. Hence, clay seems to call for bronze casting if it is to be permanent. For a master like Rodin, the capacity of clay to yield a surface of great tactile variety—one which modulates light at the same time that it describes shape—was perhaps its principal attraction. That bronze casting of clay models is a difficult and expensive process has not diminished the virtue of clay as a cheap and versatile material for sculptors; it remains one of the quickest, easiest, most direct and satisfying ways of "thinking" in three dimensions.

Wood appeals for its grain, its color, and its origin in a living tree. It has greater tensile strength than stone, and hence can be given long projecting forms without fear of breaking. As might be surmised from its wide use in handles and in furniture, wood is warm and pleasant, even sensuous to the touch. It is not cold like metal or abrasive like stone. It acquires a patina with time, as does bronze. The disadvantages of wood lie in its dimensional insta-

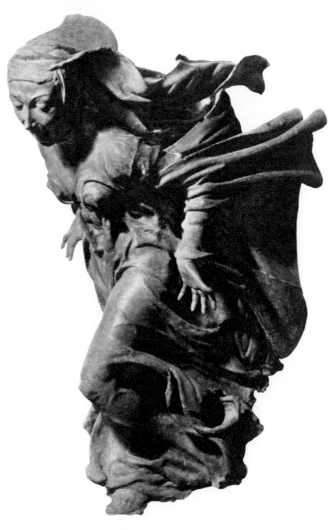

NICCOLÒ DELL'ARCA. Detail of *The Lamentation.*
c. 1485–90. Sta. Maria della Vita, Bologna

bility—its tendency to warp or crack. Wood can be carved, filed, drilled, and polished more easily than stone, yet it offers enough resistance to cutting and carving to require similar carving tools which leave similar marks. A great advantage of the material, much exploited in contemporary work, is its versatility in techniques of constructed or assembled sculpture. There is a particular expressiveness in wooden joints, whether those of the skilled cabinetmaker or of the sculptor employing improvised methods of joinery and attachment. In today's climate of indifference to permanence, the fact that wood may warp or crack counts little as a liability. Also, the new adhesives, some of which bind on contact, form joints which are often stronger than the materials they join. Finally, there is a long tradition of painting wood, covering it with fabrics, and embedding foreign materials in it. Hence, it fits well into the creative strategies of sculptors influenced by collage and assemblage. One has only to think of the many materials with which wood is combined in practical objects, from plows and guns to furniture and home appliances, to realize how useful it is to the sculptor—whether he carves or constructs.

A typically contemporary use of wood is visible in *Wall Piece* by John Anderson (born 1929). It combines carving and construction techniques in a work that pretends to have some mechanical action. Forms projecting from a slot appear to be levers, gearshifts, doorknobs, or faucet handles, suggesting to the viewer that he should pull, lift, twist, or turn them, depending on their shapes and his

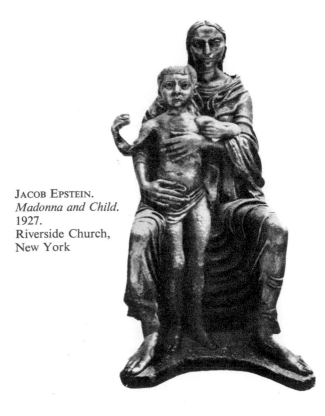

JACOB EPSTEIN.
Madonna and Child.
1927.
Riverside Church,
New York

GABRIEL KOHN. *Nantucket.* 1960. The Joseph
H. Hirshhorn Collection

JOHN ANDERSON. *Wall Piece*. 1963. Allen Stone Gallery, New York

mechanical experience. That these operations cannot in fact be performed does not prevent the sculpture from arousing our expectations of performance anyway. *It looks as if it could work*. Here we find a remarkable similarity between the visual operation of myth for modern man and for tribal man. Their magical sculptures *looked as if* they could be repositories of the souls of departed personalities; our magic sculpture *looks as if* it could throw a switch, turn on an electric motor, or put an auto engine into neutral. The viewer projects prevailing associations and expectations upon objective reality. Anderson's sculpture at the same time retains anthropomorphic features from the past—suggestions of bones and limbs among the several handles. The connection between form and meaning is logical enough, since levers and knobs are meant to be grasped, and wood is inviting to the touch. Consequently, this work can function at several imaginative levels simultaneously: it suggests a curious mechanical device and it makes connections with tribal animistic sculpture through its carved figurative forms and limb fragments.

The sensuous potential of plywood, a construction material which is usually covered or hidden, is beautifully revealed in the laminated plywood sculptures of H. C. Westermann (born 1922). *The Big Change*, a huge, sculp-

tured knot made of wood, constitutes the sort of contradiction between shape and material, the play with levels of reality, which appeal to the Surrealist interests of this sculptor. Aside from its meticulous rendering of the absurd and its use of a material without ancient credentials, the work possesses the unity of form, consummate craftsmanship, and monolithic stability of classic sculpture.

Few final sculptures are done in wax, although the material combines the responsiveness of clay with a translucent quality of its own. But it is not a very permanent material for sculpture; it can too easily be changed or damaged in handling. Wax, however, was a congenial material for the nineteenth-century sculptor Medardo Rosso (1858–1928). In *The Bookmaker*, which was made of wax over plaster, we see an almost painterly interest in light similar to that of Rodin and Degas, both of whom also executed sculptures in wax. The figure by Rosso, dated 1894, is extraordinary for its delicate treatment of a heavy body reminiscent of Rodin's monumental *Balzac* figure, and for its subtle, melting forms which do not, however, weaken or oversentimentalize the total work. The transitions from form to form are so gently accomplished that they appear to be painted or blended with a soft brush. As a result, the sculptor can direct the viewer's eye to the more defined forms with great precision. Al-

ROBERT CREMEAN. *Swinging Woman*. 1960. University of Nebraska Art Galleries, Lincoln

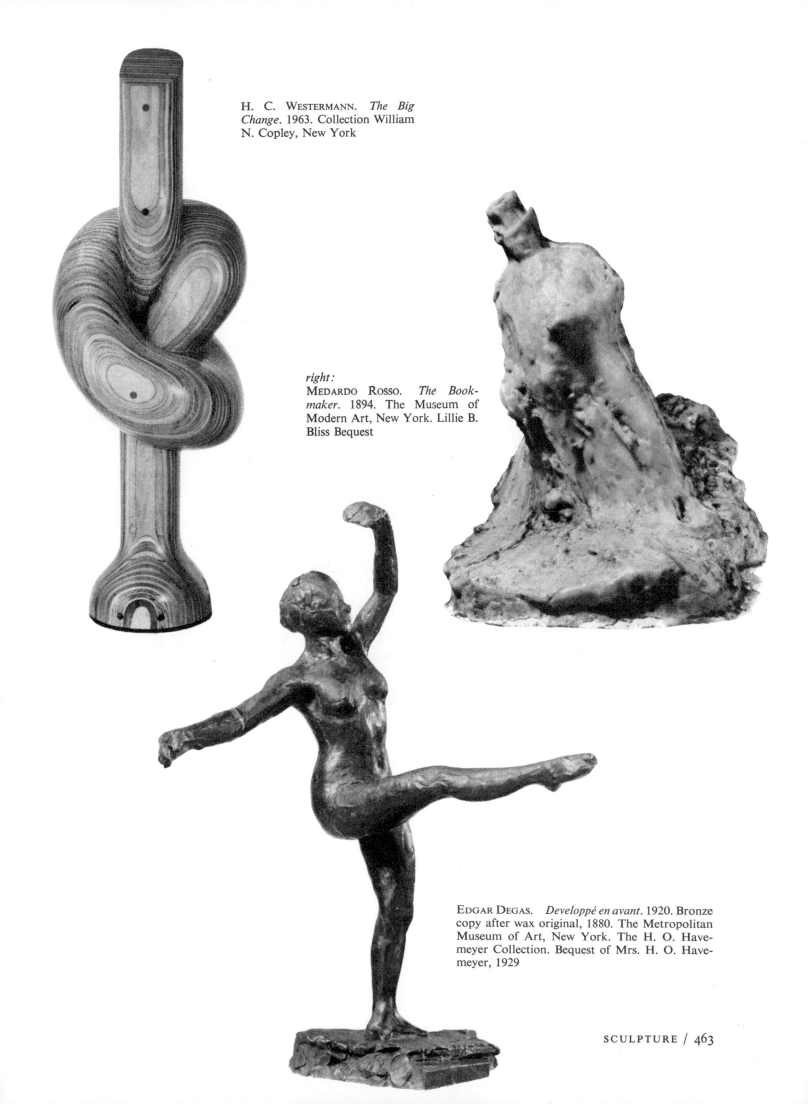

H. C. WESTERMANN. *The Big Change*. 1963. Collection William N. Copley, New York

right:
MEDARDO ROSSO. *The Bookmaker*. 1894. The Museum of Modern Art, New York. Lillie B. Bliss Bequest

EDGAR DEGAS. *Developpé en avant*. 1920. Bronze copy after wax original, 1880. The Metropolitan Museum of Art, New York. The H. O. Havemeyer Collection. Bequest of Mrs. H. O. Havemeyer, 1929

LEONARD BASKIN. *St. Thomas Aqui-nas*. 1962. St. John's Abbey Church, Collegeville, Minnesota

AUGUSTE RODIN. *Balzac*. 1892–97

though the sculpture is small, it suggests a large scale because wax has no grain, no texture visible to the eye. Hence, it is capable of almost infinitely detailed modeling. It is easy to see that the capacity of wax to confer its own liquid, melting quality upon form had great appeal for Rosso. The medium seems appropriate for a Romantic, emotionally evocative art. But its small scale and sympathetic application to the figure are precisely the virtues

which become liabilities for those contemporary sculptors who are interested in materials suitable for *art brut*—harsh effects on a massive scale.

A tremendous change in sculptural attitude has taken place since Rosso modeled his delicate wax figures in the 1890s. An excellent summary of the new view is given by the American critic Clement Greenberg: "Space is there to be shaped, divided, enclosed, but not to be filled. The

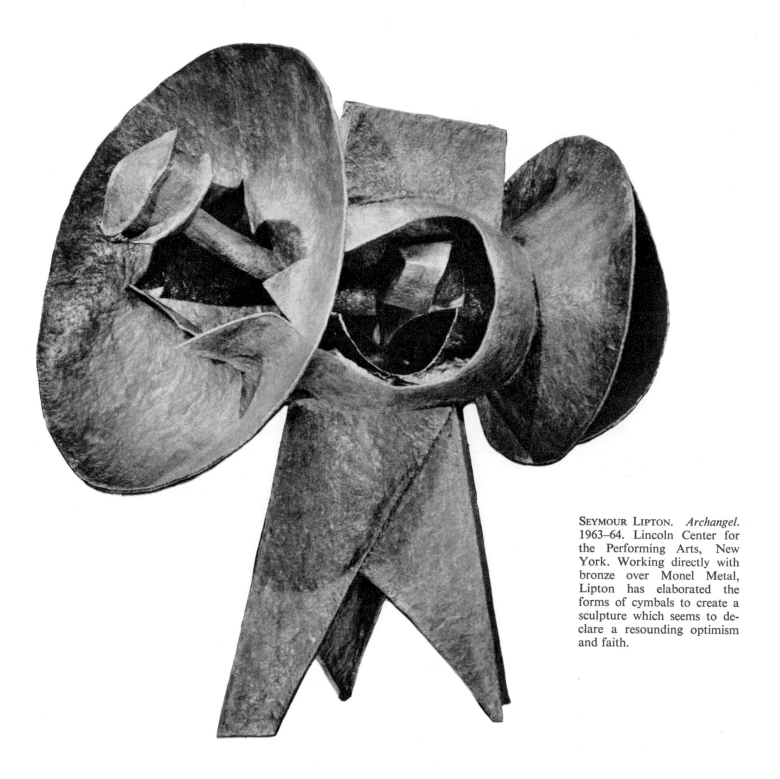

SEYMOUR LIPTON. *Archangel*. 1963–64. Lincoln Center for the Performing Arts, New York. Working directly with bronze over Monel Metal, Lipton has elaborated the forms of cymbals to create a sculpture which seems to declare a resounding optimism and faith.

new sculpture tends to abandon stone, bronze, and clay for industrial materials like iron, steel, alloys, glass, plastics, celluloid, etc., etc., which are worked with the blacksmith's, the welder's and even the carpenter's tools. Unity of material and color is no longer required, and applied color is irrelevant: a work or its parts can be cast, wrought, cut or simply put together; it is not so much sculptured as constructed, built, assembled, arranged."[31]

Clearly, we are in the midst of a revolution in sculptural materials and technique, a revolution which responds to the unprecedented social, technical, and spiritual changes of modern life. But changes in tools and materials themselves dictate new artistic ideas and aesthetic effects. In the following sections we examine some of the more prominent formal and aesthetic developments in contemporary sculpture.

"Hera," from Samos. c. 570 B.C.
The Louvre, Paris

From Monolith to Open Form

The sculpture of the old agrarian civilizations reflects the tree log, the stone block, or the marble slab from which it was carved. Even where the raw material permitted major extensions and protuberant shapes, the stresses entailed by wielding hammer and chisel could break or split parts of a work. That is why totemic sculpture, for example, so closely resembles the tree trunk and why Egyptian Old Kingdom figures closely follow the granite block. Only the casting process, perfected mainly by nomadic peoples, was capable of reproducing very complex open shapes. Even so, metal casting was used largely to fashion weapons, amulets, harness decorations, and the like, rather than the monumental figures we associate with the settled peoples of the old Mediterranean world. Sculpture in general, and carved sculpture in particular, aspired to the monolithic (similar in form to a single

stone). Whether it was hewn out of a single stone or not, it tended to adhere to the shape of the stone unit. A notable exception, the Hellenistic sculpture *Laocoön*, was carved from several blocks of marble, and although it represents a remarkable technical achievement, it is not considered aesthetically successful because its parts seem disunited; the feeling of a single, embracing shape, the *monolithic feeling*, has been lost.

In addition to considerations of material and process, monolithic form dominated early sculpture for religious and psychological reasons. Stability, permanence, and resistance to change are qualities associated with uncomplicated shapes. Perforations, extensions, and protuberances have dynamic implications, and motion is the enemy of the timeless and eternal. As we know, Rodin's *St. John the Baptist Preaching* was criticized because the

figure seemed to be walking off its pedestal. The pyramids of Egypt and the temples of Greece rely heavily on the triangle resting on its base, or the triangle supported by repeated massive verticals. Since one of the religious functions of sculpture is to *arrest* change, to create monuments which can resist the ravages of time, the sacred sculpture of the ancient Mediterranean world (excepting the later Greek, or Hellenistic, development) was largely solid, frontal, and monolithic. Sculptural movement, open form, and extension in space occur when the archaic styles are left behind, when the worship of effigies of the old tribal gods gives way to philosophic speculation about the idea of the divine and when travel and navigation begin to displace agrarian space conceptions and Euclidean geometry.

Another source of open form in sculpture comes from the art of the barbarian peoples whose incursions through Europe from the steppes of Asia eventually destroyed Greco-Roman civilization. Their nomadic existence and their skill in metalworking, especially as goldsmiths, predisposed them to an art of linear dynamism. Heated metal lends itself to curved, serpentine, and spiral shapes. And since the total nomadic economy was adjusted to continuous movement, early Celtic, Scandinavian, and Germanic art, created by the European descendants of

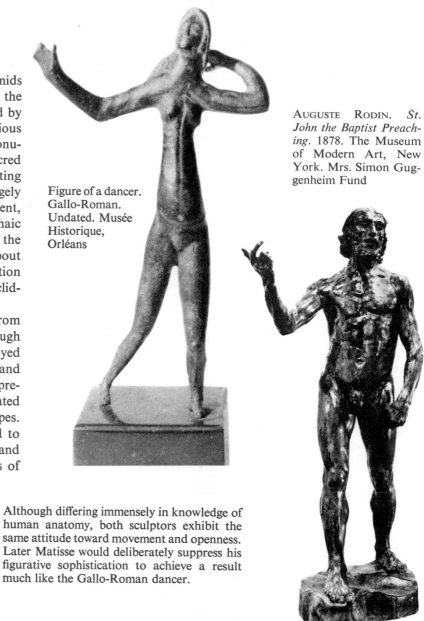

Figure of a dancer. Gallo-Roman. Undated. Musée Historique, Orléans

AUGUSTE RODIN. *St. John the Baptist Preaching.* 1878. The Museum of Modern Art, New York. Mrs. Simon Guggenheim Fund

Although differing immensely in knowledge of human anatomy, both sculptors exhibit the same attitude toward movement and openness. Later Matisse would deliberately suppress his figurative sophistication to achieve a result much like the Gallo-Roman dancer.

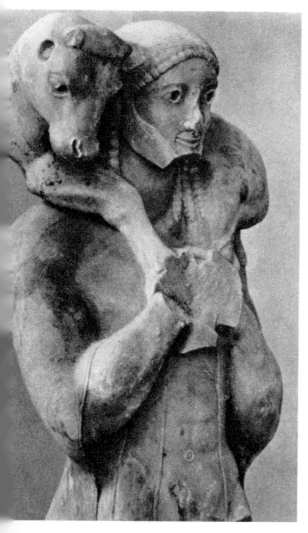

Calf-Bearer. c. 570 B.C. Acropolis Museum, Athens

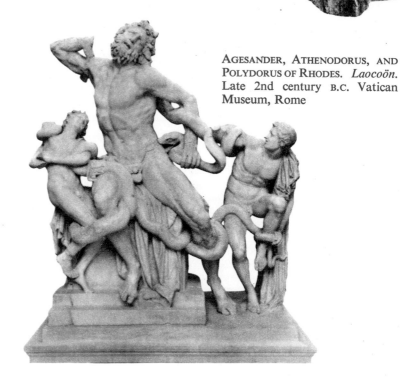

AGESANDER, ATHENODORUS, AND POLYDORUS OF RHODES. *Laocoön.* Late 2nd century B.C. Vatican Museum, Rome

Maori prow ornament, from New Zealand. Museum für Völkerkunde, Munich

Animal head, from the Oseberg ship-burial. c. 825 A.D. University Museum of Antiquities, Oslo

Vikings and Polynesians—both warlike, seafaring peoples—created a complex linear art in which spirals, interlaces, and elaborate perforations almost obliterate their much-loved animal motifs.

On the one hand, sculptors from Michelangelo to Maillol have endeavored to preserve classical sculptural order; on the other hand, Romanesque and Gothic sculpture express the barbarian obsession with infinite complexity, convulsive movement, and abstract ornament as opposed to naturalistic rendering of the human figure. If the Gothic cathedral is considered to be the culmination of Christian glyptic (carved, sculptural) arts, then nomadic conceptions of form and space can be said to have prevailed. Indeed, the revival of classical order during the Renaissance never succeeded in displacing entirely the taste for complex motion which had been whetted by barbarian art. In the styles of Mannerism and the Baroque, broken surfaces, representations of indefinite space, and linear complexity were again reasserted. To be sure, some classical restraint characterized the now civilized and Christianized sculptors of western Europe had surely left the monolith far behind. Although Bernini's sculpture is situated in the very house of Latin Christianity, its animation and tendency to expand into every space around it reflected the artistic inclinations of those barbarian hordes that swept down into Italy and captured Rome in the fourth century.

Modern critical opinion acknowledges few major sculptors between Bernini and Rodin. Although characterized by consummate skill and industriousness, sculpture as an art form was increasingly dominated by academicism, which is to say, by ideas and institutions devoted to the support of work created according to rules. If this definition of academicism is sound, then it is similar in spirit

the Eurasian nomads, reflected a fascination with, and mastery of complex abstract movement. Nomadic sculpture in wood or metal was not primarily naturalistic because the faithful imitation of appearances requires, first of all, the concept of a model fixed and motionless in time and space. But the barbarian consciousness was nourished on incessant travel, hunting, and battle. Furthermore, from the standpoint of peoples accustomed to the freedom to move indefinitely in any direction along the seemingly endless Asian plains, the concepts of visual stability and enclosed space are not easily discovered. Consequently, the art of the wanderers who eventually settled Europe from Russia to Ireland was predominantly one of endless convolution on a flat plane. Their three-dimensional or sculptural expression consisted mainly of the visual *assembly* of two-dimensional, abstract linear structures.

The development of Western art, particularly of Christian religious sculpture, reenacts the alternating struggle and synthesis of Mediterranean closed-form or monolithic conceptions and nomadic, serpentine, open-form ideas.

UMBERTO BOCCIONI. *Development of a Bottle in Space*. 1912. The Museum of Modern Art, New York. Aristide Maillol Fund. As early as 1912, Boccioni attempted to define volumes with concave spaces, thus anticipating the Constructivist analysis of matter.

Couples in Modern Sculpture

In the Brancusi, a scarred and truncated Adam, in oak, supports a smooth and rounded Eve, in chestnut; by presenting the figures in a vertical plane, a type of hierarchy is created. Giacometti, however, places man and woman on the same horizontal plane; there the man becomes a sexual aggressor.

ALBERTO GIACOMETTI. *Man and Woman*. 1928–29. Collection Henriette Gomès, Paris

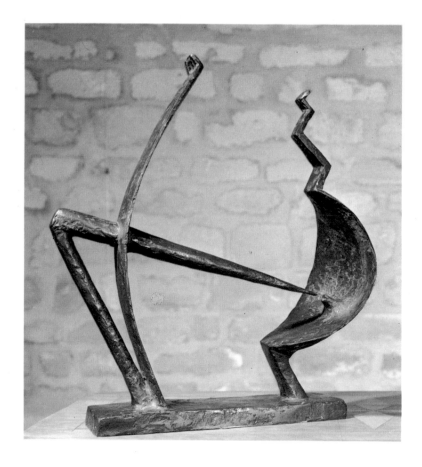

CONSTANTIN BRANCUSI. *Adam and Eve*. 1921. The Solomon R. Guggenheim Museum, New York

Max Ernst. *Le Capricorne*. 1964. Musée National d'Art Moderne, Paris. Ernst compromises the dignity of royalty by presenting this couple as a pair of hybrid creatures compounded of geometric elements and anatomical portions of man, fish, goat, steer, and giraffe.

Etienne-Martin. *Le Grand Couple*. 1946. Collection Michel Couturier & Cie., Paris. The united couple is compared to a powerful, chthonic generative force by heightening their resemblance to a huge convoluted tree root.

HENRY MOORE. *King and Queen*. 1952–53. The Joseph H. Hirshhorn Collection. In this royal couple, Moore tries to gain access to those mythic feelings which connect the destiny of a land and its people with the strength and harmony of its rulers.

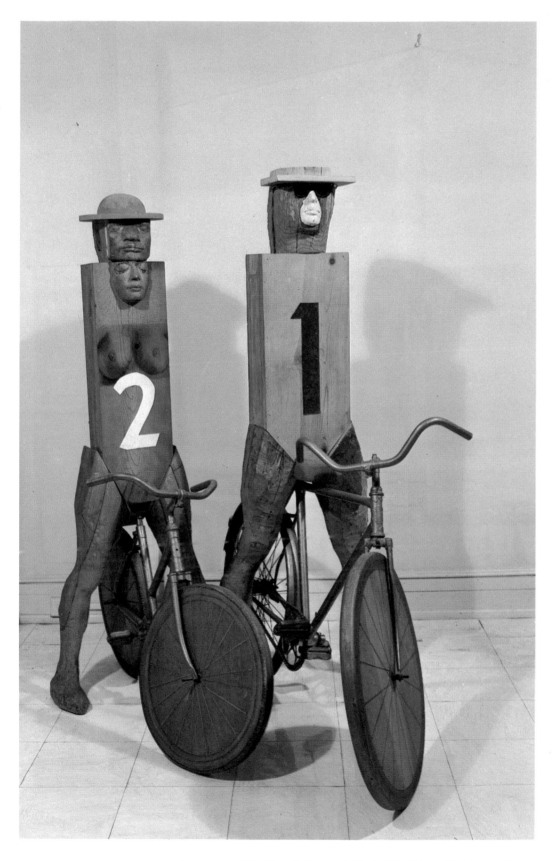

MARISOL. *The Bicycle Race*. 1962–63. The Harry N. Abrams Family Collection, New York. An almost Egyptian solemnity pervades this work. Still, there is something more than a satirical comment about a couple of earnest bicycle riders: he is No. 1, and she is No. 2—and they hate each other.

ADRIEN DE VRIES. *Mercury and Psyche*. 1593. The Louvre, Paris

left:
GIANLORENZO BERNINI. *The Ecstasy of St. Theresa*. 1645–52. Cornaro Chapel, Sta. Maria della Vittoria, Rome

to Classicism. And, indeed, the history of art bears out the similarity. Hence, today's critical estimate of academic sculpture reflects the opinion (a) that it is unoriginal, anachronistic, and not truly classical; or (b) that the classical bias in favor of monolithic form and stable composition is no longer meaningful. Probably both opinions are partly true. Consequently, contemporary sculpture would be expected to reveal anticlassic tendencies, that is, resistance to distinct, naturalistic forms and balanced relationships among parts. Furthermore, it should display shapes created by puncture; twisting, ropelike knots and coils; and an almost infinite degree of linear detail—as in the paintings of Jackson Pollock, for example.

Such expectations are, in fact, borne out in recent sculpture. As in painting, antiacademic tendencies predominate, although a minority continues to create balanced

works of classical order. (That minority is only slightly augmented by minimal and serial sculptors—to be discussed on pp. 502–505—whose reductionism is at the expense of human figuration and sensory appeal.) But even with them, the feeling of the monolith, which derives so much from the carving tradition, has been abandoned. It survives conspicuously in the work of a master like Henry Moore, although his penetrations of solid form betray a distinctly modern consciousness.

A rare monolithic work is seen in Leonard Baskin's *Seated Man with Owl*. Baskin's sculpture is a version of a theme which appears frequently in Egyptian art, as in the *Pharaoh Khafre,* behind whose head is the hawk-god,

HENRY MOORE. *Reclining Mother and Child*. 1937. Walker Art Center, Minneapolis. In Moore's penetrated forms we see the culmination of a long process of accommodation between the nomadic obsession with open, serpentine shapes and the classical Mediterranean concern for balance and stability.

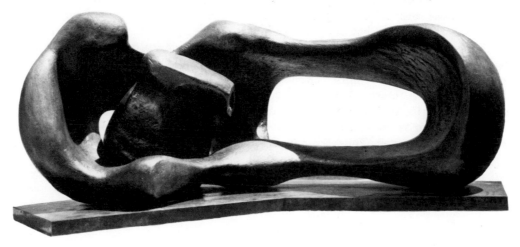

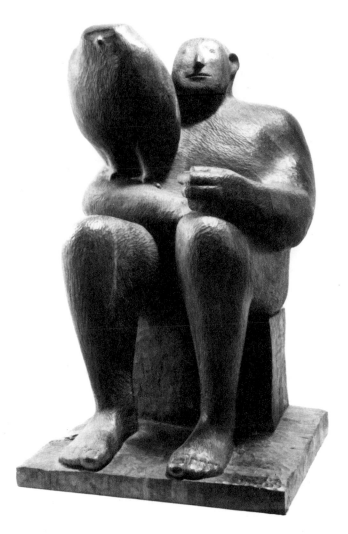

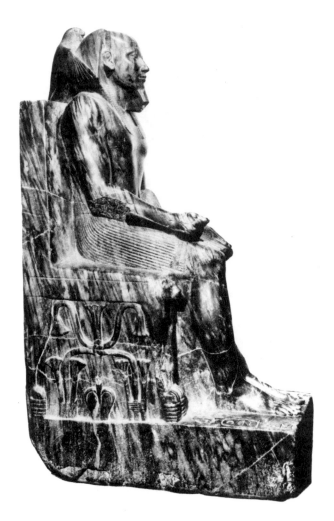

LEONARD BASKIN. *Seated Man with Owl.* 1959.
Smith College Museum of Art, Northampton,
Massachusetts

Pharaoh Khafre. c. 2600 B.C. Cairo Museum

Horus. But in the modern work, the bird—now an owl—
is much inflated, and stands forward on the man's arm,
almost obscuring him from view. Baskin's sculpture
shares the frontality and immobile expression of the
pharaoh but is otherwise a modern personality. Where
Khafre is slim, athletic, and youthful, the modern man is
overweight, stolid, and middle-aged. The Egyptian sculp-
ture conveys a powerful sense of enduring mass, in part
because it is carved from diorite, but also because it is
absolutely without a trace of motion. Baskin's figure,
carved in wood, has the ponderous bulk of a flabby person
whose sitting down is an act of collapse. The pharaoh
looks confidently toward a future which he expects to
dominate eternally, while Baskin's image of man is some-
what bored; he is resigned to the future since he knows
too much to be hopeful about it. Thus, the monolithic
quality of Egyptian sculpture, when present in a modern
work, is used for a different purpose and embodies dif-
ferent qualities. Instead of playing a role in the funerary
culture of an ancient despotism, it becomes a tool of

psychological analysis. The king's strategy for guarantee-
ing his victory over death is exploited by a contemporary
artist to portray man's resignation in the face of life's
everlasting sameness.

Additional illustrations—from the work of Maillol,
Brancusi, and Arp—could, no doubt, be brought forward
to show that monolithic form survives in the present era.
However, these sculptors are among the "old masters" of
modernism. As we approach the present day, even artists
who seem to possess some classical feeling nevertheless
choose media and techniques which yield dynamic, per-
forated, predominantly abstract form. The nonfigurative
bias of modern sculpture is also an indication of the col-
lapse of the classical, Mediterranean, monolithic tradi-
tion. One of the most persuasive signs of this collapse is
evident in contemporary ceramic sculpture (to be dis-
cussed below). The clear, stable, and functional forms
which have characterized pottery since the Neolithic era
are now giving way to busy, indistinct, and frequently
nonfunctional shapes in earthenware. Since clay thrown

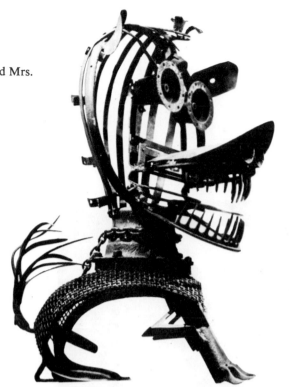

EDWARD RENOUF. *Chow.* 1960. Collection Mr. and Mrs. George Zabriskie, Red Hook, New York

on a potter's wheel inevitably assumes distinct, regular form, wheel-thrown shapes—and hand-built shapes, too—must be truncated or smashed together to create the cracks and fissures, lumps and perforations which are congenial to the contemporary *Formgefühl* (preference for form) (see Voulkos sculpture, p. 518).

It is conceivable, however, that the taste for dynamic, broken forms will eventually be oversatisfied and that a desire for its opposite will emerge. In that case, the stylistic pendulum may swing back to monolithic form. But then it will not be granite blocks or wooden logs which determine the forms; rather it will be our visual appetites which require that reason and geometry once again govern the organization of shapes.

Constructivism

Constructivism was the early twentieth-century movement which formally abandoned the monolith as the basic sculptural form and the central axis as the core around which sculptural volumes must be organized. It introduced new materials into serious sculptural practice—materials like plastics, Plexiglas, and metal wire—on the ground that several kinds of material could be combined in one work. Finally, it made a complete break with the figurative tradition, placing geometrical shapes and volumes at the foundation of sculpture. Its leading personalities were Vladimir Tatlin (born 1885), and two Russian brothers with dissimilar names, Naum Gabo (1890–1965) and Antoine Pevsner (1886–1962). They advocated an approach to sculpture which would bring it into harmony with new concepts in physics and mathematics, and hence, via engineering, with production and industrial design. But although the Communist government of Russia supported the movement following the Revolution of 1917, it became unsympathetic to abstract and experimental art by 1921, even though Constructivists hoped, ultimately, to revolutionize architecture and industrial design as well as painting and sculpture.

Leaving Russia in 1922, the Constructivists disseminated their ideas through associates at the Bauhaus in Dessau, from Berlin, and from Paris, where Pevsner settled (and where the world of modern art received its principal leadership until the end of World War II). Naum Gabo settled in the United States in 1946 and died here in 1965. But the influence of Constructivist conceptions of form and space had taken firm hold in America and throughout the world many years earlier.

Cubism had begun the development toward geometric abstraction well before World War I, although its primary impact was on painting. Futurism, an Italianate descendant of Cubism, had carried the geometric analysis of movement into sculpture, notably in the work of Boccioni and Balla. The Dutch De Stijl group and the German Bauhaus group, however, were more concerned than the French Cubists or the Italian Futurists with the problems of practical design. Thus, while manifestos issued by Futurists, Constructivists, and even Surrealists had as stated aims the reconstruction of society or, at least, the transformation of the visual environment, it was ultimately the Bauhaus which had the most practical effect. And, through exhibitions in Germany in the 1920s, and through an exchange of ideas with members of the Bauhaus faculty, Constructivism affected Bauhaus thinking and teaching.

What bearing does Constructivism have on the techniques and meaning of sculpture today? Its main traits, as expressed in the sculptures of Gabo and Pevsner, are abstraction, transparency, openness and interpenetration of sculptural form, overlapping of planes, and the employment of lines in tension to describe direction and movement in depth. Gabo's *Linear Construction #1* (1942) exhibits many of the qualities of a mechanical drawing executed in three dimensions. Its curves do not betray any irregularity because they are divorced from

below:
NAUM GABO. *Linear Construction #1.* 1942–43.
The Joseph H. Hirshhorn Collection

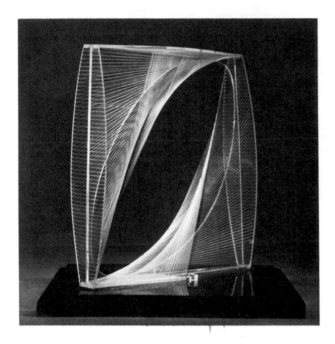

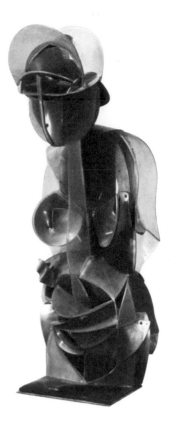

ANTOINE PEVSNER. *Torso.*
1924–26. The Museum of
Modern Art, New York. Kath-
erine S. Dreier Bequest

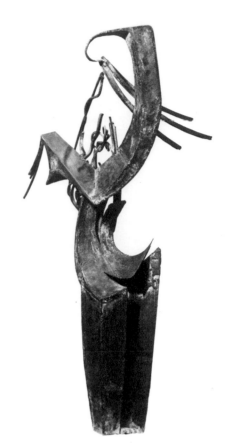

JULIO GONZALES. *Woman
Combing Her Hair.* 1936. The
Museum of Modern Art, New
York. Mrs. Simon Guggen-
heim Fund

the effort to record organic shapes. The construction
endeavors to provide the viewer with the kind of satisfac-
tion he normally experiences in a suspension bridge or in
a microphotograph of a crystalline structure. The key
word and idea is *structure*—the visual rendition of lines of
force which are transferred from point to point within a
sculpture whose only work is holding itself together. The
useful function of engineering structures is set aside in
Constructivist work so that, presumably, the pure, math-
ematical beauty of energy transmission may be de-
monstrated.

Torso, which was executed by Pevsner in 1924–26, is,
by contrast, a figurative abstraction very close to Cubist
painting. Like the sculpture of another Russian, Archi-
penko, it stresses negative—that is, concave—volumes,
in the presentation of forms which in life are convex.
The materials used are translucent, brownish plastic
sheets, and copper. In this work, the doctrinaire Con-
structivist determination to avoid volume or solid forms
in the representation of space is especially evident. The
translucency of plastic enables Pevsner to stress lightness,
that is, the negation of mass or weight. Hence, two basic

traits of the monolith are undermined: (1) solidity or
volume: the occupation of space by opaque three-dimen-
sional forms; (2) mass or weight: the determination of
forms by gravity requirements and the need for immo-
bility. As with Cubism, the influence of concepts in
physics is present. The idea that negative forms can ex-
press matter occupying space seems to violate common
sense. Yet modern physics claims to have discovered
antimatter, and we realize that apparently solid materials
are really collections of energy paths.

Gabo's *Monument for a Physics Observatory* (1922)
very appropriately expresses his interest in physics and
his elimination of distinctions between sculpture and ar-
chitecture. Although the model is made of plastic, metal,
and wood, and follows strictly geometric curves, as sculp-
tural form it bears an interesting resemblance to a later
(1936) wrought-iron sculpture, *Woman Combing Her
Hair*, by Julio Gonzalez (born 1908). Since Gonzalez
followed Picasso's precedents primarily, there is no ques-
tion of direct influence from Gabo. The work of both
artists, however, demonstrates the new openness of sculp-
tural space. From its agelong condition of rootedness in

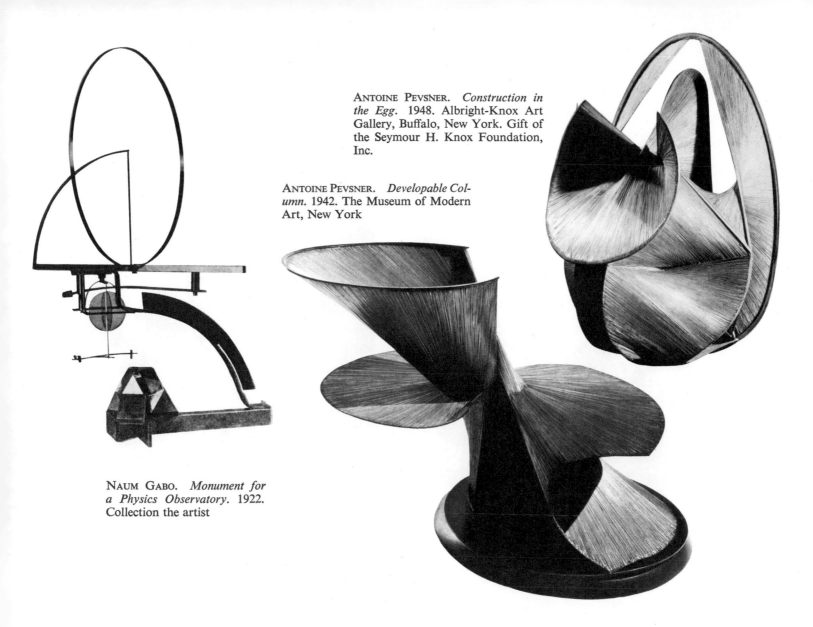

ANTOINE PEVSNER. *Construction in the Egg*. 1948. Albright-Knox Art Gallery, Buffalo, New York. Gift of the Seymour H. Knox Foundation, Inc.

ANTOINE PEVSNER. *Developable Column*. 1942. The Museum of Modern Art, New York

NAUM GABO. *Monument for a Physics Observatory*. 1922. Collection the artist

the earth, from its resemblance to masonry-wall construction, sculpture had moved confidently, during the period between the two world wars, into a kind of interstellar space.

Although modern physics has permanently altered our ideas about the concreteness of matter and the nature of space, sculptors would not entirely abandon the use of massive, opaque, volumetric materials in favor of plastics, wire, and glass. Pevsner, who was trained as a painter, inclined to use solid metals, particularly bronze rods

bonded into curved planes, in his later work, like *Developable Column*. Apparently, the sensuous appeal of metals counteracts tendencies toward dematerialization with transparent substances. In any event, sculpture cannot be created without some substance which has mass and volume. Heavy, opaque materials continue to be used along with light, transparent substances, but open space is now treated with immense sophistication, as if it were one point on the continuum of matter rather than as an element totally foreign to matter.

Sculptural Assemblage

The efforts of painters to "annex" sculpture have already been noted. Largely as a result of collage experiments, painters found themselves assembling three-dimensional objects, and so, in a certain sense, they invaded sculpture's domain. Is there any significant difference in result when artists who call themselves sculptors employ assemblage

processes? It would appear there is none. There are more differences *among* artists employing assemblage than there are between painters and sculptors. For example, there are obvious differences between the work of Louise Nevelson (p. 498) and Jason Seley (p. 275), both of whom are sculptors using assemblage techniques. However,

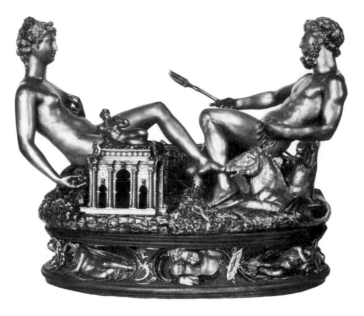

BENVENUTO CELLINI. *Saltcellar of Francis I*. 1539–43. Kunsthistorisches Museum, Vienna

Nevelson is closer to a painter like Kurt Schwitters (p. 429) than to many of her sculptural colleagues. Therefore, one cannot assert, for example, that painterly assemblage retains the sense of the wall and that sculptural assemblage occurs in the round.

Sculptural assemblage is significant with respect to the *history* of sculpture in that it represents the abandonment of carving, modeling, and casting. It begins with materials and objects which already have a rich accretion of meaning. It parallels the flight of painting from the creation of illusions. The sculptor apparently does not wish to participate in a process which pretends that stone is flesh or that metal is hair. Seley's automobile bumpers are very sculptural in the spatial sense, but they do not cease to be bumpers. In other words, assemblage does not involve any *transmutation of materials*. Rather it involves composition with the meaning as well as the substance of existing materials.

The reluctance of sculptors to engage in transmutation of materials represents a profound change in art and in sculpture. As we know, medieval alchemists, the precursors of modern chemists, labored to transmute ordinary materials into gold. There was, for them, a hierarchy of substances. Modern men are less willing to accept such a hierarchy. Certainly, science and technology have encouraged this attitude, since so many things we value are derived from relatively abundant and cheap substances like coal, petroleum, nitrogen, soy beans, and so on. Secondly, the entire process of creating illusions has acquired some of the associations of deceit. "Honesty of materials" was one of the goals of the pioneers of modern industrial design, but that goal or principle was a reaction against practices like marbleizing wood or painting wood grains on metal. Nevertheless, the honesty-of-materials idea has helped to create an aesthetic climate in which any transformation of the inherent properties of a material seems faintly unethical.

The influence of democratic ideas should not be minimized. Particularly in the United States, democratic beliefs militate against the existence of social classes in ascending or descending order: speech, manners, and dress are not as reliable indicators of status or income as they are in Europe. There is an inclination to evaluate persons in terms of their performance rather than their origins or presumed status. Although this attitude may not be strong in all sectors of American life, it is certainly powerful among artists. It is logical and, I believe, empirically justified to expect that the social ideas of artists

will find their way, perhaps unconsciously, into matters of technique, into the "proper" handling and purpose of materials.

Another reason for the importance of sculptural assemblage lies in the sense of inadequacy a sculptor may feel when confronting the forming and fabrication achievements of industrial production. When Cellini made his famous saltcellar, he could rightly feel that it represented the highest degree of technical mastery which his age could produce. But the modern artist is daily exposed to miracles of miniaturization in electronic components, for example, which make hand carving and casting seem to be puny achievements. Space flight represents a social organization of technology so remarkable that meticulously carved stone and marble appear, from a technical standpoint, to be medieval survivals. Aside from their often tasteless shapes, mass-produced auto bodies or bathroom fixtures represent forming and shaping achievements which would tend to frustrate any sculptor inclined to attempt the same thing.

From the standpoint of creating form, the resources, versatility, flexibility, and control available in the tool-and-die shop of a modern machine-building concern are enormously greater than anything available through the older techniques and processes of sculpture. Consequently, there is a certain practical wisdom on the part of the sculptor who takes possession of these resources by incorporating the products (usually worn-out) of industry into his work. His creative strategy shifts from an emphasis on forming skills to an emphasis on ideas and composition, which is to say, on *design*.

There is always a danger, however, that the sculptor as welder, riveter, or architectural impresario will lose the "feeling" for materials which carvers and modelers had. Tactile contact with the work, particularly in modeling clay, was one of the main sources of humanistic value in sculpture. The clay sketch functioned for the traditional sculptor very much as drawing did for the painter (although sculptors also draw). However, drawing and clay modeling become increasingly less relevant to the assemblage of found objects. Drawing and modeling constitute a means of thinking in advance of final artistic execution. But they do not adequately convey in advance the textural and volumetric qualities of rusted metal parts, for example. The sculptor must compose with the materials themselves. Such an approach to design with materials has been advocated from the days of the Bauhaus. One of the most trenchant criticisms of the older practice of industrial design was its excessive reliance on design conceived on the drawing board. It was held that design should grow out of direct work with three-dimensional materials. Today, almost all industrial-design firms employ model makers who build prototypes of new products in plaster, clay, wood, or plastic. They are, in a sense, the industrial sculptors behind manufactured reality. The assemblage sculptor, however, is one step closer to reality

CLAES OLDENBURG. *Soft Pay-Telephone*. 1963. Collection William Zierler, New York

A fire-damaged telephone echoes the form of Oldenburg's soft telephone. Using nonrigid materials like canvas, vinyl, kapok, and foam rubber, Oldenburg has elevated limpness to high status among the expressive qualities of modern sculpture.

Burned phone, from advertisement for Western Electric Phone Company. 1968. Courtesy Cunningham & Walsh, Inc., New York

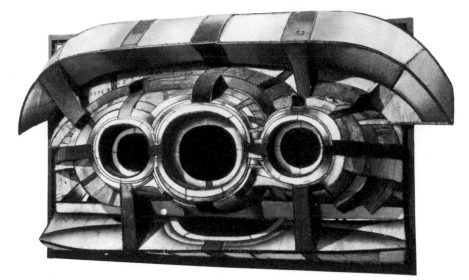

The magical motifs of tribal artists are often taken up, either unconsciously or intentionally, by the creators of "museum" art. But little has changed except the labels assigned by critics and historians: concrete art, mechanized abstraction, hard-edge painting.

Man's shirt, woven by the Tlingit Indians of Alaska. c. 1900. Museum of the American Indian, New York

LEE BONTECOU. *Untitled.* 1962. Collection Mr. and Mrs. Seymour Schweber, King's Point, New York

since he makes no model but builds the final object directly.

Some of the richness and variety of sculptural effect possible through assemblage is suggested in the works which follow. They seem virtually a new art form. Even so, the viewer with a good visual memory will not find it difficult to discover echoes of historical form and idea amid contemporary themes and materials.

AN ASSEMBLAGE ANTHOLOGY

Lee Bontecou (born 1931) capitalizes on a personal and craftsman-like assemblage technique in her untitled relief

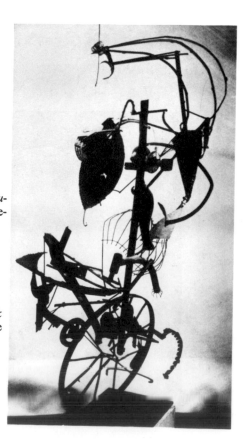

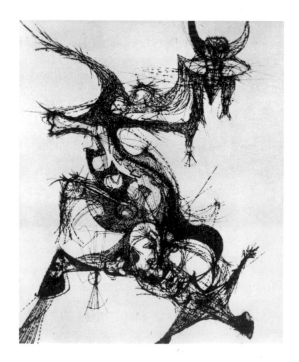

right:
RICHARD STANKIEWICZ. *Europa on a Cycle.* 1953. Whereabouts unknown

far right:
GABOR PETERDI. *The Black Horne.* 1952. Collection the artist

at right:
BRUNO LUCCHESI. *Woman on Bicycle.* 1902. Collection Mr. and Mrs. Jack Wexler, King's Point, New York

JEAN DEWASNE. *Le Demeure antipode*. 1965. The Solomon R. Guggenheim Museum, New York. Gift of Herbert C. Bernard

made of canvas stretched over bent steel wire mounted on a metal frame. But the forms of this sculpture bear a strong resemblance to tribal masks and to the totem pole sculptures of the Northwest American Indians. The technique is similar to one employed in early aircraft manufacture—stretching and gluing fabric over a wire-

frame skeleton; and its alternating light and dark canvas areas suggest the painted wood effects in masks carved by Nigerian sculptors in the nineteenth century. But the most prominent elements in her sculpture are the ovoid apertures which can be experienced as eyes, as openings in a curiously abstract mask, or as the entrances to mysterious caves.

The fundamental sculptural metaphors here are the mask and the membrane. The light, sturdy construction of the mask permits a massive yet buoyant organization of positive and negative spaces. It suggests the Indian practice of building a canoe by stretching hides over a frame rather than hollowing out a log. The membrane, which we feel would vibrate if it were snapped, is the source of a primitive, animistic feeling; air trapped inside the sculpture seems to be exerting a force outward, a living, invisible force which holds the forms away from the wall surface, just as an invisible, "magical" force holds up airplane wings in flight. The ability of the sculptor to sustain and encourage the viewer's illusion that expansive forces are at work inside the mask creates surface tensions which are further supported by the visible stretching of canvas over the wire frame. As a result, the work elegantly demonstrates the interactions among materials, technique, and meaning in sculpture.

Europa on a Cycle by Richard Stankiewicz (born 1922) is one of this artist's most fully realized works in the assemblage idiom of welded junk metal. His debt to Gonzalez and to David Smith is clear, and there is also a hint in this work of the kinetic sculpture of Tinguely. In committing himself to rusted metal as his basic material, Stankiewicz arrives at the same unity of material, color,

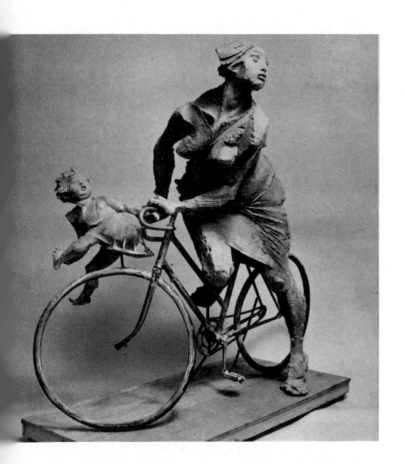

Eau de Vroom. Advertisement for Crêpe de Chine perfume. 1967. Courtesy Berta, Grant & Winkler, Inc., New York. The sculptural strategy of assemblage is brilliantly illustrated in a perfume advertisement that combines masculine machinery (the Honda), a soft saddlebag (Can it symbolize Europa?), and a precious fragrance.

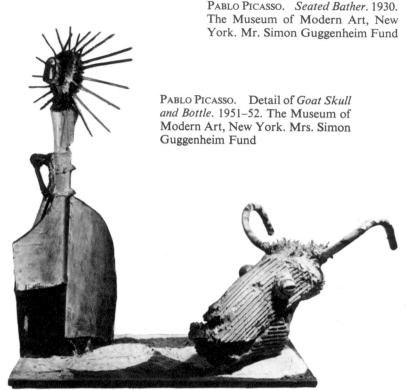

PABLO PICASSO. *Seated Bather.* 1930. The Museum of Modern Art, New York. Mr. Simon Guggenheim Fund

PABLO PICASSO. Detail of *Goat Skull and Bottle.* 1951–52. The Museum of Modern Art, New York. Mrs. Simon Guggenheim Fund

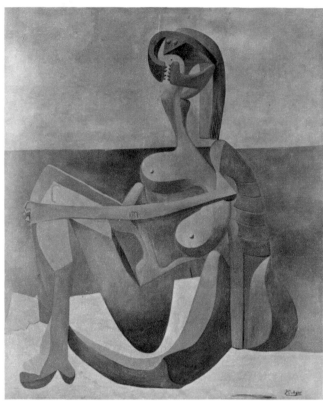

and texture traditionally achieved with a classic metal like bronze. He draws and constructs with old chains and rods, builds with parts as they are found, or cuts metal shapes with his torch. The several forms of metal—wire, pipe, sheet, rod, spring, tube, bar, and plate—all are united by a single process of attachment—welding—and a single color and surface texture—rust. The sculptor is thus free to deal with problems of volume and contour, movement and balance, illusion and reality. The silhouette of the *Europa* has some of the graphic interest of a print by Gabor Peterdi (born 1915). That is, it sustains interest as a two-dimensional, linear work. Its idea might be derived from Picasso's *Minotauromachy*, but Stankiewicz has replaced the bull of Cretan and Picassoid memory with a unicycle dating from the era of the auto graveyard. The notion of a beautiful woman carried off by a rusty wheel would surely appeal to Picasso, who made good use of bicycle handlebars in his *Goat Skull and Bottle*. As for the maiden, she seems to descend, via Gonzalez, from one of Picasso's bathing beauties, *Seated Bather* (1930), who has left her abode by the sea to join the motorcycle set.

The use of a form language developed by his predecessors is not a negative reflection on the artist's creative capacities or artistic integrity. Surely Picasso has borrowed heavily from the whole of Mediterranean civilization, extracting meaning from the play of old forms against their new contexts. If anything, the Stankiewicz sculpture illustrates the recurrence of perennial themes in the most modern media, and the artist's wit—his ability

to make a kind of sculptural "crack" about the human and the mechanical. The lady and the bicycle theme has attracted many contemporary artists—Léger, Lucchesi, and De Kooning, for example. It would be interesting to compare the Stankiewicz approach to that of Léger in *La Grande Julie*. The lady-and-the-wheel theme possesses a mysterious appeal for a variety of artistic temperaments.

The Juggler by Robert Mallary (born 1917) is executed in particularly exotic materials for sculpture—plastic-impregnated fabric and wood. Using a man's shirt and trousers, which are soaked in plastic and attached to a burnt-wood support, Mallary can arrive at the figure through the suggestions of the clothes meant to cover it. The hollow arms and legs, now given a certain structural rigidity, exist as real limbs and as heavy rags at the same time. The plastic manages to "freeze the action" of the fabric stretched apparently by its own weight and suspended from a wooden frame in the manner of a crucifixion. Burnt wood is, of course, one of the primal materials of religious sacrifice; hence, Mallary has brought together in new form some of the basic symbols of suffering, destruction, and transfiguration. As he "puts on his act," the juggler falls into the position of the Christ on the Cross, thus expressing the dying-in-living and the failure-in-success which are implicit in all of man's enterprises.

Mallary's form and vision are traditional in many respects; he is not unlike Rouault in point of view. Assemblage, in his case, means giving a type of three-

dimensional rigidity, hence quasi-permanence, to a surface material—fabric—which wears out quickly and is normally associated with softness and formlessness. Swatches of fabric have long been used in collage and assemblage, of course. It is their manipulation in the form of *clothing* which stirs a host of existential feelings about the human predicament. The empty tuxedo, often included in Mallary's constructions, becomes, not a fabric shell or covering for a man, but the man himself. Literary metaphors embodied in phrases like "hollow men" or "stuffed shirt" are thus transmuted into sculptural reality by a plastic-impregnated sleeve.

The Stove by Claes Oldenburg, a Pop version of assemblage sculpture, consists of painted plaster "food" displayed on a real, but very antiquated cooking range. The range is reminiscent of the "ready-mades" of Marcel Duchamp. But the luridly colored provisions are the contribution of Oldenburg alone. Further, the authentic kitchen environment helps explain why Pop art has been called "the new realism."

Sculpture as the logical or pleasing organization of forms and volumes is completely irrelevant here. The design principles of unity, rhythm, balance, and so on are ignored. Instead, the viewer is encouraged to perceive food and food preparation as a supremely vulgar, if not disgusting, phenomenon. The artist seems to be directing a program of sabotage against what the housekeeping magazines, with all their delicious colorplates, attempt to encourage. The absence of any attempt to create logical or ingratiating sculptural form and space contribute to the shock value of the work as a whole. We seem to be seeing the nakedness of groceries and cooking. A familiar event thus divested of the glamor, zest, and comfortable associations in which we normally attempt to clothe it, becomes hideously ugly. Such an antiart objective tries to create a new kind of legitimacy; it also becomes aesthetically valuable if it stimulates new perceptions and sustains new meanings beyond its initial shock.

John Chamberlain's assemblage of crumpled automobile parts seems to constitute an earlier stage in the process of machine destruction seen in the final "compression" sculptures of César Baldaccini. Although these parts are "found" in junkyards, Chamberlain (born 1927) bends, paints, and welds them himself, constructing works which do not rely heavily on their automotive origins. In other words, the dead automobile serves this sculptor as a source of cheap raw material. His *Essex* acknowledges that venerable vehicle as ancestor but is more closely influenced by action painting than by philosophic speculation about the destiny of machines in Western civilization. The scale of the work (nine feet high by seven and a half feet wide) and its aggressively jutting forms create some difficulty for the viewer if he attempts to see it as a very large, colored metal painting. But that is clearly one of its objectives. The work adheres to the rectangle; its holes, valleys, and crevices occur in the consistently shal-

ROBERT MALLARY. *The Juggler*. 1962. Allan Stone Gallery, New York

CLAES OLDENBURG. *The Stove*. 1962. Private collection

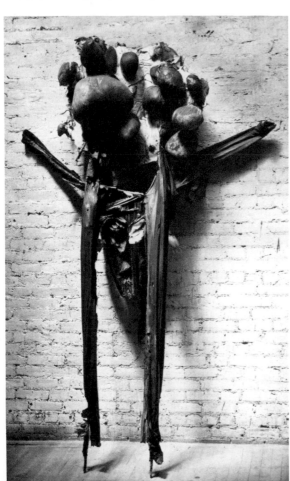

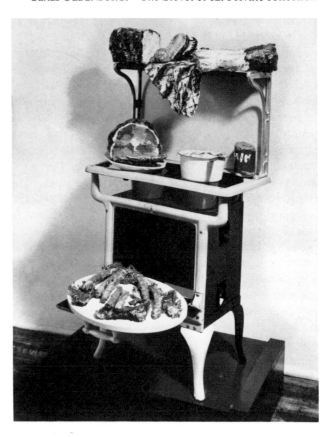

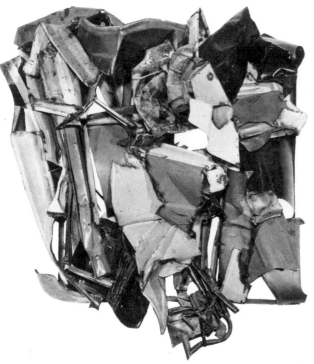

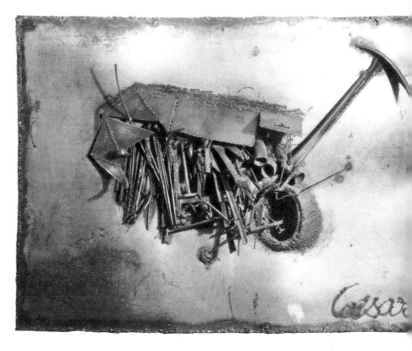

JOHN CHAMBERLAIN. *Essex.* 1960. The Museum of Modern Art, New York. Gift of Mr. and Mrs. Robert C. Scull and Purchase

CÉSAR. *Sculpture Picture.* 1956. The Museum of Modern Art, New York. Gift of G. David Thompson

low space one encounters in Abstract Expressionist painting. However, the achievement of unity of form and expression seems to elude the sculptor. Why is this so?

Crumpled auto metal inevitably records a history of violence. When assembled in the context of visual image, this history of violence is present as a palpable idea just as much as the shape and gauge of the metal. Consequently, the application of bright enamel paint creates a contradiction between form and appearance which upsets the viewer's effort to achieve unified perception, closure. Clearly, the artist is aiming at an original transformation of a common material, but his color interferes with the attempt; we remain unconvinced. The effort to carry sculpture into painting runs these perils: crumpled metal occupies "real" space, applied color creates "optical" space, and the two kinds of space are inclined to fight with each other. Signs of age in the metal conflict with the new and shiny paint film given to the old surfaces. A "logic of materials" is not permitted to assert itself. César's *Sculpture Picture* would appear to be a more successful attempt to integrate sculpture in a painterly format.

The painted plaster food of Claes Oldenburg also contradicts its form but does so intentionally. The total work succeeds because the sculptural forms, which are large and simple, establish their identity quickly and unambiguously: they are, without doubt, oversized hamburgers. The contradiction works because we see clearly that the forms exist only to be decorated, embellished, or ridi-

culed. The *Essex* does not manage to establish an initial sculptural concept—simple or complex—hence, there is no "leverage" for the subsequent painting to exert force, that is, convey meaning. But the effort is very ambitious: it is an endeavor to transform materials and meaning three or four times in the context of a single work of assemblage. Perhaps such failures are more commendable than easier successes.

A ceramic relief panel by John Mason, designed to be seen against the marble wall of a building lobby, illustrates the assemblage attitude applied to ceramic sculpture. Slabs and strips of clay have been joined and pressed together in a manner similar to John Chamberlain's assembly of auto parts. An impression of ruggedness which the sculpture conveys is due, in part, to its resemblance to natural rock formations. But its loops, perforations, and shapes running *across* each other suggest the arbitrary constructions of man rather than the geologic formations of nature. As in the "action" sculpture of Peter Voulkos (see *Gallas Rock*, p. 518) the unadorned clay slabs of the ceramist, together with his characteristic way of compressing or throwing them together to form a bond, constitute the "subject matter" of the work. Although such sculpture is abstract, it performs a humanistic function when placed against the austere walls of modern buildings. It sounds a note of earthiness and hand fabrication within the impersonal spaces we create with glass and steel.

Edward Kienholz works in the Pop art vein but is more bitter and explicit in his social criticism than other members of this group. His *John Doe* is an assemblage consisting of a manikin, a perambulator, paint, wood, metal, and plaster. A lettered placard at the bottom reads:

RIDDLE:
Why is John Doe like a piano?
ANSWER:
Because he is square, upright and grand.
—OLD SOOTHE SAYING

The "square-ness" of some Americans is a concept that has been well developed in literature by H. L. Mencken, Sinclair Lewis, and others. Finding plastic expression for the idea, however, is another matter. Of course, there is something "square" about Grant Wood's *American Gothic*, although "plain" would be a more appropriate term. But Kienholz approaches the square American in the manner of a truculent satirist—viciously and with loathing. The regular features of the manikin's head (which includes, perhaps unintentionally, an archaic Greek smile) have been "abused" with painted stripes and spills; the eyes have been crudely outlined in paint, so that the usually inoffensive store-window dummy exhibits a gruesome countenance. John Doe wears an outsized, gleaming badge over his heart—an unsubtle reference to the square passion for insignia which declare lodge membership, loyalty, patriotism, and good fellowship. The paint runs and spatters are similar to those employed by De Kooning in *Woman, II* (p. 408) to express contempt for the creature the artist has created and now holds up for scrutiny. And, of course, placing an adult in a child's perambulator, without *saying* he is a fool, is nevertheless an insulting comment about his level of maturity. It is a bitter statement, not a compassionate one. It reveals little inclination to indulge the square. He is offered as a monument fit for oblivion.

In other works, such as *The Widow*, Kienholz exhibits the same corrosive wit but relies somewhat more on his construction to tell the story. The use of aged, discarded objects seems to combine well with the artist's deliberately crude paint application—Kienholz was trained as a cabinetmaker—and inelegant assembly of parts. The disdain for "finish" and for any display of sculptural virtuosity characterizes the art of many, although not all, workers in assemblage. The artist's ability to create form by fastidious carving or modeling is now beside the point. Such skills are embodied in already created manikin heads which he exploits for their thematic values. The artist "changes" them (assuming that *changing* a material is a prerequisite for art) by smearing the busts with paint, or battering them a bit to create among all the objects a harmony of age, wear, and disintegration.

The Widow, now a faded relic among relics, rides a seesaw which elevates her periodically in front of a

JOHN MASON. Relief panel in Wilshire-Flower Tishman Building, Los Angeles. 1961

wrinkled mirror. Kienholz has chosen the kind of manikin which used to grace the windows of beauty shops, the type of head which is more finely modeled than figures for displaying apparel. Consequently, the widow's falling away from the look and fashion of young womanhood is heightened. He deals with the same theme which occupied Ivan Albright (*Into the World There Came a Soul Called Ida*, p. 183). Albright, however, offers the portrait of a particular individual, whereas Kienholz is more of a sociologist: he is concerned with a collective human type as it occurs in a certain cultural milieu.

The employment of *wrappings* in assemblage has enlarged the now-popular artistic vocabulary of terror. Using methods we associate with prisons, mortuaries, and shipping rooms, two sculptors, Bruce Conner (born 1933) and Christo (born 1935) have independently developed a gruesome and enigmatic sculptural rhetoric. Both create an imagery in which enshrouded figures or objects seem to be struggling to escape their wrappings. The situation has clinical as well as sculptural overtones, relying as it does on the viewer's fear of close confinement. That is its

Head of the Rampin Horseman.
c. 560 B.C. The Louvre, Paris

EDWARD KIENHOLZ. *The Widow.* 1961. Dwan Gallery, New York

EDWARD KIENHOLZ. *John Doe.* 1959. Collection Sterling Holloway, South Laguna Beach, California

funereal side. But the convention of the chained or bound figure has a history as old as the legend of Prometheus. Michelangelo's *Rebellious Slave* describes a drama of imprisoned form which, under various disguises, appears in all his portrayals of the figure. And the nineteenth-century American sculptor William Rush carved a lifesize wooden sculpture, *The Schuylkill Chained*, which today rests in Fairmount Park, Philadelphia, serving as an allegorical reminder to Philadelphians of the Prometheus myth and the fate of a river condemned to collect refuse as it flows through the industrial confines of a modern city.

Conner's *Child* shows a wax figure on a highchair enmeshed in a transparent, gauzelike material made of torn nylon stockings. Bank robbers use nylons to conceal their identities; here the device suggests the flimsy but entangling concealment of cobwebs. The nylon also functions like Francis Bacon's blurred form to create the illusion of movement and to project the quality of an anguished, agonized, but silent scream.

Package on Wheelbarrow by Christo describes the quiet, somewhat ghoulish struggle of an unknown thing against a random but effective system of knots and bindings. Its wrapping, a sheet, maintains the anonymity of the imprisoned figure, and the wheelbarrow keeps the secret, adding only the possibility that the writhing form

(Why else is it tied?) will be carried away. As a result, the viewer's fear and curiosity enable him to experience the nameless tensions which are usually sustained by "abstract" sculptural form. But, of course, a lively imagination nourished on horror films may discover a taste for the macabre rather than abstract art at the root of its perceptions.

Little Hands by Arman (born 1929) continues the macabre note struck by Conner and Christo. Consisting of dolls' hands (some of them broken) glued in a wooden drawer, it readily initiates a series of grotesque perceptions, beginning with a collection of mutilated toys and ending with the uncovered mass graves periodically discovered in wartime. The drawer functions at first as a frame, then as a container, and finally as a tomb (see section below, "Niches, Boxes, and Grottoes"). To equal its content of horror, one would have to go back to Hieronymus Bosch. Even then, the images wrought by hand lack the clinical detachment possible for the artist who assembles hands or limbs originally meant to function in a normal context.

In a humorous vein, Arman created *Chopin's Waterloo* (1962). Many citizens, it seems, harbor a secret desire to tear a piano apart. Arman has done it for them (as Jimmy Durante or the Marx brothers used to do), and has given

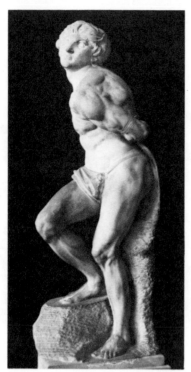

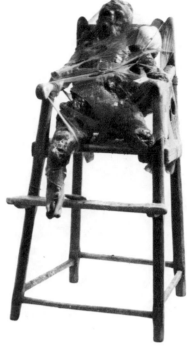

MICHELANGELO. *The Rebellious Slave*. 1513–16. The Louvre, Paris

BRUCE CONNER. *Child*. 1959. The Museum of Modern Art, New York. Gift of Philip Johnson

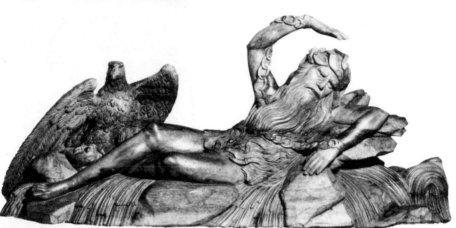

WILLIAM RUSH. *The Schuylkill Chained*. c. 1828. Philadelphia Museum of Art. Commissioners of Fairmount Park

CHRISTO. *Package on Wheelbarrow*. 1963. The Museum of Modern Art, New York

RICO LEBRUN. *Bound Figure*. 1963. Collection Constance Lebrun Crown, Malibu, California

ARMAN. *Chopin's Waterloo*. 1962. Collection the artist

ARMAN. *Little Hands*. 1960. Collection the artist

the dismemberment permanent form in a type of piano collage. The idea of this work may be trivial, but the visual effect is one of beautiful destruction—the splinters, ivories, and piano wire in gorgeous disarray. It seems that a music-making device sustains more visual interest in its disintegrated state than it does when healthy and whole, awaiting the pianistic attack of a tail-coated virtuoso. By tearing a piano open, the sculptor reveals it as a type of machine and then employs assemblage techniques to gratify the perverse human desire to see machines break down, fall apart, or go hopelessly awry. For these or similar reasons, Jean Tinguely (born 1925), a Swiss sculptor celebrated for machines which destroy themselves, included a flayed piano in his kinetic sculpture performance at the Museum of Modern Art, *Homage to New York*. Arman's piano collage might represent the aesthetic vindication of small boys who take clocks apart and fail to put them together again.

The interest in violent, macabre, and gruesome phenomena is today visible in all forms of art and popular culture. There has been, for example, a vigorous and sustained market for the horror films of Vincent Price; and revivals of the early (1933) film *King Kong* have been enthusiastically received. Sculptural assemblage has been technically congenial to the expression of extreme emotions, or, more accurately stated, it seems capable of dealing with ordinary themes which are very acutely felt. The advantage of the medium lies in the extraordinary range of objects and qualities which are accessible to the sculptor when he does not have to fashion forms *ex nihilo* —out of nothing, so to speak. In assemblage, the sculptor *begins* at a fairly well-developed level of meaning and is able to devote much of his effort to exploring the outer-

JEAN TINGUELY. Piano before its incorporation into *Homage to New York*. Self-destroyed March 17, 1960, in the garden of the Museum of Modern Art, New York

most reaches of the ideas and emotions suggested by his materials.

It would be a mistake to attribute the prolific assemblage activity of today's younger sculptors to reluctance or inability to master the traditional sculptural materials and processes. Rather, the classic techniques must seem sterile to many of them or, at best, inadequate for the expression of the ideas which they feel are significant. When the present artistic interest in agitated movement,

symbolic destruction, and the exploration of urgent emotions has abated; when a preference for stable forms, controlled movement, and moderate feeling reasserts itself; then the vocabulary developed by assemblage sculptors may still turn out to be adaptable to the aesthetic demands placed upon it. In other words, while it is not possible (or desirable) to offer a final requiem for carved and modeled sculpture, it can be asserted with reasonable confidence that assemblage will occupy sculpture's mainstream for a long time to come.

Niches, Boxes, and Grottoes

The niche is a recessed place in a wall where a sculptured figure or bust can be located. It was used in Roman architecture but is known to us primarily through its evolution from Romanesque relief carvings. As low relief was succeeded by high relief, as more stone was cut away behind the relief forms, the sculpture emerged more fully in the round. In the fourteenth century, high relief reached its three-dimensional fulfillment in Gothic sculpture. Then the niche became part of a wall *built around* a sculpture rather than an *excavation in* the wall. However, the sense of the sculpture as originating *in* the wall and belonging to it remained, even if it were executed elsewhere and set into a niche already erected.

It is important to think of niche sculptures as *born from* walls, conceived out of the necessity to endow the plane at a particular point with dramatic meaning. The niche encloses the forms physically and psychologically. It governs the angle of vision from which the sculpture can be seen, and it strongly affects the incidence and amount of light admitted to reveal the forms. Psychologically, the sculpture is *protected* by its enclosure; it is removed from full exposure to the elements and can thus be perceived as something precious—something which requires shelter, possibly because it contains a highly valued secret.

These psychological meanings of niche sculpture also adhere to the box sculptures and constructions which figure prominently in twentieth-century art. The box sculpture can be regarded as a detached niche, a contemporary secular shrine which has been lifted from an architectural setting that never existed. When we look at the box sculptures involved in the abstract and symbolic form language of industrial civilization, it is difficult to avoid projecting on them all our associations of the cathedral niche, of a mysterious and sequestered hiding place which is seen and addressed in the intimacy of private worship.

The grotto, like the niche, is a man-made recess or excavation. But it is not associated with the wall. It relates instead to the vault or the convoluted inner spaces of natural caverns. The sculpture of interior space is, of

LORENZO MAITANI and others. Detail of *The Last Judgment*. c. 1320. Facade of cathedral, Orvieto, Italy

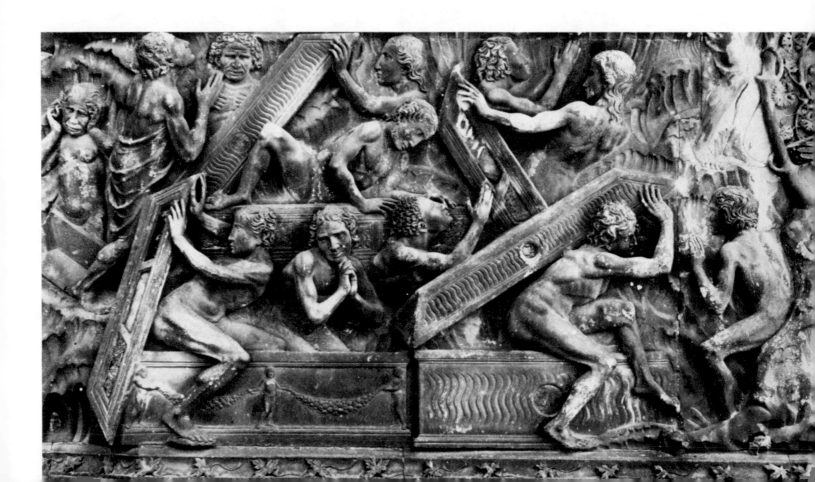

Santo Jesús Nazarino. El Santuario de Chimayo, Chimayo, New Mexico. 1813 –16. The architectural and sculptural idea of the niche is entwined with its religious function. A curtained alcove serves as a dramaturgic container for a sacred figure, but its architectural necessity is no longer visible.

BENEDETTO ANTELAMI. *King David.* c. 1180 –90. West facade, Fidenza Cathedral, Lombardy, France

FREDERICK KIESLER. *Endless House.* 1949–60.

ANTONI GAUDÍ. Original attic (garret), Casa Milá Apartment House, Barcelona. 1905–10

course, a type of architecture, and the work of the architect Frederick Kiesler (1896–1965) does indeed resemble such a hybrid art form. But the grotto as a modern sculptural type has little concern with shelter. It is better understood as the opposite of modeling surfaces; it is interior sculpture. Certainly Schwitters's Hanover Merzbau (p. 429) was a quasi-Cubist grotto, employing geometric solids instead of the organic forms Kiesler used to shape interior environments. And in the grotesque—that is, grotto-like—passageways and roof structures of Antoni Gaudí, we see not so much the expression of architectural ideas as the creation of purely sculptural concavities. Interior sculpture by architects like Gaudí and Kiesler reflects the modern survival of man's eternal attraction to the cave. Siegfried Giedion has observed that prehistoric men lived beneath overhanging rocks or near cave openings, but never in the depths of a cave. They ventured into the interior recesses only to carry out sacred rituals. Hence, caves are not architecture.[32] But the cavernous spaces created by natural action and barely visible in the feeble light available to early men must have been tremendously impressive. Such spaces may constitute unconscious models for those contemporary architects and sculptors who seem so powerfully drawn to the grotto form.

The *Room* by Lucas Samaras (born 1936) is a twentieth-century grotto, a three-dimensional interior assemblage. It consists simply of the aggregate of possessions collected and attached to the walls of a teen-age cave. Its claim to style lies in a total lack of style, and its vividness is reinforced by the viewer's knowledge that the room is utterly real and quite typical. If the clutter and visual disorganization of the grotto seem to constitute a scandal, a poor reflection on adolescents growing up in America, then we should remember that it accurately mirrors the space organization of the large-scale environment created by generations of adults in our society. There is also the possibility that modern conceptions of order—influenced by the austerities of Mondrian and Mies—fail to perceive a logic hidden in the apparent illogic of the Samaras room. But as art, the room comes too close to life to fall within a frame of aesthetic relevance. It is really a manifestation of a quasi-art fashion called "camp"—a set of attitudes about film viewing, interior decorating, curio collecting, personal dress, and word choice.

Camp seems to be deliberately perverse, as with the Samaras assemblage. It chooses to celebrate films, novels, decorative objects, book illustrations, fabrics, paintings, sculptures, and so on, which have either been universally condemned by prevailing critical opinion, treasured in primitive regions and cultural backwaters, prized by children before they become aware of aesthetic alternatives, or cast aside by households, museums, and even rummage shops. Much of Pop art is influenced by campy attitudes, and therein lie some of its assets as well as its liabilities. Pop has been imperiled by its addiction to the

Mammoth Cave, Kentucky

AARON BOHROD. *Grotto*. 1964. Private collection

LUCAS SAMARAS. Detail of *Room.* 1964. Pace Gallery, New York

ANDRÉ BLOC. *Sculpture Habitacle No. 2.* 1965

A sculpture in which one could live, or a dwelling which invites the plastic responses appropriate to sculpture.

ANDRÉ BLOC. Detail of *Sculpture Habitacle No. 2*

garish and banal; its practitioners may lose the capacity to take pleasure in anything which is not superficial or tawdry. And we who enjoy Pop run a similar risk. The willingness to admire and prize what has been passed over and discarded is the way we contribute to the just evaluation of art by history. Moreover, the relics of fashion are always instructive and frequently valuable. But uncritical admiration of yesterday's trivia, which may have been wisely discarded, is no better than the unthinking acceptance of all novelty in the arts. When this happens, the enjoyment and understanding of art becomes cultic and unreflective. We lose contact with our intelligence and capacity for feeling, substituting mechanical reactions, "inside" jargon, and the doubtful security of repeating the right words and liking the right things without knowing why.

Boxes differ from grottoes and niches in that they close and become a package. The niche is part of a stationary wall; the box is a portable container for something worth keeping. It has many of the ancient associations of a reliquary—a container which holds the bones of a saint or the remnant of a precious scroll or garment. The Ark of the Covenant in Jewish houses of worship, for example, is a chest in which are kept the Scrolls of the Law. Originally the ark was portable; now it is usually built into the wall behind the altar and is opened only on special occasions. These religious uses of boxlike containers suggest the ancestry of boxes in modern sculpture. And boxes in ordinary usage provide additional connections between everyday behavior and sculpture; we have toolboxes and lunch boxes, silver chests and hope chests, strongboxes and wall safes. The kitchen shelf-units of modern homes are collections of wall boxes and base cabinets; every drawer or closet can be perceived as a type of reliquary. How often housewives perform the modern ritual of opening the door to a kitchen cabinet, casually reaching for a package which has been extolled, reproduced, and *glorified* by the best resources our civilization has for conferring the magical power to banish care! But the most remarkable box we have—transcending even the radio and the refrigerator—is the television set. It is more magically potent than the motion picture screen because its sounds and images are not projected upon it but come from within, and, besides, it looks like sculpture from behind. Indeed, the television box may be the twentieth-century shrine which reveals to contemporary man the hypnotic potential of all niche sculptures.

The authority of the niche is powerfully demonstrated in the sculpture of Louise Nevelson (born 1904), which usually consists of a collection of boxes or cells—little rooms. Painted in monochrome—black, white, or gold—her constructions convey first of all the impression of compulsive neatness and order, of well-arranged, frequently cleaned drawers. Without knowing what the contents are, one senses they have been carefully classified, reviewed from time to time, and periodically dusted. They

GEORGE SEGAL. *Girl in Doorway.* 1965. Whitney Museum of American Art, New York

consist, in fact, of pieces of wood molding, bowling pins, newel posts, chair legs, plain wooden boards, and lumberyard odds and ends. What distinguishes *Royal Tide I*, for example, is not so much the origin of the fragments as the precision and control one senses in their location. Since no significant meaning can be attributed to the wooden shapes themselves, how can we explain their oddly gratifying power?

Just as the monolith is a basic sculptural type for the expression of order, so also is the box a type which automatically commands belief; it is convincing on sight. The box-form in general, and Mrs. Nevelson's work in particular, constitute a latter-day magical art. The artist employing this form is a shaman or sorcerer, and the box sculpture becomes a potential container for fetish objects. It is not necessary to know what the wooden shapes mean inherently so long as we believe they will ward off evil spirits, that is, the tensions and anxieties we normally treat with aspirin and tranquilizers. Indeed, the anonymity of the boxes sustains faith in their magical influence. It is a case of the *form of presentation* taking possession of and governing the material which is presented. The monochrome paint changes each wooden object into a talisman, a kind of charm. Since five sides of the box are enclosed, the sixth side surely has been opened to us as a special privilege, just as the doors of an altarpiece are

LOUISE NEVELSON. *Totality Dark*.
1962. Pace Gallery, New York

Advertisement for air freight. Courtesy American
Airlines Freight System, New York. 1964. An
application of box sculpture to meet the needs
of advertising; but emphasis is on the security of
many closed containers rather than the compelling magic of their contents.

LOUISE NEVELSON. *Royal Tide I*.
1960. Collection Howard and Jean
Lipman, New York

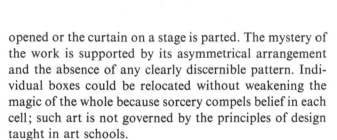

MARCEL DUCHAMP. *Boîte-en-valise (The Box in a Valise)*. 1938–42. Dwan Gallery, New York

Crafts for Tour advertisement. 1963. Courtesy The 7 Santini Brothers Fine Arts Division, New York

opened or the curtain on a stage is parted. The mystery of the work is supported by its asymmetrical arrangement and the absence of any clearly discernible pattern. Individual boxes could be relocated without weakening the magic of the whole because sorcery compels belief in each cell; such art is not governed by the principles of design taught in art schools.

Marcel Duchamp's *Boîte-en-valise* (*The Box in a Valise*) is a craftily compartmented little museum contained within a box which resembles an attaché case. Its carefully dimensioned spaces make room for small reproductions of each of the sixty-eight principal works Duchamp created before abandoning art for chess. In all, three hundred editions of the "museum" and its contents were built. But the box is more than a handy container for the artistic output of the pioneer Surrealist. Its identity as a work of art lies in the relationship between the contents and the container. It is not merely a portable educational device designed to introduce students to miniaturized but "real" versions of genuine art objects, though the serio-comic possibility of such a device is raised by Duchamp in order to dwell on the distinctive ironies which appeal to him as a man and as an artist. (1) There is irony when the enthusiasm, productivity, and intellectual ferment of an important artist's career can be neatly contained in a small valise. (2) There is irony in Duchamp's resolution of the conflict between Dadaism and design; all the anti-art, antimeaning, and glorification-of-chance tendencies in Dada must submit to the precise, orderly, engineering requirements of the box form. (3) There is irony in the domestication of Dada; in a box it becomes tame. By miniaturizing works of art which were originally con-

sidered scandalous and giving them neutral locations in a container according to the impartial logic of space requirement, their disturbing possibilities are minimized; the barbarian ideas are civilized; the objects and reproductions become a type of inventory—merchandise which can be displayed as in a salesman's sample-case.

A comprehensive irony in Duchamp's traveling case can be seen in its role as a metaphor for liberal education as a whole. The box functions as a symbol of educational institutions—libraries, museums, colleges, and universities: the compartments are subjects, courses, disciplines, and curricula; the objects are teaching equipment, books, slides, lab manuals, and catalogues; their arbitrary arrangement corresponds to the elective system. Finally, their miniaturized resemblance to reality suggests the artificiality of the art world as well as the remoteness from life of educational institutions.

The boxes of Joseph Cornell (born 1903) are also surreal containers—collections of objects which seem related until the viewer suddenly realizes that the logic of common sense leads to a series of uncommon questions he cannot answer. For example, *Soap Bubble Set* (1950) has all the serenity and simplicity of a Chardin still life. The objects are not anonymous, as are Louise Nevelson's wood fragments, and they assume no magical or fetishistic role. But they have the capacity to induce dreams of old possessions and places, recollections of childhood, and images which seem to belong to the future. Many observers react nostalgically to Cornell's work. Apparently, he manages to scramble one's time sense, which is fitting and proper for Surrealist art. The experience is entirely pleasant and nonviolent; it leaves no scars. The

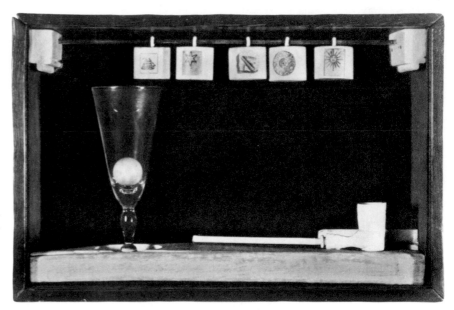

JOSEPH CORNELL. *Soap Bubble Set.* 1950. Collection Mr. and Mrs. Daniel Varenne, Paris

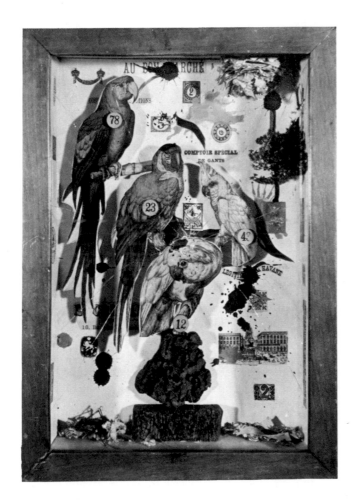

JOSEPH CORNELL. *Blériot.* 1956. Collection Mr. and Mrs. E. A. Bergman, Chicago

JOSEPH CORNELL. *Habitat for a Shooting Gallery.* 1943. Collection Irving Blum, Los Angeles

collections have no erotic suggestion; if they awaken a another place or time and then to return to the preents.

Cornell has been creating his enigmatic and delightful constructions since the 1930s, apparently uninfluenced by contemporaneous developments in art. In his work the connection with sculpture is very tenuous; he is really an Imagist poet who uses objects in space to create opportunities for reverie, or an occasional ironic comment. *Habitat for a Shooting Gallery*, for example, communicates more explicitly than is the artist's custom. Still, its cutouts and dated printing matter introduce some Victorian evocations at the same time that the shattered glass cracks the silence of the collection. *Blériot* (1956), on the other hand, has the spare, open structure of Constructivist sculpture. It is also a prime exemplar of quietly stated visual wit. The rusted spring mounted on a kind of trapeze or parrot's perch is intended as a symbol of the first Frenchman to fly across the English Channel. Ever economical with his means while seeking to encompass the widest span of time and space, Cornell extends the metaphor to bird and machine flight, to planetary orbits in space, and back to the bird in its cage.

H. C. Westermann's boxes are distinguished by their careful craftsmanship and their grotesque connection with the human figure. *Memorial to the Idea of Man, If He Was an Idea* is a large (fifty-five inches high), well-made cabinet-and-Cyclops who has for a crown crenellations just like the battlements on a castle tower. The door of his torso, when opened, reveals an interior that is lined with bottle caps and contains the figures of a headless baseball player and an armless acrobat, plus a black ship sinking in a sea of bottle caps.

It is not unusual for primitive sculpture to include magical substances in the abdominal cavity. Werner Schmalenbach in *African Art* says: "A figure is a fetish and can be used as one only when it is charged with some magic content. . . . Every conceivable thing is used as a magic content: bits of bone, teeth, animal claws. . . . They are often placed in a cavity hollowed out in the head or belly, or, too, in a little horn on top of the head."[33] Westermann, responding to a similar impulse, lavishes considerable effort on the interior finish of his boxes and contained forms. Since the inside of the construction will not be seen in a casual inspection, his approach to box sculpture embodies a totally different concept from previous examples. The artist does not rely entirely on the outward visual aspect to make his statement; he feels obliged to fabricate the visceral contents too, although they will not necessarily be seen. Together with the evidence of superior joinery and the obvious durability of the box, this completeness of construction suggests that Westermann is not merely concerned with the creation of artistic illusions. He appears to be fashioning real beings who exist by virtue of their own built-in equipment and according to their own laws. The fact that their insides are lined with the debris of an afternoon at a baseball

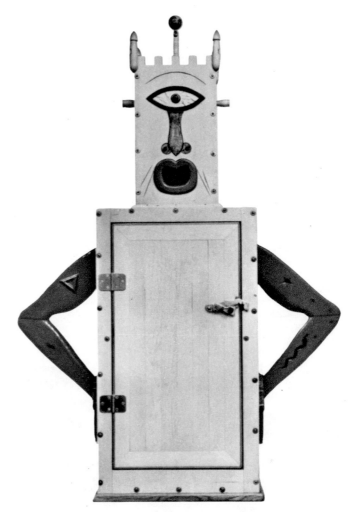

H. C. WESTERMANN. *Memorial to the Idea of Man, If He Was an Idea.* 1958. Collection Lewis Manilow, Chicago

stadium is no more remarkable than the fact that the insides of other creatures contain partly digested hamburger and coke.

The arms akimbo may be a reference to the famous Leo Durocher stance before angry baseball umpires. Indeed, the whole work is a scathing "memorial" to man as sports fan. But these symbols function within a new conception of the sculptor's role: the sculptor is an architect. His constructions, like architecture, exist to be used and seen, but they also possess operative parts which are not seen. These unseen operations are essential to the validity of the work as a whole. So, just as the architect builds heating, cooling, plumbing, and electrical systems into a building, the sculptor builds a consciousness into his creations: memories, visceral emotions, ideals of heroism, fears of defeat, undigested experiences, and the assorted rubbish of the creature's personal history. *Memorial* is a monster, of course, but only in those respects wherein it resembles a human being. Otherwise, it is a fine job of cabinetry—inoffensive and soundly put together.

Beyond Constructivism: Primary Structures

Under the influence of Constructivism, sculpture has tended to divest itself of figurative, gestural, and symbolic meanings. Not only did Constructivism emphasize the analysis of matter and motion as if sculpture were an extension of physics, it also encouraged the dissolution of monolithic forms and thus contributed substantially to the breakdown of classic conceptions of sculpture. It was perhaps inevitable, then, that sculpture would reconstitute itself more as a process than a thing. That is indeed what has happened with those sculptors who create primary structures: sculpture has redefined itself as a new process of visual inquiry—the exploration of architectural space.

Primary structures are not chiefly intended to be precious objects—to be worshiped, owned, institutionalized, isolated in special places, or employed as architectural adornments. They are instead the monumental by-products of spatial investigations—rational, intuitive, geometrical, and technical—undertaken to discover the

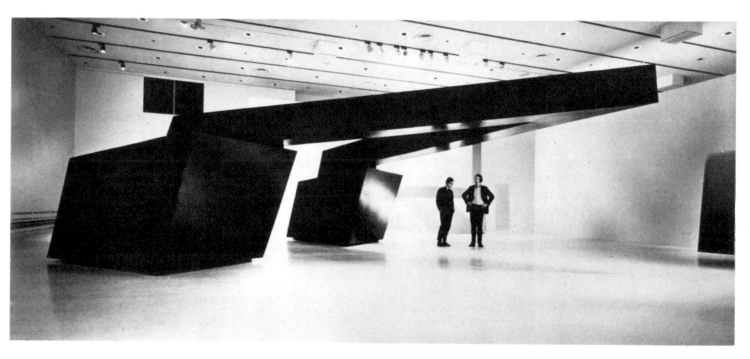

RONALD BLADEN. *Cathedral Evening.* 1969. South Albany Mall Project, Albany, New York. An important change in perception occurs when sculpture (or painting) assumes the scale of architecture: we no longer feel ourselves in the presence of represented forms; we tend to regard the object as a primary rather than a derived phenomenon.

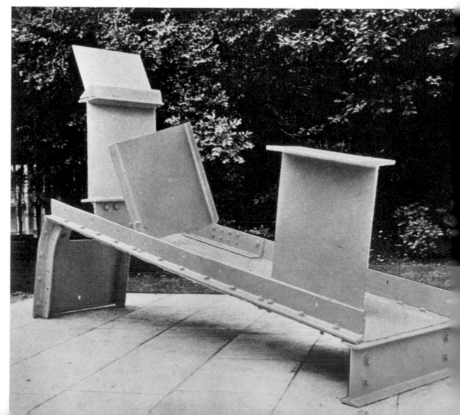

ANTHONY CARO. *Midday.* 1960. Collection T. M. and P. G. Caro, London

impact of large-scale, three-dimensional forms on human thought, feeling, and awareness. A similar goal was pursued by the painters who created Environments, although they operated from a base established by Dada and Surrealist collage-makers. The primary structuralists, on the other hand, are the inheritors of an artistic tradition whose natural role involves the building of real forms in real space. Hence, no matter how cerebral their works may appear, we are continuously aware of their corporeal existence—not as virtual forms in an imaginative world, but as authentic occupiers of the same *Lebensraum* we all share.

If the figure of man is not visibly present in primary structures, man's typical responses to spatial openings and enclosures must nevertheless be assumed. This presence is what most abstractionists invoke when they insist that a humanistic art need not include *representation* of the figure: like all artists, they have to design with the perceptual and physiological behavior of human beings in mind.

Primary structuralists vary, however, in the degree to which they are committed to intuition or calculation in design. Some are willing to surrender the control of sculptural form (as are some architects) to prepared number systems or the impersonal operation of mathematical equations and formulas. Some would use com-

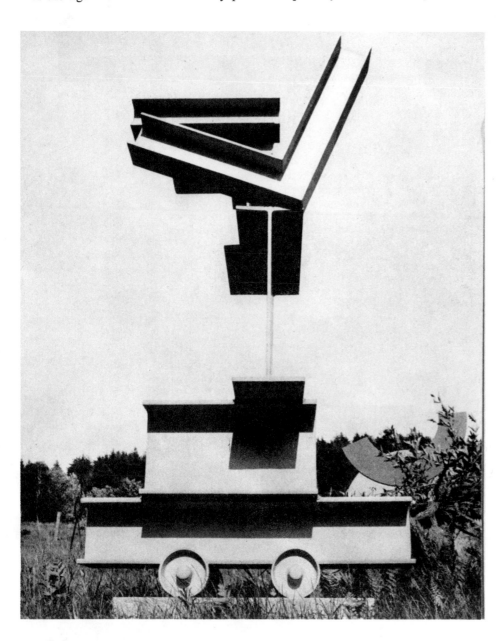

DAVID SMITH. *Untitled.* 1964. Estate of David Smith. Courtesy Marlborough Gallery, New York

Composing with I-beams reinforces the sculptor's determination to liberate himself from dependence on the figure. He wants sculpture to enjoy the same freedom as nonobjective painting.

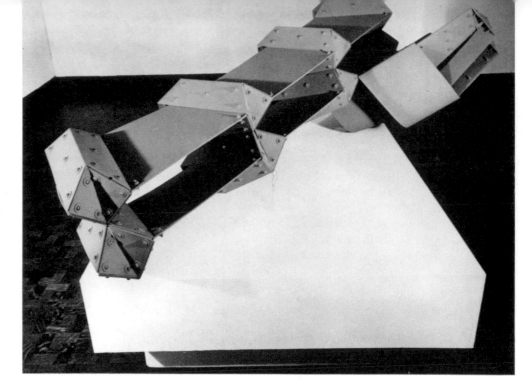

Sculpture becomes the art of engineering a stately geometric twist, or of subjecting post-and-beam forms to diagonal stresses, seeming to bury and then resurrect them. Despite their monumental scale, these are humorous works.

EDGAR NEGRET. *The Bridge*. 1968. Collection Mr. Alfred Bonino, New York

left:
GEORGES VANTONGERLOO. *Construction $y-2x^3-13.5x^2-21x$.* 1935. Kunstmuseum, Basel. An early and austere example of sculpture created according to a mathematical equation. But notice the uncontrolled reflections, shimmers, and diffractions in the nickel-silver surfaces. Were they also planned?

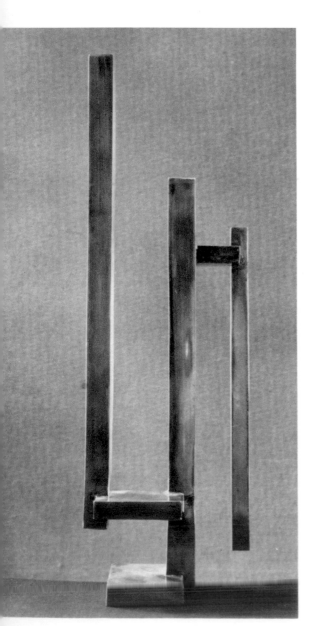

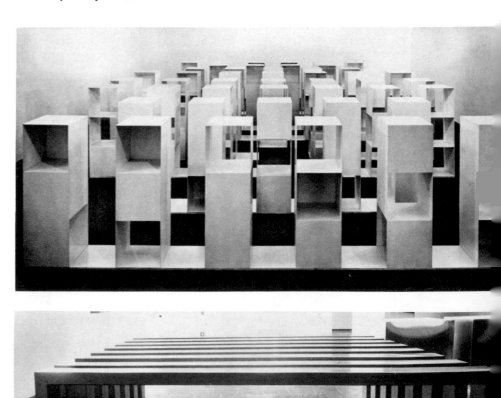

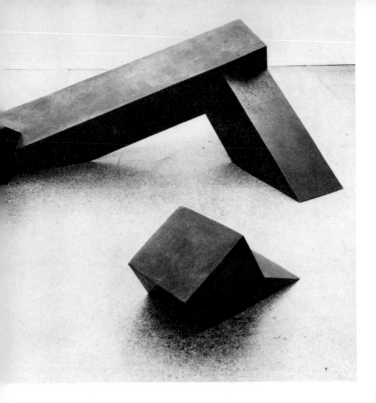

ISAMU NOGUCHI. *Floor Frame.* 1962. Collection Robert A. Bernhard, Portchester, New York

TONY SMITH. *Cigarette.* 1961–66. Albright-Knox Art Gallery, Buffalo, New York. Gift of the Seymour H. Knox Foundation, Inc.

puters for design. Of course, artists have sought a "science of proportion" since the time of the ancient Greeks, and mathematics has often been the artist's device for avoiding the influence of subjective feelings and preferences in the design process: a mathematically precise series of voids and solids seems to obey laws outside the chaos of man's thought and desire.

Today, labels like "serial sculpture," "system sculpture," and "ABC art" are used to describe sculpture which relies heavily on simplicity of basic volumes and voids, mechanically produced surfaces, depersonalization of shape, and the algebraic playing out of permutations and combinations of form. Impact on the viewer, however, is anything but simple and precise; architectural

emotions are inevitably involved if only because of the scale of what the viewer sees, the obviously engineered character of the forms, and the implied invitation to move under, around, and through the sculpture. There is no way, of course, for artists or spectators to escape their humanity. The very mathematics to which sculptors would entrust their design decisions are, in fact, the creations of men who practiced the ancient arts of measure and poetic invention.

at left:
SOL LEWITT. *47 Three-Part Variations on 3 Different Kinds of Cubes.* 1967. Dwan Gallery, New York

Through the absolute predictability of serial imagery, the sculptor tries to empty his forms of emotional and historical "debris." But then a conflict arises: these constructions occupy real space on a real planet, earth, whose gravity, atmosphere, and motion (night and day, light and dark) inevitably affect man-made or natural structures and our perceptions of them.

MAX BILL. *Endless Loop I.* 1947–49. The Joseph H. Hirshhorn Collection. A former student of Albers, Max Bill looks to mathematics and crystalline forms for a way out of the "anarchy" of artistic self-expression.

at left:
DONALD JUDD. *Untitled.* 1968. Collection Mr. and Mrs. Frederick B. Mayer, Denver

Kinetic Sculpture

Sculpture in motion has a history as old as the Trojan horse and as recent as the figures which strike the hour in the Piazza San Marco in Venice or in New York's Herald Square, in front of Macy's Department Store. It is demonstrated in the widely owned but aesthetically unmentionable Swiss clock, as well as in the millions of spring-driven, motor-driven, and rocket-actuated toys. The combination of sculpture with mechanical motion occupied some of the great minds of the Renaissance, including that of Leonardo da Vinci, who, among his multifarious activities, designed sculptural-mechanical devices for princely entertainments and city festivals.

As we know, Leonardo also designed an early flying machine, repeating the exploit of the Greek sculptor, Daedalus, who, according to the myth, achieved successful flight but with disastrous results for his son, Icarus. Flying too close to the sun, which melted his wax wings, the boy fell into the sea and was drowned. Thus did the ancients describe the fate of men who seek to share the prerogatives of the gods. But the myth may have other meanings. According to the poet Robert Graves, the idea of melted wax wings is connected with the *cire-perdue* (lost-wax) method of bronze casting, which was brought from Crete to Greece by Daedalus.[34] Daedalus may also have been the mythical progenitor of all kinetic sculptors, since he is supposed to have devised dolls with movable limbs for the daughters of the king of Sicily. At any rate, the ability to make objects which can move by themselves —whether machines or sculpture, whether on land or in the air—has always seemed to be one of the great mysteries. Men who possess this capacity must be more than ordinary mortals: they must somehow have gained access to secrets about the movement of the universe itself.

It is the mystery surrounding motion as an idea and as a phenomenon which fascinates artists. We realize that science possesses a vast body of knowledge about motion, and we are familiar with the useful applications of that knowledge in technology and especially in mechanization. With respect to motion, science is like a runner who drives his body as fast as he can to win a race; the goal is realized at the end of the race through increased knowledge of energy and matter. But art is like a dancer who moves her body as gracefully as she can because it feels better to move that way; her goal is realized *during* the dance through feelings of pleasure in bodily movement for its own sake.

Static sculpture, like painting, is obliged to use optical devices to convey an illusory impression of movement. In figurative art, the position of the body, the twisting of the trunk, the contraction of certain muscles, or the portrayal of postures associated with exertion can be read directly as frozen action or, by arousing empathic responses in the

RICHARD HUNT. *Icarus.* 1956. Albright-Knox Art Gallery, Buffalo, New York

viewer, can communicate some of the bodily feelings described in the work of art. In kinetic sculpture, however, motion becomes one of the visual elements, like shape or color.

Futurist art was, as we know, officially dedicated to the expression of movement, especially of mechanical movement, which was considered "more beautiful than the *Victory of Samothrace*." But for the most part, the Futurists stayed within the static conventions of painting and sculpture; their work *represented* motion and mechanization, but did not *absorb* them into the art form itself. Similarly, the Impressionists were interested in light, but they continued to paint pictures with pigment rather than create works of art with light itself as László Moholy-Nagy was to do later.[35]

In 1920, Naum Gabo created the first modern work to be designated "kinetic" sculpture and exhibited it in Berlin in 1922. The statement which he and his brother

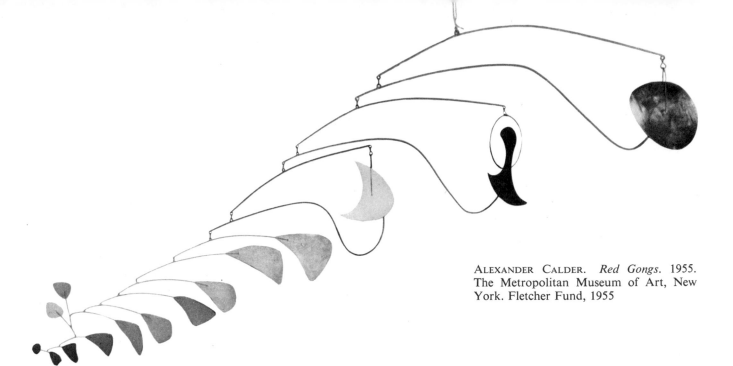

ALEXANDER CALDER. *Red Gongs.* 1955.
The Metropolitan Museum of Art, New
York. Fletcher Fund, 1955

made in their *Realist Manifesto* (1920) serves as a foundation principle for kinetic sculpture as well as Constructivist aesthetics: "We free ourselves from the thousand-year-old error of art, originating in Egypt, that only static rhythms can be its elements. We proclaim that for present-day perceptions the most important elements of art are the kinetic rhythms."

But Gabo concentrated on constructions which penetrate volume and minimize mass. He executed few works which actually employ movement as an element. It remained for the American sculptor Alexander Calder to

create in the 1930s an art form—mobiles—which successfully integrates motion into art without abandoning any of the essential traits of sculpture.

Calder's mobiles do not sacrifice the material, spatial, or design properties of static sculpture, and, although he has occasionally used motors to impart movement, his best-known works seemingly move by themselves. They are sensitively balanced systems which are set into motion by the gentlest of air currents. Thus, while they receive their motive force from the invisible environment, the parts and subsystems of mobiles move in orbits designed

MOVEMENT AND PRECARIOUS BALANCE CONVEYED BY STATIC SCULPTURE

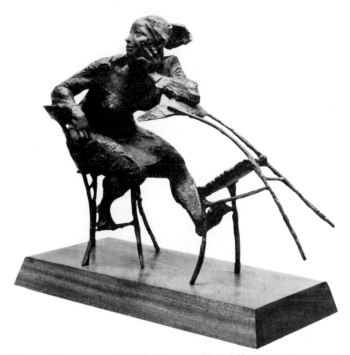

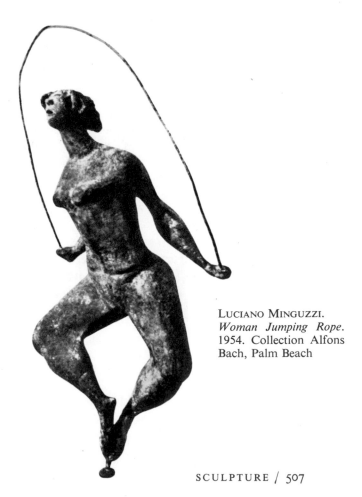

LUCIANO MINGUZZI.
Woman Jumping Rope.
1954. Collection Alfons
Bach, Palm Beach

BRUNO LUCCHESI. *Seated Woman #2.* 1963.
Whereabouts unknown

by the sculptor. Hence, the energy which actuates the mobile is random, whereas the character of its movement is largely anticipated, which is to say, formed.

It is possible to discuss the meaning of the shapes in Calder's sculpture as if they were parts of static sculpture. The original contribution of mobiles, however, is to raise the possibility of responding to *qualities* of movement as attributes of an organized art form. Calder's shapes appear to be biomorphic forms similar to those used by Arp and Miró. For the most part, they are playful, reminiscent either of child and primitive art or of natural forms—fish, animals, leaves, flowers, planets, and stars. But his sculptural movement interests us here, and it is expressive both of nature and the man-made world. Some works suggest the stately motion of great tree branches in a deep forest; others are as comic as Charlie Chaplin strolling, hopping, and dancing his way down a street after stubbing his toe. The fact that mobiles are widely imitated—they have become virtually an American folk art—suggests that it is their organized motion which has caught the popular imagination, since abstract forms do not usually evoke such broad acceptance, and especially the kind of approval which is implied by imitation.

While Calder is the best-known of kinetic sculptors, there are other men who employ motion, either in elaborations of Calder's works or in new kinetic forms of their own. Furthermore, the artistic "breakthrough" which kinetic sculpture represents has introduced new problems related to the study of kinetic art. Just as *motion* pictures require a conceptual framework and terms of reference which differ from those used to study *still* pictures, so also does motion sculpture require its own categories and special terms.

Kinetic sculpture might be classified according to its *source of energy*, in which case the following categories can be established: natural kinetics and artificial kinetics.

NATURAL KINETICS

Here we describe the operation of invisible, nonmechanical forces which drive Calder mobiles—for example, wind currents, gravity, temperature and humidity changes in the environment of the work. The weathervane and the windmill exploit such energy sources, although for different purposes. Inside a room, as we know, warm air rises naturally and its upward movement can be used to impel sculpture. If it is directed against forms shaped to act like fins or sails, they can be set in motion; they can also be used in conjunction with controlled light to cast moving shadows. Using a chemical or mechanical heating device to accomplish such a purpose would seem to violate the "rules," although the movement of air by convection is invisible. Another type of motion derives from sculptural forms which have an insecure, rocker-like base; its energy comes from the force of gravity working on the sculptor's shapes and assisted by his location of the masses. We are, of course, mainly familar with the operation of gravity to promote stability and the absence of motion in sculpture. But the swing, the seesaw, and the pendulum are instances of stability *and* motion which pleasurably or usefully employ the force of gravity, and they constitute models for kinetic sculpture. Water falling against man-made forms, pouring into container systems, or spilling out of them in a calculated sequence also constitutes a source of naturally available energy. But its use, as in the waterwheel, involves a more-or-less sophisticated machine. In fact, all of the above-mentioned arrangements for using natural energy in sculpture entail relatively primitive ways of harnessing air, heat, gravity, or moisture to create motion, to do work. However, they do not obviously—that is, visually—introduce mechanical force, fuel combustion, or electricity.

Thin metal or plastic rods fixed at one end can exhibit vibratory motion based on their resonance and elasticity; such energy is a property of the material and its shape, as in the case of a watch spring. But a spring must be wound, and a metal rod requires outside energies to make it flex and vibrate—a controlled electrical force, say, if the resultant motion is to achieve the aesthetic objectives of the artist, as in the *Fountain* by Len Lye (born 1901). Kinetic sculptors are understandably tempted to use gadgetry of one sort or another to manipulate the energy available in natural forces and materials. But there appears to be a group among kinetic sculptors who would rather avoid the introduction of "outside" energy sources. Perhaps they feel that motion should *seem* to be independent of any mechanical assistance or obvious manipulation of nature.

JOSÉ DE RIVERA. *Homage to the World of Minkowski.* 1955. The Metropolitan Museum of Art, New York. Fletcher Fund, 1955

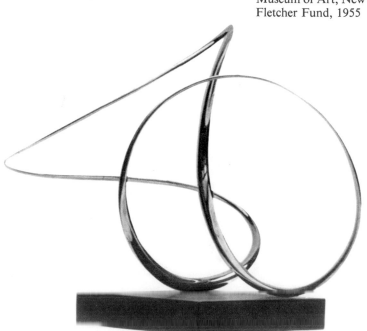

Whistle in the form of a swinging girl, from Remojadas region, Veracruz, Mexico. 300–900 A.D. The Museum of Primitive Art, New York

Noguchi's little person, though static, expresses the same dynamism as the swinging-girl whistle.

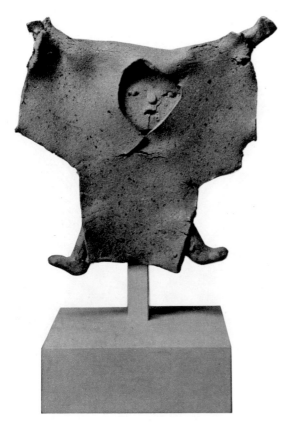

ISAMU NOGUCHI. *Big Boy.* 1952. The Museum of Modern Art, New York. A. Conger Goodyear Fund

ARTIFICIAL KINETICS

This category designates man-made motive force used to drive sculptures which would not achieve motion either spontaneously or by the introduction of a small initial "push" from the outside. All energy sources arise ultimately in nature, but some kinetic sculptors are willing to interpose artificial devices between nature and art in order to operate their creations and to regulate the energy flow and exchange which nature might or might not provide. Since small electric motors are now very efficient, they are often used to drive kinetic sculptures. Their power comes from batteries or house current. But electrical energy, like wind energy, is invisible; it must be translated into mechanical action to create the visual movement which is the actual content of kinetic sculpture. Similarly, energy from other sources, such as watch springs or electromagnets, must find mechanical expression to achieve visible results. Eventually, perhaps, photochemical effects will become part of the visual repertory of kinetic art, and then translation into mechanical movement may not be necessary. But at present, kinetic sculpture is largely dominated by what can be done through mechanical and electronic devices.

TYPES OF MOTION

Clearly, the *source of energy* has a bearing on the *type of motion* which a kinetic sculpture will exhibit. That is why natural and artificial sources of energy have been distinguished here. We are ultimately interested, however, in types of motion because they constitute (along with the visual forms) the embodiment of aesthetic quality in kinetic sculpture. Wind, the flow of water in a stream, air convection in a room, or the casual gesture of a hand against an object—all are intermittent forces. If they are employed as energy sources, they will not influence sculptural movement in the same fashion as the regular output of energy from an electric motor or a gasoline engine. An electrically driven Calder mobile does not move as his wind-driven works do, although there are some similarities. In general, artificial energy causes regular rhythms, recurrent events, intentional movements, whereas the unpredictable and irregular character of natural energy imparts some of its own random quality to the sculpture it animates.

There are several types of motion which could potentially be imitated and abstracted in kinetic sculpture. As with the other visual arts, sources arise in nature, in man himself, in the man-made world, and in the interactions among all these. Kinetic sculpture permits treatment not only of the color of clouds or the shapes of fruit but also of atmospheric movement, of leaves blown from trees, of hail striking cobblestones, of airplane shadows moving across cattle grazing in a field. That is, kinetic sculpture can deal with qualities of motion in these events apart

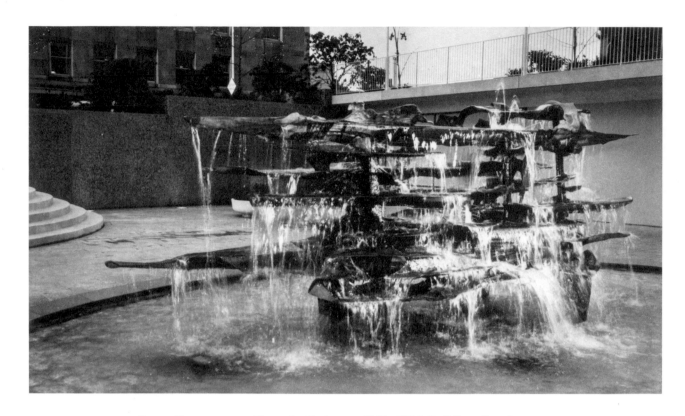

JAMES FITZGERALD. *Fountain Sculpture*. 1961. IBM Building, Seattle. The action of a rugged natural waterfall is simulated by the organization of hovering metal planes in an abstract fountain sculpture.

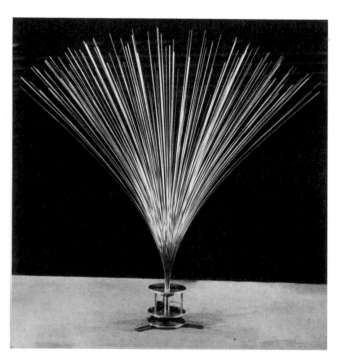

LEN LYE. *Fountain*. 1963. Collection Mr. and Mrs. Howard Wise, New York

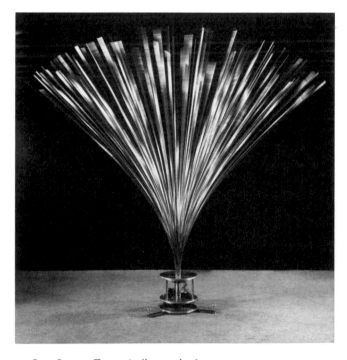

LEN LYE. *Fountain* (in motion)

TAKIS. *Signal Rocket.*
1955. The Museum of
Modern Art, New York.
Mrs. Charles V. Hickox
Fund

KONSTANTIN MILONADIS. *Flower Garden.* 1961.
Collection Dr. and Mrs. Malcolm A. McCannel,
Minneapolis

from the appearance of the participants in them. It can be
highly abstract, similar to the musical organization of
sound. The movement of the human figure, varied accord-
ing to age, sex, or occupation, now becomes available to
plastic art—not ephemerally as in the dance or the film—
but in a form which is relatively permanent, concrete, and
reproducible.

Mechanical motion is understandably attractive to kinet-
ic sculptors because they must use it themselves to
combine sculptural form with movement. In addition,
the machine as an idea and as a feature of the visual en-
vironment is inevitably part of the artistic expression of
our time. The problem of the kinetic sculptor lies in going
beyond the mere incorporation of machines and machine
forms in his work. Since mechanical action is often fasci-
nating in itself, some kinetic sculptures consist of ma-
chines designed for no purpose other than to exhibit their
own operation. They are distinguished from "real"

machines in that their "working" parts are exposed al-
though they perform no practical work. In his fantastic
designs for machines, the cartoonist Rube Goldberg
based his humor on a single idea—the absurdity of an
enormously complex apparatus for the performance of a
simple, really unnecessary job. Our fascination with the
precision, reliability, and mathematical order of machines
is mixed with various kinds of resentment and hostility
toward them: they seem perfect and absurd at the same
time.

Music Machine by Arthur Secunda appears to exhibit
Goldbergian absurdity in a craftsmanlike, operational
form. It consists of a gilded construction of wood, metal,
and machine parts built around a music box. Its associa-
tions with the mechanics of sound are abetted by radio
antennae, a built-in xylophone, a guitar handle, and other
noise-making and electronic odds and ends. Here the
externalization of gears, sprockets, springs, and so on is

part of a total effort to derive visual poetry from mechanized innards. Furthermore, it is consistent with the general tendency in contemporary art to avoid concealment of working parts.

The steam locomotive, for example, was a more dramatic and visually interesting combination of forms before it was streamlined, endowed with a skin, and made to resemble a fountain pen. But although we still cover machines with metal or plastic skins—cosmetic operations for the purposes of "styling"—we have overcome the Victorian distaste for mechanical forms. Victorians were enamored of mechanically duplicated imitations of handcraft. Consequently, artists like Secunda, Edwardo Paolozzi, or Julius Schmidt (born 1923) see meaningful ornament, power, and grace in the parts and operation of complex machines, much as in a bygone era small boys who wanted to be locomotive engineers saw magnificence in those steam engines and in the men who commanded them.

EXAMPLES OF KINETIC SCULPTURE

A practical application of kinetic sculpture is seen in Lin Emery's *Homage to Amercreo*, a mobile fountain whose forms fill with water until they tilt over, empty themselves, and then return to position to be filled again. Although

below:
JULIUS SCHMIDT. *Untitled.*
1962. Marlborough
Gallery, New York

ARTHUR SECUNDA. *Music Machine.* 1964–65.
Whereabouts unknown

the work functions as a machine, its mechanical operation is clearly subordinate to its visual performance. Perhaps this idea could be applied to other machines in our civilization with immense visual and psychological benefits. Of course, the purpose of a fountain is to create visual entertainment by the display of water in motion. In the past, sculptured figures were usually employed to hold a spout in position, but, from a certain standpoint, the frozen figure of a human being forever holding a water spray is faintly ridiculous. Emery's abstract forms, on the contrary, appear entirely suitable to their visual and mechanical function. The viewer may be grateful that they are not nymphs and sea creatures acting out an allegorical charade.

Study: Falling Man (Figure on a Bed) by Ernst Trova presents an aluminum figure strapped to an apparatus with clinical-experimental overtones. The work is terrifying because the apparatus is so obviously clean, efficient, and well calculated to carry out its job of scientific dehumanization. The figure is a model of urban, middle-aged man—slightly paunchy, swaybacked, faceless, and curiously without arms. In some respects he resembles the manikins used in place of drivers in auto-crash experiments. Trova has created an image of man as ideal subject for clinical experiment, the "patient etherized upon a table" of T. S. Eliot's poem "The Love Song of J. Alfred

LIN EMERY. *Homage to Amercreo.* 1964. American Creosote Works, Inc., New Orleans

Locomotive of the Norfolk and Western Railway

LIN EMERY. *Homage to Amercreo* (in motion)

Man-size manikin, from advertisement for Ford Motor Company. 1966.

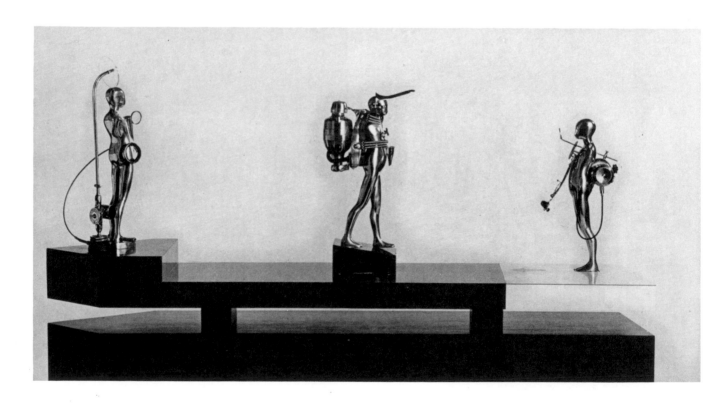

ERNEST TROVA. *Study: Falling Man (Landscape #1)*. 1964. Pace Gallery, New York

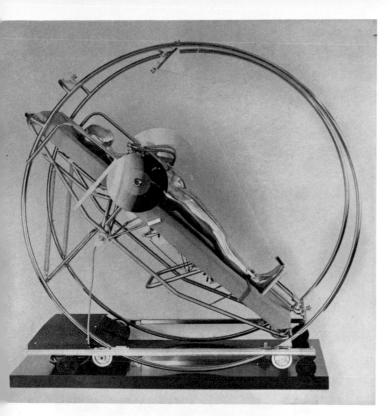

ERNEST TROVA. *Study: Falling Man (Figure on Bed)*. 1964. Pace Gallery, New York

cidal machine constituted a junkyard parody of contemporary civilization.

The short career of *Homage* was witnessed by a distinguished audience on March 17, 1960, in the garden of the Museum of Modern Art. But, contrary to expectation, the machine did not destroy itself completely, and M. Tinguely's intervention was required to set its course finally on the path to self-immolation. Following the ministrations of its maker, the entire whirring, flapping spectacle began to smoke, and at last it exploded into flame, its "useful" life ended with the assistance of a fire extinguisher.

Homage to New York, like the Happenings of Kaprow and associates, falls more conveniently into the category of dramatic performance than of sculpture because its existence is so brief. However, Tinguely has created other works which resemble *Homage* but do not attempt to explode. *Méta-Mécanique* exhibits the sculptor's fascination with mechanical movement and his addiction to bicycle wheels, discarded metal, and belt-driven systems for transmitting motion. Tinguely's kinetic sculptures move

Prufrock." He seems to be a willing victim of technology. But we do not know the purpose of the experiment. The figure is about to be rocked, whirled, and rotated as if he were an astronaut undergoing a simulated experience in weightlessness. Another of Trova's works, which is entitled *Study: Falling Man (Landscape #1)*, constitutes a deadly portrayal of a frail human organism beset with mechanical equipment to regulate its movement. The nakedness of the man, the Buck Rogers accessories strapped to his body, and the shiny aluminum surface he has for skin convey eerie evocations of that depersonalized humanity described by George Orwell in his not-very-fantastic novel, *1984*. A rather harmless creature is about to go through several very sophisticated gyrations. Precautions have been taken so that he will emerge whole, but will his manhood survive?

Jean Tinguely's kinetic sculptures are essentially mechanical poems about the absurdity of machines and, by implication, of a civilization which permits itself to be governed by them. His *Homage to New York* was a type of mechanized Happening. In addition to the battered piano mentioned earlier, drums, bicycle wheels, coke bottles, a typewriter, a drawing-machine, and a weather balloon figured as performers. Fifteen rickety motors powered the rather shabbily constructed affair. The entire assembly was designed to make music, create drawings, issue reports, give birth to machine offspring, set itself on fire, and finally destroy itself. The noise, the drawings, the typed reports, and the bursting activity in general were aimless in true Dada fashion. At the same time, the sui-

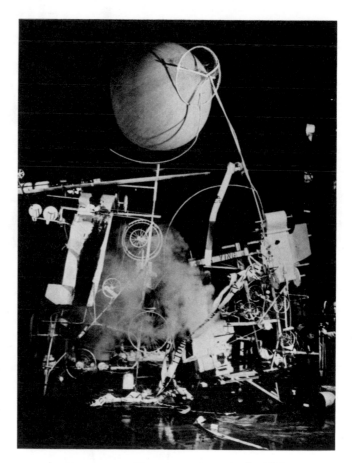

JEAN TINGUELY. *Homage to New York*. 1960. Self-destroyed March 17, 1960, in the garden of The Museum of Modern Art, New York

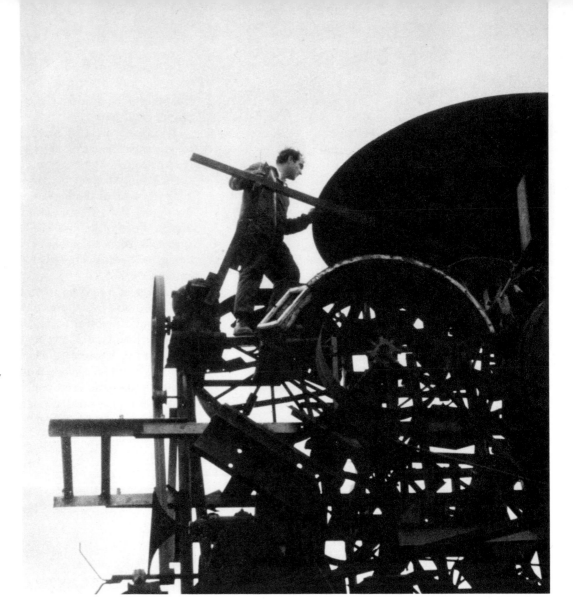

Photograph of Jean Tinguely
at work

JEAN TINGUELY. *Méta-Mécanique*. 1954. Museum of Fine Arts, Houston. Purchased with funds donated by D. and J. de Menil

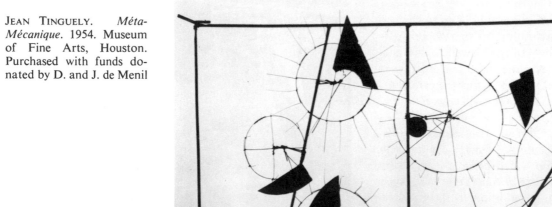
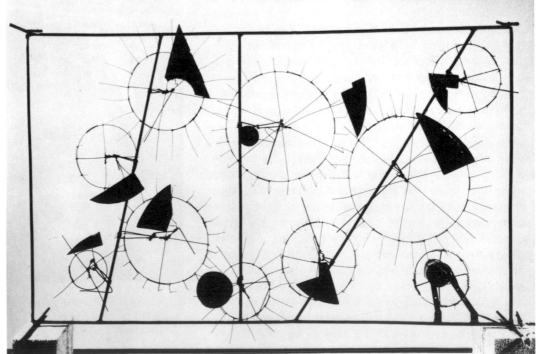

and sound something like a one-man band, with motors substituting for the embattled musician. They thump and pound, vibrate and oscillate, producing repetitious movement—sometimes to-and-fro alternations, sometimes simple ongoing cycles, as in *Homage*, where the machine endlessly dispatches soft-drink bottles down an inclined plane to a crashing finale.

Ever since Henry Ford perfected the assembly line and made ownership of a complex machine feasible for average citizens, Europeans have tended to identify America with both the triumphs and excesses of mechanization. Consequently, it is not surprising that the Swiss Tinguely should create in *Homage* a device which symbolizes a somewhat stereotyped understanding of America—Coca-Cola, rhythm and blues, automation, big business (typed reports), and explosive potential—perhaps to express resentment of the American economic and cultural colonization of Europe. By employing the quasi-ritualistic action of kinetic sculpture to smash Coke bottles, the artist presumably gave form to his aggressive feelings about the North American colossus of mechanization.

From the water clocks of Greece to Leonardo's mechanized entertainments for the Duke of Milan, to the Swiss cuckoo clock, to Calder's mobiles, to the parodies of Rube Goldberg, to the automated protest sculpture of Jean Tinguely is a long kinetic voyage. But it is altogether likely that Tinguely's work is a belated reaction to what Lewis Mumford has called the "paleotechnic" phase of civilization.[36] Tinguely's machines have not come abreast of modern, electronically guided tools; they more nearly resemble the equipment which must have adorned the bicycle shop of Orville and Wilbur Wright during the first decade of the twentieth century. That comfortable old noise and clangor has today been supplanted by new, quiet, and more subtly insidious processes of mechanization and automation. Perhaps that is why *Méta-Mécanique* is not at all frightening, but quaint, in the manner of antique coffee mills and sculpture that stands still.

The Crafts and Sculpture

The crafts have been involved in a maneuver of disengagement from useful manufacture, steadily fortifying their claims to fine-art status, that is, to being sculpture. Even though they are defended vigorously as useful art forms, the crafts are increasingly prized for their sculptural values rather than their practical function. Handmade ceramic pots, for example, serve as containers but cannot compete economically with mass-produced containers made of metal, plastics, or clay. Nevertheless, they continue to be made by potters, exhibited by museums, and purchased by collectors. Clearly, they satisfy aesthetic as well as utilitarian needs. This argument is strengthened by the fact that pottery forms—that is, shapes created from clay thrown on a wheel—are often assembled with no claim to function as containers. The potter's wheel is a tool of sculpture; clay formed in the characteristic manner of potters is a sculptural material, as it always was.

Peter Voulkos (born 1924) is perhaps the best-known of American potters who have extended their efforts to sculpture. He has been in the vanguard of artists who saw and explored the expressive possibilities of forms developed over the centuries by ceramic craftsmen. There are overtones of assemblage in his *Gallas Rock*, which was created by combining hand-built pottery forms. The act of putting them together, of crushing the former containers against each other, endows the result with some of the violence and kinaesthetic excitement one associates with action painting. Voulkos might be regarded as an "action potter," one who has taken the crucial step away from the pot as container and into the realm of sculpture as assembled, nonfunctional container.

BRUCE KOKKO. *Paint Can with Brush*. 1965. Whereabouts unknown

DORIAN ZACHAI. *Complacent Man* (tapestry). 1962

Jewels from the former collection of Helena Rubenstein. Courtesy Parke-Bernet Galleries, New York. The aspiration of the crafts to sculptural expressiveness and scale can result in spectacular and grotesque effects, as in these jewels, or in the rings, pins, bracelets, and lavalieres worn by the late Edith Sitwell.

PETER VOULKOS. *Gallas Rock*. 1959–60. Dr. and Mrs. Digby Gallas, Los Angeles

Similarly, jewelry and metalwork, silversmithing and enameling may be regarded as small-scale sculpture practiced with special materials. Woodworking in combination with metal, clay, fabric, or leather, or as employed in furniture, falls into the same sculptural category. Blown glass corresponds to clay shaped by the potter's wheel: it is a sculptural material which employs a specialized forming process. In addition, of course, glass can be cast like metal or cut like jade. The important point is that the crafts seem to be emerging from their "previous condition of servitude." Although they may continue to serve practical ends, they also perform the expressive functions of sculpture, and hence they should be seen in the same light.

ROGER LUCAS. Three-finger ring. 1969. Without a visual cue to its scale, this ring might easily be mistaken for monumental sculpture

Beyond the Museum: Earth Sculpture

We know that almost all objects *in* the environment have been designed by man. Now, a number of artists (some of them sculptors) want to create on the basis of an extension of this idea: they want to work on an immense environmental scale. But their "environment" is not the designed local space of human communities; it is the entire terrestrial environment—mostly the land, air, and water outside heavily populated places. Like civil and mining engineers, or like farmers, they would change the shape of the earth. Natural space, which has hitherto been the *container* of art, would become the object and perhaps the victim of man's designing impulses.

The results of sculpture's new ambition are called earthworks, skyworks, or waterworks. They yield a cliff wrapped in canvas, a small hole in a park or a great trench in the desert, captured stones and contained dirt, redirected streams of water, immense shafts of light or luminescent gas-filled bags of plastic sent into the sky. Like Happenings, these constitute events or things that are frequently too vast, fragile, temporary, or distant to be experienced for long by many persons; often they can only be heard or read about. They can be commissioned, but they are difficult to purchase, sometimes impossible to see, and meaningless to own. Surely they cannot be exhibited in museums. In a parody of commodity ownership, the artist may issue a certificate to a patron, testifying to the ownership of an earthwork, just as a broker conveys certificates for shares he has sold in cotton and grain futures or pork bellies.

No doubt the terrible but effective depredations of technology have contributed to a conception of sculpture as an exercise in megalomania—a tendency further encouraged by the formation of organizations uniting artists, scientists, and technologists. In addition, the recent

OTTO PIENE. Stage of *Manned Helium Sculpture*, one of three days of "Citything Sky Ballet," Pittsburgh. 1970

These gestures have little to do with the ecological ethic presently emerging. They are meaningful only with reference to what they reject in the history of art and in the implied revision of our ideas about artistic materials and forming processes.

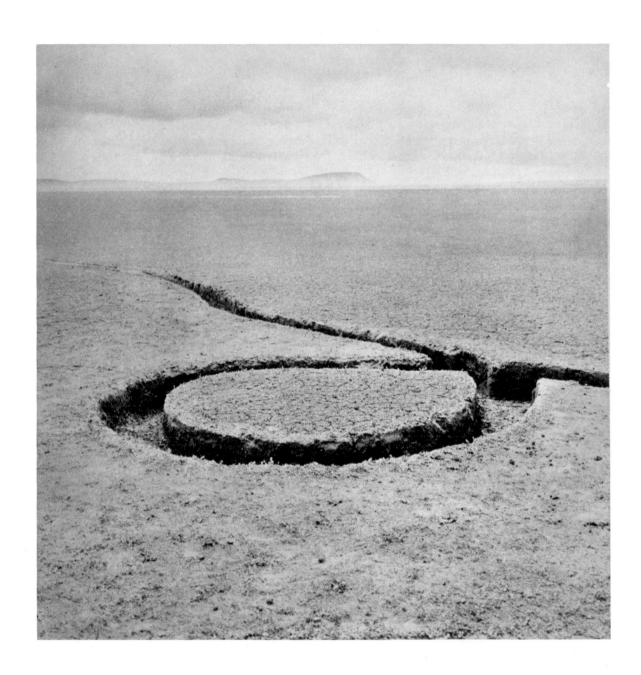

MICHAEL HEIZER. *Isolated Mass/Circumflex.* 1968. Massacre Dry Lake, Nevada

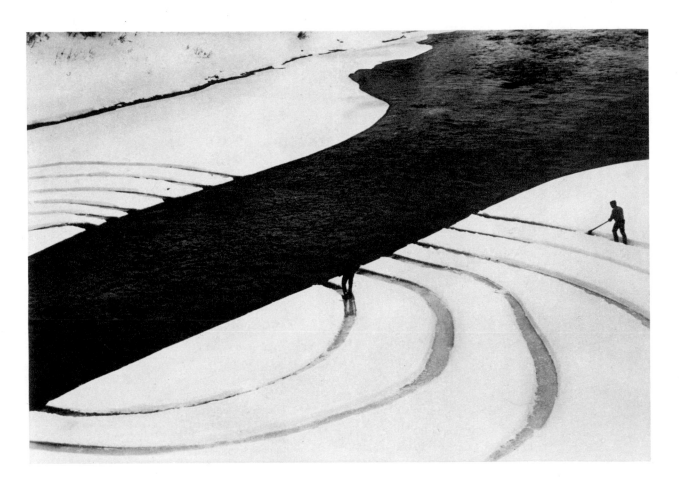

Dennis Oppenheim. *Annual Rings*. Aerial photograph of the frozen St. John River at Ft. Kent, Maine, the time zone and international boundary between the U. S. and Canada. 1968. Courtesy Mr. and Mrs. Kelly Anderson

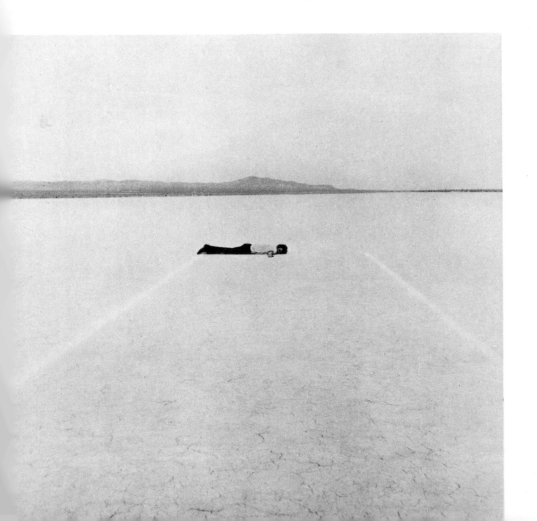

Walter de Maria. *Mile Long Drawing*. 1968. Mohave Desert, California. Eroded by wind within one month

right:
ALAN SARET. *Untitled.* 1969–70. Art Gallery of Ontario, Toronto

ROBERT MORRIS. *Earthwork.* Installed in the Dwan Gallery, 1968. Courtesy Leo Castelli Gallery, New York

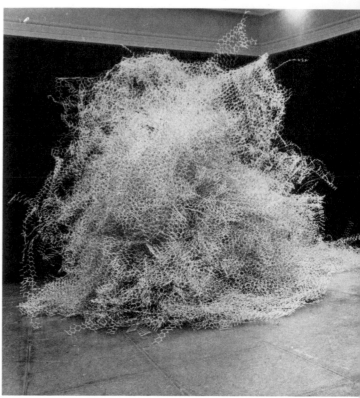

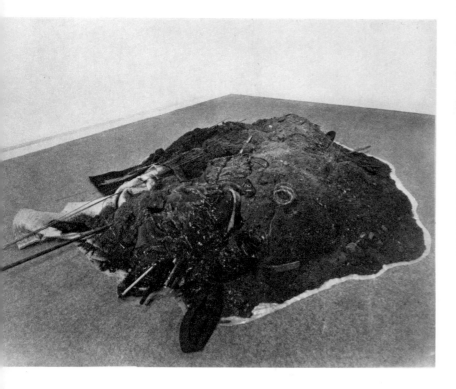

Dirt, assorted trash, and industrial waste have been dumped where they are not supposed to be. We are invited to examine them affirmatively, sympathetically—not as something to get rid of. Does the artist rely too greatly on our aesthetic tolerance and credulity? Is he serious?

ROBERT SMITHSON. *Spiral Jetty.* 1969. Great Salt Lake, Utah. Through the progressive design of the containers for his rocks, Smithson betrays a forming and not merely a collecting intention. Presumably the rocks seemed too anonymous without their shaped enclosures.

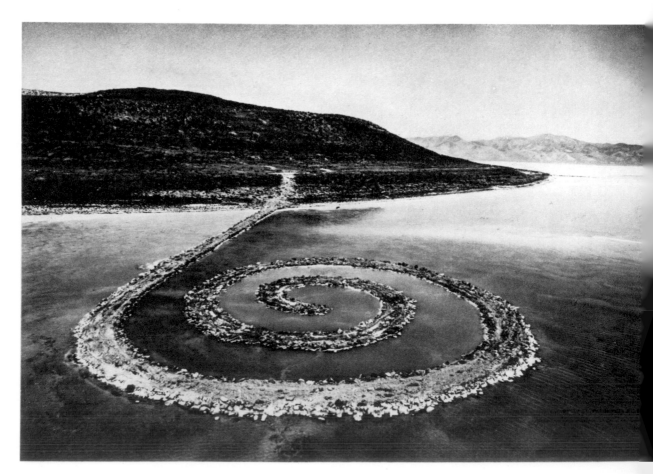

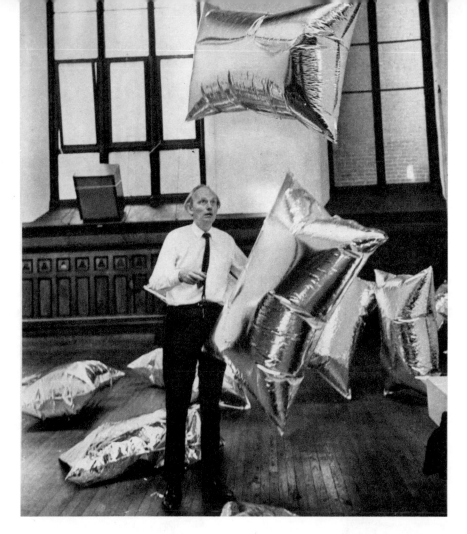

Photograph of Dr. Billy Kluver, electronics engineer, creating sculpture with helium-filled pillows, 1967. The marriage of art and technology has thus far produced amazement if not inspiration. But what remarkable progeny are yet to be born if the marriage lasts?

upsurge of ecological concern has stimulated thinking in terms of planet-wide ecosystems; man's imagination now ranges over the biosphere, the noosphere, and the atmosphere. Such developments would seem to open up extraordinary creative vistas for sculpture, and there is in earth sculpture the promise of prolific aesthetic offspring —the fruit of a marvelous synthesis between human

forming capacities and the earth and life sciences. But thus far, earth sculpture constitutes mainly a change in the materials, scale, and ambition of art; it appears to be, moreover, a type of antiart—a gesture by artists that expresses disgust with civilization, resentment toward art institutions, and contempt for the artistic traditions of usefulness, object-ness, and signification.

Conclusion

Of sculpture it can truly be said that in the midst of change there is also abiding sameness. Magic and sorcery persist in the art while its materials and techniques undergo radical transformations. Through all the innovations of form and concept, sculpture has retained its identity as an art of physical material occupying real space, compelling men to believe that the resultant forms are somehow alive. The history of sculpture is a history of innovation in material and technique, changes in form concept, and shifts in the interrelations of the various media. But the pursuit of vitality remains constant.

Ancient conceptions of volume and mass have been revised under the impact of modern science and technology. Classical notions of order and stability have given way to new emphases on dynamism. That is, many moderns are looking for ways to express vitality through agitated movement just as the Hellenistic Greeks did. Kinetic sculpture appears to be a departure from static sculpture, a "spin-off" which is similar in some respects to the departure of motion pictures from painting. In assemblage, sculpture and painting have come together, and in primary structures both have returned to architec-

A fortuitous resemblance, of course. But consider how Henry Adams regretted the replacement of the twelfth-century Virgin by the twentieth-century dynamo. For us, the RL10 inspires faith—just in the seeing. Without doubt it is the sculpture of our time.

Snake Goddess. c. 1600 B.C. Heraklion Museum, Crete

Pratt & Whitney RL10 rocket engine, from advertisement for United Aircraft Corporation. 1969. Courtesy Cunningham & Walsh, Inc., New York

ture, to serve as walls, vaults, niches, gates, caverns, and grottoes.

Perhaps assemblage has been responsible for calling attention to the sculptural character of the crafts. The use of exotic materials and found objects in "fine art" has had the effect of breaking down the old hierarchies among sculptural materials: marble, stone, bronze, and wood, with ivory, jade, and precious metals at the periphery. It is, of course, obvious that the material is important in any art object. But the importance of a material lies in the way it influences form and meaning, not in any arbitrary rank it possesses by virtue of its rarity, cost, or resistance to the artist's effort. The transformation of metal in sculpture is a case in point. Because metal is ductile, it can be drawn into long, thin strands of wire, a material used mainly for industrial purposes during the past two cen-

turies (although the barbarian metalsmiths of northern Europe and Asia excelled in the use of serpentine metal forms at least one thousand years ago). Now wire has become an important sculptural material—and not only for armatures. Threads, strands, and filaments are themselves expressive elements. Wrought iron, too, has changed in status from a decorative and structural material to one of the major media of sculpture. As was seen in the work of Gonzalez, wrought iron approximates wire in that both can describe form and enclose volume with a minimum of solid material and a maximum of open space.

Wire constitutes, of course, a metal line in space. Hence, it would seem to be an extension of drawing rather than an authentic sculptural material. But in addition, as was noted in the discussion of Constructivism, a line can be regarded as a more legitimate way of expressing volume

than a solid. At least, the line in space conforms with contemporary ideas about the energy trails of particles of matter as they move through their orbits. In the wrought-iron sculpture of Gonzalez (*Grande Maternity*, p. 289), we saw how converging lines could be employed to describe volumes. And in the sculpture of David Smith (p. 291), metallic line was used as a type of calligraphy. Do handwriting and particle physics constitute the only sculptural metaphors for which drawn wire or wrought iron are the media?

There are many others. Richard Lippold (see p. 227) has used filaments of gold- and silver-colored wire to suggest light emanations, mostly from celestial bodies. Of course, light rays are an obvious instance of the role energy particles play in daily life, but sunrays have been so conventionalized in art, even in the earliest efforts of children, that we do not find the sculptural representation of light energy especially strange. And, as mentioned earlier, Bernini used metallic lines to represent light behind his *St. Theresa* (p. 477). In the seventeenth century, the light represented by metal had a mystical connotation; but in the twentieth century the mysteries of science are intended.

Painting and sculpture have long dealt with light, but indirectly—in terms of its effect upon the grosser forms in the world which we can grasp or see with the unaided eye. Since the materials of sculpture have always been palpable, however, it is difficult to deny their physical existence. Consequently, the effort to use polished and anodyzed wire or fine metallic filaments to represent the very light which permits us to see constitutes an ambitious but ultimately frustrating artistic undertaking. As an alternative, artists endeavor to trap light itself, to bend it and bounce

LÁSZLÓ MOHOLY-NAGY. *Light-Space Modulator*. 1923–30. Busch-Reisinger Museum, Harvard University, Cambridge, Massachusetts. Almost fifty years ago, Moholy-Nagy anticipated many of today's experiments with light-and-motion sculpture. His machine is not only a working device, it is also a kinetic sculpture.

LUTHER GREENE (landscape gardener). Grotto in an apartment. Folk sculpture makes it possible to enjoy the best of two worlds—residence in a shell-lined grotto that strongly suggests life in an undersea cave, together with the comforts of a Manhattan apartment.

ANGELO LELII. Cobra Lamp. 1970. Distributed by George Kovacs, Inc., New York

Further evidence of the powerful attraction that contemporary sculpture has, not only for craftsmen but also for industrial designers.

FRANCESCO BOCOLA. Quasar Lamp. 1970

it between mirrors and prisms, or to fire it like a gun against photographic film, thus creating new optical effects. But such adventures risk becoming unsophisticated versions of experimental physics: they cease to be sculpture. Cinema represents, for the time being, our best model of the artistic application of light physics; and its aesthetic possibilities have just begun to be exploited.

Sculpture's loss of volume and mass—from the monolith to the metal filament—and its gain in motion—from the static statuary of Old Kingdom Egypt to the kinetic sculpture of the twentieth century—find art knocking at the door of physics. But it is interesting to observe that artists like Gabo, Pevsner, and Moholy-Nagy—men with strong scientific interests—became increasingly attracted to the sensuous qualities of matter as their artistic careers unfolded. To the extent that they were sculptors, and men, the medium continued to make tactile claims which could not be denied.

ARCHITECTURE

A building results from the interaction of many factors: function, style, site, climale, materials, structural design, financing, client requirements, building codes, workmanship. For any given structure, one or more of these factors can assume crucial importance. But *all* of them must inevitably be considered at some time in the solution of an architectural problem. That is, from the standpoint of the architect, factors such as cost, site, and client are elements in a total problem of design. We who are not architects see the physical result, but rarely do we know the priorities which affected the architectural solution. It would be almost impossible to know every relevant fact about a building's design and construction. It *is* possible, however, to know in general terms the materials and devices available to architects and to know how they work —visually and symbolically.

In the introduction to this section, media were defined as materials used in a characteristic way. The fundamental media of architecture are structural devices like arches, domes, trusses, and cantilevers, which can be made of materials like wood, stone, or steel. The structural devices are fundamental because they determine the kind and amount of space that can be enclosed in a building. Materials are important because they determine the effectiveness and mode of operation of structural devices. A truss can be made of wood or metal, a post can be made of stone or steel. But different materials require different dimensions to do the same job; hence, visual results depend on the architect's choice and design of particular structural devices and materials.

Now, in these choices the art of architecture begins to appear. In any given situation, there are usually several ways to enclose space, to support weight, to manage circulation, to admit light, to shape an exterior, to finish a surface. The architect makes his choices and solves his problems in the light of *an idea*—usually an idea about the impact of shaped space on people. (Churchill once said, "We shape our houses and then they shape us.") If he had no choice among materials, structure, and plan— if he did not know how to *design* solids and voids—his services could be performed by a computer, and architecture would not be an art. Some buildings indeed appear to have been designed by computers, which means, in practical terms, that the same architectural solution has

been used over and over again. Similarity of needs—in office buildings and hotels, for example—plus standardization of building components have led to a certain amount of computer-like efficiency and monotony in modern architectural practice. But despite the existence of insensitive design, the distinguished buildings which *are* constructed demonstrate that architectural problems are *not* all alike, that design alternatives *do* exist, that architecture *is* an art.

Meaning in architecture emerges, in part, from the viewer's capacity to understand how materials and structural devices affect his perception. Consequently, the following pages will be devoted to examining the principal ways men have built with the materials available to them. When material was limited and architectural devices few,

labor and patience were apparently abundant. Hence, the architecture of the past offers monuments of extraordinary richness and beauty, notwithstanding the fact that its creators possessed less knowledge and fewer resources than we do. Today, engineering knowledge is immense, and the variety of materials is almost bewildering. But labor is costly and not always very skilled; in addition, we are impatient to build—and impatient to raze structures after they have repaid their sponsors. Consequently, when a magnificent modern space appears, it represents not only an architectural achievement but also a triumph over an array of social and economic obstacles which were probably never imagined by Egyptian pharaohs, Athenian aristocrats, Roman emperors, medieval bishops, Florentine bankers, or absolute kings.

The Classic Materials

The earliest builders used construction materials which were close at hand and in good supply. Then as now, building devices and techniques resulted from a combination of human ingenuity and the inherent possibilities of available material. The African villager today builds his hut with sticks and grass because vegetable fibers are the most profuse material in his environment. For the same reason, the Eskimo builds an igloo of ice when he settles down for the winter. On the move, he fashions shelter from reindeer skins and bone, much as the American Indian constructed a tepee of wooden poles and animal hides. The humble igloo is a domical structure resting over an excavation in the ice, solving in its modest way

the same problem as Michelangelo's dome of St. Peter's; and the Indian's conical tepee may be comparable as portable housing and superior as architectural form to the modern auto trailer. The African hut of grass and twigs often consists of a cone-shaped roof resting on cylindrical walls. Its materials may be primitive, but their geometric form is, from an architectural standpoint, quite sophisticated.

During the great periods of Egyptian and Greek architecture, stone grew to be the favored material as the tools for quarrying, transporting, and erecting it were developed. But the Mesopotamians, having little stone, used brick and glazed tile for building. In most places, how-

Aerial view of Stonehenge

Stonehenge. c. 1800–1400 B.C. Salisbury Plain, Wiltshire, England

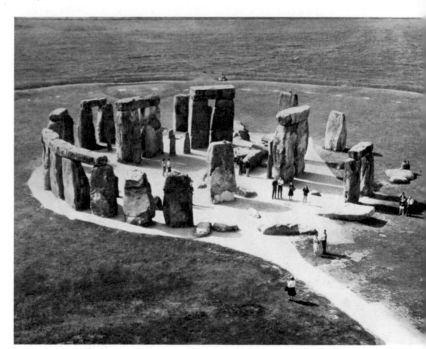

Model of Hypostyle Hall, Temple of Karnak, Egypt. 1350–1205 B.C. The Metropolitan Museum of Art, New York. Levi Hale Willard Bequest, 1890

ever, wood probably preceded stone and mud as a structural material, or at least it was used as the supporting framework for "curtain-wall" surfaces of vegetable fiber and mud. Early men used stone for religious and commemorative purposes as in their mighty *menhir* statues (upright stones serving as homes for departed souls) and *dolmens* ("table" slabs set on upright supporting stones and serving either as altars or as open tombs). Such stone arrangements, which must have involved enormous energy expenditures and engineering difficulties for prehistoric men, found more complex expression in the *cromlechs* at Carnac and Stonehenge. Cromlechs were circular arrangements of menhirs around a dolmen, which probably served astrological and religious purposes. The total plan of this organization of stone, with its axis, regular spacings, and orientation toward the sun, prefigured later architectural and ritualistic developments in the temple, the amphitheater, and the cathedral.

It is important to recognize ecological influences on the beginnings of architecture. Egypt had not only an abundance of stone but also a great river, the Nile, along which heavy stone could be carried to construction sites. The wood of native palm trees was not very strong and the importation of better woods was too expensive. Hence, the Egyptians used stone roof lintels rather than timbered ceilings. As a result, their interior spaces look like forests of massive columns, since stone cannot span a very wide space. Understandably, Egyptian architecture favors tall, narrow spaces. Of course, the passageways inside the pyramids had to be narrow because of the enormous weight overhead. Hence, the pyramids were virtually

solid volumes surrounding a relatively small space for the king's burial chamber. The Egyptians built with monoliths that for size, hardness, and weight would be rejected by contemporary builders, despite the mechanical aids at our disposal. But the Egyptian builder, who worked with little more than the lever, the pulley, and the inclined plane, had, in his slaves, thousands of efficient human engines. For the pharaohs, it was economical to raise grain in the fertile Nile valley, feed it to human beings, and exploit their labor for a lifetime greater than that of a modern machine. *Our* civilization would rather convert the grain to alcohol and use it as fuel to operate machines devised by the creativity of men released from animal toil.

Following is a brief survey of the classic materials—wood, stone, and brick—with observations about their working properties, their advantages, and their liabilities.

WOOD

Wood appears in nature as a working, structural material rather than as an inert, mass material like stone. Its wide distribution in all but the most arid regions, and its strength, ease of handling, and adaptability to a variety of tooling enable it to compete successfully with many specialized materials. It can serve as a covering surface as well as a structural member. But the variety of its grain, the principal source of wood's beauty, also accounts for its structural unreliability. In the natural state, wood varies in strength; consequently, wood construction requires inefficient safety factors: larger dimensions than would seem necessary, and frequent reinforcement to

defend against failure due to hidden defects. Recently, manufacturers have developed scientific methods of grading lumber reliably, eliminating much of the uncertainty about the inner structure of each board. Their efforts could substantially modify the design of American houses, which are usually built by the balloon-frame method, using far more lumber than is really necessary. The typical wall made of two-by-four studs spaced at sixteen-inch intervals is not only wasteful of lumber, but it also inhibits more open and flexible design.

American building has always been lavish in its use of wood, but design considerations, the disappearance of the frontier, prudent conservation practices, and the development of competing materials will probably reduce at least the excessive and ill-considered uses of wood. Furthermore, wood has distinct disadvantages. (1) It is combustible: what must have been magnificent Japanese temples and Scandinavian and Russian churches are lost to us because of fire. (2) Wood is highly responsive to temperature and moisture changes. It warps. Therefore, its dimensions are not stable. Nails shift and slip as the wood in which they are embedded dries out and shrinks; wooden joints loosen. (3) As an organic material, wood is subject to attack by rot, fungus, and insects.

Some of these liabilities have been overcome by technology. Plywood, for example, is a remarkable building material made of sheets, or veneers, of wood glued together at right angles, thus virtually cancelling out the tendency to warp. These veneers, made by a rotary shaving of the log, constitute a very economical use of the raw material. Plywood is more consistently uniform in strength than natural wood and, as we know, can be molded and stamped into complex shapes. It can be employed in skeletal structures or in stressed skin and shell structures. Wood in general is remarkably light for its strength; for plywood, the ratio between strength and weight is even better than that of steel. Consequently, in the construction of small and medium buildings, boats, and aircraft, where strength and lightness are desired as well as resistance to chemical and insect attack, plywood is very useful to designers. Laminated wooden beams (to be discussed below) create a vast array of architectural possibilities. Indeed, plywood, molded wood, and pressed wood, or fiberboard, constitute wholly new materials using trees as a raw material much as perfumes or synthetic rubber employ coal or petroleum.

STONE

Men originally found shelter under stone ledges and in the mouths of caves. Later they dwelt in circular holes in the ground, protected by a low wall of piled stones surmounted by a roof of sticks and pine branches. They used stone for their earliest tools and weapons and kindled their first fires within stone enclosures. The stone fireplace is still a symbol of warmth and safety in dwellings otherwise bearing no resemblance to a cave. Heavy, resistant, but virtually indestructible, stone was probably the first material erected by early man to commemorate the dead, to express his belief that powerful personalities live on. But erecting monoliths or piling up stones was not, strictly speaking, building. Construction with stone began

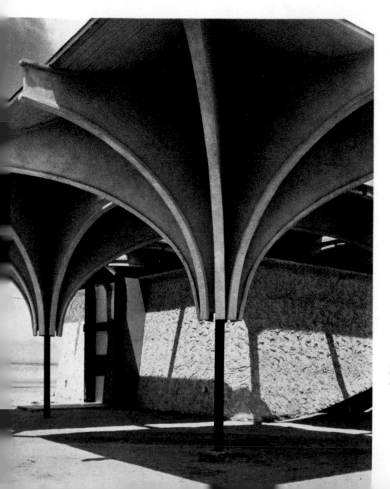

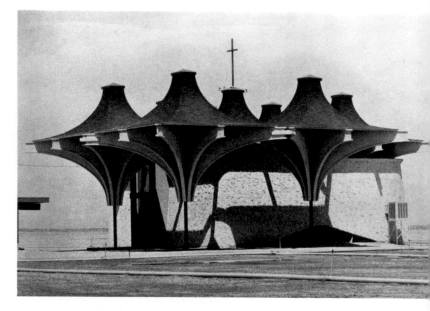

SMITH & WILLIAMS. Congregational Church, California City. 1964

SMITH & WILLIAMS. Detail of plywood supports, Congregational Church

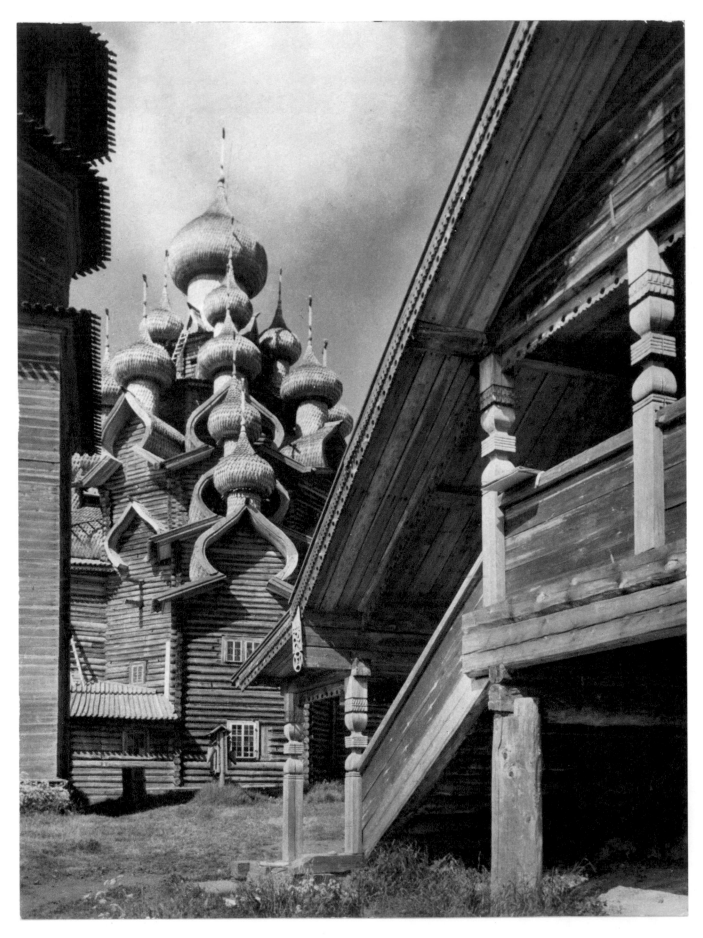

Church of Lazarus, Kizhi Island, U S S R 14th century

BALLOON FRAME

Abo ruin. Ruins of the seventeen-century Spanish mission at Abo, New Mexico, exhibit thick-walled rubble masonry construction similar to that of the Romanesque churches of medieval Europe.

with the building of the so-called Cyclopean walls—made by placing rough stones on top of each other (as in dry-wall masonry today), a type of masonry in which sheer weight and bulk produce a crude form of stability. When satisfactory cutting tools were developed, it became possible to shape stones, to fit them accurately together, to create true masonry. It was then feasible to build stone shelters—not only for the dead, but for the living as well.

The earliest construction employed no mortar. Instead, in most of the ancient civilizations, stone and marble blocks were fitted together with accuracy. A knife could not be inserted into the joints of the masonry used to face the pyramids. The same can be said of stone walls built by the Incas of Peru. Since the Greeks did not develop mortar until the Hellenistic period, they used metal dowels and clamps to prevent any shifting of the marble in the classic monuments of the Acropolis. But their engineering and craftsmanship, based on fundamentally simple structural devices, produced virtually immovable structures. Stone masonry employing mortar offers new assets: it does not require the laborious precision of dry masonry, and it offers greater resistance to shifting. The weight and bulk of stones joined together by mortar create a structural fabric of tremendous durability. While stone and mortar may chip or erode somewhat over the years, the walls they create are likely to survive indefinitely if placed on a sound foundation and protected from human depredation.

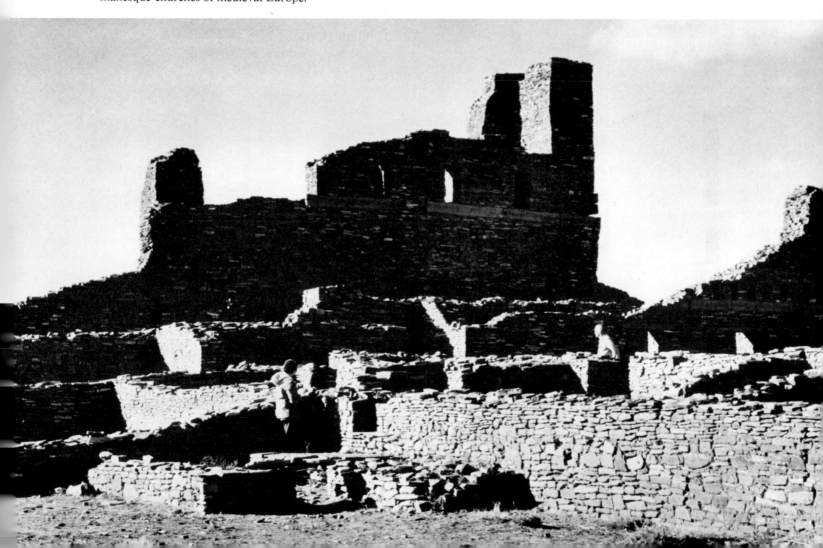

But stone is heavy, costly to quarry and transport, and expensive to erect. Like brick, it is rarely used in modern building as a structural material. Stone and marble veneers are laid over structures of steel, concrete, or cinder block. As such, stone masonry becomes a cosmetic operation—a far cry from the pure stone engineering of the Parthenon, the great pyramids, or the Romanesque and Gothic cathedrals. The Romans may have been the first large-scale builders to veneer brick or rubble masonry with stone or marble slabs. The Babylonians, on the other hand, had to use what little stone they could secure for statuary but followed a practice similar in principle to veneering by facing brick walls at key locations with glazed tiles assembled in the form of large, colored reliefs.

The prestige of stone today is such that great cities and important buildings must exhibit large expanses of it, even if some commoner material lies beneath. The Sam Rayburn House Office Building for the House of Representatives in Washington, D.C. cost between 80 and 100 million dollars; much of that expense was due to the mountains of marble and limestone required to clothe its steel and concrete fundament. Almost universally regarded as an architectural disaster (Wolf von Eckardt comments that it is "not only the most expensive building of its kind in the world but probably also its ugliest."[37]) the building is, hopefully, the last structure which will endeavor to overcome the defects of poor design with simulated classical masonry. The United Nations Building, on the other hand, employs marble veneers on its end

walls more successfully. Authentic stone masonry could never reach that high in a single plane: the marble frankly declares that it is a thin, crystalline covering that serves to accent the severe planarity of a tall, slablike structure.

The outstanding characteristic of stone is its great strength in compression and its relative weakness in tension. Classical building took advantage of this compressive strength by creating structural systems which consisted essentially of one stone resting on top of another. The load was almost always transferred directly downward. But stone walls must be very thick to support their own weight and yet remain stable. Any substantial height calls for the kind of reinforcement and buttressing so marvelously developed in Gothic architecture. Indeed, the great achievement of Gothic engineering was to transfer heavy roof loads to the ground by multiplying the paths they could take downward. Small stones and mortar used in the arch and flying buttress enabled stresses to be carried away horizontally to piers located some distance from the wall. Later, a massive, load-bearing wall became unnecessary: weight could be concentrated in the piers and pilasters alone. But achieving the great height of modern buildings with stone walls, columns, piers, and pilasters would call for impossible thicknesses regardless of transverse buttressing. Notwithstanding the engineering superiority of the stone arch to the stone post and lintel, pure masonry construction is limited by the very quality which accounts for its stability —weight. The loads on bearing walls and columns of

HARBESON, HOUGH, LIVINGSTON & LARSON. The Sam Rayburn House Office Building, Washington, D.C. 1965

WALLACE K. HARRISON and others. United Nations Building, New York. 1949

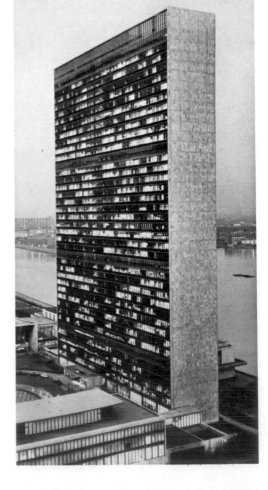

stone build up too quickly. Today, when "Gothic style" churches are built, their characteristic forms cover "working" structures of steel and reinforced concrete. "Collegiate" Gothic libraries and towers are usually air-conditioned shams from the standpoint of architectural structure. And yet, this reluctance to abandon the appearance of masonry, even when it calls for structural deceit, reveals the extraordinary sense of satisfaction men derive from a building system of stone piled on stone. Let the stone be expensive and damp; let it cover electrical conduits and steel reinforcing rods unimagined by the medieval Abbot Suger; let elevator shafts be hidden behind compound piers while the clatter of IBM machines is heard in the side aisles; memory and imagination will nevertheless feel life in the stone ribs, warmth in the slanting light, and protection under the vaulted ceilings.

BRICK

Lacking fuel to fire brick, and living in an arid land where wood was scarce, the Sumerians made sun-dried bricks much like the adobe bricks of the Southwestern American Indians. Even in a relatively dry climate, however, the so-called "mud-brick" wall is subject to erosion and needs to be repaired or replaced regularly. Fired brick, however, constitutes one of the earliest of manufactured materials. (Prefabrication in building probably started when bricks made in a distant brickyard were transported to the construction site.) It is really a type of artificial stone—not "reconstituted stone" as Le Corbusier designated concrete—but a truly artificial, man-made type of stone which has several advantages over natural stone: standardized dimensions, uniform quality, variation in shape and size within the limits of hand use, strength and lightness, wide range of color and texture, and adaptability to mass-production manufacture from inexpensive raw materials —clay or clay-and-concrete mixtures.

Since brick is usually made of clay fired in a kiln, it is a ceramic material and tends to resemble a ceramic mosaic when laid up in a wall. But a mosaic is a type of wall "painting," whereas brick is a structural material capable of constituting the wall itself. Today it is most commonly used as a brick veneer—it really *is* a mosaic applied to a wall built of some other structural material. For modern usage, then, brickwork is valued for its textural and coloristic properties—its painterly qualities—as well as for its remembered association with the hand-fabricated wall. Because it is such an ancient material, brick confers familiarity and acceptability on architectural forms which might otherwise seem unconventional. Its warm colors and its weather- and fire-resistant qualities inspire confidence. The viewer also knows that a brick wall has been laboriously built, so that costliness as well as durability seem to characterize brick masonry even though clay is a cheap and common substance.

The mortar joints of brick masonry constitute a grow-

Stone wall built by the Incas in Cuzco, Peru

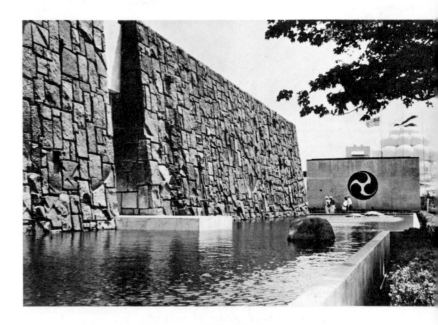

MASAYUKI NAGARE. Wall of the Japan Pavilion, New York World's Fair. 1964. Stone-masonry wall given a contemporary treatment. Stones from the wall were given to Manhattanville College in Purchase, New York, to be incorporated in a new structure. Some of the stones have already been used in the formation of a Japanese garden leading to the college's East Asian Center.

ing disadvantage of the material: brick masonry is expensive. A large proportion of the area of a brick wall consists of mortar joints which require careful hand labor, and mortar joints are also subject to far more shrinkage than the brick itself, which is fairly stable. Finally, a brick wall is fabricated slowly; for tall buildings, an elaborate scaffolding is required by the workmen. That is

Spiral minaret of Samarra, Iraq. 9th century

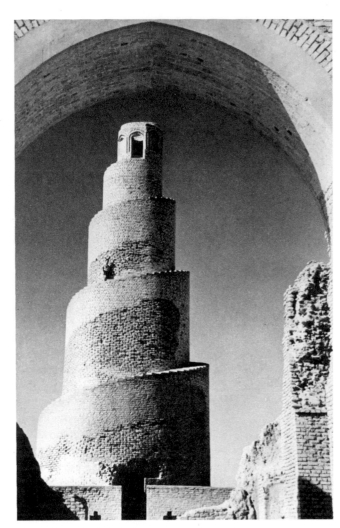

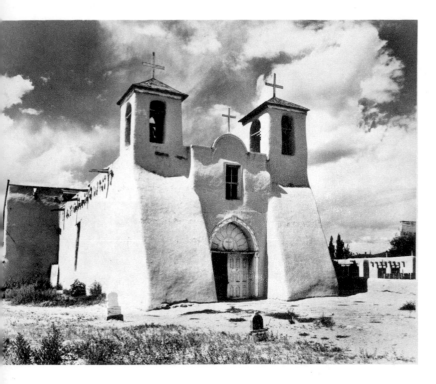

The Mission of St. Francis of Assisi, Taos, New Mexico. 1772–1816. A basic building material can impose architectural form regardless of time, place, or building tradition. Sun-dried adobe brick requires the construction of walls of enormous thickness, tapering as they go up, thus creating inclined planes of magnificent abstract power and simplicity.

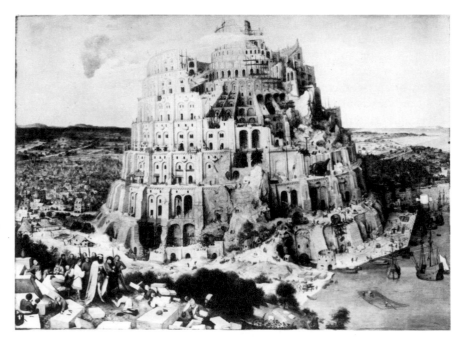

PIETER BRUEGEL THE ELDER. *Tower of Babel.* 1563. Kunsthistorisches Museum, Vienna

Design in the Urban Environment

PIAZZA SAN MARCO, Venice. Begun 1063. Underlying the visual pleasure of the piazza, and in addition to the delights of its architectural forms and colors, is a governing proportion which can be felt only by a man on foot—the citizen standing, walking, or talking with his fellows. A marvelously exhilarating arrangement of space and structure, it depends on a scale or measure that encourages only human modes of watching, moving, and meeting. Nothing that happens here is possible for automobile passengers, telephone conversationalists, viewers of television, or operators of electronic computers.

SAFDIE, DAVID, BAROTT, and BOULVA. Habitat, EXPO 67, Montreal. 1967. Safdie's Montreal megastructure, like Rudolph's project for a Manhattan Graphic Arts Center (p. 582), aims at fulfilling one of the great dreams of twentieth-century architecture: the industrial fabrication and construction of staggered, add-on units that will afford exceedingly versatile visual and spatial combinations and affect the environment in a manner at once explosive and infinitely liberating.

LE CORBUSIER. Secretariat Building, Chandigarh, India. 1958. Le Corbusier wanted to separate the excitement and variety of life on the ground from its inconveniences and confusion. At Chandigarh he created a vertical city of high-rise apartments, government offices, shops, schools, gardens, and theaters. This was his great contribution to architecture and urban planning: to liberate ground space for the circulation of men, to segregate people from dangerous machines, and to enclose and shape overhead space for human beings to live and work in.

why metal panels are used increasingly for the exterior walls of large structures. Brick offers good sound insulation but tends to transmit dampness, as does stone, unless combined with additional insulating material.

Using mud bricks which had little strength in compression or tension, the Babylonians built their ziggurats (huge, stepped, pyramidal structures with a shrine at the top) employing heavy walls as much as twenty-eight feet thick. The massiveness of the Biblical Tower of Babel was really necessary to compensate for the structural weakness of sun-dried bricks as well as to simulate a mountain on whose crest, it was believed, the gods dwelt.

Such man-made mountains on the plains of Sumer, like the pyramids in the valley of the Nile, were also expressions of the monstrous egotism of ancient despots. Even then, the attempt to reach the sky by piling up mountains of masonry symbolized "towering" pride, not to mention limited architectural imagination. Our own setback skyscrapers—the ziggurats of today—have different origins: high land values, steel-frame construction, high-speed elevators, and, in the case of Manhattan, a bed of solid rock which makes an excellent foundation for high-rise structures. (The "setback" restrictions on American skyscrapers were presumably intended to let light into the street, although they also reflected economic and aesthetic considerations.)[38]

In the stone and brick architecture of Egypt and Babylonia, the amount of interior space compared to the amount of exterior volume was exceedingly low. Such construction seems to us not only inefficient from the standpoint of labor and material, but also appalling in its social and political implications. Perhaps the ratio of interior space to exterior volume in the architecture of any civilization is an index of the freedom of its people. Slave labor inhibits architectural imagination. Today's light and thin-walled buildings create interior space almost equal to the volume of the whole—a remarkable triumph of engineering. Aside from aesthetic considerations, such structures reveal the sort of valuation a civilization places on human labor, since they reflect, in part, a response to the high wages paid in the construction industry. But does our architecture manifest concern for human skill and personality, or does it seek to avoid the economic costs of handcraft, finding answers in prefabrication and mechanization to the problems of building quickly to create inexpensive space?

To say that wood, stone, and brick are classic materials does not imply that they have been totally displaced in contemporary architecture. They continue to be used, but less frequently for structural reasons. Now their contribution is aesthetic and symbolic, since they have been divested, in most cases, of weight-bearing and space-enclosing functions. The classic materials may linger awhile in the intimacy of the domestic dwelling. But even there, glass, steel, aluminum, and plastics yet unheard of will probably supplant them in their structural roles. When a material begins to be simulated, when it becomes part of the vocabulary of "interior decoration," its structural career can be considered waning if not finished. Now that marble, stone, brick masonry, and wood graining can be convincingly imitated, we shall not long see the classic materials performing their authentic roles except in museum restorations and in monuments which society has the good sense to preserve.

Modern Materials

Steel, concrete, and glass are, of course, old materials, but their structural use in architecture is comparatively new. The Romans mixed stone rubble with mortar in the construction of walls, a practice which was really an extension of masonry. But the use of *poured* or *cast* concrete, reinforced with steel rods, is entirely different from stone masonry. Similarly, the tempered-steel weaponry of medieval warriors has little in common with the rolled-steel I-beams which make modern steel-frame construction possible. And the lovely opalescent glass bottles of ancient Egypt are only distantly related to the large sheets of plate glass which fill the rectangular openings in cage structures today.

Architecture has been hugely transformed by these "new" materials because, in the case of glass and steel, the specialized techniques of mass manufacture produce a superior product on a large scale and at reasonable cost. Factory manufacture and prefabrication reduce costs and improve quality, while the handcraft operations which still survive in building are often associated with waste of materials, uneven quality, and frequent delays and confusion. Reinforced concrete structures are usually fashioned at the building site, although some prestressed concrete beams and slabs are factory-produced like steel beams to standard size and strength specifications. But ferroconcrete fabrication at the site is not a handcraft process in the classical sense; it is better described as a collective manufacturing operation, the plywood forms and steel rods being set locally while concrete mixed in transit to precise engineering specifications is brought in from a plant which may be several miles distant.

Laminated wooden beams have to be manufactured in a factory and carried to the site. Here again, the techniques of bending and gluing wood were known to tradi-

right:
Concrete section, Tecfab Industries Plant, North Arlington, New Jersey. 1965. The prefabrication of complex architectural forms now replaces many laborious and time-consuming operations formerly performed on the site.

below right:
KIRK, WALLACE AND McKINLEY. Church of the Good Shepherd, Bellevue, Washington. 1964. The versatility of concrete is demonstrated in this church whose seemingly precarious support is a strong and graceful hyperbolic paraboloid form springing from a single ferroconcrete post.

below:
Prefabricated stack houses in housing project in Israel. 1965. Reinforced concrete rooms, cast on the site, are lifted into place.

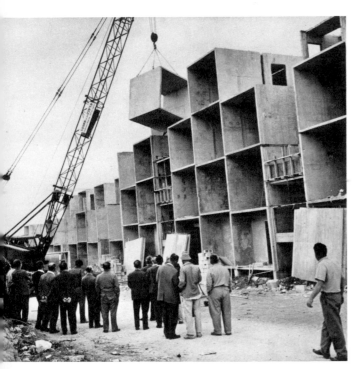

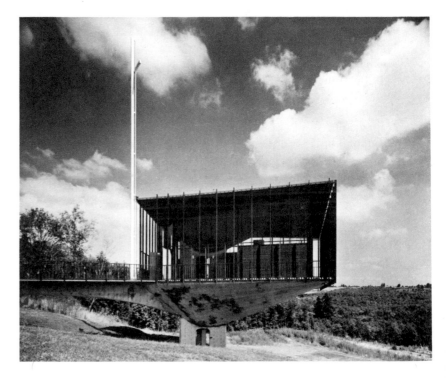

tion. But the older, animal-skin-glues cannot compare with today's powerful adhesives. As a result, we possess the technology to exploit the lightness, strength, and resilience of wood in continuously curved, load-bearing members of considerable beauty and grace. They permit the spanning of good-sized spaces without interior supports, creating some of the dramatic structural excitement of Gothic stone arches. Laminated beams and arches are monolithic members and hence can be erected by cranes, thus avoiding the complex scaffolding of stone masonry. And they can be chemically treated to make them fire-resistant although not fireproof. The warmth of wood, the pattern of its grain, and the rhythmic effect created by the repeated laminations make such beams attractive and practical devices for homes, churches, auditoriums, shops, and so on. They show that prefabricated materials are compatible with architectural excellence; mass-produced structural devices can be visually exposed without the ap-

plication of handmade cosmetics if the designer is sensitive to their distinctive qualities.

Prefabrication of building materials and industrial production of whole buildings or of large, interchangeable building units has steadily advanced—both in quality and amount—during recent decades. Many of the new products used for wall partitions, roofing, insulation, and utilities have been developed in the course of mechanizing and industrializing architecture. Plastic tubing replaces copper and cast-iron piping; various new exterior wall- and partition- "sandwiches" replace the old masonry, lath, and plaster walls. These substitutes may not always be qualitatively superior to the materials they supplant. It is certain, however, that their development is substantially due to the inertia and resistance to innovation of the building industry. Here, architecture is inevitably influenced by social and economic factors. Trade unions, lending institutions, municipalities, federal agencies, manufacturers' associations, and a host of others have a special interest in building materials and construction methods. Frequently, they exercise restraints through building codes which necessarily affect design and the total character of architecture. The costs of land, the availability of credit, rates of amortization, subsidies for housing, the award of construction contracts—all these nonarchitectural factors have an ultimate bearing on materials, design, and quality of construction. Therefore, the materials of modern architecture constitute not only the "bricks and mortar" of structures but also a reflection of the society which develops and uses them.

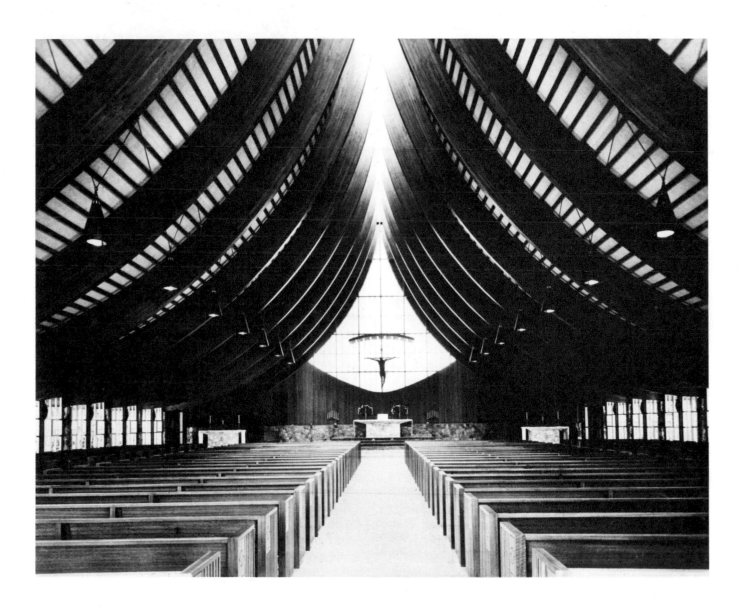

Interior, the shrine chapel of Our Lady of Orchard Lake, Oakland, Michigan. 1963. Laminated wood beams.

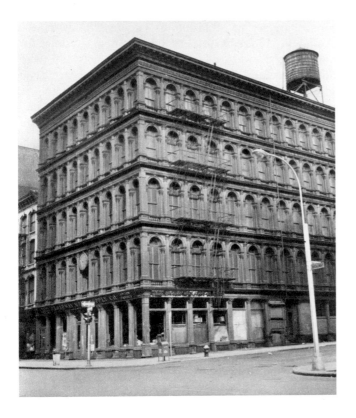

J. P. Gaynor. The Haughwout Building, New York. 1857

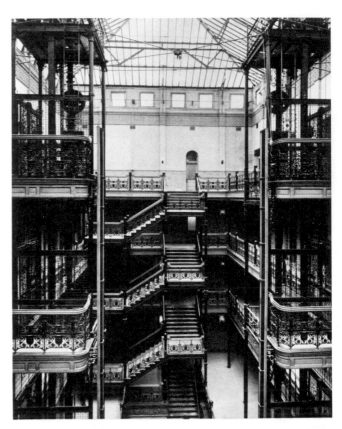

George Herbert Wyman. Interior, Bradbury Building, Los Angeles. 1893

CAST IRON

Cast iron, the first metal substitute for wooden posts and stone columns, has some characteristics similar to stone: great compressive strength, brittleness, heavy weight, and hidden internal flaws or strains which develop as the molten iron cools in its mold. But cast iron permits the erection of tall buildings without prohibitively thick walls. Hence, the second half of the nineteenth century witnessed the construction of huge and often exceedingly delicate structures built with prefabricated cast-iron columns and beams. Often they were manufactured by a resourceful American promoter of prefabricated construction, James Bogardus. They tended to imitate the stone masonry of Italian Renaissance buildings, hence the palatial magnificence of the facades for factories, shops, and warehouses built in lower Manhattan in the 1850s and now, alas, threatened with extinction. The Haughwout Building, designed by J. P. Gaynor and erected in 1857, is a cast-iron version of a Venetian palazzo, but in the future it may be demolished to make way for a major expressway. The Bradbury Building in Los Angeles, designed by G. H. Wyman in 1893, is chronically in danger of destruction;

and yet it ought to be preserved, not only for historical reasons, but also to show the delicacy of wrought iron in the hands of a gifted designer and the splendid lightness and openness of interior space which Wyman could achieve at a time when the rusticated Romanesque masonry of H. H. Richardson was very popular.

Cast iron set the stage for steel-skeleton construction in a number of nineteenth-century railroad sheds, exhibition halls, libraries, market halls, and so on. Bridge engineers appreciated iron and steel better than architects, who had used iron structurally (as in the dome of the Capitol in Washington) but made sure to conceal it. Even today, few designers are willing to expose steel structural members if it can be avoided. When cast iron was brought out of hiding by nineteenth-century designers, it was often given some sculptural form based on work in stone or wood which branded it forever as a utilitarian but aesthetically inferior material. Unlike steel, which usually is employed by engineers and architects in a straightforward manner (that is, in the form of the process of rolling or extruding which shapes it), cast iron lends itself to a variety of derivative and uncongenial shapes. Since it is a plastic material like concrete, though capable of being

modeled in greater detail, it has been fair game for some questionable sculptural impulses. The Paris Métro Stations by Hector Guimard (see pp. 103–4) and the ornamental cast-iron columns, banisters, and canopies of other Art Nouveau designers show the material imitating terra-cotta panels or High Gothic stone filigree. Engineers like Joseph Paxton, John Roebling, and Gustave Eiffel, on the other hand, were the most authentic designers with metal in the nineteenth century. Henri Labrouste (1801–1875), designer of the Bibliothèque Sainte-Geneviève (1843–50) and the Bibliothèque Nationale (1858–68), both in Paris, was exceptional in that his career combined conventional Beaux-Arts training in architecture with an original mastery of cast-iron engineering.

John Roebling's Brooklyn Bridge (1867–83) used the compressive strength of stone masonry for its massive piers but demonstrated a dramatic new combination of delicacy and strength in its steel suspension cables. Roebling (1806–1869) pioneered in the development of engineering data for suspension bridges, but his aesthetic contribution to architecture lay in the design of a metal structure which could stir men's emotions while it superbly performed a practical function. The graceful and soaring qualities of the bridge grow out of the magnificent curves of the supporting cables and the vertical web of spun steel strands which carry the deck. Perhaps admiration for the venerable shape of the arch explains the extraordinary affection in which suspension bridges are still

held. The great Spanish structural engineer Eduardo Torroja compares the suspension bridge to a reversed arch, the piers functioning as posts, while the deck, suspended from the crown of the arch formed by the cables, corresponds visually to the tie rod sometimes used to counteract lateral thrusts in a conventional arch.[39]

Although suspension bridges made of wood and rope may have been used in Asia thousands of years ago, the nineteenth-century development of suspension engineering, so dramatically advanced by Roebling, revealed the distinctive structural and aesthetic possibilities latent in metal under tension. In the twentieth century, designers like Pier Luigi Nervi (born 1891) and Eero Saarinen would employ suspension engineering to create unobstructed interior space.

The Crystal Palace (1851) owed its originality in material and construction to the fact that its designer was not formally trained as an architect and hence did not have to overcome the Beaux-Arts addiction to classical construction methods based on timber and stone engineering. The design experience of Joseph Paxton (1801–1865) was gained in building huge greenhouses. His structure for the London Exposition in 1851 consisted almost exclusively of prefabricated wrought- and cast-iron units and glass panes, manufactured throughout England, and bolted together on the site, one story at a time. The Crystal Palace was then the largest building in the world, enclosing seventeen acres under one roof. Yet it was

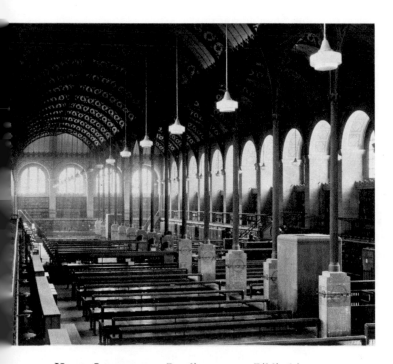

HENRI LABROUSTE. Reading room, Bibliothèque Sainte-Geneviève, Paris. 1843–50

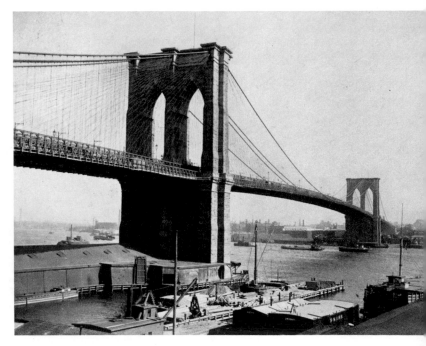

JOHN A. ROEBLING and WASHINGTON A. ROEBLING. Brooklyn Bridge, New York. 1869–83

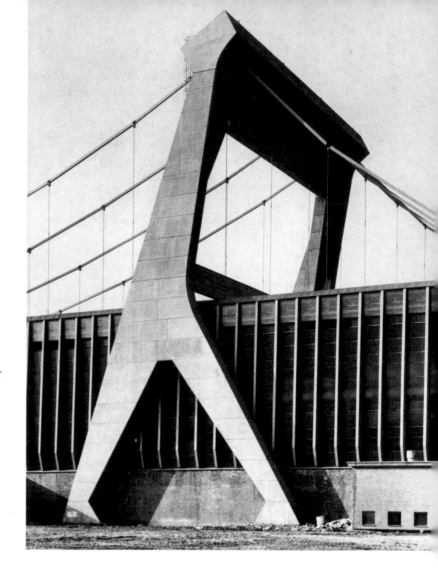

PIER LUIGI NERVI. Detail of Burgo Paper
Mill, Mantua, Italy. 1964

EERO SAARINEN. Dulles Airport, Chantilly, Virginia. 1962

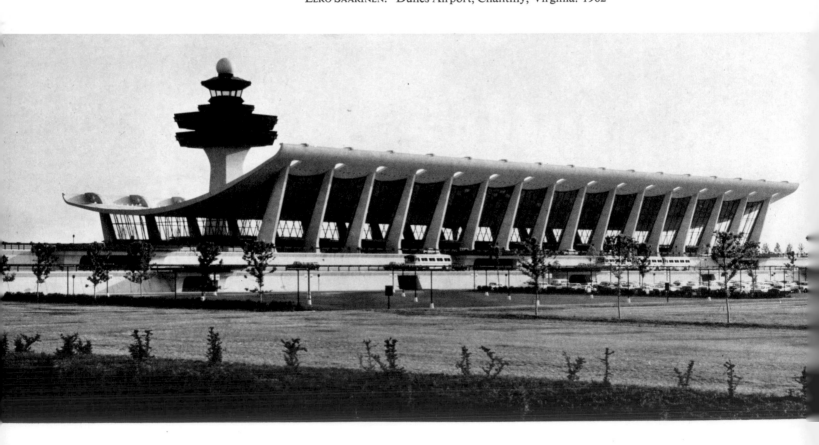

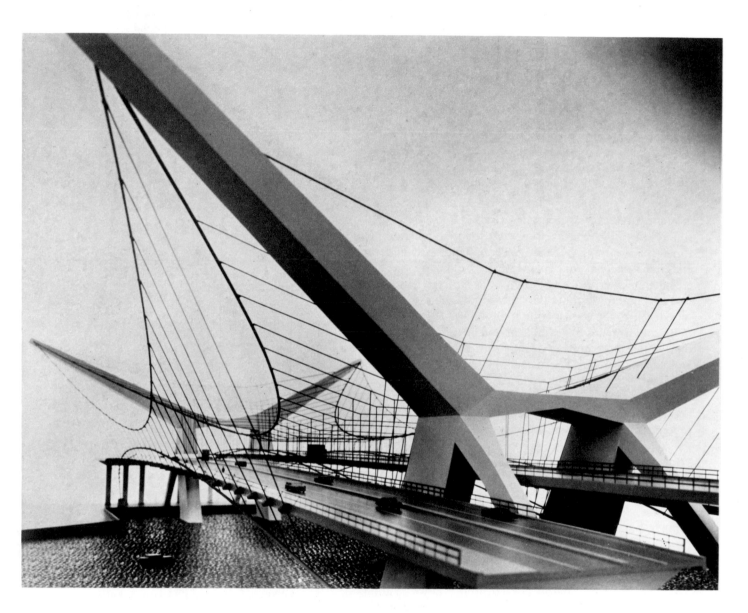

LEV ZETLIN ASSOCIATES, INC. Proposed bridge for Baltimore inner harbor. Dramatic suspension engineering which strives for the body imagery of sculpture.

constructed in six months, easily dismantled when the Exposition was over, and erected again at another site, where it stood until 1935. The construction method and the use of an iron skeleton anticipated the present-day bolting, riveting, and welding of prefabricated steel components into a cagelike structure. Manufacture of standardized parts for on-site assembly was shown to be practical and economical. Masonry vaults and domes whose strength depended on mass and, as in St. Peter's, on ten iron chains embedded in their mortar, could be supplanted eventually by thin membranes of concrete or glass. Strength could be achieved by substituting lightness and precision for heaviness and bulk. Although contemporary critics like Ruskin did not realize it, the architecture of large spaces would never be the same.

The Eiffel Tower in Paris, like Paxton's Crystal Palace built for a large industrial exposition (1889), was also made of wrought iron. Even though steel produced by the Bessemer process was available, Gustave Eiffel (1832–1923) built with iron since he lacked performance data about steel in high-rise structures. (Nevertheless, his fellow designers at the exposition, Dutert and Contamin, constructed the immense Halle des Machines using steel in arched trusses.) For the same reason, Eiffel used masonry rather than reinforced concrete for the foundations. In his specifications, however, he anticipated steel-girder and ferroconcrete construction. His originality lay in erecting an open structure without the expected masonry facade—a boldness for which he was severely castigated. Nevertheless, the thousand-foot tower went up, despite objections from leading architects and artists, and became one of the most popular symbols of Paris. The entire structure was prefabricated and was assembled by only 150 men using scaffolds, winches, and rigging also designed by Eiffel. The project was completed without accident in seventeen months and established a crucial precedent for skyscraper architecture.

STRUCTURAL STEEL

Much of the distinguished work of the "Chicago School" of architecture, leading to the development of the skyscraper, was carried out with wrought-iron or rolled-iron framework. Rolled-iron "I" beams were a vast improvement over the cast-iron columns so extensively used in American commercial architecture earlier in the century. The principles of skeleton construction, known in the 1890s as "Chicago construction," were developed with iron. But iron is not as strong as steel (particularly under tension); hence its members cannot be as slender as steel girders. High-rise structures (above twelve or fifteen stories) could be built with iron, but not as economically as with steel. Consequently, steel has almost completely replaced iron in modern construction.

The cost of steel per pound, however, is higher than that of any other structural material. And, since steel has

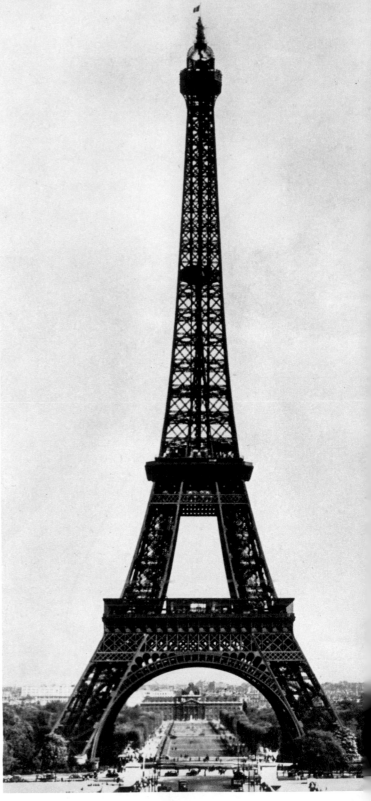

GUSTAVE EIFFEL. Eiffel Tower, Paris. 1889

high tensile strength, rolled steelplate beams are designed in shapes which exploit that strength while keeping weight and cost to a minimum. The I-shaped beam is most common because the vertical section can be quite thin while resisting any force which seeks to bend it, and the horizontal flanges defend the beam against lateral bending. But large structural members, such as trusses and built-up girders, cannot be manufactured in the form of a single

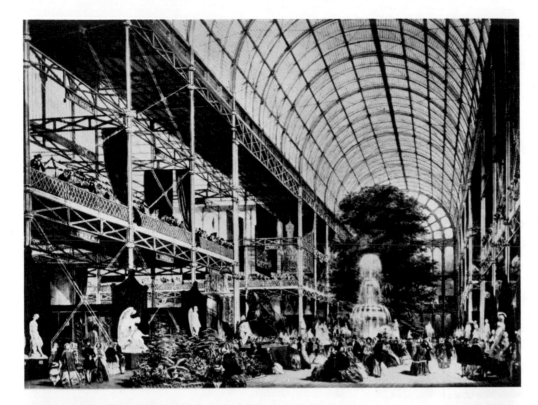

SIR JOSEPH PAXTON. The Crystal Palace, London. 1851

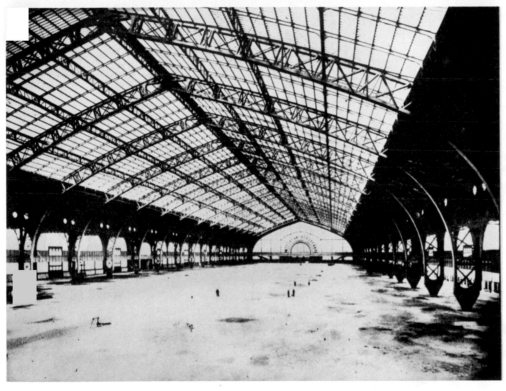

DUTERT and CONTAMIN. Halle des Machines, Paris. 1889 (demolished)

rolled-steel beam. They must be assembled, usually in the form of latticework, to reduce the weight of the member and to take advantage of the tensile properties of the material. The visual result, as seen in bridges, factories, elevated railroads and highways, airplane hangers, and the like, is of complex geometric openings and weblike patterns of metal. Viewed from a distance, the poetry of steel construction is often very striking, as in the Golden Gate Bridge, for example. When seen up close, however, steel construction often appears crude and harsh, because designers must work with standardized rolled-steel shapes. In addition, the common methods of fastening steel—riveting and bolting—further limit the designer in that he must organize connections and joints so that construction men will have adequate space to work on them. Open steelwork must be painted periodically to prevent

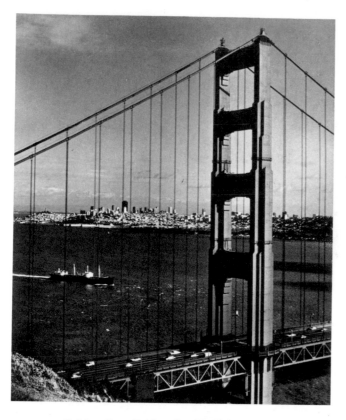

Golden Gate Bridge, San Francisco. 1933–37

UGO STACCHINI. Structural steelwork in Milan Railway Station. 1931. An instance in which the straightforward use of exposed steelwork expresses the confidence and masculine grace of modern engineering.

rusting; hence, finished structures expose their bolts and rivets with more frankness than is evident in other construction methods. Notwithstanding the value placed on structural honesty and the general antagonism to concealment or embellishment, steel construction often exhibits an almost deliberate indifference to aesthetic effect. Indeed, when we think of engineering as inhospitable to art, we probably have reference to the insistently technical, defiantly ugly character of some highly visible steel structures.

But the technology of steel manufacture and fabrication advances in response both to the competition of other structural metals—notably aluminum—and the requirements of designers. Welded connections may eventually yield cleaner joints and greater continuity within a structural system. Tubular, extruded, and corrugated steel products may open up new formal possibilities. Still, covering steel with a skin of another material will probably continue because it is so difficult to achieve appealing steel surfaces although the material remains indispensable for many structures.

A few architects have successfully exposed steel members, thus converting a practical necessity into an aesthetic asset. In Maryville College, Maryville, Tennessee, the designer, Paul Schweikher (born 1903), shows how exposed steel I-beams can be exploited to give linear emphasis to large planes of brick masonry. And Crown Hall at the Illinois Institute of Technology, by Mies van der Rohe, is a brilliant demonstration not only of exposed steel but also of structural function in the suspended roof. The rolled-steel I-beam, of course, offers a precise edge and a clean surface—qualities difficult to obtain in the lacy webs of built-up girders and latticework trusses. That open steelwork looks better at a distance suggests that the color, texture, and joinery are mainly responsible for its poor aesthetic performance. Perhaps metal sculpture can serve as a type of exploration of the aesthetics of form and fabrication in steel. Admittedly, sculpture does not confront the problems of scale and engineering encountered in architecture. But experiments and pilot projects have to be conducted on a small scale and with limited variables. At present, the example set by metal sculpture (often inspired by architectural forms) may be partly responsible for our feelings of dissatisfaction with open steel construction which is not sensitively handled.

The essentially technical and aesthetically indifferent character of steel is often responsible for the anonymous quality of so many modern buildings, the Seagram Building and Lever House being conspicuous exceptions. In general, the very versatility of the steel frame has placed designers in a quandary. So far as the skyscraper is concerned, they do not know whether to emphasize its verticality or horizontality. Should its model be a slab, a honeycomb, or a crystal? Is it an obelisk or a layer cake? As a young man, Mies proposed a circular steel-and-glass skyscraper. More recently, Gropius collaborated in the

A joint of the Eiffel Tower

EDUARDO TORROJA. A joint of the Tordera Bridge

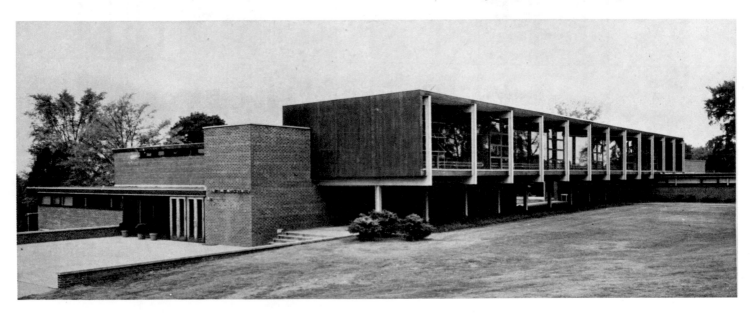

PAUL SCHWEIKHER. Fine Arts Center, Maryville College, Maryville, Tennessee. 1950

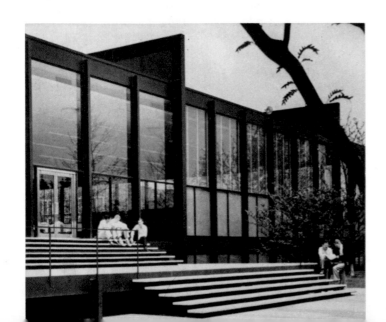

LUDWIG MIES VAN DER ROHE. Crown Hall,
Illinois Institute of Technology, Chicago. 1952

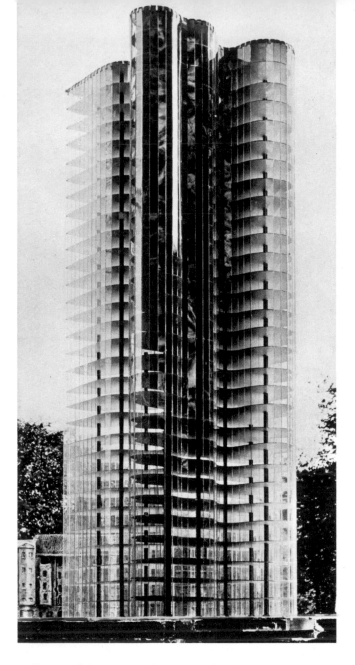

LUDWIG MIES VAN DER ROHE. Project for circular glass skyscraper. 1920–21

DEETER-RICHEY-SIPPEL. Circular dormitories, University of Pittsburgh. 1963

design of the Pan Am Building, a huge slab with tapered ends. But the building is less than successful. The glass skyscraper proposal of Mies was not accepted, although other circular towers have since been built. The most spectacular is Lake Point Tower in Chicago, a modern glass and concrete core version of Mies's 1921 proposal. In his maturity, would Mies have built that wavy wall under his own name? It seems doubtful. Perhaps we have been overconditioned to the rectilinearity imposed by rolled steel girders to accept rounded towers gladly. At any rate, major construction in steel proceeds furiously in a variety of directions, with the Miesian rectilinear idiom dominating high-rise architecture. But when horizontal space is available, when the problem is an arena, a library, a chapel, or an airport, the most exciting buildings seem to be made of reinforced concrete.

REINFORCED CONCRETE

Although the Romans developed a mortar based on volcanic ash, it was not until 1824 that the first Portland cement was produced by Joseph Aspdin in Leeds, England. In 1868, a French gardener, Jacques Monier, hit on the idea of reinforcing concrete flower pots with a web of wire, thus creating a small-scale reinforced structure. However, reinforced concrete, or ferroconcrete, was not widely employed as a building material until the 1890s. As mentioned earlier, Eiffel was reluctant to use it for the foundations of his tower, although he contrived a similar result through wrought-iron bars embedded in masonry piers, thus joining the superstructure to its foundations. The development of reliable performance criteria for ferroconcrete is generally credited to two French engineers,

SCHIPPOREIT-HEINRICH, INC. Lake Point Tower, Chicago. 1968

structure. It is also vastly more efficient than stone-masonry piers and arches, while serving as an exceedingly versatile structural device.

Although curved slabs and shells enclose space in an efficient and pleasing manner, their curves must be correct from an engineering standpoint. The distribution of reinforcing rods as well as their thickness and shape must be confirmed by mathematical calculation and practical tests. But it is worth noting that as engineering criteria are refined and perfected, their visual results tend to approximate natural forms. The eggshell, for example, is one of the strongest and most beautiful of natural containers because its curvature constitutes the simplest, most efficient and accurate relationship between its contents, the shell material, and the environment. Consequently, it is interesting that some of the most dramatic ferroconcrete structures exhibit curves which resemble organic forms such as one sees in seashells, honeycombs, mushrooms, tree limbs, soap bubbles, coral, and so on.

It is generally conceded that the joints are the weakest points in classical structures: they are the places where loads change direction and where a multitude of complex stresses are situated. One of the assets of the curved fer-

ROBERT MAILLART. Schwandbach Bridge, Canton of Bern, Switzerland. 1933. Reprinted by permission of the publishers from Siegfried Giedion's *Space, Time and Architecture*, Harvard University Press, Cambridge, Massachusetts. Copyright 1941, 1949, 1954, 1962 by the President and Fellows of Harvard College

Hennebique and Coignet; two other Frenchmen, Perret and Garnier, pioneered the use of ferroconcrete in the skeletons of buildings as well as in their membranes. But once again, an engineer—a Swiss, Robert Maillart (1872–1940)—best exploited the plastic quality of the material for bridges, reducing the thickness of concrete beams so that they became slabs, and then bending or warping the plane of the slab to produce structural forms of sculptural beauty and engineering precision.

The continuously curved and warped ferroconcrete slab results in a structural member which does not imitate masonry, wood, or metal. Since complex stress patterns are distributed throughout the slab, there is *no distinct break between the functions of supporting and being supported*. Thus, the curved ferroconcrete slab is the logical and organic fulfillment of older types of supporting

André Morisseau. Marketplace, Royan, France. 1958

roconcrete member consists in its virtual elimination of such joints. As with the eggshell, loads are distributed over the entire fabric rather than concentrated at particular points. This feat is accomplished by locating the steel rods at the points of greatest tensile stress, that is, the points where the concrete particles would tend to tear or pull apart. The concrete is thickest at points of greatest compression, that is, places where the particles would tend to be crushed, causing the member to fracture. The steel rods are covered with sufficient concrete to prevent rusting, and they are given slight irregularities of surface to prevent slippage after the concrete is hardened and subjected to a live load. As a result, ferroconcrete possesses the virtues of steel *and* of stone without their disadvantages. Stresses are transferred back and forth between the two materials. A slab of ferroconcrete can span a much greater space than a stone slab which is subject, over any large span, to breakage from its own weight. The slab can also support more weight at less cost than rolled steel, which is subject to deformation and failure under high compressive loads. Steel surpasses ferroconcrete when light weight is essential, as in a suspension bridge. Concrete, however, is fire-resistant whereas steel is not. Steel does not feed flame itself, but naked steel will twist, deform, and fail when exposed to intense heat. Consequently, most building codes require that steel skeletons be covered with insulation such as firebrick or poured concrete.

Aside from its practical advantages, ferroconcrete appeals to the designer because it is not usually manufactured in standardized shapes and sizes. It must be designed for a specific structure and is usually manufactured at the site. The designer can choose among several structural solutions and thus can give expression to his forming and shaping impulses. Of course, his sculptural aspirations are limited by the wooden forms which can be built, the setting of the steel rods, and the process of placing the concrete. As the technology of ferroconcrete is advanced, more and more is known about the interactions between steel and concrete; the size of stone aggregates and the amounts of mortar needed to bind them together; and the usefulness of additives which lower weight, speed drying, add color, or transmit light. Such knowledge permits the designer to work with greater precision and certainty; it also enlarges the range of potential aesthetic effect.

One of the supposed disadvantages of concrete, reinforced or not, is its alleged unsuitability as a surface material. Many architects use concrete for structural purposes only, covering it with veneers of brick, stone, marble, opaque glass, metal, plastic, wood, and so on. Others try to cover it with stucco and various more-or-less ineffective concrete paints. One of the unsatisfactory qualities of Frank Lloyd Wright's Guggenheim Museum (completed after his death) is the thin stucco covering of its bold, poured concrete forms. Any surface treatment applied to a Wright building is ironic, since he denounced

even painted wood. Could he condone painted concrete? He had shown himself an original master of surfaces in concrete-block masonry, for example—the blocks cast to his own design. But although he used ferroconcrete in the Kaufmann House and in the Guggenheim Museum, he may have felt the surfaces of brick and stone masonry more congenial. Small fissures and minor irregularities in the stucco do not follow the underlying concrete forms, and hence the heroic effect of the structure is somewhat spoiled by what is apparently an unsatisfactory cosmetic operation. Quite possibly, the cosmetics were unnecessary. Le Corbusier, followed by many others, has shown what vitality and textural interest can be obtained by exposing the concrete aggregate and the marks of the formwork. Furthermore, rough concrete surfaces function very effectively as a foil for smooth, machine-made materials like glass and metal, whose precise, gleaming, and reflective skins shine more brilliantly in contrast to coarse, granular, stone-sand-and-cement mixtures. Pigments added to the cement do not seem to help much. Apparently gilding and cosmetics are not the answer either.

Along with the steel-frame skeleton, ferroconcrete has revolutionized architecture by eliminating the weight-bearing masonry wall. Windows used to be small openings in a wall, openings whose width was governed by the strength of a stone or wood lintel, a metal plate, or a masonry arch. Skeleton construction combined with recessed columns permits a skin almost totally composed of glass, if the designer wishes. Such buildings as Lever House and its numerous imitations show how appealing the tinted-glass curtain wall has become. The structural revolution brought about by ferroconcrete and steel has changed many of our deep-rooted attitudes about inside and outside, privacy and exposure, skeleton and membrane. Great spaces are spanned without visible support; prodigious strength is developed without convincing bulk. But we are so accustomed to handling wood and stone that there is some tendency to feel insecure under a concrete dome whose weight is not carried down by a system of trusses and posts we can see. Perhaps these fears will be overcome in a generation of children who have seen for themselves how strong constructions can be made with folded paper, drinking straws, toothpicks, raffia, and wire.

PRESTRESSED CONCRETE

Prestressed concrete is a refinement of reinforced concrete which further strengthens the material and improves its structural performance. It involves the stretching of high-tensile steel strands within concrete forms before the concrete sets. After the concrete is bonded to the tensioned or stretched steel, the tension is released and the strands, now encased in concrete, attempt to return to their former length. As a result, the steel "squeezes" the concrete particles together. Concrete, as we know, is weak

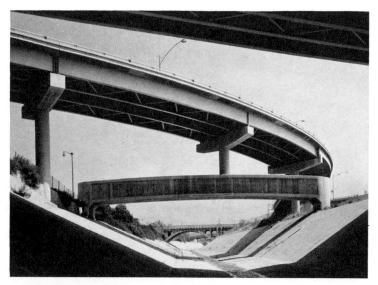

Elysian Viaduct over Arroyo Seco Flood-control Channel near Los Angeles. 1964

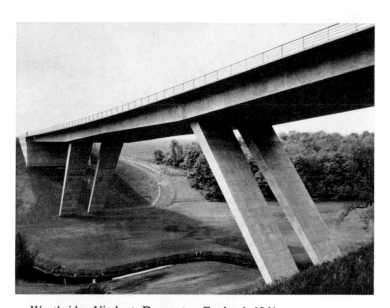

Wentbridge Viaduct, Doncaster, England. 1961

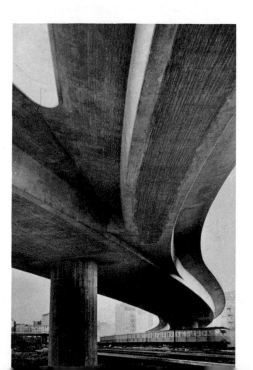

Elevated highway, Berlin. 1963

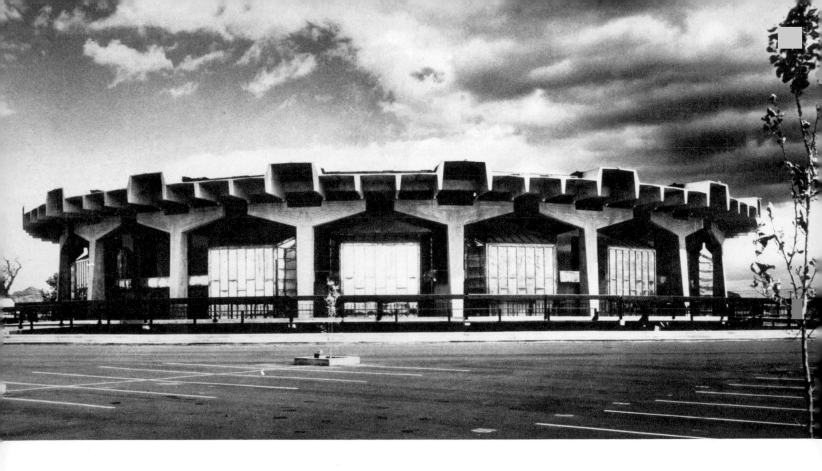

PERRY NEUSCHATZ AND GARY CALL. Convention hall, Phoenix, Arizona. 1964

under tension, that is, it tends to crack or break when subjected to forces which seek to pull it apart. Since the bottom of any beam is under tension while the top is under compression, the bottoms of concrete beams will develop cracks due to their own weight as well as the weight of a live load. (Steel beams resist forces which would pull them apart, but may deform under compressive or crushing forces that concrete would resist. In other words, a steel beam is vulnerable along its upper portion, where concrete is strong.) But prestressing gives the concrete a slight upward arch, neutralizing the beam's own weight and developing a continuous resistance to tensile forces along its bottom portion.

In practice, beams are prestressed in two ways—by *pretensioning* and *post-tensioning*. As the terms imply, the steel strands are stretched either before the concrete is poured or after it has been poured and has set at a certain strength. Both methods yield the same results, but pretensioning is usually done at a plant, thus lending itself to standardization and prefabrication. Post-tensioning is usually done on the site, the steel strands being first encased in tubes or channels, especially for large and specialized beams. Sometimes the tensioning of the steel wires in post-tensioned beams is increased long after the concrete has set. This is possible if the channel around the tension wires has not been filled, or grouted, and if the anchorage at the beam ends is accessible.

Prestressing means ultimately that stresses—that is, forces within the material tending to move in certain directions—are built into concrete during the process of manufacture. They are calculated to counteract the loads and stresses which the structural member will undergo when in use. Since concrete is the heaviest of modern materials, concrete beams must support their own "dead" weight before they can begin to carry "live" loads. It is easy to see that in bridges with long spans, the dead-weight load of concrete beams would be immense. But through prestressing, the dead weight is counteracted, and the strength of the beam and its built-in upward thrust can be used entirely for the support of live loads. The dead weight can then be transferred to the bridge towers or foundations.

The plastic quality of concrete, combined with the great strength of steel wire, makes prestressed concrete a superb architectural material, as is beautifully demonstrated in the work of Maillart and Freyssinet. One disadvantage of the material lies in the difficulty of tensioning wires in a member which has more than a slight curve. Conventional reinforcing rods must be used in complex or sculptural concrete forms, and thus the advantages of prestressing are lost. But it is very likely that technology will find ways to prestress complex forms. In that case steel-truss construction will face a worthy aesthetic and economic competitor.

The Structural Devices

One of the aims of architecture is to enclose space. To carry out this aim, materials must be organized so that they define the space around them as inside and outside, protected and exposed. But materials will not perform space-enclosing tasks of their own accord, and nature, in the form of gravity, tends to oppose the human effort to organize materials so that they will stand—safe, stable, and secure. Architectural structure, therefore, is the science and art of shaping, arranging, and fastening materials to resist successfully the continuous opposition of gravity, the intermittent attacks of weather, the wear caused by human use, and the processes of fatigue and decomposition within the materials themselves.

The problem of structure is to find the best ways to pit the resistant qualities of materials against the steady, predictable force of gravity in order to produce equilibrium and stability. To show how structural devices function in this task, I devoted the previous sections to a discussion of the inherent virtues and limitations of ancient and modern materials used in building and their effects upon construction. The following section carries the discussion further into the interaction of materials with specific structural devices.

The emphasis on structure and building in this chapter should not be equated with indifference to the role of architecture as a vehicle of ideas and emotions. On the contrary, an understanding of how structures are designed and put together should enhance the capacity to experience architectural forms intelligently and with an intuitive grasp of their structural role. The meanings we discover in architecture are partly derived from our perception of buildings as symbolic configurations of form. Such perception is not highly dependent on a knowledge of structure. (In this connection, R. Buckminster Fuller writes: "I am astonished at how accurately and quickly the eye can see balance between mass and verticality. Most men's eyes can read what engineers call slenderness ratio in construction: the ratio of cross section to length in, for example, a column. I think every man can judge a woman's leg to a 32nd of an inch at 70 paces. This ability is built into the eye; it isn't something taught to humans by other humans."[40]) On the other hand, the ability to make a sound critical judgment about a building depends on at least *some* knowledge of the way its materials and structure operate objectively. Since architecture is a social art, and frequently is publicly supported, such "technical" knowledge may be more vital in a civic sense than it is in painting or sculpture. Perhaps the best argument for an understanding of structure as necessary for the designer *and* the layman is that of Eduardo Torroja: "This matter of the unseen thickness of dimensions is fundamental in construction. It might be said that it constitutes a fourth dimension in the interplay of volumes enclosed by the apparent enveloping surfaces. 'It is this quality of depth that alone can give life to architecture,' says Frank Lloyd Wright; the designer must be continually reminded of the necessity to make it easy for the viewer to sense and feel these thicknesses. The work cannot be appreciated without that 'fourth dimension' essential to the nature and beauty of the whole."[41] In another place, Torroja gives to designers advice which, with less urgency, might be useful for anyone seeking a genuine understanding of architecture: "One should become so familiar with the structure as to have the feeling of being, in full vitality and sentiment, part of it and of all its elements."

The discussion which follows constitutes only a beginning of that endeavor to "feel" structure. But you will surely improve your powers of judgment and your capacity for enjoying architecture if you carry your study of structure beyond the foundation presented here.

THE POST-AND-LINTEL

The post-and-lintel is the most ancient of construction devices and it continues to enjoy wide use today. In it, two vertical supports are bridged over by a horizontal beam. The dolmen of prehistoric man was an approximation of the post-and-lintel, the upright stones serving as posts and the horizontal table rock acting as a lintel. In this system there is a sharp and visually distinct demarcation between the supporting and the supported members. Certainly its clarity of function appealed to the Greeks, admirers of reason and precision in all things. It was also used exclusively by the Egyptians, since the post-and-lintel is very secure and capable of withstanding great weights.

Stone, as we know, was the chief material employed in ancient post-and-lintel construction; in modern times wood-frame construction involves post-and-lintel as well as truss features. But ferroconcrete and steel are mainly used in modern post-and-lintel construction, especially in large buildings. The contemporary architect, however, may have different motives for using this system: the resolution of the principal resistant forces into vertical and horizontal components permits a high degree of rationality in the planning of space and considerable efficiency and precision in the use of materials. Further, since each structural member is very specialized, performing the function for which it is best suited, a high degree of standardization becomes possible, leading to prefabrication, mass production, and lowered costs.

The post-and-lintel system is also responsible for the strong emphasis on window walls in modern building.

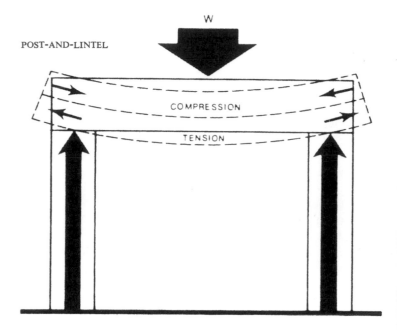

POST-AND-LINTEL

W

COMPRESSION

TENSION

Temple of Hera, Paestum, Italy. c. 460 B.C.

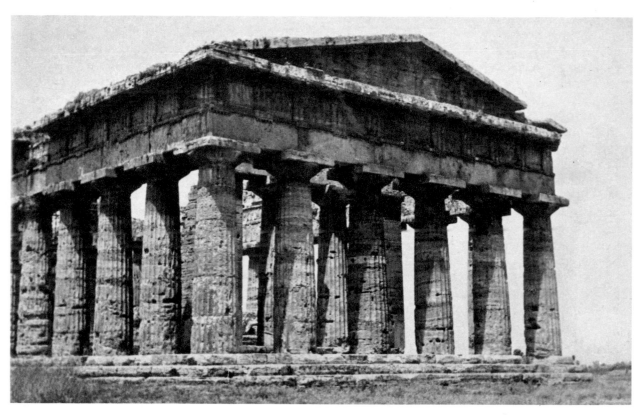

Large openings permit wide windows, wide vision, excellent interior ventilation, and generous display possibilities for outside viewers. As a result, the design of fenestration for steel-cage construction became a major architectural problem before the development of central air conditioning. The most common solution involved a large, fixed pane of glass in the center of each horizontal rectangle, with vertical bands of louvered windows at the sides. With supporting posts set back from the curtain wall, no structural interruption of the fenestration was necessary; window design was restricted only by the optimum size of

glass panes and the framework needed to hold the glass in place. The Bauhaus building, designed by Walter Gropius (1883–1969) in Dessau, was an early instance of the use of continuous horizontal bands of glass uninterrupted by exterior posts. This type of design became common in all kinds of buildings—but especially those in which a great deal of daylight was required. In the 1930s, factories were the main beneficiaries of the recessed posts and continuous window walls made possible by steel-cage construction. Today, designers rely far more on artificial illumination for industrial plants, office

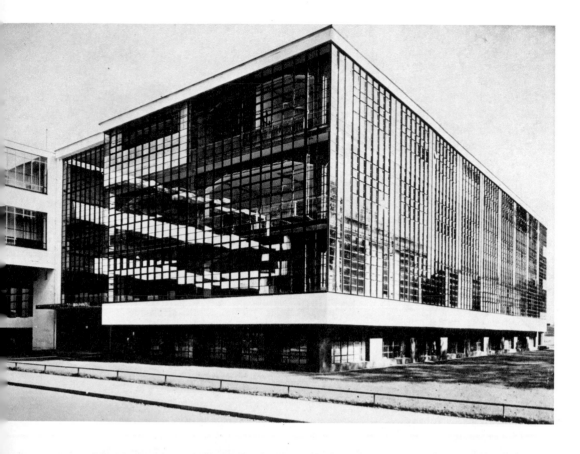

WALTER GROPIUS. Workshop wing, The Bauhaus, Dessau, Germany. 1925–26

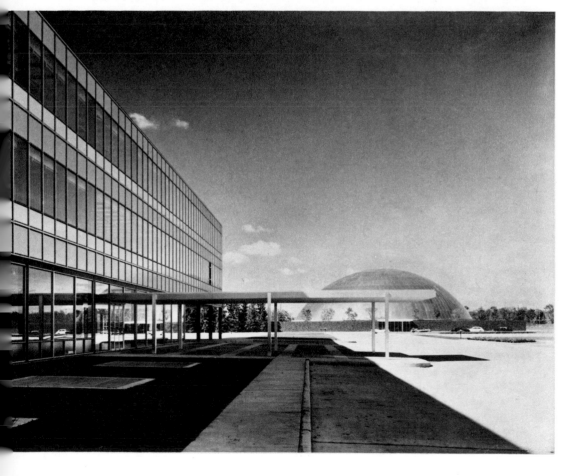

EERO SAARINEN. General Motors Technical Center, Warren, Michigan. 1951–55

buildings, department stores, and so on, but the glass wall is retained if only because, viewed from the outside, reflections in the glass enable the frequently austere forms of contemporary architecture to harmonize with the environment.

In addition to its role in glass-wall design, the post-and-lintel system as used in steel- or ferroconcrete-cage construction affords regular spacing of posts and thus of partitions, creating interchangeable cubical spaces. Like the grid plan of land subdivision, such spaces lend themselves to the rational—that is, measurable and calculable —methods required by modern commercial and industrial enterprise: efficient sale and rental of space; standardized design of fixtures and furnishings; rapid and orderly transportation and circulation of people; and maximum utilization of the space which has been created. It is easy to see how space created by arches, vaults, and domes is wasteful from a commercial standpoint. What is lofty and inspiring in a church or the reading room of a library represents an uneconomic expenditure of funds in a commercial structure.

Cage construction based on the post-and-lintel also permits the raising of a building on stilts, or *pilotis*, as Le Corbusier called them. In effect, a basement and first floor are eliminated, and the entire weight of the structure is supported by a series of strong, built-up girders along the bottom of the building. The load is carried from these members to the ground through the stilts very much as it is in a chest of drawers or a dresser on legs. Only a steel or ferroconcrete beam, of course, would have the strength to do the job without creating intolerable bulk or multiplying the stilts, which would nullify the advantages of ground level circulation beneath the building.

The steel posts of skyscrapers are so slender that when visible they are commonly encased with bulkier materials, not only for fireproofing and concealment of plumbing, wiring, and so on, but also to provide psychological assurance that the building is being supported. Although the post-and-lintel is an old device, we are conditioned to its use in the dimensions appropriate to wood or stone. Only during the construction process do we see the lightness and openness of the steel cage. Its strength is a product of the material and the structural system. Stone lintels *rested* on their supports, but steel posts and lintels are *fastened* together. Unlike stone their joints resist lateral and rotary movement so that the inherent strength of the material is enhanced by the strength of the joint system. Consequently, it is a mistake to think of modern cage construction as merely a translation of the ancient post-and-lintel into new materials. Similar cubical spaces are created, but the modern system does not rely on gravity for its strength.

Our cubical spaces, unlike those of classical buildings, require fewer interior supports. Hence, design emphasis is not on columns and capitals, or lintels and architraves. Instead, the principal design problem lies in the treatment

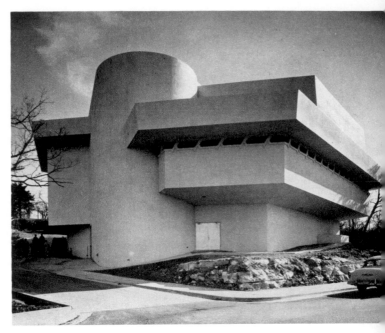

FRANK LLOYD WRIGHT. The Kalita Humphreys Theater, Dallas, Texas. 1959

of the curtain wall and the total space envelope. That is why it is not unusual for an architect commissioned to design a large office building to employ a firm specializing in the organization of interior space and utilities to handle those details while the designer applies himself to refinement of the skin and the planning of elements visible at the ground level. Thus, the post-and-lintel system combined with modern materials has created new constructional advantages as well as new architectural dilemmas.

THE CANTILEVER

A cantilever is basically the horizontal extension of a beam or slab into space beyond its supporting post. Its free or external end is unsupported, and the point where it rests on its post acts like the fulcrum of a lever. If the internal end of the beam were not bolted down or counter-weighted in some fashion, the cantilever would rotate around its fulcrum. But since the inside end is fixed, the free end is rigid. The overhanging front and rear ends of an automobile function as cantilevers. The thumb extended on the hand acts like a cantilever. But a bracket is not truly a cantilever, as some suppose, because although its upper surface resembles an extended beam it is really supported by a diagonal brace in compression. The cantilever, like a beam supported at both ends, relies simply on the resistance to breaking of its material and the secure fastening of its internal end.

The cantilever principle has been known at least from the time of the first overhanging stone lintel. A tree branch resembles the cantilever, and the strength-to-weight ratio of lumber makes the material suitable for light cantilever construction. But steel and ferroconcrete are the ideal cantilever materials. Some steel bridges that resemble arch construction are in fact the product of a pair of

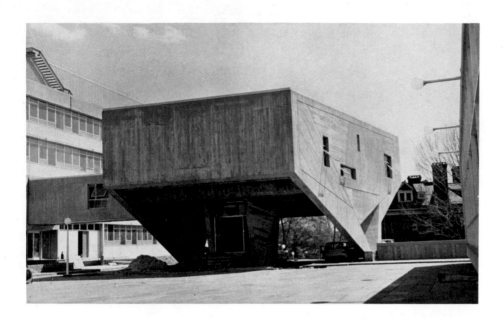

MARCEL BREUER.　Begrisch Hall, New York University. 1961

cantilevered beams projected out from their piers and meeting in the center of the span. Bracket-type bracing in the shape of a half arch creates the impression that the whole span is supported by an arch.

As an architectural device in major construction, the cantilever has become increasingly feasible and popular with the availability of strong materials at reasonable cost. For domestic dwellings in a moderate price range, the steel needed for cantilevers of any substantial projection may be too expensive. Although wooden cantilever beams are used, they cannot be extended as dramatically as steel. As noted earlier, multiple dwellings often employ narrow cantilevered balconies as design clichés or as sunbreaks. But the dramatic impact of cantilever construction is not felt unless an extension approaching the limits of the material is created. As with the suspension bridge and the light-weight truss, the defiance of gravity by strength of material and ingenuity of design accounts for the distinctive beauty and excitement that are characteristic of the device.

The portion of the floor projecting beyond the columns in buildings exhibiting a continuous band of windows is, of course, cantilevered. The supporting columns may be concealed within wall partitions so that

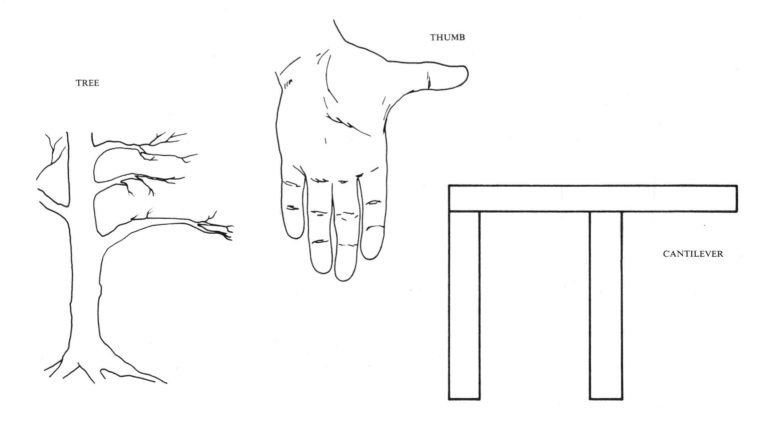

TREE

THUMB

CANTILEVER

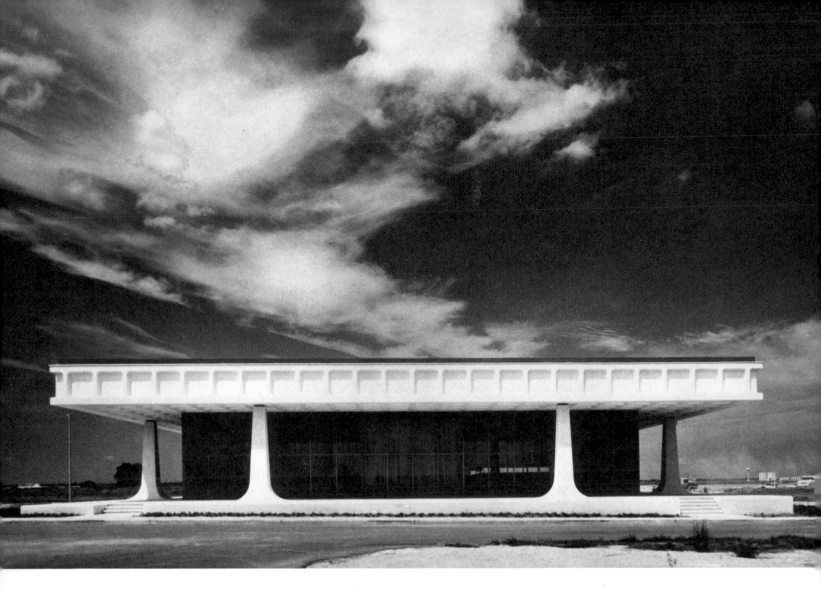

WELTON BECKET AND ASSOCIATES. First State Bank of Clear Lake City, Texas. 1965

no interior posts are seen. Thus, instead of being extended freely in space, the edge of the cantilevered floor becomes an attachment for a curtain wall of glass or metal panels, or the support for bands of brick veneer. Hence, the cantilever is not visible, although its operation is essential for this type of curtain-wall treatment.

Among the most exciting uses of the cantilever are in ferroconcrete canopies, roofs, pavilions, grandstands, aircraft hangars, and theater balconies. Here the imagination of the architect and the ingenuity of the structural designer combine to create some of the most striking and uniquely modern structures in contemporary architecture.

THE TRUSS

The truss is an application of the geometric fact that no angle of a triangle can be changed without altering the dimensions of the sides. It is a system of triangles (with the exception of the rectangular Vierendeel truss) arranged to work like a beam or lintel. Such systems of triangles can be made very rigid, and thus capable of

bridging exceedingly wide spans. Truss construction is used where great spaces must be spanned with few or no interior supports. Wood and metal are the principal materials used because these materials possess high tensile strength for their weight, and most of the members of a truss are in tension. In bridges, theaters, convention halls, gymnasiums, assembly plants, and in most dwellings featuring gable roofs, the truss is almost indispensable.

The pediment of the Greek temple constitutes the most beautiful application of the truss in the shape of a triangle itself. This triangle has so firmly established itself in the consciousness of men of almost all cultures that it is difficult to imagine a traditional house, barn, or church which does not have a triangular gable. Even though the comparatively short distances between the walls of domestic dwellings can be spanned by other means, the triangular-gable roof "feels" safe and stable because of our long conditioning to its use. A flat roof is accepted very reluctantly, if at all, in low structures. Of course, for many centuries the space *within* the gable roof has been useful in the form of a sleeping loft, grain storeroom, attic

Roof truss, Fairbanks House, Dedham, Massachusetts. c. 1636

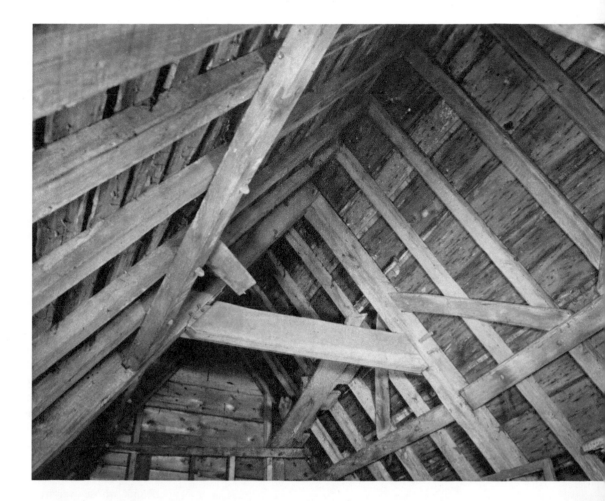

CHARLES AND HENRY GREENE. Hall and stairway, R. R. Blacker House, Pasadena, California. 1907

WOODEN ROOF TRUSS

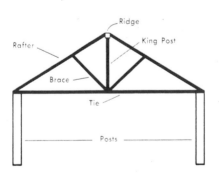

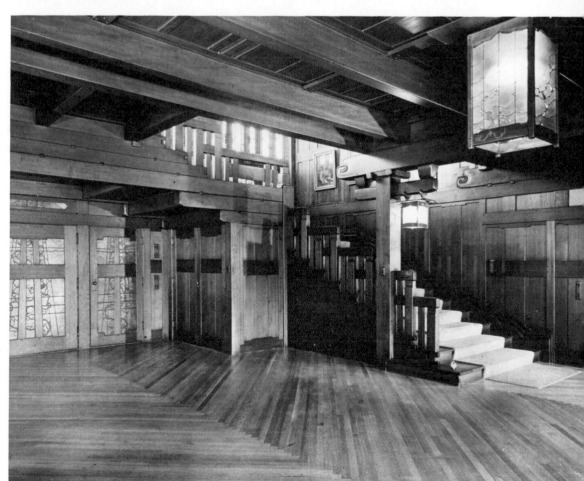

TYPES OF TRUSSES

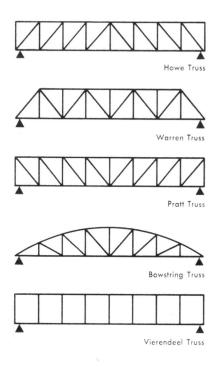

Howe Truss

Warren Truss

Pratt Truss

Bowstring Truss

Vierendeel Truss

SUSPENSION BRIDGE

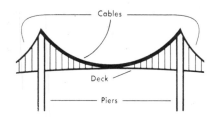

Cables

Deck

Piers

ARCH

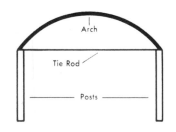

Arch

Tie Rod

Posts

(appropriately a Greek word), or merely as an insulating space. In the sturdy Cape Cod cottage, Yankee ingenuity found space for extra bedrooms, which accounts for the wide popularity of the New England saltbox dwelling even today. In contemporary homes, less economical of space, the flat ceiling is raised or eliminated, converting the gable space into the prestigious "cathedral ceiling." Furthermore, the gable roof not only encloses the space between the walls of a dwelling, it also sheds snow and rain conveniently and offers a profile of low resistance to wind.

Although trusses are usually systems of triangles, their overall shape is not necessarily triangular: most trusses are long rectangles in the shape of a beam. As mentioned above, they are indeed a type of beam which substitutes stiffening struts, braces, or bars in place of the solid wood, metal, or stone of a beam. Other trusses may be straight along the lower edge and arched or paraboloid along the top—the so-called bowstring truss. Usually the upper chord of a truss and its vertical members are in compression while the lower chord and the diagonals are in tension. The stresses on these members correspond to the stresses which would operate within the solid material of a beam. In effect, the truss designer locates bars of appropriate length, direction, and cross section in places of greatest stress, eliminating the intervening solid material which does no work. Some trusses—the lattice type—superficially resemble the so-called open-web or trellis-work girders. But such girders are essentially built-up beams whose weight has been reduced by substituting steel web bracing for solid metal. They do not possess the lightness and strength of genuine trusses whose triangulations are designed specifically for the requirements of a particular type of load. A truss can span a much greater distance than a built-up girder because a girder is a standardized building part while the calculated design of a truss is responsible for its great strength in relation to its weight.

Surely anyone who has traveled over a bridge supported by a truss or stood in a great hall whose roof is supported by trusses has wondered how such vast spaces can be spanned by what are apparently fragile and slender members. Any insecurity we feel is usually based on our willingness to believe only in the strength of materials under compression and to underestimate the strength of materials—especially of steel—in tension. Most of the members in an overhead truss have been designed so that the weight of the roof works to *pull apart* rather than *bend* the steel braces. The crystalline structure of steel is such that it is almost impossible to pull it apart, and the designer has usually given each brace a length and cross section which will stubbornly resist bending. So, those fears based on age-old memories can be put aside. Few of us can visually estimate the enormous tensile strength of steel, just as we cannot form a percept for a billion dollars. This observation may point to fundamental distinc-

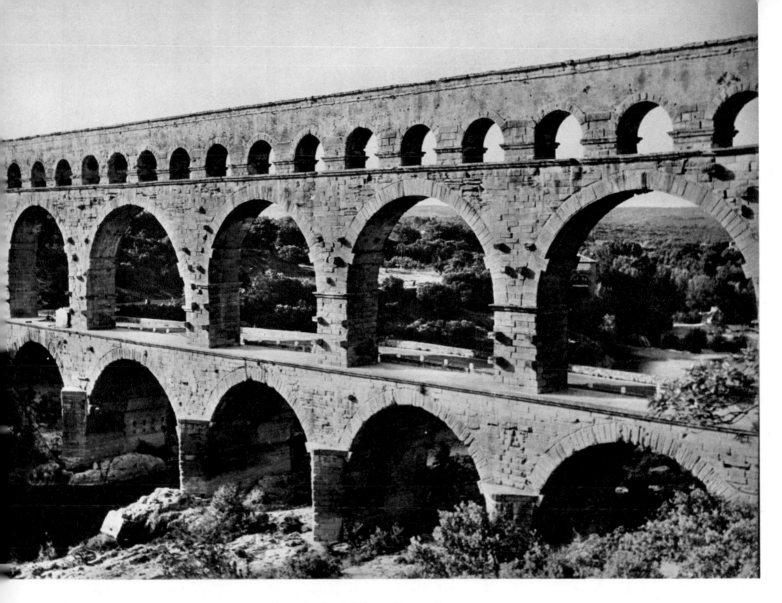

Pont du Gard, Nimes, France. 1st century A.D.

tions between art and engineering: art deals with visually ponderable effects; engineering employs mathematics to manipulate data which our senses cannot adequately perceive. But the results of engineering are visible to the senses and ought to be pleasing, since mathematical calculation is a tool of design just as imagination and sensibility are tools of art. If steel and wood are remarkable materials because they tenaciously resist being pulled apart, isn't human ingenuity even more remarkable in being able to design structures—with or without mathematical calculation—which magnificently exploit the properties of materials?

THE ARCH

The post-and-lintel represents the simplest means of using gravity to enclose space; the arch is considerably more sophisticated. In both cases, vertical supports or columns are used. But the means of bridging over space, which has

always been the central problem of architecture, is vastly different. The arch originally relied on the compressive strength of bricks or cut stone. The separate units of an arch, called *voussoirs*, are in effect "welded" into a single curved member as they are squeezed together by the weight above and around them. The arch does not begin to function until the voussoir in its center, called the *keystone*, is set into place. As the keystone is the last stone to be placed, the arch has to be supported, during construction, by a structure of wooden forms, called *centering*. The curve of the arch carries weight to its columns along a path which is not only graceful but which also corresponds to the pressure line of forces over the opening which the arch protects. In other words, if a square-shaped opening were cut in a solid wall, and if we could see the distribution of the stresses in the wall over the opening, they would meet over the door to form a curve similar in shape to an arch.

The arch was probably developed by the Mesopota-

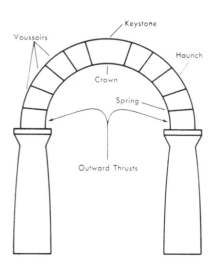

ROUND ARCH

Voussoirs

Keystone

Haunch

Crown

Spring

Outward Thrusts

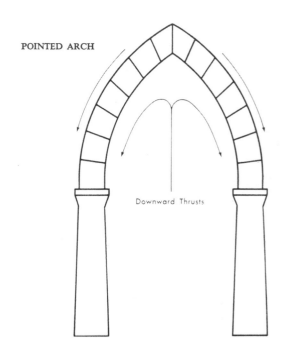

POINTED ARCH

Downward Thrusts

mians some four thousand years ago. They found that wedge-shaped bricks could be fitted into a semicircle to hold each other in place and to support weight above them. However, the load which the arch carries to its supporting posts develops almost horizontal reactions, called thrusts, which tend to force the posts outward, bringing about collapse. That is why arches appear in series or in walls but rarely alone. The outward thrust of the arch must be resisted by some type of buttressing or by a heavy masonry wall. The area of masonry which surrounds an arch is called a *spandrel*. It prevents bulging or deformation of the arch under pressure, no matter what its shape. It was the principal mode of reinforcement used by ancient builders. A *free* arch, on the other hand, requires some buttressing, but it relies mainly on the correctness of its design and the strength of its own materials for security. It is the principal type used in modern construction. The systems of abutments and buttresses used in place of solid masonry to counteract the outward thrusts of the free arch grew out of engineering necessity, yet they are responsible for much of the aesthetic effect of late medieval and Gothic architecture.

The arch was much used in Renaissance construction, in combination with the post-and-lintel, but usually as part of a wall and without external buttresses. The triangular pediment shape, based on the roof truss, was commonly alternated with the arch over windows and portals, frequently *as a decorative rather than a structural element*. Although builders of this period possessed the engineering knowledge and capacity of their Gothic pre-

decessors, their architectural tastes differed: structural functions were frequently concealed, while pilasters, blind arcades, arches, pediments, columns, architraves—the entire panoply of the classical building orders—were exploited for visual purposes. The Greeks and Romans, from whom the Renaissance architects derived their inspiration, also employed decorative and constructional details for visual effect, but their buildings rarely included nonfunctional structural members. And even Gothic building, which is more closely identified with pure engineering than any of the other great architectural traditions, possesses features which perform visual and symbolic rather than structural functions. Still, the arch tempts builders to become great engineers. Only in Italy was the arch a compositional device among others: it was often a shape employed to decorate a wall.

The arch permits high and large openings, and the successive positions of its frames help to establish a rhythmic pattern of forward or upward visual movement. It is also an extremely versatile device, lending itself to the rugged honesty of early Christian architecture, in which coarse masonry walls and piers were used for abutment, or to the delicate, soaring effects of Gothic architecture, in which weight-bearing walls were virtually eliminated. In both cases, tall, vertically shaped space was the objective. The early Romanesque basilica, however, emphasized a darkly mysterious interior, lit mainly from within; those chapels, like early Christians themselves, were indifferent to their outer garments. By contrast, Gothic interiors were illuminated from without by light

passing through colored glass. Their exteriors revealed not only the bones of their construction but also a host of sculptured images formerly visible in the flickering light of nave and apse mosaics. Romanesque masons could not build very high because their method of vaulting and abutment—the masonry wall and the buttress hidden under the roof of the side aisles—contained limitations inherent in the amount of stone which could be safely piled on stone. The Gothic method of abutment—the pier and flying buttress (which is really a half arch)—permitted as much height (up to 157 feet at Beauvais) as could be managed without setting up bending and twisting stresses in the fabric of the stone arches and ribs. The stability of the masonry arch, it must be remembered, depends on the compressive strength of relatively small stones or bricks bonded together with mortar. These materials fail when subjected to tension or torsion. Apparently the vaults of Beauvais fell, in 1284, because the builders made their arches too light and too high, leaving the structure vulnerable to bending or twisting stresses from live loads caused by wind and weather.

The capacity of an arch to withstand uneven and moving loads is increased if heavy stones are used to build it. Heavy stones, in turn, require strong and well-engineered *centering* (the hemispherical wooden framework used to support the arch under construction before it is subjected to load), sophisticated machinery to raise them into place, massive piers to sustain their dead weight, and, of course, a sacrifice of the slenderness to which Gothic vaulting aspires.

The pointed Gothic arch had the effect of directing its thrusts more nearly downward than in the almost horizontal direction of the round arch. As a result, its flying buttresses could be quite slender and its intervening stained glass windows could be relatively unobstructed by thick masonry abutments and cast shadows. In addition, the pointed arch raised the height of interior space. Gothic ribbed vaults based on the pointed arch became, in effect, segmented domes, the area between the cross ribs being filled with a masonry fabric which functioned much as the membrane materials in contemporary geodesic domes designed by Buckminister Fuller.

In today's architecture, the free arch is used mainly to support bridges and viaducts and in association with large domical and vaulted structures. Made of reinforced concrete, steel, and also of laminated wood, the modern arch is a monolithic member—much stronger than its brick or stone ancestors. In wide-spanning concrete arches, such as the Ingalls Hockey Rink at Yale by Eero Saarinen, the supporting posts are omitted; the arch virtually springs (begins its curve) from the ground. Consequently, the action of the arch resembles the action of a huge bowstring truss, or a beam employing a single, curved brace. Nevertheless, true arch action is involved, since the entire member is in compression while the ground level serves as a tie rod or as the lower chord of a truss.

The modern free arch, because of the strength of its materials and the precision with which engineers can calculate lines of pressure, is capable of spanning enormous spaces while it also yields considerable variation in shape. Often its shape results from its function as the

Crypt, Speyer Cathedral, Germany. 1040

EERO SAARINEN. Interior, Ingalls Hockey Rink, Yale University, New Haven, Connecticut. 1958

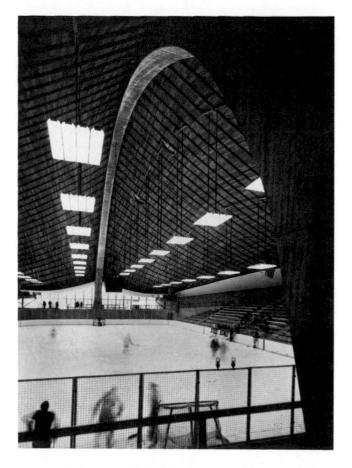

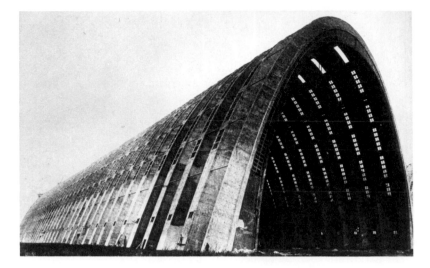

Eugène Freyssinet. Airport hangar,
Orly, France. 1921

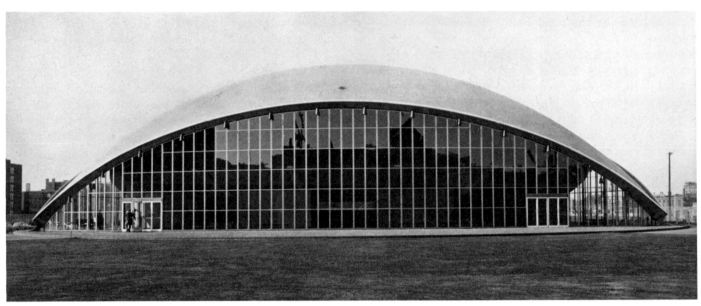

Eero Saarinen. Kresge Auditorium, Massachusetts Institute of Technology, Cambridge. 1954

opening for a curved shell structure, as in Saarinen's
Kresge Auditorium at M.I.T. or in Freyssinet's airport
hangar at Orly. Today's assimilation of the arch into
stressed-skin shells and vaults recapitulates the evolution
of the classical arch and the Romanesque cross vault into
late Gothic vaulting, as in the cathedral at Exeter and the
chapel of King's College, Cambridge. Mastery of struc-
tural devices and building materials reaches the point
where an almost organic unity is achieved; there is hardly
any separation between skin and bone, between sup-
port*ing* and support*ed* members; the designer employs
his mastery to disperse the structural function through
the entire building fabric. The dissolution of the weight-
bearing arch into fan vaulting, as at Cambridge, may
represent a decline in straightforward structural perfor-
mance. The modern imagination, however, pines for
the drama of a single arch springing unassisted over open
space. Hence, it is satisfied by those contemporary de-
signers who use the arch for its emotional properties and
as a structural device of enhanced strength and reliability.

THE VAULT

The classical vault was a succession of identical arches
in file order—one behind the other. The wall was a
masonry plane punctuated by arches. Bridges and aque-
ducts were arcades, successions of arches in rank order—
side by side. Interior space of any size was spanned by
arches in the form of a semicylinder—the so-called barrel
vault. (Even the dome, which was also employed to en-
close large spaces, can be thought of as a shape which
results from the rotation of an arch around a vertical axis
formed by a line drawn through its keystone, or mid-
point.) The groined vault of Romanesque and Gothic
building resulted originally from the intersection at right
angles of two barrel vaults.

Since the intersecting barrel vaults were of the same
size in early construction, the *bay*, or space below the
cross vault they formed, was square. As a result, the
groined vault over a square bay, usually found in Roman-
esque construction, produced a shape similar to a seg-

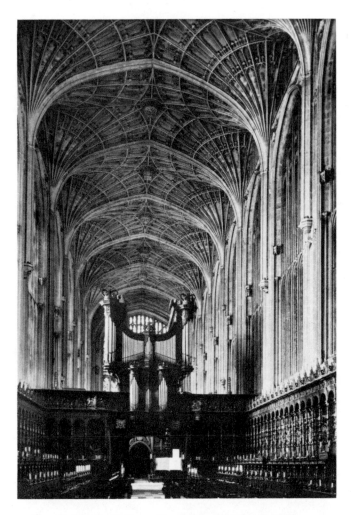

Chapel, King's College, Cambridge, England. 1446

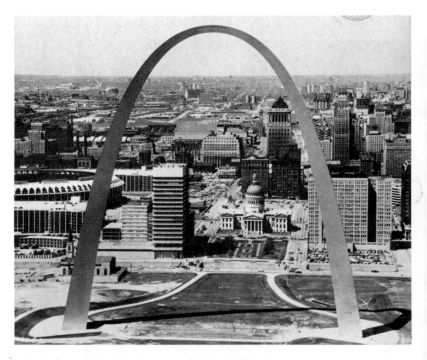

Eero Saarinen. Gateway Arch, St. Louis. 1965

mented dome. Italian builders employed this type of vaulting even after the introduction of ribbed vaults permitted long, narrow bays. Symmetry is a pervasive quality in Italian culture and in classical culture in general. In Gothic building, rectangular bays and vaults were preferred; hence, the transverse, longitudinal, and diagonal arches had to be carefully adjusted in their rise and curvature so they would meet in the same place at the top of the vault. The vaults of classical construction, then, were created from a solid succession of arches, followed afterward by groined cross vaults. Subsequently, with greater sophistication, the groins were succeeded by a network of archlike members called ribs, between which a fill-in fabric of stone masonry was set to complete the enclosure. The important point is that the choice of the rectangular bay created problems in the design of the ribs—problems whose solution demanded considerable ingenuity and led to a steady reduction in the weight of the vault, increased height, and further penetration of the walls.

The disadvantage of the barrel vault, going as far back

as the Romans and Chaldeans, was that it could not be pierced by windows without being substantially weakened. That is one of the reasons why early Romanesque naves were so dark. The replacement of barrel vaults by a succession of groined vaults enabled the nave to go higher because the vaulting had become lighter and hence did not require such heavy walls and abutments for support. By the twelfth century, however, pointed arches and rib vaulting began to replace the round arches, heavy groins, and square bays of Romanesque construction. The ribs were lighter than the groins they replaced and could be built wherever they were needed—not just at the points where the old barrels would have intersected. By multiplying ribs, the stone panels between them could be narrowed, and lighter weight stone could be used, greatly reducing the total weight of the vault. As the ribs multiplied, both for decorative and structural reasons, the panels between them grew lighter, and their weight-bearing function was distributed through the whole surface of the vault. The result, as mentioned earlier, was a dynamic

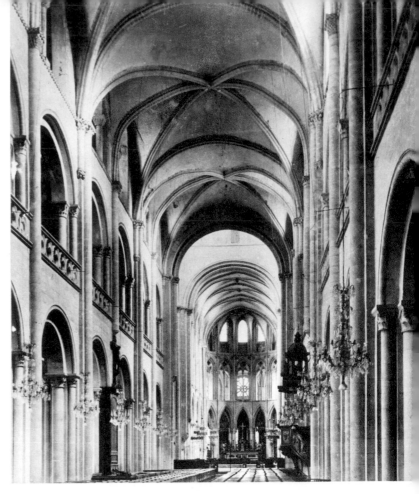

Nave (vaulted c. 1095–1115), St.-Savin-sur-Gartempe, France. Barrel vault.

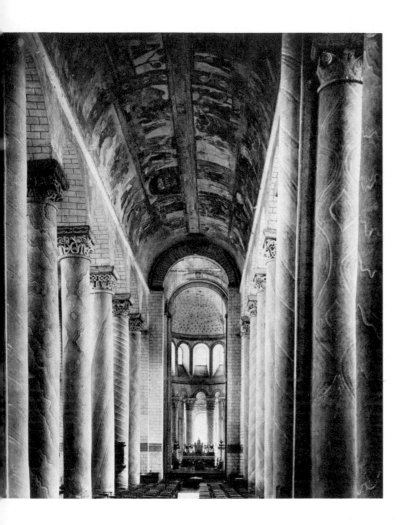

Nave (vaulted c. 1115–20), St.-Etienne, Caen, France. Groined vault.

Vaulting of choir, abbey church of Asnières, France. Early 13th century. Ribbed vault.

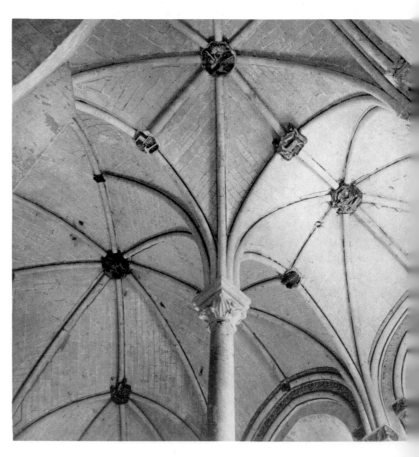

pattern of stresses which resembles modern stressed-skin or shell construction. The ribs tended to prevent lateral slipping, a danger of groined vaults which discouraged their use over very wide spaces. The rib vault, the pointed arch, and the flying buttress—all variations of the same device—made possible the triumph of Gothic construction.

THE DOME

The vault evolved as a solution to the perennial problem of bridging great spaces without interior supports while avoiding wooden trusses—which might burn—or stone lintels—which would break of their own weight. The solution was based on arch combinations. The dome represents another solution. A dome is essentially a hemisphere, although it can bulge to approximate the bulbous shape of an onion, as in the famed multiple domes of the Cathedral of St. Basil the Beatified, Moscow (1555–60), or seem to be somewhat flattened at the equator, as in St. Peter's. Like the vault, the dome must be made of stone, brick, or concrete to resist fire. Usually a circular opening or skylight, called an *oculus*, or a *lantern* if the opening is surmounted by a tower is left at the top. The weight of a tower, of course, increases the tendency of the dome to bulge. That is why chains or metal rings were embedded in the masonry of classic domes. The Pantheon in Rome, built in 120–24 A.D., although hemispherical when seen from inside, has on the outside a very high, thick mass of masonry surrounding it up to the haunch (the area on the curve of an arch or dome which is about halfway up to the top, or crown), so that the dramatic exterior form of the dome is almost lost. It appears to be a shallow mound resting on a high drum (the cylindrical ring of masonry upon which the dome rests).

The placement of a dome on a cylindrical drum over a circular foundation is logical from the standpoint of geometry and construction. But most domed structures rest on rectangular foundations, because a rectangular ground plan lends itself to a more logical (for Western eyes) subdivision of space. (Domes totally unrelated to their supporting structure are built today, as in the Corn Palace in Mitchell, South Dakota.) The dome emphasizes a vertical orientation of vision, while the rectangle, preferred in Western churches, stresses a forward-looking orientation. Aesthetically, it appears to be an extravagant device for focusing dramatic attention on a point directly beneath its center. In the Middle East, where the dome probably originated, its ceiling was regarded as an image of the cosmos and was frequently covered with stars. (Even the modern planetarium is dome-shaped.) It had religious and cosmological meaning, then, and was not devised merely to create a difficult and spectacular construction problem. The cosmological function survives in Western churches in the semidomes of apses with their mosaic representations of Christ as Pantocrator (ruler of the

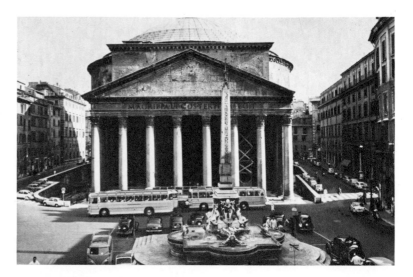

The Pantheon, Rome. 120–24 A.D.

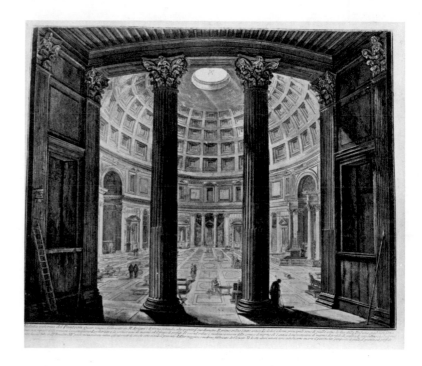

G. B. PIRANESI. *Interior of the Pantheon.* c. 1760

cosmos). For the same cosmological reason, perhaps, the Pantheon, the Roman temple of all the gods, is not especially impressive from the outside. From within, however, it conveys the sense of a world apart, self-contained and secure. Doubtless these qualities of the dome appealed to the emperor Hadrian, its builder, and later motivated Pope Julius II in 1505 to rebuild the wooden basilican church of St. Peter as a great stone structure under a central dome.

Cathedral of St. Basil, Moscow. 1555–60

Corn Palace, Mitchell, South Dakota. 1921. Domes, turrets, and annually rotated mosaic panels made of corn illustrate the uninhibited expression of folk architecture.

JOHN NASH. The Royal Pavilion, Brighton, England. 1815–18

The Architecture of Interior Space

INTERIOR, ST. MARK'S, VENICE. 1063–94. Christianity is an indoor religion; hence it has traditionally required large, unobstructed interior spaces. The Byzantine tradition created them magnificently, simultaneously generating immense surface areas for the play of light, color, and imagery. These surface areas were used for Biblical depictions to explain the faith; thus the meaning and function of the church structure were chiefly visible on the inside.

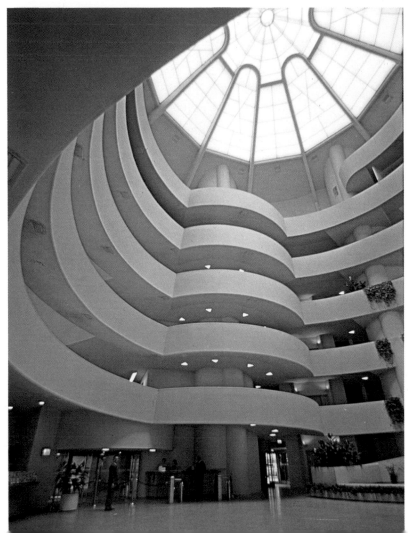

FRANK LLOYD WRIGHT. Interior, The Solomon R. Guggenheim Museum, New York. 1959. Wright's museum is like a cathedral and is very much in the tradition of early Christian domed churches. But unlike the mosaics of St. Mark's or St. Sophia, the pictures in this "church" keep changing. Hence, the building and its art do not explain, they only tolerate, each other.

Louis I. Kahn. Interior, The Salk Institute for Biological Studies, La Jolla, California. 1962–66. Kahn's detailing—his clarity in design of surfaces, joints, and changes of plane—results in a brilliant revelation of the total structure at work. There is no sculptural or decorative excess, only the expression of the building's integrity in each of its spaces.

I. M. Pei. Interior, Everson Museum of Art, Syracuse, New York. 1965–68. A monumental room in a small museum building can be achieved by unaffected attention to fundamentals: honest and uncomplicated enclosure of space, a practical device for washing the walls with light, and a modest amount of wall punctuation that allows the art objects to breathe.

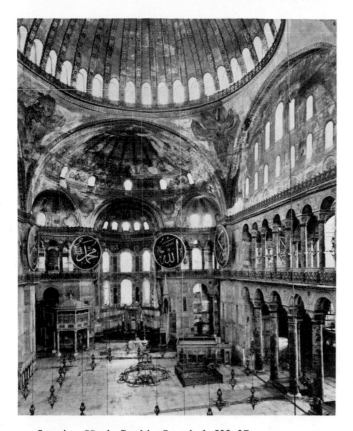

Interior, Hagia Sophia, Istanbul. 532–37 A.D.

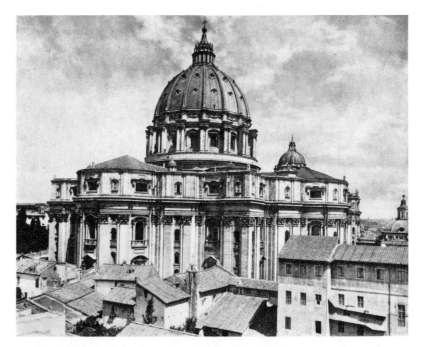

A number of devices have been used to manage the transfer of load from the circular edge of the dome to the rectangular foundation on which it ultimately rested. The most common were called *pendentives* and *squinches*. The pendentive system, in effect, rests the drum of the dome on four arches springing from four powerful piers located at each corner of the square plan. The arches meet the rim of the drum at only four points, however. Between these points are the four triangular sections of a sphere—the actual pendentives—which serve to connect the entire rim of the drum to the curves of the arch and carry its weight down to the piers. Hagia Sophia in Istanbul, built under Justinian in 532–37 A.D.—an unsurpassed construction achievement—is the supreme example of a dome on pendentives. The great outward thrusts developed in the arches and pendentives are carried down by a beautiful system of half domes and powerful exterior abutments. The dome itself has no oculus but is pierced instead by windows running continuously around its lower edge, a device which creates the impression that the dome is floating. The narrow spaces between the windows seem to define vertical ribs which transfer the dome's weight to the drum. In the interior of the Pantheon, a system of hollow rectangular shapes called *coffers* seems to define vertical and horizontal ribs, although the dome was in fact built of horizontal courses of brick laid to form two shells between which concrete was poured. The coffers therefore emphasized the thickness and stability of the dome for Hadrian, while the shaft of light from the oculus may have strengthened his consciousness of divine

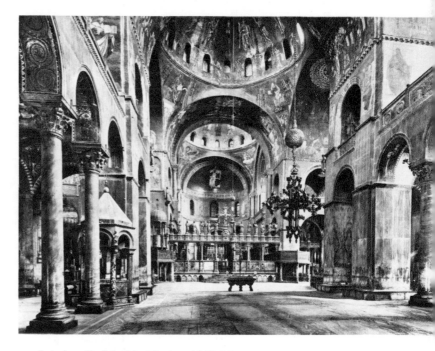

Interior, St. Mark's, Venice. 1063–94

descent. Similarly, the windows piercing the thick base of St. Sophia's dome must have reassured Justinian by their depth and dazzled him by the ring of light they shed on his imperial person and court.

The system of squinches, used by Mohammedan and Byzantine builders, is not as rationally articulated as the

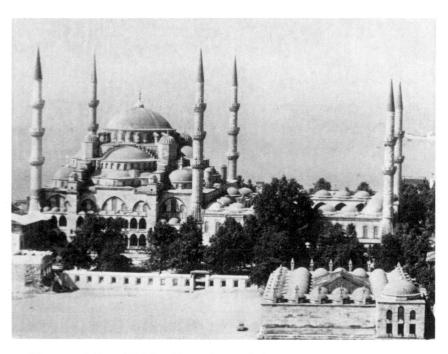

Mosque of Ahmed I (Blue Mosque), Istanbul. 1609–16

Interior, north dome, Congregational Mosque, Isfahan, Iran. 1088

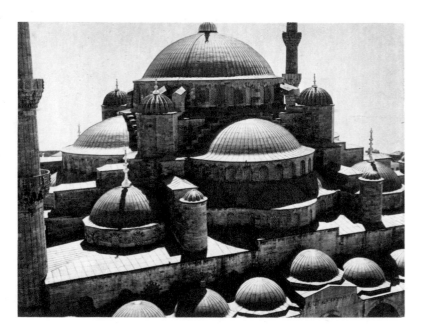

Detail of Mosque of Ahmed I

pendentive solution. It too rests the dome on four arches sprung from four corner piers, creating a square support for a circular edge. But in place of pendentives in the corners, smaller arches called squinches are substituted, forming an octagonal support at eight points. The octagon approximates a circle better than a square, and so, with some adjustments in the masonry, the dome can rest on what is, in effect, a polygonal drum. Squinches have the visual advantage of creating niches in the corners between the main supporting arches, forming semidome shapes which rhythmically repeat the shape of the major dome they support, as is seen in the detail from the dome interior of the mosque at Isfahan. But otherwise they represent an *approximate* solution as compared to the pendentives found in some of the world's great domed buildings: St. Sophia and the Mosque of Ahmet I in Istanbul, St. Peter's in Rome, and St. Paul's in London.

SHELL STRUCTURES

Modern shell structures are the beneficiaries of reinforced concrete and superior mathematical tools for the calculation of stresses and the resistant strength of materials. As a result, the classical masonry dome as a distinct structural type has been virtually supplanted by shell structures which are usually much flatter and wider than their predecessors. Concrete shells are so thin that their dead weight is negligible, and the engineering problem becomes the maintenance of stability and resistance to buckling because of stresses caused by rain, snow, wind, or uneven heating by the sun. Since shells enclose a great deal of space with a minimum of material, they are very economical. Also, the plasticity of ferroconcrete permits the shell to be thickened where its curvature and the concentration

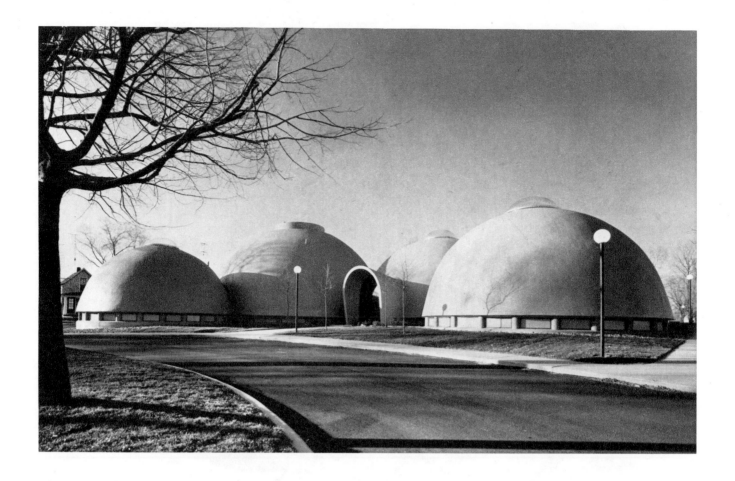

E. H. Brenner. Women's Clinic, Lafayette, Indiana. 1965. A complex of seven interlocking domes built by spraying concrete over a wire mesh framework resting on a structure of curved polystyrene planks. A band of translucent glass admits light, maintains privacy, and creates a floating effect—much as in the ring of windows at the base of St. Sophia's dome.

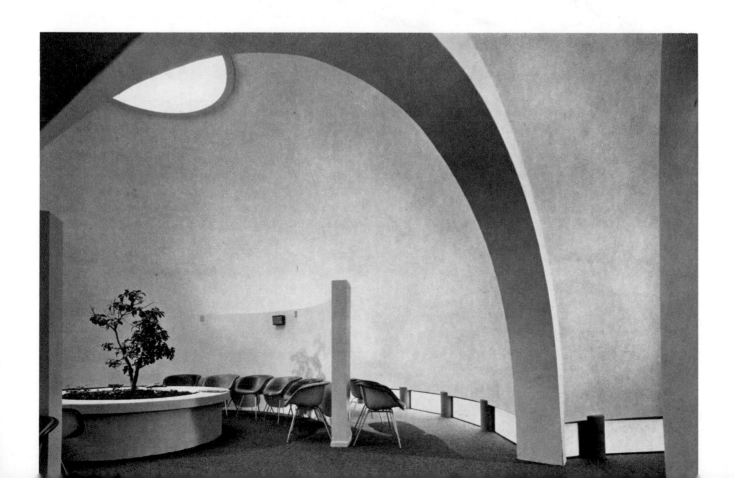

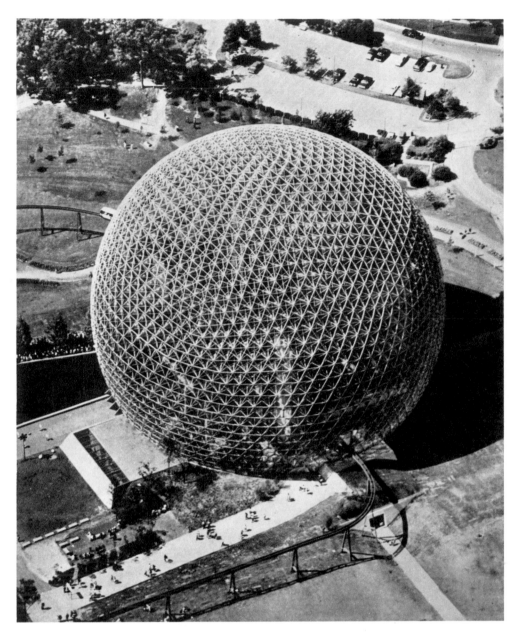

BUCKMINSTER FULLER. American Pavilion, EXPO 67, Montreal. 1967

of stresses require. If necessary, of course, the thin-shell dome can be stiffened by visible internal or external ribs as classic domes were.

Shells can also be made of metals, such as aluminum, steel, or copper. Geodesic domes designed by R. Buckminster Fuller (born 1895) have been made of aluminum, steel, wood, concrete, plastics, and even paper. Plastic and Fiberglas sheets stretched over cable systems or metal-mesh supports may eventually compete with concrete for the construction of shells. These materials create forms similar to those seen in tents, kites, and umbrellas. Shell structures have already been constructed by spraying cement over an inflated rubber balloon, then deflating the balloon after reinforcing members have been embedded and the concrete has set. Sprayed plastics and

impermeable fabrics have design potentials which are now being seriously investigated.

Since fair and exposition architecture is temporary, it is frequently the source of new material applications and structural devices. The Berlin Pavilion at the New York World's Fair of 1964–65 was a type of shell or tent structure made of vinyl-coated canvas stretched into a stressed skin and supported by tension cables and steel masts. The "drum" of the structure consisted of a steel ring resting on steel columns. Buildings of this type are not only visually pleasing, they are also inexpensive. If problems of long-term durability and weather resistance can be overcome, their use will unquestionably spread to permanent buildings. Like the tents of nomads or the geodesic domes of Buckminster Fuller, these structures may cause

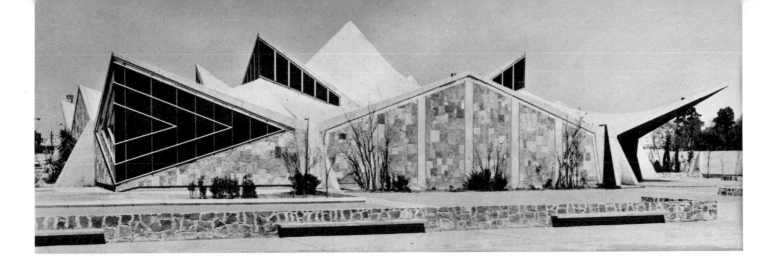

above:
JULIO MICHEL. Sanlazaro Subway Station, Mexico City. 1969

left:
Umbrellas over trade section, Swiss National Exposition, Lausanne. 1964

Architects persistently seek the tent experience—for religious or secular purposes—because of the sense of protection it fosters while one feels bathed in a wonderful overhead light.

below left:
WALLACE K. HARRISON. Interior, First Presbyterian Church, Stamford, Connecticut. 1958

below:
FRANK LLOYD WRIGHT. Interior, Wayfarer's Chapel, Palos Verdes Estates, California. 1951

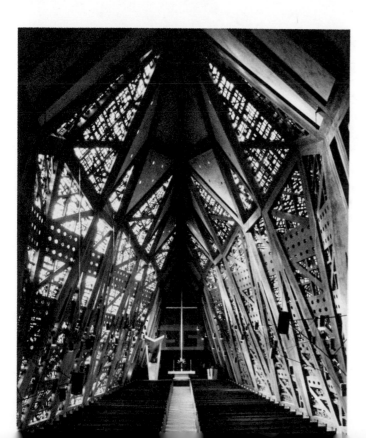

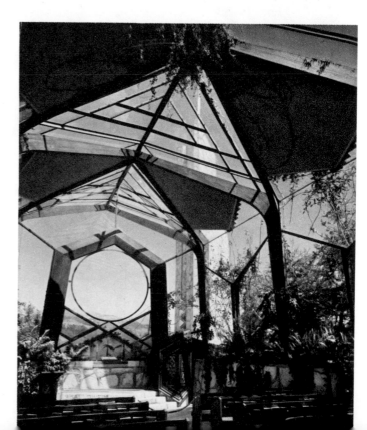

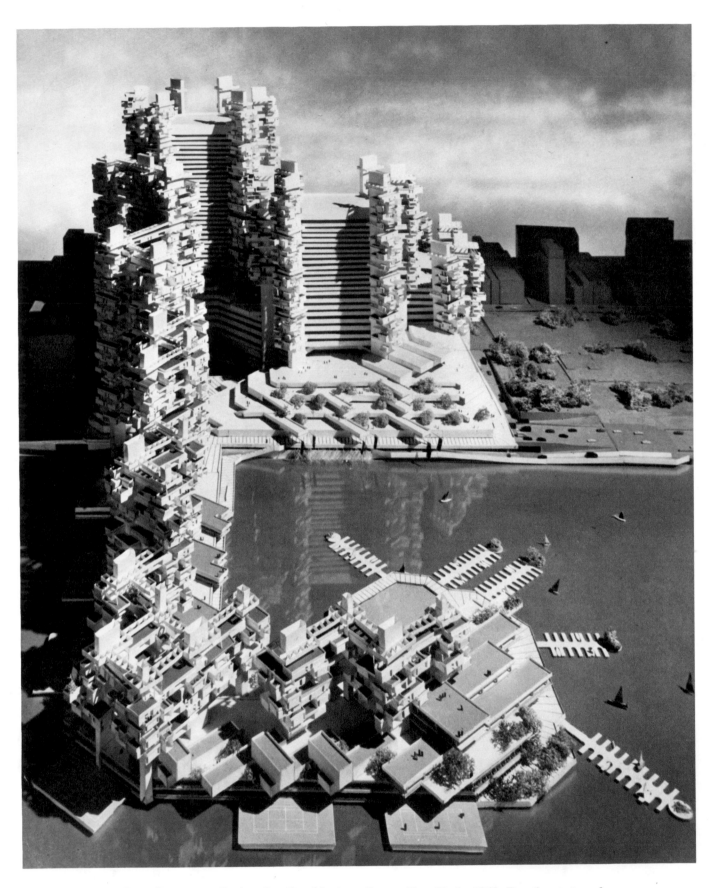

PAUL RUDOLPH. Project for Graphic Arts Center, New York. 1967. For the center of Manhattan—a megastructure visually if not functionally—Paul Rudolph has proposed one immense, articulated building complex which would carry out rationally the unwitting logic of the island's architecture since the skyscraper mania began in the early twentieth century.

a general revision of our attitudes toward temporary and permanent architecture. By radically lowering the costs of construction, new space-enclosing methods may alter total philosophies of design. That is, designers have conceived of roof structures, building shapes, and interior spaces which could not be built because of the economics of traditional construction. In the future, their structural ideas may be thoroughly practical.

The ability to enclose enormous spaces, combined with the steadily increasing wealth and productive efficiency of modern societies, may lead to the design of total communities in single structures—to so-called *megastructures*. Our technical ability to carry out such enterprises has been apparent for some time—perhaps since Le Corbusier planned his Unités d'Habitation as comprehensive structures for most of the essential living requirements of a large communal group. Similar ideas are implied by huge hotels, oceangoing superliners, great shopping and entertainment centers, industrial parks, and resort centers. By locating all of their building units on a single raised platform, for example, designers of academic centers and office building complexes suggest the direction of future plans: comprehensive design of communities through integration of their major solids, voids, and utilities in a single structure to which additional units can be added, clipped on, or removed as necessary.

This idea does not represent a sharp break with the past, nor does it constitute a threat to individualism. Rather it confirms in architectural terms what is already a fact—namely, that communities are multicelled organisms increasingly interrelated by common systems of power, transport, communication, government, recreation, and so on. The structures in communities of the past were always huddled together; their separateness was only nominal, imposed by the inability of materials and design to unite structurally a multitude of building units. Today's communities, particularly cities undergoing urban renewal, are not only single organisms in the social sense, they are also effectively single structures, or megastructures, in the architectural sense. That is why on speaks of the New York or Chicago or Dallas skyline as a single entity. The unity that was formerly imposed by imagination and perception is now becoming a structural fact.

Constructors and Sculptors

Is any pattern discernible in contemporary architecture as a whole? Is there any common idea about building shapes, structural systems, or interior and exterior space which seems to pervade architectural practice now? The answer has to be that no single idea of structure or of space dominates architecture either in the United States or in other major countries. In almost any given place, buildings are being erected which express divergent philosophies of architecture while using similar materials and structural devices. Yet, to the extent that the variety of contemporary architectural expression can be generalized about and categorized, two camps—with individual members varying in their distance from each other—can be described: constructors and sculptors. These labels may be unfair to any given architect. Certainly work by designers within each category is not visually similar. What is common to each camp is an attitude toward form, engineering, architectural emotion, and the purposes of design.

From the preceding discussions, we can see how the structural and technological developments of the past seventy-five years have liberated architecture from decorative, ornamental, and constructional systems which had existed for centuries. A revolution against applied ornament, the classical orders, facades false to their interiors, eclectic mixing of styles, and imitation of materials has been won. The turning point may have come with the great nineteenth-century engineers—Paxton, Roebling, Labrouste, and Eiffel; or it may have been the writing and example of the Americans—Sullivan and Wright; or the central Europeans—Gropius, Mies van der Rohe, and the Bauhaus designers; or the genius of Le Corbusier alone; or the great modern engineers—Perret, Maillart, Nervi, Morandi, Freyssinet, Candela, and Torroja. At any rate, all living designers possess tools and enjoy freedoms inherited from these figures of recent or current activity. A heritage of design freedom has come down to everyone, and it has been used to generate architectural quality through an emphasis on (1) the revelation of structure, or (2) the subordination of structure to sculptural form.

The label "constructor" can be applied to designers who favor the dramatization of engineering devices to create architecture which is exciting and stirring to the imagination. The word "constructor" is also used, mainly in Europe, to designate the person who practices what Americans call structural engineering. In both Europe and America, architecture and structural engineering are independent though cooperating professions. But their separation is historically recent. Although designing major structures has almost always been regarded as an art, the responsibility was not divided between two pro-

REED, TORRES, BEAUCHAMP, MARVEL. Chase Manhattan Bank, San Juan, Puerto Rico. 1969

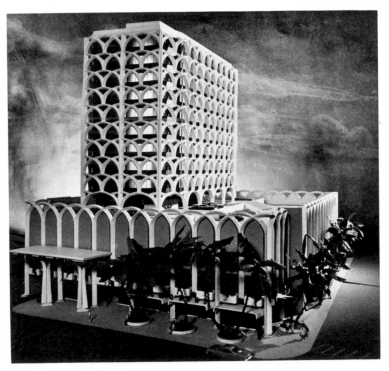

WIMBERLY, WHISENAND, ALLISON & TONG. Model of Waikiki branch, Bank of Hawaii. 1965

Two branch banks, both in warm climates. One expresses the engineer's intelligence and calculation while the other aspires to the picturesque, straining for sculptural significance and symbolic meaning.

fessions—one aesthetic and the other structural—until after the Industrial Revolution. Today, while the professions are formally distinct, each shares many of the competencies of the other. That is why it is accurate to think of some architects as constructors—designers who try to exploit the emotional qualities of engineering. For them, the engineering solution is fundamental; architecture is, as Nervi has called it, "structural truth."

The label "sculptor" characterizes designers who are interested in pictorial and symbolic form as a source of architectural emotion. They must, of course, use engineering devices to build, but these devices are regarded as a means rather than as ends. The sculptural architect is interested in the play of light and texture among forms for the sake of visual excitement; he endeavors to create space-enclosing shapes that symbolize the purpose of a building or the attributes of its users. Such designers believe that, in addition to being utilitarian, architecture should be expressive of ideas and feelings.

Today, many buildings exhibit an elaboration of form which goes beyond the strict requirements of structure and utility, a tendency sometimes apparent in the work of Edward Stone, Paul Rudolph, and Minoru Yamasaki, architects who have received a growing number of important commissions in recent years. Philip Johnson (born 1906), notwithstanding his former association with with the austere constructor Mies van der Rohe, can also be classified with the sculptors. His effects, while restrained, betray a devotion to surfaces and a primary emphasis on the sensuous qualities of materials, often at the expense of the revelation of structure. The arbitrary cross section of the columns and the ornate chandeliers in his New York State Theater at Lincoln Center reflect this designer's growing concern with pictorial imagery in architecture, the achievement of elegance through adjustment of intervals and shape and size relationships addressed to the eye of a detached viewer. The forms do not necessarily grow out of the building's structure or the plain requirements of physical function. Similarly, Johnson's rich orchestration of domes for the museum at Dumbarton Oaks involves the decorative rather than structural employment of a building device. The numerous interior space divisions indicate that the engineering advantage of the dome—enclosure of large-scale interior space without internal supports—does not constitute the reason for its use. Instead, the symbolic function of the dome, its creation of a whole and separate world, its shaping of space around the individual at its center—these properties have been exploited to create a contemplative and mystical atmosphere for the viewer's examination of small, exquisitely presented art objects.

It is easy to see that from the standpoint of the constructors—designers like Gropius, Mies, Neutra, I. M. Pei, Marcel Breuer, and Gordon Bunshaft—the work of the sculptor might represent a turning away from the tenets of modernism. It may seem to be a revival of the

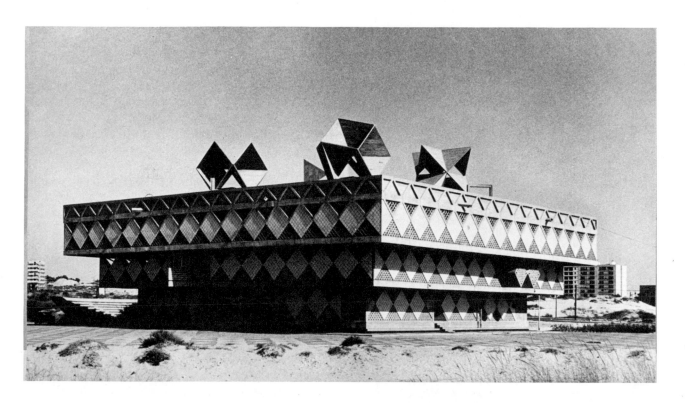

HACKER and SHARON. City Hall, Bat Yam, Israel. 1964. An interesting wedding of art and engineering: the utilitarian structures on the roof—"cubactohedrons"—have been converted into powerful abstract sculpture.

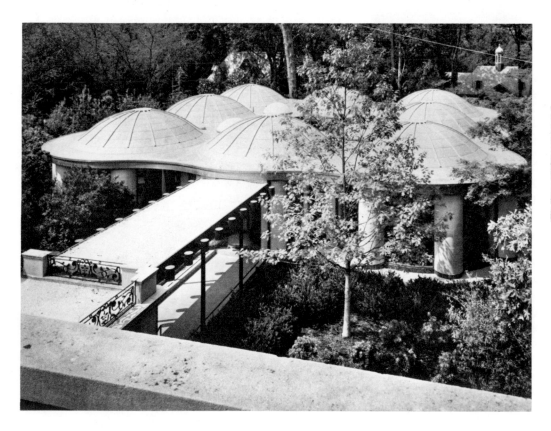

PHILIP JOHNSON. Plan of Museum of Pre-Columbian Art

PHILIP JOHNSON. Museum of Pre-Columbian Art, Dumbarton Oaks, Washington, D.C. 1963

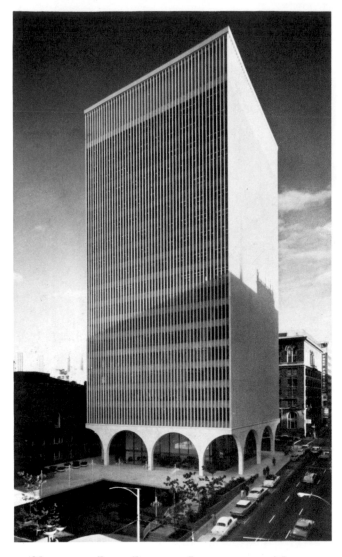

the same human appetites for richly patterned surfaces and stately abstract shapes which were so successfully appeased in the medieval architecture of India and Iran. Compare his Beckman Auditorium at the California Institute of Technology with the colonnade in the Court of the Myrtles of the fourteenth-century Moorish-Spanish palace, the Alhambra. Although the forms are not identical, the designer of the modern building has clearly drawn on the qualities of the older building, employing ferroconcrete to achieve continuous curves and regularity of shape which only a machine technology could fashion.

It is ironic that a Moslem mosque recently built in Malaysia breaks with the medieval tradition of Asian and African mosques. The new National Mosque in Kuala Lumpur, designed by Baharuddin bin Abu Kassim, features a huge prayer hall whose pleated roof of reinforced concrete indicates acceptance of the most modern structural idiom for large interior spans. Rather than revive memories of the Alhambra, a potent influence on Stone and Yamasaki, Abu Kassim has built more in the spirit of the Harrison & Abramovitz assembly hall for the University of Illinois or the market at Royan, France (p. 554). The single minaret may harken back to traditional Islamic architecture, but it also bears a remarkable resemblance to modern airport control towers—for example, the television tower at Stuttgart, Germany, designed by Fritz Leonhardt.

In contrast to the sculptural architects, the constructors take pride in an unsentimental approach to design. Indeed, the term "new brutalism" was used to describe the

NARAMORE, BAIN, BRADY & JOHANSON AND MINORU YAMASAKI & ASSOCIATES. IBM Building, Seattle. 1961. Steel arches at ground level covered with marble.

old architectural traditions, with the exception that modern materials and structural devices have been substituted for classical orders and systems of embellishment. In Yamasaki's work, for example, Gothic arches of metal or pagoda-like roof canopies in ferroconcrete are employed, not only in modern adaptations of still viable ancient devices, but also in the spirit of architectural revival. His buildings appear to be engaged in "borrowing" some of the symbolic meaning of older systems of construction without indulging in the obvious eclecticism of the nineteenth century. Edward Stone, too, uses modern materials and devices to create architectural reminiscences—particularly of the lacy arabesques of Persian and Moorish structures of the late Middle Ages. But while his arcades, forests of columns, and perforated metal or concrete walls may exhibit some of the qualities of the great periods of Islamic building, they also represent a search for living symbols in architecture by a designer who is not too proud to base his style on the past. It might be accurate to say that Stone endeavors to satisfy with modern devices

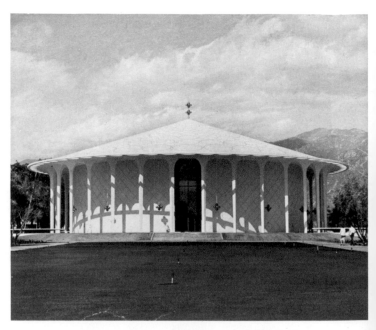

EDWARD DURELL STONE. Beckman Auditorium, California Institute of Technology, Pasadena. 1960

HARRISON & ABRAMOVITZ. Assembly hall, University of Illinois, Urbana. 1963

BAHARUDDIN BIN ABU KASSIM. National Mosque, Kuala Lumpur, Malaysia. 1965

Court of the Myrtles, The Alhambra, Granada, Spain. 1368

FRITZ LEONHARDT. TV tower, Stuttgart, Germany. 1956

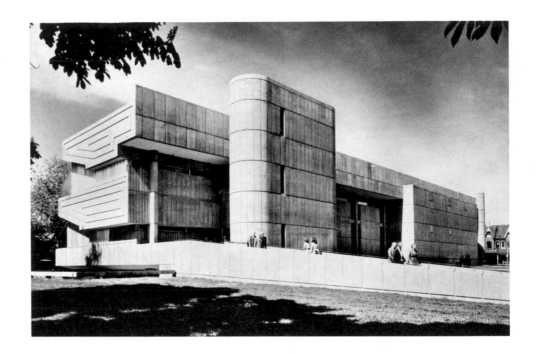

FAIRFIELD AND DUBOIS and
F. C. ETHERINGTON. Central
Technical School, Toronto.
1965

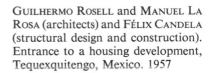

GUILHERMO ROSELL and MANUEL LA
ROSA (architects) and FÉLIX CANDELA
(structural design and construction).
Entrance to a housing development,
Tequexquitengo, Mexico. 1957

MARIO PANI (architect) and FÉLIX
CANDELA (structural design and con-
struction). Band shell, Santa Fé,
Mexico. 1956

EDUARDO TORROJA. Grandstand,
La Zarzuela Racecourse, Madrid.
1935

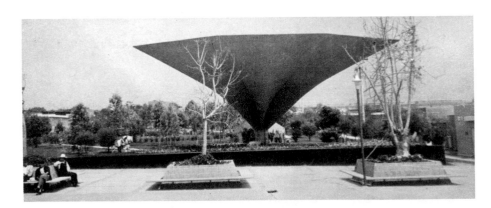

work of a British group of structural architects in the 1950s. An example, by no means harsh, of this philosophy of design is seen in a Canadian art school, the Central Technical School, Toronto, designed by Fairfield and Dubois. The building, framed in ferroconcrete, employs generous glass areas to light its studios, quarry tile floors which are easy to maintain and almost indestructible, concrete block walls, and movable plaster partitions. The rugged strength of the structure is not merely the result of a rough, poured concrete, exterior surface; it grows also out of a highly rational solution to the specific light and space requirements of an art school and the typical operations which must be performed in its studios.

The drama of a pure engineering solution is visible in Eduardo Torroja's Grandstand for the Madrid Hippodrome, where the great cantilevered roof over the grandstand is anchored in, and tied to, the roof of a betting hall under the stands. The stands themselves act as a half arch or flying buttress, serving to resist any lateral movement of the single post from which the huge shell is cantilevered. Another exciting cantilevered form is seen in Félix Candela's band shell for a housing development in Mexico. It, too, lets the engineering speak for itself.

Although Pier Luigi Nervi (born 1891) is one of the great constructors, he has probably used more columns than are structurally necessary in his Palazzo del Lavoro Exhibition Hall in Turin, Italy. The same is true of Wright's Administration Building for the Johnson Company in Racine, Wisconsin (p. 109). Nervi has designed a modern equivalent of Gothic fan vaulting, and Wright's mushroom columns, like all man-made "trees," serve to establish a sense of scale, a structural reference to which man can relate himself and thus "feel" the dimensions of a great interior space. Anthropomorphic suggestions are not necessarily absent from the work of constructors: Morandi's Parco del Valentino Exhibition Hall in Turin and Freyssinet's Pius X Basilica in Lourdes express a

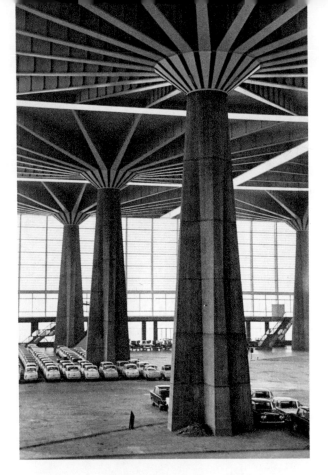

PIER LUIGI NERVI. Palazzo del Lavoro Exhibition Hall, Turin, Italy. 1959

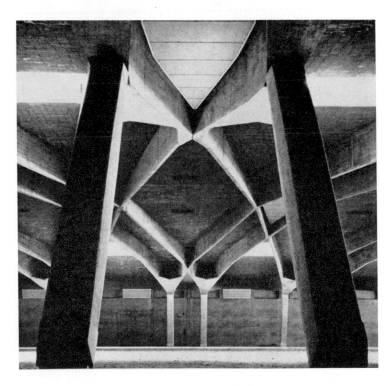

RICARDO MORANDI. Parco del Valentino Exhibition Hall, Turin, Italy. 1958–60

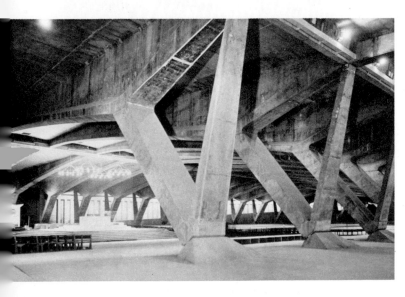

EUGÈNE FREYSSINET. Basilica of Pius X, Lourdes, France. 1958

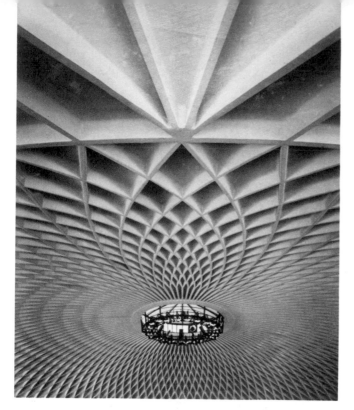

PIER LUIGI NERVI. Little Sports Palace, Rome. 1957

sense of powerful supporting legs, arms, and ribs. It is interesting that both structures are earth-covered and employ prestressed concrete arches and braces. From within, one gains the impression of an enormous cavern or grotto. The inclined pillars and the absence of rectangles or of cubical spaces encourage an underground feeling. In the basilica at Lourdes, of course, such associations serve to enhance the mystical atmosphere of this famous pilgrimage shrine.

Architectural emotion, therefore, arises from several sources: it can result from the careful adjustment of purely visual spaces and intervals, from the magic of geometry; it may rely on immemorial recollections of masonry and, conceivably, from memories of life under ledges, in front of caves, in the tops of trees, underneath woven boughs and bundles of straw, or in small earthern craters—memories carried in the old brain stem and rarely brought to conscious awareness; it may depend on the model of a tent in which a thin membrane barely separates

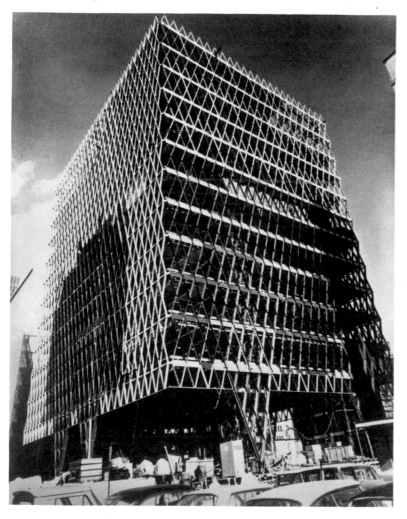

CURTIS & DAVIS. IBM Building, Pittsburgh. 1964. Construction photo

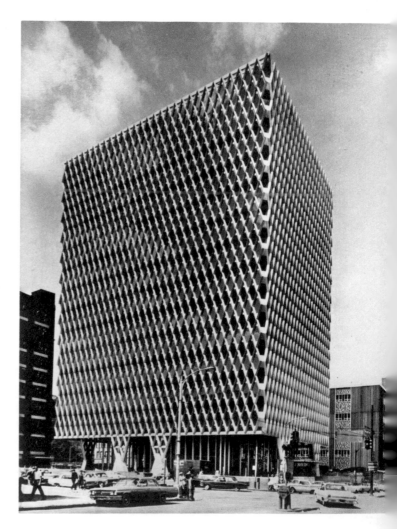

CURTIS & DAVIS. IBM Building, Pittsburgh. 1964. Finished photo. Here truss-wall construction serves as the structural reason for a distinctive, diamond-shaped facade and window treatment.

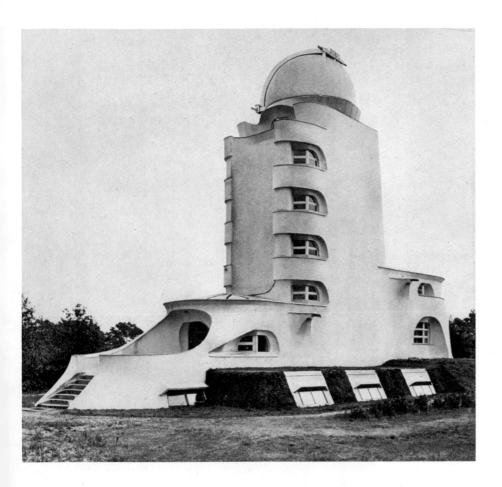

ERIC MENDELSOHN. Einstein Tower, Potsdam, Germany. 1920–21 (destroyed)

ERIC MENDELSOHN. Drawing for Einstein Tower. 1919. Mendelsohn's powerful ink drawing reveals his approach as a sculptural designer—one who initially *feels* a form and then creates a structure to match his emotion.

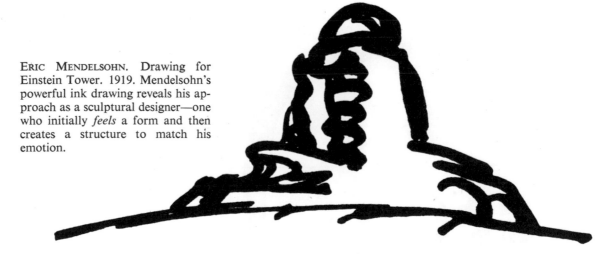

a private world from the vastness of infinite space, a tent whose capacity to control openings, promote circulation, admit light, and move air remains a goal of architecture even yet; it may recall huge stones modeled to resemble human bodily parts, the imagined dwelling places of procreative power and fertility. At different stages of his development man has sought to live in the bowels of the earth or on the summits of mountains. Depending on his luck and his mood, he reverts back to one or another of these widely divergent, dimly remembered locations for shelter. That is why architecture is so various, so perplexing, so personal, so inconsistent. If we interpret the art as the evolution of spatial envelopes from closed to open forms, we are certain to be disappointed by modern caves and grottoes. If we believe engineering defines architecture, visual contradictions abound in painted,

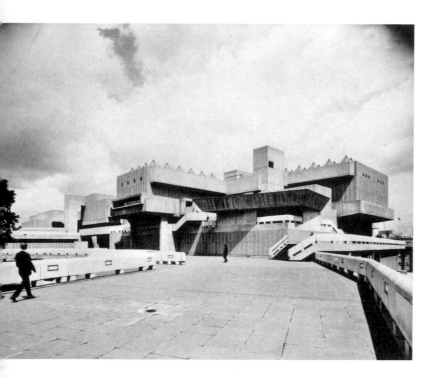

HUBERT BENNETT & ASSOCIATES. Hayward Art Gallery, London. 1968

Reinforced concrete is versatile enough to convey the slender grace of Yamasaki's synagogue or the formidable power of Bennett's art gallery.

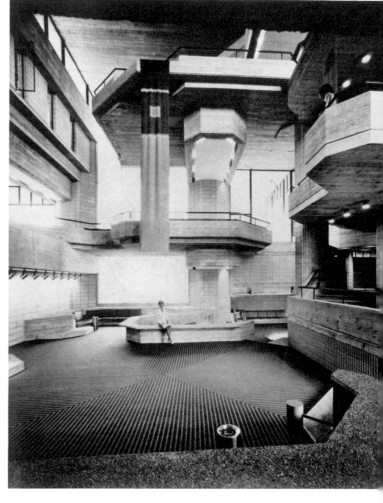

PAUL RUDOLPH. Interior, Southeastern Massachusetts Technological Institute, North Dartmouth. 1966

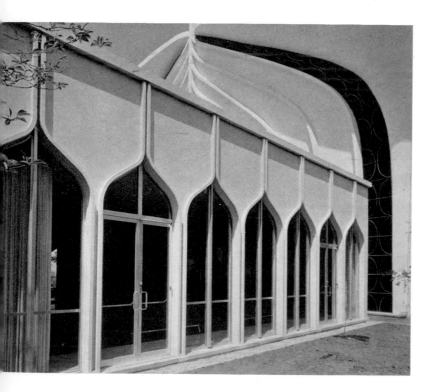

MINORU YAMASAKI & ASSOCIATES. North Shore Congregation Israel Synagogue, Glencoe, Illinois. 1964

colored, and ornamented structures which obviously satisfy a still persisting need for symbols, for glitter, for exhibition of status or technique. The moral and aesthetic superiority which constructors feel toward their sculptural brethren who are less inhibited in the pursuit of "exciting" space, may turn out to be, on close inspection, the perennial conflict between abstraction and empathy, between the geometric and the pictorial. For one camp, architecture is structure, and structure is measure, and measure is geometry, and geometry is reality. For the other, architecture is sculpture, and sculpture is magic, and magic is illusion. And so the architectural conflict is in the end a conflict between views of the world as real or illusory. Although the conflict cannot be settled to everyone's satisfaction, it reveals, at least, that architecture and art deal with matters of ultimate importance. Architecture is both the end product of a philosophy of design and also the concrete source of a philosophy of community—of men sharing common structures and facilities as they pursue their individual destinies.

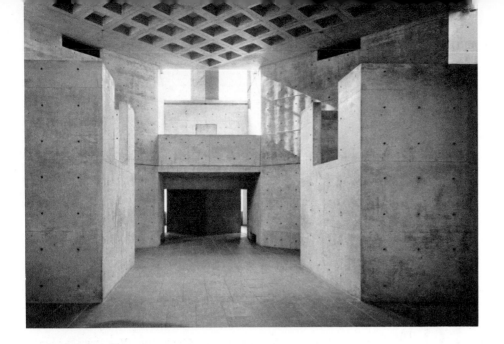

LOUIS I. KAHN. Stair hall in residence hall, Bryn Mawr College, Bryn Mawr, Pennsylvania. 1964–65

Design excellence in a distinguished private institution and in a newly established public institution. Here architecture practiced as an art results in shaped spaces that enhance human dignity.

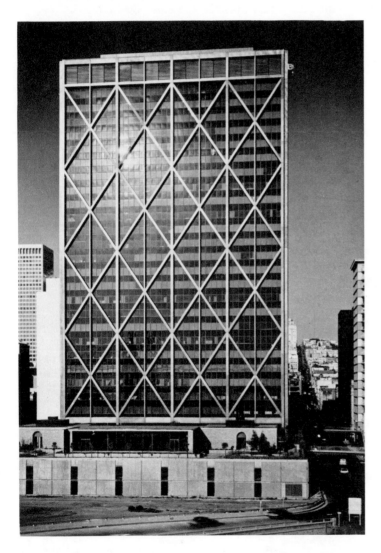

SKIDMORE, OWINGS and MERRILL. Alcoa Building, San Francisco. 1968. The crisscross beams designed to brace the structure against earthquakes convert the facade of this building into a single, huge truss.

LOUIS SULLIVAN. Detail of cast-iron ornament over main entrance to Carson Pirie Scott and Company Department Store. Chicago. 1903–4. Sullivan, the apostle of functionalism and principal founder of the sleek modern skyscraper style, nevertheless possessed a powerful sculptural impulse—expressed in the fantastically intricate cast-iron ornamentation for his clean-lined masterpiece.

IMAGES IN MOTION: FILM AND TELEVISION

Although an elaborate technology stands behind motion pictures and television, it is correct to think of these media, historically and aesthetically, as extensions of painting. The pioneers of still photography operated on the basis of a painterly sensibility, and even today a venerable pictorial tradition supports the work of avant-garde photographers, cinematographers, and film and TV directors. This must be the case, inevitably, so long as cinema and television remain essentially visual media which present themselves in a two-dimensional format. But the creation of a credible illusion of motion, as we shall see, is the revolutionary element that has opened up and utterly transformed the ancient art of painting.

The illusions of reality created by the cinematic media are so convincing that we are rarely aware of their pictorial connections. (In this chapter, the terms "cinematic" and "motion pictures" are used to refer to imagery created either by film projection or cathode ray scanning, that is, television.) We are, perhaps, in the position of Renaissance viewers confronting the remarkable optical

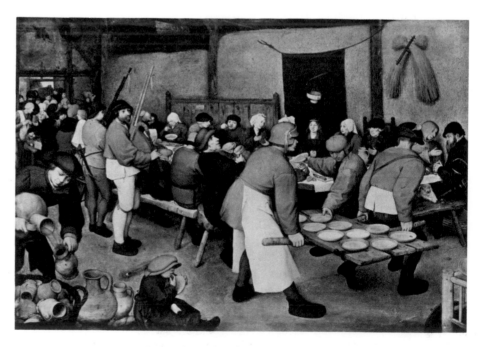

PIETER BRUEGEL THE ELDER. Detail of *Peasant Wedding*. c. 1565. Kunsthistorisches Museum, Vienna

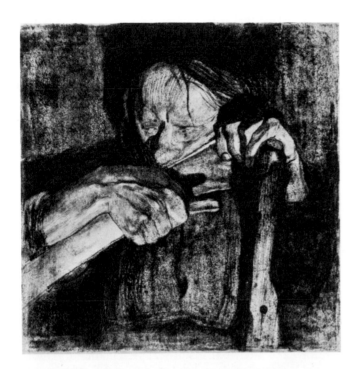

KÄTHE KOLLWITZ. *Peasant War Cycle: Sharpening of the Scythe*. 1905. Museum of Fine Arts, Boston. L. Aaron Lebowick Fund

Film still from *The Cabinet of Dr. Caligari*: Dr. Caligari. Directed by ROBERT WIENE. 1919

Film still from *Greed*: the "wedding feast." Directed by ERICH VON STROHEIM. 1924

In developing his theme of avarice in San Francisco around the turn of the century (the film is based on an 1899 novel), the Austrian Von Stroheim could draw on a well-established European painterly tradition devoted to the gluttony of peasants at the table.

After World War I, a great central European film style emerged based on German Expressionist graphic art which had generated a powerful message by demoniacal lighting of subjects from below and by alloting more area to grotesque shadows than to the people and objects that cast them.

illusions created by the newly discovered science of perspective. The convincing representation of objects in depth constituted a revolutionary liberation of the imagination for artist and viewer alike. A persistent goal of the pictorial tradition has been the achievement of a lifelike illusion so veritable that man could be, like God, a creator of reality in the most fundamental sense. From one viewpoint, painting has been a succession of triumphs in the realm of optical illusionism: each triumph has increased the viewer's credibility, and he has been skillfully encouraged to believe that he is in the presence of still further dimensions of reality. Motion pictures seem to have accomplished the ultimate suspension of the viewer's disbelief. If history is any guide, however, man's present mastery of realism will be reduced, in time, to the not inconsiderable but distinctly human dimensions of his mastery over optical perspective during the fifteenth century.

In trying to understand motion pictures, we must consider two separate but interdependent factors: the continuity of a long pictorial tradition with its drive toward the creation.of veritable reality substitutes; and the social and aesthetic effects generated by new technical devices

for representing visual reality and simulating human perceptual processes: the camera, synchronous sound and imagery, stereophonic sound recording, color film, the iconoscope or videocamera, wide-screen projection, videotape, and so on. Out of these technical inventions grew aesthetic devices like montage, close-up, slow motion, split screen, slow dissolve, and fade-out. It can be argued, of course, that artistic necessity motivated these technical innovations. But in my judgment, the human drive to master reality by simulating its visual appearance or its inner, haptic effects (the inner physical sensations it produces) is the ultimate source of both technical and aesthetic change—in cinema and in the other visual arts as well. Whatever the case, students of filmed and televised imagery are obliged to consider technical and aesthetic factors—in short, media-meaning relationships—if they hope to gain a comprehensive understanding of motion pictures as art.

The Manipulation of Space-Time

Artists have always tried to represent motion visually, but they have had to be content with creating more-or-less crude pictorial and sculptural suggestions of movement. They blurred the edges of forms, introduced "speed" lines, or represented what they imagined were the positions of bodies in motion—as in equestrian statues or paintings and drawings of birds. Of course, the arts of dance and drama enabled men to suggest natural movement through their bodily powers of mimicry and impersonation. But the actor's or the dancer's range of bodily imitation is necessarily limited: it is a transient mode of representation; it has no durable physical existence; and viewers of the performing arts must understand in advance a number of fairly difficult spatial-temporal conventions before a credible illusion—hence, an aesthetically potent experience—can be generated. To be sure, tribal perception manages to overcome many of the barriers that seem to stand in the way of a modern man's acceptance of aesthetic illusion. But that is because tribesmen perceive the dance or drama in a total context of ritual and magical incantation. We moderns, on the other hand, respond primarily to the incantations of science and technology.

Most contemporary men are not very willing to believe that a dancer wearing a reindeer's head and antlers is in fact the animal. But they are willing to believe in the reality of light-and-shadow patterns created by pieces of photographic film passing across a beam of light at the rate of twenty-four pictures or frames per second. Of course, a physiological effect is involved: each picture lingers as an afterimage; it is not instantly extinguished in the viewer's eye; his eye fails to see the empty intervals (lasting 1/48 of a second) between the separate still images. Neither can he see the swift motion of the tiny electronic beam that scans the TV tube to create an image with little points of light. The optical persistence of the still image (or the "running together" of the points of light) combined with our delayed perception of the tiny changes from image to image cause us to believe we are witnessing real movement. Movement, in turn, is one of the most reliable indicators of life—of natural vitality. A chain of physiological and psychological events, therefore, identifies in our minds the viewing of motion pictures with the viewing of reality.

When technology succeeded in representing motion credibly, and after that mode of representation was thoroughly identified with reality, a new artistic exploitation of space and time became possible. The artists of the cinematic media could manipulate time and space because of their control over the machines that create the fundamental illusion and because they had access to a cultural convention that identifies cinematic space-time with real or chronometric space-time. In this respect, the artists of the new media were no different from Renaissance draftsmen who could draw lines converging on a

HAROLD E. EDGERTON. Stroboscopic study of motion: swirls and eddies of a tennis stroke. 1970

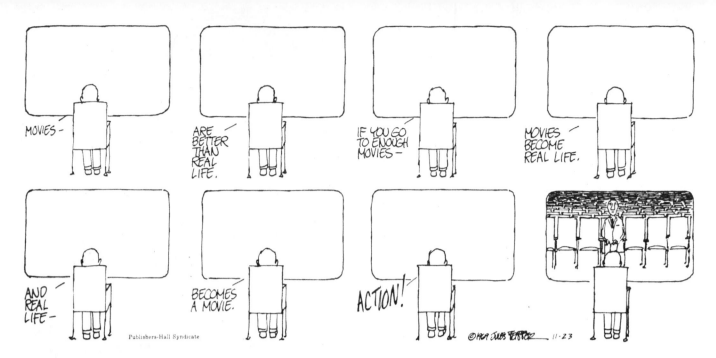

JULES FEIFFER. Cartoon. 1969

MARCEL DUCHAMP. *Nude Descending a Staircase, No. 2.*
1912. Philadelphia Museum of Art. The Louise and
Walter Arensberg Collection

horizon line, and thus convince viewers that they were
seeing deep space. The Renaissance perspectivist could
speed up, slow down, or otherwise punctuate a viewer's
optical journey along a drawn line moving toward or
away from the horizon. Similarly, the cinematographer
can represent the crossing of great distances or the passage
of long periods of time in a few hundred feet of film.
Conversely, he can make a brief event last interminably
or make a short distance very long. Best of all, the viewer
will not question the reality of these illusions.

There is a theoretical possibility that the cinematic
illusion of motion is a crude model of the illusion of con-
tinuity we perceive in real life. That is, the perception of
continuously existing real objects and spaces may be,
from the standpoint of physics, an illusion comparable to
the cinematic illusion, and reality may in fact be a
permanent process of breakdown and reconstitution.
Perhaps we *project* visual continuity on discontinuous
states of matter.[42] If this is so—that is, if the cinematic
illusion constitutes a fairly accurate imitation of the
structure and perception of reality—then we can begin to
understand the extraordinary fascination the medium has,
both for its creators and its viewers. We can make the
statement—not as a metaphor, but as a reasonably objec-
tive truth—that the motion picture media are *time
machines.*

Unlike literature, which exists when it is read or
listened to, the film exists when it is seen. Its reality is thus
intimately connected to the real space-time perception of
its viewers. This condition does not rely simply on the
film director's use of realistic devices; it grows out of the
close correspondence between our perception of physical
reality and our perception of cinematic reality. A similar
physiological principle is at work in both cases. That is
why the cinematographer can effectively represent slow
motion, reverse motion, or speeded-up motion: his time
machine allows him to control pieces of reality contained
or trapped by film. Through editing, which is the funda-
mental creative act of film making, he can play with

segments of film, fully confident that he is playing with segments of the viewer's perception of life. He can make the viewer live in his (the cinematographer's) world. Paradoxically, the technology that creates these fantastic possibilities is relatively primitive compared to other achievements of modern applied science. Still, it is revolutionary so far as human imaginative life is concerned—the wheel, too, was a simple machine.

FILM DEVICES

The artistic devices available to the film maker can be divided into two categories: those that simulate the natural activity of the eye as it fastens upon objects and explores space; and those that simulate our mental activity in experiencing the duration and quality of time.

The basic tool of cinematic space simulation is the *visual continuity sequence*. This consists, very simply, of the long shot, the medium or transitional shot, and the close-up. The camera imitates the eye as it scans a scene, establishing an overall situation for the viewer; selects a subject within the situation by moving closer to it; and concentrates finally on some significant detail of the subject by moving very close to it, greatly enlarging its size on the screen. David W. Griffith is generally credited with the earliest use of the close-up, a cinematic invention he employed sparingly and eloquently—the way a good painter uses highlights or a well-dressed woman uses jewelry. As an aesthetic device, the close-up is tremendously powerful: it can exaggerate enormously the most subtle and transient visual effects; it generates a unique sense of intimacy; and it has contributed very considerably to a distinctive type of screen style—facial acting. Exceedingly limited and transient facial movements acquire exaggerated expressive meanings through the close-up. In addition, the enormous enlargement of persons and objects in the close-up forces the viewer to attend to the tactile qualities of his visual experience. Not only can the film director draw attention to significant dramatic details by focusing on a hand, a foot, or an item of clothing, but he can also generate an intense awareness of the texture of these details. As a result, the viewer perceives the sensuous qualities of images with a vividness perhaps unequalled since his early childhood, when tactile examination of objects prevailed over visual observation. Film close-ups break the normal cultural conventions about the proper distance between a viewer and another person or thing.[43] As conventions of distance are broken down, the visual sense becomes the avenue to the tactile in particular, the sensory in general, and ultimately to synaesthetic awareness—the simultaneous activity of all the senses together with thought and feeling.

The duration of a filmed sequence may be very brief or relatively long; its long shots may be distant or relatively close; its transitions may be smooth or abrupt; its close-ups may be used selectively or with monotonous regu-

Film still from *The Sea*. Directed by PATRONI GRIFFI. 1962

larity. In any case, some type of visual continuity is established, and objects and persons are located in space. However, the continuity sequence is only a primitive unit, albeit a fundamental one, of the motion picture art; it corresponds in literature to the writer's words, phrases, and sentences. They do have a limited meaning by themselves, but they must be assembled, marshaled, and orchestrated in paragraphs and chapters in order to support the range of meaning we encounter in a novel, for example.

This assembling, marshaling, and orchestrating is more nearly an intellectual than a visual activity. One of its chief purposes is to govern the viewer's experience of time. To be sure, it is time felt in, and qualified by, the presence of particular objects, persons, and places. Nevertheless, time thus becomes duration—a palpable artistic element—in the hands of the film editor; it becomes a separable entity. In the film, time is *abstracted* from things and felt increasingly for its own qualities. The other visual art forms—painting, sculpture, and architecture—also endeavor to manipulate time—for example, in a new art genre like kinetic sculpture. But they do not enjoy the technical advantages of the motion picture camera, which converts time into linear feet of film or tape. By cutting and splicing film, the film maker can establish temporal rhythms far more convincing than those created by the muralist, the comic strip artist, or the easel painter. By "convincing" I mean that they are very close to the organic perception of time. The film maker simulates the activity of the mind as it imaginatively orders represented events in relation to its own biologically generated sense of time.

The motion picture camera permits us to be eyewitnesses at scenes of the utmost intimacy and poignancy.

Film still from *The Loves of a Blonde*. Directed by MILŎS FORMAN. 1967. Courtesy CCM Films, Inc.

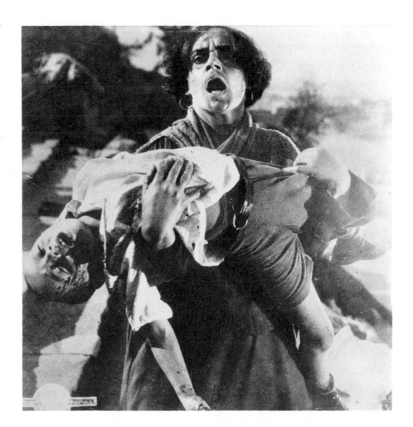

Film still from *Potemkin*: woman holding wounded child. Directed by SERGEI EISENSTEIN. 1926. Courtesy Rosa Madell Film Library. Artkino Pictures, Inc.

PABLO PICASSO. Detail of *Guernica*. 1937. On extended loan to The Museum of Modern Art, New York, from the artist

Eisenstein's films are designed visually. Their emotional and ideological impact rely on more than the accumulation of realistic detail. They are composed like the pictorial masterpieces of Goya´and Picasso.

SOME MOTION PICTURE TERMS, DEVICES, AND TECHNIQUES

Frame	A single picture on a strip of film.
Shot	The fundamental compositional unit in a film sequence; a visual unit consisting of many frames. One element in a film scene, the shot corresponds to a sentence within a paragraph.
Sequence	A single filmic idea corresponding to a paragraph in prose. It consists of one or more shots or scenes, alone or in combination.
Montage	The editing of film through various sorts of cutting and dissolves.
Cut-in	Insertion of a detail, usually a close-up, drawn from the main action of a film sequence.
Cut-away	Insertion of a detail outside of, but related metaphorically to, the main action of a film sequence.
Overlap	Repetition of action from an immediately preceding sequence at the beginning of a new sequence.
Fade-in	The gradual emergence of the film image from darkness.
Fade-out	The gradual disappearance of the film image into darkness.
Dissolve	The fade-out of one image as another, over which it has been superimposed, takes its place.
Wipe	The displacement of a film image by another image or shape taking any direction across the screen as it erases its predecessor.
Dollying	Continuous motion of a platform-mounted camera toward or away from a subject, causing its image to grow larger or smaller on the screen.
Panning	Following the action of a subject with the camera, or moving the camera across relatively stationary objects.
Zooming	Rapid movement toward the subject by dollying or by use of a zoom lens which can achieve the same effect with a stationary camera.

Cinematic Types

Like all new media, films and television began their artistic careers by serving as new ways of presenting established art forms. In a sense, they resembled the automobile whose engine is still in front of the passenger compartment because the horse was in front of the buggy. Consequently, we see in films and television vestiges of older forms of art and communication such as the novel, the stage play, the lecture, the sermon, the newspaper, the magazine, the comic strip, the poem, the short story, the outdoor poster, the circus, the medicine show, and the party joke. This variegated ancestry seems to justify Pauline Kael's irreverent description of the film as "a bastard, cross-fertilized super-art."[44]

These older forms have been translated, more-or-less unchanged, into the new media, where they emerge as documentaries, animated cartoons, commercials, situation comedies, daytime serials, teaching films, travelogues, feature-length dramas, news analyses, celebrity interviews, panel discussions, horror shows, and so on. To the extent that traditional forms have adapted themselves to the special features of the cinematic media, they have acquired a new and distinctive aesthetic identity. This is especially true of the documentary, the film drama, and the feature-length animated cartoon. But insofar as older art forms are reproduced unchanged in the new media, their aesthetic potential is diminished. For example, the movie viewer's awareness of a proscenium arch, stage movement, theatrical diction and voice projection deny him the unique values of the motion picture camera without offering him the special excitement of live actors. Similarly, a televised lecture can be as dull as its live original in a classroom or auditorium. At times it can be improved, if skillful camera work contributes visual qualities to an oral presentation that would otherwise have been undistinguished. In general, however, the reproduction of older forms in new media results only in

the wider dissemination of an aesthetically inferior commodity.

There are, of course, information and entertainment values accessible through film even when it is simply used to transmit the content of another medium. Conceivably, one could enjoy a poem recited over the telephone. But insofar as viewers have been conditioned to expect cinematic qualities in the representation of space, time, and movement, they are disappointed by the visual reproduction of qualities typical of literature, the concert hall, or the lecture platform. The cinema viewer's disappointment (which amounts to aesthetic failure in what he sees) results from an incomplete understanding of motion picture media by its producers and directors: the new media do not consist simply of words and music *added to* filmed imagery; all of these ingredients are utterly changed by film or videotape because they occupy *visually represented* space instead of written space, printed space, or aural space. Consequently, a documentary film, for example, is not identical to, or even similar to, an encyclopedia article. To be sure, modern readers and viewers are continually engaged in performing inter-media operations—making imaginative translations between spoken, written, heard, and filmed imagery. But in so doing, they are no longer dominated by the traditional hierarchies among the media. The authority of print has yielded, inevitably, to the authority of cinematic representation. Motion picture literacy makes the modern viewer increasingly aware of the typical structural qualities as well as the characteristic distortions of the older art and information forms that once held him in thrall. A paradigm of this development is revealed, perhaps, in the folk saying: "Believe all of what you see, half of what you read, and none of what you hear."

Filmed Versus Televised Imagery

Too much can be made of the technical differences between filmed and televised imagery. Both media exploit fundamentally similar aesthetic conventions: the realistic imitation of motion, and the identification of the illusion of motion with reality. There are, of course, clearly visible differences in the quality or resolution of their images, the faithfulness of their color, and the size of their respective types of picture. Moreover, differing social and architectural circumstances attend the viewing of each medium. Still, we may expect most of these differences to be minimized by technical improvements in television, which, in any case, relies heavily on the broadcasting of film. In all likelihood, the media will tend to converge in their types of imagery because they are both responsive to the central drive of all artistic representation—the mastery of reality through imitation or through symbolic transformation.

A fundamental difference between filmed and televised imagery lies in their social effects which, in turn, grow out of differences in their modes of production, distribution, and presentation to the public. These differences account for the distinctive qualities of television. When it is not showing feature films or material recorded on videotape, television has the unique ability to present living events with almost the same immediacy as personal witness. The TV viewer usually knows when he is looking at a "live" telecast, and this knowledge becomes a ponderable factor in his visual and aesthetic experience. Motion picture film, however, must be processed, and hence there is an inevitable time lapse between an event it records and the presentation of that event to the public. The time lapse provides the opportunity to heighten or isolate features and qualities of an event—through editing—so that we may say that cinema today is the more "artistic" of the two media. Television is the more "historical" medium, although, like written history, it possesses the capacity to shape the record of events.

Motion pictures are normally seen by a large audience, although it is possible to attend private screenings. Still, the medium is typically designed for an audience of the

Photograph from a "Dick Cavett Show." From left: Noel Coward, Cavett, Lynn Fontaine, and Alfred Lunt. 1970. Courtesy ABC Television Network, New York. The collective TV interview has become an electronic version of an old, perhaps obsolete social form—conversation. Emphasis is on the glamour, opinions, and wit of famous guests. The popularity of the genre demonstrates the effectiveness of the medium in exploiting more-or-less spontaneous human interactions.

Photograph of the hosts of the TV children's series "Sesame Street." From left: Bob McGrath, Matt Robinson, Will Lee, and Loretta Long. 1970. Courtesy Children's Television Workshop, New York. While it seems obvious that TV has enormous potential as a teaching medium, its educational values have nevertheless remained potential. Only "Sesame Street," the first noncommercial educational series to become a popular and critical success, combines visual excitement, fresh entertainment, and vivid teaching.

Photograph of professional football players in action during a game

sort that attends a play, for example. Hence, films are planned and directed with the expectation of group responses. Television shows are also intended for groups—indeed millions of viewers. But usually a closely related group—the family, or the family and friends—views television shows together. Consequently, television cannot depend on the influence of a large, anonymous audience upon the perceptions of an individual viewer. Unfortunately, television often tries to *simulate* large audience response by superimposing recorded noise and laughter over the videotape of a performance played to no audience but the director and technicians—a banal device—or by televising performances before live audiences recruited to be seen and heard. In the latter case, television tries to approximate the experience of theater, but does so with very inferior results.

These inauthentic uses of television result from a failure to appreciate the distinctive advantages of the medium, which are always based on its close proximity to the reality of history. In other words, television alone is capable of presenting to a vast audience the raw materials of history—events as they occur—before they have been processed by journalists, artists, or historians. Television makes it possible for each viewer to act as his own historian. If we shift context and compare the viewer as his own historian with the individual as his own theologian or interpreter of sacred texts, we can see what immense opportunities and difficulties are created by the medium. The immediate and autonomous processing of historical materials by all the members of a society—no matter what their condition or qualification—sets into motion fundamentally new social and political forces comparable to extending citizenship and the voting franchise to all the citizens of a society. We encounter a social effect that is larger, potentially, than the influence of compulsory education.

The immediate relation of television to history is now best exploited in the reporting of sports events and news in general. Here TV easily demonstrates its superiority over the old filmed newsreel, which always reached its audience after it had learned of events through radio and newspapers. The new element in today's situation is the viewer's awareness of the simultaneity of the occurrence of an event, its representation in the TV medium, and its transmission to his living room. Indeed, the awareness of this simultaneity introduces a new distorting element in the viewer's perception of history: he tends to believe implicitly in the truth of what he sees—by contrast with his reaction to verbal accounts—and may not realize that events can be staged, selected, abbreviated, and isolated from context while appearing photographically accurate to him. In other words, television can employ the aesthetic devices of painting, theater, literary fiction, or film drama without breaking its historico-journalistic spell. We have not yet built adequate defenses against the televised distortion of social reality; consequently, we encounter perils to our political life from the same source

that deepens and extends our historical experience. Only with televised sports events—which are, after all, games—can we suspend historical judgment and surrender ourselves to the purely aesthetic pleasures available through instantaneous, visual participation in real events. And this heightened pleasure accounts for an extraordinary social phenomenon: millions of men isolate themselves from their families every Sunday afternoon during the autumn to watch professional football—an exceedingly impressive demonstration of the power of the medium.

Films and Dreams

The darkened theater; a soft, comfortable seat; controlled temperature and humidity; and thousands of shadowy images moving across the screen—these elements strongly suggest the dream world that each of us occupies while sleeping. It is possible to think of cinema as the deliberate manufacture of dreams. Psychological experiments reveal that individuals deprived of dreams—allowed to sleep but awakened when they begin to dream—move quickly into a psychotic state. Clearly, dreaming is a biological and cultural necessity. In some manner as yet unknown, our human psychobiological equipment is purged, refreshed, and regenerated while we sleep. Sanity is maintained, it would appear, by the curious, illogical flow of images we call dreams. But why do we require man-made dreams during the waking state?

It can be maintained that art, in the form of music, literature, and painting, has always served man as an alternative type of dream-stuff. That is, men have always manufactured visions to supplement the spontaneously generated imagery of their dreams. But it is doubtful that this could be demonstrated scientifically—that dream-deprived individuals could be satisfied with man-made dreams such as pictures and films. Or perhaps such experiments have not been attempted. One need not, however, carry speculation that far. It is sufficient to observe, on the basis of the history of art, daydreaming, and the contemporary evidence of film and television viewing, that people have an obvious and considerable need for a waking fantasy life which bears a remarkable resemblance to their dream lives.

It is the technical resemblance of films to dreams that arouses our interest. One of the earliest uses of motion picture photography was in the study of animal movement. And films have considerable value as tools of scientific investigation. But that is not the use which has guided their most elaborate technical development. Films have moved steadily in the direction of simulating the visual perceptions associated with imaginative life, both in the waking and the sleeping state. Indeed, cinematic images are in many respects superior to the images human beings can construct with their biological equipment. It would seem, therefore, that a civilization such as ours, which has created the most complex and elaborate technology in history, is simultaneously impelled to create fantasy or dream-generating devices together with a

Film still from *The Silence*: boy in room of dying aunt. Directed by Ingmar Bergman, 1962. Courtesy Janus Films, Inc.

> These two Scandinavian masters have used similar devices to express the contrast between the pain of living and the finality of death. We can see that the tensions between silence and speech, past and future, resignation and hope are sustained, fundamentally, by visual relationships of size, shape, direction, light, and space.

EDVARD MUNCH. *The Dead Mother*. 1899–1900. Kunsthalle, Bremen

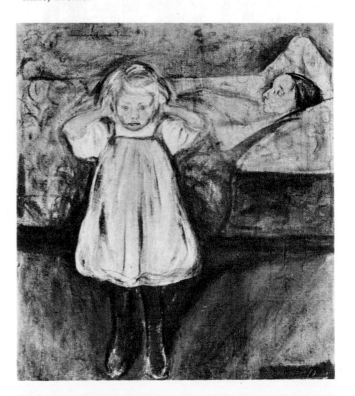

specialized culture to attend the users of its technology. In other words, our need for synthetic, or man-made, dreams grows in direct proportion to the growth of complex machinery and technical systems in our work, play, and interpersonal relations. Paradoxically, the dreams we create organically may have to be supplemented by dream machines in order to maintain some sort of human balance, and hence sanity, in our culture. In this way, perhaps, we can explain the development in the twentieth century of a major new art and its evolution toward a form that constitutes so remarkable a simulation of our dreams.

The Democracy of Film

Both film and television eliminate distinctions based on money and class, because access to them is relatively inexpensive compared to attending live theater, the symphony, opera, or the ballet. But they are democratic in a more fundamental and personal sense in that every seat in a motion picture theater is equal. That is, each viewer sees the same imagery; film actors cannot play to the boxes; seats in the balcony are as good as seats in the orchestra; sound is audible throughout the house. And, despite a certain amount of family scrambling, each tele-

Film still from *The Grapes of Wrath*: the Joad Family. Directed by JOHN FORD. 1940. © Twentieth Century-Fox Film Corp., 1940. Every generation, every group, and every class needs its own image—the mythic or historical account of its founding. For the displaced Southern and Midwestern farmers of the 1930s, that account was provided by John Ford's version of Steinbeck's novel. Using a realistic style based on the documentaries of Pare Lorentz, Ford fashioned the classic epic of migration and resettlement on a continental scale. It occupied the imaginations of many Americans until they died.

vision viewer has a prime location. Cinematic imagery tends to devour the space between the screen and the viewer; every member of the audience feels that the performance is being played for him alone. Futhermore, the moving camera has a compelling power to lead the viewer's eye into the spaces and places represented on the screen, and the physical location of one's theater seat is forgotten as we begin to occupy cinema space. Happily, since cinema space is not real, there is room in it for everyone.

Close-ups eliminate the distance between actors and audience—a distance that is social as well as spatial. This leads, among other things, to the star system and the phenomenon of the movie fan who takes a deep personal interest in the lives of his favorite actors. More important, the film initiates and encourages very active processes of psychological identification; film and television audiences vividly experience life-styles that are not necessarily available to them in reality. They may "enjoy" products and services normally reserved for persons of wealth and privilege, thus acquiring a taste for these products and services that they want to satisfy in their everyday lives. And, as we know, television is the most effective of advertising mediums.

Although the democracy of film leads to commercial exploitation, it also plays other, more constructive roles. The first lies in its obvious educational influence on the lives of ignorant, illiterate, or impoverished people. Cinema gives them access to versions of behavior, history, and social change that only educated persons otherwise enjoy. To be sure, motion picture viewing does not of itself solve the fundamental problems of poverty and ignorance, but it is perhaps the chief contributor to what has been called "the revolution of rising expectations" among the impoverished people of the world. It is unlikely that they would have begun to enter the modern era technically, politically, or psychologically without the aid of the new media for disseminating ideas and information.

A second democratizing consequence of films and television applies mainly to advanced industrial cultures: the capacity of the cinematic media to generate a sense of community and social cohesion. Television, especially, can unite the anonymous and often alienated citizens of

an otherwise depersonalized mass society. As spectators of the same media events—even banal situation comedies—the millions share a common set of imaginative experiences with more vividness and intensity than the eighteenth- and nineteenth-century literary publics that avidly read the novels of Fielding, Goldsmith, and Dickens. It is especially through televised events—whether tragic or triumphal—that the masses have an opportunity to identify with powerful symbols of communal anxiety, hope, or achievement. One thinks of the funerals of presidents and martyrs, the triumphant return of space explorers, or the great festivities staged for real or synthetic heroes—celebrities of the media, athletes, beauty queens, visiting statesmen, and uncommon common men. Without these media events, it would be far more difficult for the individual citizen of a mass society to satisfy his need for identification with a community larger than his family or neighborhood—social units that appear to be increasingly fragmented and temporary. Thus, quite apart from their aesthetic merits as vehicles of high art, the motion picture media perform a vital civic function: they help create a community—perhaps a national community—out of millions of separate, more-or-less isolated viewers.

The Critical Appreciation of Cinema

Despite a vast literature devoted to the film—historical, philosophical, technical, and sociological—very little material instructs viewers in how to *attend* to films for the sake of increased pleasure and understanding. Critics and reviewers write opinions and plot synopses; they offer comparisons, analyses, and interpretations of films; they publish anthologies of their critical writings and discourse learnedly on the theory of film making. Still, this literature does not directly instruct the viewer, who is rarely privileged to know how critics operate or how they arrive at their distinctive insights.

To begin to deal with this problem, I offer a typology,

A TYPOLOGY OF CINEMATIC FORMS

Image (medium)

I VISUAL COMPONENT	Texture:	rough-smooth, hard-soft, wet-dry
	Shape:	round-pointed, organic-geometric
	Size:	large-small, exaggerated-reduced
	Focus:	blurred-distinct, near-distant
	Light:	natural-artificial, strong-weak
	Color:	pale-intense, warm-cool, earth-sky
	Space:	shallow-deep, defined-unlimited
II DRAMATIC COMPONENT	Sound/Music:	emotive-descriptive, faster-slower
	Language/Diction:	spoken-recited, lyrical-literal
	Performance/Representation:	naturalistic-stylized, accurate-distorted
	Montage/Editing:	rythmic-staccato, dominant-subordinate
	Movement/Composition:	continuous-interrupted, parallel-diagonal
	Time:	swift-slow, cinematic-chronological
III LITERARY COMPONENT	Object:	whole-fragment, quality-thing
	Place:	open-closed, now-then, familiar-exotic
	Event:	many-few, probable-unlikely, verbal-visual
	Sequence:	linear-simultaneous, logical-irrational
	Plot:	simple-complex, narrative-poetic
	Symbol:	personal-collective, realistic-abstract, spectacular-didactic

Idea (meaning)

Film still from *Blow-Up*: photographer and model. Directed by MICHELANGELO ANTONIONI. 1966. © Metro-Goldwyn-Mayer, Inc., 1966

The combined man-and-woman forms are skillfully used here to suggest animality—the loss of human dignity in Fellini's image, and a crude parody of physical love in the Antonioni image.

Film still from *La Dolce Vita*: party scene. Directed by FEDERICO FELLINI. 1960

a set of conceptual devices, which I hope will direct the viewer's attention to the principal elements in the cinema experience. Its bias is that of art history and criticism. As a typology, it makes no claim to theoretical originality. Its purpose is to suggest some of the polarities within each element of the film. (The reader will recognize here a similarity to Wölfflin's categories, described in Chapter Ten.)

Deployment of this typology accords with the critical method recommended in Chapter Sixteen. It should assist the viewer in describing and analyzing his film experience before proceeding to interpretation and judgment. Hopefully, the device will enable viewers to overcome their habituation to verbal-chronological modes of attending to cinema—an understandable tendency since all of us have been strongly conditioned in our schooling by literary narrative. Instead, we must learn to attend to all sources of imagery in the cinema—visual, aural, tactile, kinetic, and verbal—while endeavoring to fathom their simultaneous interaction and comprehensive meaning.

The typology mentions nineteen separable elements of cinematic form (no doubt others can be thought of), each of which is followed by some typical polar pairs, as in Wölfflin. The viewer may feel he is being asked to function like a computer if he is to entertain all of these elements and their interactions as he experiences a film work. But aesthetic perception does in fact replicate the operation of an exceedingly complex and efficient computer. Some effort may be involved in learning sequentially the elements of cinematic form listed here and their relevance to aesthetic effect. Once learned, however, they are easily and almost spontaneously utilized, with an

Film still from *La Dolce Vita*: Christ figure suspended from a helicopter. Directed by FEDERICO FELLINI. 1960. In one of the great symbolic images of modern film art, Fellini defines decadence for modern culture: just as cynical promoters exploit popular religious feeling by staging a fake miracle, so does Fellini's art, the film, contribute to the general corruption by encouraging people to believe in its shoddy spectacles. Fellini does not exempt himself, in this quasi-autobiographical film, from the charge of cynicism. Nevertheless, he is not loathe to recount his experiences and temptations in the world of the Beautiful People.

immediate reward in breadth and depth of experience attending the viewer's effort.

For simplicity, the visual, dramatic, and literary components of cinematic form can be epitomized in the perception of the elements: Space, Time, and Symbol. We should consider the perception of symbolic values in cinema as similar to the work of explicating a poem: it is an intermediate process between analysis and interpretation.[45] The viewer is asked to examine a quality of Focus, for example, and relate it to Time or Symbol, if he can. Or he may notice an attribute of Light and relate it to Object or Place. He must try to consider as many of the possible interfaces among these elements as he can, all the while being guided by the design of the film, that is, the internal organization of the entire work, and its influence on the affective and cognitive tendencies of his own personality.

As with the experience of all art, the richest reward in cinema viewing accompanies the ability to attend to the largest number of simultaneously discriminable elements. This implies that aesthetic intensity is a quantitative phenomenon. Although we have hitherto believed that possessing a quantity of *information* about a work of art was the highroad to pleasure and understanding, it is the quantity of *fused perceptions* that accounts for the vividness and intensity of aesthetic experience. To be sure, the capacity to fuse perceptions meaningfully remains a personal art for whose mastery only some general advice can be given. The typology offered here, then, is merely a map indicating where those perceptions can be sought.

PART FIVE

THE PROBLEMS OF
ART CRITICISM

Etching depicting exhibition of painters and sculptors at the Louvre. Bibliothèque Nationale, Paris. Today, as in the seventeenth century, the display and criticism of art is a social phenomenon, conducted with various degrees of knowledge, seriousness, and intellectual probity.

EXPOSITION DES OUVRAGES DE PEINTURE ET DE SCULPTURE PAR M^{rs} DE L'ACADEMIE DANS LA GALERIE DU LOUVRE

INTRODUCTION TO *The Problems of Art Criticism*

ALMOST EVERYONE FANCIES HIMSELF an art critic. At least, most people are willing to deliver critical opinions, no matter how unfamiliar they may be with art or with theories of art criticism. This may be so because a democratic society encourages all its citizens to feel that their views on any subject have equal weight, just as their votes count equally in politics. As a result, a great deal of heat is generated in critical discussions of contemporary art, and this heat is one of the factors which brings contemporary art so forcibly to everyone's attention. Hence, it is regrettable that formal education at all levels fails to devote much time to the development of a systematic foundation for practicing criticism. Even well-educated persons—when they look at art—find themselves delivering the authoritative opinions of others, or offering their own views without really knowing how they arrived at them. To deal with the problem, this section of the book is devoted to critical theory and critical method as applied to contemporary art. No attempt is made to deal comprehensively with the body of material known as aesthetics or philosophy of art. Rather, my goal is to assist in the development of an intelligent *approach* to the business of forming interpretations and making critical judgments about art. Although I do not believe there are eternally valid, permanently correct interpretations and evaluations of particular works, I *do* think there are systematic procedures for making interpretations and evaluations which are fairly durable and defensible. Hence this discussion of art criticism as a practical activity in which one can gain proficiency as one's critical grounds and procedures are subjected to logical scrutiny.

THE THEORY OF ART CRITICISM

The chief goal of art criticism is understanding. We want to find a way of looking at art objects, and thinking about them, which will yield the maximum of knowledge about their meanings and their real or alleged merits. Works of art yield information to the trained viewer, and this information is useful in the forming of critical judgments. But we are not interested in information for its own sake; for the purposes of criticism, we want to know how information about a work is related to its excellence. It is for this reason that archaeological, historical, or literary data based on works of art may be fascinating but not necessarily useful in art criticism. In short, we seek to understand the causes *in* the work of the effect the work has upon us.

Another goal of art criticism, perhaps as important as the first, is, quite frankly, delight or pleasure. To be sure, we derive some pleasure from understanding, from knowing what it is in art that gives rise to our emotions and the sense of gratification we may feel. But the critical process enables us to carry on the search for meaning or pleasure systematically, that is, more carefully and for a more sustained period than would be the case if we had no organized approach to art. The trained viewer is often able to augment and intensify the satisfactions a work is capable of yielding. It may seem obvious, but it bears restating: the value we derive from an aesthetic situation depends on the art object, to be sure, but also on the critic or viewer: who he is, what his experience has been —with life and art—and how well he can bring his experience to bear on the examination of a particular work. The practice of art criticism should yield a certain *quantitative* benefit—the increase of satisfaction derivable from any particular work.

Some persons, artists among them, believe that careful and systematic scrutiny of art kills the satisfactions, desiccates the values, particularly the emotional values, that art can yield. They assume, however, that careful study is aimed only at finding information. And such may be the case with the archaeologist, anthropologist, or historian who sees the art object as evidence for the reconstruction of a remote culture. But the information sought by the art critic is mainly about the sources of his satisfaction or about the bearing of the work on his world and his existence in it. Moreover, as we look, we

discover that we are pleased or displeased. Then, because we are human, hence curious, we want to know what combinations of color and shape or subject matter and execution cause our feelings. Then we may want to know why.

The purposes of art criticism are not entirely hedonistic or centered exclusively on introspection and a search for causes. There is a very real interest in sharing what we have discovered in art. It is very difficult, perhaps impossible, to experience any satisfaction absolutely as an individual without so much as a thought for the reactions of someone else. That is why we talk about art, music, films, and literature. We want to know whether others share our feelings when they have experienced the same work. Or, if they do not, we want to tell them about its worth to us. Negatively, we may want to persuade others that a work is bad, not worth their attention. There is, then, a social motive in art criticism—assuming that, whatever else it may be, *art criticism is talk about art.*

Why do all of us, experienced critics or not, enjoy talking about art? Is it not enough to see a work, to enjoy it or dislike it, to set the experience aside privately, and then move on to the other business of life? It seems that talk about art, or art criticism, is probably one of the ways we share the substance of our inner lives without embarrassment. Consequently, very few of us can resist the impulse to deliver at least our concluding opinions about a work of art, whether or not we can go into the details of the experience itself. Great critics have an unusually rich and varied capacity for aesthetic pleasure, so that when they disclose discoveries they have made about art, they also assist us to enlarge our own capacities for understanding and delight. In this sense, art criticism is very much like teaching; it is the sharing of discoveries about art or, in some cases, about life, where art has its ultimate source.

One of the most commonly accepted purposes of criticism is to make some objective statement of the worth or rank of an art object. Indeed, the purposes mentioned above are often held to be preliminary to the ultimate judgment of "how good" a work is. Here again, we are confronted with a persistent human tendency—the need to say that something is "better than" or "poorer than" or "worth more than" something else. Obviously, part of this need derives from our wish to possess what is valuable, both materialistically and spiritually. This particular motive for making critical judgments is not especially elevated although it is plainly very human. But its pervasiveness may account for the development of art criticism as a serious discipline. Clearly, many persons want to have a sound foundation for their judgments about what is good, better, or best. And, in the case of many works of art, large sums of money are related to those judgments. To some extent, even a scholarly discipline like art history is based on the need to establish firmly that an art object is what someone claims it to be—

that its authorship, place of origin, or date of execution are what a seller asserts before a potential buyer. In the course of answering questions of authorship, provenience, and so on, the historian discovers information which is humanistically valuable, quite apart from the data required to secure a transaction. In connection with modern works of art, there is usually little question about the authenticity of a work. Hence, critical evaluations become more crucial in the establishment of monetary values for contemporary works. (Of late, however, the existence of some exceedingly clever forgers and dealers in faked works by modern masters has come to light. Aside from the criminal aspect of this activity, complex questions of aesthetics and art criticism are raised when an apparently significant work suddenly loses its worth after it is discovered to be the original creation of a forger.) Even when no financial transaction is involved, critical evaluations are important in the determination of prestige among artists and styles in the art world. And, of course, prestige is sought for its own sake as well as for its connection to fame or wealth.

It is apparent, therefore, that the purpose of art criticism which we might consider least important—ranking and valuation—absorbs most of the energy of the contemporary art world and has most influence on the destinies of artists, the aspirations of art students, perhaps on the teaching of art, and on the complex business of exhibiting and selling art.

Collecting art, too, is related to art criticism, since the collector, by his purchase, confirms his own or someone else's critical judgment about a work. In Western societies, many people have the opportunity to collect art since the range of prices is so great, works are so widely available, artists are so productive, and we are, in general, so affluent. And, since money is a very potent symbol in our culture, all the activities leading to or following the purchase of works of art have enormous cultural significance. Clearly, art criticism as carried on in newspapers, magazines, and universities, and by implication in galleries and museums, has the function of influencing what artists create. Thus we encounter an interesting phenomenon: criticism of art—that is, more-or-less informed talk about art—tends to affect the production of what it talks about. This phenomenon should not really surprise us, though, since talk about automobiles or television shows tends to influence what auto manufacturers build as well as the programs networks produce and sponsors support. Therefore, our usual conception of the relation of artist to the public needs to be enlarged. Among the materials an artist works with, there is a large amount of *critical commentary* coming to him from a great variety of sources; he does not confront his muse privately or create in a vacuum. Consequently, one of the indirect functions of art criticism is to create a body of material which ultimately constitutes *a set of standards* against which artists measure their work. Of course, some artists

may deny that critical opinions influence them, much less that critical opinions constitute standards for their work. Nevertheless, many other artists, in their desperate pursuit of recognition, endeavor to discern the critical standards which seem to be most prominent in the places where they wish most to be admired.

If the purposes of criticism begin with the need to understand art and to seek out its satisfactions, they end with the formulation of a body of opinions and reactions which serve as *standards* for the creation of art. As individuals, we may not have set out upon the critical enterprise with the goal of influencing what artists create. But in the course of discovering what art means, searching for what we like, and talking about it, we may have indirectly brought critical standards into being. Such standards shift, of course, and are difficult to formulate with precision at any particular time or place. Nevertheless, a process of social interaction and critical communication seems to be constantly at work, involving popular discussion of the meanings and values of art, together with artistic efforts to discern the direction of this discussion and its implications for the further creation of art.

The Tools of Art Criticism

What kind of equipment must an art critic possess in order to function adequately? What sort of knowledge must he have, or what skills need he have mastered, to be qualified beyond the layman who so freely offers unsupported critical judgments?

Obviously, wide acquaintance with art, especially with the kind of art he proposes to judge, is a fundamental requirement. Usually, this acquaintance is acquired through formal study, particularly of art history. It is most important that knowledge of art be gained by direct experience of original works as well as through reproductions. Many artists who are also critics have acquired their knowledge from intensive examination of works in museums as well as from studio experience. But it is very difficult, if not impossible, to gain an authentic understanding of art from lantern slides or reproductions alone. These devices should serve mainly to *remind* us of qualities we have found in original works.

Wide acquaintance with art implies more than visual recognition of the principal monuments of art history. It also calls for understanding the styles and functions of art, the social and cultural contexts in which artists have worked, the opinions of critics and scholars during the principal periods, and the technical factors governing artistic execution in various media. However, the chief benefit conferred upon a critic by a wide acquaintance with art is breadth, or catholicity, of taste. He should know and appreciate an extended range of artistic creativity as it has been manifested in many places and times. This knowledge would be at least one defense against critical narrowness, the tendency to invoke standards which are derived from scant knowledge of styles or limited experience with technical methods. Art historians, for example, do not usually gain through their training as much technical knowledge as do artists. However, this lack can be in some measure compensated for by extensive examination of works in many styles and by study of works in various stages of execution. If nothing else, such experience enables the prospective critic to gain some understanding of the gap between artistic intent and artistic achievement.

Many critics of contemporary art also have a wide acquaintanceship among artists. This situation is almost inevitable since artists and critics are thrown together by work and common interests. But acquaintance with artists may act as a critical handicap if it leads to biases because of the personalities of the artists whom a critic happens to know. It almost seems preferable for the critic, particularly the journalistic critic, to be acquainted with artistic personalities through biographies and other documents. Thus, he may be assisted in achieving some measure of critical distance or objectivity. However, the interest we all have in persons who are successful creators, or who are prominent in artistic circles, militates against social distance between artists and critics. Consequently, it is most important that the critic have some means of guarding himself from undue bias against, or sympathy for, the work of artists he knows personally. Certainly it would assist critics if they were more familiar with the education of artists—that is, if they spent some time in art schools—for it is useful to see the struggles of the novice if one is to understand the achievement of the professional.

Many artists would hold the judgments of critics in greater esteem if they knew these judgments were based on some experience with artistic execution and technique. Still, is it fair to require that a critic lay an egg before he can comment on an omelet? Of course, a number of practicing critics have had artistic experience, and some are artists themselves. But usually the criticism we read emanates from persons with only avocational artistic experience or with purely literary and theoretical preparation for the task. It would be safe to say that most artists have very little respect for the criticism of persons having only theoretical training, although artists are concerned about the influence of criticism, no matter who writes it.

ARTHUR G. DOVE. *The Critic.* 1925. Terry Dintenfass Gallery, New York. Arthur G. Dove Estate. The artist's mischievous image of the critic—a ridiculous, top-hatted figure who rides around the galleries on roller skates wielding a vacuum cleaner.

On the other hand, critics and scholars readily recognize emotional distortion and partisanship in the critical opinions of artists. Indeed, some feel that artists are almost constitutionally incapable of making critical judgments objectively and dispassionately. The question will doubtless continue to be argued as long as there are artists and critics. For a long time, universities employed only theoreticians to give art instruction. Now there is a growing tendency for educational institutions to employ theoreticians *and* practitioners, or individual instructors who have both kinds of training.

In summary, it would appear that a critic with mainly theoretical and verbal preparation may be ill-equipped to assess properly the elements of technical intention and quality of execution in works of art. Indeed, there is a tendency among critics so trained to denigrate technical facility, to regard it as a fault, as *prima facie* evidence of superficiality. In addition, such critics often do not recognize poor craftsmanship when they see it, or they may construct theoretical grounds for consigning craftsmanship and the well-wrought object to the junk-heap of history. As a consequence, the art world is annually embarrassed when the work of amateurs, neophytes, practical jokers, or animals is given serious attention, and occasionally prizes, in art exhibitions. These stunts, which are probably intended to indict modern art in its entirety, do not have anything to do with the achievement of serious artists. Nevertheless, they *do* constitute a kind of scandal in the practice of art criticism and cannot be casually ignored when regarded as a comment on the quality of criticism so frequently encountered in newspapers and art journals. Conscientious critics are eager to be fair, to be open to the legitimacy of artistic expression no matter how unusual, shocking, or experimental. Hence, it is possible for them to be occasionally deceived by a fraudulent or insincere work, unless they have sufficient technical experience and connoisseurship to *recapitulate imaginatively the technical execution of the work.* In short, the critic, if he is to be more than an essayist on the themes of the works he evaluates, must know in general terms how the work was made. This knowledge is the *sine qua non* for connoisseurship and critical expertise; without it, critical judgments may be interesting but hardly defensible except as literature.

"Critical sensibility" designates, in general, the ability of a viewer to respond to the variety of meanings in an art object. It might also be defined as the capacity for discriminating among one's feelings in the presence of a work of art. We know that people vary in capacity for feeling, in the range of emotions they can experience in connection with events in life. Likewise, individuals vary in their capacity for feeling or understanding in connection with art. A critic, however, must have access to a wide range of aesthetic emotions, else his usefulness is severely limited. Many heated controversies about contemporary art may, indeed, be based on a restricted sensibility or range of aesthetic perception on the part of a critic. An oversimplified example would be the case of a person who regards straight lines, rectilinear composition, simplified planes, and crystalline structures as harsh, cold, impersonal, mechanical, repellent, and so on, but who has a strong preference for curvilinear composition, for convex shapes, for smooth surfaces, for the S-curve which theorists used to consider the "curve of beauty." The reasons for his preferences and antipathies might be traced by a psychologist and quite possibly could be changed clinically. Otherwise, the sensibility of the individual would prevent his dealing adequately as a critic with the work of Feininger, Mondrian, Mies van der Rohe, Albers, Gabo, and many others. Before a critical judgment could be made about the work of any of these men, it would first be necessary to experience the meanings in their work. But a critic who dislikes

planimetric forms would be emotionally prevented from experiencing fully the architecture of Mies or the paintings of Mondrian and many others.

It is important that a critic be able to experience a work in its fullness. Some of us may be debarred from the fullness of experience by emotional "blindspots" or by strongly held preferences, as cited above. Or we may be limited in our emotional range and reluctant to extend that range further. Much of education, particularly in the humanities, should be directed toward enlarging the range of aesthetic responses we are capable of having in the presence of art. Needless to say, the extension of our aesthetic range is also a humanly enriching enterprise, a chief goal of liberal education. That is why emphasis upon critical capacity is as important as the accumulation of information in the study of the fine arts.

Not that a critic has no preferences, or that he sees himself as a *tabula rasa* in carrying out his critical responsibilities. He carries with him, as everyone does, a host of experiences, predilections, biases, and constitutional affinities, as well as gaps in his knowledge and experience. However, the seasoned critic possesses devices, critical techniques, which permit him to act judiciously in the presence of the work of art. Hence, another item of critical equipment might be called judicious temperament. By this I mean, essentially, the ability to withhold judgment until all the evidence is in. Persons untrained in art criticism make judgments too quickly; they state conclusions first and then set about finding reasons why their conclusions are valid. Naturally, the experience of a work of art takes place in an interval of time, and *during* that interval many impressions present themselves to the critic, impressions which in themselves seem to lead toward a particular interpretation or judgment. But the virtue of a judicious temperament is the ability to allow time for the multitude of impressions, associations, sensations, and half-formed judgments to interact, to permit intelligence to operate in the task of sifting, sorting, and organizing. In short, we need time to exercise logic and rationality when our feelings are being skillfully assaulted. The judicious temperament supplies that time. (In Chapter Sixteen, *The Critical Performance*, some specific operations of the critical intelligence will be described in detail.)

It follows from the remarks above about a judicious temperament that art criticism is mainly an empirical enterprise, as opposed to a deductive process. As in a legal proceeding, the process of arriving at a verdict involves the orderly gathering of facts and presentation of evidence and the suspension of judgment until the end. We begin without knowing what the critical judgment will be, and we gradually adduce facts and feelings until a defensible evaluation seems warranted. This is the best way to avoid the pitfalls of excessive subjectivity, of partisanship, of emotional intoxication. In general, forming conclusions on the basis of "first principles" or axioms about art—in other words, proceeding *deductively* from premises which may or may not be applicable to the work in question—results in bad art criticism. It is difficult to avoid deductive critical procedures entirely, and sometimes they are useful, but it is usually best, when confronting a difficult work, to attend to one's experience systematically, relying on the soundness of one's critical technique to lead rationally toward a verdict.

Types of Art Criticism

Although I have referred to a type of person called an art critic, there are in fact several kinds of art critic, differing according to the social or professional role each performs. We are most familiar with the journalistic critic, the person who writes reviews of exhibitions, plays, books, and concerts. There are several varieties within this category, since a newspaper may employ one reporter to "do" art, music, and drama criticism, while an art journal may employ several critics with considerable specialized training. (Perhaps such journalists might better be designated "art writers.") Another kind of criticism occurs in schools, art schools, colleges, universities—wherever art is taught. Such criticism, conducted by teachers and art instructors, might be called pedagogical criticism. In addition, scholars, usually associated with universities, but also with museums, write criticism which is distinctly different from the journalistic or pedagogical varieties. Finally, there is popular criticism conducted by nonprofessionals—by laymen; they are clearly the majority of critics and they vary greatly in the degree of their expertise. The artist, too, is a critic, as has been implied throughout the book. Every decision he makes in the act of execution has a critical dimension. He learns criticism, however, not from the journals but from his teachers and fellow artists.

JOURNALISTIC CRITICISM

The chief characteristic of journalistic criticism is that it is a category of news. It is written for the readers of a newspaper or magazine to inform them of transient events in the art world and also to retain their interest as readers of a particular newspaper or journal. Hence, we speak of the "review," which is a brief summary of an

exhibition and is rarely long enough to constitute a systematic analysis of all or many of the works in a show. Indeed, a style of review writing has emerged which endeavors to create verbal equivalents of the works which a reader might see if he were able to attend the exhibition. Obviously, a form of criticism which endeavors to be news and at the same time to substitute words for visual and aesthetic experience, while also passing critical judgment, labors under an almost impossible burden. The brevity of journalistic criticism obliges the writer virtually to eliminate analysis and to rely instead on critical conclusions and heavily weighted descriptions to create exciting and vivid copy. Unfortunately, this style of critical writing also appears in some longer magazine articles on art, where there is less excuse for offering page after page of opinion and assertion as if these constituted reasoned and responsible critical analysis.

Notwithstanding the obligation of a journalistic critic to satisfy the curiosity of a wide variety of readers, to entertain perhaps, to describe works his readers may not have seen, to avoid writing "over their heads," and despite necessary limitations of space, some excellent critical writing is found in outstanding newspapers and in some of the weekly news magazines. The specialized monthly art journals differ considerably among themselves as they sometimes become engaged in promulgating a "party line" or in castigating the museums and foundations for failing to support their favorite artists. In general, the magazines serve to stoke the fires of critical controversy and, by expressing their biases forcefully, are largely responsible for the atmosphere of vitality and internecine rivalry which surrounds the contemporary artistic scene. In the 1950s, critics like John Canaday, Hilton Kramer, and Frank Getlein, by questioning some of the established and well-fortified views of advocates of action painting such as Harold Rosenberg and Thomas Hess, helped to create a freer market of aesthetic ideas at a time when significant critical dissent was virtually nil.

Because journalistic critics write so much and so often, and under the pressure of deadlines, their output suffers from the perils of much newswriting: inaccuracy, hasty conclusions, the substitution of opinion for analysis, and a tendency to exercise wit at the expense of the unseen artist. But the discriminating reader of such writing learns to discount the biases of a critic in advance, to compensate by reading several writers, and to check for accuracy by viewing the work himself. Without such safeguards, the individual who relies excessively on journalistic criticism finds, after some time, that his knowledge and critical understanding of contemporary art consist chiefly of a body of received opinions about the principal current reputations. Coteries and intrigues abound in the art world, and one's critical judgment can easily become a by-product of the incessant jockeying for position and prestige which necessarily characterizes a realm where talented persons struggle for recognition.

PEDAGOGICAL CRITICISM

Pedagogical criticism is intended to advance the artistic and aesthetic maturity of students. It does not so much seek to render authoritative judgments upon work by students as to enable students eventually to make such judgments themselves. The teacher of art needs to be aware of critical opinion in the professional art world and should be capable of functioning as a critic of mature work; but he is not mainly engaged in holding student work up to contemporary professional standards. For the pedagogical critic, contemporary opinions and standards may represent possibilities for stimulation and discussion, but they should not represent absolute goals for achievement.

A difficult task for the teacher of art, one which involves his critical capacities in the process of instruction, is the sensitive analysis and interpretation of a student's work *to the student.* From this criticism, the student learns how to conduct analysis and interpretation himself and also gains some insight into the direction and character of his achievement. In their early artistic efforts, children require serious responses to their work as much as adolescents and adults do. Since the creation of art has social implications (art is made for someone else to have, use, or admire as well as to satisfy one's self), art instructors need to function as critics *during* the process of execution as well as at its conclusion. Indeed, the decision about when a work is "finished" has immense critical meaning and is often the result of a critical collaboration between an instructor and a student.

Art instruction until the period of the 1930s usually involved the invocation by a teacher of his personal preferences and standards in the evaluation of student work. Students, in turn, sought out teachers whose work they admired and wished to imitate. It rarely occurred to teachers or students that criticism might be based on standards other than those embodied in a teacher's own work. The instruction and criticism which resulted from this assumption might nevertheless be valuable insofar as the teacher was a person whose maturity did not require that he reproduce his style and artistic personality endlessly among his students. Certainly Robert Henri (1865–1929) was an inspiring teacher of this type; his instruction grew out of personal discoveries and convictions about painting and yet did not constitute a constricting influence upon his students. Thomas Hart Benton (born 1889), on the other hand, from the force of his personality or the narrowness of his vision, succeeded in producing a host of "little Bentons." One such little Benton was Jackson Pollock, whose early work was touchingly Bentonesque. Later, Pollock moved on to stylistic affinities with Picasso, Arshile Gorky (1904–1948), and others, before arriving at the style of dripped and thrown paint for which he became famous.

The prevailing philosophy of pedagogical art criticism

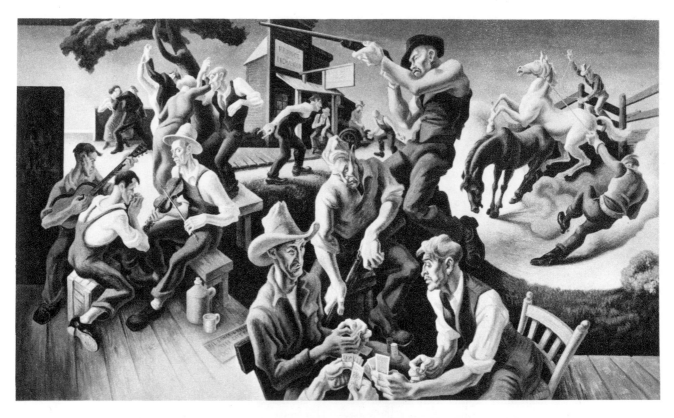

THOMAS HART BENTON. *Arts of the West*. 1932. The New Britain Museum of American Art, New Britain, Connecticut. Harriet Russell Stanley Fund

JACKSON POLLOCK. *Untitled*. c. 1936. Collection Mrs. Lee Krasner Pollock, New York

would seem to call for a certain self-abnegation on the part of the artist-teacher. His function is to assist in the gestation of critical standards *within* the student—standards which are congenial to the *student's* artistic personality as it appears to be emerging. Needless to say, some students, as they go through adolescence, have exceedingly well-developed conceptions of the direction and value of their work; others are painfully lacking in confidence. For the art instructor, both types constitute genuine challenges to his critical and teaching skill.

SCHOLARLY CRITICISM

Academic art criticism is the fully developed product of scholarship, critical sensibility, and judicial temperament. Its function is to provide the thorough analysis, interpretation, and evaluation of recent or traditional art and artistic reputations which ample time, space, and the best available evidence can make possible. Generally, such efforts can only be accomplished with the sponsorship of universities. Scholarly criticism represents the closest approximation to "the judgment of history" about an artist who is still alive, and it constitutes part of the changing judgment of history for an artist who is dead. Presumably, the scholarly critic, settled in the safety and security of academic tenure and undergirded by university traditions of scrupulous research and disinterested truth-seeking, is least vulnerable to special interest. Like a justice of the Supreme Court who holds a life appointment, he can function as well as his critical equipment will permit, without regard for fear or favor.

Unfortunately, as academic criticism directs its attention toward contemporary art, it becomes vulnerable to some of the disabilities which afflict journalism. That is, notwithstanding the advantages and the protected place of the university professor, his sensibility is involved in the current way of seeing and feeling, and he is thus subject to the same enthusiasms and aversions as journeyman critics who have less time for reflection. In addition, the academy now contains living, practicing artists as teachers, and they have an influence on professorial critics who in the past were wont to turn their gaze away from the "chaos" of modernism. Inevitably, as the university confronts contemporary life, it begins to lose its precious detachment and objectivity.

A very useful function of academic critics is their re-examination of artistic reputations which most of us have already categorized and set aside. Each new era has its characteristic way of seeing, and thus an artist who seemed unintelligible in his time may be discovered to have fresh meaning for the present. Museums frequently function in this manner when they resurrect the reputation of a school or style of art which has fallen into disesteem. Such an operation was carried out by the Museum of Modern Art and its then curator of painting and sculpture, Peter Selz, in its 1960 exhibition and scholarly catalog devoted to Art Nouveau. Hitherto regarded as a *fin-de-siècle* art movement of only minor decorative value, Art Nouveau was shown to have had a significant influence on many of the leading painters, sculptors, architects, designers, and craftsmen whose work we regard as modern classics today. However, the demonstration of historical influence was not the only benefit conferred by the exhibition. A skillful installation, combined with a thorough and keenly analytic publication, enabled the public to discover in Art Nouveau a comprehensive artistic philosophy which might conceivably meet contemporary aesthetic needs. That is, the linear approach to imagery in Art Nouveau may have served as a refreshing "new opening" for contemporary painters, wedded closely to massive, loaded-brush attacks on the canvas, and paying little attention to precision of line or design as it was conceived in 1900. In addition, one could see how a total aesthetic approach had permeated all of the visual arts, from magazine illustration to jewelry and industrial design to architecture and sculpture. In its endeavor to extend the beautiful to all aspects of the man-made world —however exotic the results may seem today—Art Nouveau anticipated the ecological and environmental ethic presently emerging.

POPULAR CRITICISM

Throughout this discussion, I have referred by implication to popular art criticism, to the judgments made forthrightly or indirectly by that majority which has no claim to critical expertness. Quite clearly, this majority of our citizens will continue to make critical judgments whether or not they are regarded as qualified to do so. Therefore, the existence of a vast body of popular critical opinion, more or less informed and experienced, has to be considered in its effect on the total art situation. We must seriously entertain Mark Twain's view: "The public is the only critic whose opinion is worth anything at all."

As mentioned earlier, critical opinion constitutes an important influence on what artists create. And this would be true of popular criticism as well as expert criticism. The concept of an avant-garde, of a body of artists working in advance of existing popular taste, assumes, of course, the existence of popular taste as a sort of huge, laggard collection of conventional preferences. But if it were not for this popular majority, there would be no body of conventional preference for the avant-garde to rebel against! The idea of progress in art, of advanced and retarded preferences, is very misleading—a misapplication to aesthetics of the idea of progress in history.[46]

There will always be large numbers of people who judge art intuitively, who regard their possession of normal vision as satisfactory equipment for the conduct of art criticism. The number of such persons is so large, and their critical consensus so consistent through history, that their opinions and intuitive standards inevita-

bly constitute a foundation for at least some of the activity in the visual arts. Their desire for an art which is faithful to the visual facts, an art of verisimilitude, has been discussed in connection with the style of objective accuracy. Of course, the popular success of cinematic imagery serves to satisfy the desire of the popular majority for realism and also creates the opportunity for the older visual arts to depart from realism or naturalism. Nevertheless, we can expect that the contemporary artist of each new era will work in a context mainly determined by the obvious and candid preference of the multitude

for an art which imitates appearances. We may hope, however, that the improvement and extension of aesthetic education will enable many persons to discriminate among types of realism, so that a vulgar or "tricky" naturalism will not be taken seriously. It should not be impossible for most people to learn to see the difference between a mechanical realism in art and a mimetic style which reveals the *character* of things by imitating their appearances or typical modes of being. Popular criticism, in other words, can become discriminating within its own standards of fidelity to the visual facts.

Kinds of Critical Judgment

What are the ultimate grounds on which a critic justifies his evaluations? Assuming that a critic is knowledgeable and disciplined, and that he possesses the appropriate temperament and sensibility, are there any final standards to which he can repair?

It would be enough in most cases if critics possessed the right credentials and practiced a method which was open to reason and discussion. Such equipment would satisfactorily enable them to carry on the work of description, analysis, and interpretation. But evaluation must take place in the light of some idea of what artistic excellence is. Hence, I shall discuss here a few of the principal ideas of artistic excellence which seem to underlie what critics and others say is good.

FORMALISM

Once we have abandoned the notion that artistic excellence consists of the accuracy with which art imitates reality, or of the amount and kind of information a work yields, we can turn to what is called formalist criticism. Such criticism locates excellence in the integrative quality of the formal organization of a work of art. By formal organization we mean the relationships among the primary visual elements of the work, independent of any labels or associations or conventional meanings which these elements may have when encountered in life, in practical affairs. For example, any visual beauty or excellence in a building by Mies depends on the internal relationships visible in the building as an image and as a structure, since the individual parts are neutral: they do not look like anything other than themselves, and we have difficulty forming extrastructural associations with the glass and steel members. On the other hand, it is easy to form associations with shapes and textures in a house designed by Frank Lloyd Wright: his houses deliberately carry the viewer beyond their structural elements to a host of meanings and associations related to the land, rocks, the sky, and nature in general.

For a formalist, successful relationships are designed; they usually result from calculation and planning by the artist rather than from the subjective tendencies of a viewer's perception. Obviously, Cézanne or Mondrian would appeal to the formalist since they minimize accidental effects. There is no uncertainty on our part about the artist's means or method: it is to put together the parts of a work in as interesting and unified a manner as he can without permitting "extraneous," that is, non-artistic, considerations to enter.

Formalist excellence, however, does not require a geometric style or a totally abstract style. In the paintings of Poussin, representational imagery is combined with the simulation of naturalistic space, but the entire composition is organized so that the various masses, contours, directions, and representations of mass and space are related to each other with almost mathematical precision: they balance, or cancel out, like books which have been audited by an accountant.

In viewing a work of art, the formalist critic may encounter value in the meaning of the subject matter or the sensuous appeal of the materials. However, he is willing to confer the judgment of excellence upon the work only insofar as its *form*, its underlying organization, is responsible for his *perception* of meaning or sensuous quality. For example, he would admire the bronze metal skin of Mies van der Rohe's Seagram Building, not because bronze is an inherently beautiful material, but only because Mies gave the bronze members precisely the right dimensions and located them at the best intervals in relation to the quantity of tinted glass, the height of the building, and the total spatial envelope which affects our perception of the whole.

Formalist criticism takes some interest in craftsmanship, since putting things together soundly and working them to the "right" degree of finish necessarily invoke formal criteria of pleasing relationships. However, craftsmanship is ultimately based on durability and the logical use of tools and materials—utilitarian concerns which

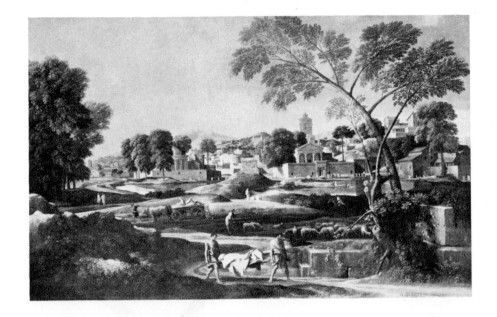

NICOLAS POUSSIN. *Landscape with the Burial of Phocion.* 1648. The Louvre, Paris

First the formalist tries to capture nature within a measured, orderly framework (Poussin); next he tries to recover nature's vitality without losing control of its underlying structure (Cézanne); finally, he uses nature as a source of plastic forms that can fit into his vision of the universe as a perfect machine (Léger).

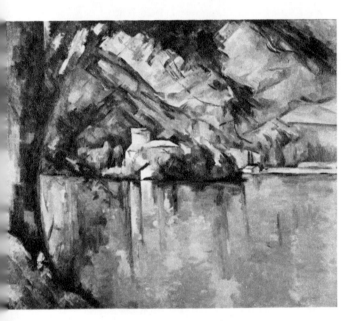

PAUL CÉZANNE. *Lac d'Annecy.* 1896. Courtauld Institute Galleries, London

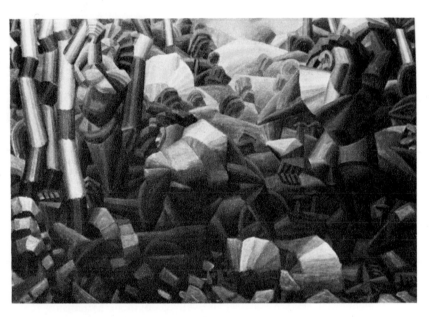

FERNAND LÉGER. *Nudes in the Forest.* 1909–10. Kröller-Müller Museum, Otterlo, The Netherlands

are not a primary focus of formalist criticism. If we try to penetrate to the heart of the formalist critique, we should probably encounter a wish that works of art depend for their effectiveness *solely* on the principle of *unity in variety*, with that unity achieved through the nonsymbolic properties of the materials employed in the work.

Formalism has had a healthy influence on art when it has been negative in its strictures; that is, when it has insisted on the elimination of literary and associative elements as the principal vehicles of meaning. In its positive implications, however, formalism experiences some difficulty in establishing just what its canon of excellence is. That is, how do we know that the formal relationships

in a work are pleasing or significant? The great formalist critics Roger Fry and Clive Bell never succeeded in defining the criteria of formal excellence; they merely associated it with the capacity to generate disinterested, aesthetic emotion.

If the formalist were pressed further, he might say that a formal organization is best or most significant when it *embodies the ideal structural possibilities of the particular visual elements present in the work.* But how do we know whether the organization we are viewing represents the *ideal* possibilities of its particular components? Here, the formalist must fall back upon the quality of perception of the viewer—that is, he must rely upon the viewer's

conviction that his perceptions in the presence of the work are intrinsically satisfying. The late connoisseur and critic Bernard Berenson was relying on formalist ideas of aesthetic value when he employed the term "life-enhancing" to describe the characteristics of great works of art. This term (which is really an elegant way of saying "good") represents a judgment by a viewer that his pleasure in aesthetic perception is based solely on qualities of visual form in the object he is examining.

This criterion of aesthetic value may not be as subjective as it appears. Qualities in the organization of an art object which elicit from the formalist critic the designations of "excellent" or "beautiful" or "life-enhancing" are presumably the qualities a reasonably intelligent, reasonably perceptive person would discover to be pleasing. That is, they approximate an *ideal standard*, or *norm*, which connects with whatever it is in men that seeks or requires the perception of such a standard, or norm.

Now we have come, in effect, to a theory of communication which underlies the formalist idea of aesthetic excellence. The formalist shares with the Platonist the view that there is an ideal or perfect embodiment of all things, and that art, when it is successful, reveals, represents, or *communicates* that ideal embodiment. The formalist and the Platonist might quarrel about whether the ideal embodiment exists *before* or *after* the work of art is created. But they agree that art approximates to a greater or lesser degree an idea or form of perfection; and the normal man, *l'homme moyen sensuel* (the man of moderate feeling), as the French put it, has, because of his biological and psychological makeup, the ability to recognize and to enjoy ideality of form. Thus, excellent form communicates itself to individuals, not only because of learning or personal culture but also because as normal persons they cannot help responding to it.

These views about the foundations of aesthetic excellence are held by artists as well as laymen. Mondrian and Kandinsky, notably, were interested in discovering the combinations of forms which would embody to perfection certain feelings or ideas. It is interesting that Mondrian used mainly a measured, geometric path to formal perfection and that Kandinsky, although devoted to geometry in his late work, is best known for irregular, "expressionistic" colors and shapes. Often, artists invoke formalist criteria as they create, particularly when they are faced with the problem of deciding when a work is finished. There is a strong artistic tendency to "perfect" the forms in a work, long after the theme or subject matter has become plainly visible. The artist continues to adjust and modify formal relationships until *he feels* they can be carried no further. In measuring the finish or perfection of the work against his ideal requirements, he is, in effect, proposing his own ideas of what is normative for the approval of reasonably sensitive and intelligent viewers, thus demonstrating the formalist theory that universal norms and ideal possibilities communicate

PIET MONDRIAN. *Painting I*. 1926. The Museum of Modern Art, New York. Katherine S. Dreier Bequest. An exceedingly subtle work that involves the formalist sensibility. The viewer is obliged to measure and compare the forms. Then he must make some adjustment in his feeling that will correspond to the totality of what he sees.

themselves among men who are attuned to apprehend them. Such men, in turn, are those regarded by their group or society as having all the normal appetites and capacities in proper measure.

Part of the task of art criticism, if one is a formalist, is deciding whether an artist has carried the mutual adjustment of forms precisely to the point where they should be carried or whether he has "spoiled" them in some way. Clearly, the exercise of such judgment calls for knowledge of the formal possibilities open to the artist as well as appreciation of the technical possibilities employed or left unexploited by the artist. Consequently, the formalist critic must be a widely experienced person, yet he must avoid the temptation of all critics to condemn the artist for failing to create the work which he, the critic, would have created. Obviously, the critic cannot evaluate a work of art which does not exist, one which someone *might have* executed; hence, he must hold the work up to the standard of formal perfection *toward which it appears to be striving*. He tries to learn through *internal evidence*, that is, through visual hints and signs *within* the art object, what goal the work is striving to reach.

Many artists and critics are probably formalists without knowing they are. Their criteria of excellence consist of feelings of sympathy with the organization of the art object, feelings ultimately derived from design qualities, and communicated perhaps by pleasing or affirmative signals received from their glandular, nervous, muscular, and skeletal systems. One can only suspect that these sources participate in the formalist awareness of aesthetic

WASSILY KANDINSKY. *Study for Composition 7*. 1913. Collection Felix Klee, Bern. For Kandinsky, painterly forms constitute an independent language: they generate rather than echo experience.

value. Formalism as a theory provides us only with a guide to the values it rejects as aesthetically irrelevant: social, historical, and psychological description; literary and emotional association; and imitation or representation of real objects. Beyond the *form preferences of the normal person*, confirmed by his experience of a distinctively aesthetic emotion, it offers no certain guide to artistic excellence.

Expressivist criticism, as might be surmised from the term, conceives of excellence in terms of the ability of art to communicate ideas and feelings effectively, intensely, and vividly. It is at the opposite pole from formalism in its lack of interest in the niceties of formal organization for its own sake. A good example of art admired by expressivist criticism is seen in the work of children. Children rarely possess the skill or the desire to arrive at perfect organizations of form. For them, the impulse to communicate, to objectify some inner need, is usually stronger than the desire to embellish, modify, or adjust the results so that they are "beautiful" as adults understand beauty. The art of children may often be enjoyed for the delight afforded by its uninhibited color, design, and imagery. Yet the principal reason for its appeal to adults seems to lie in the naivete of the child's *view* of the world. Some expressivist critics believe that children (and primitives) portray a world of ideal possibilities, since they can see through to the "heart" of things without the cultural distortions that plague adult vision. This suggests that we are interested in the ideas and emotions expressed by child art more than we are attracted by the technical and organizational qualities of their work. The expressivist critic, in short, perceives the formal elements and their combinations mainly as vehicles for the communication of ideas or the sharing of specific feelings.

Now, all art, regardless of style, and whether it is successful or not, to some extent communicates ideas or feelings. Consequently, expressivism as a criterion of aesthetic value must provide some way of deciding whether we are in the presence of something *beyond* the

PAUL KLEE. *Shame*. 1933. Paul Klee Foundation, Kunstmuseum, Bern

Drawing by a four-year-old child

What Klee found in child art was a combination of primal innocence and insight. Like the expressivist critic, he prized truth over beauty.

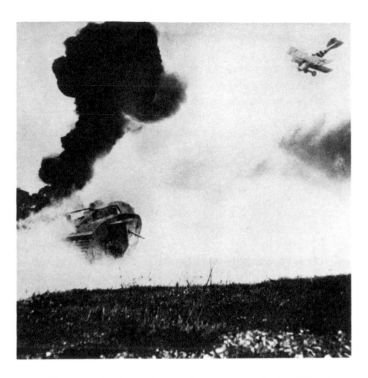

Photograph of an air attack on a tank during World War I

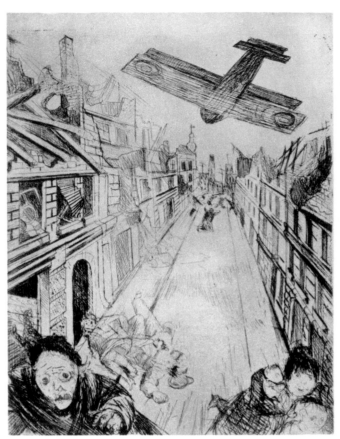

GEORGE GROSZ. *Punishment*. 1934. The Museum of Modern Art, New York. Gift of Mr. and Mrs. Erich Cohn

mere sharing of feelings and ideas. To meet this problem, expressivist criticism offers us the idea of *intensity of experience* in the presence of art. That work is best which stirs us most deeply, which arouses vivid feelings in connection with the material communicated—feelings that are stronger than those we would experience if we encountered the same material in everyday life. Furthermore, the intensity of our experience is partly based on our knowledge that an artist's intention is responsible for the way we feel. For example, if a photographer offers us a mechanical, purely descriptive view of a catastrophe —an earthquake, a sea disaster, or an airplane attack— we may respond with feelings of shock or sympathy; but we do not especially regard the photographer as being responsible for our feelings. However, when an artist (who may be a photographer) deals with the same thematic material, we are aware that he is in some manner governing our intellectual and emotional responses. The expressivist critic, therefore, is interested in art which (1) carries him beyond his customary range of intensity in the apprehension of ideas and the awareness of feelings and (2) achieves this result because it communicates ideas of importance through compelling technique or through the sheer force of conviction and depth of emotion originally experienced by the artist.

It thus appears that the expressivist critic believes art should "have something to say," which implies that the artist should have something to say. This school of criticism, therefore, shares with large numbers of laymen the preference for art as a source of insight about life. It sees the artist as in some sense wise in a way that the officially designated wise men in our society are not. That is, the artist has taken hold of some truths about life, possibly through intuition and, because of his skill, talent, and imagination, has found means of embodying those truths. Consequently, the *originality, contemporary relevance*, and *cognitive validity* of the ideas communicated by art become important criteria for judgment. Although the expressivist critic recognizes the desirability of excellence in technique and formal organization, he regrets that these qualities are often associated with the communication of trivial ideas or that they have themselves become the subject matter of art.

It is not uncommon for expressivist critics to apply the criterion of truthfulness to life in judging art. Certainly, critics of the film, drama, and literature talk about the credibility of characters and situations. This criterion does not necessarily require that art be a photographic imitation, a tape-recorded account, of life. It *does* require that the viewer or audience be sufficiently convinced of

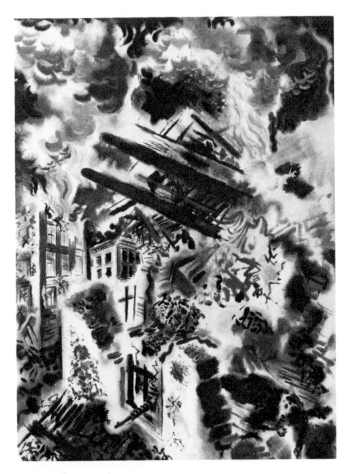

OTTO DIX. *Lens Bombed.* 1924. Philadelphia Museum of Art. Gift of Anonymous Donor

open-minded. A survey among such persons could never actually be taken, particularly since they have lived in all historical eras; hence, it is one of the tasks of art criticism to establish procedural standards in order to function *as if* such a body of persons existed and could be consulted, *as if* one could appeal to their preferences and capacities for knowing and feeling. But because of the indeterminate character of the group of persons to whom art criticism appeals to support ultimate judgments of excellence, art criticism is not a science. It is rather one of the humanities, one of those continuous inquiries about questions men are interested in; only tentative assertions of value can be offered while we wait for the evidence of present taste and historical judgment about art to accumulate.

INSTRUMENTALISM

Instrumentalist theories conceive of art as a tool which helps to advance some moral, religious, political, or psychological purpose. Artistic excellence, according to such theories, is not based on the ability of artists to solve problems inherent in the use of their materials—the solution of problems *internal* to the artistic enterprise. Neither is artistic excellence based on the expressivist criteria of vividness, credibility, and intensity in the communication of ideas or the sharing of feelings. The instrumentalist is concerned with the *consequences* of the ideas and feelings expressed by art. He wishes art to serve an end more important than itself, or, stated in another way, art is excellent when we are not aware of it but rather find our thoughts and emotions involved with the purpose art is supposed to serve.

An ordinary illustration of the instrumentalist idea of art is found in the background music that accompanies a film. Ideally, the music should not be obtrusive, the audience should be unaware of it. The music should support the dramatic action we see, heightening its meaning or possibly anticipating climactic moments, but never calling attention to itself. The relation of art to social, political, or moral ends thus should be the same as the relation of background music to the visual and dramatic action on the cinema screen.

The history of art is rich in illustration of the instrumentalist theory of art. In a sense, the history of art is the history of its service to society's principal institutions and dominant classes: Church, priesthood, nobility, princely court, mercantile dynasty, imperial monarchy, totalitarian despot, and, always, the managerial elite. It has only been in the modern era that art has functioned to some extent as a free-floating activity, unattached and unpatronized by a single dominant class or institution. More recently, modern museums, universities, and foundations have emerged as sponsors of art or of artists; but, for the most part, they have taken great care not to alter the free-floating, unattached character of artistic creativ-

the possibility of what is presented to be willing to suspend disbelief and enter imaginatively into the aesthetic experience. However, although the theory of imitation, or mimesis, has influence on the criticism of drama and the novel through the criterion of credibility, it has less obvious applicability to the visual arts and music, especially during this century. The idea of art as a credible imitation of life survives in the expressivist demand that art be *relevant* to life; works of art need not look like recognizable objects, places, persons, and events, but they must support ideas and emotions which have immediate meaning for the reasonably perceptive person. We come again to the normal individual, *l'homme moyen sensuel,* who serves to establish a standard of emotional and intellectual relevance for the expressivist critic as he established a standard of satisfying structural relationships for the formalist critic.

In relying on that mythical person, the normal individual, for standards of credibility, thematic relevance, or formal coherence in art, we are, in effect, approaching a criterion of universality for the judgment of excellence. Not that everyone must admire a work for it to be deemed excellent, but great works of art must have the capacity to elicit sympathy or acquiescence from the *majority of persons* who are reasonably well informed, sensitive, and

King David, Cathedral of Santiago de
Compostela, Spain. c. 1077–1124

South portal, Abbey of St. Pierre, Moissac,
France. Early 12th century

ity. They have tried not to have their support seem to be
contingent upon any loyalty of the artist to the people
who help him or the institution which feeds him. Cer-
tainly they have not consciously endeavored to influence
the *content* of art. Hence, the instrumentalist theory of
art finds support mainly in the institutional practices of
the past. At present, instrumentalists must accept the
independence of the artist as a working person, his detach-
ment from institutions; but they can argue for the sub-
servience of *art*, the necessity that art advance some ex-
ternal purpose, usually a purpose embodied in an institu-
tion.

One difficulty with the instrumentalist interpretation
of historic art—art, for example, in the service of the
Church—is that today we admire ancient art for reasons
different from those it was created to serve. Romanesque
sculpture, for example, was created to teach Christian
dogma, to communicate the doctrines of the Church to
people who could not read. But we moderns can read;
our religious indoctrination derives from books and a
variety of other media. Nevertheless, we admire Roman-
esque sculpture for the vigor of its forms, its relatedness
to the architectural structures of which it was a part, and
for its symbolic and expressive power. For us, such sculp-
ture is art *about* religion, while for its contemporaries,

Romanesque sculpture was inevitably *part of* the religious
life.

A strong argument in favor of the instrumentalist
theory lies in its implied analysis of artistic creativity.
The instrumentalist has to recognize that art which for-
merly served some purpose outside itself is now prized
for its formal or expressive qualities. These qualities are
present, he believes, because they had to be "built into"
the art object so that it would function adequately in the
service of church, state, or aristocracy. In other words,
the creation of excellent art entails suitable motivation—
the motivation of a cause or institution, or collective
psychological need. The desire to place skill, energy, and
imagination at the service of an idea or institution in
which one strongly and sincerely believes results in the
creation of forms whose aesthetic potential is consider-
able. Another type of motivation which the instrumental-
ist must accept, and which history illustrates, is the incen-
tive of continuous support from a patron, or generous
payment for individually commissioned works. There is
no evidence that such payment had more disastrous artis-
tic consequences than present arrangements or nonar-
rangements for the patronage of art and the support of
artists.

However, is the instrumentalist critic really a formalist

or expressivist critic, differing only in his requirement that art have extra-artistic motivation in order to be excellent? This view would be incorrect, since it converts instrumentalist theories of art into theories of artistic motivation or of pedagogy, when, in fact, instrumentalist critics *derive* artistic motivation from the transcendent purpose of the institution art serves. Instrumentalists are unwilling to accept the view that aesthetic values exist independently, that satisfactions or meanings in artistic forms can be experienced apart from their involvement in some larger, external purpose. The reason, they would argue, that Michelangelo's *Pietà* is a great work is not only that it illustrates a central event in Christianity, but also that its formal organization supports crucially important ideas about death, grief, and maternal love. These ideas are the *purposes* for whose expression the forms were created. We have a psychological need to understand maternal love, and the extremity of the situation represented in the *Pietà* challenges the artist to organize a work whose forms can effectively embody love, grief, and resignation. These ideas, to be sure, support particular moral and religious doctrines while they satisfy universal concerns about creating and sustaining life through motherhood or denying life through practices like war and execution. The meaning of the forms and our judgment of their excel-

lence depends on our perception of the purposes or ends which the forms are intended to support. There is a clarity in the relationship between the visual organization of forms and the purpose of the work, which provides the instrumentalist standard of judgment. Unlike the formalist critic, who must speculate about whether the organization he perceives has realized its ideal possibilities, the instrumentalist critic can more readily discern the purpose of the work. Hence, he can direct his critical energies to the estimation of the artist's success in fulfilling his purpose.

There is a vulgar kind of instrumentalist criticism which requires of art that it illustrate ideas or endeavor to stimulate emotions which have been shown in prior argument to have political or social value. Thus, some Marxist critics require that art illustrate the class struggle, the impoverishment of the masses under capitalism, the heroism of workers, and so on. At more sophisticated levels, Marxist critics tend to evaluate artistic excellence in terms of the ability to present or re-present "correct" versions of the operation of dialectical materialism in history. At its best, Marxist thought can be convincing in its historical explanation of the social relations having to do with the creation and use of art, but it tends to be unsatisfactory in the formulation of criteria of artistic

MICHELANGELO. *Pietà*. 1498–99. St. Peter's, Rome

excellence. Diego Rivera, himself a Communist, was an artist whose work meets with approval by Marxist canons of taste but who is also widely admired by non-Marxist critics. His murals and paintings dealing with the exploitation of the Mexican Indian masses were intended to present a dramatized version of history and at the same time to provide the motivation for revolutionary change. It is likely, however, that the foundation of Rivera's enduring reputation as an artist is established more securely on formalist than instrumentalist grounds. He was a masterful designer, possessing great skill in organizing large, complex surfaces whose cumulative effect is spectacular, dramatically exciting, and visually appropriate to their architectural settings.

The efforts of the Soviet government, and of authoritarian governments in general, to stimulate the creation of art which supports and illustrates the regime's official views have been almost uniformly productive of mediocrity. We should not hastily conclude that such failures are due to the employment of instrumentalist theories of art by government. They are more likely due to the promulgation by such governments of an "official style"—socialist realism—and to bureaucratic rigidity or clumsiness, not to say, ignorance. Citizens and politicians of all persuasions, however, may adhere to critical theories of vulgar instrumentalism: art is excellent when it illustrates the achievement of our officially proclaimed goals; it must never reveal our personal or collective inadequacies; it must conform with official characterizations of hostile or competitive social systems. To this it should be added,

DIEGO RIVERA. *Agrarian Leader Zapata.* 1931. The Museum of Modern Art, New York. Abby Aldrich Rockefeller Fund

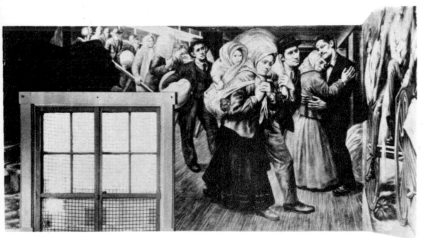 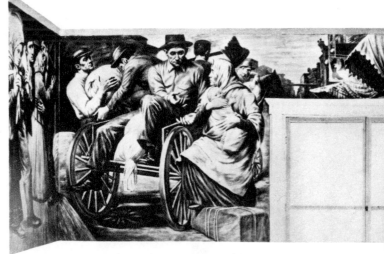

EDWARD LANING. *Newcomers to the New World* (detail of *The Role of the Immigrant in the Industrial Development of America,* mural series at Ellis Island). 1907. Courtesy National Park Service. Like much art of the time, Laning's mural strives to create the visual equivalent of an American saga. Thus it corresponds in purpose to Steinbeck's *The Grapes of Wrath.* But the work fails to establish a working relationship with its architectural space, and its literal account of events cannot compete with the space-time dynamics of cinema—a powerful social force in the thirties.

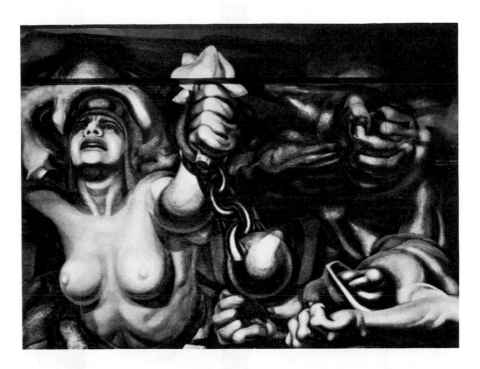

DAVID ALFARO SIQUEIROS. Detail of *New Democracy*. 1945. Whereabouts unknown

Rivera's affinity for Metzinger's almost decorative Cubism reveals the essentially formalistic foundation on which Rivera built his revolutionary art.

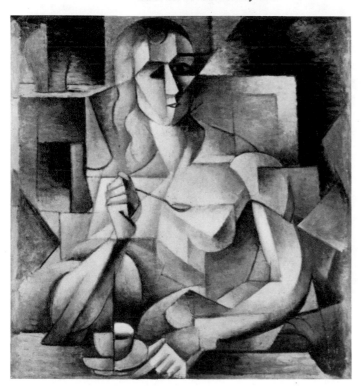

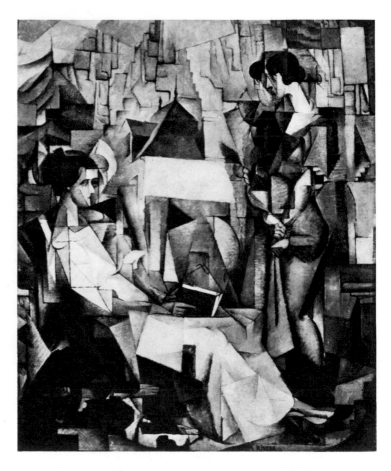

JEAN METZINGER. *Tea Time*. 1911. Philadelphia Museum of Art. The Louise and Walter Arensberg Collection

DIEGO RIVERA. *Two Women*. 1941. The Arkansas Arts Center, Little Rock. Gift of Abby Rockefeller Mause, 1955

GERALD GOOCH. *Hmmm.* 1968. Hansen-Fuller Gallery, San Francisco

HONORÉ DAUMIER. *The Connoisseurs.* c. 1840. Boymans-van Beuningen Museum, Rotterdam

however, that notwithstanding uninformed criticism of art from prominent persons, artists in Western societies usually enjoy substantial creative freedom; and some, even those who are enemies of the "Establishment," are prosperous too.

Notwithstanding the vulgar application of instrumentalist theories—especially in old-fashioned censorship—instrumentalism often provides useful grounds for the criticism of art. It encourages the critic to seek out the social, moral, or psychological purposes which art has historically served and to assess the degree to which these purposes are satisfied in contemporary creativity. It also serves to emphasize the legitimacy of an art which is related to the dominant concerns of life and thus acts as a corrective to the artistic tendency to become excessively involved with narrow, purely technical problems.

PIETER BRUEGEL THE ELDER. *The Painter and the Connoisseur.* c. 1565. The Albertina, Vienna. What could better express the artist's awareness of the critic—looking over his shoulder, eagerly awaiting the birth of a masterpiece.

"*I think you have something to say, all right, but I don't think you're saying it.*"

GEORGE PRICE. "*I think you have something to say, all right, but I don't think you're saying it.*" Carton © 1960 The New Yorker Magazine, Inc.

Conclusion

Philosophers and aestheticians mention many other theoretical grounds for critical judgment in addition to, and in distinction from, those mentioned here. I have tried to indicate just some of the main types of argument used to justify critical assertions of aesthetic value. For the student, it is perhaps useful to know that theoretical and logical justifications exist and must ultimately be relied on to support judgments of value in the realm of art. Some individuals may wish to develop critical justifications which stress the hedonic or pleasurable element in art; they may stress the sensory, biological, and physiological foundations of art; or they may prefer to view aesthetic value chiefly as the communication of personality, of the character of the age, or of man's aspirations for a more just society. In connection with the criticism of architecture, the crafts, and industrially produced objects, it may be found useful to rely on theories which analyze social utility, workmanship, technical efficiency, formal coherence, and the expressiveness of processes of forming and fabrication. The types and purposes of visual art are so varied that no single critical theory is like to be adequate for the evaluation of all works. Indeed, the adequacy of some theories of art criticism results from ruling out certain classes of objects as aesthetically irrelevant, thus confining consideration to the kinds of art where a particular set of critical principles can be applied. The layman who says, "Such and such a work is not art," avoids the task of criticizing work he does not like or understand

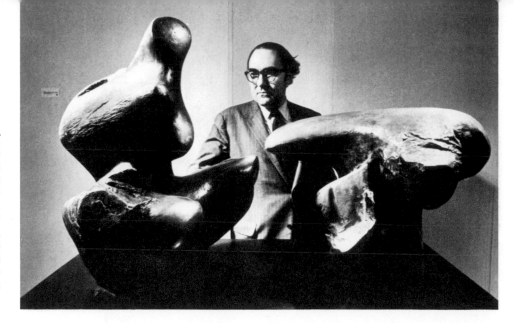

DUANE MICHALS. Photograph of Hilton Kramer, an art critic for the *New York Times*, from advertisement for the *New York Times*. "He has a marvelous eye for art. He is uncorruptible and beholden to no one". The quotation is from an award by a jury of artists at Knox College, Galesburg, Illinois. It affirms what every good critic struggles to achieve —impartiality—even though his calling requires a critic to be, at times, an enthusiast.

An early photograph of a sculpture class in the school of the Art Institute of Chicago

DAVID SEYMOUR. Photograph of the connoisseur Bernard Berenson at the Borghese Gallery in Rome, 1955

simply by refusing to examine it. He probably does this because he knows of no critical theory which will allow him to examine the object in question intelligently. But obviously, if we want to understand art and assess its value, theories of art criticism which deliberately exclude works of art from consideration are not very useful. We would be wise to employ a definition of art which is as comprehensive as possible, which includes potentially everything that man makes. Then, reasonably equipped with a suitable critical apparatus, we can proceed to examine the merits of any work that presents itself for judgment.

THE CRITICAL PERFORMANCE

Having discussed the theory of art criticism—the qualifications of a critic, the purposes of his work, and the kinds of argument he can use to support his judgments—we can turn to a consideration of the critical performance itself. Throughout this book, in the course of discussing works of art, I have functioned informally as a critic. Indeed, any statement about art is likely to contain examples of critical performance, since it is difficult to talk about specific works without carrying out some of the operations of art criticism. Now it would be appropriate to describe in some detail the principal features of the critical performance.

My guiding assumption is that there is a form, a systematic way of behaving like a critic, just as there is a systematic way of behaving like a lawyer. In presenting an argument for his client, a lawyer presumably has some method of offering evidence, of refuting his adversary,

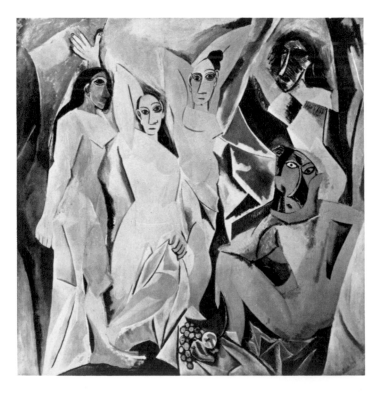

PABLO PICASSO. *Les Demoiselles d'Avignon*. 1907. The Museum of Modern Art, New York. Lillie P. Bliss Bequest

of citing appropriate precedents, of appealing to his hearers, and so on. Art criticism may not have the form of legal debate, but it *does* have a form. If we wish to be effective as critics, we must become conscious, *critically* conscious, of the form or process or system (if any) we use in making critical statements.

I have divided the *performance* of art criticism into four stages: Description, Formal Analysis, Interpretation, and Evaluation or Judgment. It would be possible to break down these categories further, and it is also likely that they overlap. Nevertheless, they consist of fundamentally *different* operations that a critic must perform, and their *sequence* proceeds from the easiest operation to the most difficult. Since art criticism is more empirical than deductive, the stages go from the specific to the general. That is, we focus on particular visual facts before drawing conclusions about their meaning and their corporate value.

Description

Description is a process of taking inventory, of noting what is immediately presented to the viewer. We are interested at this stage in avoiding, as far as possible, the drawing of inferences. We wish to arrive at a simple account of "what is there," the kind of account with which any reasonably observant person would agree. A legal analogy is pertinent: a witness in a courtroom is usually cautioned by the judge not to draw conclusions, *no matter how he feels* about the case. He must reply to questions as factually as possible; it is for others—the judge or jury—to interpret what he has said and to deliver a verdict. Likewise in critical description, interpretation must be deferred. The language of the critic should be as "un-loaded" as possible. That is, it should not contain hints about the value of what is described.

The reason for deferring inferences and value judgments about what is described is to make certain that the description, or inventory, is complete. "Inventory" is an appropriate term here: it comes from the Latin *invenire*, meaning "to find; to come upon," and it is the critic's function *to find* what is objectively present in a work. If the critic became involved in assertions of value at this stage, he might also, quite possibly, try to justify his evaluations. This effort would tend to prevent the critic from completing his description, that is, from finding everything which is "there" to be discovered. We can assume that an art object, which may have engaged the skill, imagination, and judgment of an artist over a long period of time, contains a number of things which are not quickly and superficially visible. Indeed, it is common for people to claim that they continually make new discoveries in works they have owned for a long time. Another reason for deferred judgment is that we do not wish the final critical statement to be based on a nonreflective perception of the work.

You might say that there is no such thing as observation without value judgment, that we see everything in terms of its value or meaning to ourselves. However, I am trying to describe a *system* of criticism, which implies a *discipline* of seeing, interpreting, and judging. The natural mode of perception, which inevitably involves valuing, has to be resisted in an enterprise which claims to be disciplined and systematic. Consequently, although our perceptions appear to lead toward certain interpretations and evaluations, we defer or postpone them—they will not be forgotten—while we complete our inventory. Furthermore, a good critic does not wish to be embarrassed subsequently by the necessity of changing a premature interpretation, one that was made before all the evidence was collected.

What are the kinds of things in a work of art which we are interested in describing? First of all, we should mention what is most obvious. If we are dealing with a naturalistic work, we note the *names* of the things we see. In description we use words at a level of generalization which will minimize disagreement. For example, we might say of Picasso's *Les Demoiselles d'Avignon* that it contains the figures of five young women. But, notwithstanding the title, it may not be immediately apparent that one of the figures is a woman. We should say, then, that the painting contains five *figures*, four of whom appear to be women. It would be better for the critic to *prove* that the fifth figure is a woman. Quite possibly, the uncertainty about the identity of the figures may in itself be useful in subsequently forming an interpretation. In noting the things that cannot be a source of disagreement, we should mention the title. As with a poem or a play, I feel that the title of a painting or sculpture should be considered a part of the work. Certainly there is ample precedent for the use of letters and words as integral elements of pictures. We may regard the words in a title as having a nonvisual but nevertheless ponderable influence on the total experience of a work of art. We know that the title may be misleading, but there are safeguards against being misled by titles.

As works increase in degree of abstraction from nature, it becomes difficult to name objects, trees, persons, and so on. In other words, the subject matter we are accustomed to recognize easily in traditional works disappears or shifts to something else. We are obliged to describe

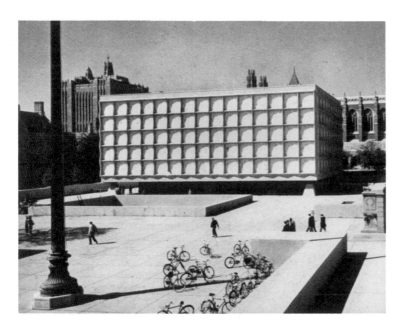

SKIDMORE, OWINGS and MERRILL. Beinecke Rare Book and Manuscript Library, Yale University, New Haven, Connecticut. 1963

Scully's reference to De Chirico is a *tour de force* of the critical imagination. Not only does he diagnose the technical difficulty in the building, but he also identifies the symbolic source of its aesthetic failure.

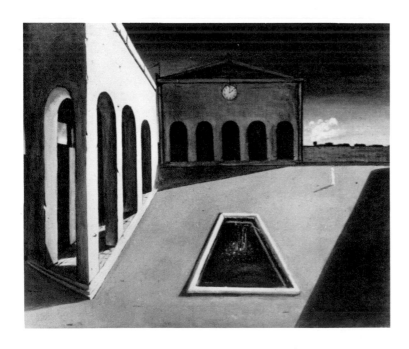

GIORGIO DE CHIRICO. *Delights of the Poet.* c. 1913. Collection Helen and Leonard Yaseen, New York

the principal conformations, colors, and directions which meet our inspection. In noting such matters, we should try to give information without offering propositions about their meaning. A shape is ovoid or rectangular; the edge of a contour is sharp or indistinct. But we should not say a shape is beautiful or grotesque, a color harmonious or harsh. Beyond describing forms, the trained critic should also point out the compositional features of a work, and these, too, can be described without making value judgments. That is, the critic can readily recognize repetitions of shapes and colors; he can identify the axes or directions which forms seem to take. He can direct the attention of viewers to spatial characteristics which the viewer would not have found for himself.

One of the more difficult, but necessary, tasks in description is to call attention to characteristics of execution, since these affect the ultimate interpretation. In examining sculpture, we should not only mention the obvious fact that a bronze has been cast from a clay model, but also observe how the clay has been built up—compare it, for instance, with the surface of a bronze sculpture by Rodin, Epstein, or Maillol. The application of paint, too, is significant and should be described. The critic with technical knowledge can discern whether the paint has been thinned or not, how it has been brushed out, how it has been mixed, whether it contains additives, and whether the surface is built up of transparent layers or applied in one coat, *alla prima*. In architecture, technical features, such as the use of cast-concrete or steel-frame construction, should be considered. In handcraft as well as manufactured objects, final critical judgments should be informed by a description of the process of fabricating: is a container turned, built up by hammering, stamped out, or cast? Are the distinctive marks of the tools or forming process visible or concealed? The answers to these questions inevitably affect our perception of the object, our understanding of how it would be handled, how its form emerged, what purpose it serves best.

It would appear, therefore, that critical description involves (1) making an inventory of the names of the things we see in an art object and (2) performing a technical analysis or description of the way the work seems to have been made. It is an operation intended to permit the viewer to "take in" the whole work while deferring the tasks of interpretation and appraisal. In this respect, critical description has some of the character of a "delaying action," a postponement, in the interest of greater critical acuity later on, of our impulse to draw conclusions. We realize that asserting a patch of color is sky or land or clothing or skin is itself a process of drawing inferences from sensory data. Therefore, we invoke our rule that in critical description a level of generalization must be used which is sufficiently broad to minimize disagreement among reasonable observers. With abstract or nonobjective works, description becomes more gen-

eralized and we tend to make greater use of technical analysis. For discussion of technique, viewers are more dependent on the authority of the critic. In architectural criticism, for example, we may have to rely on a critic who knows building construction to the extent that he can distinguish between a curtain wall and a load-bearing wall. Such a distinction is not, of course, a matter of subjective judgment. The question whether a wall is load-bearing or not can be empirically verified. An *aesthetic* question may subsequently arise about whether a curtain wall appears or "feels like" a load-bearing wall. Here, too, objective visual evidence can be discovered to take into account our feelings about the wall.

A good example of such criticism at work is in the following comment by Professor Vincent Scully: "Moreover, the Beinecke Library wall is actually a Vierendeel truss; it thus need be supported only at the four corners of the building. But the truss does not look structural to the eye, which therefore sees the building as small, since the span looks to be a little one. Yet the building is huge and therefore disorienting to the viewer."[47] Here the critic complains that the engineering qualities of a great span—qualities that he knows are there, potentially—have been visually violated. Note that Mr. Scully implies a criterion of architectural excellence in his distinction between the way in which the building *is* constructed and the way in which it *appears* to be constructed. There should be a *correspondence*, he implies, and since there is none, the building "is disorienting to the viewer." Thus we see, in a brief excerpt, how technical analysis leads to an aesthetic percept, "disorientation," which this critic holds up to his standard of visual and structural correspondence, and which then culminates in his critical judgment: "It all ends, I think, by creating an atmosphere of no place, nowhere, nobody, matched only by some of De Chirico's images of human estrangement and by a few similarly motivated Italian buildings of the Thirties and early Forties."

Although it is not pertinent to our discussion of critical description, it is interesting to observe the form in which Professor Scully offers his critical estimate. We know his judgment is negative, that he feels the building is unsuccessful, and that he has given what are for him adequate technical reasons for his view. However, he also endeavors to *persuade* us to this view by sharing his subjective impressions of the building, by citing an analogy to the forlorn imagery of Giorgio de Chirico (born 1888), and by making a comparison with the generally condemned architecture of the Fascist era in Italy. The judgment, in short, begins as a conclusion and concludes as an attack.

In ordinary journalistic criticism, subjective impressions and unflattering comparisons frequently constitute the whole of the critique. Hence, while such criticism may be exciting or entertaining to read, we are never very certain whether it is responsible—that is, based on objective description and analysis and on assumptions about aesthetic value which can be examined. In Professor Scully's short critique, however, his aesthetic assumption is apparent, and he possesses the knowledge to give us a technical description of what is, for him, the crucial failure of the building. Whether or not we agree with his conclusions, this critic has *earned* the right to make them.

Formal Analysis

In formal analysis, we endeavor to go "behind" the descriptive inventory to discover how the things we have named are constituted. We may have identified five female figures in *Les Demoiselles*, but now we want to know how they have been organized as shapes, as areas of color, as forms with particular contours, textures, and locations in space. Formal analysis is also a type of description, but not the type which requires that we name things or tell about the technical features of a work. Instead, we describe the relations among qualities of line, shape, color, and illumination which are responsible for the existence of the things and subjects included in our descriptive inventory. (For color, see p. 649.)

In *Les Demoiselles*, we note that some of the figures appear to be made of angular, flat planes of color, whereas the two central figures are more curvilinear, have gentler transitions of flesh-toned color, and seem less distorted from a naturalistic standpoint. One of the central figures also has white lines for the delineation of shapes. Strangely, the outer figures have heads which are in marked contrast to their bodies. The central figures, while more naturalistic and frontally posed, present the nose in profile; and one figure seems precariously based, like a statue which might fall from its pedestal. Her torso is erect, but the position of her feet could not possibly permit the weight to be supported.

My notion that the figure seems to be falling illustrates one of the sources of inferences about form: the erectness of man's posture and the influence of gravity. No matter what style of art we examine, certain physical and biological assumptions about man are shared by artist *and* viewer. We cannot view a tilted representation of the

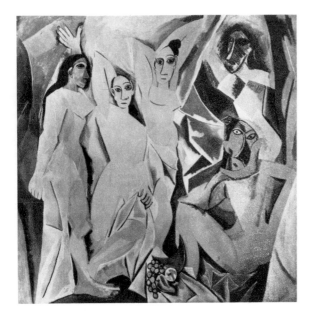

PABLO PICASSO. *Les Demoiselles d'Avignon.*
1907. The Museum of Modern Art, New
York. Lillie P. Bliss Bequest

Details of *Les Demoiselle d'Avignon*

human figure without feeling that it may fall. The idea of falling, the expectation of collapse, therefore, may be an important perception which might affect any interpretation of the work.

Although the color in *Les Demoiselles* varies in value and seems to be deployed as if it were modeling forms, we have in general very little impression of depth, of hollowed-out space in which the figures are contained. There is instead a quite shallow space, implied by the overlapping of the forms; that is, by the location of figures in front of or behind each other. But there are no perspective devices, no changes in size relationships, focus, color intensity, or sharpness of edge to suggest a representation of space deeper than the picture plane. (This list of negative statements is critically relevant because it alludes to the viewer's expectations which the work of art fulfills, disappoints, or modifies.)

Notice that the drawing of the hand in the central figure involves some skill in foreshortening; it is more or less believable, but the other two hands in the painting are crudely drawn: one is a childlike representation, while the other is schematic and stiff—part of an arm which resembles a carved substance more than it does flesh. But that arm, at the left of the canvas, is painted in the typical rose tones of conventional European figurative art. Thus, there is a conflict, within the arm, between the drawing and the color and paint quality. Is this the type of conflict that Scully noted in his architectural critique, or is it an intended conflict which has relevance to our interpretation of the work?

We should also notice that there are three kinds of distortion in the heads of the three outer figures. In the head at the left, color shifts from pink to brown, the eye is much enlarged, and the planes of the nose are simplified in a manner characteristic of African carved wood sculpture. The *shape* of the head remains naturalistic, however. This head is also conventionally illuminated with a logically implied light source which accounts for its convincing sculptural quality. Moving to the upper right head, we depart from logical representation. Indeed, there is hardly any bow in the direction of naturalism: very pronounced, really harsh, green lines are employed to indicate part of the nose plane in shadow, and inconsistent treatment of the eyes and a rough, unfinished kind of execution characterize the head in general. The breast is converted into a diamond shape with no subtlety in the transition from light to shadow. (Obviously, in this head the artist has abandoned the effort to convince us that we are looking at a representation of something which exists in reality somewhere else. In other words, the painting at this point begins to depart from the simple imitation of appearances as the goal of painting.)

Nevertheless, the upper right head has a normal attachment to the body. The head on the seated figure, lower right, however, is uncertain in its relation to the body. The nose with its shadow plane has been flattened out; the convention of a shadow plane has been employed as a decorative element, or an element of pure form in what might be called a synthetic composition based on the head. The alignment of the eyes is now completely illogical. A collection of forms based on different views of the head and different modes of representing the head have been assembled and located in the approximate place where the head would be. But only the left shoulder conforms with this approach, as the rest of the figure is consistent with the two central figures. From the head alone, we cannot deduce the sex, race, age, or any other distinguishing characteristic of the figure. Only the hips and thighs, plus the title, confirm that the figure is a woman.

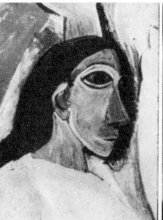

Detail of *Les Demoiselles d'Avignon*

At the extreme left position of the canvas is a brown area which seems to be a close-up, a large-scale detail of a female figure, employing the typical forms of African art. It is clearly not one of the *demoiselles* but seems to be an echo of some of their forms, this time carried out in the brown color of carved wood sculpture. Perhaps it is an announcement of the *leitmotif* of the painting as a whole. In purely formal terms, however, we might guess that the area shows an enlarged version of the shapes which might be seen in a rear view of the figure at the left.

The material discussed above constitutes an example, albeit incomplete, of formal analysis. In discussing the forms, I alluded to their possible meaning, thus anticipating the work of interpretation. I attempted to take notice of artistic effects varying from what might be normally expected: straight lines where we expect curves, flat forms where we expect modeling, distortion where we expect naturalistic representation, harsh changes of surface, shape, or direction where we expect gradual transitions.

The idea of the viewer's expectation is very important in formal analysis. As mentioned earlier, there are certain universal expectations based on our erect posture and our experience with gravity. Our associations with the horizon also affect our visual expectations when we perceive departures from the horizon. Likewise our expectations are conditioned by natural phenomena which have jagged, zigzag, spiral, circular, ovoid, crystalline, triangular, and rectangular directions or shapes. In art schools, students learn, usually in classes in design, to organize forms employing combinations of these directions and shapes. That is how they gain skill in controlling the viewer's perceptions and purely formal reactions, without the employment of illusionistic devices. However, in addition to our reactions based on experience with nature, we respond to forms on the basis of our experience with other

Detail of *Les Demoiselles d'Avignon*

works of art as well as cultural conditioning to what artistic forms should look like. The artist is usually well aware of the viewer's conditioning and uses it in planning the total impact of his work. Picasso knows how to use linear perspective and knows very well that viewers in the Western world are accustomed to a logic of picturemaking which calls for perspectivist illusions to create the space occupied by the *demoiselles*. Nevertheless, he deliberately breaks up any opportunity for the perception of illusionistic space. The still life in the bottom center of his painting provides the merest hint of a flat plane leading *into* the picture space. But the artist does not follow through on that kind of spatial representation. Indeed, he locates the foot of the figure on the left in the same plane and at the same height as the still life. The foot must be standing on the floor, yet the floor cannot be at the same level as the table top on which the still life rests. Obviously, the logic of spatial representation we have

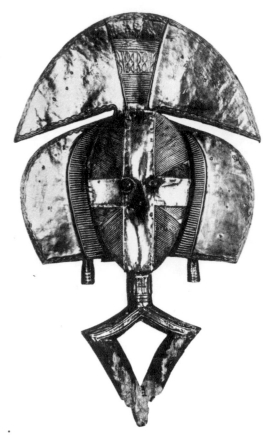

Guardian figure, from the Bokota area, Gabon. 19th–20th century. Ethnographic Collection of the University, Zurich

An interesting transformation occurs here: the dancer is adapted from a type of African funerary figure which is usually armless. But Picasso has broken the symmetry of the African model and has added arms folded behind the staring face. Why?

PABLO PICASSO. *Dancer*. 1907. Collection Walter P. Chrysler, Jr., New York

been conditioned to expect is destroyed in this painting.

It is plain that in making a formal analysis, we have been accumulating the evidence which will help us to attempt interpretations of the work and also to make judgments of its excellence. Under certain circumstances, the breakdown of spatial logic would justify a conclusion that the work we are examining is unsuccessful. However, we must first ascertain whether a different kind of logic has been created to supplant the one we expected. Or, perhaps a logic of spatial representation is irrelevant for the purpose of evaluating this particular work. In the case of *Les Demoiselles*, it is sufficient for the purposes of formal analysis to say that the activity of most of the forms we see takes place mainly in a shallow space parallel to the plane of the picture. We arrive at this conclusion by elimination, since no consistently employed pictorial device carries the eye *into* a convincingly real representation of space. Rather, the linear and coloristic clues keep us fairly close to the surface. In a sense, as soon as our eyes begin to penetrate inward, they are turned to one side. This is the effect of the two central heads which begin conventionally enough in front view, and then turn our vision to one side by presenting the nose in profile.

The tradition of looking at pictures, from the Renaissance onward, is based on the assumption that the viewer does not move. (Children, of course, have never shared this tradition; they *learn* it at sometime approaching puberty.) Picasso's picture makes the viewer feel he must move in order to make sense of the profile view of the nose. A fixed position for the viewer will not enable him to deal adequately with a front view of the face and a profile of the nose in the same head. In fact, *we are obliged to move imaginatively from left to right as we view the two central figures.* And this imaginative movement of ours is in the same direction the "falling" central figure seems to be taking; furthermore, we in the West read from left to right, and tend to examine pictures and other visual phenomena from left to right. Thus, we encounter a pictorial reinforcement of our cultural tendency to "read" everything in a clockwise direction, together with numerous violations of our other expectations. By the time we reach the seated figure at the right, we are almost willing to accept the joining of the shoulder, arm, forearm, and hip in a single continuous form, with the emphasis shifted from the anatomy of the limbs to the *shape of the opening* which they form.

Les Demoiselles d'Avignon

PABLO PICASSO. *Les Demoiselles d'Avignon*. 1907. The Museum of Modern Art, New York. Lillie P. Bliss Bequest.
Can this work be explained on the basis of what we see? Or should it be approached via the history of art?
Must we know the Western conventions for dealing with the pose and composition of female nudes before we
can adequately appreciate Picasso's departure from those conventions? The answer depends on whether we
regard the work as one document in a continuing story or whether we see it as an independent, organic thing.
It is possible, however, with agility in shifting one's perceptual gears, to understand the work through visual
sensibility *and* scholarly intelligence. But that obliges us to discipline our seeing and knowing.

JEAN-AUGUSTE-DOMINIQUE INGRES. *Venus Anadyomene.*
1848. Musée Condé, Chantilly, France. This Venus
clearly aspires to a Raphaelite grace but somehow lacks
nobility: a strange, almost insipid mixture of the sensual
and the sentimental creeps in. Surely Picasso was react-
ing against her.

Our formal analysis has now begun to move from an objective description of the forms to statements about the way we perceive the forms. We appear to be groping for a principle of organization, an idea or set of ideas which accounts for the way the work of art is structured. As our observations of the work increase, as the information begins to accumulate, it becomes increasingly difficult to defer the work of interpretation. However, we can undertake the task of interpretation with certain modest feelings of security: we have *tried* to be objective in our descriptive account of the work; we have tried *not* to overlook evidence which might affect our inferences; and we have endeavored to make assertions about the work which would not in themselves be the subject of disagreement.

Interpretation

By interpretation in art criticism, I mean a process through which the critic expresses the meanings of the work under scrutiny. I do not mean that the critic is engaged in finding verbal equivalents for the experiences which the art object yields. Neither do I mean that interpretation is a process of evaluating the work. Evaluation, or judgment, is an independent operation which necessarily follows interpretation. Obviously, we are not in a position to evaluate a work until we have decided what it means, what its themes are, what problems—artistic and intellectual—it has succeeded in solving.

All works of art require interpretation if we propose to deal with them critically. Even the object which on first and superficial examination appears to be weak can sustain meanings—meanings which can be expressed and which enter into our consideration of the value of the art object as a whole. If our method of art criticism is sound, it should be capable of dealing with the work of serious artists, with work by children and by untrained or primitive artists, and, to some extent, with the work of emotionally disturbed persons (although special clinical training is also needed in the latter case).

The work of interpretation is tremendously challenging; it is certainly the most important part of the critical enterprise. Indeed, if we have thoroughly interpreted a work, the business of evaluation or appraisal can often be postponed or dispensed with. Generally, college and university instruction about art is heavily centered on identification and recognition—usually historical, iconological, and stylistic—with only passing attention paid to explaining and appraising a work. One of the faults students find in such instruction is that the value of a work for them is too rarely discussed, that emphasis in teaching is on the factual knowledge needed to establish names, dates, influences, style, provenience, and authenticity. Students are not impatient with historical explanations of art provided that these help in the search for explanations of life as they live it—a not unreasonable desire.

Explaining or interpreting a work of art, then, involves discovering its meanings *and also* stating the relevance of these meanings to our lives and to the human situation in general. Now we come to another educational implication of art criticism: as mentioned earlier, it is a human-istic enterprise because men gain insights through criticism that relate to the vital questions they are interested in. We study art not only to learn the facts about *its* existence but also to learn the bearing which art has upon *our* existence.

Certain assumptions underlie our work in the critical interpretation of art. We assume that art always has, clearly or by implication, some ideological (in the nonpolitical sense) content. We assume that an art object, being a human product, cannot escape some aspect of the value system of its maker. Just as a human being cannot go through life without consciously or unconsciously forming a set of values, so also an art object, which is the very intimate result of an individual's encounter with ideas, materials, and experiences, cannot avoid being the vehicle of ideas. As critics, we are not particularly interested in whether the ideas expressed by art are faithful to the artist's deliberately or publicly expressed views. That is, we are not primarily interested in using art to find out what an artist thinks; we do not wish to invade his privacy. It is necessary, however, to observe that an art object somehow becomes charged with ideas—ideas which are frequently significant in more than a technical sense. They may, indeed, be present in the work without the conscious knowledge of the artist. But it is our function as critics to discover what these ideas or meanings are.

From the discussion above, an important inference for criticism is that *the artist is not necessarily the best authority on the meaning of his work.* Some artists readily assent to this proposition; others vehemently disagree. Whatever they believe, however, the conduct of serious art criticism is fraught with difficulties if we accept the artist as the most authoritative interpreter of his own work. As critics, we are, of course, interested in what the artist thinks about his work; we are interested in anything he can tell us about it. We should examine his views as we would those of any knowledgeable person who cared to offer them; but we must regard such views as material which requires confirmation by our own methods of analysis and critical interpretation.

It is not uncommon for artbooks and catalogues to quote statements by artists alongside reproductions of their work. Such statements are at times enlightening or entertaining or both. They can also be misleading. Artists,

like other people, vary in their ability to write or speak clearly; also, like others, they vary in their willingness to be candid about their motives; finally, like others, they vary in the degree of their self-knowledge, their understanding of what factors are involved in their behavior, especially with regard to something as complex as their artistic behavior.

For persons accustomed to viewing naturalistic works of art with more-or-less obvious thematic meanings, the interpretation of abstract and nonobjective art is quite difficult. This difficulty may account for the recourse to the artist's statements, his diaries, and the views of his close associates to throw light on the mystery of his work. Then, too, certain theories of artistic creativity assume that the artist "knows" what he is trying to express or what problem he was trying to solve, and at some level of awareness he does "know." The critic, however, should not confuse knowledge of *intent* with knowledge of artistic *achievement*. As critics, we should follow the rule of making statements of explanation about a work only when such statements can be confirmed by visible traits of the art object itself. In confronting contemporary art, it is not unusual to be influenced unduly by the reputation of the artist or the quantity of written material devoted to his work. However, the literature of art and the reputability of artists, especially of contemporary artists, should be used as a *guide* to the meanings to be found in specific works; ultimately the critic must discover these meanings for himself.

In the discussion of critical theory I referred to the common opinion that analysis of art is a deadening or desiccating process. Likewise, it may be similarly felt that interpretation of art objects inevitably does scant justice to the qualities of art which are not readily verbalized. That is, how can one verbalize the sensuous appeal of the object? Since criticism is "talk about art," how can one talk about colors and textures and shapes except in very imprecise, possibly exaggerated terms? My reply is that art criticism is not intended to be a substitute for aesthetic experience. I realize that if the content of a work of art could be expressed verbally, it would not be necessary to paint, carve, or build the object in the first place. Discovering the meaning of art does not entail the discovery of verbal equivalents for the visual qualities of the art object. Unfortunately, some writing about art endeavors to do just this, with disastrous results for art criticism. In critical interpretation, however, we deal with sensuous and formal qualities of the art object by examining the *impact* these qualities have upon our vision. As we perceive the work, its formal and other qualities seem to organize themselves into a kind of unity, and it is this unity which becomes the meaning of the work, the meaning we wish, however badly, to verbalize.

During the process of description and analysis we named and talked about colors and shapes in order to *direct the attention* of viewers to *actual* colors and shapes

in the art object, not our language about them. One of the central problems of aesthetics and of art criticism is that there is no way to avoid the perception of art by organisms called human beings. When we are involved with human perception, we are inevitably involved with the distortions and biases of human learning and culture. Unlike scientists, we cannot use instruments to gather sense data and then convert the data into mathematical symbols. Indeed, if there were such instruments we would not wish to use them, since variations in human perception of the same work (often by the same person) create a substantial part of our interest in art and in aesthetics. Variation in perception is itself a source of delight and part of the joy of being alive, but it is troublesome when we are faced with the problems of art criticism, of making statements about art which others can accept without surrendering their uniqueness as individuals. Therefore, in the following discussion about forming a hypothesis, I shall attempt to offer a solution to the problem of the subjectivity of perception as it affects critical interpretation.

FORMING A HYPOTHESIS

How do we begin the work of interpretation? Fortunately, the tasks of description and analysis have preceded interpretation, and several possible explanations of the work may already have presented themselves spontaneously. Now we must consciously and deliberately attempt to formulate a specific explanation which will fit the evidence we have been assembling. The explanations which seemed to suggest themselves as we analyzed the art object may have been based on an incomplete examination of the work as a whole. Technically, they were explications— partial explanations of the work as it unfolds during perception. Yet we can try one or more of them as hypotheses to see if they are satisfactory as explanations of the whole. Of course, explanation or interpretation in art criticism is somewhat different from the same process in science, which also employs hypothesis. In science, we seek a cause or set of causes which can account for an observed phenomenon. Scientists are willing to *interfere* with the phenomenon, that is, experiment with it to find what causes it to occur. In art criticism we are not so much interested in what caused the creation of an art object; we are interested in the *idea or principle of organization which accounts for the effect which the work has upon us.* The art historian asks: Why this work, at this time in the life of the artist, or in the existence of a nation or ethnic group? Why does it exhibit certain visual traits and not others? Who caused it to be made? For what purpose? With what effect? The historian endeavors to answer these questions with reference to the point in time occupied by the art object when it was originally created. If the critic asks these or similar questions, it is with reference to the point in time occupied simultaneously by

the art object *and* the viewer. The effect which the work has on us, unlike the phenomena which are studied by scientists, is not observable. Indeed, there is a strong suspicion that the same art objects affect individuals differently. Science, on the other hand, is based in part on the assumption that different individuals will make the same observations of a given phenomenon if they follow the same experimental discipline. Because the *effect* of art, the aesthetic experience, takes place "inside the skin" of an observer, so to speak, I have tried to develop a method which would minimize the subjectivity inherent in the nature of our problem. I have attempted to find a way to be reasonably certain that art criticism, "talk about art," can be talk about something we have perceived in common. Hence, I have insisted on description and analysis, and on the principle of making only those assertions (or observations) about which reasonable persons could agree. In other words, since we cannot very successfully study the effect which art has *inside* us, it seemed wiser to study the descriptions, assertions, and observations which have been made *about* particular art objects and which are *outside* our persons; although they arise within us, they are capable of being externalized where they can be scrutinized by everyone.

For the purposes of interpretation in art criticism, *a hypothesis is an idea or principle of organization which seems to relate the material of description and formal analysis meaningfully.* And, just as in science, where more than one hypothesis can account for a given phenomenon, more than one hypothesis can adequately explain a work of art. The reason more than one hypothesis or "theory" may be entertained by scientists to explain a phenomenon (for instance, the wave theory and the particle theory about the emission of light and other radiant energy) is that *the current state of knowledge* in science seems to support both theories equally well. Presumably, new knowledge will cause the preponderance of evidence to favor one of the theories or to favor their being supplanted by a new theory entirely. Science always regards its current knowledge as tentative and subject to revision. In art, explanations of works and estimations of their value change also, but not chiefly because new knowledge has made the old estimations obsolete. I do not subscribe to the idea of improvement or progress in art. However, changing social and cultural conditions change our individual perceptions. The things we see and hence value or *dis*value vary among persons and are changed by historical and environmental circumstances so that we are quite justified in finding more than one satisfactory hypothesis to serve as the interpretation of a work.

If more than one hypothesis can adequately explain a given work, should the critic abandon his efforts to furnish a single explanation? The answer to this question depends partly on the public or publics the critic believes he is serving. If he is functioning mainly to increase his own understanding and enjoyment, he may be satisfied with a single explanation at a given time, or he may revise his interpretation of the same work from time to time because his own experience and insight have been enlarged. The critic who serves others, as does a teacher or scholar, may determine to advance a single interpretation which can most adequately satisfy the interest of his particular audience or public at its stage of development and capacity for understanding.

For example, the teacher of children may explain Seurat's *A Sunday Afternoon on the Island of La Grande Jatte* as a picture of ladies and gentlemen enjoying a day off by strolling along a river bank, by resting in the shade, by watching fishermen and sailboats, and by playing social games. In other words, an adequate interpretation for small children might consist of little more than an account of the kinds of subject matter visible. For other

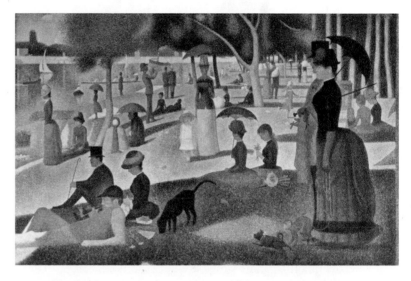

GEORGES SEURAT. *A Saturday Afternoon on the Island of La Grande Jatte*. 1884–86. The Art Institute of Chicago. Helen Birch Bartlett Memorial Collection

Photograph of staff assistant and children before the *Grande Jatte* at the Art Institute of Chicago, 1970

Seymour Lipton. *Cerberus*. 1948. Collection Mr. and Mrs. Alvin S. Lane, New York

children, the tapestry-like quality of the picture's surface might be explained in terms of the pointillist technique employed by the artist and the relation of this technique to the representation of light, the flattening and simplification of forms, and the control of contours. One could speak further of the dignity, silence, and order of the painting as opposed to the noise and random movement which must have characterized an *actual* Sunday afternoon. Finally, we might offer the hypothesis that the picture is "really" an abstract work of pictorial architecture which uses familiar objects, people, and subject matter only to arouse the interest of viewers, to sustain their attention until they become aware of complex relationships of pattern, light and shadow areas, silhouettes, flat and deep space representation, atmospheric effects, and imitations of sunlight and shadow effects with pigment. Another hypothesis, not incompatible with the others, is that the picture constitutes a *game* played by the artist with his viewers, in which he employs the pictorial conventions of drawing, cast shadows, light and

dark, perspective, and a new way of applying pigment to induce their recognition of familiar things in forms which are almost exclusively painterly inventions. What the viewer believes is quite familiar is in fact a set of quite unfamiliar constructions in pigment. The viewer has been "taken in" by a few contours and perspective devices; he has been "fooled"—to his own advantage and delight, it must be said.

This latter interpretation of the *Grande Jatte* introduces an idea about the artist's designs upon his viewers as expressed in this and possibly other of his works. That may be a superfluous idea for some persons so far as their appreciation of the picture is concerned. And it may not be possible to support the idea with material from the artist's biography. However, it may legitimately be used in the interpretation of the picture if it seems to give *a plausible explanation of our perceptions* in the presence of the work. Our interpretation or hypothesis, at least, is useful as a tool in explaining the simplification and flattening of the forms combined with the diminishing size of the figures as our eye moves from the bottom to the top of the canvas. It also explains the uniform pointillist treatment of water, foliage, grass, flesh, and fabric. We might have tried the hypothesis that the work is an investigation of the leisure-time behavior of the French middle classes, or an admiring portrait of the decorousness with which the French comport themselves in the daytime. Some objective evidence would support these explanations (and we came close to such an interpretation in presenting the picture to small children). However, such hypotheses are essentially frivolous and would not do justice to the material developed in a description and formal analysis of the work.

THE MIMETIC THEORY

We have offered examples of hypotheses for the interpretation of a single work, a painting executed in the 1880s, one which is not very difficult to fathom, at least superficially. But how is the hypothesis formed? A hint about the process can be gained, curiously enough, from the remarks people make about very "experimental" works of art, works which seem "wild," "crazy," "far out." In museums and galleries we are accustomed to the things people say when they are frustrated in the effort to understand a difficult work. Sometimes they express their frustration by trying to be funny. "That looks like a picture of a cow eating grass, but the grass is gone and the cow went back to the barn." A free-form sculpture reminds someone of a "dog taking a bite out of a mailman's leg." The humor is dubious and yet amazingly recurrent. It probably indicates embarrassment as much as anything else. But it also reveals the normal impulse to use what might be called the "looks-like-feels-like-and-reminds-me-of" reaction. The mind, confronted with material it cannot organize meaningfully, struggles to

find some correspondence between present, confusing perceptions and past experience which has already been organized and understood.

A mimetic theory of art is spontaneously employed by persons who never heard of mimesis. The art object must look like, or resemble in some way, something they have seen, felt, heard of, or read about. They search their experience for configurations which might resemble what is presently under scrutiny. The unprepared viewer is at a disadvantage compared to the person who has studied criticism, since the former usually attempts to interpret the work before analyzing it very thoroughly. His "looks-like," "feels-like," and "reminds-me-of" reactions are correct in their form but tend to be superficial and un-enlightening, because the viewer has not searched his experience systematically, has not really "looked" at the work, as art teachers are wont to say.

At a certain level of analysis, the sculpture *does* look like a dog biting a mailman, if you wish. But if we are satisfied with that hypothesis, we deny ourselves a number of potential meanings which are more valuable than the saga of dog and mailman celebrated so frequently in the adventures of Dagwood Bumstead. Consequently, we must employ the "looks-like" reaction, which is an easy and spontaneous response, at a more sophisticated level. That is, what is there about an episode in which a dog bites a man corresponding in some manner with the art object which suggested the episode in the first place? Are we dealing with some lofty concept such as the inability of a noble creature like man to avoid becoming entangled in the ordinary, low concerns of creatures far below him in moral and intellectual stature? That would be a potential line of exploration in the work of an artist like Charlie Chaplin. Is the episode an "excuse" for an artist to create forms which play among the categories of structure, organism, and animality? That idea is explored by Seymour Lipton (born 1903) in *Cerberus*. The hypotheses suggested by a simple "looks-like" or "reminds-me-of" reaction are plentiful. Fortunately, our previous analysis of the art object enables us to select among them and to modify our statement of them so that we begin to approach an adequate explanation of the work itself.

INTERPRETING "LES DEMOISELLES"

Let us return to Picasso's *Demoiselles*, which was used to illustrate formal analysis in the preceding section. Perhaps the same work can be employed to illustrate interpretation. We can discard some hypotheses first. The work is not on the surface a celebration of female beauty. (But it does evoke references to works of that type, such as Rubens's *The Judgment of Paris* or the same theme executed by Raphael, *The Three Graces*.) The work does not involve the display of artistic virtuosity—that is, skillful drawing and brushwork, painterly modeling of forms and representations of light. Color and shape are not employed as if they were intended to be a source of sensuous delight in themselves. In other words, this is not a *decorative* work whose values and meanings lie in the optical enjoyment of its surface. Rather, the forms we have analyzed previously exist in order to designate or symbolize ideas. And, if this work is truly significant, the ideas it symbolizes could not be as well expressed in any other medium of artistic creation. Indeed, it is quite possible for *Les Demoiselles* to express ideas which are original from a cognitive standpoint, that is, in terms of the history of ideas. Let us form our hypothesis on the basis of the clue offered by the left-central figure which *looks like* a statue on an insecure base. The figure seems to be falling, but, being a statue, maintains a serene expression; the statue does not *know* it is collapsing. *This work of art, it seems to me, deals with the idea of falling.*

We observed earlier that the artist used white lines instead of dark ones to delineate the forms of the torso in the central figure. One of the earliest historical uses of white line drawing in the figure occurs in Greek vase painting, especially in the so-called black-figured style of the sixth century B.C. The faces of the two central figures also have the expressionless, wide-eyed stare which is characteristic of early Greek portrayals of the female in vase painting and in sculpture. A more recent ancestor of the central figures might be found in a highly sentimental work, *Venus Anadyomene* by Jean-Auguste-Dominique Ingres (1780–1867). Even without this information, however, we sense the classical origins of the two central figures. They appear to symbolize conceptions of female beauty which originated in the ancient cultures of the Mediterranean world and which are part of the heritage of Western civilization—a heritage which Picasso has amply shown that he feels deeply. Another clue lies in the Greek hairstyle of the right-central figure. By contrast, the other two standing figures are derived from non-Western sources—African, Peruvian, or Pre-Columbian Mexican imagery. And, as observed earlier, they employ angular as opposed to curvilinear shapes. These figures deliberately disappoint the expectations of Mediterranean pulchritude aroused by the central figures. The upper-right figure is aggressively ugly. The leg of the left figure is unfeminine and belongs to a human type which is not at home in the cities of the Western world. We have here a change of race along with a change of artistic treatment. Picasso has intentionally juxtaposed Western and non-Western racial and plastic representational types to express the *fall* of Western ethnocentrism. The classical beauty symbolized by the central figures is at first contrasted with the form ideas of the other two standing figures and finally is synthesized in a new development which appears in the lower-right figure. Its head is based on non-Western plastic forms subjected to a type of Western cerebral play with inherited art. (On this interpretation, Picasso is, for visual art, our *magister ludi*—Western man epitomized as *homo ludens*.)

The relaxed calm of the classical figures is contrasted with the tribal intensity of the others. In the *fall* of the classical figures we can also see the fall of a culture in which beauty is the object of serene contemplation. This ideal is displaced by ideals of frenetic activity, beauty as procreative potency, and the victory of magical incantation over rational reflection.

Historians tell us that Picasso originally intended to paint a scene showing a sailor surrounded by nude women, fruit, flowers, and a symbolic intimation of death. The final version of the canvas does not, of course, carry out this plan. But it should be stressed that a defensible interpretation of the work need not follow Picasso's original or modified intent; indeed, the viewer could easily be misled by the artist's plan or the history of changes in the plan, interesting though these may be. Our critical procedure should be designed to get at those meanings which can be visually confirmed in the present work—meanings of which Picasso may not have been consciously aware.

In 1907, well before World War I and the beginning of the dissolution of European colonialism in Africa and Asia, Picasso's painting represented, at the very least, a remarkable anticipation of the political and cultural developments which came into prominence some forty years later. If this analysis and interpretation are correct, then Picasso's painting has value for the history of ideas as well as the internal development of artistic styles. Not only does it anticipate social and political developments, but it also serves a didactic function in the history of art. By employing the artistic devices traditionally used to create the illusion of deep space and verisimilitude, the artist creates expectations in the viewer of seeing a typical figure composition, a kind of *tableau vivant*. But he uses these pictorial conventions to frustrate our usual expectations, to teach us that a picture is made of painted forms resting on a flat surface. These forms are not veritable substitutes for reality; they are symbols of reality—including some non-Western symbols—as seen and thought about by a Western man. We see again how painterly forms employed as symbols can function at several levels of meaning. The art of painting becomes, with this work, capable of dealing with a wider range of experience and meaning than was hitherto thought possible.

My interpretation of *Les Demoiselles* has led, almost imperceptibly, to an appraisal, or judgment. It should be plain that the work is regarded as having enormous significance. In the following section on evaluation I shall try to analyze some of the considerations which lead critics to make their judgments of artistic value.

Judgment

Evaluating a work of art means giving it rank in relation to other works in its class—deciding on the degree of its artistic and aesthetic merit. As mentioned earlier, this aspect of art criticism is much abused and is for some purposes unnecessary if a thorough and satisfying interpretation has been carried out. Nevertheless, for a variety of motives, human beings seem unable to dispense with ranking art objects. Even artists, who do not have critical obligations to the public, commonly indulge in the ranking of art and of other artists. And there are many practical situations where ranking and appraisal are unavoidable. For example, a museum usually has limited funds for acquiring new works of art. Obviously, the museum's trustees and staff are anxious to spend their money on works which are considered important and superior. The same problem arises for individuals who wish to collect works of art. They are encouraged to buy what pleases them. But usually, and especially if a large outlay is involved, collectors wish to know that what pleases them also possesses substantial intrinsic value to justify the investment. That is, a work of art must be valuable for reasons other than the pleasure it gives us aesthetically. To put the problem in another way, we should like to be assured that works of art which afford us aesthetic plea-sure afford comparable pleasures for others, thus rendering the works durably valuable.

If a preference survey could be taken in connection with a particular work or group or style, we should gain some information about their current acceptability, and presumably we could draw limited inferences about the "value" of the works, even their money value. But such surveys are impractical, they would probably be unreliable for any extended period, and we should like to think there are better methods for arriving at our judgments—judgments which are also more lasting.

Certain kinds of art scholars are called connoisseurs, that is, persons who "know" a great many things that relate to judgment about artistic excellence. When dealing with older works, such as the art of the Renaissance, a considerable part of connoisseurship is the determination of the authenticity of a work. Since the importance of an artist like Botticelli, for example, has already been well established, problems of connoisseurship involve deciding whether he did, in fact, execute a certain work; when in his career the work was completed; whether other versions exist; whether the work is a good example of his style; what the opinion of collectors and connoisseurs has been about the work; and so on.

In the case of contemporary art, somewhat different problems of connoisseurship exist. Authenticity is usually not a problem. Most of the facts about the execution, display, sale, and ownership of a work are known. There is also likely to be a large body of critical opinion about the artist and about particular works he has created. However, the short time during which these opinions have been accumulated tends to limit the reliance we are willing to place on them. Furthermore, many collectors and museum directors desire to acquire significant works of art *before* their artists have become well known. They wish to exercise critical judgment in the form of a risk, a wager, a "bet." Such persons would like to believe that they can identify artistic excellence before the multitude discovers it. Hence, connoisseurship of contemporary art is related more to the prediction of durable aesthetic value than it is to exhaustive knowledge about art which has already been judged valuable. This game is one of the excitements of connoisseurship and of art collecting, apart from the aesthetic excitement which specific works yield. Art is, after all, a commodity as well as a type of experience, and, as a commodity which fluctuates in money values, it gives rise to methods of anticipating the fluctuations. It is also possible, alas, that methods for *controlling* as well as anticipating the fluctuations of art values may be devised. This is to say that, where there is a market for a commodity, persons will be found who endeavor to manage market conditions for the sake of financial gain. However, these are extra-aesthetic considerations, and we are here concerned only with the development of critical instruments which will enhance aesthetic satisfactions.

COMPARISONS WITH HISTORICAL MODELS

In making a critical evaluation, it is important that the work under scrutiny be related to the widest possible range of comparable works. One of the errors made by young artists and neophyte critics is to form estimations of value with reference to a very recent or narrow context of artistic creativity. Perhaps this is done because the critic may sincerely believe that a certain date, say 1950, constitutes a watershed in history and that artistic events preceding and following that date must be treated as if they belonged to separate, self-contained categories. It would appear that many persons who make judgments about art operate unconsciously on some such assumption. But if they do, their assertions about artistic value should be qualified in terms of the time span over which they are intended to be regarded as applicable. The point is that if we are to take critical judgment seriously, judgmental statements ought to specify or imply the range of art objects in time and space which have been considered relevant for making the judgment. Since we know of examples of artistic creativity beginning approximately twenty thousand years ago and continuing to the present day, the range of relevant objects is enormous.

I do not cite the long history of art in order to multiply the difficulties in making critical judgments. But I wish to stress the necessity that the critic be acquainted with as many artistic styles and genres as possible. Modern artistic communication and exchange, the inexpensive dissemination of reproductions, and the wide display of original works greatly extend the known history of art. This development is quite recent, but, as André Malraux has eloquently demonstrated in *Museum Without Walls*, artistic creativity today is inevitably conditioned by the fact that almost every artist is aware of, and has seen, South Pacific primitive stone carving, Cycladic figures, Roman fresco painting, Pop art, and Indian temple sculptures. The critic who judges according to standards derived only from familiarity with the works of artists in a certain "school," geographic location, or historical epoch is severely limited.

If we examine a portrait, a figure painting, or a landscape painting, it is natural that we relate it to works of similar purpose in the history of art. The same point applies to our examination of a house, a church, or a government building. We know that modern developments in technology and patterns of living change the way we think about domestic architecture, for example. But it is desirable to know the forms and types from which modern structures have evolved or departed in order to judge properly their value within the type as well as their capacity to afford aesthetic pleasure. Philip Johnson's glass house becomes more significant as a valid contemporary architectural solution if we understand the evolution of the domestic dwelling. His house must be judged not only in terms of the possibilities afforded by glass-and-steel-frame construction, but also in terms of social change from a closed to an open society.

We can judge the adequacy of public buildings more intelligently if we know how they derive from ancient models which were often erected for different purposes (temples, palaces, fortifications) at a time when modern conceptions of representative government were unknown. That is, judgments of architectural excellence must obviously be preceded by analysis of the functions which a building is intended to perform. The formal excellence of a building has to be related to what happens within and around it. One reason our banks and libraries were often based on Greek and Roman temples is that the sculptural power and symbolic effectiveness of those ancient structures were admired for their own sake and were thought to be transferable to any modern building type, no matter what its use. But we realize now that a building intended to house the statue of the female deity worshiped by the citizens of Athens is not ideally designed for carrying on the banking business of a modern industrial community.

Thus, we approach a criterion of excellence which applies with special force to architecture: we expect buildings to work; and we expect them to express, as

authentically as possible, the spirit of the time in which they are built. (Spirit of the time, or zeitgeist, is easily confounded with fashion; but fashion is synonymous with superficiality. The zeitgeist is authentic and distinguishable from fashion when it expresses necessary functions, fundamental needs, underlying drives. Fashion raises or lowers a lady's hemline; the zeitgeist determines whether women should wear clothing that hobbles their movement or enlarges their freedom of activity.) This does not not mean that a building must reflect in some obvious way the popular opinion of the character of our age. After all, buildings are examples of technology as well as art, and hence they are a *cause* of the character of the period as much as its reflection. Perhaps our criterion can best be stated negatively: a building should not express the character of an age other than its own. In other words, the Gothic style covering a working structure of steel girders or reinforced concrete makes little sense in contemporary architecture.

There may seem to be a paradox in our requirement that judging art calls for relating it to historical examples at the same time that we require it to express present needs and aspirations. But a comparison with the best work of the past does not imply *imitation* of the past. Historical examples are misused if they are reproduced; they are intelligently employed if they serve as bench marks, or touchstones of excellence. When we have to judge excellence, Shakespeare, Rembrandt, and Beethoven give us some ideas about the capacity of genius operating within specific historical and cultural contexts. An art that significantly "expresses" its time does not reflect the banal interpretations of editorial writers and Fourth of July orators. Its expressive excellence is an indirect *consequence* of having applied the best analysis of function, the best use of known technology, and the most imaginative organization of forms to the problems presented by the convergence of a particular artistic type with the needs of a particular human community.

Our discussion thus far can be summarized by asserting that critical judgment or evaluation calls for: (1) ascertaining the purpose or function of a work; (2) relating the work to the widest possible range of similar works; (3) determining in what ways the present work has continued or departed from historical prototypes; and (4) relating the work to the characteristic needs and outlook of the time in which it was created.

If we examine a contemporary portrait, we know that its function as a historical record of appearance has been to some extent superseded by photography. We also know that modern investigations in psychology and personality theory can influence an artist's perception of his sitter. Hence, compared to its historical prototypes, a contemporary portrait should embody a new response to the problem of delineating personality *at the same time* that it acknowledges persisting elements of the old problem: who is this person? Knowledge of history frees us

AGNOLO BRONZINO. *Portrait of a Young Man.* c. 1535–40. The Metropolitan Museum of Art, New York. The H. O. Havemeyer Collection. Bequest of Mrs. H. O. Havemeyer, 1929

from the past rather than making us its slave. We can admire the *Portrait of a Young Man* by Agnolo Bronzino (1502–1572) without failing to understand *Self-Portrait in a Tuxedo* by Max Beckmann (1884–1950). Both works tell us something about their subject, of course. Bronzino, in addition to establishing the grace, poise, and self-confidence of a rich young man, takes pains to create a highly credible illusion of his skin, clothing, and architectural surroundings. The hand at the waist, for instance, is magnificently drawn and modeled. Beckmann, contending with himself (which always involves special problems of introspection and objectivity), portrays an older person who wears a more experienced and cynical expression. Although the pose has a certain grace, the portrait as a whole is hardly a celebration of manly beauty. Despite the evening clothes and the effort to exhibit nonchalance in the positions of the hands and in the holding of the cigarette, we gain the impression of almost malevolent power—held in check perhaps, but close to the surface and ready to erupt. In the Bronzino portrait, the element of psychological analysis is minimal. In the Beckmann portrait, psychological analysis dominates, especially in the grim set of the mouth, the dramatic lighting of the face, and the exaggerated sharpness of the facial planes. Bronzino's young man is a specific person,

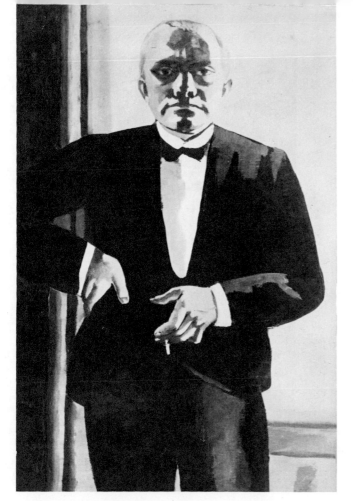

MAX BECKMANN. *Self-Portrait in a Tuxedo*. 1927.
Busch-Reisinger Museum, Harvard University, Cambridge, Massachusetts

but he can be interpreted as the symbol of an age and of an attitude toward youthful masculine grace, rich but restrained dress, and elegant classical surroundings. The book he holds is meant to symbolize the intellectual interests of Renaissance men, just as Beckmann's cigarette symbolizes today's neurotic tendencies—the frantic wish to achieve a measure of poise, social assurance, and pseudoserenity from the smoke of a weed.

The more we penetrate Beckmann's portrait, the more apparent it becomes that we are in the presence of a work of the highest order. Obviously its values are strongly at variance with those of the Bronzino. Both pictures are of the same type or genre. It is this typological similarity which enables us to compare them, to seek a range of meaning and a power of expression in the modern work which is comparable to the range we find in the sixteenth-century work. We do not pursue the *same values*, but we *do* seek the same *capacity to support values*. A formal analysis would reveal that technique and organization in each work is directly responsible for the meanings we are able to discover. The flawless surface of the Bronzino is a vehicle of aesthetic expressiveness just as are the harshly manipulated planes in the Beckmann.

I advocate, consequently, that in making critical judgments, contemporary works be held up against their outstanding prototypes in the history of art. Where recent or contemporary models have to be used, they should

be employed carefully. That is, one should compare works that are typologically similar; one should not seek the same meanings but comparable power to support meanings; and one should be inventive (there lies the special pleasure of criticism) in the choice of models for comparison.

THE PROBLEM OF ORIGINALITY

Other instruments of critical judgment need to be employed, especially for those highly original contemporary works for which it is difficult to discover historical prototypes. Some contemporary paintings and sculptures seem to have almost nothing in common with older works in the same media. It is this "excess" of originality that accounts for those highly subjective critics who appear to regard even the recent history of art as irrelevant. For them, the span of relevance (and hence of comparability) extends as far back as the most recently celebrated "breakthrough." A "breakthrough," as conceived by journalistic criticism, is similar to a scientific discovery like the equivalence of matter and energy. Previous artistic achievement becomes dated and obsolete—interesting but irrelevant. Just as Copernicus supplanted Ptolemy, and Newton supplanted Copernicus, De Kooning supplanted Rubens and was, in turn, supplanted by Robert Rauschenberg. But progress is a meaningful concept for technology, not for art. We can admire Rubens *and* De Kooning, without concern about their distance from, or proximity to, the most "advanced" modes of artistic creativity during their active careers.

If a modern work cannot be related to some comparable work, and if we do not wish to judge it in terms of how "advanced" it is—that is, with respect to the vanguard of stylistic change—how can we decide on its merit? First, we must rely upon our techniques of description, formal analysis, and interpretation, since they can be employed almost independently of historical comparison. Second, we can shift our emphasis in the task of interpretation: instead of attempting to discover the *idea which explains the work*, we should try to identify *the artistic problem* which the work endeavors to solve. Works of art are difficult to judge when they are embodied in "excessively" original artistic forms. However, the functions of art, the purposes art serves in human affairs, tend to remain the same, regardless of form or technique, since human needs remain fundamentally the same. Hence, it is innovation in the *means* of artistic expression which makes critical judgment difficult. Once we recognize that Georges Mathieu, for example, is coping with a new *artistic* problem, some of our confusion may be dispelled. Indeed, we may even be able to discover relevant antecedents with which Mathieu's work can be compared.

We might identify the artistic problem of Mathieu as finding a way to use linear movement so that it expresses

Both Tobey and Mathieu represent a universe made of highly charged energy paths. For Mathieu the motion occurs in shallow space —virtually on the picture plane. For Tobey it is in deep space. Perhaps that is why his world is credible as a place that exists in its own right. Mathieu's world, on the other hand, seems wholly contingent on the artist himself, his talent, his brilliance, his caprice, and his virtuoso performance.

GEORGES MATHIEU. *Noir sur Noir*. 1952. The Solomon R. Guggenheim Museum, New York

MARK TOBEY. *Tundra*. 1944. Collection Roy R. Neuberger, New York

the elegance, grace, and excitement of a dance, say a minuet, or the motion of the feet and action of the sword of a skillful fencer—doing so, that is, by implication, without representing a dancer or a fencer visually. If this statement of the problem is correct, the artist is trying to create a painting which is expressive in the same manner as music. We know that linear movement suggests motion, but the artist here tries to *characterize* motion, just as a composer organizes sound, so that it expresses feelings and ideas—attributes which sound, physically considered, does not have. Mathieu's historical antecedents would appear to be Watteau and Fragonard, both very French, very close to the revelry and *fêtes galantes* of courtly life before the Revolution. Although Watteau's *Embarkation for Cythera* is not a visual prototype of Mathieu's *Noir sur Noir*. It anticipates his work in spirit. Watteau also sought to express a type of aristocratic, frolicsome commotion and gaiety. This he accomplished using the full range of pictorial imagery and compositional maneuver available to the eighteenth-century painter. But Mathieu is the beneficiary of modern developments in abstraction, Surrealist experiments with automatic writing, the scientific study of scribbling, and the "white writing" of such contemporary American painters

as Mark Tobey and Bradley Walker Tomlin. Still, to cite the relationship with certain contemporaries is not to detract from the originality of Mathieu. His work is very personal and unquestionably elegant. Having said this much, we may also regard the work as somewhat frivolous. Notwithstanding the elegance of the artistic solution, one searches in vain for the relevance of his theme to life as we feel it now. The artist entertains by the deftness and facility of his performance, but his work seems unable to support any other significant human interests. My judgment, therefore, is that the work by Mathieu is successful in that it solves an original artistic problem, that it possesses a unique formal distinction, but that it is not memorable or truly significant because it does not deal with ideas or emotions which make more than a temporary claim on the imagination of the viewer.

This evaluation of the Mathieu, if it is warranted, illustrates an instance in which a work is technically adequate (even brilliant), original, and successful in its approach to the problems of artistry, but insufficiently *ambitious* to attain the highest rank. There is, of course, a legitimate need for art which does not strain mightily for significance; and all works are not required to be masterpieces. However, it may be useful for critics to observe

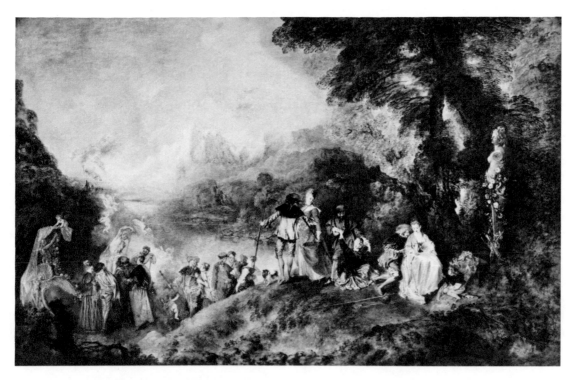

ANTOINE WATTEAU. *Embarkation for Cythera.* 1777. The Louvre, Paris

that aesthetic worth is likely to result from the effort to solve formidable problems of artistic meaning *and* contemporary human relevance.

The worth of innovation is inevitably brought into discussions of critical judgment. In spheres of activity outside of art, we often set a high value on originality. Certainly this is so in science, where new knowledge is highly valued provided that it is also reliable or true. One of the criteria of art criticism in the Renaissance was "invention," the capacity to create new forms and novel elaborations of traditional forms. Yet at other times in history, conformity to established models was valued, even demanded. Our own period seems to set a higher value on innovation than any other historical era. Art instruction in the schools places a premium on originality, and the tendency of children to copy or imitate is discouraged, although not with conspicuous success. In the gallery world, emphasis on originality can be understood as emphasis on rapidity of stylistic change. In this sense, artistic innovation may be induced by the general tendencies of our commercial culture where style changes, model changes, and "revolutionary new principles" are regularly employed to increase sales. Opposed to originality as a criterion of aesthetic value was the late master

architect, Mies van der Rohe, who is supposed to have said, "I would rather be good than original."

Obviously, originality is not an absolute good so far as art criticism is concerned. The enormous influence of the long and productive career of Pablo Picasso has probably had a considerable influence on modern notions about the desirability of innovation in content, style, and technique within the career of a single artist. However, these innovations are characteristics of the creativity of a remarkable artist and are mainly relevant to him as a personality and prominent figure in the history of modern art. His individual works have to be assessed on the basis of the aesthetic values they support. The reputation of a person as eminent as Picasso tends to intrude on the critical evaluation of his individual works. It is quite possible that some of his production—so much esteemed for originality and versatility—will be less admired by future generations than it is today, although it has been, for a good part of the twentieth century, heretical to suggest such an idea. The impact of originality, especially on those in our civilization who have been conditioned to crave it, is based, I think, on the wish to be amazed and astonished. Like those tribesmen whom the ancient Greeks and Romans called barbarians, we do not easily

distinguish between the original, the astonishing, and the beautiful.

The art of ancient Egypt or of Byzantium exhibited uniformity for thousands of years. To moderns, it appears hopelessly monotonous and slavish, the expression of people who would not "improve" themselves. We value change for its own sake. We believe excellence is a matter of being first to own or do something. We want to see and possess "the latest thing." It would be strange indeed if art did not respond to these strong and pervasive cultural influences. The critic, however, must be professionally cynical if he is to be socially useful. He must ask of originality that it not be novelty for its own sake, but that it provide truly new insights, that it illuminate rather than merely dazzle. Art can be ingeniously entertaining, as in the work of Mathieu discussed earlier, and when it is, our critical discrimination should enable us to recognize and admire it for what it is. But the normal human desire for entertainment, for relief from the monotony or sameness of experience, should not distract us from seeking values in art which possess some durable significance as well as immediate sensuous appeal. At the same time, it is a mark of critical discrimination to expect that the feelings and ideas embodied in art be "well expressed."

THE RELEVANCE OF TECHNIQUE

Our final consideration in connection with critical judgment has to do with the last phrase above, "*well* expressed." What is the role, for the purposes of art criticism, of craftsmanship, mastery of technique, skill and facility in the use of materials? To answer, let us begin with the proposition that *art is making*. It is what the Greeks called *techne*; they recognized no distinction between art and technical skill. Art is not an idea *followed by* its technical expression; it is idea *and* materials simultaneously united through the employment of technique. The notion of technique as subordinate to idea is a philosophic error that has bedeviled education, aesthetics, and art criticism for hundreds of years. Art is in the first instance making or forming; we cannot afford in criticism to ignore the *character* of that making and forming. One *result* of making and forming is the embodiment of ideas through materials, and we legitimately study those ideas, but we must also study the processes which brought them into being, giving them identity and expression.

Earlier, technical analysis was mentioned as an important phase of art criticism. There we endeavored to find clues to the ultimate interpretation of a work by studying how the work was executed. Now we wish to study execution with a view toward making judgments about artistic and technical excellence. Craftsmanship and technique are legitimate subjects for critical judgment because they are themselves supportive of aesthetic value. Technique is not merely a means toward an end; it is an end in itself. In other activities, we readily admire tech-

nique for its own sake—especially in sports, where an athlete's performance may be praised for its form and execution even if he loses a contest. Conceivably, the roots of aesthetic pleasure in skilled technique arise from our tendency to identify with any exhibition of the effects of using our hands and hand-tools, and, by extension, hands and machine tools. The logical and effective use of tools is one of the most fundamental demonstrations of man's mastery over his environment. Man is called, after all, "the tool-using animal." With his hands and their extensions, he leaves his characteristic marks on materials, and these materials in the form of art survive after the men who formed them are dead.

How do we judge whether a work is technically successful? Some critics evaluate technique indirectly—by ignoring it in favor of judging expression. If a work is expressive as a whole, if it pleases us or yields meaning, then the technique is adjudged adequate for the expression of the meanings which have been apprehended. But this circular argument amounts to asserting that every effect has a sufficient cause. It does not treat adequately the aesthetic values which inhere in the *cause* of art, which is technique, workmanship, skill. It avoids the fact that works of expressive power may be technically deficient, just as works of technical excellence may be expressively inferior. The modern era has seen many departures from traditional craftsmanship, departures from the rules and formulas of artistic technique which used to be taught academically and which were thought to be guarantees of excellence. Also, modern media and materials have been developed by technology so rapidly that a logic or tradition of using them has not had time to evolve. Consequently, contemporary art is frequently weak in quality or craftsmanship, and contemporary criticism tends to focus on other matters.

In other eras, craftsmanship may have been chiefly a concern with the *durability* of whatever an artisan built, formed, or fabricated. It may also have been a visible sign of the labor expended in fashioning an art object and, hence, a symbol of its cost and so a further sign of its owner's power to command the labor of artisans. But in modern times, craftsmanship or technical excellence means *logic in the use of tools and materials* and *correspondence between the appearance of an art object and its function*. Durability remains one of the meanings of excellent craftsmanship, but it is less prominent today because modern materials permit even poorly executed works to survive. The evidence in an art object of much expenditure of human effort is less valuable as a sign of status since some of the most costly things we possess are made by machines. Thus, the older meanings of technique have given way to the idea of a logic of materials and of function.

Logic in the use of tools and materials can be illustrated simply, for our purposes, in the observation that one would not use a nail to join two pieces of paper. The idea

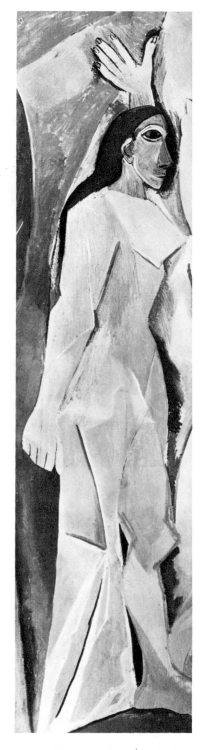

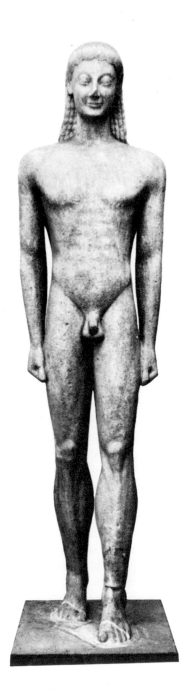

The uncanny resemblance among these figures could be entirely fortuitous. Still, the critic may discover clues in their resemblance that help establish a hypothesis about the Picasso work. Our problem is not to assign influence but to arrive at an interpretation by accounting for similarities and differences among archaic and modern forms apparently based on the same type.

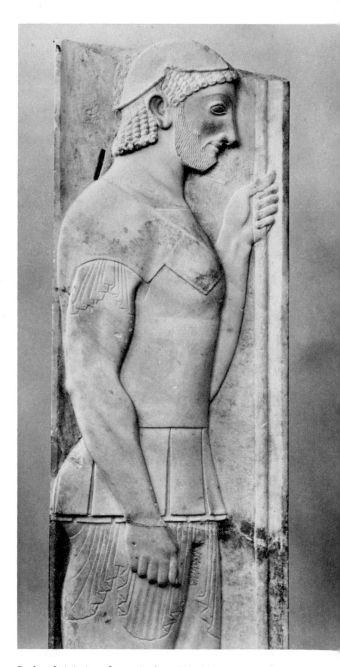

Kouros, from Melos. 6th century B.C. National Archaeological Museum, Athens

PABLO PICASSO. Detail of *Les Demoiselles d'Avignon.* 1907. The Museum of Modern Art, New York. Lillie P. Bliss Bequest

Stele of Aristion, from Attica. 510–500 B.C. National Archaeological Museum, Athens

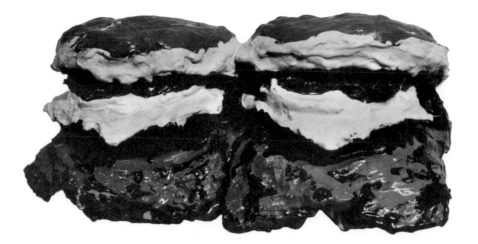

CLAES OLDENBURG. *Two Cheese-burgers, with Everything (Dual Hamburgers)*. The Museum of Modern Art, New York. Philip C. Johnson Fund

is absurd because something within us rebels at the thought of the disproportion of the means to the end. We *know* there are better ways to join paper. The physical properties of materials tend to govern what may or ought to be done with them. A sculptor should not attempt to execute forms in stone which are more appropriate to wood, metal, or fabric. Craftsmanship may consist of extracting the maximum of performance and meaning from materials without violating their essential nature. Of course, as Dr. Johnson observed, it is possible to train a dog to walk on his hind legs, but the sight of the performance is not especially inspiring. Certain things that can be done with materials *ought not to be done*. Perhaps craftsmanship can be defined as the *morality* as well as the logic of technique. Plastics can be formed and treated to resemble a variety of materials from marble to wood, but we invariably feel cheated when we discover the deception. Fortunately, contemporary product designers have learned to use plastics in ways appropriate to their versatile character. To be sure, our ideas about the "appropriate" use of tools and materials are not fixed forever; they are based on our direct experience with materials and conditioning by prevailing custom. Manufacturers, engineers, and designers are continually extending our ideas of the appropriateness of new materials or conventional materials used in new ways. And when the designer is an artist, he works deliberately with the technical expectations of the public. As an artist he may even employ a *perverse* logic of materials so that a viewer's shock in connection with his *anticraftsmanship* becomes one of the intrinsic meanings of the work.

Certainly this is the case with Pop art. In *Two Cheeseburgers with Everything (Dual Hamburgers)* by Claes Oldenburg (born 1929) we have a "sculpture" of an everyday object. The oversized hamburgers are made of plaster painted in vivid, garish colors to drive home to the viewer the banality of everyday features in our environment. Because of the crudely painted plaster, the distortion of scale, and the general lack of "finish" of the craftsmanship, the feeling of vulgarity that the artist is trying to achieve is heightened. Technique is here employed not only to identify the object, but also to violate our sense of the logic of materials so as to arouse a strong emotion of disgust. There is enough naturalistic accuracy in the work to remind the viewer that he is looking at something meant to be eaten; then the viewer realizes that he is imaginatively sinking his teeth into painted plaster. Thus, the "aesthetic" reaction approaches physical revulsion. Anticraftsmanship becomes a positive instrument for the achievement of the artist's aesthetic intent.

By *correspondence between appearance and function*, we mean that craftsmanship should be employed to suggest the use, meaning, or operation of an object. Oldenburg's anticraftsmanship becomes operative because we have expectations of *craftsmanship* which he can intentionally offend. Without our expectations, his hamburgers would merely be bad or unsuccessful art. Industrially produced art often illustrates the violation of our criterion that objects should *look like* what they do. Automobiles commonly reveal a separation, a disjunction, between their appearance and their purpose. An automobile can be regarded as a type of moving sculpture which is often designed to conceal the way it works. But one of the modern maxims of art calls for "honesty of materials," that is, revelation of what an object is made of and how it functions; hence, as sculpture, the automobile is frequently dishonest. The desire to conceal the operational features of utilitarian art is a survival of the nineteenth-century aversion to machine imagery and to practical functions in general. Happily, contemporary ideas of design encourage the creation of forms whose function need not be concealed and whose materials need not imitate nature. Instead, we insist that the inside and the outside of a machine or a house be equally considered, as carefully designed, and as excellently constructed. We protest against the creation of objects with shoddy workmanship or inferior materials on the inside which are

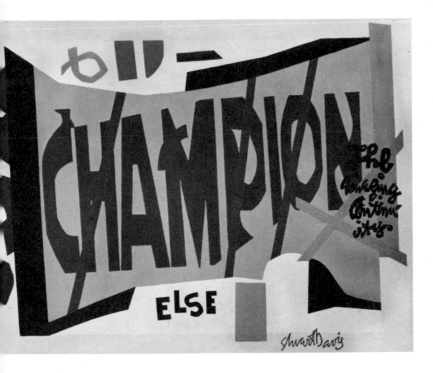

then covered with a gleaming "skin," a package which is all pretense and deceit. These principles of handcraftsmanship, now extended to the design and production of industrial art, constitute an ethical position while they also create an aesthetic foundation for art criticism. By "inferior materials" we do not imply that some materials are intrinsically superior to others. All materials are suitable for some purpose which the ingenuity of art and design can discover. Materials become "inferior" when

they are employed improperly, from the standpoints of reasonable durability, honesty of appearance, and logic of forming or fabrication.

While craftsmanship can be seen as an important aspect of the criticism of handmade objects, manufactured objects, and three-dimensional objects in general, it is a somewhat more elusive problem in the criticism of painting, drawing, graphics, and other "fine art" objects. This is because craftsmanship in painting and related

WENDELL CASTLE. Double chair. 1968

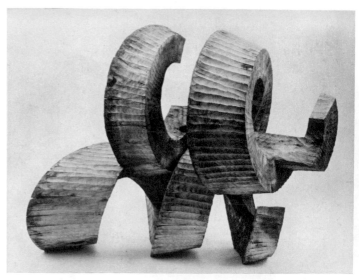

HANS HOKANSON. *Helixikos No. 1*. 1968. Borgenicht Gallery, New York

When the creation of illusions and the representation of images are not artistic objectives the critic can attend directly to relationships among materials, forms, processes, meanings, and purposes.

arts has been closely associated with the technical capacity to create convincing illusions, whereas the crafts stress the physical and operational results of technique. Another consideration of traditional pictorial art—resistance to peeling, cracking, crazing, and fading—is also in decline. Modern control of temperatures and humidity, plus superior media and supports, permit many works to survive whose craftsmanship is bad by older standards. Technique in modern painting, therefore, is almost independent of two of its principal reasons for being: illusion and permanence. Thus, when examining contemporary art critically, we look for signs of *technical mastery* in the artistic *performance*. We study execution—the application of paint, the development of shapes, the control of edges, the employment of drawing, the deployment of pigment for surface quality, the pursuit of coloristic effects—to learn whether these aspects of painterly performance have been managed successfully. Do they emerge from the artist's understanding of his medium, or do they represent failures of the artist to achieve what he apparently set out to do? The knowledgeable critic should be able to recognize technical incapacity; he should not confuse technical inadequacies with aesthetic innovation.

It would appear, then, that although permanence and illusion have receded in importance so far as craftsmanship is concerned, art criticism must nevertheless rely on analysis and evaluation of technical performance. When we study art, we are studying the results of technique, the consequences of a process of making. As critical experience increases, one becomes more skilled in distinguishing between artistic intent and aesthetic effect and thus more authoritative in judging the success of technical performance. Technical evaluation, then, is an instrument of aesthetic judgment which is indispensable for completing the critical act.

One of the most crucial decisions an artist needs to

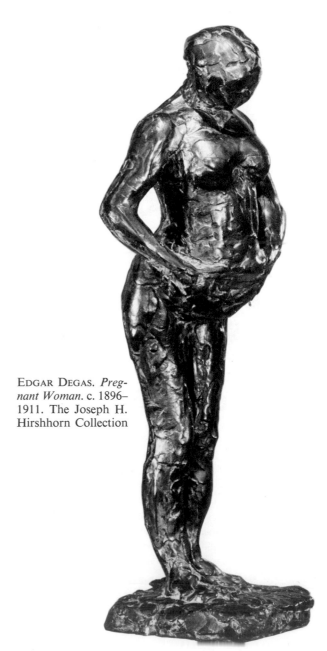

EDGAR DEGAS. *Pregnant Woman*. c. 1896–1911. The Joseph H. Hirshhorn Collection

make about his work is the decision to stop working. The process of execution is strewn with difficulties, but it also yields pleasures which are only reluctantly set aside. A time arrives, however, when the artist's critical judgment begins to overcome his desire to embellish and tinker with a substantially completed project. Since there is no rule which tells him when to quit, no buzzer signal announcing that the roast is done, no aesthetic policy of compulsory retirement from his labors, only prudence can stay the artist's hand. Prudence suggests that further elaboration *may* enhance an effect but is more likely to imperil those effects already achieved. This is true of a book, especially one that undertakes to discuss the art of criticism. The author of such a book ought to cherish conciseness more than exhaustive explanation; he should exhibit critical discrimination if he has not always displayed scholarly depth; he should be prudent if he has not always been wise. And he can demonstrate these virtues, or such portions of them as he may possess, by showing that he knows when it is time to conclude.

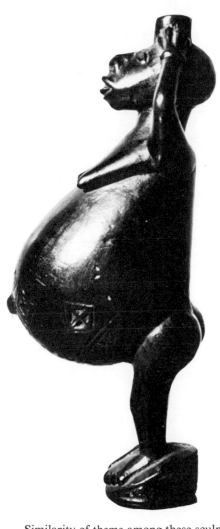

Fertility fetish, from the Lower Congo. Collection Mme J. Stoclet, Brussels

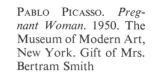

Pablo Picasso. *Pregnant Woman.* 1950. The Museum of Modern Art, New York. Gift of Mrs. Bertram Smith

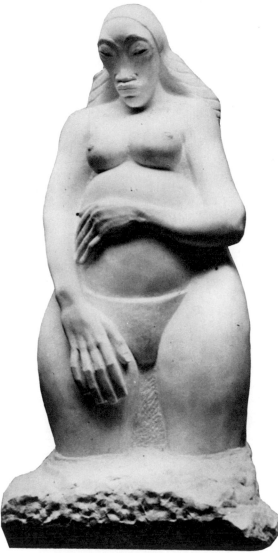

Similarity of theme among these sculptures provides a rough basis of comparability. Of course, the works differ in their dates, technique, and, to some extent, social function. But today's critic is most likely interested in the excellence of each work from the standpoint of plastic form and expressive effect. Clearly, the common motif has posed a common problem in the generation of meaning through sculpture. Hence we have reasonable grounds for relating the works and judging them. Were I to judge on the basis of these grounds—form and expressive power—I would have no doubt as to which is the superior work; it is the Congo fetish.

Jacob Epstein. *Genesis.* 1931. Whereabouts unknown

NOTES

1. *Garden Cities of Tomorrow* (London: Swan Sonnenschein, 1902).
2. Baker Brownell and Frank Lloyd Wright, *Architecture and Modern Life* (New York and London: Harper and Brothers, 1937), p. 302.
3. *The Living City* (New York: Horizon Press, 1958).
4. *Concerning Town Planning*, trans. Clive Entwistle (New Haven: Yale University Press, 1948), p. 118.
5. *Survival through Design* (New York: Oxford University Press, 1954).
6. *City Development* (New York: Harcourt, Brace and World, 1945), p. 121.
7. *The Life and Death of Great American Cities* (New York: Random House, 1961), p. 372.
8. See also Jane Jacobs, *The Economy of Cities* (New York: Random House, 1969).
9. *The Art of Painting* (New York: Philosophical Library, 1957), p. 172.
10. "How to Read a Painting," *Saturday Evening Post*, July 29, 1961, p. 20.
11. *Twentieth Century Engineering* (New York: Museum of Modern Art, 1964), unpaginated.
12. *Principles of Art History*, trans. Mary D. Hottinger (New York: Dover, 1950).
13. Gyorgy Kepes, *Language of Vision* (Chicago: Theobald, 1944), p. 13.
14. See David Riesman and Ruel Denney, "Football in America: A Study in Culture Diffusion," in *Individualism Reconsidered*, ed. David Riesman (Glencoe, Ill.: The Free Press, 1954).
15. See Erwin Panofsky, "The History of the Theory of Human Proportions as a Reflection of the History of Styles," in *Meaning in the Visual Arts* (New York: Doubleday, 1955).
16. Eliseo Vivas and Murray Krieger, *The Problems of Aesthetics* (New York: Holt, 1960), p. 181.
17. *The Play of Man*, trans. E. L. Baldwin (New York: D. Appleton, 1901).
18. *The Work of Art* (Bloomington: Indiana University Press, 1955), p. 153.
19. Kurt Koffka, *Principles of Gestalt Psychology* (London: Routledge and Kegan Paul, 1962), p. 98.
20. Koffka, *op. cit.*, p. 225.
21. Wolfgang Köhler, *Gestalt Psychology* (New York: New American Library, 1947), p. 98.
22. Koffka, *op. cit.*, p. 225; quotation from R. H. Thouless.
23. *History of Art Criticism* (New York: E. P. Dutton, 1936), p. 294.
24. *The Language of Drawing* (Englewood Cliffs, N.J.: Prentice-Hall, 1966), p. 93.
25. Allan Kaprow, "A Service for the Dead," *Art International*, January 25, 1963.
26. Quoted in Michael Kirby, *Happenings* (New York: E. P. Dutton, 1965).
27. Quoted in Peter Selz, "Jesse Reichek," *Art in America*, September–October, 1968, p. 98.
28. "Writings," in *The New Art: A Critical Anthology*, ed. Gregory Battcock (New York: E. P. Dutton, 1966), p. 205.
29. Quoted in Douglas M. Davis, "The Dimensions of the Miniarts," *Art in America*, November-December, 1967, p. 86.
30. *Art and Craft of Drawing* (London: Oxford University Press, 1927), p. 9.
31. "The New Sculpture," in *Art and Culture* (New York: Beacon Press, 1961), p. 142.
32. *The Eternal Present: The Beginnings of Art* (New York: Pantheon Books, 1962), pp. 525–26.
33. *African Art* (New York: Macmillan, 1954), p. 132.
34. *The Greek Myths* (New York: G. Braziller, 1959).
35. See his experiments with photograms and light modulators in *Vision in Motion* (Chicago: Theobald, 1947).
36. *Technics and Civilization* (New York: Harcourt, Brace, 1934).
37. "Design for Culture in Washington," *Saturday Review*, May 23, 1964, p. 23.
38. For a full discussion, see John Burchard and Albert Bush-Brown, *The Architecture of America* (Boston: Little, Brown, 1961), pp. 348–51.
39. Eduardo Torroja, *Philosophy of Structures* (Berkeley and Los Angeles: University of California Press, 1958), pp. 207–8.
40. *Conversations on the Arts* (Harrisburg: Pennsylvania Department of Public Instruction, 1967).
41. Torroja, *op. cit.*, p. 273.
42. See Milic Capec, *The Philosophical Impact of Contemporary Physics* (Princeton, N.J.: Van Nostrand, Reinhold, 1961).
43. See Edward T. Hall, *The Silent Language* (New York: Doubleday, 1959).
44. *Going Steady* (Boston: Atlantic-Little, Brown, 1970).
45. See William J. Free, "The Film as Poem," *The Georgia Review*, XXII (Summer, 1969).
46. See John Bagnell Bury, *The Idea of Progress* (London: Macmillan, 1920).
47. "Architecture and Man at Yale," *Saturday Review*, May 23, 1964.

BIBLIOGRAPHY

Following is a selected list of books and articles related to the major themes discussed in this volume. It is by no means complete. Rather the list is intended to be suggestive of the range and type of published material which can be consulted in connection with questions raised in the text. Specialized monographs and publications about individual artists have been omitted as much as possible. The listing of periodicals, too, has been kept to a minimum. World histories of art are not included on the assumption that the reader is already familiar with them or has access to a bibliography of the outstanding works of comprehensive art history.

THE FUNCTIONS OF ART

BOWMAN, WILLIAM J. *Graphic Communication.* New York: Wiley, 1967.

DORNER, ALEXANDER. *The Way beyond "Art."* New York University Press, 1958.

FELDMAN, EDMUND B. "Homes in America." *Arts and Architecture,* October and November, 1957.

FISCHER, ERNST. *The Necessity of Art: The Marxist Approach.* Translated by Anna Bostock. Baltimore: Penguin Books, 1964.

GOTSHALK, D. W. *Art and the Social Order.* University of Chicago Press, 1947.

HAUSER, ARNOLD. *The Philosophy of Art History.* New York: A. A. Knopf, 1959.

HUDNUT, JOSEPH. *Architecture and the Spirit of Man.* Cambridge: Harvard University Press, 1939.

HUYGHE, RENÉ. *Art and the Spirit of Man.* New York: Abrams, 1962.

———. *Ideas and Images in World Art: Dialogue with the Visible.* New York: Abrams, 1959.

KAVOLIS, VYTANTAS. *Artistic Expression: A Sociological Analysis.* Ithaca, N.Y.: Cornell University Press, 1968.

LARKIN, OLIVER. *Art and Life in America.* New York: Rinehart, 1949.

LOMMEL, ANDREAS. *Shamanism: The Beginnings of Art.* New York: McGraw-Hill, 1968.

MALRAUX, ANDRÉ. *The Voices of Silence.* New York: Doubleday, 1953.

MORRIS, WILLIAM. *On Art and Socialism.* London: Lehmann, 1947.

PELLES, GERALDINE. *Art, Artists and Society: Origins of a Modern Dilemma.* Englewood Cliffs, N.J.: Prentice-Hall, 1963.

RANK, OTTO. *Art and Artist.* Translated by Charles F. Atkinson, New York: Agathon Press, 1968.

READ, HERBERT. *The Grass Roots of Art.* New York: Wittenborn, Schultz, 1947.

SHAHN, BEN. *The Shape of Content.* Cambridge: Harvard University Press, 1957.

THE STYLES OF ART

ADAM, LEONHARD. *Primitive Art.* Baltimore: Penguin Books, 1949.

BARR, ALFRED H. *Fantastic Art, Dada, Surrealism.* New York: Museum of Modern Art, 1936.

BAUR, JOHN I. H. *Revolution and Tradition in Modern American Art.* Cambridge: Harvard University Press, 1951.

BOAS, FRANZ. *Primitive Art.* New York: Dover, 1955.

CLARK, SIR KENNETH. *The Nude.* Garden City, N.Y.: Anchor Books, 1959.

HITCHCOCK, HENRY-RUSSELL, and JOHNSON, PHILIP. *The International Style: Architecture since 1922.* New York: Norton, 1932.

HUNTER, SAM. *Modern American Painting and Sculpture.* New York: Dell, 1959.

KROEBER, A. L. *Style and Civilizations.* Ithaca, N.Y.: Cornell University Press, 1957.

LIPPARD, LUCY. *Pop Art.* New York: Praeger, 1967.

MADSEN, STEPHAN T. *Art Nouveau.* New York: McGraw-Hill, 1967.

MYERS, BERNARD. *Expressionism in German Painting: A Generation in Revolt.* New York: Praeger, 1947.

O'DOHERTY, BRIAN. "Miami and the Iconography of the Pompadour Style." *Art International,* Vol. XIII, No. 7, March, 1959.

ORTEGA Y GASSET, JOSÉ. *The Dehumanization of the Arts.* Garden City, N.Y.: Anchor Books, 1956.

PANOFSKY, ERWIN. *Meaning in the Visual Arts.* Garden City, N.Y.: Anchor Books, 1955.

REWALD, JOHN. *Post-Impressionism from Van Gogh to Gauguin.* New York: Museum of Modern Art, 1956.

RITCHIE, ANDREW C. *Abstract Painting and Sculpture in America.* New York: Museum of Modern Art, 1951.

ROSENBERG, HAROLD. "The American Action Painters." *Art News,* December, 1952.

ROWLAND, BENJAMIN. *Art in East and West: An Introduction through Comparisons.* Cambridge: Harvard University Press, 1954.

RUBIN, WILLIAM S. *Dada, Surrealism, and Their Heritage.* New York: Museum of Modern Art, 1968.

SEITZ, WILLIAM C. *The Art of Assemblage.* New York: Museum of Modern Art, 1961.

SELZ, PETER, ed. *Art Nouveau: Art and Design at the Turn of the Century.* New York: Museum of Modern Art, 1959.

SEUPHOR, MICHEL. *Abstract Painting.* New York: Dell, 1964.

SHAPIRO, MEYER. "Style." In *Anthropology Today*, edited by A. L. Kroeber. University of Chicago Press, 1953.

SOBY, JAMES THRALL, and MILLER, DOROTHY C. *Romantic Painting in America.* New York: Museum of Modern Art, 1943.

TAYLOR, JOSHUA C. *Futurism.* New York: Museum of Modern Art, 1961.

VENTURI, LIONELLO. *Impressionists and Symbolists.* New York: Scribner's, 1950.

WÖLFFLIN, HEINRICH. *Principles of Art History.* Translated by Mary D. Hottinger. New York: Dover, 1950.

WORRINGER, WILHELM. *Abstraction and Empathy: A Contribution to the Psychology of Style.* Translated by Michael Bullock. New York: International Universities Press, 1953.

——. *Form in Gothic.* Translated by Herbert Read. London: Putnam, 1927.

ZUCKER, PAUL. *Styles in Painting.* New York: Viking Press, 1950.

THE STRUCTURE OF ART

ANDERSON, DONALD M. *Elements of Design.* New York: Holt, Rinehart and Winston, 1961.

ARNHEIM, RUDOLPH. *Art and Visual Perception.* Berkeley and Los Angeles: University of California Press, 1954.

——. "A Review of Proportion." *Journal of Aesthetics and Art Criticism*, Vol. XIV, No. 1, September, 1956.

CATALDO, JOHN W. *Graphic Design and Visual Communication.* Scranton, Pa.: International Textbook, 1966.

COLLIER, GRAHAM. *Form, Space and Vision.* 2nd rev. ed. Englewood Cliffs, N.J.: Prentice-Hall, 1967.

DEWEY, JOHN. *Art as Experience.* New York: Minton, Balch, 1934.

EHRENZWEIG, ANTON. *The Psychoanalysis of Artistic Vision and Hearing: An Introduction to a Theory of Unconscious Perception.* New York: Julian Press, 1953.

GOMBRICH, E. H. "How to Read a Painting." *Saturday Evening Post*, July 29, 1961.

HILL, EDWARD. *The Language of Drawing.* Englewood Cliffs, N.J.: Prentice-Hall, 1966.

ITTEN, JOHANNES. *Design and Form: The Basic Course at the Bauhaus.* New York: Reinhold, 1964.

KEPES, GYORGY. *Language of Vision.* Chicago: Theobald, 1944.

KLEE, PAUL. *Pedagogical Sketchbook.* New York: Praeger, 1953.

KOFFKA, KURT. *Principles of Gestalt Psychology.* London: Routledge and Kegan Paul, 1935.

MENDELOWITZ, DANIEL M. *Drawing.* New York: Holt, Rinehart and Winston, 1967.

MOHOLY-NAGY, LÁSZLÓ. *The New Vision.* 4th rev. ed. New York: Wittenborn, Schultz, 1949.

——. *Vision in Motion.* Chicago: Theobald, 1947.

MOLES, ABRAHAM. *Information Theory and Esthetic Perception.* Urbana: University of Illinois Press, 1966.

PEPPER, STEPHEN C. "The Concept of Fusion in Dewey's Aesthetic Theory." *Journal of Aesthetics and Art Criticism*, Vol. XII, No. 2, December, 1953.

——. *The Work of Art.* Bloomington: Indiana University Press, 1955.

WEYL, HERMANN. *Symmetry.* Princeton University Press, 1952.

WÖLFFLIN, HEINRICH. *The Sense of Form in Art: A Comparative Psychological Study.* New York: Chelsea, 1958.

PAINTING

ARNASON, HARVARD H. *History of Modern Art.* New York: Abrams, 1968.

BERGER, JOHN. *The Success and Failure of Picasso.* Baltimore: Penguin Books, 1965.

CANADAY, JOHN. *Mainstreams of Modern Art.* New York: Holt, Rinehart and Winston, 1959.

DOERNER, MAX. *The Materials of the Artist.* Translated by Eugen Neuhaus. New York: Harcourt, Brace, 1949.

HAFTMANN, WERNER. *Painting in the Twentieth Century.* 2 vols. New York: Praeger, 1960.

HENRI, ROBERT. *The Art Spirit.* Philadelphia: Lippincott, 1923.

HITCHCOCK, HENRY-RUSSELL. *Painting Toward Architecture.* New York: Duell, Sloan and Pearce, 1948.

JANIS, HARRIET, and BLESH, RUDI. *Collage: Personalities, Concepts, Techniques.* Philadelphia: Chilton Book, 1962.

JENSEN, LAWRENCE N. *Synthetic Painting Media.* Englewood Cliffs, N.J.: Prentice-Hall, 1964.

KANDINSKY, WASSILY. *Concerning the Spiritual in Art and Painting in Particular.* New York: Wittenborn, Schultz, 1947.

KIRBY, MICHAEL. *Happenings.* New York: E. P. Dutton, 1965.

LEONARDO DA VINCI. *The Art of Painting.* New York: Philosophical Library, 1957.

MAYER, RALPH. *Artist's Handbook of Materials and Techniques.* New York: Viking Press, 1947.

READ, HERBERT. *A Concise History of Modern Painting.* New York: Praeger, 1959.

SEITZ, WILLIAM C. *The Art of Assemblage.* New York: Museum of Modern Art, 1961.

SELZ, PETER. *New Images of Man.* Prefatory note by Paul Tillich. New York: Museum of Modern Art, 1959.

VENTURI, LIONELLO. *Modern Painters.* New York: Scribner's, 1947.

WILLIAMS, HIRAM. *Notes for a Young Painter.* Englewood Cliffs, N.J.: Prentice-Hall, 1963.

SCULPTURE

ARNHEIM, RUDOLPH. "The Holes of Henry Moore." *Journal of Aesthetics and Art Criticism*, Vol. VII, September, 1948.

GEIST, SIDNEY. "Miracle in the Scrapheap." *Art Digest*, Vol. XXVIII, December, 1953.

GIEDION-WELCKER, CAROLA. *Contemporary Sculpture: An Evolution in Volume and Space.* New York: Wittenborn, Schultz, 1955.

GOOSEN, E. C., GOLDWATER, R., and SANDLER, I. *Ferber, Hare, Lassaw: Three American Sculptors.* New York: Grove Press, 1959.

IRVING, DONALD J. *Sculpture: Materials and Processes.* New York: Van Nostrand-Reinhold, 1969.

Modern Sculpture from the Joseph H. Hirshhorn Collection. New York: Solomon R. Guggenheim Museum, 1962.

MYERS, BERNARD. *Sculpture: Form and Methods.* New York: Reinhold, 1965.

READ, HERBERT. *A Concise History of Modern Sculpture.* New York: Praeger, 1964.

RICKEY, GEORGE. *Constructivism: Origins and Evolution.* New York: G. Braziller, 1967.

RITCHIE, ANDREW C. *Sculpture of the Twentieth Century.* New York: Museum of Modern Art, 1952.

RITCHIE, ANDREW C., ed. *German Art of the Twentieth Century.* New York: Museum of Modern Art, 1959.

RODIN, AUGUSTE. *On Art and Artists.* New York: Philosophical Library, 1957.

SCHMALENBACH, WERNER. *African Art.* New York: Macmillan, 1954.

SEUPHOR, MICHEL. *The Sculpture of This Century.* New York: G. Braziller, 1960.

ARCHITECTURE

ANDREWS, WAYNE. *Architecture, Ambition and Americans.* New York: Harper, 1955.

BURCHARD, JOHN, and BUSH-BROWN, ALBERT. *The Architecture of America.* Boston: Little, Brown, 1961.

CONRADS, ULRICH, and SPERLICH, HANS. *The Architecture of Fantasy: Utopian Building and Planning in Modern Times.* New York: Praeger, 1962.

DREXLER, ARTHUR. *Ludwig Mies van der Rohe.* New York: G. Braziller, 1960.

FITCH, JAMES M. *American Building.* Boston: Houghton Mifflin, 1948.

GIEDION, SIEGFRIED. *Space, Time and Architecture: The Growth of a New Tradition.* 3rd rev. ed. Cambridge: Harvard University Press, 1954.

HITCHCOCK, HENRY RUSSELL. *In the Nature of Materials: The Buildings of Frank Lloyd Wright, 1887–1941.* New York: Duell, Sloan, and Pearce, 1942.

JEANNERET-GRIS, CHARLES E. [LE CORBUSIER]. *New World of Space.* New York: Reynal and Hitchcock, 1948.

JEANNERET-GRIS, CHARLES E. [LE CORBUSIER], and JEANNERET, PIERRE. *Complete Works.* Edited by W. Boesiger and H. Girsberger. Vols. 1–4 (1910–1946). New York: Wittenborn, 1960, 1964 (Vols. 1 and 3), and 1961.

NEUTRA, RICHARD. *Survival through Design.* New York: Oxford University Press, 1954.

RAGON, MICHEL. *Aesthetics of Contemporary Architecture.* New York: Wittenborn, 1969.

RASMUSSEN, STEEN EILER. *Experiencing Architecture.* Cambridge: Massachusetts Institute of Technology Press, 1959.

RICHARDS J. M. *An Introduction to Modern Architecture.* Baltimore: Penguin Books, 1948.

RUDOFSKY, BERNARD. *Architecture Without Architects: An Introduction to Non-Pedigreed Architecture.* New York: Museum of Modern Art, 1964.

SALVADORI, MARIO, and HELLER, ROBERT. *Structure in Architecture.* Englewood Cliffs, N.J.: Prentice-Hall, 1963.

SCOTT, GEOFFREY. *The Architecture of Humanism: A Study in the History of Taste.* London: Constable, 1914.

SCULLY, VINCENT J. *American Architecture and Urbanism.* New York: Praeger, 1969.

TORROJA, EDUARDO. *Philosophy of Structures.* Translated by Milos and J. J. Polivka. Berkeley and Los Angeles: University of California Press, 1958.

CITY PLANNING

BLAKE, PETER. *God's Own Junkyard: The Planned Deterioration of America's Landscape.* New York: Holt, Rinehart and Winston, 1964.

CHERMAYEFF, SERGE, and ALEXANDER, CHRISTOPHER. *Community and Privacy: Toward a New Architecture of Humanism.* Garden City, N.Y.: Anchor Books, 1963.

GOODMAN, PAUL and PERCIVAL. *Communitas: Means of Livelihood and Ways of Life.* New York: Vintage Books, 1960.

GROPIUS, WALTER. *Rebuilding Our Communities.* Chicago: Theobald, 1945.

HALPRIN, LAWRENCE. *Cities.* New York: Reinhold, 1963.

HOLLAND, LAWRENCE B., ed. *Who Designs America?* Garden City, N.Y.: Anchor Books, 1966.

JACOBS, JANE. *The Death and Life of Great American Cities.* New York: Random House, 1961.

JEANNERET-GRIS, CHARLES E. [LE CORBUSIER]. *Concerning Town Planning.* Translated by Clive Entwistle. New Haven: Yale University Press, 1948.

LARKIN, OLIVER W. *Art and Life in America.* New York: Rinehart, 1949.

LYNCH, KEVIN. *The Image of the City.* Cambridge: Technology Press and Harvard University Press, 1960.

MEYERSON, MARTIN, and ASSOCIATES. *Face of the Metropolis.* New York: Random House, 1963.

MOHOLY-NAGY, SIBYL. *Matrix of Man: An Illustrated History of Urban Environment.* New York: Praeger, 1968.

MUMFORD, LEWIS. *The City in History.* New York: Harcourt, Brace, 1961.

RUDOFSKY, BERNARD. *Streets for People: A Primer for Americans.* New York: Doubleday, 1969.

SERT, JOSÉ LUIS. *Can Our Cities Survive?* Cambridge: Harvard University Press, 1942.

SITTE, CAMILLO. *The Art of Building Cities.* New York: Reinhold, 1945.

TUNNARD, CHRISTOPHER, and PUSHKAREV, BORIS. *Man-Made America: Chaos or Control; An Inquiry into Selected Problems of Design in the Urbanized Landscape.* New Haven: Yale University Press, 1963.

WRIGHT, FRANK LLOYD. *The Living City.* New York: Horizon Press, 1958.

ZUCKER, PAUL. *Town and Square.* New York: Columbia University Press, 1959.

THE CRAFTS AND INDUSTRIAL DESIGN

BANHAM, REYNER. *Theory and Design in the First Machine Age.* New York: Praeger, 1960.

DANIEL, GRETA. *Useful Objects Today.* New York: Museum of Modern Art, 1954.

DITZEL, NINNA and JORGEN. *Danske Stole* (Danish Chairs). Copenhagen: Høst, 1954.

DREXLER, ARTHUR. "The Disappearing Object." *Saturday Review*, May 23, 1964.

DREXLER, ARTHUR, and DANIEL, GRETA. *Introduction to Twentieth Century Design*. New York: Museum of Modern Art, 1959.

GIEDION, SIGFRIED. *Mechanization Takes Command*. New York: Oxford University Press, 1948.

GROPIUS, WALTER and ISE. *Bauhaus, 1919–1928*. Edited by Herbert Bayer. New York: Museum of Modern Art, 1938.

KOUWENHOVEN, JOHN A. *Made in America: The Arts in Modern Civilization*. New York: Doubleday, 1949.

MORRIS, WILLIAM. *Hopes and Fears for Art*. Vol. 23 of *Collected Works*. London: Longmans, Green, 1914.

MUMFORD, LEWIS. *Art and Technics*. 2nd rev. ed. New York: Columbia University Press, 1934.

———. *Technics and Civilization*. New York: Harcourt, Brace, 1934.

PEVSNER, NIKOLAUS. *Pioneers of Modern Design from William Morris to Walter Gropius*. New York: Museum of Modern Art, 1949.

READ, HERBERT. *Art and Industry*. London: Faber & Faber, 1934.

ROSENTHAL, RUDOLPH, and RATZKA, HELENA L. *The Story of Modern Applied Art*. New York: Harper, 1948.

FILM

ARNHEIM, RUDOLPH. *Film as Art*. Berkeley and Los Angeles: University of California Press, 1958.

CERAM, C. W. *Archaeology of the Cinema*. New York: Harcourt, Brace and World, 1965.

KRACAUER, SIEGFRIED. *Theory of Film: The Redemption of Physical Reality*. New York: Oxford University Press, 1960.

MACGOWAN, KENNETH. *Behind the Screen: The History and Techniques of the Motion Picture*. New York: Delacorte Press, 1965.

MANVELL, ROGER. *Film*. Harmondsworth, England: Penguin Books, 1950.

NILSEN, VLADIMIR. *The Cinema as a Graphic Art: On a Theory of Representation in the Cinema*. Translated by Ivor Montagu. New York: Hill and Wang, 1959.

PANOFSKY, ERWIN. "Style and Medium in the Motion Pictures." In *Aesthetics and Criticism in Art Education: Problems in Defining, Explaining, and Evaluating Art*, edited by Ralph A. Smith. Chicago: Rand McNally, 1966.

SPOTTISWOODE, RAYMOND. *Film and Its Techniques*. Berkeley and Los Angeles: University of California Press, 1966.

STEPHENSON, RALPH, and DEBRIX, JEAN R. *The Cinema as Art*. Baltimore: Penguin Books, 1965.

TYLER, PARKER. *Classics of the Foreign Film*. New York: Citadel Press, 1962.

———. *The Three Faces of the Film*. Cranbury, N.J.: Barnes, 1967.

WHITAKER, ROD. *The Language of Film*. Englewood Cliffs, N.J.: Prentice-Hall, 1970.

ART CRITICISM

ACKERMAN, JAMES L., and CARPENTER, RHYS. *Art and Archaeology*. Englewood Cliffs, N.J.: Prentice-Hall, 1963.

BOAS, GEORGE. *A Primer for Critics*. Baltimore: Johns Hopkins University Press, 1937.

CANADAY, JOHN. *Embattled Critic*. New York: Farrar, Straus and Cudahy, 1962.

FELDMAN, EDMUND B. "The Critical Act." *The Journal of Aesthetic Education*, Vol. I, No. 2, Autumn, 1966.

———. "Works of Art as Humanistic Inquiries." *The School Review*, Vol. LXXII, No. 3, 1964.

GREENBERG, CLEMENT. "How Art Writing Earns its Bad Name." *Encounter*, XIX:6.

GREENE, THEODORE M. *The Arts and the Art of Criticism*. Princeton University Press, 1947.

VON HOLST, NIELS. *Creators, Collectors and Connoisseurs: The Anatomy of Artistic Taste From Antiquity to the Present Day*. New York: Putnam's, 1967.

JACOBS, JAY. "What Should a Critic Be?" *Art in America*, No. I, 1965.

KADISH, MORTIMER R. *Reason and Controversy in the Arts*. Cleveland: Case Western Reserve University Press, 1968.

KAPLAN, ABRAHAM. "Referential Meaning in the Arts." *Journal of Aesthetics and Art Criticism*, Vol. XII, No. 4, June, 1954.

LIPMAN, MATTHEW. *What Happens in Art*. New York: Appleton-Century-Crofts, 1969.

LYNES, RUSSELL. *The Tastemakers*. New York: Harper, 1954.

MARGOLIS, JOSEPH. *The Language of Art and Art Criticism*. Detroit: Wayne State University Press, 1965.

NEUMEYER, ALFRED. *The Search for Meaning in Modern Art*. Englewood Cliffs, N.J.: Prentice-Hall, 1964.

PANOFSKY, ERWIN. *Studies in Iconology*. New York: Oxford University Press, 1939.

PEPPER, STEPHEN C. *The Basis of Criticism in the Arts*. Cambridge: Harvard University Press, 1949.

PYE, DAVID W. *The Nature and Art of Workmanship*. Cambridge University Press, 1968.

RADER, MELVIN. *A Modern Book of Esthetics*. New York: Holt, Rinehart and Winston, 1960.

ROSENBERG, HAROLD. *The Anxious Object*. New York: Horizon Press, 1964.

STOLNITZ, JEROME. *Aesthetics and Philosophy of Art Criticism: A Critical Introduction*. Boston: Houghton Mifflin, 1960.

VENTURI, LIONELLO, *History of Art Criticism*. New York: E. P. Dutton, 1936.

VIVAS, ELISEO, and KRIEGER, MURRAY. *The Problems of Aesthetics*. New York: Holt, Rinehart and Winston, 1960.

INDEX OF NAMES AND WORKS

Horyu-ji (Nara, Japan), caricature from ceiling of, 71
HOWARD, EBENEZER, 116; Garden City plans, 116–17, 117
HOWELLS, JOHN MEAD, Chicago Tribune Building, 371, 371; Daily News Building (New York), 371, 371
HUBERT BENNETT & ASSOCIATES, Hayward Art Gallery (London), 592
HUNT, RICHARD, Icarus, 506
Hypostyle Hall, Temple of Karnak (Egypt), model of, 530

INDIANA, ROBERT, 425, 429; Beware–Danger American Dream #4, 428
INGRES, JEAN-AUGUSTE-DOMINIQUE, 228, 390, 406; Madame Moitessier Seated, 405; Odalisque with a Slave, 445; Venus Anadyomene, *644, 649
ISAACS, KENNETH, Ultimate Living Structure, 97
ISENBERG, ARNOLD, 350

JACOBS, JANE, 142
JAWLENSKY, ALEXEJ VON, 317; Self-Portrait, *402; Still Life with Lamp, *209, 317
JEFFERSON, THOMAS, 76, 117; Monticello, 76
JENKINS, PAUL, Phenomena in Heavenly Way, *224
Jockey, 203
JOHNS, JASPER, 425
JOHNSON, PHILIP, 107, 414–16, 584; glass house (New Canaan, Conn.), 107, 107, 368, 369; Beckman Auditorium, California Institute of Technology (Pasadena), 586; Museum of Pre-Columbian Art (Dumbarton Oaks, Washington, D.C.), 584, 585; New York State Theater at Lincoln Center (New York), 584
JŌKEI, Shō-Kannon, 458
JUDD, DONALD, Untitled, 505
JUHL, FINN, 163–64; leather-and-teak armchair, 162; teak armchair, 163, 163
JULIUS II, POPE, 57
JUSTINIAN, Hagia Sophia (Istanbul), 577, 577–78

KAEL, PAULINE, 600
KAHN, ELY J., 139; Municipal Asphalt Plant (New York), 139
KAHN, LOUIS I., residence hall, Bryn Mawr College (Bryn Mawr, Pa.), 593; Salk Institute for Biological Studies (La Jolla, Calif.), *576
KANDINSKY, WASSILY, 228, 312, 317–18, 349, 370, 437, 622; Concerning the Spiritual in Art (book), 228; Landscape with Houses, *222, 317; Study for Composition No. 2, *222, 317; Study for Composition 7, 623
KANE, JOHN, 186; Self-Portrait, 186, 187
KANT, IMMANUEL, 354
KAPROW, ALLEN, 429, 431–33, 515; Orange, 432
KAZAN, ELIA, 59; America, America (film stills from), 59, 60
KELLY, ELLSWORTH, 349, 414; Aubade, 301
KEPES, GYORGY, 327
KIENHOLZ, EDWARD, 489; Beanery, 430–31; Friendly Grey Computer—Star Gauge Model #54, 366; John Doe, 489, 490; State Hospital, *419; Widow, 489, 490
KIESLER, FREDERICK, 495; Endless House, 494
King David (Cathedral of Santiago de Compostela, Spain), 626
King Mycerinus and His Queen Kha-merer-

nebty (from Giza), *454
KINGMAN, DONG, 65; "El" and Snow, 65, 66
King's College (Cambridge, Eng.), Chapel of, 568, 569
KIRCHNER, LUDWIG, Portrait of Gräf, *403
KIRK, WALLACE AND MCKINLEY, Church of the Good Shepherd (Bellevue, Wash.), 542
KLEE, PAUL, 90, 286–87, 303, 372–73, 412; And I Shall Say, 292, 292; Bust of a Child, 91; Child's Game, 91; Daringly Poised, 338; Family Walk, 286, 287; Flight from Oneself, 286, 287, 300; Great Dome, 298–300, 300; Portrait of a Pregnant Woman, 361; Self-Portrait, 303, 304; Shame, 623
KLINT, TAGE, 163–64
KLINE, FRANZ, 65–67; Painting No. 7, 338; Third Avenue, 65, 66
KLUVER, BILLY, creation of sculpture with helium-filled pillows, 523
KOCH, JOHN, 26; Siesta, 26, 27
KOFFKA, KURT, 362–63
KÖHLER, W., 363
KOHN, GABRIEL, Nantucket, 461
KOKKO, BRUCE, Paint Can with Brush, 517
KOKOSCHKA, OSKAR, 26, 29, 246, 308; Self-Portrait, 246, 246, *401; Wind's Bride (Tempest), 26, 26
KOLLWITZ, KÄTHE, 30–31; Death and the Mother, 30, 31; Peasant War Cycle: Sharpening of the Scythe, 595; War Cycle: The Parents, 305
Kouros (from Melos), 657
KRAMER, HILTON, 617
KRICKE, NORBERT, Raumplastik Kugel, 283
KRIEGER, MURRAY, 350
KURCHAN, JUAN, lounge chair, 157

LABROUSTE, HENRI, 545, 583; Bibliothèque Sainte-Geneviève (Paris), 545, 545
LACHAISE, GASTON, 22–25; Standing Woman, 22–25, 25
Lady Nofret, 458
LA FRESNAYE, ROGER DE, 26–29; Conjugal Life, 26–29, 28; Conquest of the Air, 268, 268–73
LANCELEY, COLIN, Inverted Personage, 47;
LANDSEER, EDWIN, Isaac van Amburgh with His Animals, 257
LANGE, DOROTHEA, White Angel Breadline, San Francisco, 61
LANING, EDWARD, Newcomers to the New World (detail of The Role of the Immigrant in the Industrial Development of America), 628
LA ROSA, MANUEL, entrance to housing development (Tequexquitengo, Mex.), 588
LAROYE, SAMUEL, Bicycle mask of the Gelede Secret Society, Yoruba tribe, 50
LASSAW, IBRAM, 368, 376; Sirius, 369
LA TOUR, GEORGES DE, 308; Saint Mary Magdalen with a Candle, 131, 308
LAWRENCE, JACOB, 63; Pool Parlor, 63, 63
LAWSON, ERNEST, 59
Lazarus, Church of (Kizhi Island, U.S.S.R), 532
LEBRUN, RICO, 244–45; Bound Figure, 491; Migration to Nowhere, 244, 245
LE CORBUSIER (CHARLES-EDOUARD JEANNERET-GRIS), 40, 97, 98, 104, 107–14, 121, 352, 376, 410, 414, 535, 555, 560, 583; armchair with adjustable back, 160, 160; chaise longue, 160; chaise-longue frame, 108; High Court Building (Chandigarh, India), 110; Modulor (Module), 120–21, 120, 345, 346; Notre Dame du Haut (Ronchamp, France), 40, 111, 112, 297, 297, *574; Secretariat Building (Chandigarh, India), *540; Unité

d'Habitation, 108, 108, 111–12, 121, 583; Villa Savoye, 107–8, 108, 109; Villa Shodan, 108–9, 109; Ville Radieuse: Voisin Plan for Paris, 119, 119–22
LEE, VERNON, 364
LEGER, FERNAND, 80, 84, 196, 207, 291–92, 486; Grande Julie, 291, 291–92, 486; Nudes in the Forest, 621; Three Women (Le Grand Déjeuner), 80, 81
LEHMBRUCK, WILHELM, 18, 185, 241, 242, 349; Young Man Seated, 184, 185
LELII, ANGELO, Cobra lamp, 526
LE NAIN, LOUIS, Peasants at Supper, 22
LEONARDO DA VINCI, 71, 197, 230–31, 295, 304, 306, 380–81, 506, 517; Caricature of an Ugly Old Woman, 71; Last Supper, 381; Plans for a Spinning Wheel, 94; Portrait of a Musician, *394; Studio del Corpo Humano, 201; Study for Adoration of the Magi, 388
LEONHARDT, FRITZ, TV tower (Stuttgart, Ger.), 586, 587
LEVINE, JACK, 72, 75, 383; Banquet, 242; Feast of Pure Reason, 72, 73; Welcome Home, 241–42, 242
LEV ZETLIN ASSOCIATES, INC., proposed bridge for Baltimore inner harbor, 547
LEWITT, SOL, 47 Three-Part Variations on 3 Different Kinds of Cubes, 505
LICHTENSTEIN, ROY, 424, 427, 429; Ceramic Sculpture I, 144; Kiss, 426
Lincoln Center for the Performing Arts (New York), 133, 134, 584
LINDNER, RICHARD, Hello, *191
LIPPOLD, RICHARD, 227, 331, 525; Variation Number 7: Full Moon, 227, 227, 330
LIPPS, THEODOR, 353–54, 362, 364, 434–35
LIPTON, SEYMOUR, 40, 649; Archangel, 465; Cerberus, 648, 649; Menorah, 40, 40
LOEWY, RAYMOND, 164
LORENTZ, PARE, 604
LOUIS, MORRIS, Moving In, *224
LOW, DAVID, 71–72; Angels of Peace Descend on Belgium, 72, 72; Rendezvous, 72, 72; Very Well, Alone, 52
LUCAS, ROGER, three-finger ring, 518
LUCCHESI, BRUNO, 486; Seated Woman #2, 507; Woman on Bicycle, 485
LUKS, GEORGE, 59
LUNDY, VICTOR, St. Paul's Lutheran Church (Sarasota, Fla.), 218
LUSTIG, ALVIN, 80–81; Fortune magazine cover, 80, 81
LYE, LEN, 508; Fountain, 508, 510
LYTLE, RICHARD, 391–92; Possessed, 392, 392

MACDONALD-WRIGHT, STANTON, 317; Abstraction on Spectrum (Organization, 5), *211, 317
MACIVER, LOREN, Hopscotch, *270
MAGRITTE, RENE, Personal Values, 198
MAILLART, ROBERT, 95, 553, 583; Schwandbach Bridge (Bern), 553
MAILLOL, ARISTIDE, 196, 202, 343, 468, 478, 636; Desire, 24, 25
MAITANI, LORENZO, Last Judgment, 493
MALEVICH, KASIMIR, 303, 349, 437; Eight Red Rectangles, 342; Suprematist Composition: White on White, 303, 304
MALLARY, ROBERT, 486–87; Juggler, 486, 487
MALRAUX, ANDRE, Museum Without Walls (book), 651
Mammoth Cave (Ky.), 495
MANET, EDOUARD, 29, 59, 308–10; Dead Christ with Angels, 198; Déjeuner sur l'herbe (Luncheon on the Grass), 28, 29, 308; Luncheon in the Studio, *397; Olympia, 234, 308–10, 309

MANTEGNA, ANDREA, *Lamentation* 198
MANZU, GIACOMO, 184, 185; *Children's Games*, 203; *Girl in Chair*, 184, 184–85
Maoist poster, 52
MARC, FRANZ, 368; *Blue Horses*, 368, 368
MARGOULIES, BERTA, 59; *Mine Disaster*, 58, 59
Marina City (Chicago), *539
MARINI, MARINO, 367; *Horse and Rider*, 366, 367
MARIN, JOHN, 247, 343; *Maine Islands*, 247, 247
MARISOL (ESCOBAR), 275; *Bicycle Race*, *476; *Generals*, 275, 276
MARKELIUS, SVEN, Vällingby, Sweden, 123
MASON, JOHN, 488; relief panel in Wilshire-Flower Tishman Building (Los Angeles), 489
MATHIEU, GEORGES, 385, 653–55, 656; *Mort d'Attila*, 384, 385; *Noir sur Noir*, 654, 654
MATHSSON, BRUNO, 163–64; armchair, 161, 161
MATISSE, HENRI, 225–27, 317, 318, 370, 434, 467; *Carmelina*, 333; *Green Stripe (Madame Matisse)*, *402; *Lady in Blue*, 225, 226; *Nude with Face Half-Hidden*, 290–91, 291
MATTA (ECHAURREN), 273; *Disasters of Mysticism*, *270, 348, 348–49; *Here Sir Fire, Eat!*, 268, 273
MATTSON, HENRY E., 233; *Wings of the Morning*, 233, 233
MAURER, INGO, giant bulb, 326
MAX, PETER, *Blues and Piano Artistry of Meade Lux Lewis* (album cover for), 78
McGOWEN, CHARLES, photograph of raindrop reflections in a screen door, 425
McKIM, MEAD AND WHITE, Pennsylvania Station (New York), 139, 140
MENDELSOHN, ERIC, Einstein Tower (Potsdam, Ger.), 591
METZINGER, JEAN, *Tea Time*, 629
Mexican: Whistle in the form of a swinging girl (Veracruz, Mex.), 509
MICHALS, DUANE, photograph of Hilton Kramer, 632
MICHEL, JULIO, Sanlazaro Subway Station (Mexico City), 581
MICHELANGELO, 76, 239, 378–79, 380, 452, 458, 468; *David*, 239; *Drawing for the Fortification of Florence*, 95; *Heroic Captive*, 239; *Isaiah* (ceiling of Sistine Chapel), 379, 379; *Last Judgment*, 239, 239; *Libyan Sibyl*, 386; *Libyan Sibyl*, studies for, 386; *Pietà*, 627, 627; *Prophet Joel*, *394; *Rebellious Slave*, 490, 491; St. Peter's (Rome), 76, 529, 571, 577, 578; Sistine Chapel frescoes, 379, 379; *Unfinished Slave*, 452
MIES VAN DER ROHE, LUDWIG, 99, 103–8, 112, 114, 160, 207–13, 283, 414, 495, 583–86, 615–16, 620, 655; armchair, 157–58, 158; Barcelona Chair, 108, 157, 157; Crown Hall, Illinois Institute of Technology (Chicago), 106, 550, 551; Farnsworth House (Plano, Ill.), 106, 107; project for circular glass skyscraper, 551–52, 552; School of Architecture, Illinois Institute of Technology (Chicago), 107, 138; Seagram Building (New York), 204, 213, 550, 620; Tugendhat House (Brno, Czech.), 105, 105
MILONADIS, KONSTANTIN, *Flower Garden*, 511
MINGUZZI, LUCIANO, *Unknown Political Prisoner: Figure Enmeshed*, 51; *Woman Jumping Rope*, 507
MINORU YAMASAKI AND ASSOCIATES, IBM Building (Seattle), 586; North Shore Congregation Israel Synagogue (Glencoe, Ill.), 592
MIRO, JOAN, 90, 216, 298, 302, 370, 508;

Harlequinade, 298, 299; *Man and Woman*, *473; *Maternity*, 338–39, 339; *Nursery Decoration*, 91; *Personnages rythmiques*, 216, 217; *Persons Haunted by a Bird*, 442; *Poetic Object*, *418
MODIGLIANI, AMEDEO, 25, 29, 81–82, 214, 241, 242, 343, 349, 443; *Anna de Zborowska*, 83; *Reclining Nude*, 25, 25
MOESCHAL, JACQUES, sculpture for the Route of Friendship, Mexico City, 129
MOGENSEN, BORGE, oak-and-leather armchair, 163, 163
MOHOLY-NAGY, LASZLO, 153, 527; *Light-Space Modulator*, 525
MOLIERE, 293
MONDRIAN, PIET, 68, 105, 202, 206, 207, 213, 231, 283, 308, 352, 370, 435, 437, 495, 615–16, 620, 622; *Broadway Boogie-Woogie*, 68, 69; *Composition with Red, Yellow, and Blue*, 206, 206–7; *Flowering Trees*, 213; *Painting I*, 622
MONET, CLAUDE, 177–78, 220, 362, 390; *Cathedral in Fog*, 178; *Cathedral in Sunshine*, 178; *Haystacks in Setting Sun*, 362; *Haystacks in Snow*, 363; *Old St. Lazare Station, Paris*, 360, 360; *Two Haystacks*, 362; *Water Lilies*, 412–13, 413–14, 414
MONIER, JACQUES, 552
MOORE, GEORGE, 385
MOORE, HENRY, 41–42, 215–16, 302, 343, 477; *Falling Warrior*, 231, 232; *Family Group*, 215, 216; *King and Queen*, *471; *Reclining Mother and Child*, 477; *Two Forms*, 449; UNESCO sculpture, 41–42, 42
MORANDI, RICARDO, 583; Parco del Valentino Exhibition Hall (Turin, Italy), 589, 589–90
MORISSEAU, ANDRE, marketplace (Royan, France), 554
MORRIS, ROBERT, *Earthwork*, 522
MORRIS, WILLIAM, 96, 152, 153
MOTHERWELL, ROBERT, *Elegy to the Spanish Republic, No. XXXIV*, *251; *Open No. 20*, 437
MOURGUE, OLIVIER, chairs, 164
MU CH'I, *Six Persimmons*, 340
MUNARI, BRUNO, *Campari*, 78
MUNCH, EDVARD, 18, 31, 33, 36, 170–71, 241, 244, 308; *Dance of Life*, 337; *Dead Mother*, 31, 32, 603; *Kiss*, 23; *Puberty*, 32, 33, *400; *Scream*, 53, 243, 243
MUYBRIDGE, EADWEARD, 345

Nachi Waterfall, 331, 331
NAGARE, MASAYUKI, Japan Pavilion at New York World's Fair, wall of, 535
NAKIAN, REUBEN, *Voyage to Crete*, 457
NARAMORE, BAIN, BRADY & JOHANSON, IBM Building (Seattle), 586
NASH, JOHN, Royal Pavilion (Brighton, Eng.), 572
NEGRET, EDGAR, *Bridge*, 504
NELE, EVE RENEE, *Couple*, *474
NELSON, GEORGE, 164
NERVI, PIER LUIGI, 95, 376, 545, 583, 593; Burgo Paper Mill (Mantua, Italy), 546; Little Sports Palace (Rome), 219, 590; Palazzo del Lavoro Exhibition Hall (Turin, Italy), 589, 589
NEUMANN, ALFRED, apartment house (Ramat Gan, Israel), 124
NEUSCHATZ, PERRY, convention hall (Phoenix, Ariz.), 556
NEUTRA, RICHARD, 104, 114, 125, 584–86; Kaufmann House (Palm Springs, Calif.), 113, 555

NEVELSON, LOUISE, 370, 481–82, 497, 499; *Royal Tide I*, 497, 498; *Totality Dark*, 498
New Zealand: Maori prow ornament, 468
NEWMAN, BARNETT, 227–28; *Adam*, *271; *Broken Obelisk*, 353
NICHOLSON, BEN, 227–28, 370–71; *Painted Relief*, 228, 335; *Still Life*, 370, 370–71
NIEMEYER, OSCAR, 109–10; President's residence (Brasilia), 111
NIETZSCHE, FRIEDRICH, 201
NOGUCHI, ISAMU, *Big Boy*, 509; *Cube*, 352; *Floor Frame*, 504; *Monument to Heroes*, 51
NOLDE, EMIL, 310; *Prophet*, 310, 310
Norwegian: Oseberg ship-burial, animal head from, 468
NOWICKI, MATTHEW, 139; J. S. Dorton Arena (Raleigh, N.C.), 139, 139

O'KEEFFE, GEORGIA, 343
OLDENBURG, CLAES, 424, 431, 487, 488, 658; *Soft Pay-Telephone*, 483; *Stove*, 487, 487; *Two Cheeseburgers, with Everything (Dual Hamburgers)*, 658, 658
OLITSKI, JULES, *Magic Number*, *210; *Prinkep*, 438
OPPENHEIM, DENNIS, *Annual Rings*, 521
OPPENHEIM, MERET, *Object*, 144, 262
Orchard Lake, Chapel of Our Lady (Oakland, Mich.), 543
ORDONEZ, JOAQUIN ALVARES, Manantiales Restaurant (Xochimilco, Mex.), 253–55, 254
OROZCO, JOSE CLEMENTE, 53–55, 207; *Gods of the Modern World*, 54, 54; *Mechanical Horse*, 207, 208

PANI, MARIO, band shell (Santa Fé, Mex.), 588, 589; *Square of the Five Towers*, 205
PANTON, VERNER, Living-Eating-Relaxing Tower, 97
PAOLOZZI, EDUARDO, 49, 367, 512; *Japanese War God*, 366, 367; *Medea*, 48; *Saint Sebastian No. 2*, 319
PASCIN, JULES, 443
PASMORE, VICTOR, *Linear Development No. 6: Spiral*, 284
PAULIN, PIERRE, undulating furniture, 115
PAXTON, SIR JOSEPH, 95, 545, 583; Crystal Palace (London), 545–48, 549
PEARLSTEIN, PHILIP, *Two Seated Models*, *190
PEI, I. M., 584–86; Everson Museum of Art (Syracuse, N.Y.), 104, *576
PEPPER, STEPHEN, 357, 360–61
PERRET, AUGUSTE, 553, 583
Peruvian: Portrait jar (from the Chicama Valley), 460
PETERDI, GABOR, 486; *Black Horne*, 484
PETO, JOHN, 193–94
PEVSNER, ANTOINE, 479–81, 506–7, 527; *Bird in Flight*, 138; *Construction in the Egg*, 481; *Developable Column*, 481, 481; *Maquette of a Monument Symbolizing the Liberation of the Spirit*, 51; *Realist Manifesto* (book), 507; *Torso*, 332, 480, 480
Pharaoh Khafre, 477–78, 478
Philippine: Carved spoon (Luzon), 146
Piazza San Marco (Venice), 134, *537
PICASSO, PABLO, 22, 31–33, 34–36, 44, 61–62, 80–81, 84–90, 171, 196, 199, 201, 207, 214, 225, 234, 243, 265–67, 285–86, 288, 312, 349, 368, 370, 372–73, 421, 427, 480, 617, 655–56; *Baboon and Young*, 265; *Bottle of Suze*, 81, 81; *Dancer*, 640; *Daniel-Henry Kahnweiler*, 82; *Demoiselles d'Avignon*, 634, 635, 637–40, 638–39, *641, 649–50, 659; *Design*, 80; *Diaghilev and Selisburg*, 285; *Fishing at*

SPENCER, STANLEY, 39; *Christ Preaching at Cookham Regatta . . . Four Girls Listening*, *39*, *39; Self-Portrait*, *187*
Speyer Cathedral (Germany), crypt, *567*
STACCHINI, UGO, Milan Railway Station, structural steelwork in, *550*
STANCZAK, JULIAN, *Gossip*, *322*
STANKIEWICZ, RICHARD, 204, 376, 485–86; *Europa on a Cycle*, *484*, 485–86; *Secretary*, 264, *264*
STEINBERG, SAUL, 287; *Diploma*, *281*
Stele of Aristion (from Attica), *657*
STELLA, FRANK, 441; *Sangre de Cristo*, *440; Sinjerli Variation I*, **212*
STELLA, JOSEPH, 67–68; *Battle of Light, Coney Island*, 67–68, *68*, 345
STIEGLITZ, ALFRED, 59; *Steerage*, *59*, *60*
STONE, EDWARD DURELL, 253–55, 584–86; Beckman Auditorium, California Institute of Technology (Pasadena), 586, *586*; United States Pavilion, Brussels World's Fair, 253, *253*
Stonehenge *529*, *530*
STRADIVARI, ANTONIO, 143
STROHEIM, ERICH VON, *Greed* (film still from), *595*
SULLIVAN, LOUIS, 154, 583; cast-iron ornament over main entrance to Carson Pirie Scott and Co. Department Store (Chicago), *593*
SUTHERLAND, GRAHAM, *Thorn Trees*, **252*, 296
Swiss National Exposition (Lausanne), *581*

TAKIS, *Signal Rocket*, *511*
TAMAYO, RUFINO, 234; *Animals*, 234, *235*
TANGE, KENZO, 111; Imabari City Hall, 111; Kagawa Gymnasium, *335;* Kurashiki City Hall, 111, *112;* Peace Museum at Hiroshima, 111; Tokyo City Hall, 111
TANGUY, YVES, 216, 274; *Infinite Divisibility* 273, *274*
TAPIES, ANTONI, 414; *Campins Painting*, *410*
TATLIN, VLADIMIR, 479
TCHELITCHEW, PAVEL, 259; *Hide-and-Seek*, 259–61, *261*
TENIERS, DAVID, *Picture Gallery of Archduke Leopold Wilhelm*, *416*
THIEBAUD, WAYNE, *Pie Counter*, *425; Seven Jellied Apples*, *340*
THONET, GEBRÜDER, 157, 449; rocking chair, *158*
TINGUELY, JEAN, 446, 485, 492, 515–17, *516; Homage to New York*, 492, *492*, 515, 515–17; *Rotozara*, *356; Méta-Mécanique*, 515–17, *516; Monstranz*, 41
TINTORETTO, 308
TITIAN, 308, 380, 389, 390
TOBEY, MARK, 68, 370, 654; *Broadway*, 68, *69; Edge of August*, **269; Tundra*, 654
TOMLIN, BRADLEY WALKER, 227–28, 343, 654; *No. 10*, 228, *228*
TOOKER, GEORGE, 55; *Government Bureau*, 55,

57; *Subway*, 66
TORROJA, EDUARDO, 545, 557, 583; grandstand, La Zarzuela Racecourse (Madrid), *588*, *589;* Tordera Bridge joint, *551*
TOULOUSE-LAUTREC, HENRI DE, 84–90, 179–81 239, 241; *À la Mie*, *240; Maxime Dethomas*, *305;* M. *Boileau at the Café*, *179*, *180*
TOVAGLIA, PINO, 80; railway poster, 80, *80*
TOVI MURRAY, *Tovibulb*, *326*
TROVA, ERNEST, *Study: Falling Man (Figure on Bed)*, 513–15, *515; Study: Falling Man (Landscape #1)*, *514*, 515
TURNER, JOSEPH MALLORD WILLIAM, 178, 311; *Snow-Storm: Steam-Boat off a Harbour's Mouth*, *179*
Tutankhamen's throne, *146*

Uma-Mahesvara Murti (Siva with Parvati and Host), **454*
UPJOHN, RICHARD, Trinity Church (New York), *347*
UTZON, JOERN, model of Sydney Opera House, *341*

VAIL, LAWRENCE, *Bottle with Stopper*, *149*
VAN DER VELDE, HENRI, 152
VAN DOESBURG, THEO, 300–2, *429; Composition: The Cardplayers*, 300–2, *302*
VAN EYCK, JAN, 378; *Man in a Red Turban*, *388; Virgin and the Canon Van der Paele*, **393*
VAN GOGH, VINCENT, 39, 40, 42, 205, 230, 231, 241, 370, 389, 407–8; *Landscape with Olive Trees*, *21; Ravine*, *407*, 408; *Starry Night*, 39, 40, *40*, 205
VAN HOEYDONCK, PAUL, *Couple*, *459; Space-Boys*, *459*
VANTONGERLOO, GEORGES, *Construction y–2x³–13.5x²–21x*, *504*
VASARELY, VICTOR, *Kalota*, *435; Vega*, *92*
VELAZQUEZ, DIEGO, 59; *Pope Innocent X*, **397; Sebastian de Morra*, *185*
VENTURI, LIONELLO, 372–73
VERMEER, JAN, *Woman Weighing Gold*, *194*
VERONESE, PAOLO, *St. Mennas*, *390*
VICTOR BISHARAT/JAMES A. EVANS AND ASSOCIATES, General Time Building (Stamford, Conn.), *254*
VICTOR GRUEN ASSOCIATES, Cherry Hill Shopping Center (Cherry Hill, N.J.), 131, *132;* Midtown Plaza (Rochester, N.Y.), 131, *132;* Southdale Shopping Center, 131
VILLON, JACQUES, *Portrait of the Artist's Father*, *355*
VITRUVIUS, 99
VIVAS, ELISEO, 350
VOULKOS, PETER, 488, 517; *Firestone*, *48; Gallas Rock*, 488, 517, *518*

WARHOL, ANDY, 342, 424–27, *429; Brillo*

Boxes, *342; Marilyn Monroe*, 424, *424*
WATTEAU, ANTOINE, 654; *Embarkation for Cythera*, 654, *655*
WEBER, MAX, 247; *Hassidic Dance*, 247, *247*
WEGNER, HANS, 103, 163; armchair, *162*, 163
WELTON BECKET AND ASSOCIATES, First State Bank (Clear Lake City, Tex.), *562*
Wentbridge Viaduct (Doncaster, Eng.), *555*
WESSELMANN, TOM, 424; *Great American Nude No. 51*, *445; Still Life No. 15*, *424*
WESTERMANN, H. C., 462, 501; *Big Change*, 462, *463; Memorial to the Idea of Man, If He Was an Idea*, 501, *501; Nouveau Rat Trap*, *75*
WESTON, EDWARD, photograph of halved artichoke, *218*
WHITEHEAD, ALFRED NORTH, 54
WHITMAN, ROBERT, 431
WHITNEY, ELI, 150
WIENE, ROBERT, *Cabinet of Dr. Caligari* (film stills from), 259, 595
WILLIAMS, ELMER, 244
WILLIAMS, HIRAM, *Guilty Men*, *245*
WIMBERLY, WHISENAND, ALLISON & TONG, model of Waikiki branch, Bank of Hawaii *584*
WÖLFFLIN, HEINRICH, 306, 365–73, 389, 507
WOOD, GRANT, 176; *American Gothic*, *175*, 176, 489
WRIGHT, FRANK LLOYD, 99–103, 104, 108, 111, 112, 114, 125, 154, 219, 255, 343, 557, 583, 589, 620; armchair, *159;* Broadacre City plan, 117–19, *119;* David Wright House (Phoenix, Ariz.), *113;* Fallingwater (Bear Run, Pa.), 101, *102;* Hanna House (Palo Alto, Calif.), 103, *103;* Johnson Wax Administration and Research Center (Racine, Wis.), 108, *109*, 136, 136–37, 589; Kalita Humphreys Theater (Dallas, Tex.), *560;* office armchair on swivel base, 158, *159;* Robie House (Chicago), 101, *101;* Solomon R. Guggenheim Museum (New York), 219, 220, 343, 414, *415*, 554–55, **573;* Taliesin East (Spring Green, Wis.), *102*, 102–3; Wayfarer's Chapel (Palos Verdes Estates, Calif.), *581*
WRIGHT, RUSSELL, 164
WYETH, ANDREW, 175, 182, 185, 197, 387, 389; *Christina's World*, *174*, 175, 185–86, *198*, 199
WYMAN, GEORGE HERBERT, Bradbury Building (Los Angeles), 544, *544*

YAMASAKI, MINORU (*see also* Minoru Yamasaki and Associates), 139, 255, 584–86; St. Louis Airport Terminal, *139*
YVARAL, *Acceleration 19, Series B*, *434*

ZACHAI, DONAN, *Complacent Man*, *518*
ZERBE, KARL, 36; *Aging Harlequin*, 36, *37*
ZEUXIS, 200
ZORACH, WILLIAM, *Embrace*, *24*

INDEX OF SUBJECTS

Ash Can School, 59, 184
Assemblage, 264–65, 274–76, 421–24; sculptural, 482–93, 524
Asymmetrical balance, 334–39
A-tectonic form, 368–70
Automobiles: appeal of, 125; bumpers, sculpture and, 274–75; highway planning and, 125–28; mass production, 150; sportcar aesthetics, 127

Babylonian architecture, 534, 541
Balance, 333–39, 352, 353; asymmetrical, 334–39; by contrast, 337–38; and formal order, 206–7, 215, 220; hidden, 333; by interest, 337; symmetrical, 333; by weight, 334–37, 338–39
Baroque art, 412; illumination, 307–8; sculpture, 468–77; stylistic development in, 367, 368, 370
Bauhaus, 479; architectural influence, 104, 108; craft influence, 108, 152–53, 163; industrial design and, 155, 483
Beauty: as aesthetic expression, 49; in Greek art, 200–1
Billboards, 129
Biomorphic order, 213–20; in architecture, 219; in sculpture, 213–16; Surrealism and, 216–19
Biomorphic shape, 295–300
Box sculpture, 493, 497–501
Brick architecture, 535–41
Bridge architecture, 544–45, 549, 564, 567
Brise-soleil, 109
Bronze sculpture (see also Sculpture), 449–52, 460, 506
Broadacre City, 117–19
Brooklyn Bridge, 545
Brushwork, 176–77, 182; technique in direct painting, 391–405, 409, 413
Byzantine: art, 656; domes, 577–78

Camp, 495
Cantilever construction, 560–62
Caricature, 71, 241
Carpenter Gothic style of architecture, 176
Cartoons, 71–72, 292, 511; cinematic, 600
Carving, 449–52, 482
Casein paint, 389
Casting, 449–58, 482, 506
Cast iron, in architecture, 544–48
Cave painting, 29, 174
Ceramic sculpture, 477–79, 488; pottery, 517
Chairs (see also names of designers in Index of Names and Works), 108, 155–64
Chance arrangement, 409
Chiaroscuro, 304
Chicago School of architecture, 548
Children: art of, 174, 283, 623; and fantasy, 256; imagery of, 90; myths and, 258; psychic distance and, 354
Christian art, see Religious art
Cinematic media, 128–31, 176, 387, 424, 594–608; collective creativity in, 76; continuous-flow rhythm, 345; criticism and, 605–8; democracy of, 604–5; devices and techniques, 598, 600; documentary films, 600–1; dreams and, 603–4; emotion and experimentalism in, 255; filmed vs. televised imagery, 601–3; forms of, 600–1, 605; graphic arts and, 84–90; illusionism in, 193; light physics and, 527; love and marriage in, 26; myth and, 258; social description, 63; social effects of, 601–3, 604–5; space-time manipulation, 596–98; typology of, 605; visual continuity sequence, 598

City planning, 96, 115–42; greenbelts, 117; highways, 125–28; Howard's Garden City, 116–17; industrial and commercial structures, 135–39; industries and, 116, 117, 119; Le Corbusier's Ville Radieuse, 119–22; mass production of housing units, 121–22; megastructures, 141, 583; Modulor for, 120–21; plazas, malls, civic centers, 128–35; principles, 119, 122; residential grouping, 122–25; shopping centers, 120, 131–32; streets, 122–24, 130; suburbs or satellite towns, 117; transportation, 119–20, 122–24, 125–28; utopianism and fantasy, 256; Wright's Broadacre City, 117–19
Cityscape, social description and, 64–68
Classicism (see also Formal order), 200–29
Clay, in sculpture, 451, 452, 458–60
Climate control, 99
Closed form, 368–70
Closure, in aesthetics, 360–65
Coffers, 577
Cognitive validity, in criticism, 623–24
Coherence in design, 329–31
Collage (see also Assemblage), 421–23, 427
Collecting art, criticism and, 613
Collective art, 76
Color, 310–18; Abstract Expressionism, 318; and aesthetic order, 220–27; analogous, 312; complementary, 312; consultants, 312; cool, 312; Cubism, 317; Der Blaue Reiter, 317; Die Brücke, 317; Expressionism, 317; Fauves, 317–18; focus and, 197; form and, 197; functions of, 197; hue, 311; illumination and, 197; Impressionism, 177–79, 220, 311, 317, 413; intensity, 311; as language, 312–18; limited palette, 312; local, 311–12; objective accuracy and, 197–99; optical, 312; organs, 312; Orphism, 317; Post-Impressionism, 317; Synchronism, 317; theory in physics, 311; tonality, 312; value, 311; vibration, 408; warm, 312
Color-field painting, 435–38
Combine art, 427–29
Comic art, see Caricature; Humor
Commercial art, see Advertising art; Graphic arts
Communication, art as, 6; distinguished from expression, 19; graphic arts, 76–93
Community planning, see City planning
Complementary color, 312
Composition, 308; in Impressionism, 179
Concrete in architecture: poured, 107–11, 541; prestressed, 555–56; reinforced, 110, 541, 552–55
Connoisseurs, as critics, 650
Constructivism, 449, 479–81, 502
Constructors and sculptors, 583–96
Contrapposto, 239
Contrast, balance and, 337–38
Coordinatograph, 302, 411
Crafts: appeal of, 144; and Bauhaus, 152–53; handcraft characteristics, 142–49; and industrial design, 142–64; industrialization and, 95–96; Industrial Revolution and, 150–52; revivals, 95, 152; sculpture, 517–18
Craftsmanship, defined, 376–77
Criticism, 611–61; artistic response to, 613–14; of cinematic media, 605–8; collecting art and, 613; connoisseurs, 650; critical sensibility, 615–16; of Demoiselles d'Avignon, 635, 637–40, 649–50; description, 635–37; emotion and, 230–31; expressivism, 623–25; formal analysis, 637–45; formalism, 620–23; historical comparisons, 651–53; instrumentalism, 625–30; interpretation, 645–50; intuitive, 619–20; journalistic, 613, 616–17; judgment, 620–30, 650–61; Marxist, 627–30;

mimetic theory, 648–49; of originality, 624, 653–56; pedagogical, 617–19; performance of, 634–61; popular, 619–20; purposes of, 612–14; scholarly, 613, 619; of technique, 656–61; theory of, 611–33; tools of, 377, 614–16; types of, 616–20
Cubism, 26–29, 42, 44, 47, 247, 308, 345, 479, 480; Analytic, 29, 44, 82, 207, 368; color, 317; formal order and, 205, 207; graphic arts and, 80–82; intellectual order, 207; Synthetic, 317

Dada, 409, 427, 429–30, 499
Dark (darkness), use of, 303–11; in Baroque art, 307–8; in modern art, 308–11; symbolism of, 306
Death and morbidity, in art, 29–33
Decalcomania, 410–11
Der Blaue Reiter, 317
Description, in criticism, 635–37
Design (see also City planning; Domestic architecture; Industrial design), 324–49, 351; balance in, 333–39; principles of, 325–27; proportion, 345–49; rhythm in, 340–45; unity, 327–31
Despair and anxiety in art, 243–46
De Stijl, 429, 435, 479
Die Brücke, 317
Dionysiac tendency in art, 201
Direct painting, 387–409; brushwork, 391–405, 409, 413
Distant stimuli, 362–64
Distortion: in caricature, 241; emotion and, 238–42, 246; Expressionism, 246; objective accuracy and, 181, 185; photographic, 238–39; proportion and, 349; in satire, 241–42
Documentary films, 600–1
Domes, 571–78; coffers in, 577; geodesic, 580; oculus or lantern in, 571; pendentive, 577; squinches of, 577–78
Domestic architecture (see also City planning), 96–115; apartment houses, 99, 111–12, 114–15, 119–22; appliances and labor-saving devices, 98; climate control, 99; family and home interaction, 96 98, 528; furnishings, 98–99, 102–3, 105; interior decoration, 102–3, 105, 114; Le Corbusier's work and influence, 107–12, 121; materials and techniques, 98–99, 101, 114; Mies's work and influence, 103–7; modern, 112–15; ornament, 101; site, 99, 113; space, 114; Wright's career and influence, 99–103
Dominance in design, 327–29, 331
Dreams, expression in art (see also Fantasy), 261–67; cinematic media and, 603–4; Surrealism and, 261–64

Earth sculpture, 519–23
Eclaboussage, 411
Eclecticism, 248–53
Effigy painting, 439
Egg tempera (see also Tempera painting), 389
Egyptian art: architecture, 529–30, 533, 541; effigy painting, 439; sculpture, 30, 452, 466, 477–78
"Eight, The," 59
Emotion, as art style, 230–55; in architecture, 253–55, 583–84, 590–92; anxiety and despair, 243–46; brushwork and, 392–406; criticism and, 230–31; distortion and, 238–42, 246; emotional perception theory, 231; Expressionism, 246; formal order and, 205; joy and celebration, 247–55; organizational sources and, 231; psychology and, 230–31,

Motion: as artistic device, 42, 44, 46, 67, 203; Dionysiac tendency and, 201; mobiles, 46–47; kinetic sculpture, 506–18
Motion pictures, see Cinematic media
Monolithic sculpture, 466–79, 480
Monuments, public, 51
Movement, cinematic media and, 596–98
Multiplicity, as aesthetic category, 370–71
Music and art, 68, 312, 338
Myths and art, 31, 258–61; and sculpture, 462

Nationalism, in art, 176
Naturalism (see also Objective accuracy), 172
Near Eastern art, 225
Neo-Plasticism, 435
News media, see Graphic arts
New York School of painting, 405
Niches, 493, 497
Nonobjective art (see also Abstraction), 45–46, 312–17

Objective accuracy: appeal of, 175; attitudes of artist, 176–85; color and, 197–99; detachment of artist, 177–81; devices of, 195–99; distortion and, 181, 185; focus and, 196–97; idealization in, 188; illumination in, 195, 199; illustration of reality, 172–73, 175; illusionism and, 193–94, 199; imitation of appearances, 174–76, 230; impersonality of technique, 176–77; individual variations, 185–94; light and, 177–78; line and, 196; magic realism, 188–93; modeling in, 195; and narration, 175–76; perspective in, 183–84, 197–98; "primitive" art and, 186; selection of detail in, 182–85; trompe l'oeil, 175, 193–94
Obscene art, 441–46
Oculus, 571
Oil painting: advantages of, 378–80; discovery of, 378
Op art, 93, 318, 412, 433–35, 441; rhythm in, 341–42, 343, 424
Open form, 368–70; in sculpture, 467–77, 479
Optical art, see Op art
Optical color, 312
Organic shapes, 295–300; Art Nouveau and, 104
Originality, evaluation of, 624, 653–56
Orphism, 248, 317

Painterly mode, 367
Painting (see also names in Index of Names and Works; specific schools, styles, and subjects), 376–447; action painting, 405, 409, 413; as architecture, 414–16; assemblage, 421–24, 481–82; brushwork, 391–405, 409, 413; collage, 80–81, 421–23, 427; color-field, 435–38; combine art, 427–29; decalcomania, 410–11; direct technique, 387–409; dramatic enactment in, 411–12; durability, 380–87; éclaboussage, 411; encaustic, 389; erotic and obscene art, 441–46; fresco painting, 378–79, 389; frottage, 409–10, 433; glazes, 389, 408; grattage, 410; Happenings, 429–31; indirect technique, 308, 389, 405–9; landscape, 20–22, 64–68, 348–49; large-scale, 412–16, 424, 437; minimal, 435–38; music and, 68, 312, 338; oil painting, 378–80; portraiture, 19–20; sculpture and, 379, 410, 421–29; shaped canvas, 438–41; "splatter" idea in, 411, 427–28; stylistic development in, 365–73; techniques, 378–412, 438; tempera, 378–79, 381, 387–89; varnish, 389; wet-in-wet, 378, 383

Paleolithic art, see Prehistoric art
Pendentives, 577
Perception, 280; absolute and relative clarity, 371–72; aesthetics and, 44, 231; closed or tectonic form, 368–70; defined, 351; funded (funding; fusion), 351, 357–60; Gestalt psychology and, 345, 360–65; large-scale painting and, 413–14; light and, 306–7; linear mode, 367; multiplicity and unity, 370–71; open or a-tectonic form, 369–70; painterly mode, 367; planar mode, 367–68; psychic distance and, 354–56; recessional mode, 367–68; Wölfflin's categories, 365–73
Persian art, 225
Personal functions of art, 18, 19–49; aesthetic expression, 44–49; expression of death and morbidity, 29–33; expressions of illness, 33–37; love, sex, and marriage, 22–29; psychological expression, 19–22; spiritual concern, 39–44
Personality, style and, 202, 207
Perspective, 197–99; in caricature, 241; illusionism and, 199; objective accuracy and, 183–84, 197–99; space-time manipulation, 597; in Surrealism, 199
Photographic realism (see also Objective accuracy), 172
Photography, 172, 175, 193, 230, 238–39, 387
Physical functions of art, 94–164; architecture: dwellings, 96–115; city planning, 115–42; crafts and industrial design, 142–64; defined, 94
Pilotis, 108, 109, 560
Planar mode, 367–68
Plastics in sculpture, 449, 457–58, 479, 480
Platonism, 203–4, 622
Plywood, 160, 161, 462, 531
Plazas, malls, civic centers, 128–35
Political expression in art, 52–62; and criticism, 625–30; satire, 54, 70–75
Polymer tempera, 389
Pop art, 75, 487, 489; camp and, 495–97; rhythm in, 342
Portraiture, psychological expression in, 19–20
Post-and-beam construction, 99
Post-and-lintel construction, 557–60
Posters, see Graphic arts
Post-Impressionism, 317
Pottery, 517
Poured concrete, 107–11, 541
Poverty, expression of in art, 34
Prägnanz, Law of, 361, 363–64
Prehistoric art, 29, 108, 174
Primary structures, 502–5
Primitivism, 186, 267; Environments and, 430–31; fantasy and, 257
Printmaking, 255, 310; frottage and, 410
Propaganda, art as (see also Social functions of art), 51; satire, 71–72
Proportion in design, 345–49; architectural, 349; Classical, 200–2; distortion and, 349; Gestalt psychology and, 345; Golden Section, 345; human figure and, 200–1, 345–46; landscape painting, 348–49; Modulor, 120–21, 345
Proximal stimuli, 362–64
Psychic distance, 354–56
Psychological expression in art, 19–22, 202, 207, 230–31, 238, 255, 435
Psychology (Gestalt), and aesthetics, 345, 360–65

Realism (see also Objective accuracy), 172
Recessional mode, 367–68
Recognition, role of, 44

Reductionism, 435–38, 477
Regionalism in art, 176
Reinforced concrete (ferroconcrete), 110, 124, 541, 552–55
Relative clarity, 371–72
Relevance, 54; as critical criterion, 624–25
Religious art, 39–40, 452, 467, 468; architecture, 39–40, 530, 571–78, 586; criticism of, 626; spiritual art compared to, 39
Renaissance, 76, 95, 184, 199, 274, 304, 378, 380–81, 468; architecture, 566; painting, 596–97; stylistic development in, 367, 368
Repoussoir, 199
Residential grouping, 122–25
Revolutionary art, in Latin America, 53–55
Rhythm in design, 340–45; alternation and, 342; in architecture, 342–43; defined, 340; as progressive flow, 342–43; repetitive, 341–42, 345, 424
Roads: highways, 125–28; residential grouping and, 122–24
Rockefeller Center, 132–33
Roman art, 349, 493; architecture, 566, 569, 651
Romanesque: architecture, 534, 541, 566–67, 568–69; painting, 55; sculpture, 468
Romanticism, 33; emotion and, 233–38, 245; line in, 283; political and ideological expression and, 53; in sculpture, 234–36; Surrealism and, 273

San Francisco School of painting, 243–44
Satire, 54, 70–75, 82, 241–42;
Scientific fantasy, 267–73
Sculpture (see also names in Index of Names and Works), 448–527; ABC art, 505; abstraction in, 46; academicism in, 468–77; aesthetic order in, 227; African, 214; architecture and, 227, 583–96; assemblage, 264–65, 274–76, 482–93; biomorphic order in, 213–16; box sculpture, 493, 497–501; carving, 449–52, 482; casting, 449–58, 482, 506; ceramic, 477–79, 488; chairs as, 157; clay, 451, 452, 458–60; Constructivism, 449, 479–81, 502; crafts, 517–18; distortion in, 185, 241; dramatic enactment and, 411–12; earth sculpture, 519–23; Egyptian, 30, 452, 466, 477–78; emotion and, 234–36, 243, 255; fantasy in, 264–65, 274–76; focus in, 196; formal order and, 202–3, 207, 213–19, 227, 468–69; Gothic, 468, 451–52, 467; Greek, 53, 451–52, 467; grottoes, 493–95; humanitarian, 59–61; indirect execution of, 452; industrial design and, 274–75, 483–84; intellectual order, 207; kinetic, 506–18; light and, 195–96, 304, 306, 525–27; line in, 288–90, 468, 479–80, 524–25; love treatment in, 22; marble, 449–52; metal, 449–52, 460; minimal, 477; mobiles, 46–47, 507–8; modeling, 449–51, 482; monolithic, 466–79, 480; niches, 493, 497; nomadic, 467–68; objective-accuracy style, 172, 174; open-form, 467–77; organic shape in, 295–98; origins, 29–30; painted, 451, 458; and painting, 379, 410, 421–29; plastics, 449, 457–58, 479, 480; political and ideological expression and, 53; pottery, 517; primary structuralists, 502–5; psychological expression, 19–20; Romanticism in, 234–36; serial sculpture, 477, 505; silhouette in, 306; spirituality in, 41–42; stylistic development in, 368; system sculpture, 505; terra cotta, 457; texture in, 319; wax, 462–64; wood, 460–62
Serial sculpture, 477, 505
Sex, as expressed in art, 22–29, 309, 441–46
Shape (see also Line), 65–67, 293–302; geo-

metric, 208, 295, 298–302; line in relation to, 294; and objective accuracy, 195; organic or biomorphic, 295–300; in sculpture, 295–98

Shaped canvas painting, 438–41

Shell structures, 578–83

Shopping centers and plazas, 120, 131–32

Silhouette, 304, 306

Skyscrapers (*see also* Architecture and architects), 99, 349, 550–52; . Le Corbusier's Ville Radieuse, 119–22

Social description, 61, 63–68

Social functions of art, 50–93; and criticism, 625–30; defined, 50; humanitarianism, 55–59; political and ideological expression, 52–62; satire, 70–75; social description, 61, 63–68; style of emotion and, 233

South America, 109

Space-time manipulation, 596–98

Spandrel, 566

Spirituality in art (*see also* Religious art), 39–44; formal order and, 205

Squinches, 577–78

Steel, structural, 544, 548–52, 554

Stone, in architecture, 531–35

Streets, residential grouping and (*see also* Highways), 122–24, 130

Structure of art (*see also* Aesthetics; Design; Visual elements), 278–79

Style (*see also* names of artists in *Index of Names and Works*; specific forms); changes of, 170–71; characteristics and definitions of, 169–70; culture and, 170; culture power factors and, 201–2; eclecticism and, 248–53; emotion as, 230–55; fantasy, 256–79; inno-vative, 170–71; objective accuracy, 172–99; of formal order, 200–29; personality and, 171, 202; regional, 176; social changes and, 171; Wölfflin's categories of development of, 365–73

Styling, industrial design and, 154

Subordination in design, 327

Surrealism, 55, 90, 144, 248, 409, 479; Abstract Expressionism and, 262; biomorphic order in, 216–19; fantasy and, 216, 261–64, 273–76; illusionism, 193 94, 199, 273–76; literary approach of, 318; perspective, 199; Romanticism and, 273

Symmetrical balance, 333

Synchronism, 317

Synthetic Cubism, 317

System sculpture, 505

Tactile values, 321

Technique, defined, 376

Tectonic form, 368–70

Tempera painting, 378–79, 381, 387–89

Terra cotta, 457

Texture in art, 318–21; in architecture, 319; in sculpture, 319, 321

Tonality in color, 312

Transportation, city planning and, 119–20, 122–24, 125–28

Trompe l'oeil, 174, 193–94

Truss construction, 562–65

Ugliness, 49, 71

Unity: and design, 327–31; coherence, 329–31; dominance, 327–29; multiplicity and, 370–71; subordination, 327

Utopianism and fantasy, 257

Value of color, 311

Varnish, 389

Vault construction, 568–69

Ville Radieuse, 119–22

Violence in art, 231–33, 492

Visual continuity sequence, in films, 598

Visual elements (*see also* subjects), 280–323, 351; color, 3, 10–18; light and dark, 303–11; line, 281–93; perception and, 280–81; percepts of, 363; shape, 293–302; structure of art and, 278–79; texture, 318–21

Visual form, defined, 351

Voussoirs, 565

War: emotion and, 243–46; humanitarian art, 61–62; World War II, 37, 61, 71–72, 161, 176, 215

Wax sculpture, 462–64

Weight, balance by, 334–37, 338–39

Wet-in-wet painting, 378, 383

"Wild Beasts" (Fauves), 317–18

Wood architecture, 530–31, 541–53

Woodcuts, 310

Wood sculpture, 460–62

Ziggurats, 541

PHOTO CREDITS

The author and publisher wish to thank the libraries, museums, galleries, and private collectors named in the picture captions, for permitting the reproduction of works of art in their collections, and for supplying the necessary photographs. Photographs from other sources are gratefully acknowledged below.

Alinari (including Anderson and Brogi), Florence: 95, 98 above left, 201, 229, 379 above, 381, 386 below left, 452, 477 above left, 494 above left, 577 above right, 577 below right; American Airlines, New York: 116; American Crafts Council, New York: 152 below; American Museum of Natural History, New York: 294 below, 466 right; Amigos de Gaudí, Barcelona: 298 below; Wayne Andrews, New York: 140; George A. Applegarth, San Francisco: 220 below; Masao Arai, © 1970 by Shinkenchiku-Sha Co., Ltd., Tokyo: 335 above left; Archaeological Survey of India, New Delhi: 298 above; Archives Photographiques, Paris: 173 below; Art Institute of Chicago: 647 below; Arteaga Photos, St. Louis: 569 left; Artek, Helsinki: 108 below center; Association of American Railroads, Washington, D.C.: 513 left; Australian News and Information Bureau, New York: 341 below; Max Baker, New York: 432 below; Bank of Hawaii, Honolulu: 584 below; H. Baranger, Paris: 589 below left; Welton Becket & Assoc., Los Angeles: 562; Ken Bell Photography Ltd., courtesy of University of Toronto Public Relations Department: 141 center; Bethlehem Steel Corporation, Bethlehem, Pa.: 110 above right; Oscar Bladh, Stockholm: 123 below; Blue Ridge Aerial Surveys, Leesburg, Va., courtesy of Gulf Reston, Inc.: 118; Grace Borgenicht Gallery, New York: 484 above right; Boudot-Lamotte, Paris: 626 left; Bowdoin College Museum of Art, Brunswick, Maine: 571 below; Office of E. H. Brenner, Lafayette, Ind.: 579 above; British Leyland Motors, Inc., Leonia, N.J.: 127; British Tourist Authority, New York: 295 below; Brown Brothers, New York: 151 below left; Rudolph Burckhardt, New York: 144 left, courtesy of Leo Castelli Gallery, 149 right, 408 below, 445 above, courtesy of Sidney Janis Gallery, 461 below left, 504 above right, 505 below, courtesy of Leo Castelli Gallery; R. D. Burmeister, Clovis, New Mexico: 424 below; Caisse Nationale des Monuments Historiques, Paris: 545 below left; California Division of Highways, Sacramento: 126 below, 555 above; California Institute of Technology, Pasadena: 586 right; Canadian Consulate General, New York: 100 below, 580; Ludovico Canali, Rome: 537, 573 above; Félix Candela, New York: 588 center below; Leo Castelli Gallery, New York: 440 below; 484 above left; Central Technical School, Toronto: 588 above; Ron Chamberlain, Warwick, N.Y.: 491 below right; Victor Chambi, Cusco, Peru: 535 above; Chase Manhattan Bank, New York: 415 below, 584 above; Chicago Tribune: 371 left; Timothy Clarke, New York: 131; Geoffrey Clements, New York: 78 above, 90 above, 197 above, 408 above, 436 below, 441, 446 left, 491 above right, 510; Colorado Highway Commission: 128 above; CBS Television Network, New York: 36 right; Community Service Society, New York: 64 below; A. C. Cooper, Ltd., London: 257 below; Commonwealth United Entertainment, Inc., Beverly Hills, Calif.: 606 below, 607; Cordier & Ekstrom, New York: 421; Craft Horizons, New York: 160 center, 512 left; Craftsmen Photo Company, New York: 603 above; Thomas Y. Crowell, Inc., New York: 150, from Primitive Art by Irwin O. Christensen; George Cserna, New York: 218 above, 581 below left, courtesy of Harrison & Abramovitz; Cunningham & Walsh, Inc., New York: 524 right; Design M—Ingo Maurer, Munich: 326 below; Augustin Dumage, Paris: 321 below left; Dumas-Satigny, Orléans,

France: 467 above left; Dwan Gallery, New York: 516 above, 520, 521 below, 522 below; Eastman Kodak Company, Radiography Markets Division, Rochester, N.Y.: 285 above; John Ebstel, New York: 593 above; Edholm & Blomgren Photographers, Lincoln, Neb.: 348 below right; André Emmerich Gallery, New York: 502 below; Foto ENIT, Rome: 134 below, 571 above; Michael Fedison, courtesy of Western Pennsylvania Conservancy: 102 above; Jules Feiffer, New York: 597 above; Fischbach Gallery, New York: 502 above, 505 above; Ford Motor Company, Dearborn, Mich.: 151 above left, 514, French Embassy Press and Information Division, New York: 549 below; French Government Tourist Office, New York: 132 below, 548; Copyright Buckminster Fuller, Carbondale, Ill.: 100 above; Copyright David Gahr, New York: 515 right; Roger Gain, Paris: 164 left, 164 right; Garden State Parkway, Woodbridge, N.J.: 128 below; General Instrument Corporation, Microelectronic Division, New York: 302 below; General Motors Corporation, Detroit, Mich.: 138 below; German Information Center, New York: 591 above; German Tourist Information Office, New York: 587 below left; John Gibson, New York: 521 above; Giraudon, Paris: 642; Marianne Goeritz, Cuernavaca, Mexico: 205; Alex Gotfryd, New York: 82 above; Greater London Council: 592 above left; Greene & Greene Library, The Gamble House, Pasadena, Calif.: 563 below; Pedro E. Guerrero, New York: 113 below; Solomon R. Guggenheim Museum, New York: 220 above; Hanes Hosiery, Inc., New York: 153; Paul R. Hanna, Stanford, Calif.: 103 above; Office of Zvi Hecker, Montreal: 124 below; Hedrich-Blessing, Chicago: 102 below, from Bill Hedrich, 139 left, from Bill Hedrich, 106 above right, 106 below, 587 above left, from Bill Engdahl, 539 above; Lucien Hervé, Paris: 108 above left, 108 above right, 108 below right, 109 below left, 109 below right, 110, 112 below, 119 below, 120, 297 below, 346 right, 574 below; John T. Hill, New York: 103 below; Hirmer Verlag, Munich: 24 above right, 332 below left, 466 left, 478 right, 657 left; Michael Holford, London: 468 above left; Martin Hürlimann, Zurich: 572 above right; Illinois Institute of Technology, Chicago: 106 above left, 551 below; Institute Eduardo Torroja, Madrid: 588 below; Intourist, Moscow: 532; Alexander Iolas Gallery, New York: 410; Office of Philip Johnson, New York: 107 right, 369 below left; S. C. Johnson & Son, Inc., Racine, Wis.: 109 above, 136; Luc Joubert, Paris: 412 above; Finn Juhl, Ordrup, Denmark: 163 left; Office of Louis I. Kahn, Philadelphia: 576 above; F. L. Kenett, London: 50 right; G. E. Kidder-Smith, New York: 578 right; Kitchens of Sara Lee, Deerfield, Ill.: 138 above; Knoedler Gallery, New York: 353, 449; Knoll Associates, New York: 108 below left; Herman Landshoff, New York: 347 above right; Alicia B. Legg, New York: 492 below; Library of Congress, Washington, D.C.: 545 below right; Terry S. Lindquist, Miami: 432 above; Roger Lucas, New York: 518 below; Magnum Photos, Inc., New York: 27 below right, 96, 632 below; Manhattanville College, Purchase, N.Y.: 535 below; Michael Maor, Jerusalem: 542 below left; Foto Marburg, Marburg/Lahn: 567 left; Marlborough Fine Art, Ltd., London: 47 center, 244 above right; Marlborough Gallery, New York: 603 above; Maryville College, Maryville, Tennessee: 551 center; Foto MAS, Barcelona: 185, 299 below left, 494 below right; Pierre Matisse Gallery, New York: 91 below; Ministerio de Informacion y Turismo, Madrid: 587 below right; Ministry of Information, Baghdad: 536 above right; Ministry of Transport, Agent Authority, County Council of the West Riding of Yorkshire, England: 555 center; Ministry of Works, London, Crown Copyright: 529 right; Monkmeyer Press Photo Service, New York: 121 below, from Hugh Rogers; Peter